PULP HOPE 2

Published by
ARCHAIA™

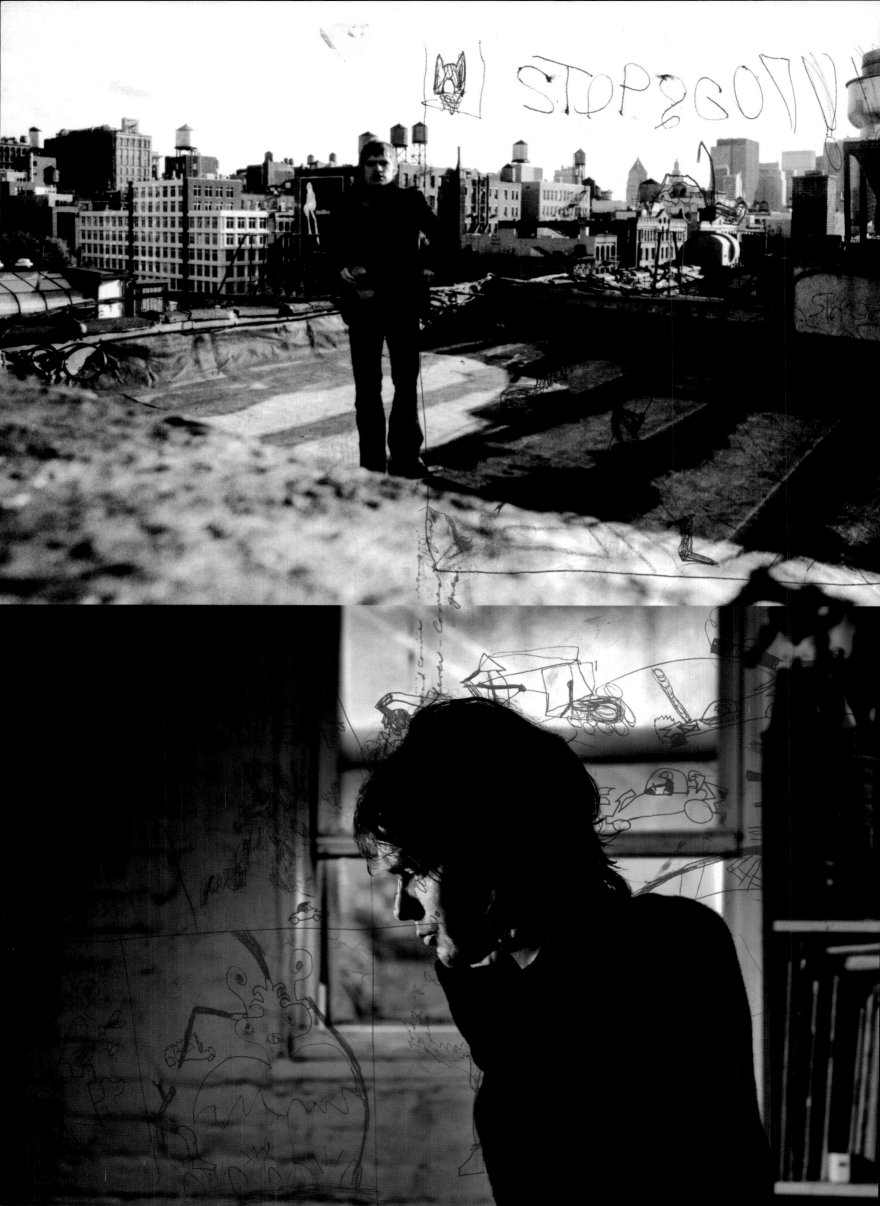

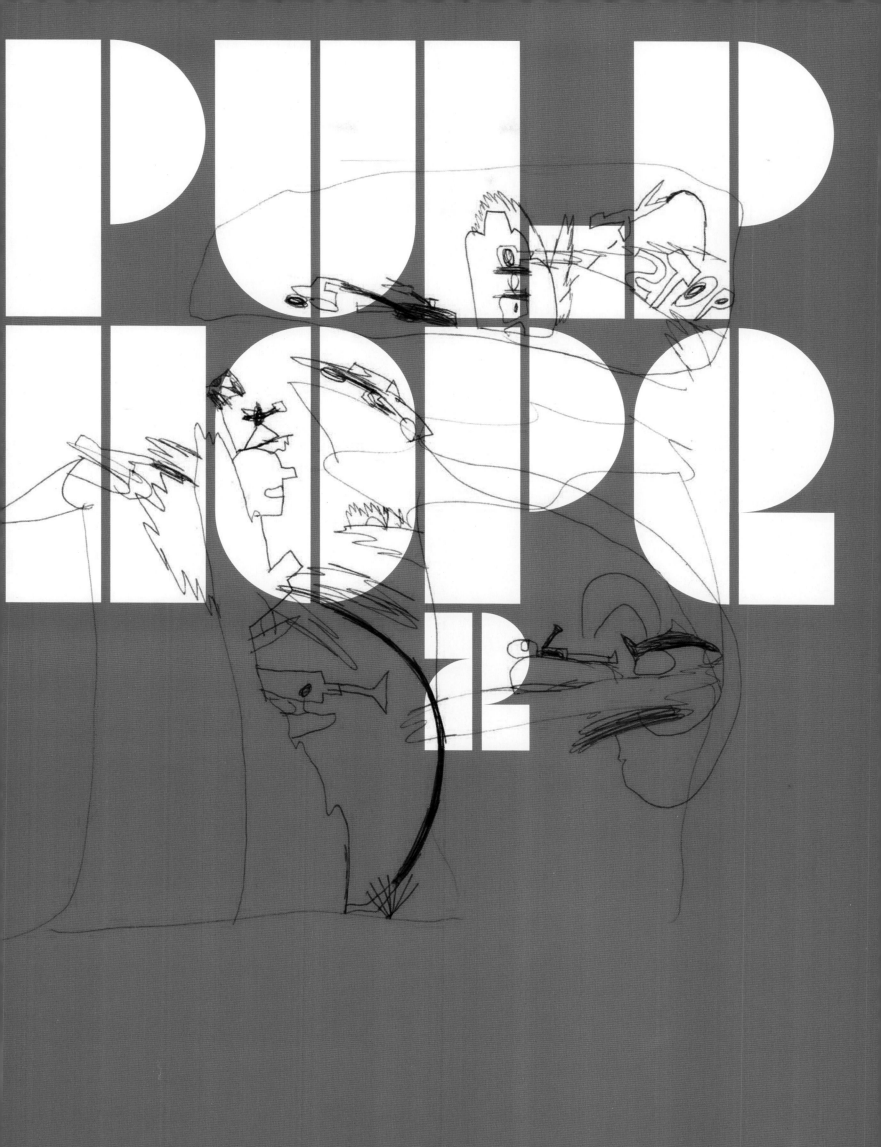

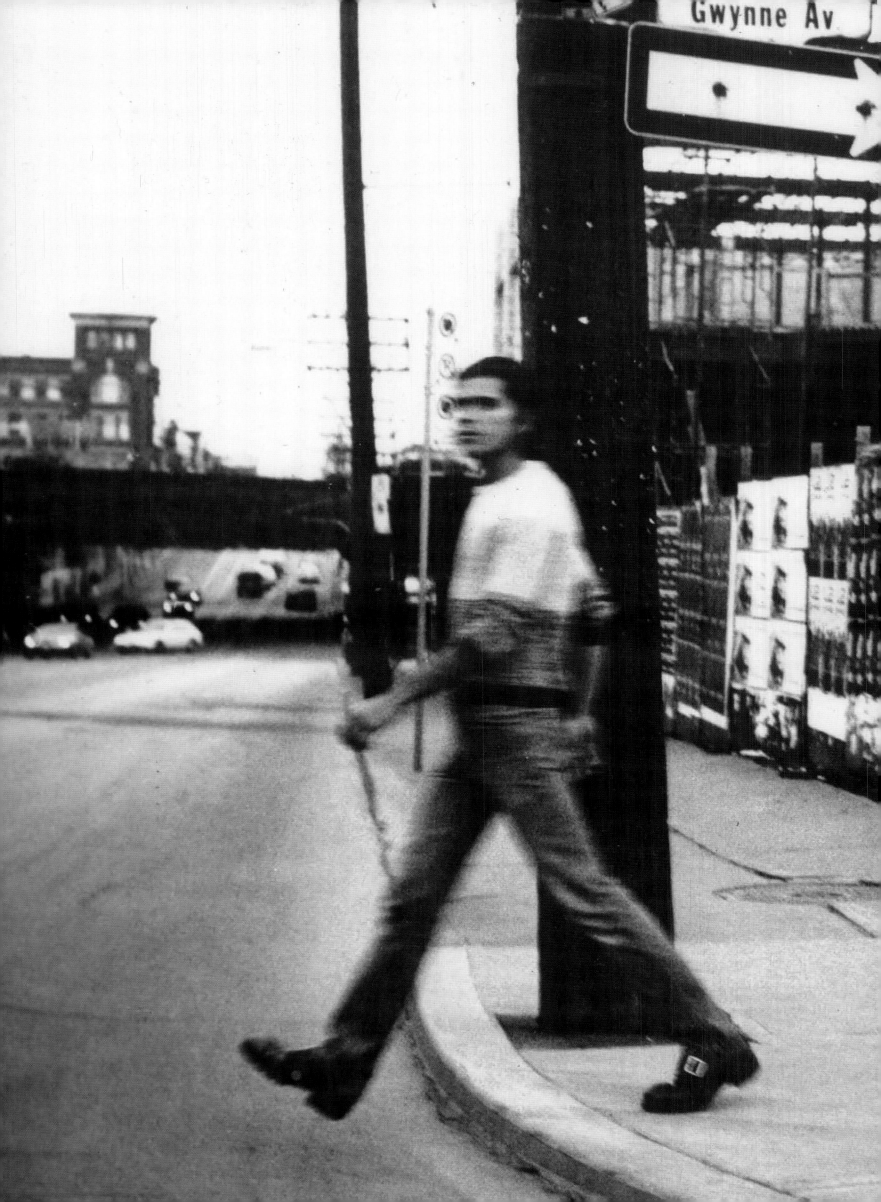

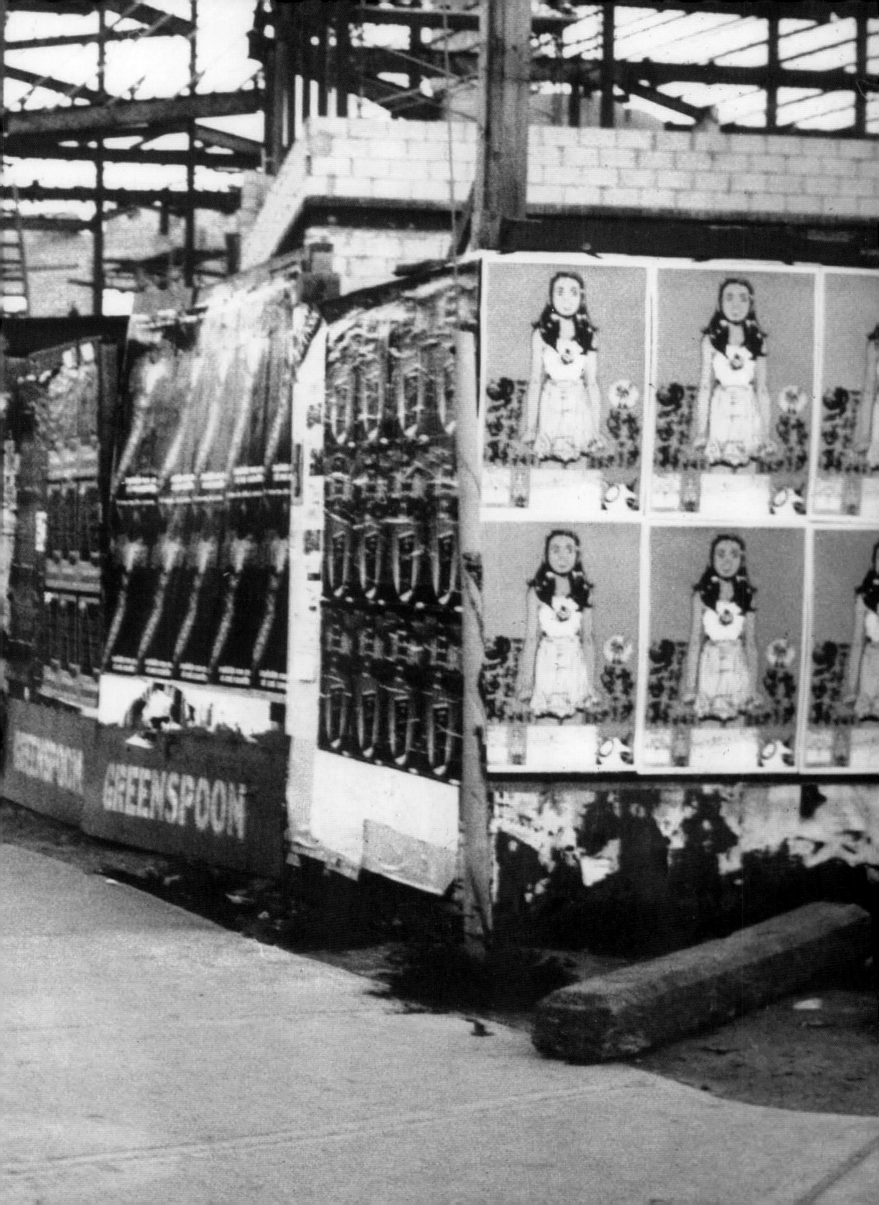

Designer
Steve Alexander

Archiving Assistant
Andrew Foster

Editors
Kathleen Wisneski & David Mariotte

Executive Editor
Bryce Carlson

Editor-in-Chief
Matt Gagnon

ARCHAIA™

PULPHOPE 2, February 2025. Published by Archaia, a division of Boom Entertainment, Inc. PULPHOPE 2 is ™ & © 2025 Paul Pope. All rights reserved. Archaia™ and the Archaia logo are trademarks of Boom Entertainment, Inc., registered in various countries and categories. All characters, events, and institutions depicted herein are fictional. Any similarity between any of the names, characters, persons, events, and/or institutions in this publication to actual names, characters, and persons, whether living or dead, events, and/or institutions is unintended and purely coincidental.

Archaia, 6920 Melrose Avenue, Los Angeles, CA 90038-3306. Printed in China. First Printing.

Softcover Edition ISBN: 979-8-89215-030-9
Hardcover Edition ISBN: 979-8-89215-029-3, eISBN: 979-8-89215-032-3
Hardcover Signed Edition ISBN: 979-8-89215-031-6

Acknowledgements

Special thanks to the creative collaborators on this project—
Andrew T. Foster, Chris Hunt, Bruno Seelig, James Harvey, Omar
F. Abdullah, David "The Vasic" Delloso, Lovern Kindziernski,
Yuko Shimizu, Jen Bender, Gui Marcondes, Daisuke Akita, Lee
Loughridge and Xylonol, Ron Wimberly, the team at Nakatomi
Inc, the team at Axelle Arts (RIP Bertrand), Luther Davis, Shay
Plummer, Jim Jones All Stars, and Jim Pascoe. To Felix Lu and
Neha Sharma, for their patience and editorial input. And finally, to
Steve Alexander for all the heavy lifting. Ad Astra.

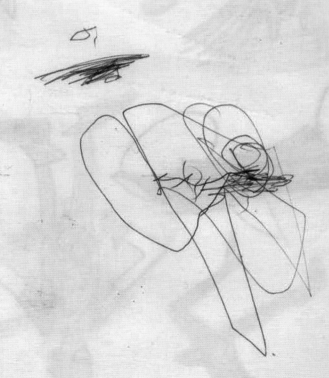

STOP&GO!!!:
Kid Art

I have a stack of pictures I drew when I was four or five, which had been stashed away somewhere on a shelf in my studio and promptly forgotten. I'm lucky in that my mom and grandmother kept piles of my drawings, tucked into deep black envelopes with silver metal clips, patiently waiting. I got them back a few years ago as a Christmas gift, and it was a shock to see these displaced things return. To say I'd forgotten having drawn them would be an understatement. It is one of those things which, without the sort of documentary evidence a drawing is, you'd never have remembered. I do remember drawing as a child. I've been drawing since before I can remember, but with one exception, I have no specific memories of drawing from before about five years old or so. It was as if the repetition of events hadn't quite yet gelled into memory. Nevertheless, there was the proof. Dozens upon dozens of pages covered in wobbly, frenetic lines, pictures drawn with pencils and crayons, and some with one of those old ballpoint pens with four ink cartridges inside — red, black, blue, and green. They seemed like mute and distant hieroglyphs from a little person who is no longer here, who is unable to speak in any other way. But just what was it he was trying to say?

Rudolf Arnheim argues in his book Visual Thinking that one primary reason children draw is that they are slowly, methodically trying to define for themselves the very shape of reality through the tools of picture-making. Before we had writing, we had drawing, going all the way back to the caves of Lascaux. "All thought is visual," says Arnheim. "My...work has taught me that artistic activity is a form of reasoning, in which perceiving and thinking are indivisibly intertwined...a person who paints, writes, composes, dances thinks with their senses". Through their rough attempts on a page, children are trying to map out the important visual attributes through which the things of the world can be identified. Elsewhere, Arnheim points out that another primary reason children draw is simply to enjoy the feeling of muscles flexing, watching their hands magically invent brightly colored shapes on pieces of paper. In truth, drawings of this sort are not drawings of anything at all, they're more accurately kinetic streaks contained on a page — graphic snapshots cataloging incidental motion. Some of my kid drawings seem to be of this type. Others are more clearly attempts at crudely recognizable monsters, robots, and superheroes, sometimes arranged along with simple logo-like word groupings (STOP&GO!!!). These drawings are like miniaturized one-note operas, sweeping epics of good versus evil compressed upon a tiny matchbox stage. Still, others resemble obsessive, spartan landscapes, blank vistas defined by a single rough mark torn across a snowy sheet, white wells of infinite space sliced in two by one wiry line. Across these wobbling wastelands, endless arrangements of melting machines and strange, oblong buildings bob up and down over the thumbtack horizons like marching armies of immediate expression. There are some which are apparently drawings I'd started and abruptly quit, probably out of boredom or distraction. Others are baffling things, hard to compare to anything else.

One drawing in particular interested me more than the others, and I found myself thinking about it if I ever woke up in the middle of the night. It was a drawing of a blue rhombic shape containing a series of fairly uniform circles, hatchet-like rectangles, and explosively jagged zigzags. It resembled nothing less than a Cubist composition. Being that I drew it and it is my own original idea, after all, (although very different from anything I would or could think of drawing now), it occurred to me I might be able to reclaim the process behind the drawing if I carefully traced it and a few others like it on a lightbox, then redraw them again as I would a page of comics, following the implicit path of the hand which made the original drawings. As I drew, I could feel my hand moving in different, older ways as I reworked the trail of lines on the page. My brush followed the thoughts behind the pictures. As I did so, I could sense how the earlier artist's hand moved, how his muscles would've controlled the drawing tool (curiously lurching up and to the right, the opposite of how my drawing hand moves now). I could tell which lines had been put down fast and which were more laboriously considered.

Gradually, I began to remember the place where I drew as a kid, how it smelled, what the lighting was like. I remembered the room I slept in, with its knocking radiator and that lovely old vacuum tube radio which got gently warmer the longer you left it on — its dim yellow dial face glowing in the dark. I remembered the Heckle and Jeckle patch on my dirty blue jeans, the stiff blue bedspread, the carpet, the cupboard with the strange carved coconut-head my grandparents must've gotten on some long-distant vacation, and the pewter cup where I kept my pencils. I remembered hearing Bowie's "Space Oddity" for the first time — that countdown to the opening. I could see that boy there, sitting at his desk, drawing as I was drawing, listening to music, incessantly twirling a pen cap with the fingers of his right hand, as I still do to this day.

In the middle of the curious rhombic composition was another form which looked at first like a diagram for an office garage viewed simultaneously from above and from the side, as if scribbled by an inebriated architect on a messy cocktail napkin. It also looked a bit like a shoebox that had been skin-grafted to the side of an airplane, complete with a tail and jet engines on the wings. A longer teardrop shape pouring out and down to the right revealed another airplane facing the opposite direction. This plane was coated with an aggressive red and black patina. From these clues, I could tell this could only be a drawing of an air battle over Germany during World War II.

The old folks my sister and I lived with talked about World War II a lot. We didn't speak. We'd sit and listen to them relive those old days. Over countless dinners, we'd hear the stories of all the colorful people from their youth. They were living, breathing characters to us — all these nurses and soldiers and pilots and farmers and the others too young to go. We heard their fractured stories in disjointed episodes, like old time radio serials, randomly,

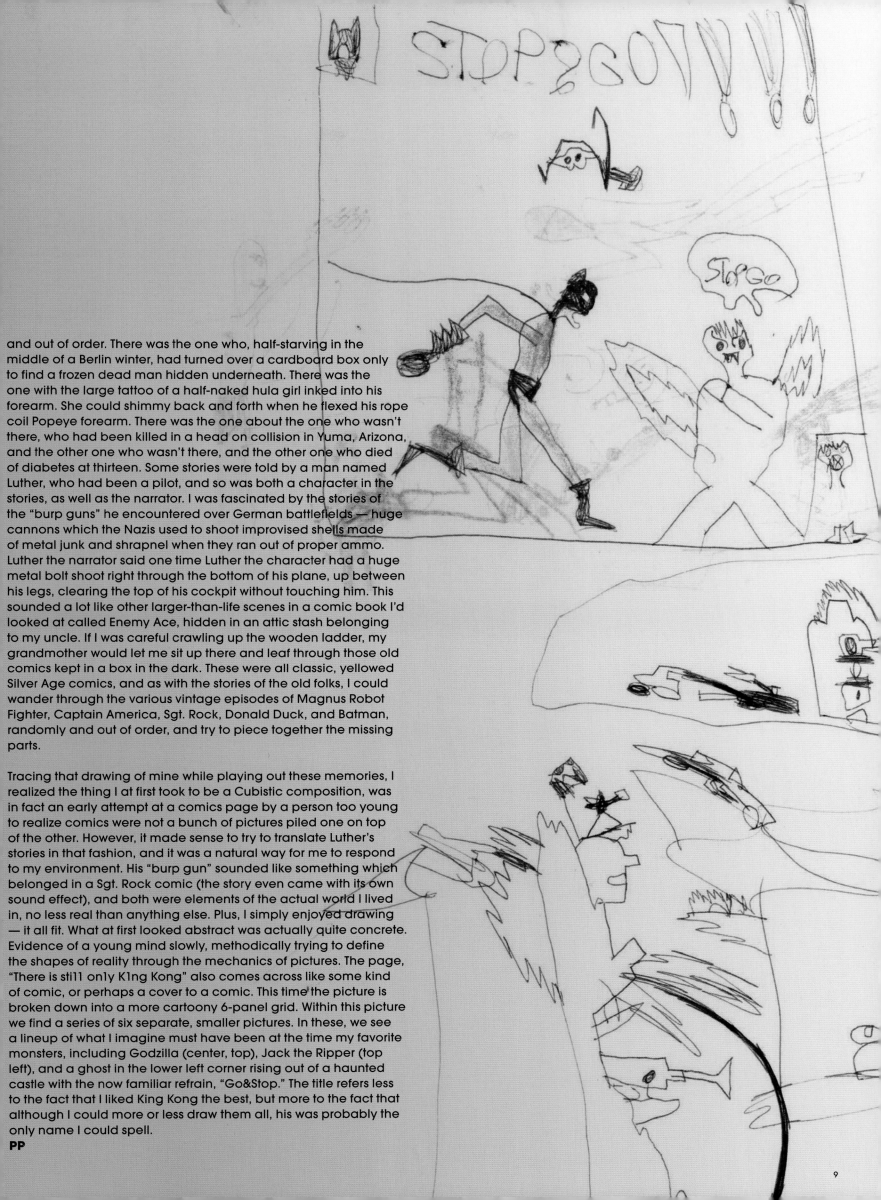

and out of order. There was the one who, half-starving in the middle of a Berlin winter, had turned over a cardboard box only to find a frozen dead man hidden underneath. There was the one with the large tattoo of a half-naked hula girl inked into his forearm. She could shimmy back and forth when he flexed his rope coil Popeye forearm. There was the one about the one who wasn't there, who had been killed in a head on collision in Yuma, Arizona, and the other one who wasn't there, and the other one who died of diabetes at thirteen. Some stories were told by a man named Luther, who had been a pilot, and so was both a character in the stories, as well as the narrator. I was fascinated by the stories of the "burp guns" he encountered over German battlefields — huge cannons which the Nazis used to shoot improvised shells made of metal junk and shrapnel when they ran out of proper ammo. Luther the narrator said one time Luther the character had a huge metal bolt shoot right through the bottom of his plane, up between his legs, clearing the top of his cockpit without touching him. This sounded a lot like other larger-than-life scenes in a comic book I'd looked at called Enemy Ace, hidden in an attic stash belonging to my uncle. If I was careful crawling up the wooden ladder, my grandmother would let me sit up there and leaf through those old comics kept in a box in the dark. These were all classic, yellowed Silver Age comics, and as with the stories of the old folks, I could wander through the various vintage episodes of Magnus Robot Fighter, Captain America, Sgt. Rock, Donald Duck, and Batman, randomly and out of order, and try to piece together the missing parts.

Tracing that drawing of mine while playing out these memories, I realized the thing I at first took to be a Cubistic composition, was in fact an early attempt at a comics page by a person too young to realize comics were not a bunch of pictures piled one on top of the other. However, it made sense to try to translate Luther's stories in that fashion, and it was a natural way for me to respond to my environment. His "burp gun" sounded like something which belonged in a Sgt. Rock comic (the story even came with its own sound effect), and both were elements of the actual world I lived in, no less real than anything else. Plus, I simply enjoyed drawing — it all fit. What at first looked abstract was actually quite concrete. Evidence of a young mind slowly, methodically trying to define the shapes of reality through the mechanics of pictures. The page, "There is still only K1ng Kong" also comes across like some kind of comic, or perhaps a cover to a comic. This time the picture is broken down into a more cartoony 6-panel grid. Within this picture we find a series of six separate, smaller pictures. In these, we see a lineup of what I imagine must have been at the time my favorite monsters, including Godzilla (center, top), Jack the Ripper (top left), and a ghost in the lower left corner rising out of a haunted castle with the now familiar refrain, "Go&Stop." The title refers less to the fact that I liked King Kong the best, but more to the fact that although I could more or less draw them all, his was probably the only name I could spell.

PP

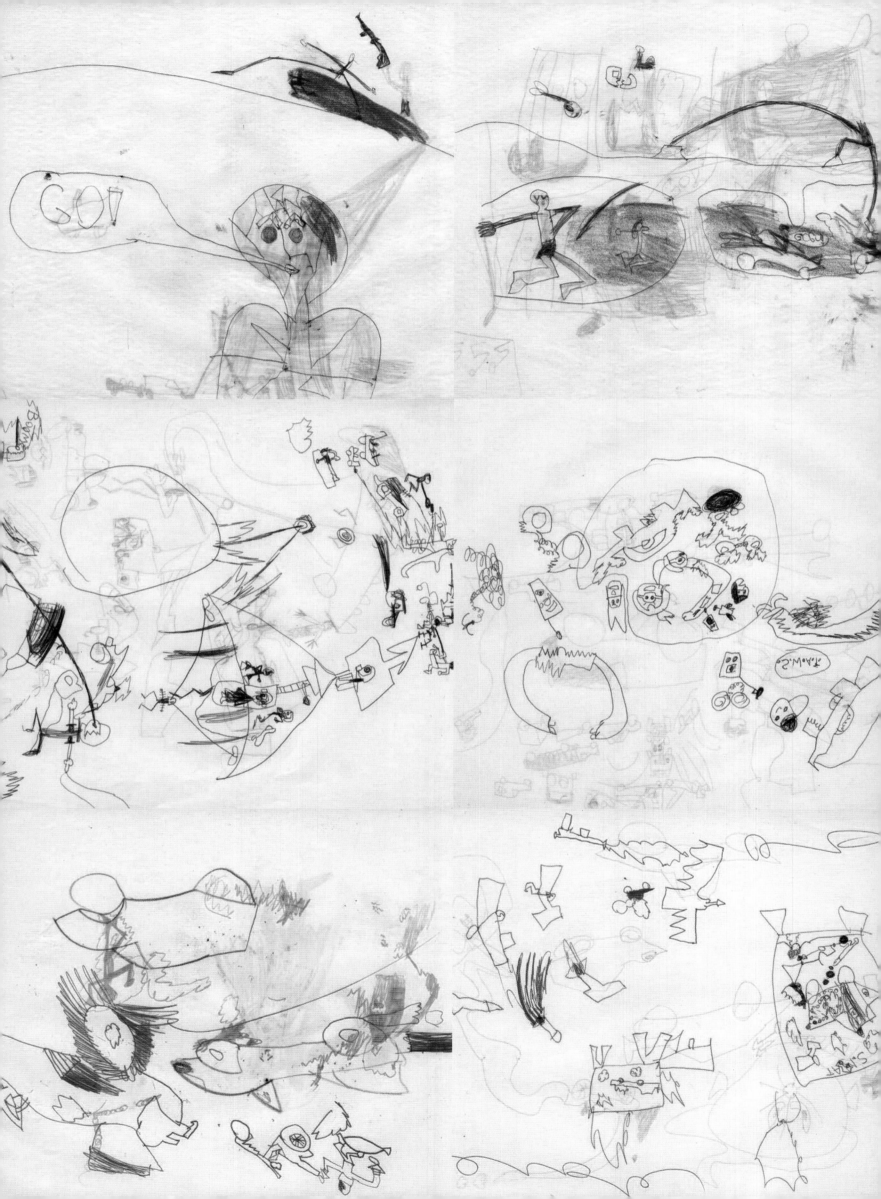

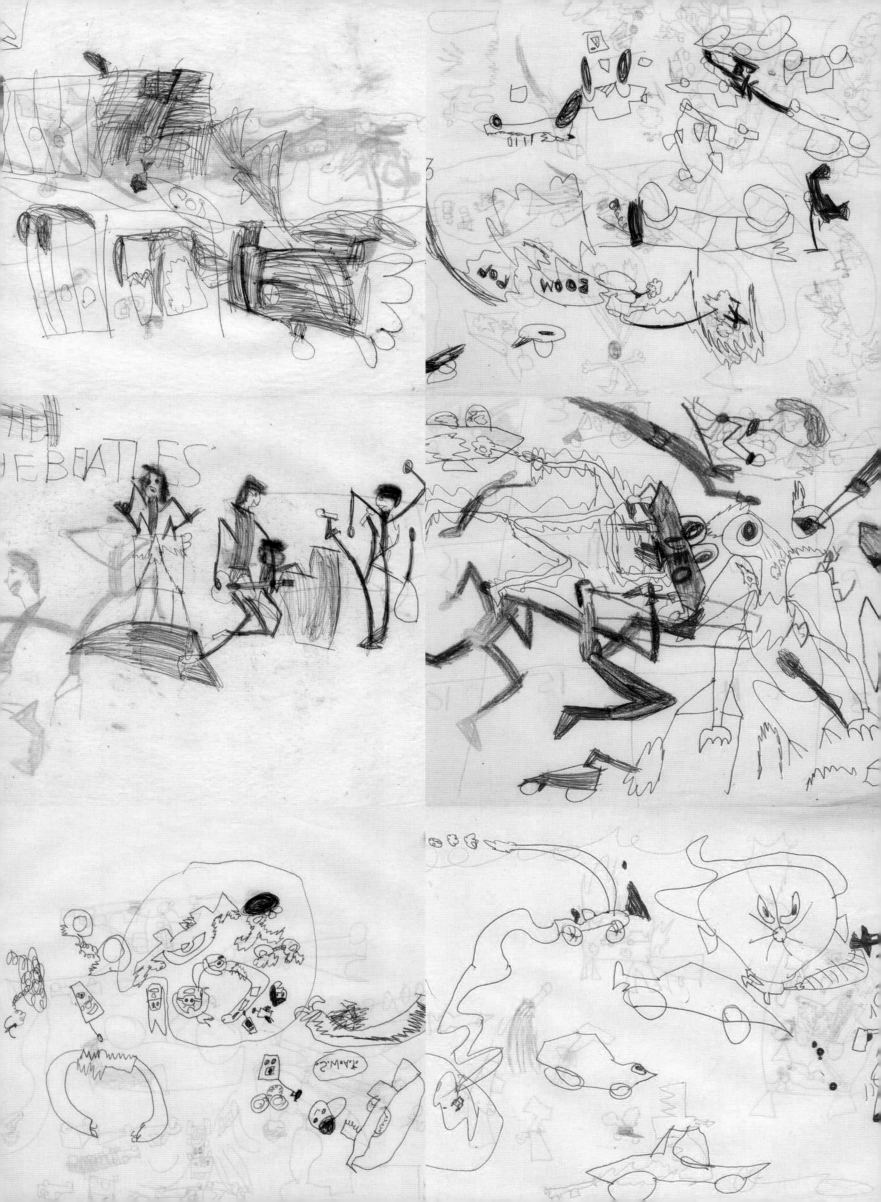

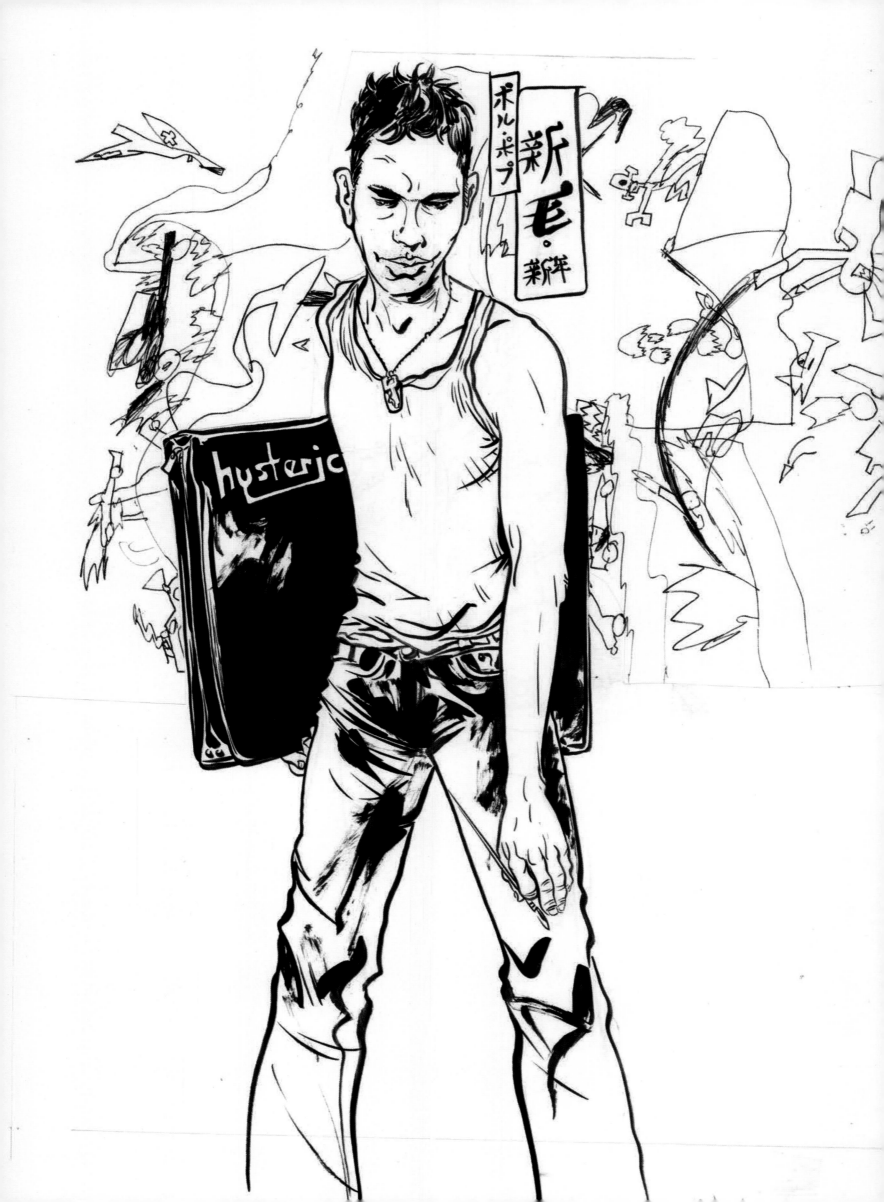

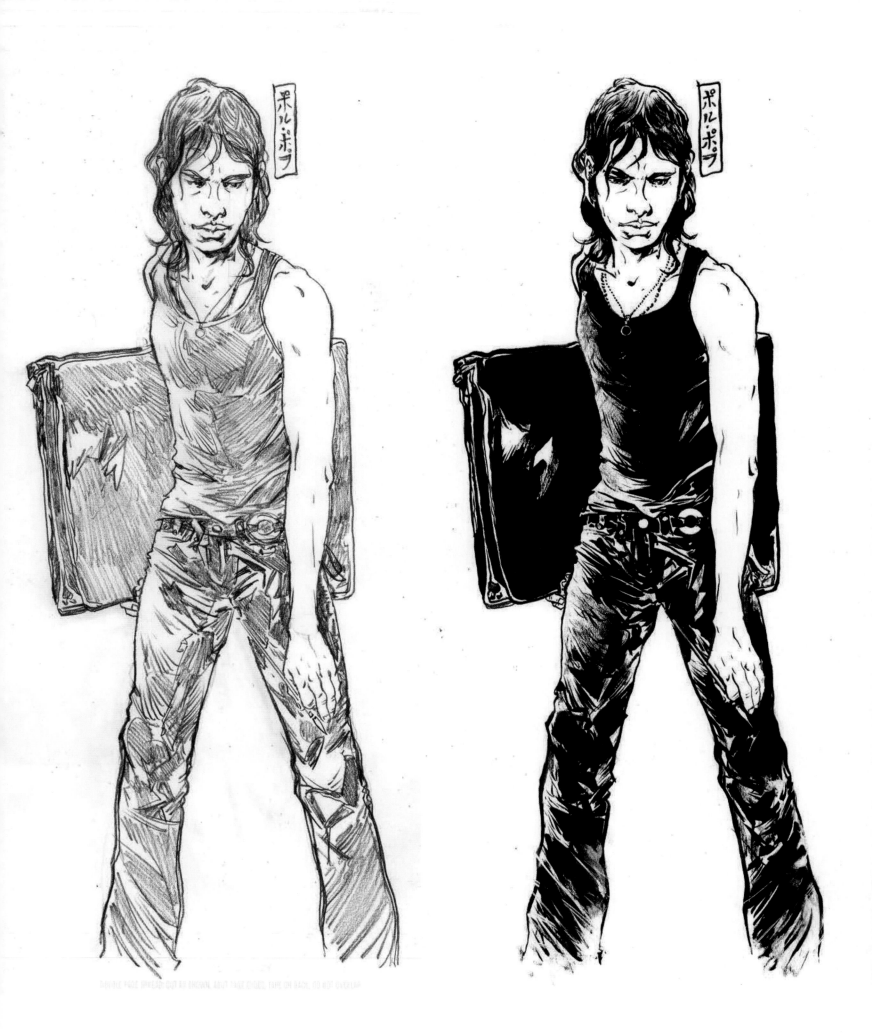

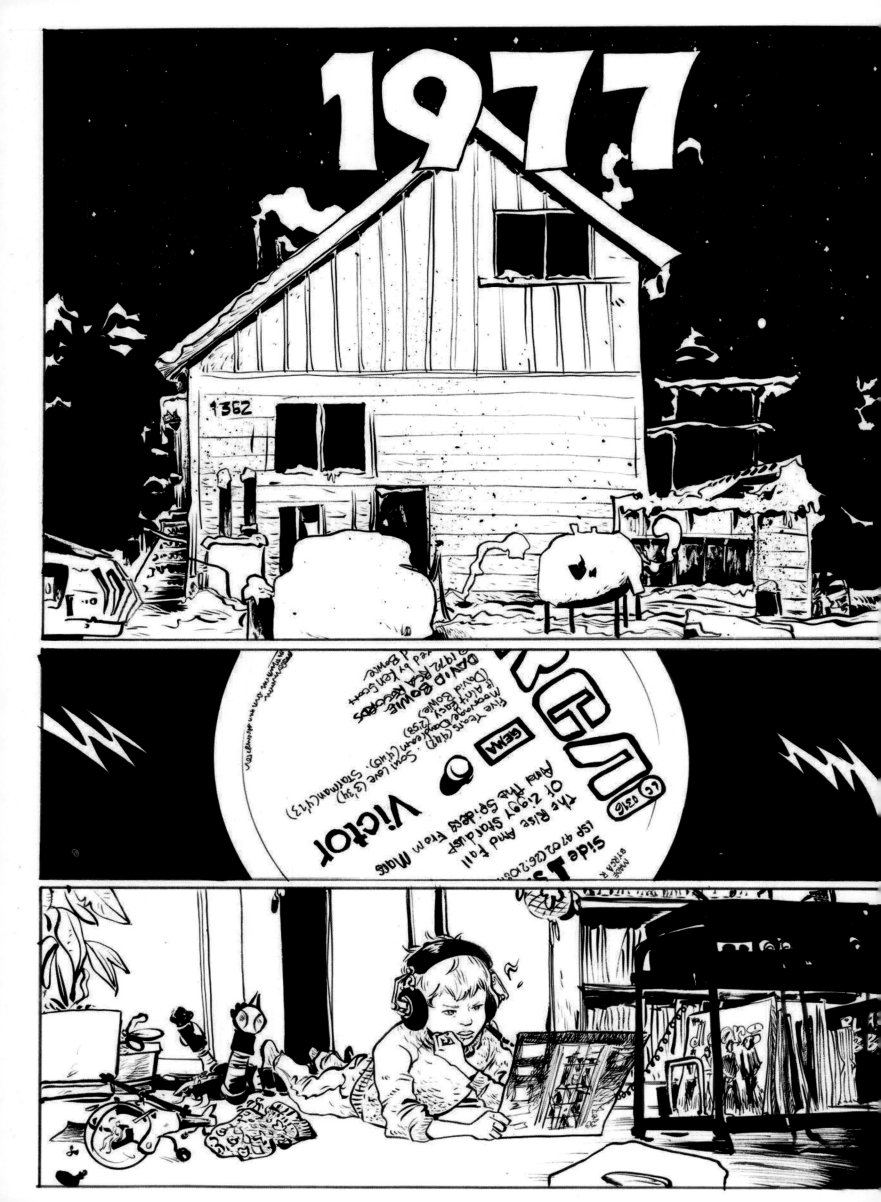

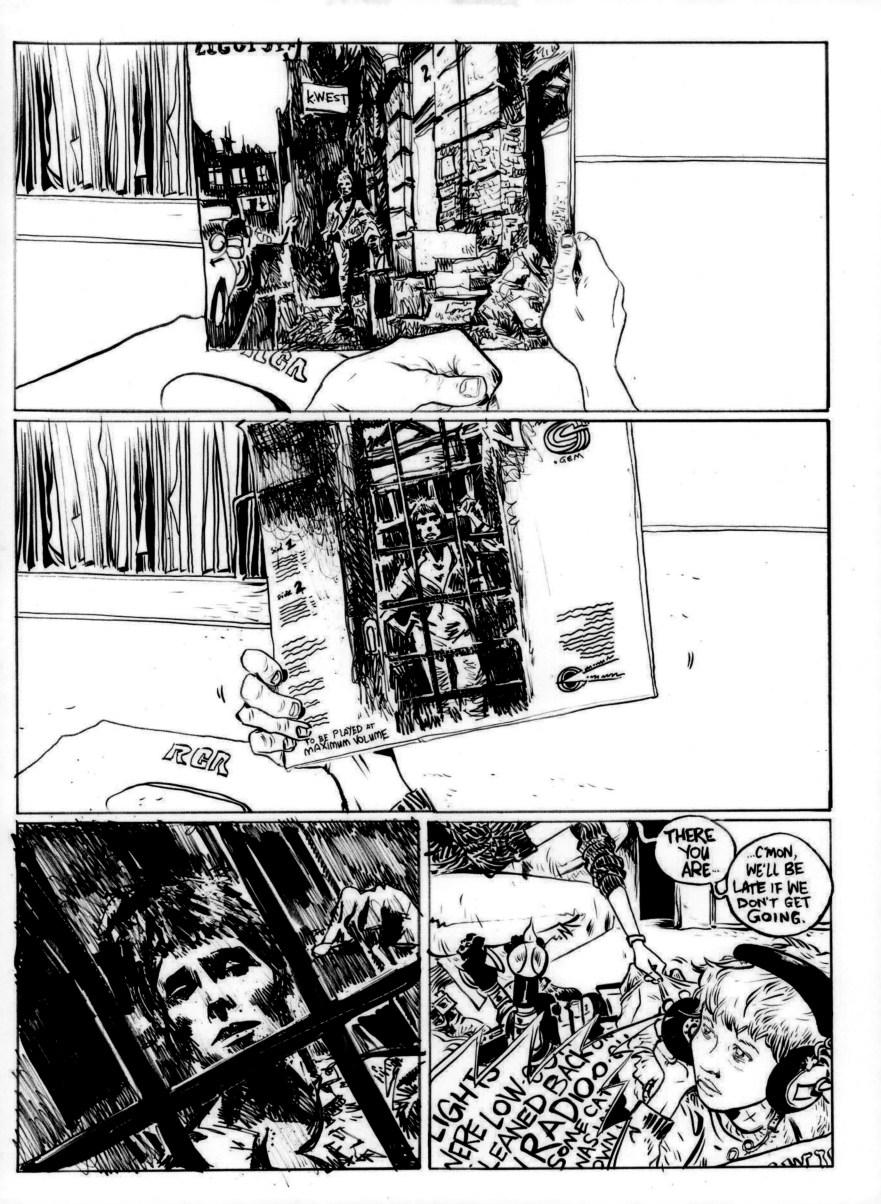

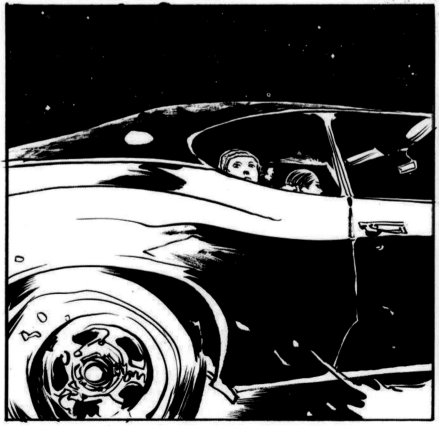
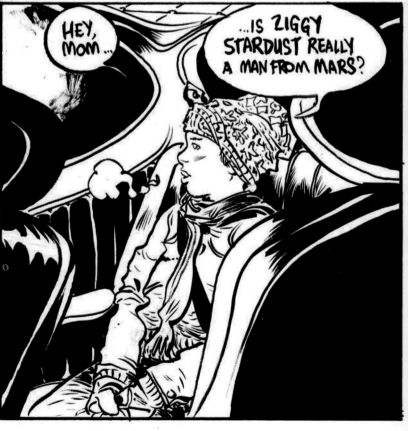

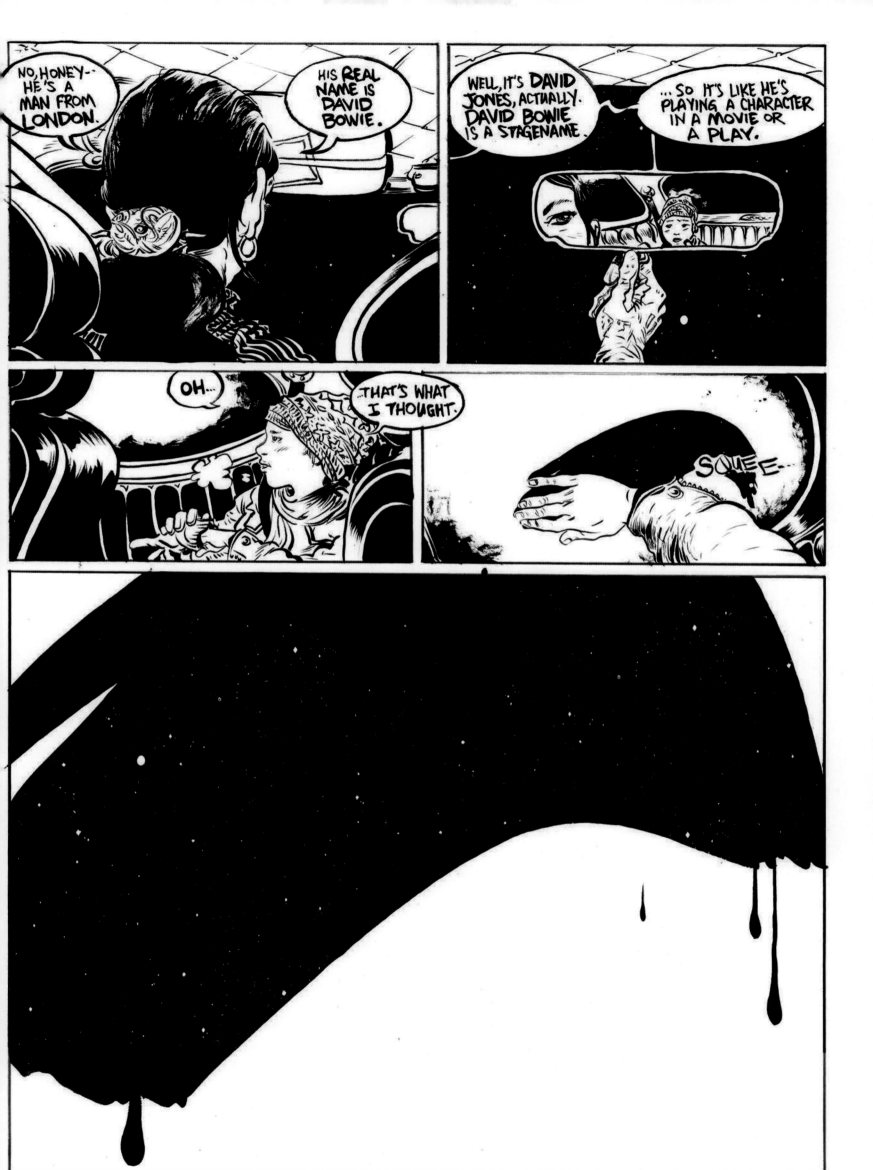

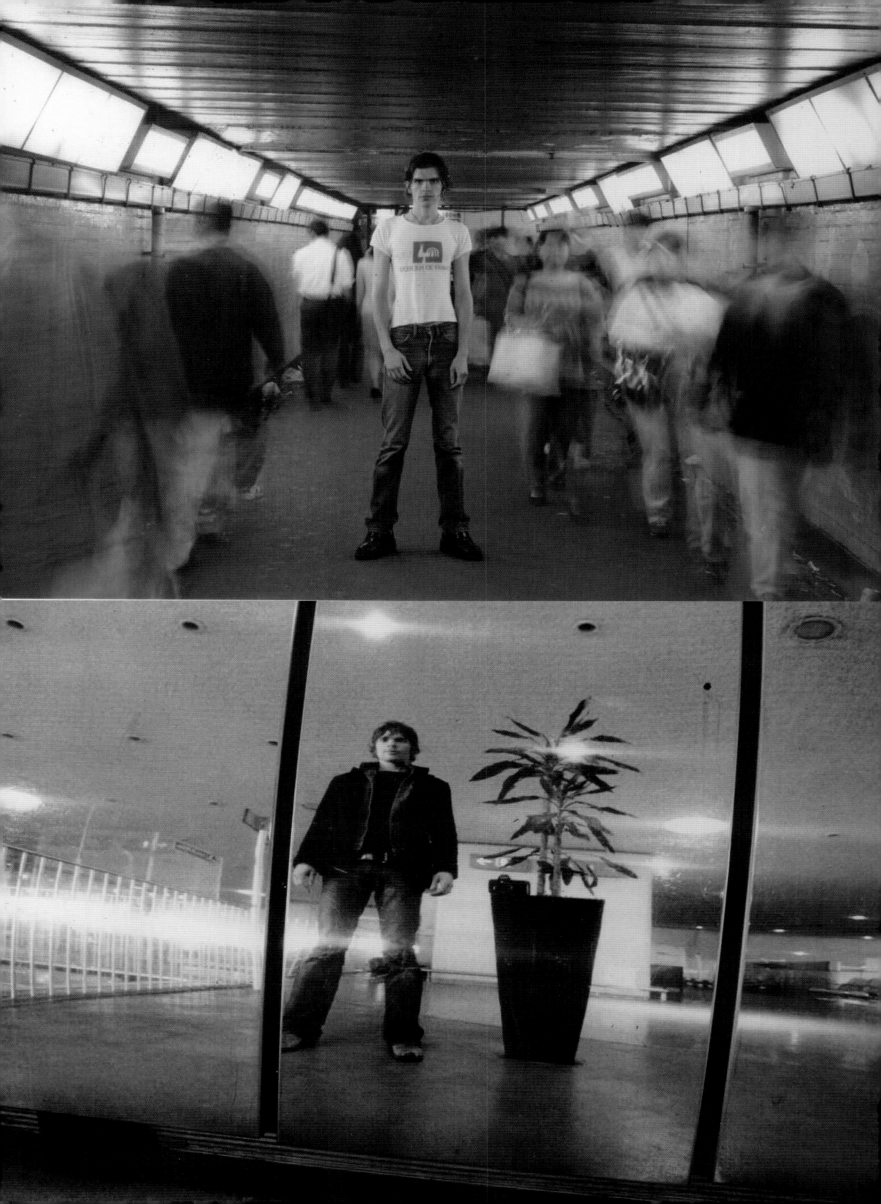

Sound In A Line
Part One

In March 2024, Paul Pope sat down in NYC with longtime friend, Emmy-award winning writer & designer Jim Pascoe (Cottons: Secret Of The Wind, Undertown, By The Balls) to talk about comics, music, the creative process, and artistic intention. Excerpts of this freeform discussion have been edited for brevity and clarity.

Jim Pascoe: What is the value of collecting your art into a book called Pulp Hope?

Paul Pope: The value is for the people who cannot find all this collected art out there. A lot of the stuff I've done has been outside of comics. I love comics. I'm a lifer. I'm in. I could go toe-to-toe with anybody about Wolverine or Colossus or Batman. But I've done a lot of work outside of comics, and we've tried hard to bring material into this that people just can't readily find. Boom! Studios (and Archaia) have been very supportive of this.

Jim: What's the importance of context for your work when it's brought together in one place?

Paul: I'm not quite sure, but I do think I've been a bit of a bridge because when I tried to break down the doors of mainstream comics, nobody was doing that. When I broke in, I was indie and that was uncomfortable. But I did it. Trying to find a way to do it so that there was a way to bring different styles or métiers into the "mainstream" side of things, I really wanted to do that because I thought there's so much more room for different styles and voices and I wanted to push the boundaries. And find new audiences.

Jim: Amazing. One of the things you said early on is talking about being generous as an artist and the importance of generosity. I feel like you've been extremely generous as a friend for all these years, and you've been very generous to comics. I'm very excited about this book.

Paul: Thank you, my friend. Thank you.

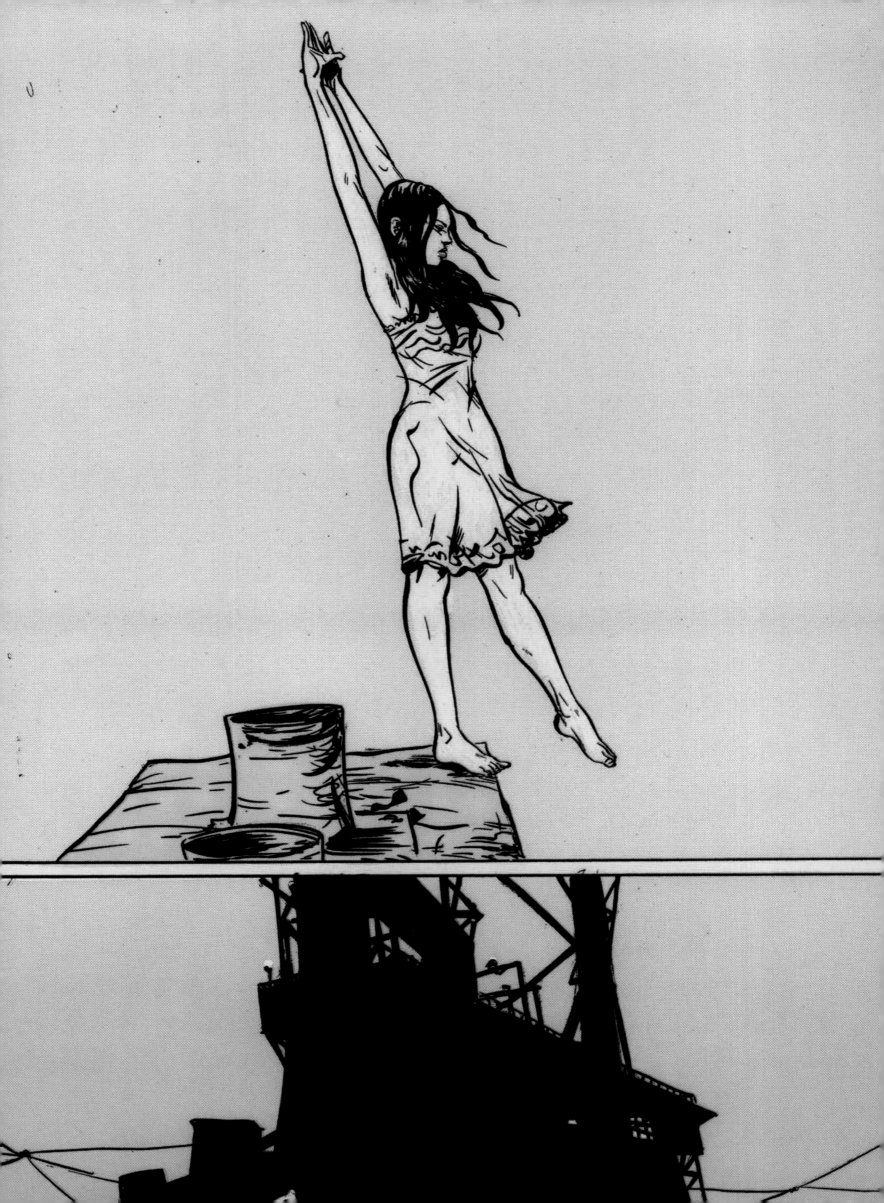

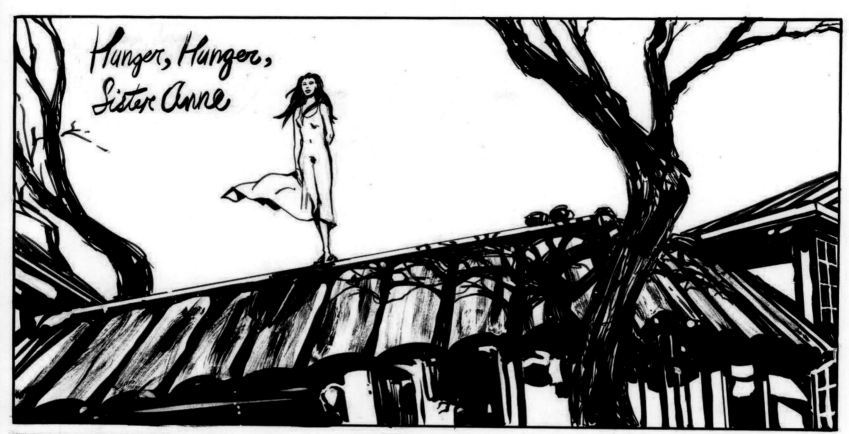

Hunger, Hunger,
Sister Anne

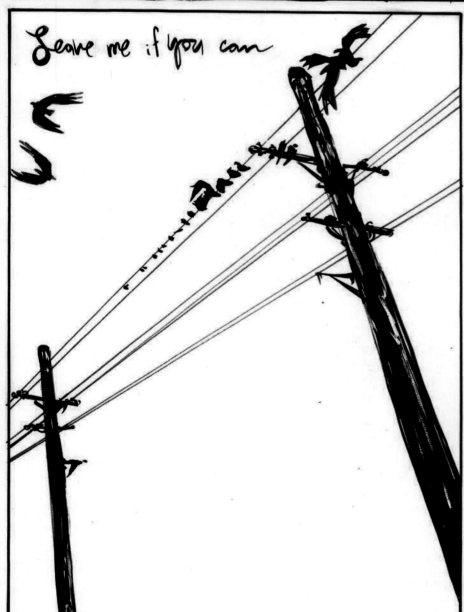

Leave me if you can

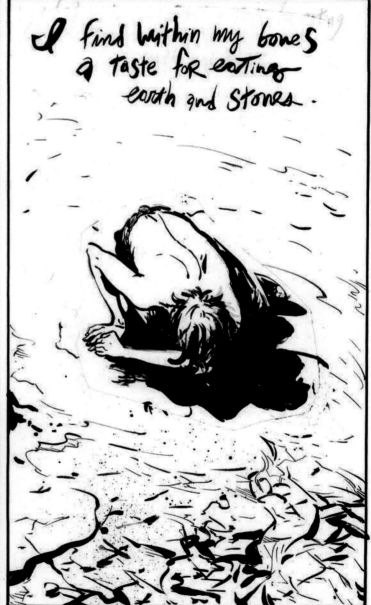

I find within my bones
a taste for eating
earth and stones.

The Triumph of Hunger
'16
1·18·94

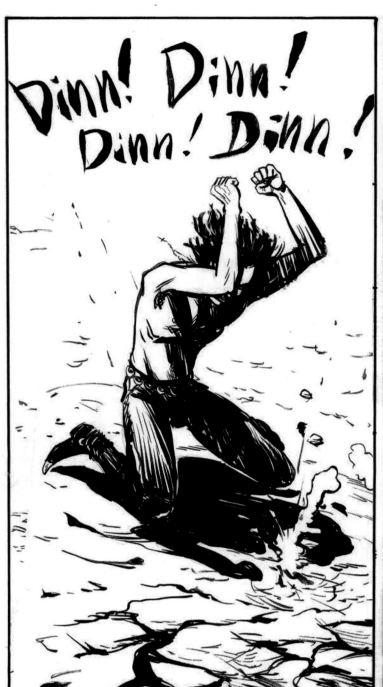

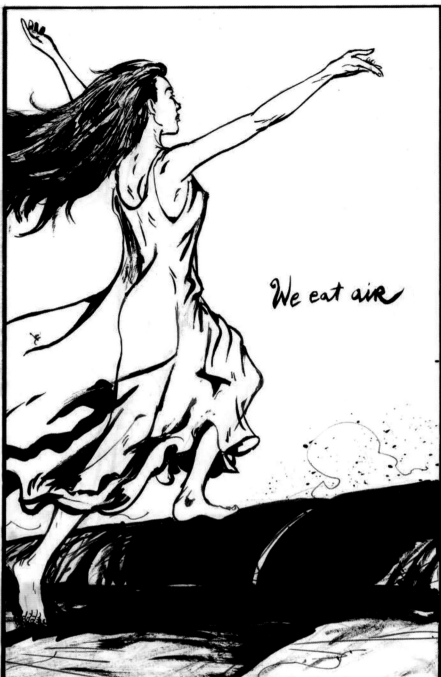

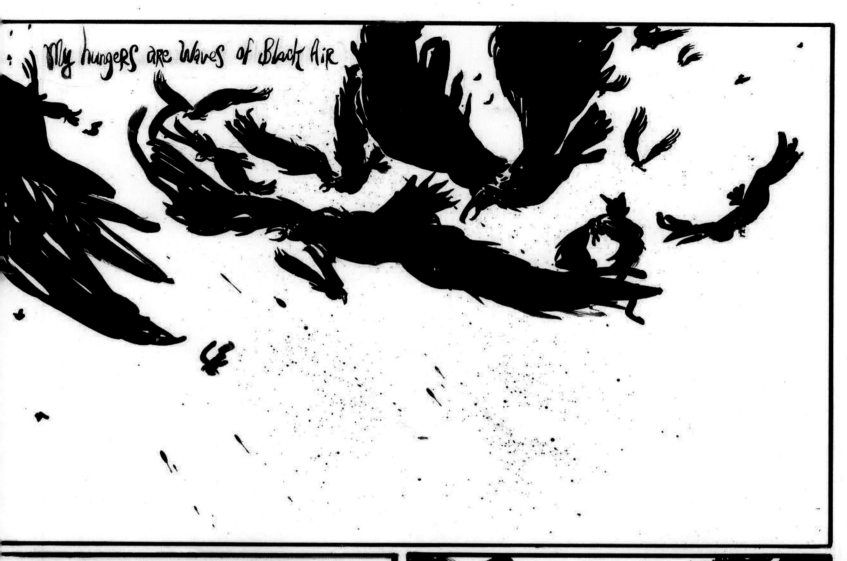

My hungers are waves of Black Air

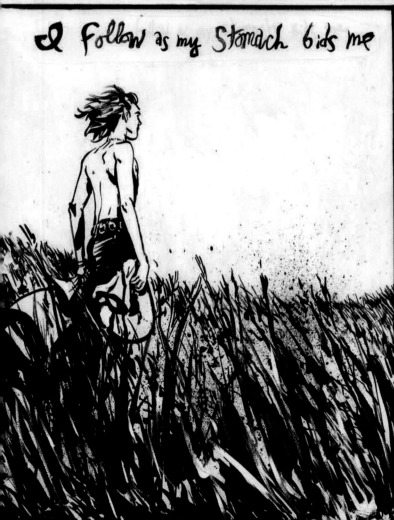

I Follow as my Stomach bids me

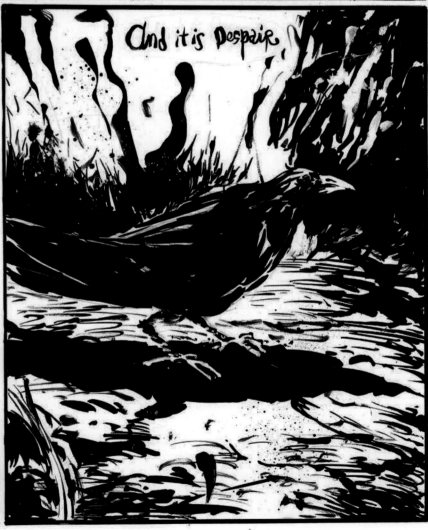

And it is Despair.

The Triumph of Hunger
5/6
1.14.94

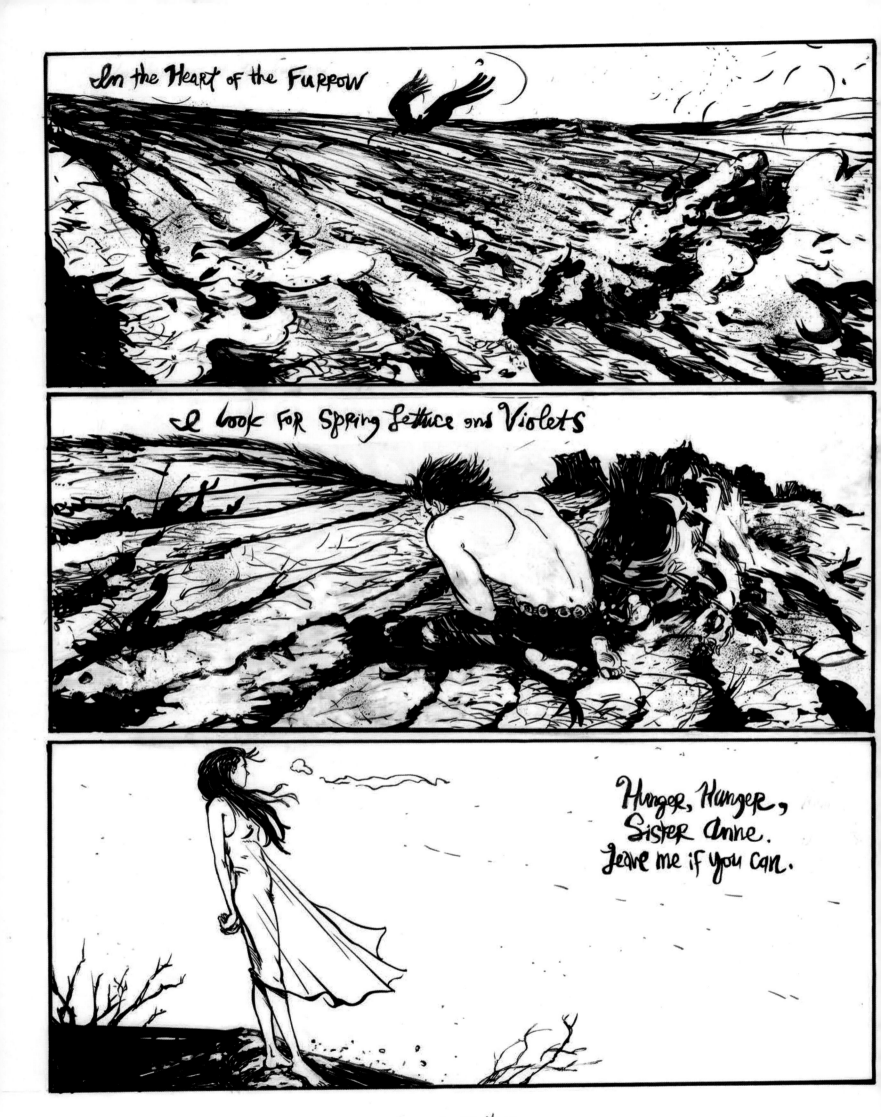

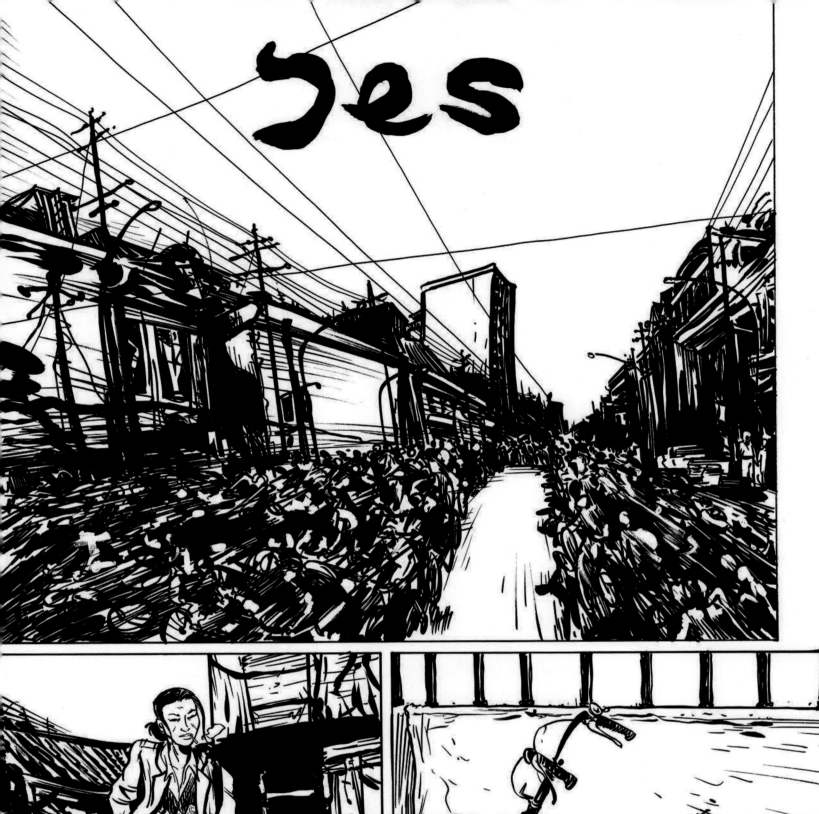
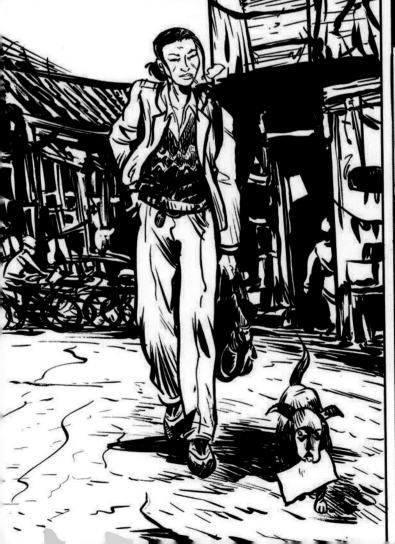

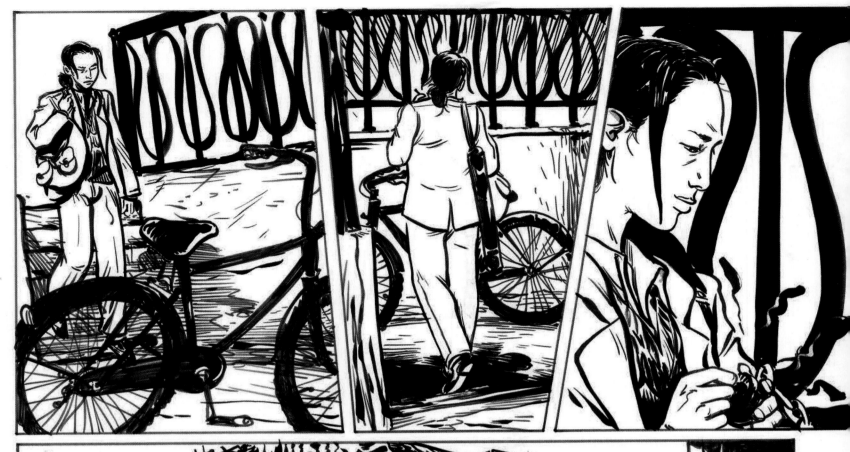

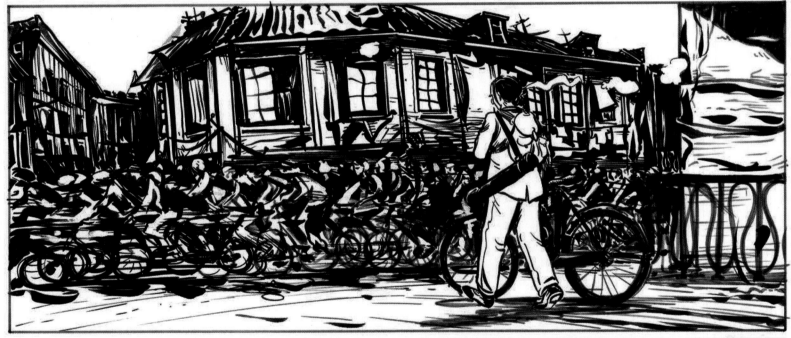

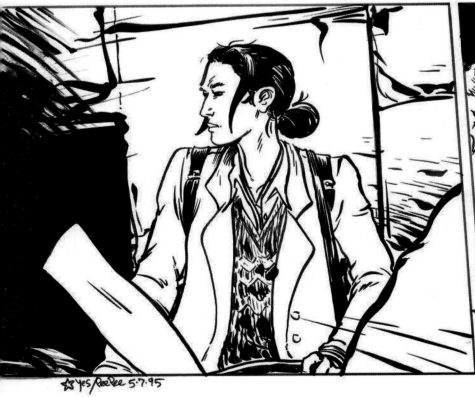

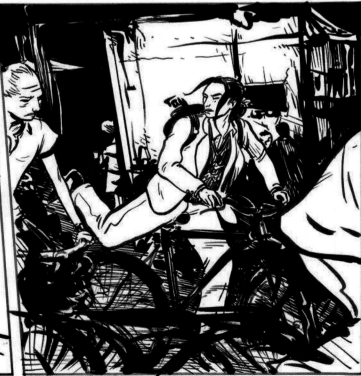

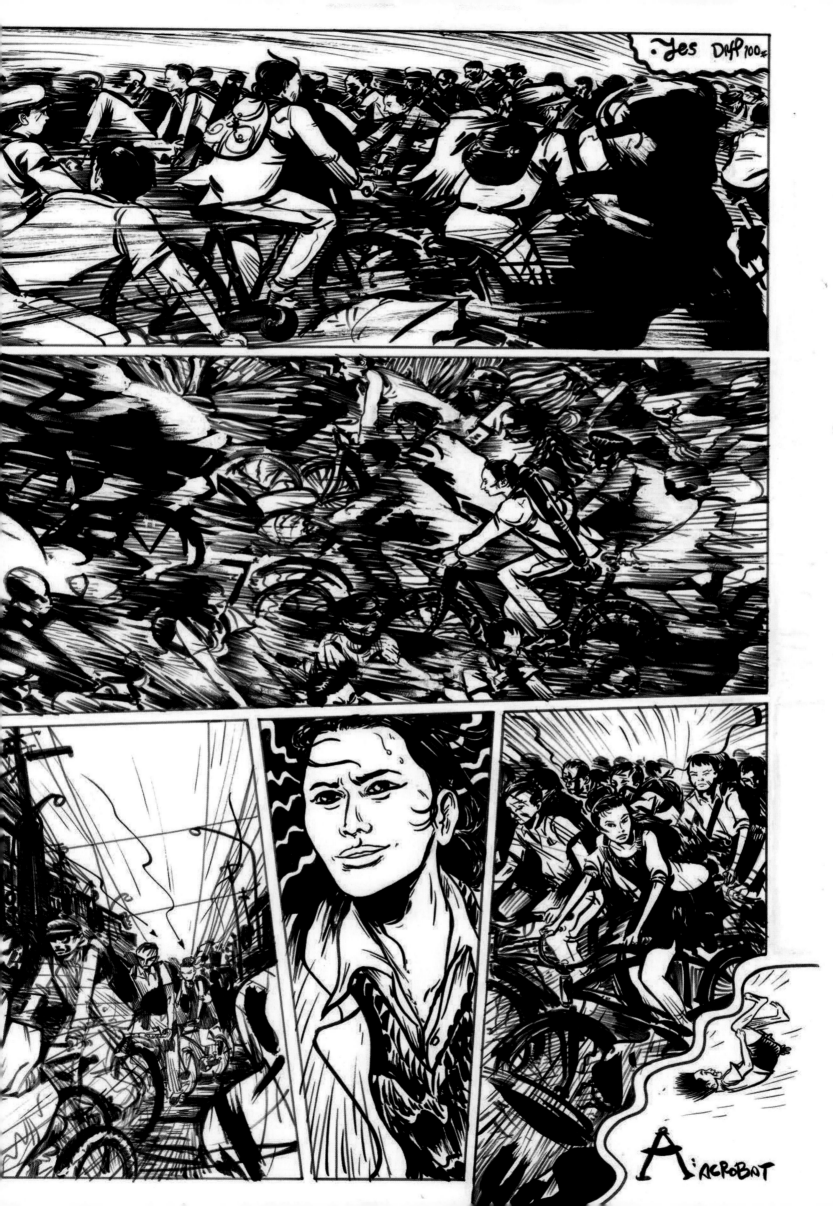

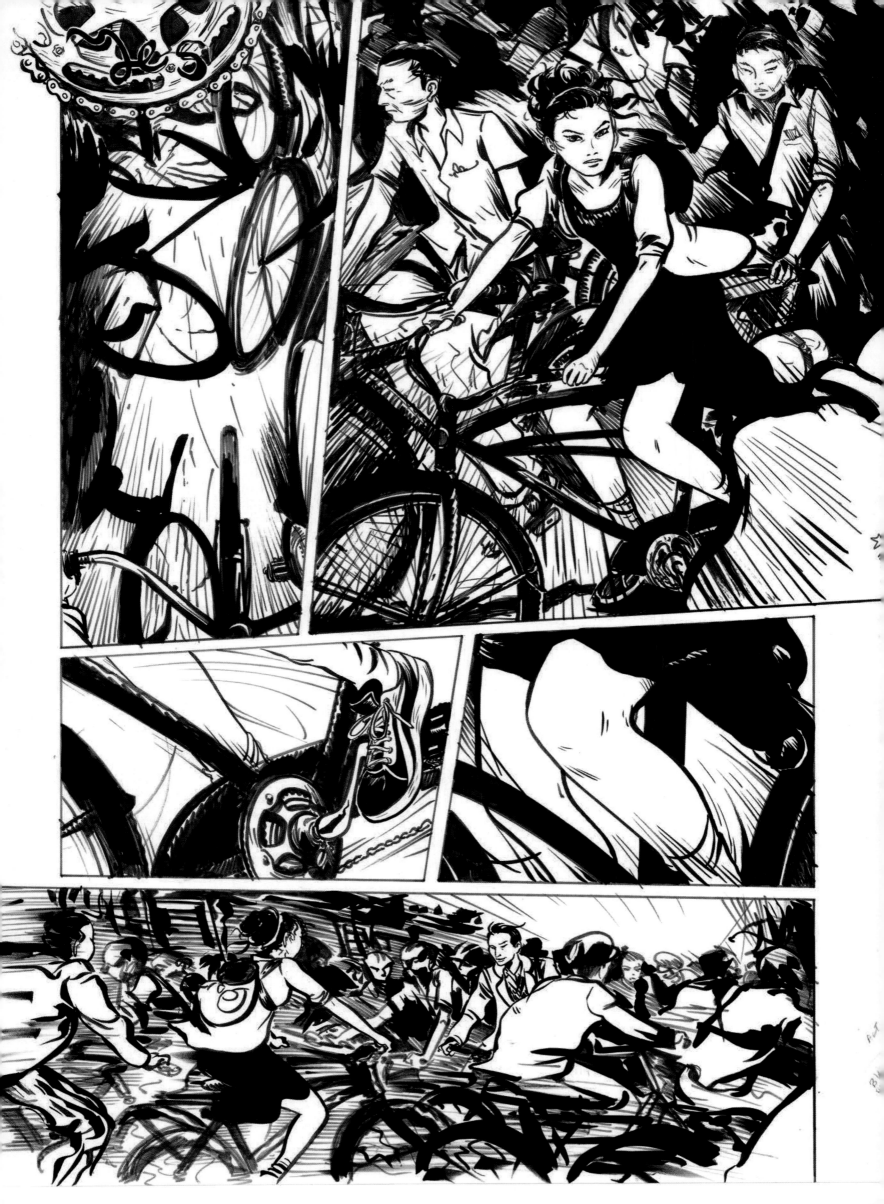

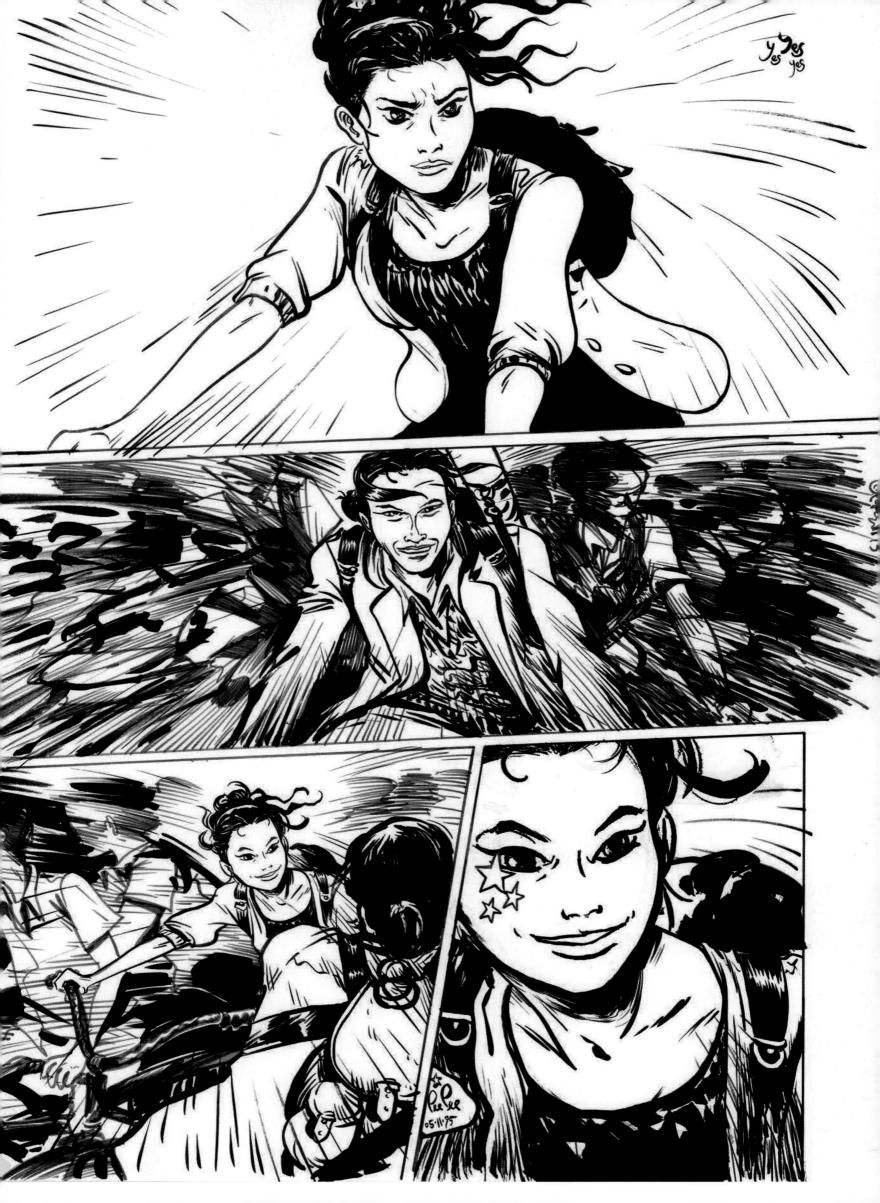

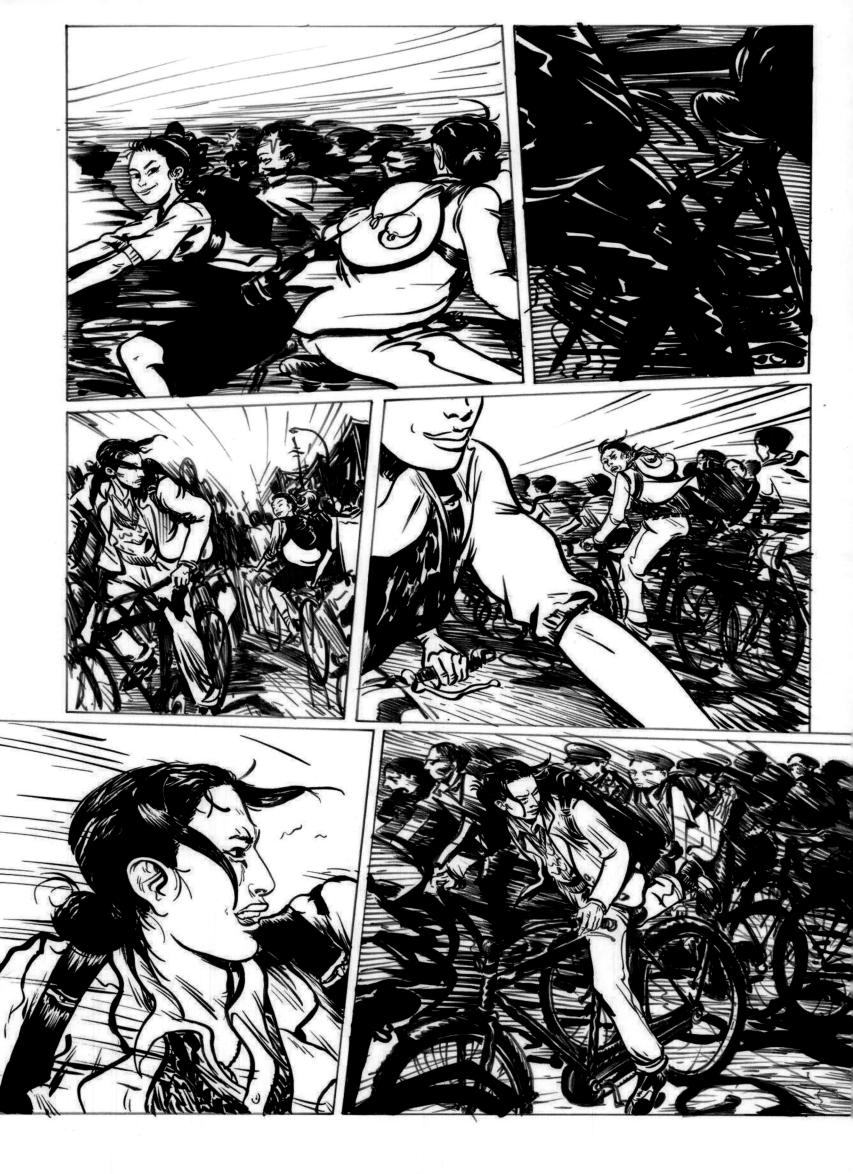

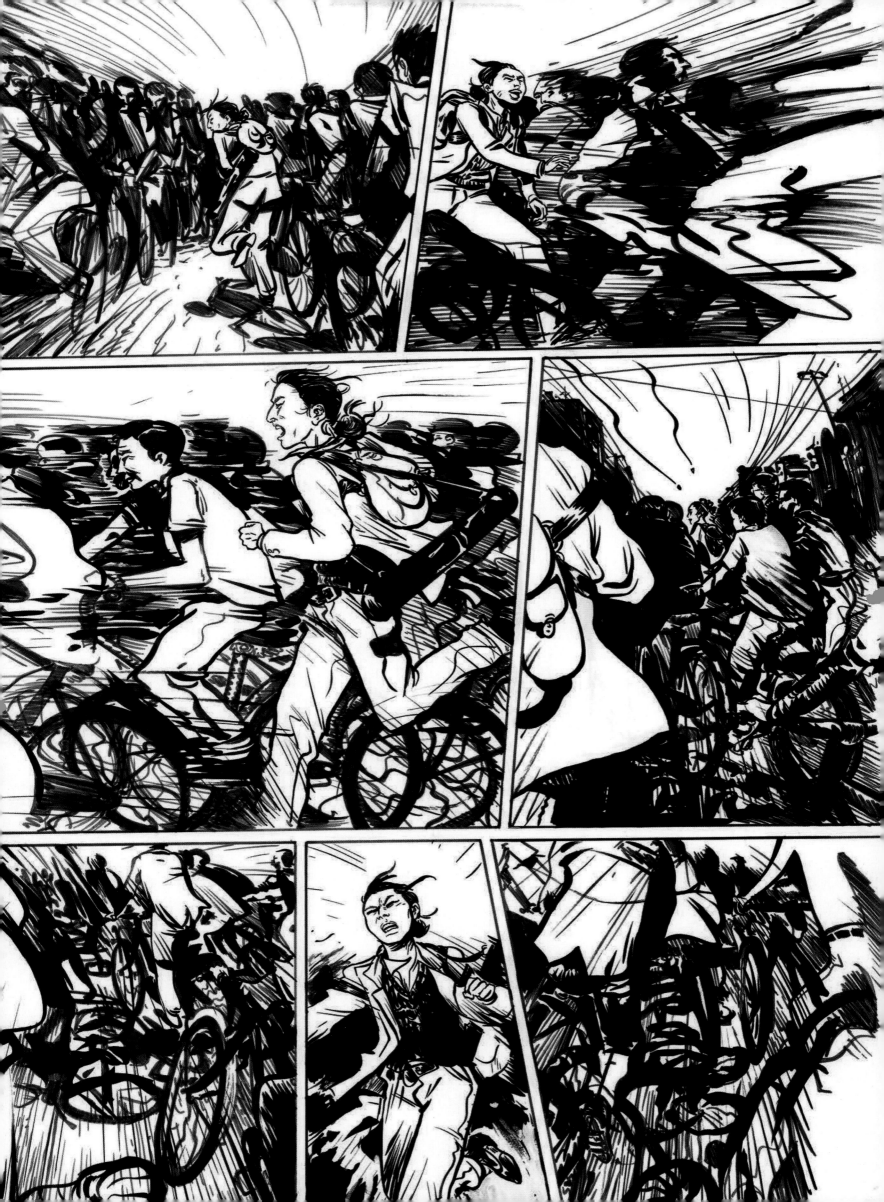

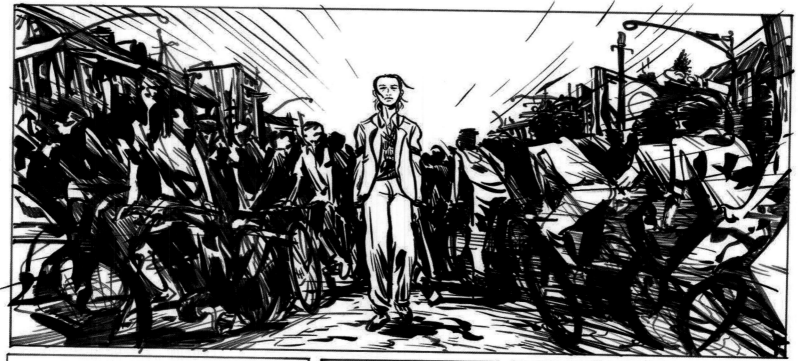

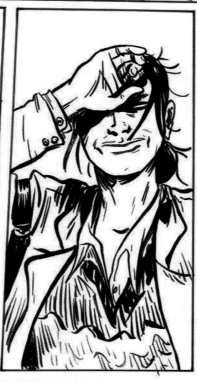

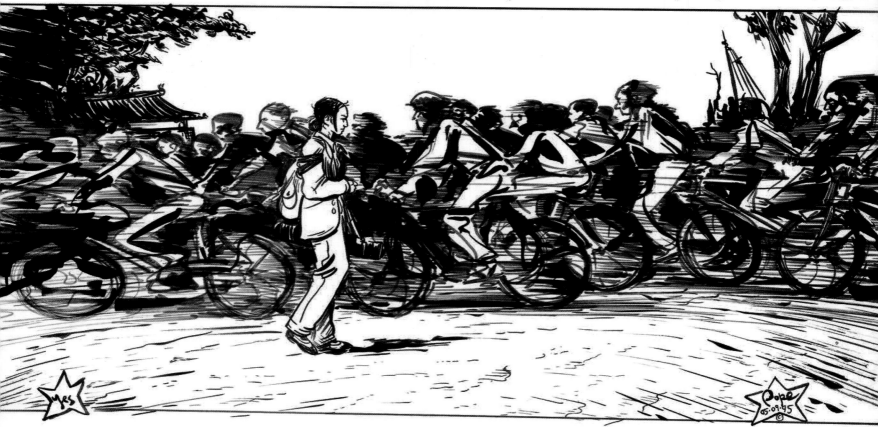

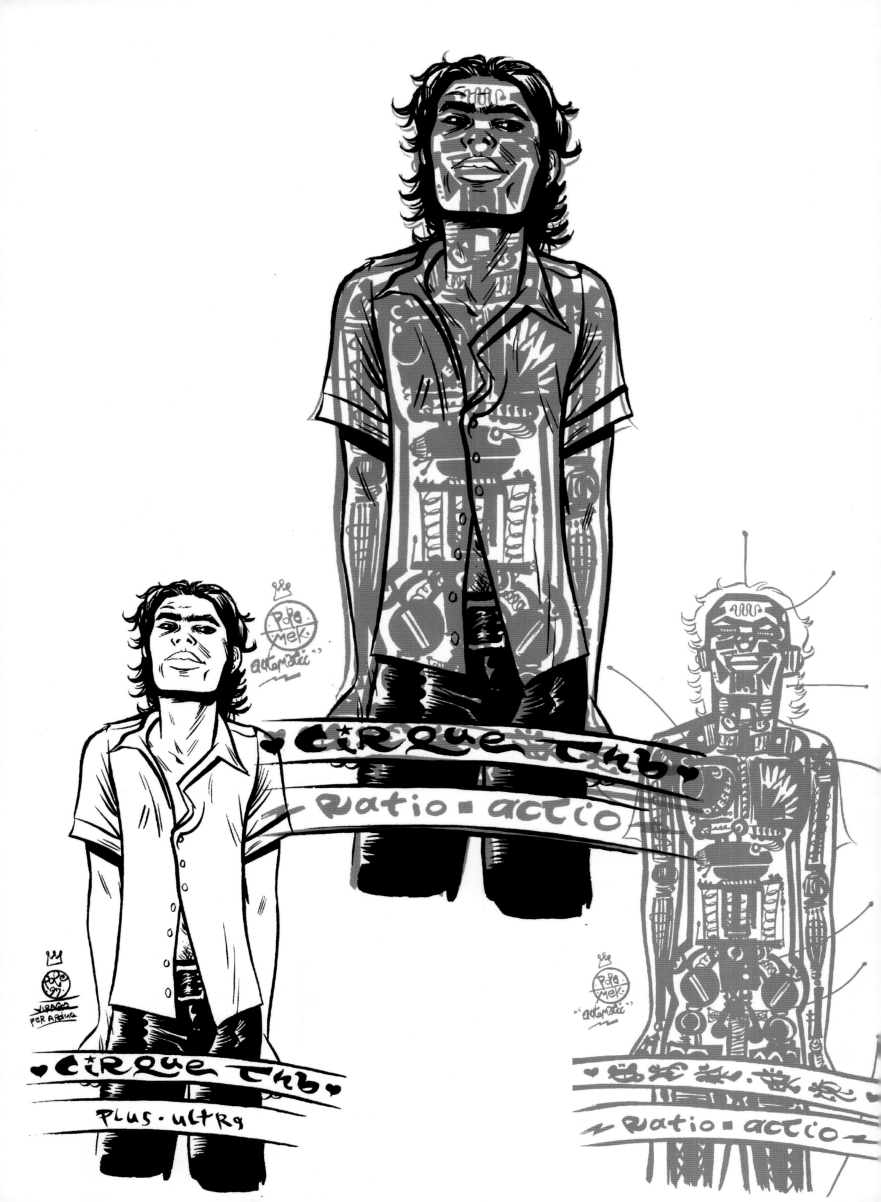

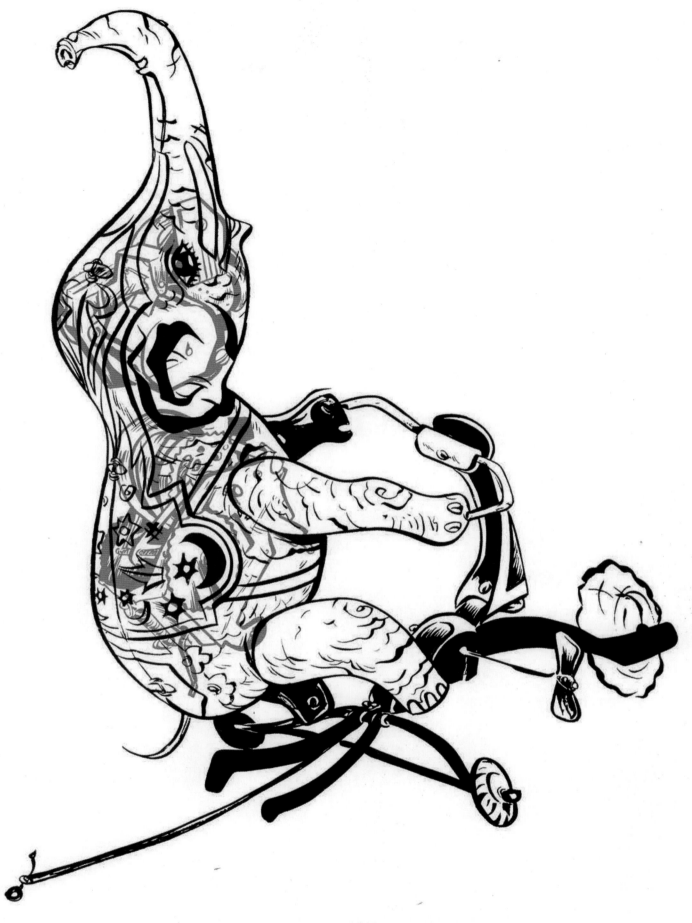

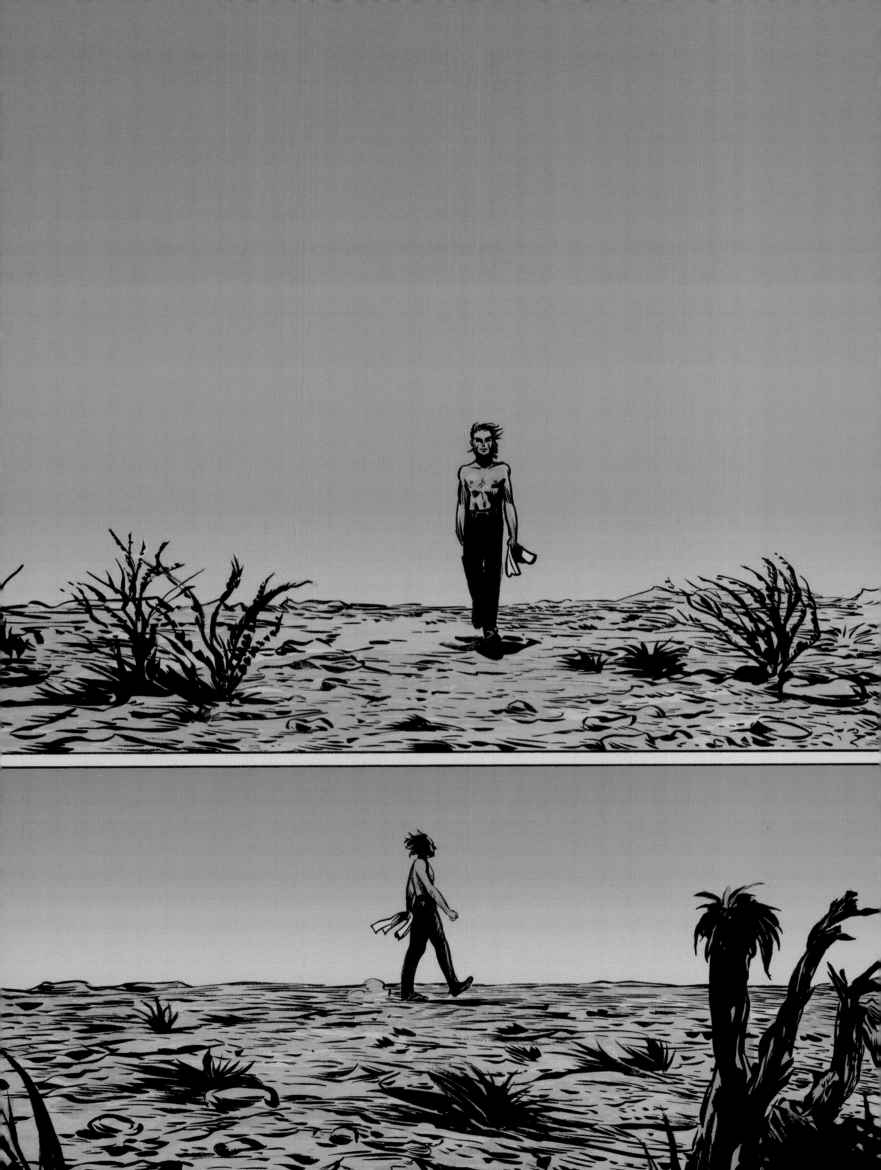

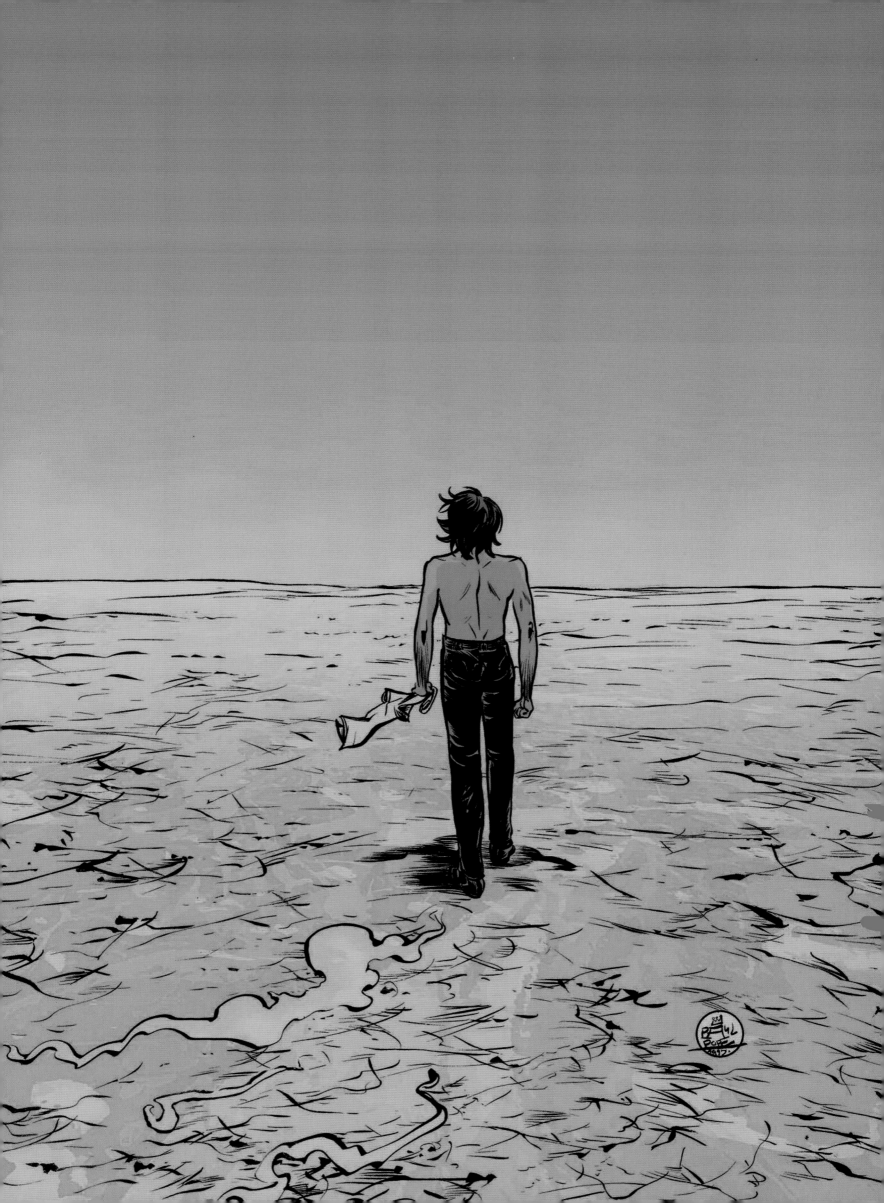

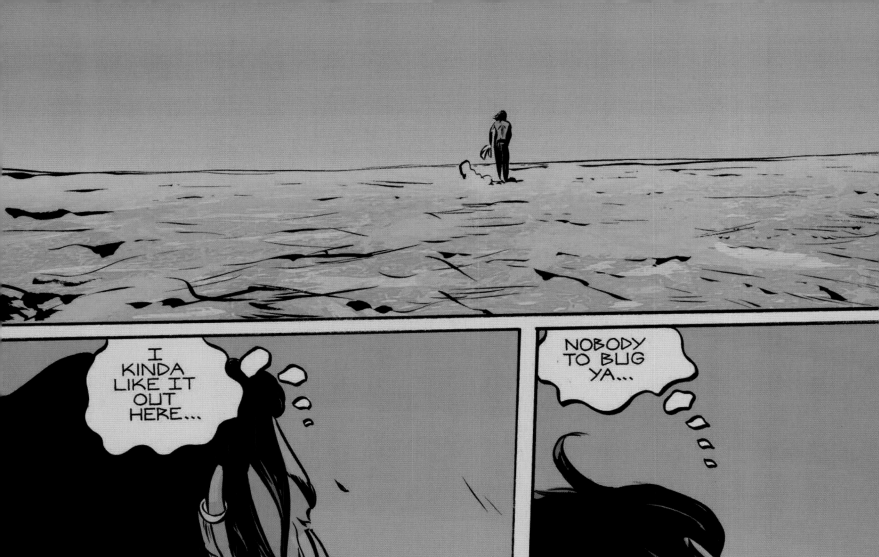

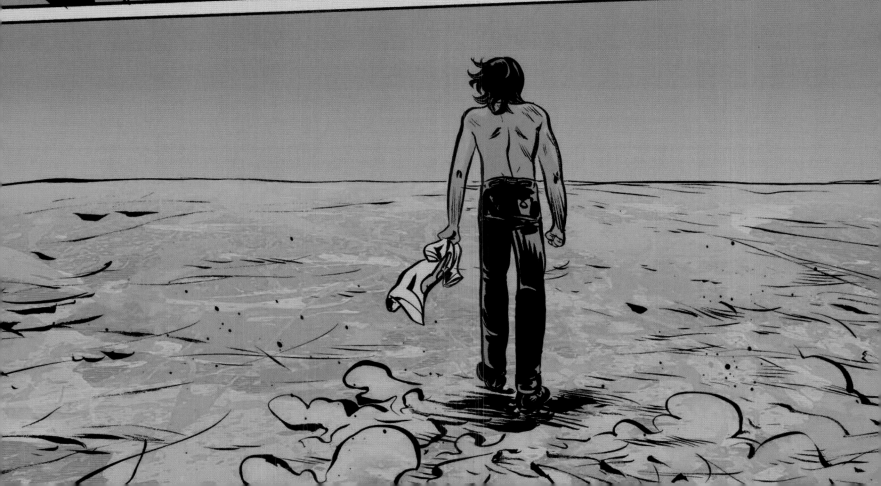

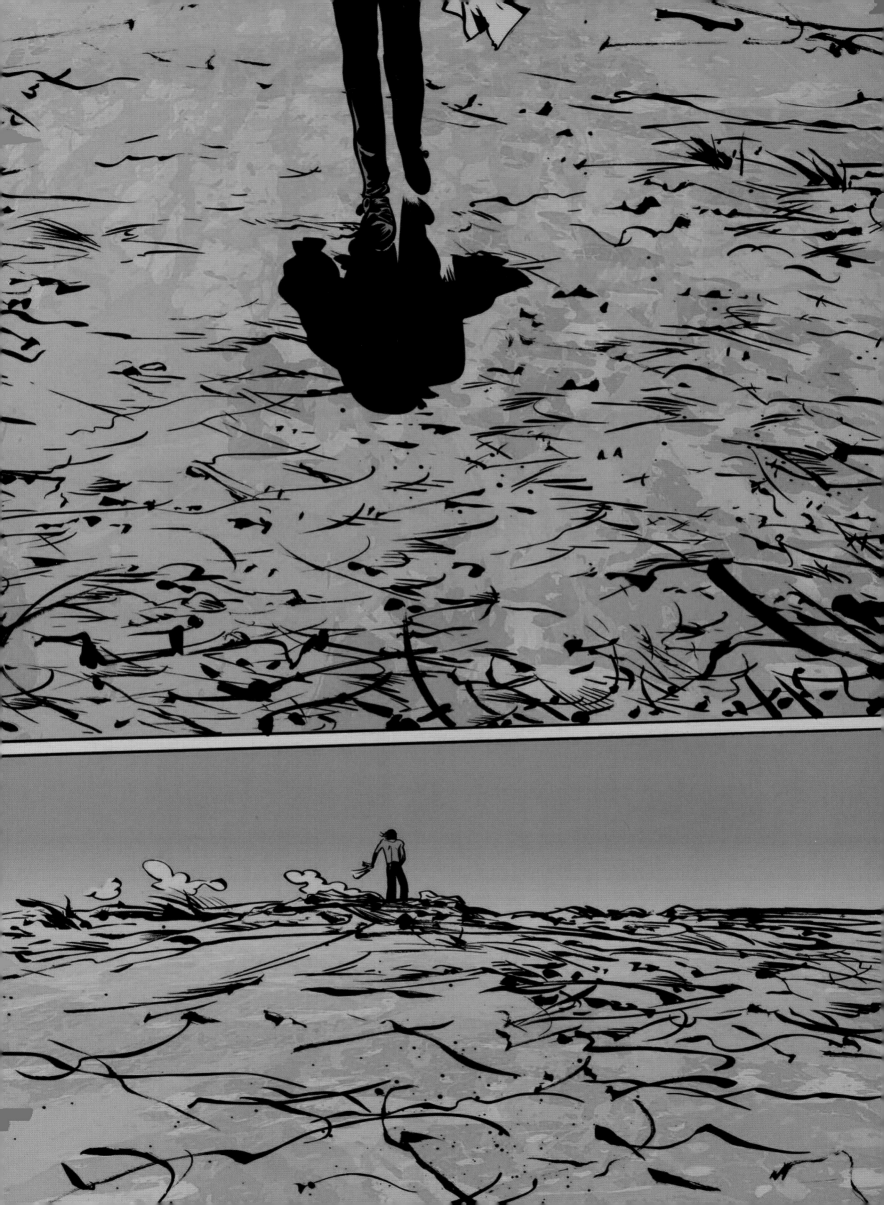

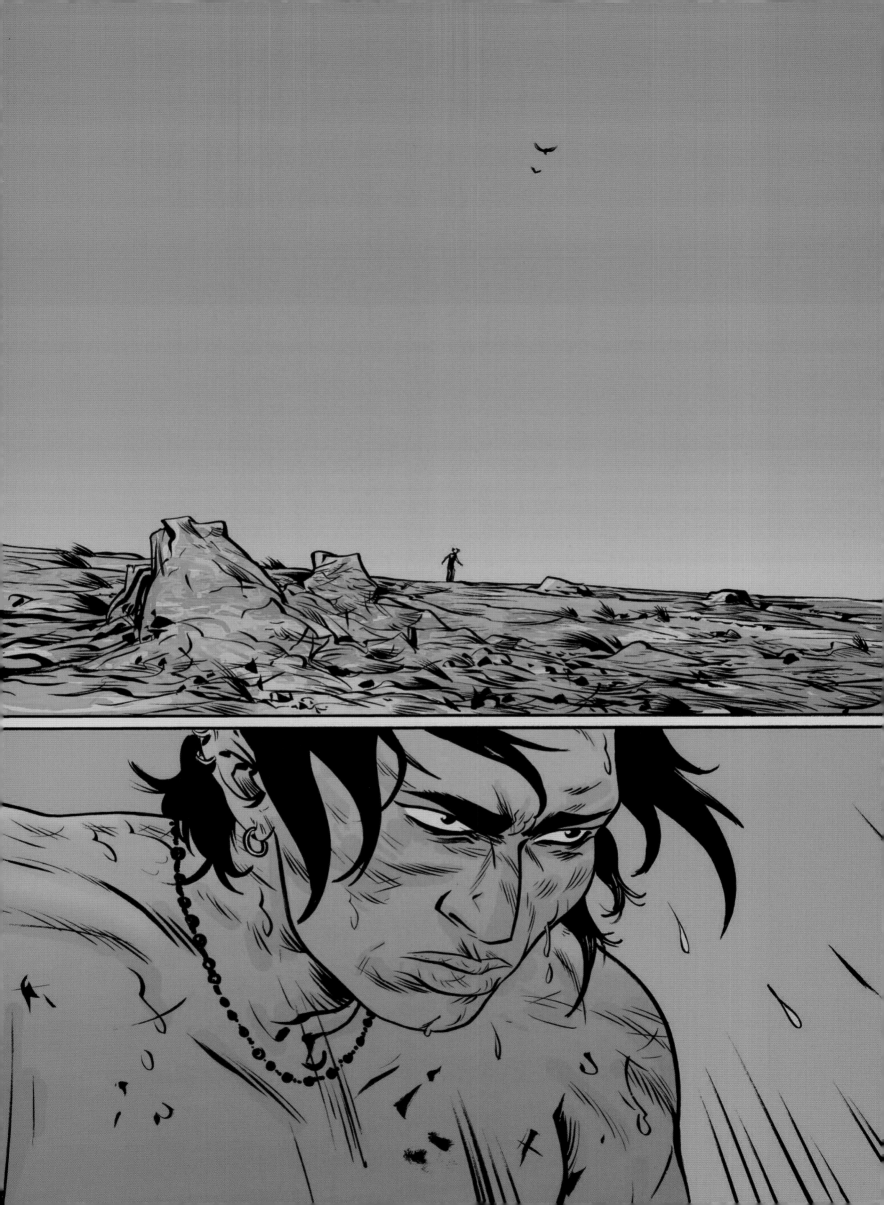

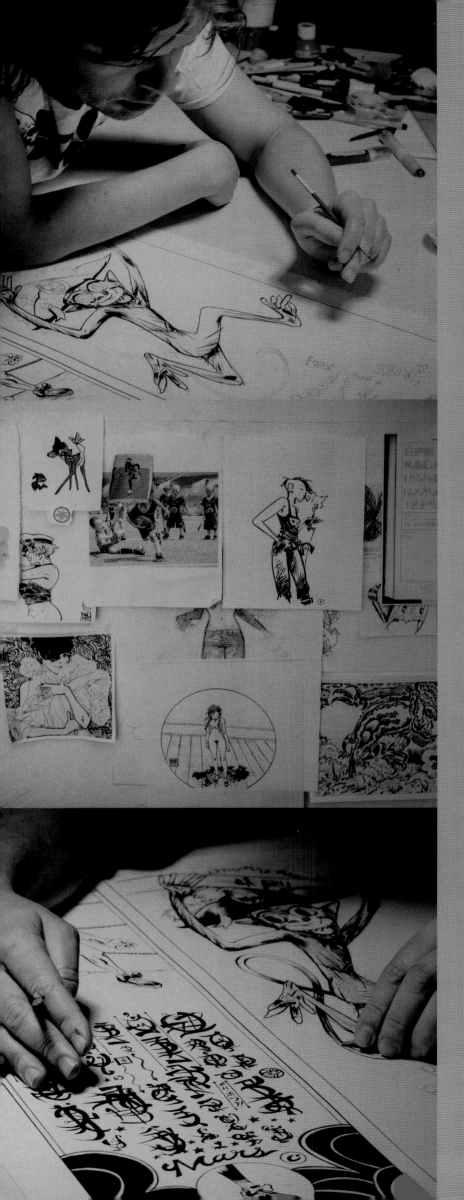

When I was a little over halfway finished with Batman: Year 100, I was in Spain. This would've been August 2005. While visiting my friends at Norma publishing, I picked up two copies of a beautiful book called Periplo Immaginario, a massive retrospective of drawings and paintings by Hugo Pratt, published by Lizard Edizioni. This huge book serves as a multilingual catalogue for a traveling exhibition of Pratt's work, and it goes well beyond the familiar, iconic images of the sea wandering Corto Maltese series. One copy of this book alone is as heavy as a slate floor tile. Carrying two was like carrying two pancaked bowling balls on your back. The book is a bottomless well, a magic mirror, page after page of Pratt's lush sketches and watercolors, many of which I'd never seen before. Many images stretch back to a period in the 1950s and '60s in which Pratt created a number of stories and paintings using the world of American Indians — and more widely, the entire scope of 17th and 18th Century American history — as subject matter. Long before going on to dream up Corto Maltese, Pratt wrote and drew a number of stories with names such as Fort Wheeling and Sergeant Kirk, stories set along the early American frontier. This setting was one he would return to again and again, as in the '80s, in the pages of a strange little book called Jesuit Joe, a violent and primal story set in the Canadian north during the days when the French trapped beaver in Ontario and Quebec, and trade was done with the First Nations all the way down into the Ohio River valley.

Jesuit Joe is a classic anti-hero, sometimes helping people, sometimes not, an Algonquin native wearing stolen Royal Mounted gear. In one scene, Joe shoots a bird for it being too happy. These are stark, existential musings on the human condition boiled down into words and pictures, a far cry from other idealized Cowboys vs. Indians adventures. Pratt made another skirmish into this same wild territory in a book called Indian Summer, drawn by the great Italian cartoonist Milo Manara, a free-form variation on Hawthorne's Scarlet Letter, another scathing critique of Colonial Puritanism.

The world of Pratt's Indians looks very much like the world I lived in growing up in northern Ohio, all snowy banks and black birds, rows of cattails and corn and spindly trees covered with a dusting of red and orange Autumn maple leaves. Growing up there, perfectly independent of the mind-achingly dull and inevitable suburban sprawl, the John Deere rider lawnmowers and the rabbit antenna-fuzzy images of David Brinkley, the history and traditions of the place bled into your unconscious like an indelible folkloric ink. History seemed very much alive and real there, not just a lot of words in a book by James Fennimore Cooper. It meant there was more to the land than just the telephone wires and the truck stops; there was more than just the fast-food windows and the three channels on the TV. More than the radio and PBS, Space Invaders and a pocket full of quarters. It practically reverberated up from out of the ground. The Shawnee general Tecumseh's last stand was there (The Battle of Fallen Timbers, 1794), and so too the ancient astronomical Serpent Mound. After nearly two hundred years, the walled garrison of Fort Meigs still stands above a rocky outcropping along the southern bank of the Maumee River, all testaments to the lives and times that had come before. It meant people were there long before any of the people I came from were there — strange, old, silent, and distant people with names like Hess and Gonyer

ET IN ARCADIA EGO:
Palm Reading

and Wolfe and Pope, who had themselves come from the Black Forest region of Germany and northern Quebec, Geneva and southern Ireland. And as for that side which ends abruptly back with that fateful knock on the door and that proverbial baby on the doorstep in the mid-1800s, maybe it's better we don't know where those ones came from. Maybe it's what they wanted for all the rest of us. It's the only rationale for why that happened that I can imagine.

So, I grew up in that place in Ohio. It's a question everyone asks, Where are you from? I am from Ohio. People ask it everywhere, even in New York. I've spent half my life in NYC and I am still asked. Everyone is curious to know where everyone else is from. I think it is rather more telling to find out when a person is from. When are you from? I am from that Ohio in the 1970s. It is a place which doesn't exist anymore.

That same Mediterranean summer I was in Spain, I was also in Ohio. The Batman: Year 100 deadlines were kicking my ass and I really needed a break, a chance to step outside myself, an escape. My brain felt like oatmeal, my body like a sack of twigs. My cousin Julia was getting married and I missed the place I had come from and I wanted to see my mom. I found myself stepping from a plane into a dingy urinal in Michigan, southbound from Detroit. I looked at myself in the mirror and I couldn't recognize the person I saw. It was me, but it wasn't. It was a person in a black button-up silk shirt and a two-piece black velvet suit, in hand-made Italian crocodile skin shoes, with a ten dollar quarter-inch Caesar cut, wearing a gaudy silver skull ring on my right hand and a big O-ring buckle on my waist.

I got a truck stop coffee and somebody asked me where I was from. I am from New York, I said. It was saying something without saying much of anything. Hours earlier, I awoke listening to the screeching brakes of a big rusty garbage truck just outside the window. I was lying on a couch in a friend's living room in South Williamsburg, Brooklyn, my bags all packed and ready, that much closer to the airport. As I dialed a car service and looked outside, I saw jagged, angular sights, I saw grey-blue shapes shot through with bright white shards. Rattling car engines spluttered morning exhaust under dirty black rubber wheels on the way to JFK. The only sound was an amorphous, cacophonous chorus of car horns puncturing the 8am air with machine-gunnish staccatos. Out on the streets, everything was lined with black bags of trash, half-torn open, half-rifled, broken glass and chicken bones and wet cardboard scraps lining the gutters, graffiti festooned walls. This is the place where I live. I am from this New York now.

At my mom's that same night as the sun set, I sat in her backyard, rocked in a metal chair and just listened. There was nothing but the smooth near silence of the leaves, the gentle punctuations of twilling night animals far off in their trees. Buzzing insects and the wind, like sand tipping in a giant scale. And there were stars. Billions of them. I'd sat through nights like this so many times before over so many years and never noticed it. How could it be I never noticed?

Restless, I walked into town and suddenly realized how much it had changed. I'd slinked through that place so many times before, looking neither left nor right. This time, I let it all sink in. This time, I noticed. This time, I wasn't Quasimodo. I sat in an Italian restaurant which didn't exist last time I was there and I had a good steak at the bar. I struck up a conversation with the owner and we talked a while and he pulled out a bottle of 25-year-old Ruby Port and we drank some as he told me about his plans to open a dance club in the old Opera house he'd just bought, which was on the second floor of the building. He wanted to show it to me, but I already knew the place. It was a place we used to think was haunted and we'd invent stories about it to scare each other. Outside, the shiny new cars rolled by like slow sharks with blue neon underlights blinking, hip-hop booming from the powerful Kenwood or Bose sound systems inside. Young women walked by, phones hooked under their ears. It was a Friday night. I looked down at the hand which held the Porto and wondered, when did I become a person who could enjoy Porto? When did I become someone with a Caesar and a velvet suit? When did I become someone strangers would want to talk to?

I used to be an outsider on the inside, and it was lonely and hard. It'd helped define me. It led me into drawing. Now I am an outsider on the outside and I'm being invited back in. When did all this happen? Where did that place when I came from go?

I walked back to my mom's, puzzled, and opened the copy of Periplo Immaginario which I had brought with me, and studied the pictures. That day I had found Pratt's book, I sat on the sands of the Mediterranean and drank red wine and looked at the lines on the palm of my drawing hand. I wondered, without really wanting to know, which of the lines was my fate line. According to the legend of Corto Maltese, he had a gypsy read his palm, only to discover he had no fate line at all. Alarmed, Corto (whose name means "cut" or "quick" in Italian, or "short" in Spanish) slashes a line into his palm using his dead father's shaving razor. He then runs away from home and takes up a life at sea like his father before him, and wanders the world without ever really finding a home. Strangely, this significant, formative event in the life of Corto Maltese — the slicing of the palm, is one Pratt never actually depicted in the stories. Neither did Pratt show us the eventual death of Corto Maltese. It is hinted Corto dies early on in the Spanish Civil War, so we know he never grows old. Maybe for Pratt to commit those fateful lines to paper would be for him to find he'd cut his own line too short, too quick. Cause of death — the end of a life-sustaining dream. He chose to leave it wide open.

Like Kurosawa's wandering ronin and Leone's cowboy drifters, Pratt's alter ego's fate is to float suspended in a self-contained sea of fiction-time, immune to the limits of the rest of us, beyond the reaches of age and change and doubt and death.

PP

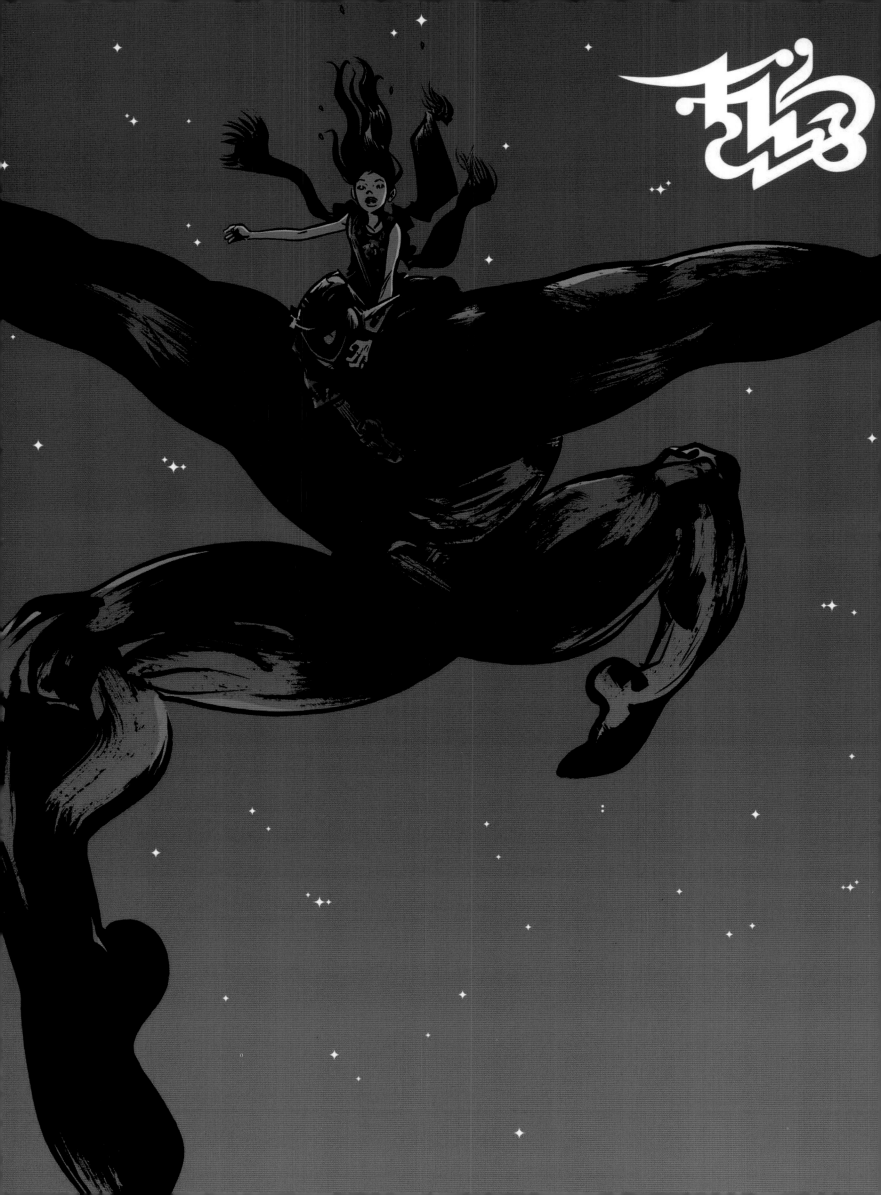

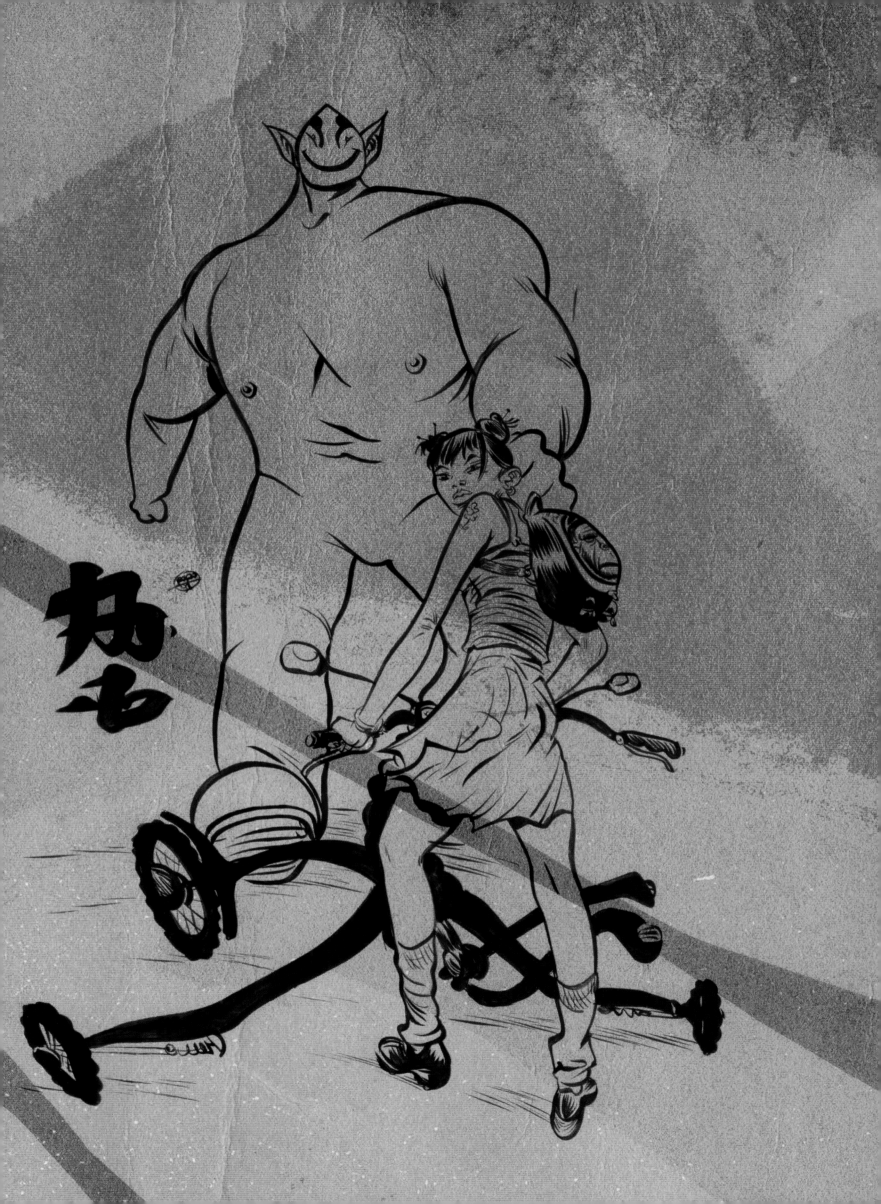

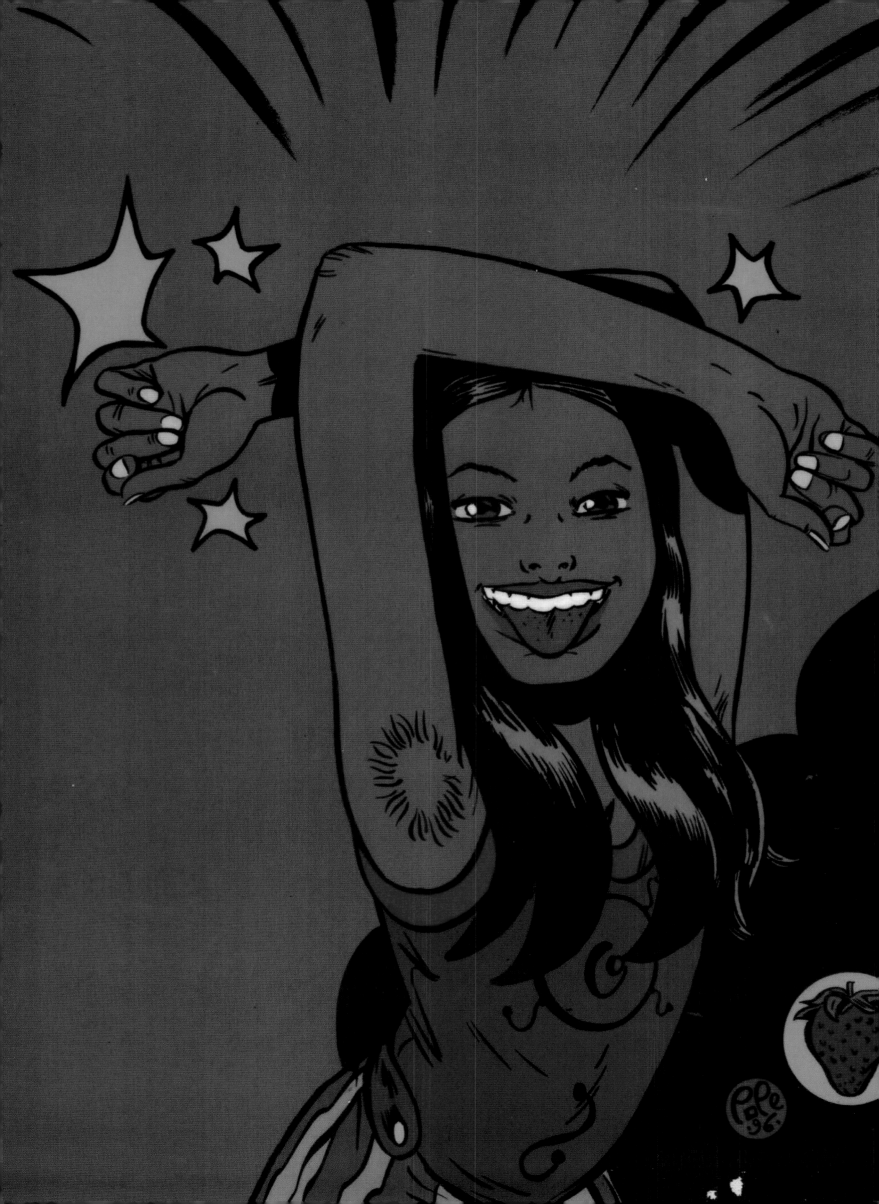

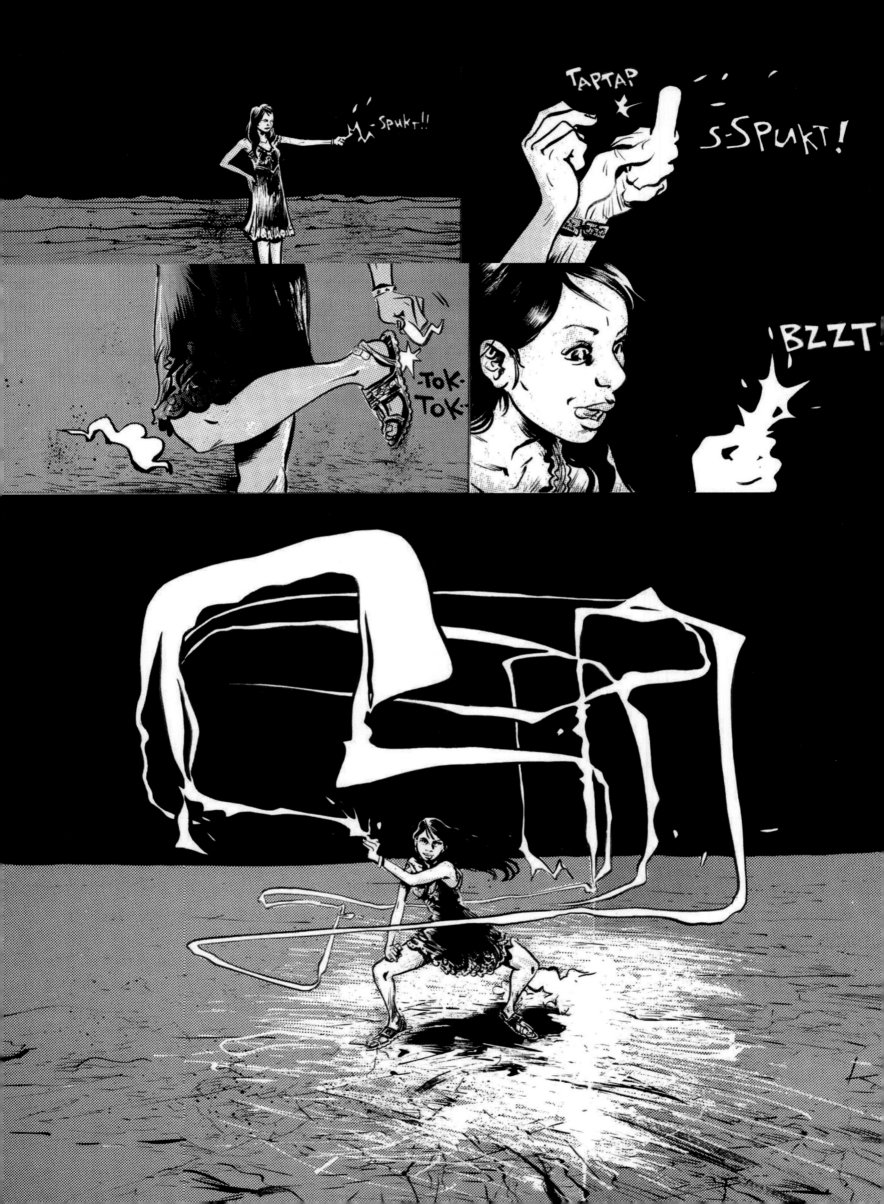

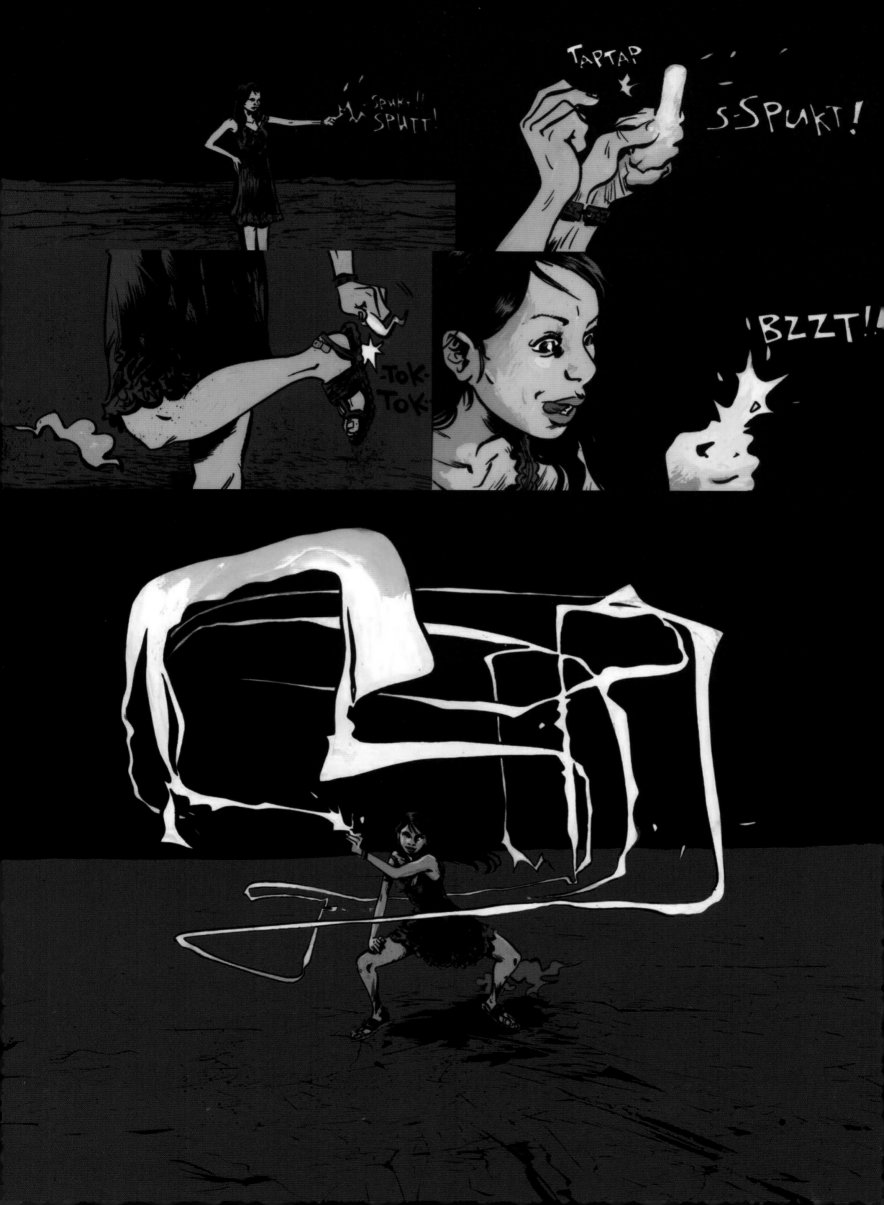

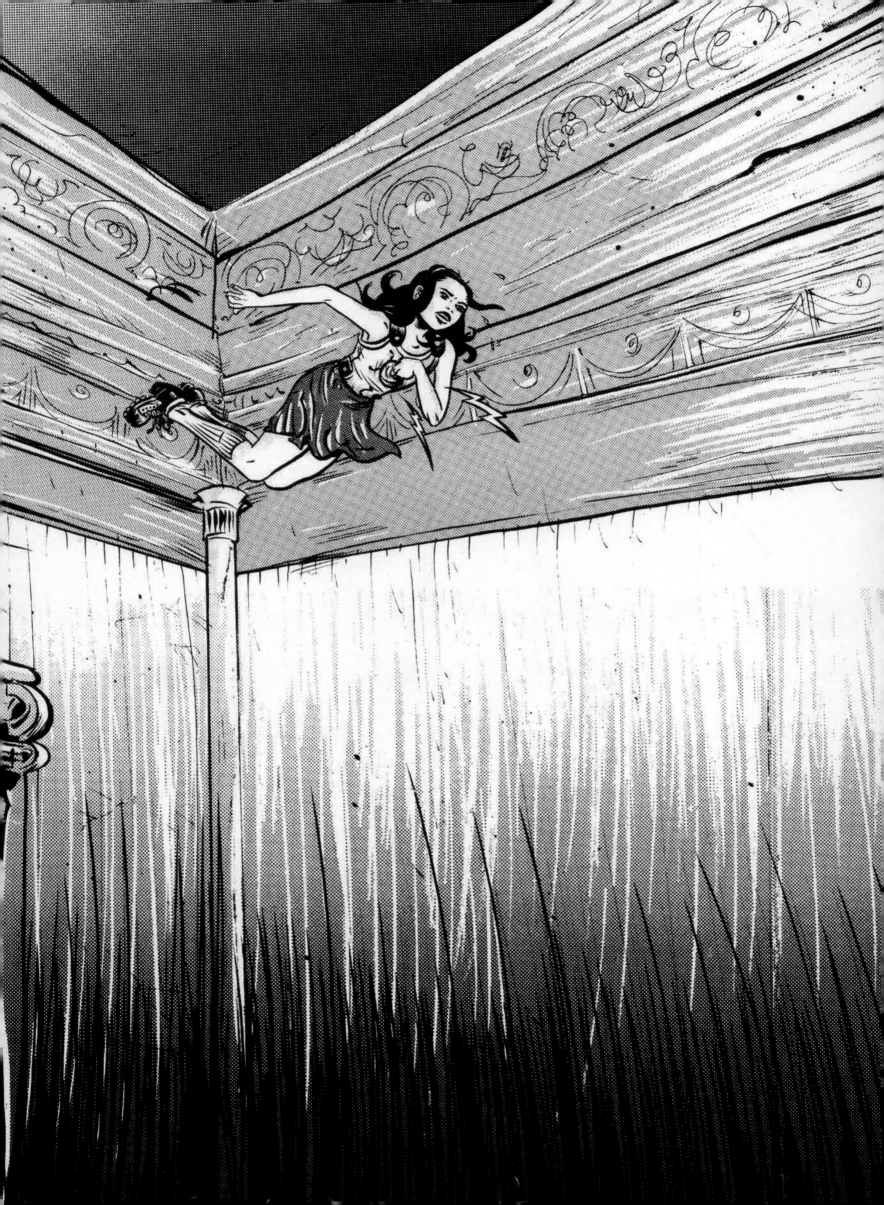

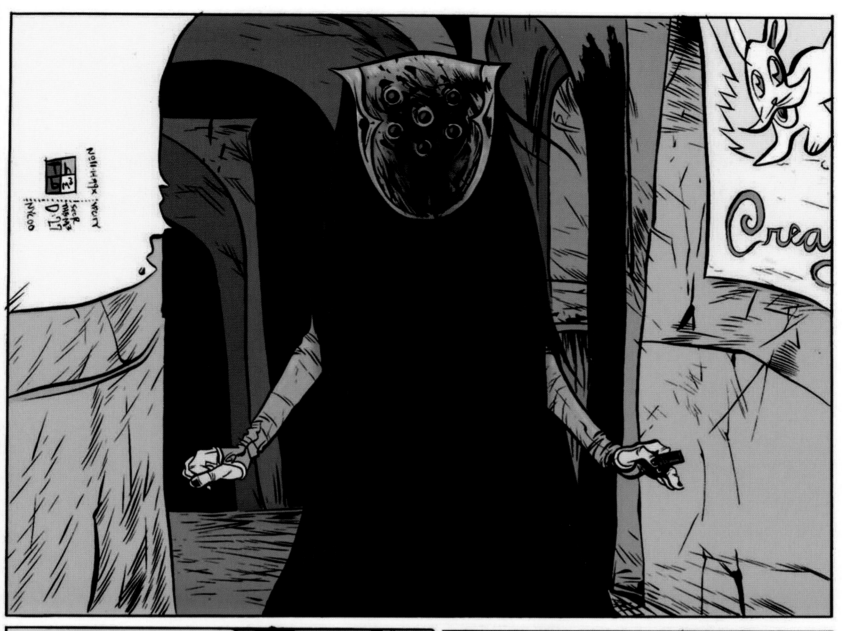
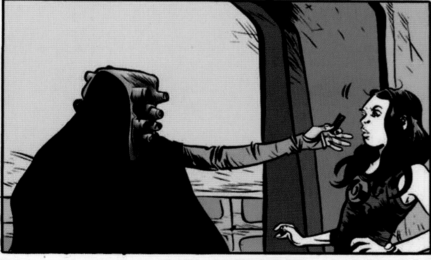
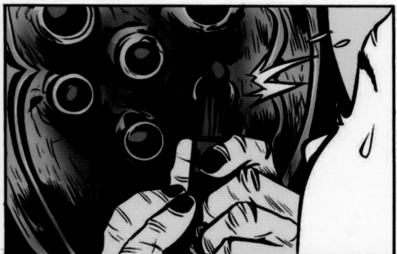

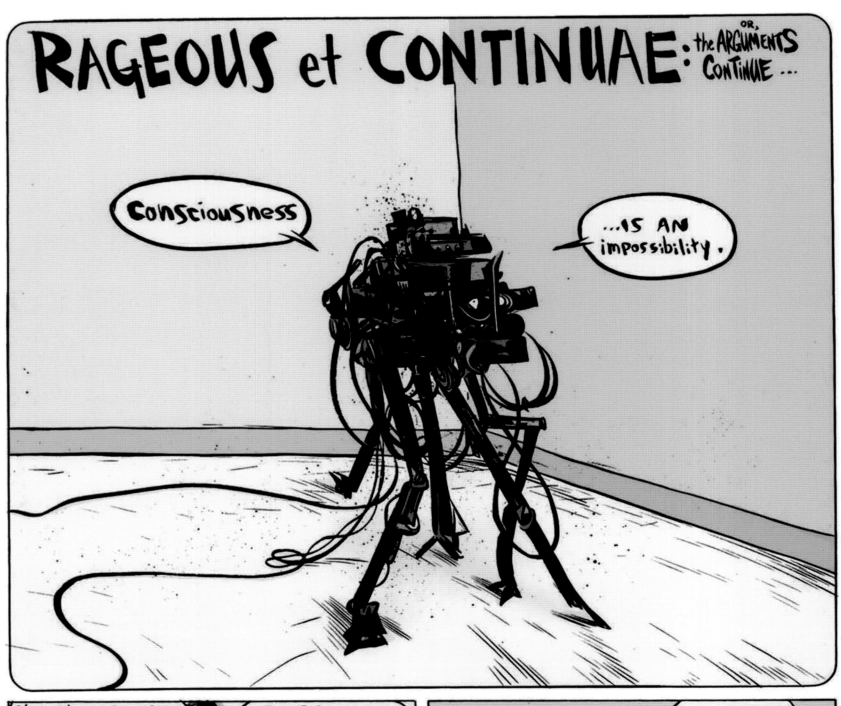

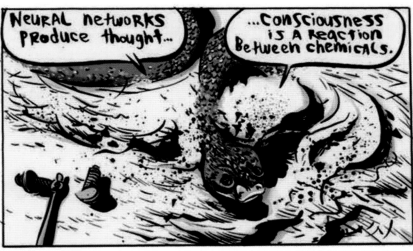

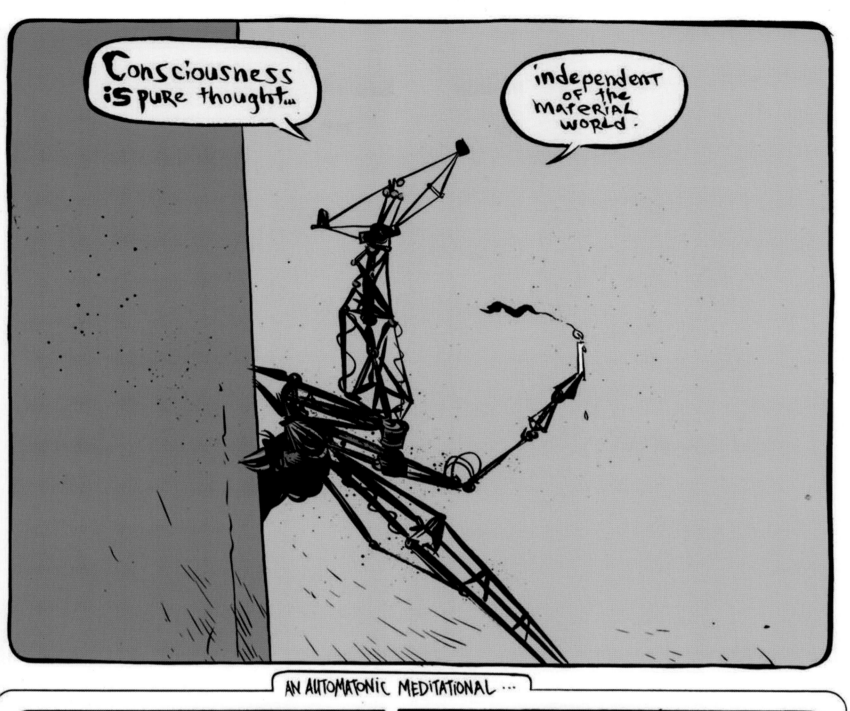

AN AUTOMATONIC MEDITATIONAL ...

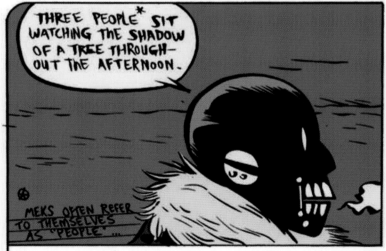

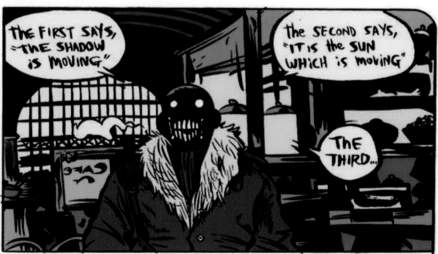

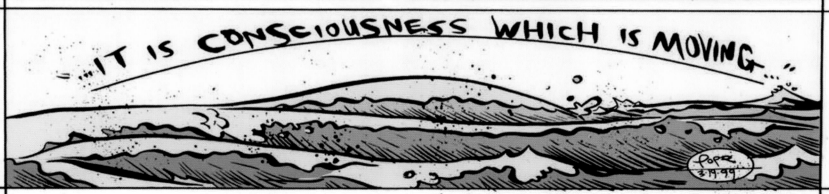

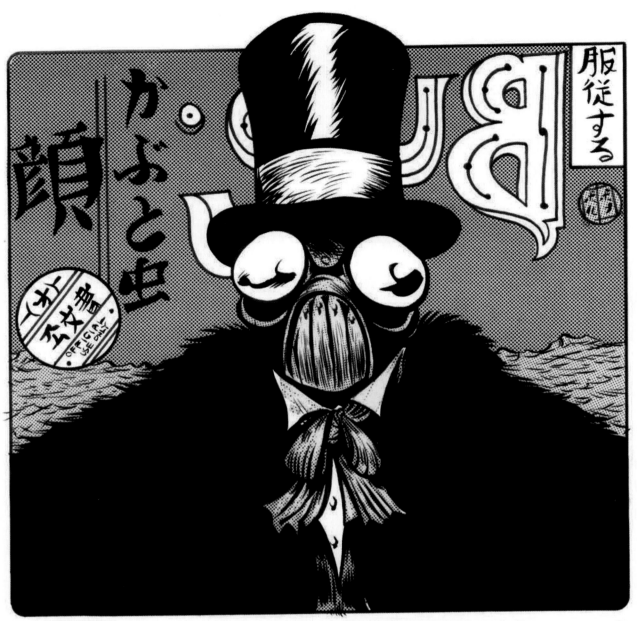

Intelligence
Flea-

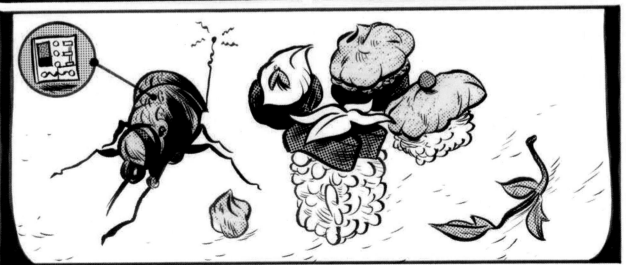

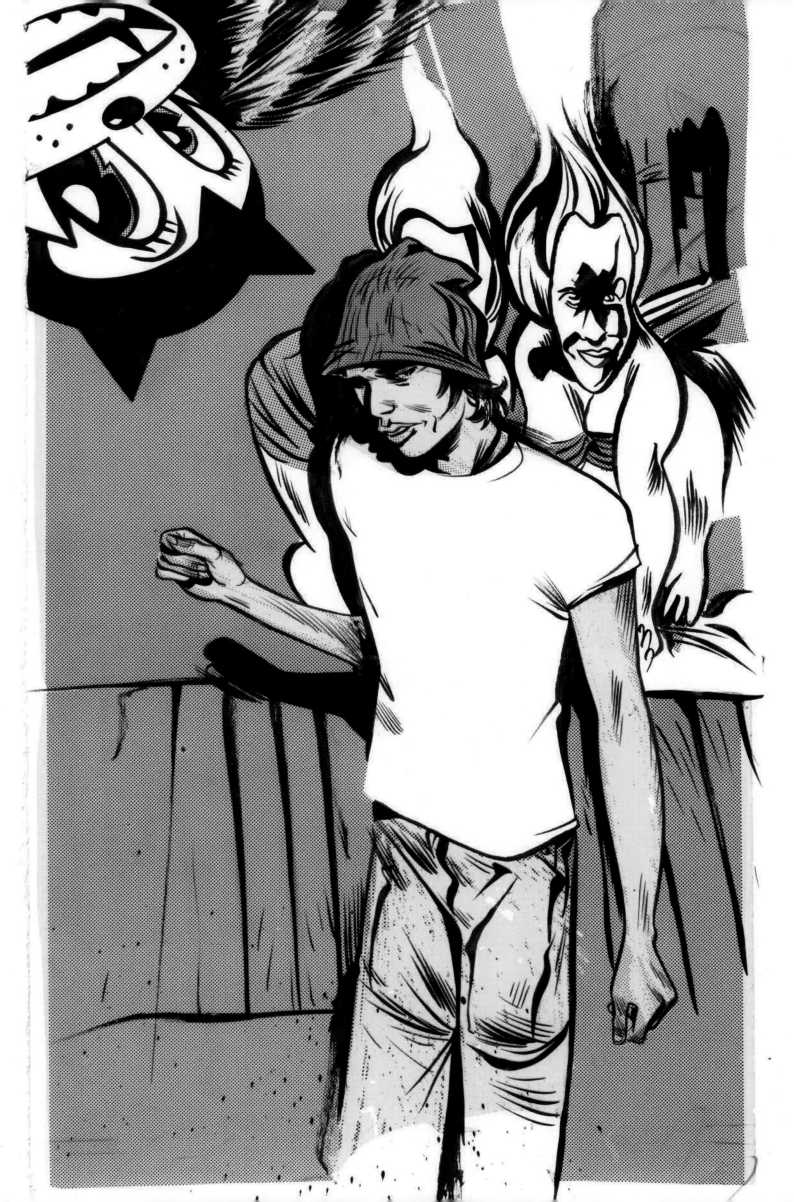

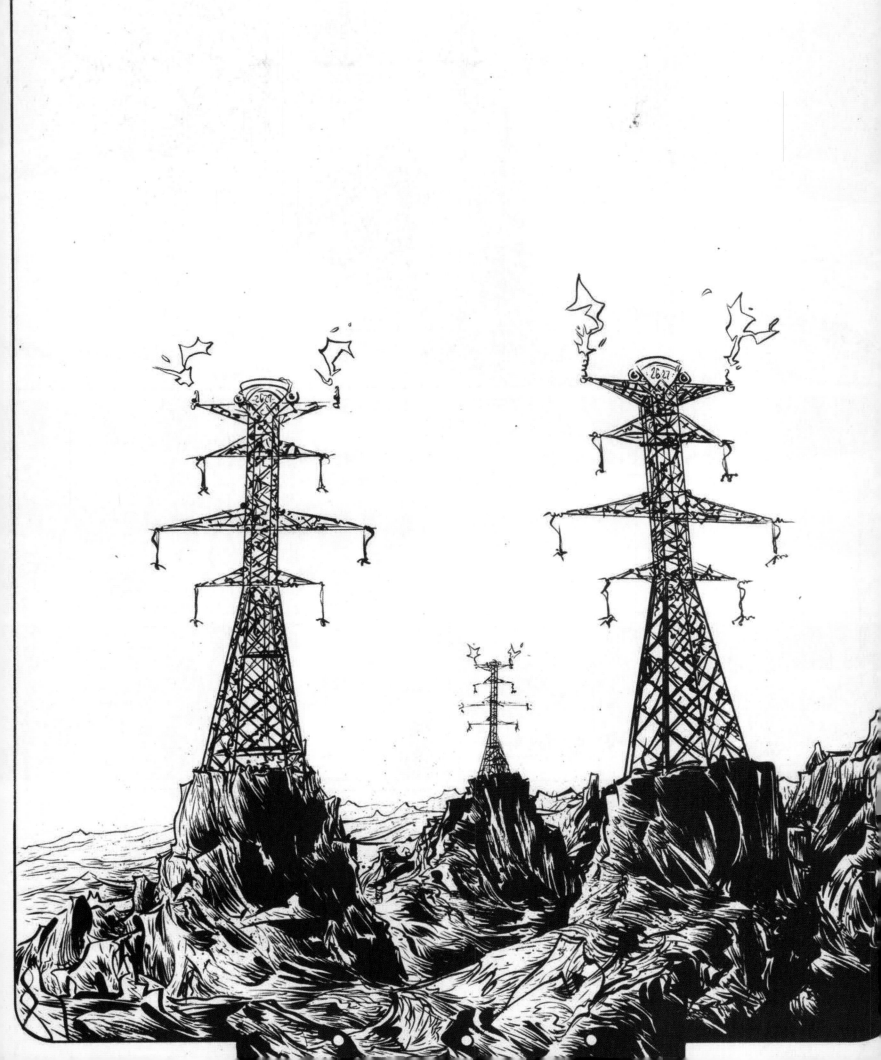

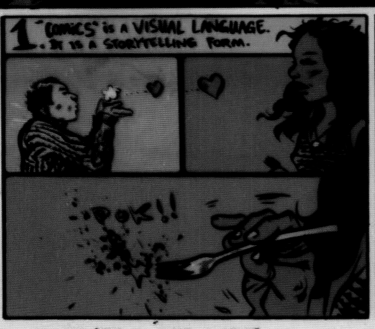

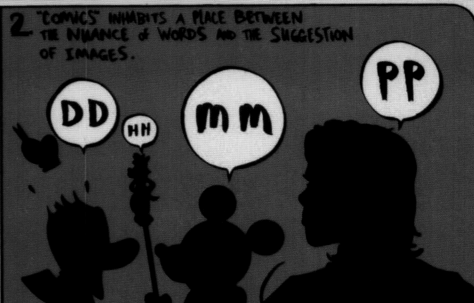

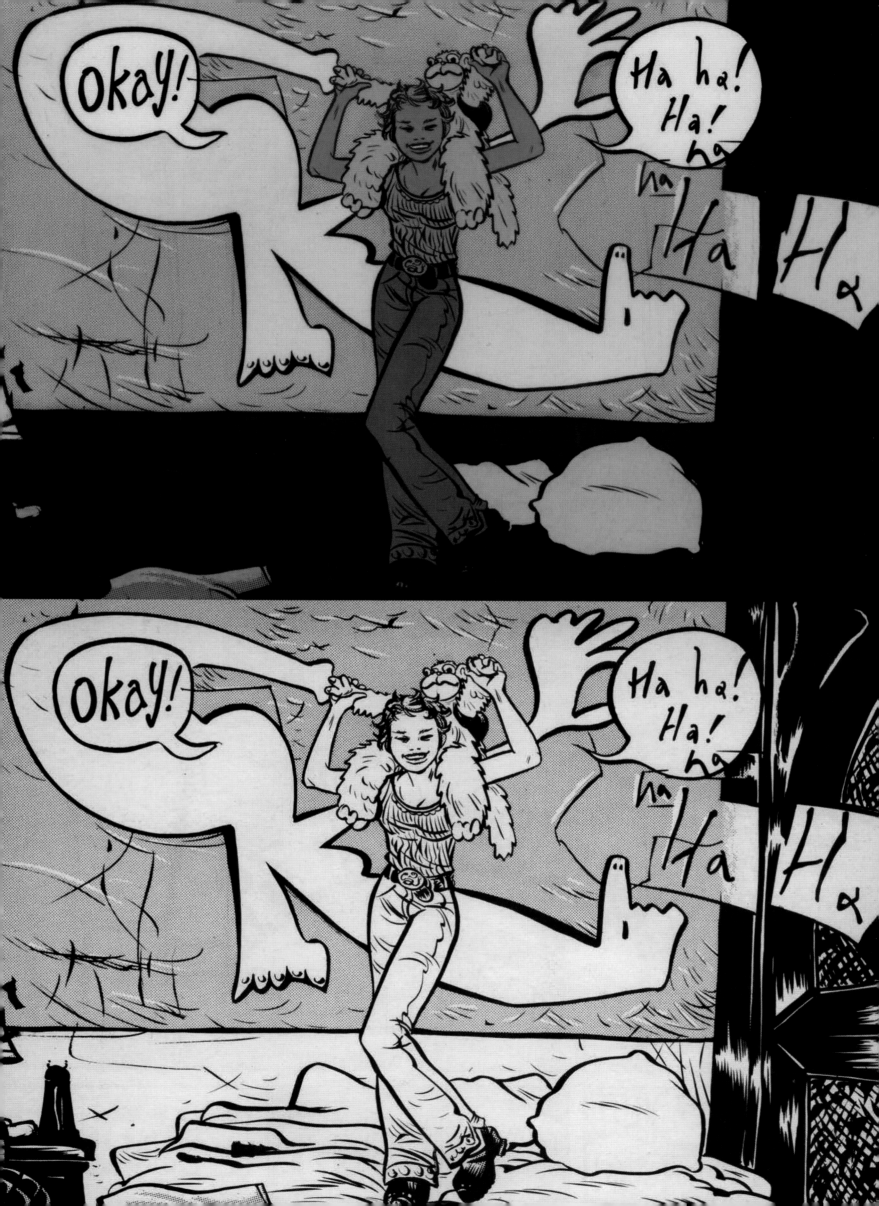

NEW
THB
LOGO

THB @ above
CITY

CITY IN
DISTANCE

GATE W/
ISLAMIC
ARCH

McHAINE
at P-CITY
GATES

8-25-03 →m

INFO
DATES

→ 10.5 × 36

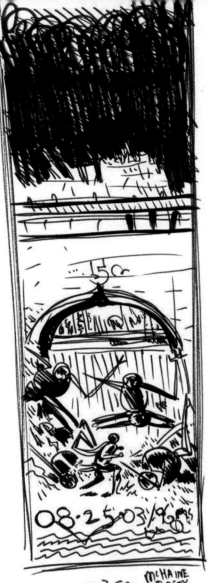

10.5 × 36

McHAINE
@ P-CITY
GATES

MN

THB/MEK-POWERED FOR
NEW ACCELERATION 9.25.03/
GIANT THB Iv.2/96 PA. NEW
COMICS ENERGY/PAULPOPE.COM

THB: MEK-POWERED FOR
NEW ACCELERATION
9.25.03 GIANT
THB Iv.2/96 PGS. OF NEW COMICS
ENERGY
SIMON@PAULPOPE.COM
RINZEN.COM

GIANT THB #Iv.2
MEK-POWERED FOR NEW ACCELERATION
9.25.03

THB: MEK-POWERED
FOR NEW ACCELERATION

9.25.03 GIANT THB Iv.2 7th ABRUPT.VERSION
NEW COMICS ENERGY 96 PGS OF NEW COMICS
ENERGY

GIANT THB Iv.2/96 PGS OF
NEW COMICS ENERGY

SEE MORE AT PAULPOPE.COM
RINZEN.COM

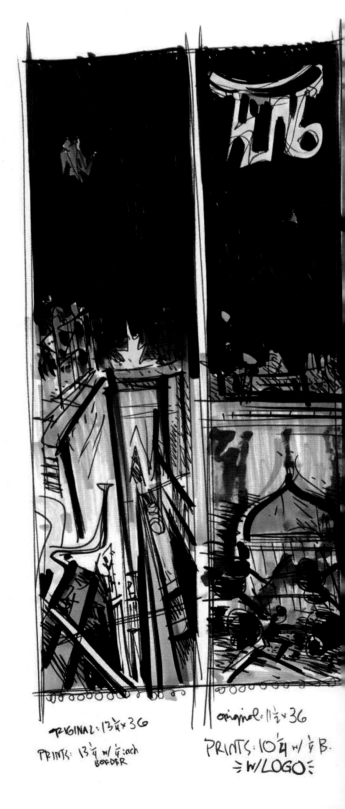

ORIGINAL: 13¼ × 36

PRINTS: 13¼ w/ ¼ inch
BORDER

original: 11½ × 36

PRINTS: 10¼ w/ ⅝ B.
= W/LOGO =

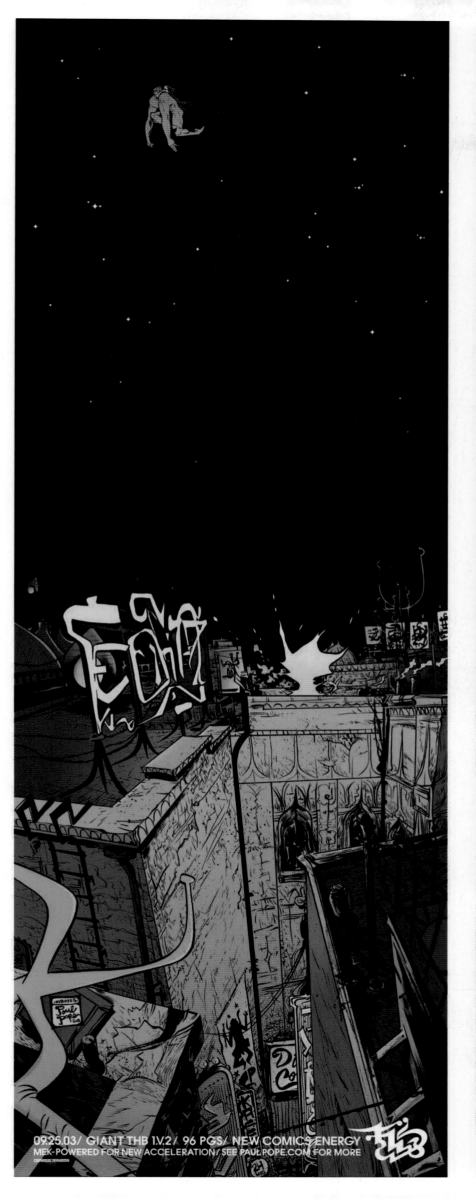

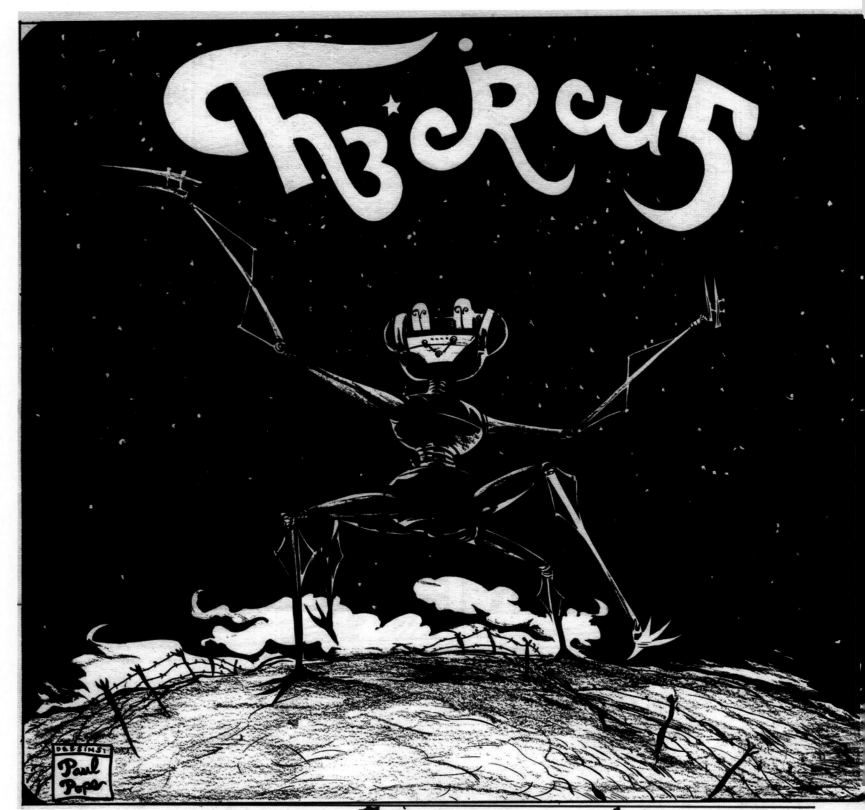

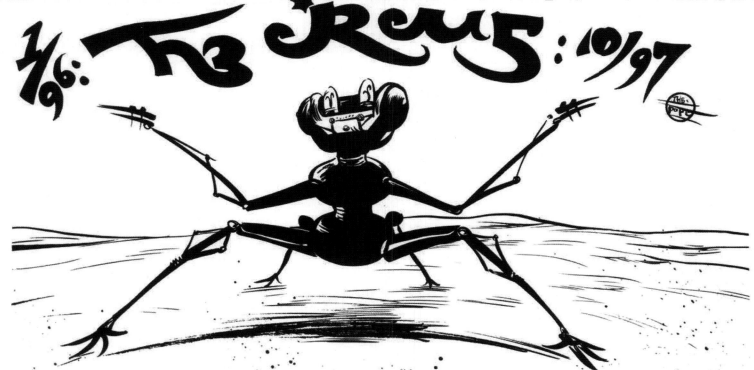

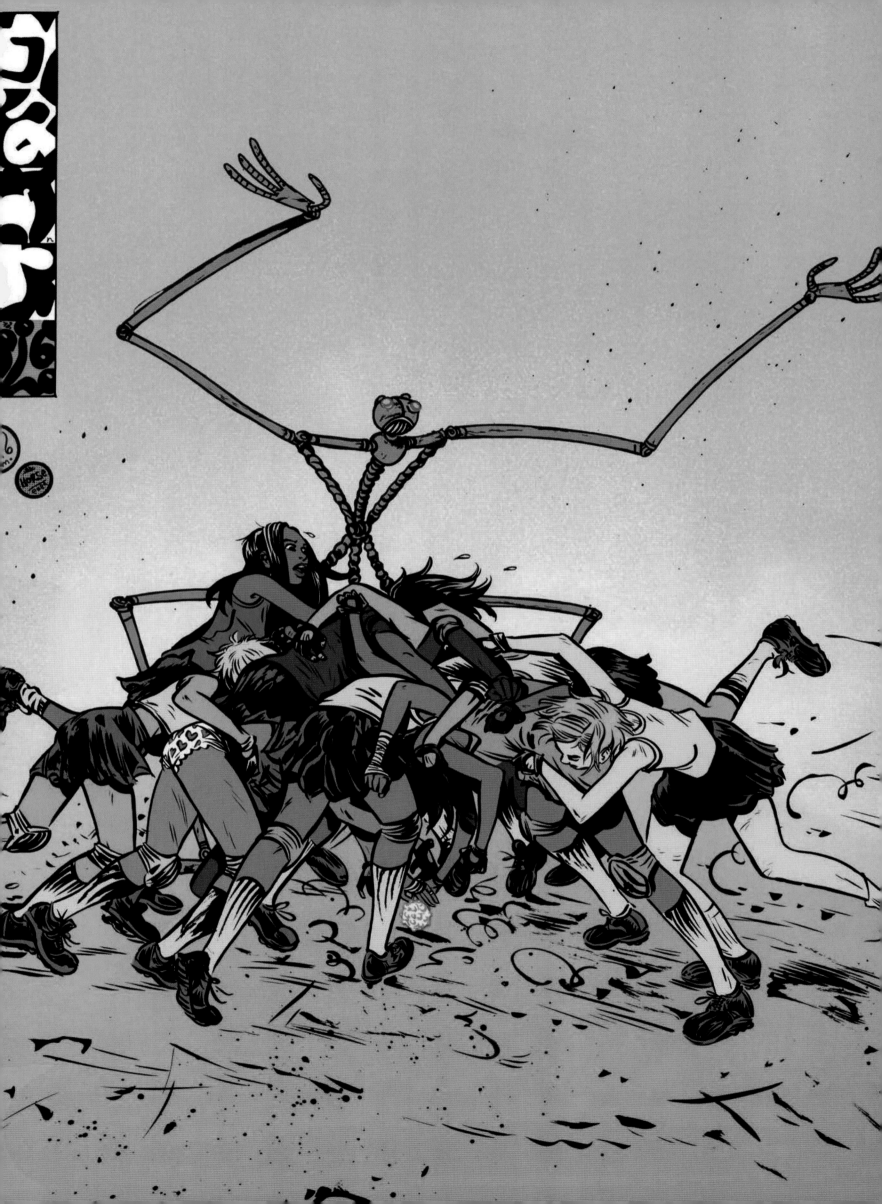

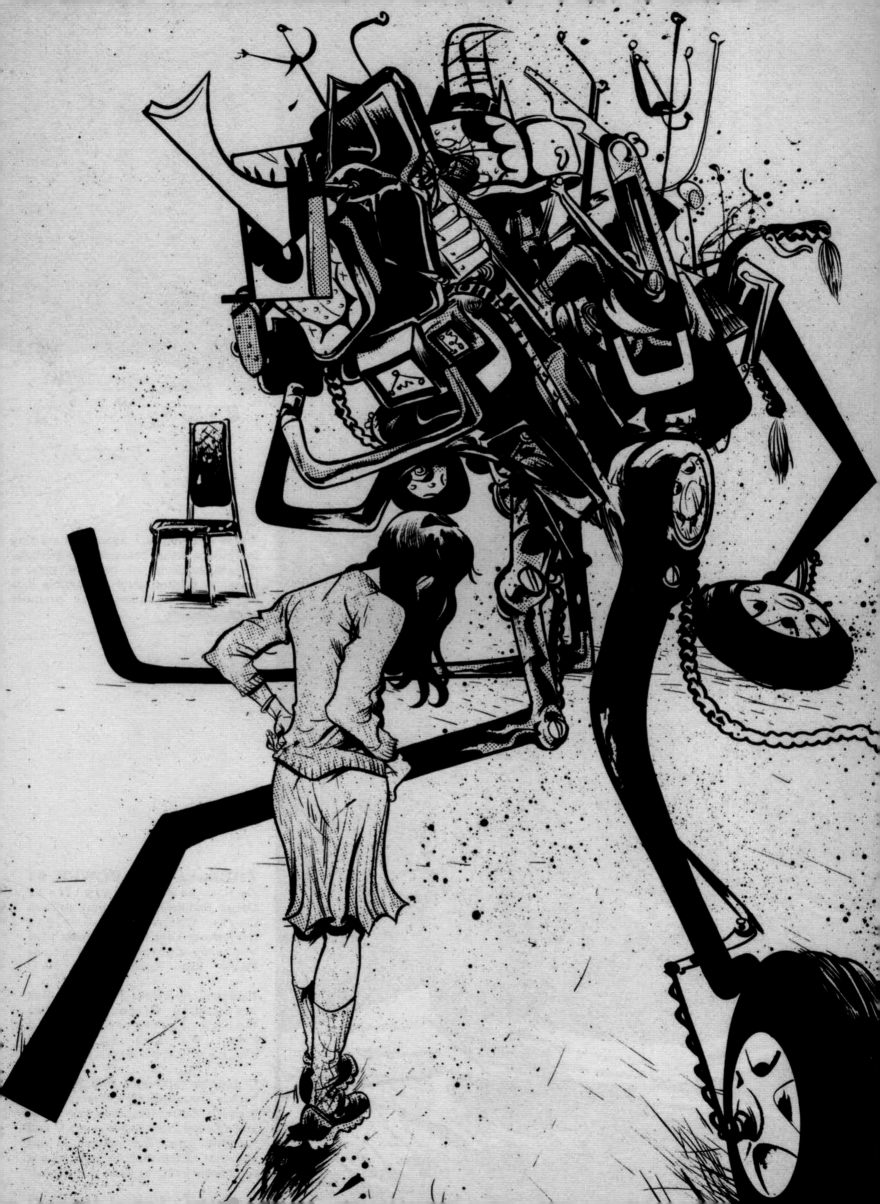

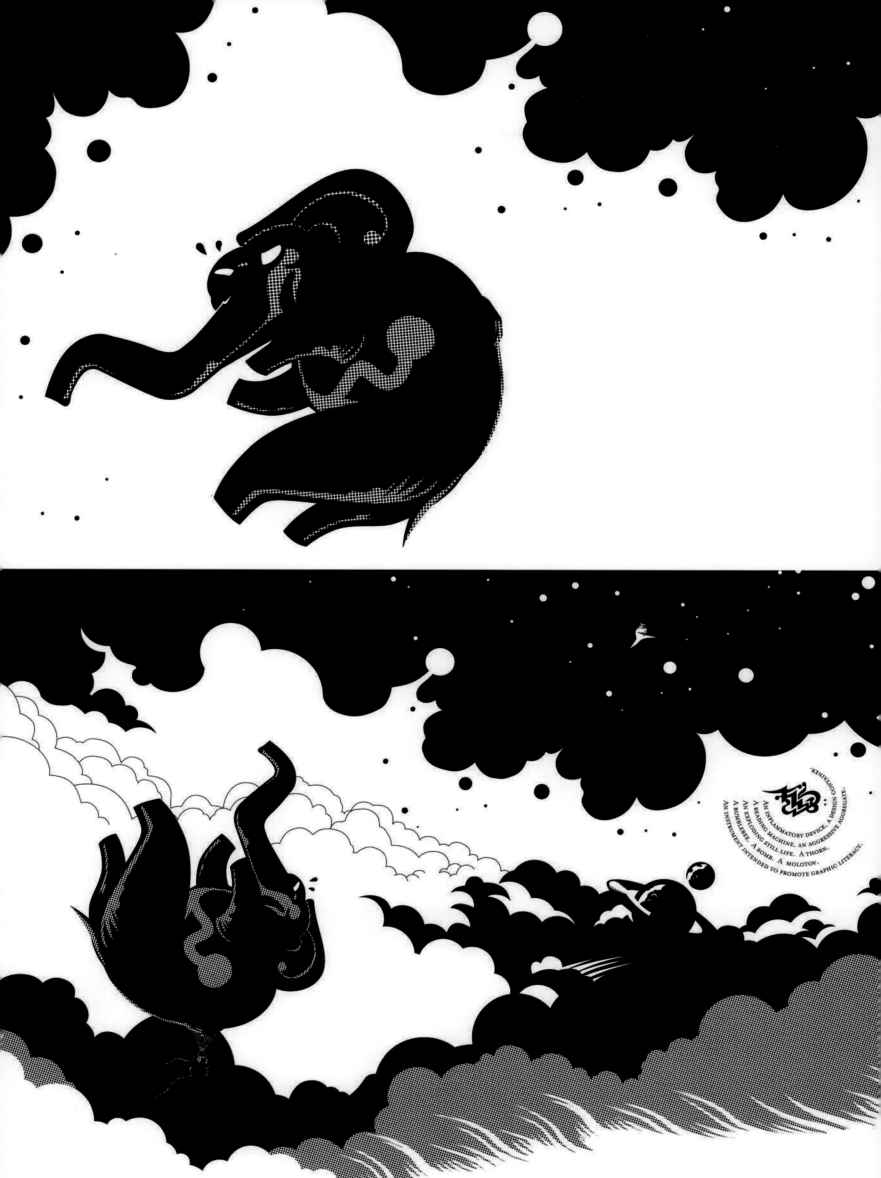

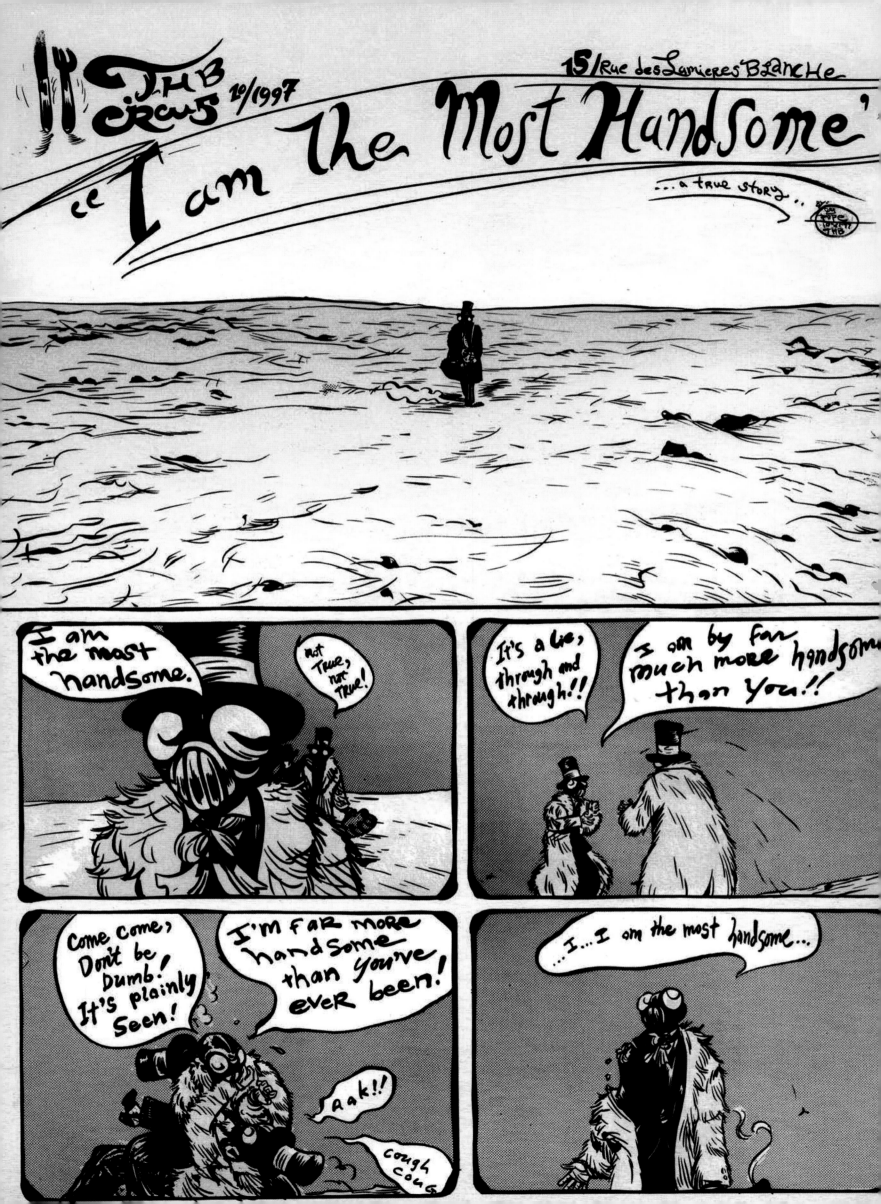

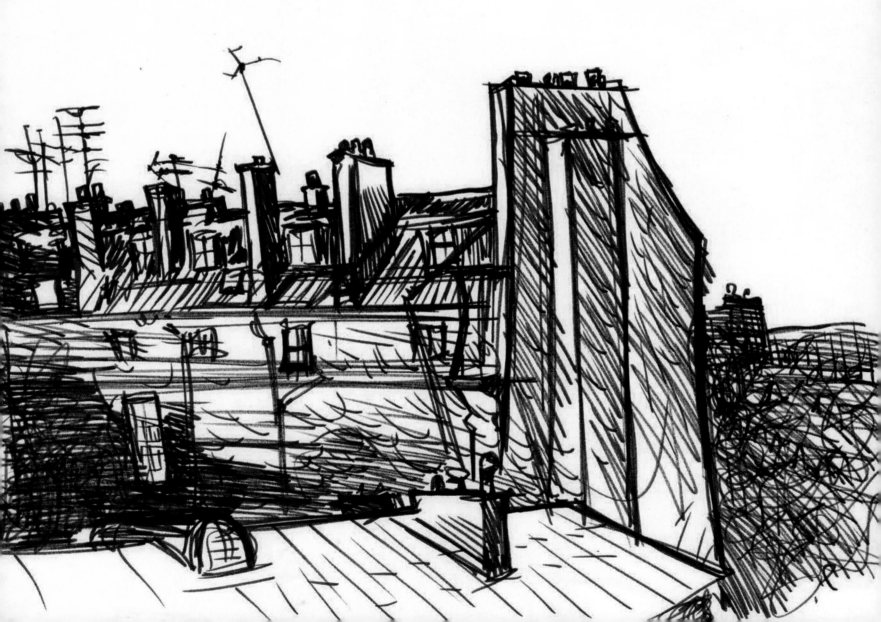

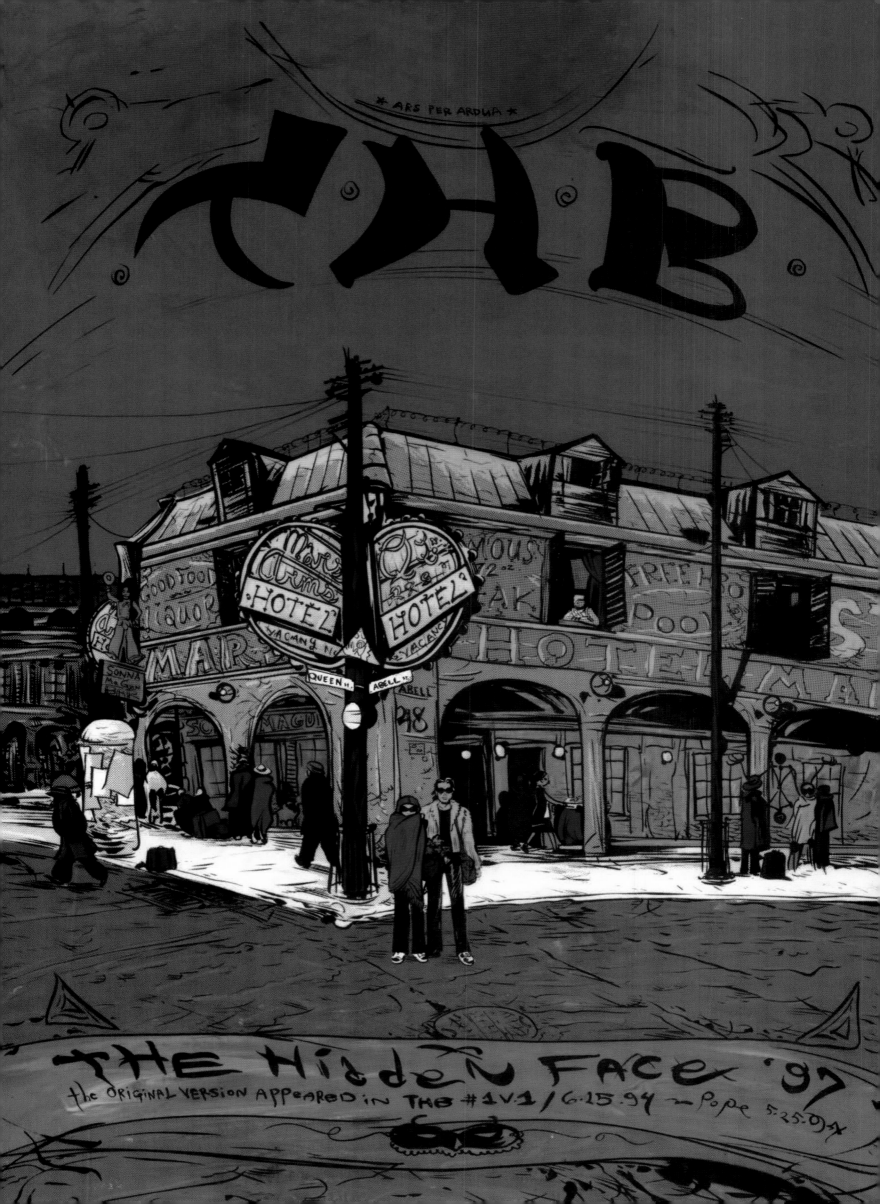

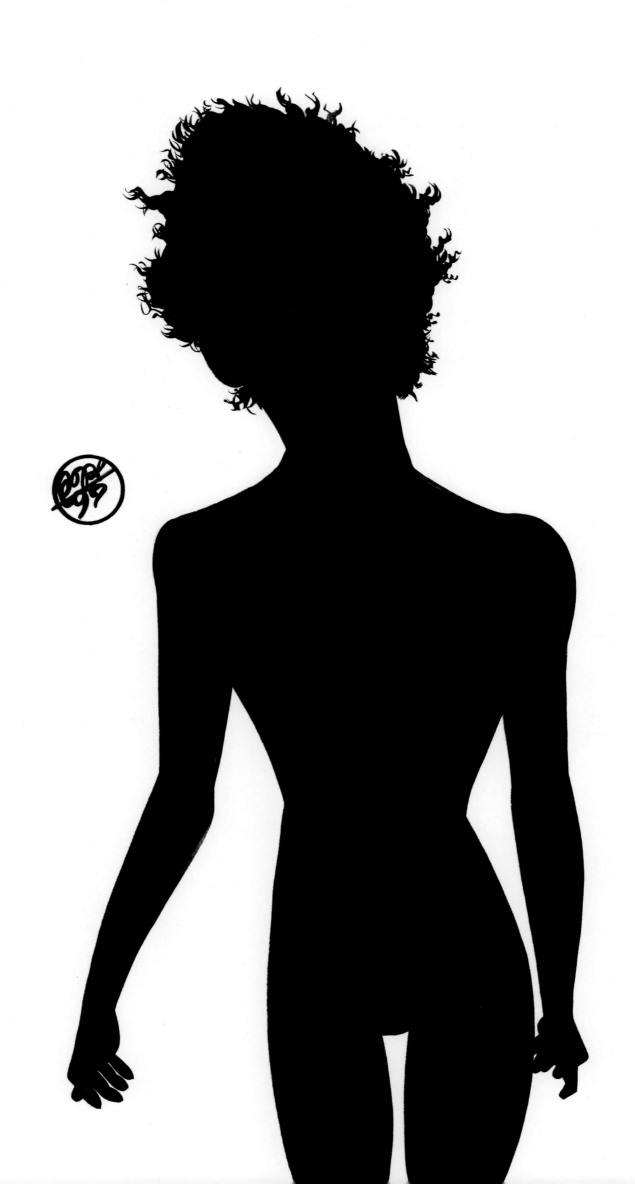

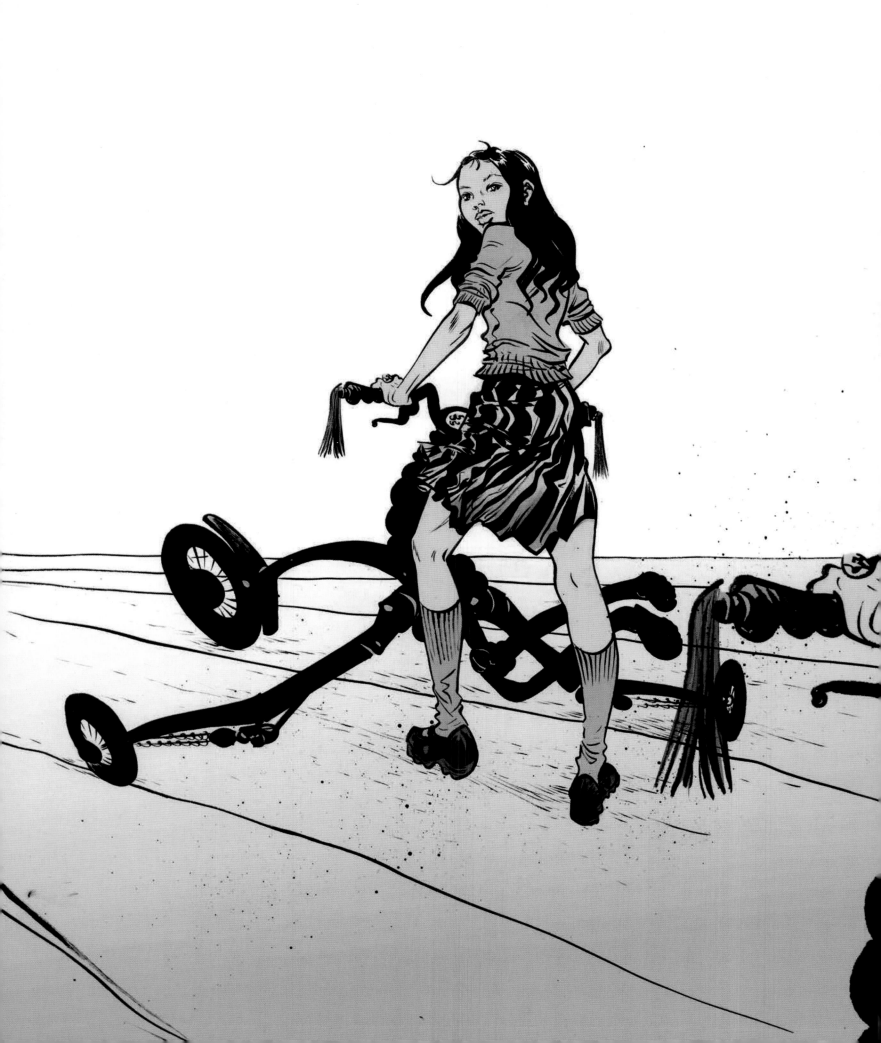

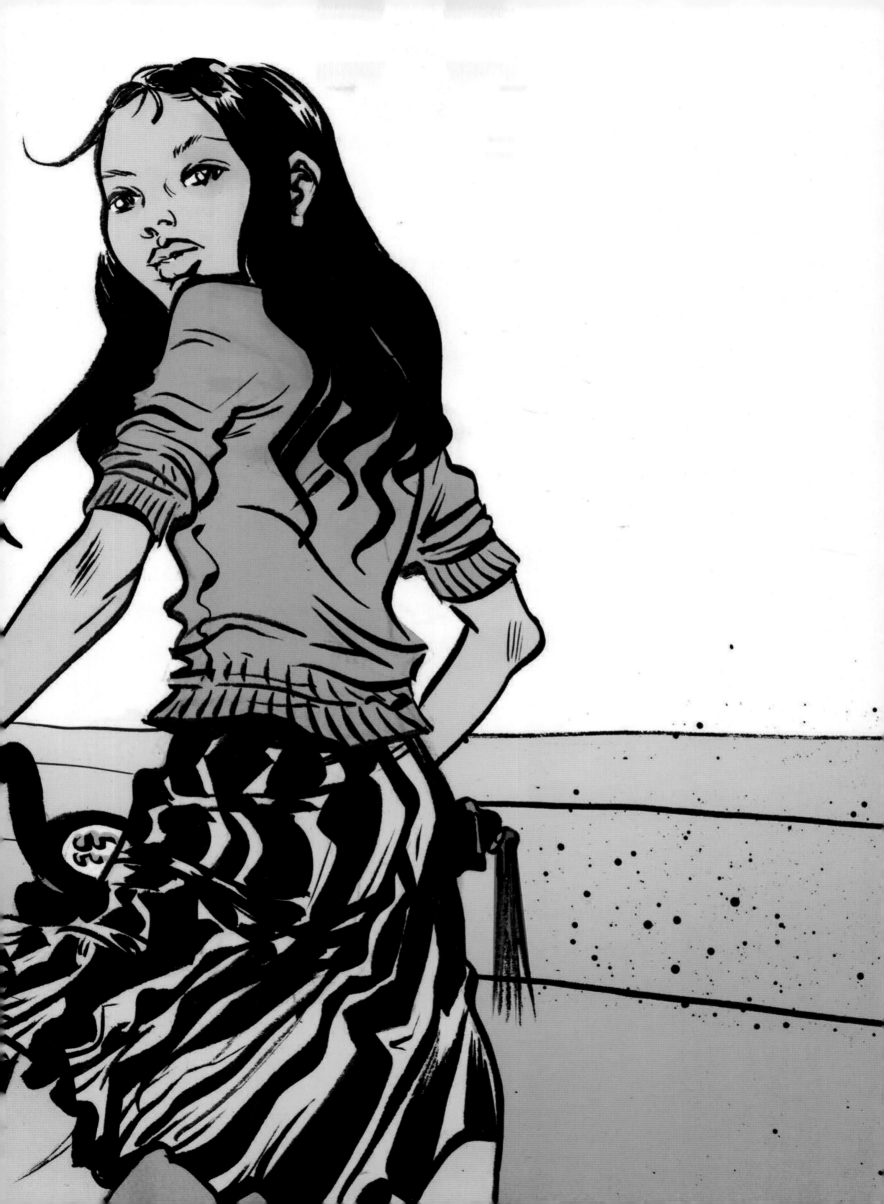

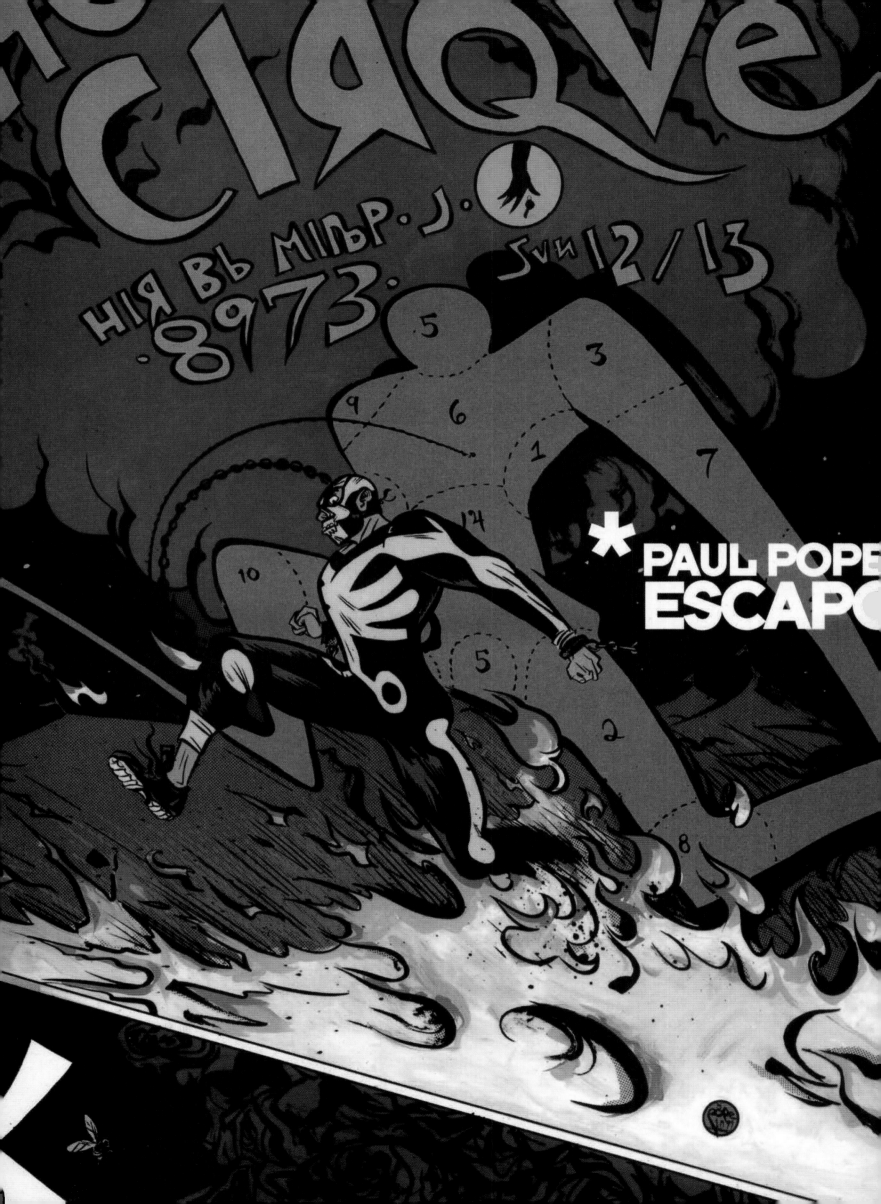

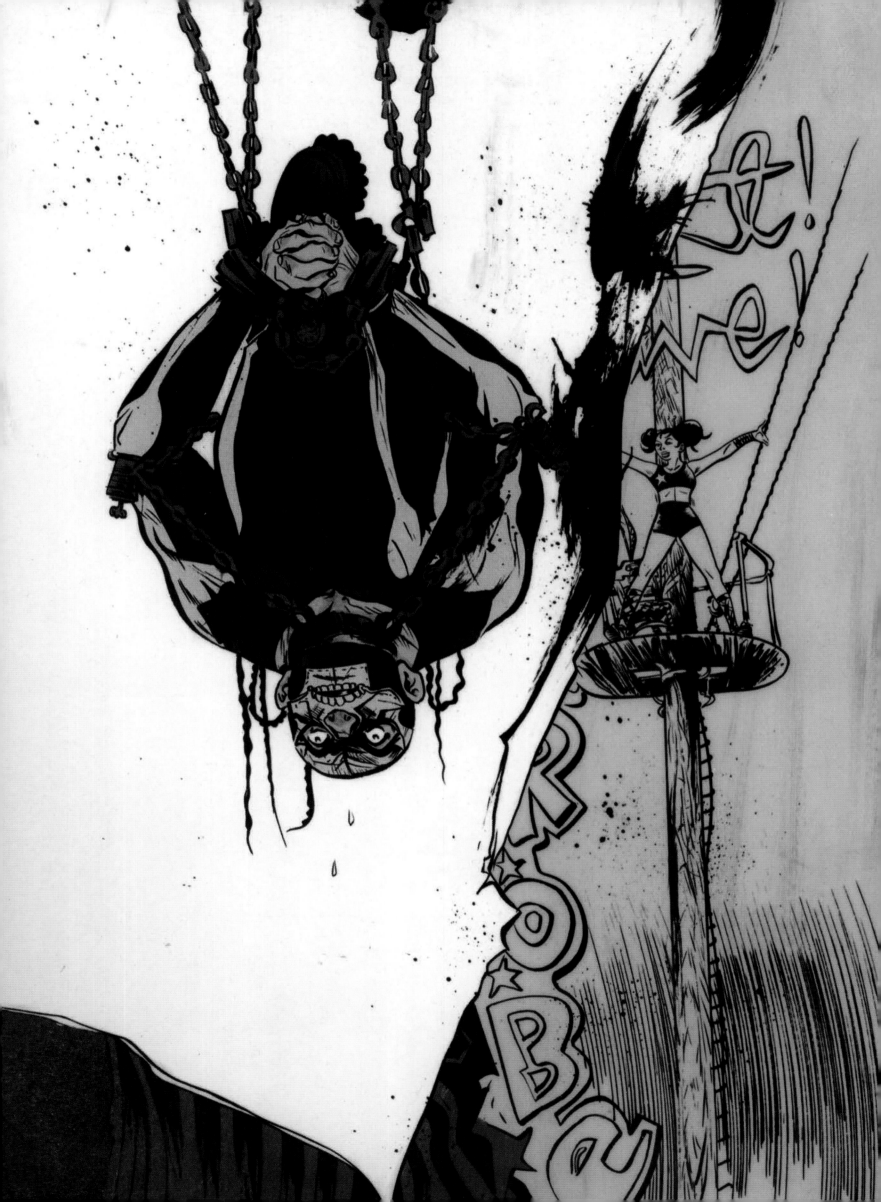

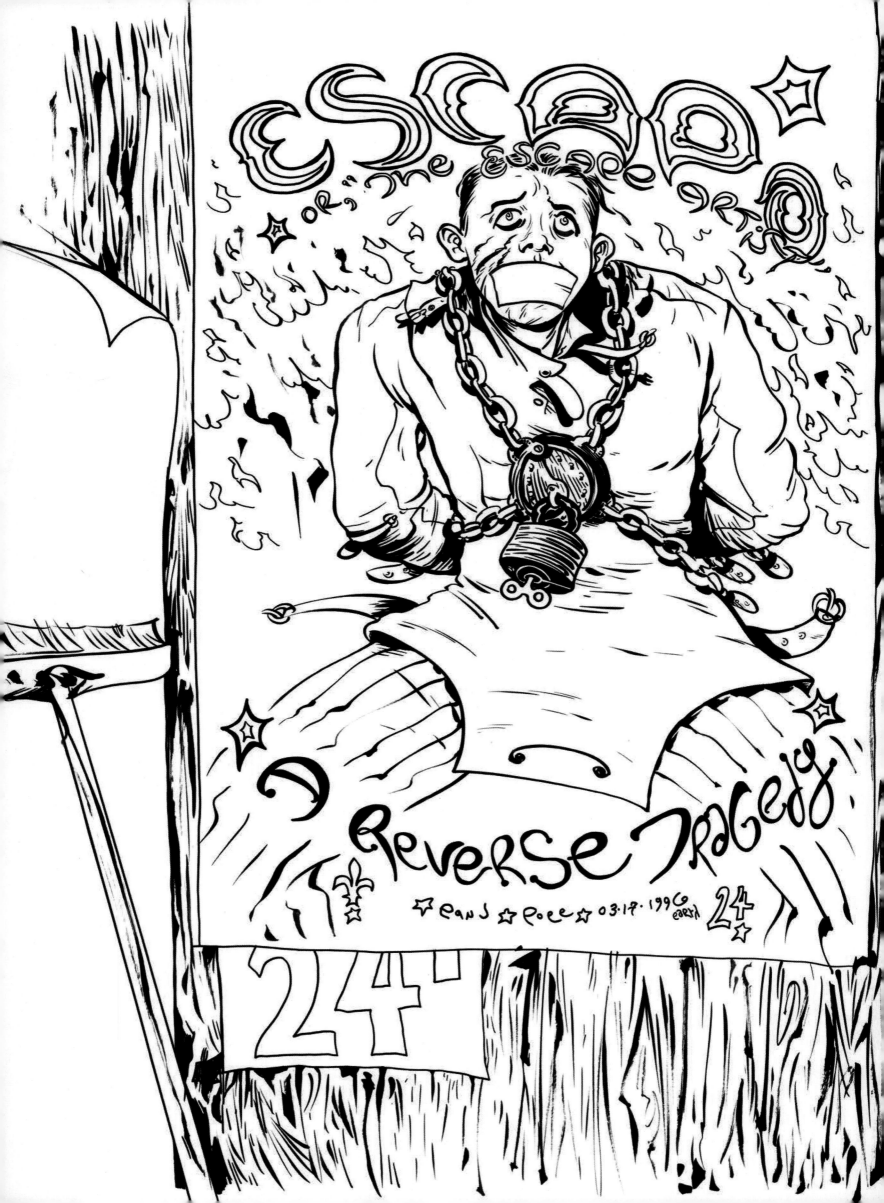

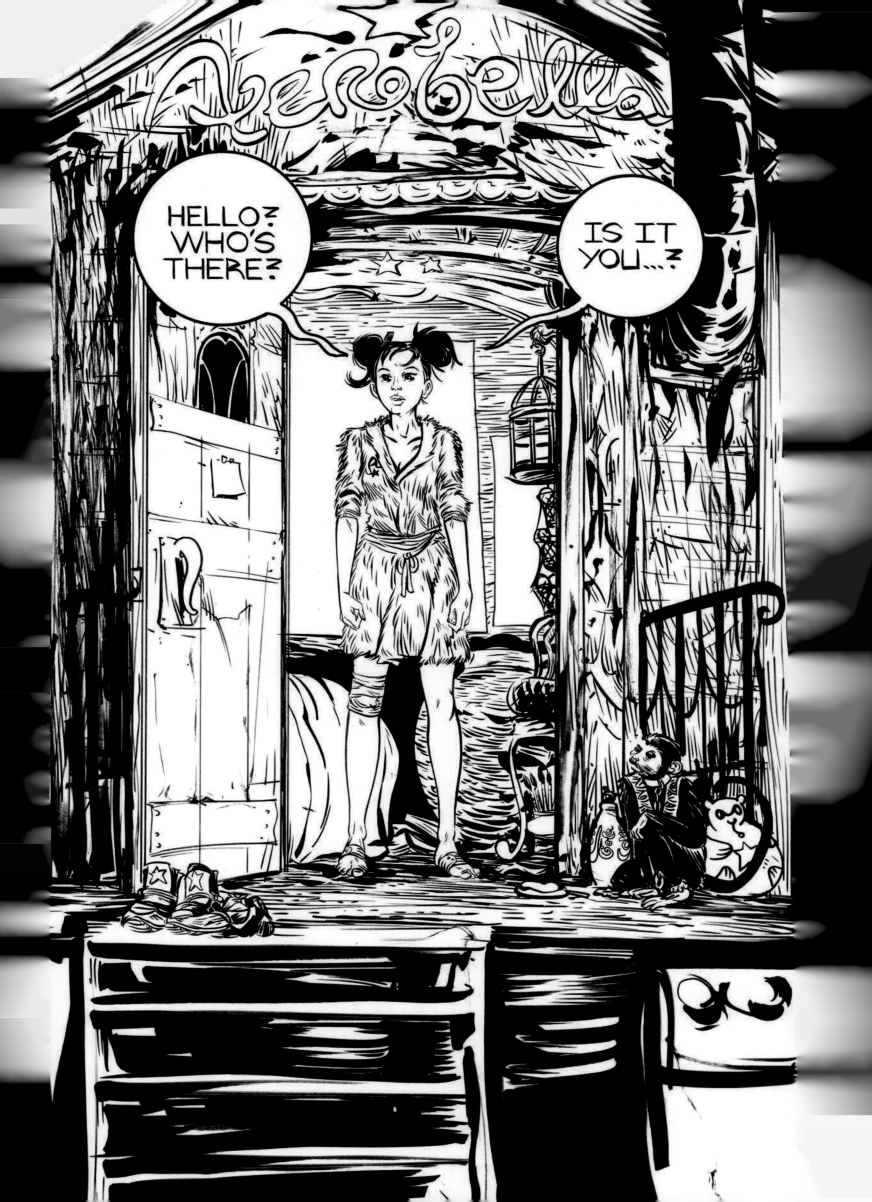

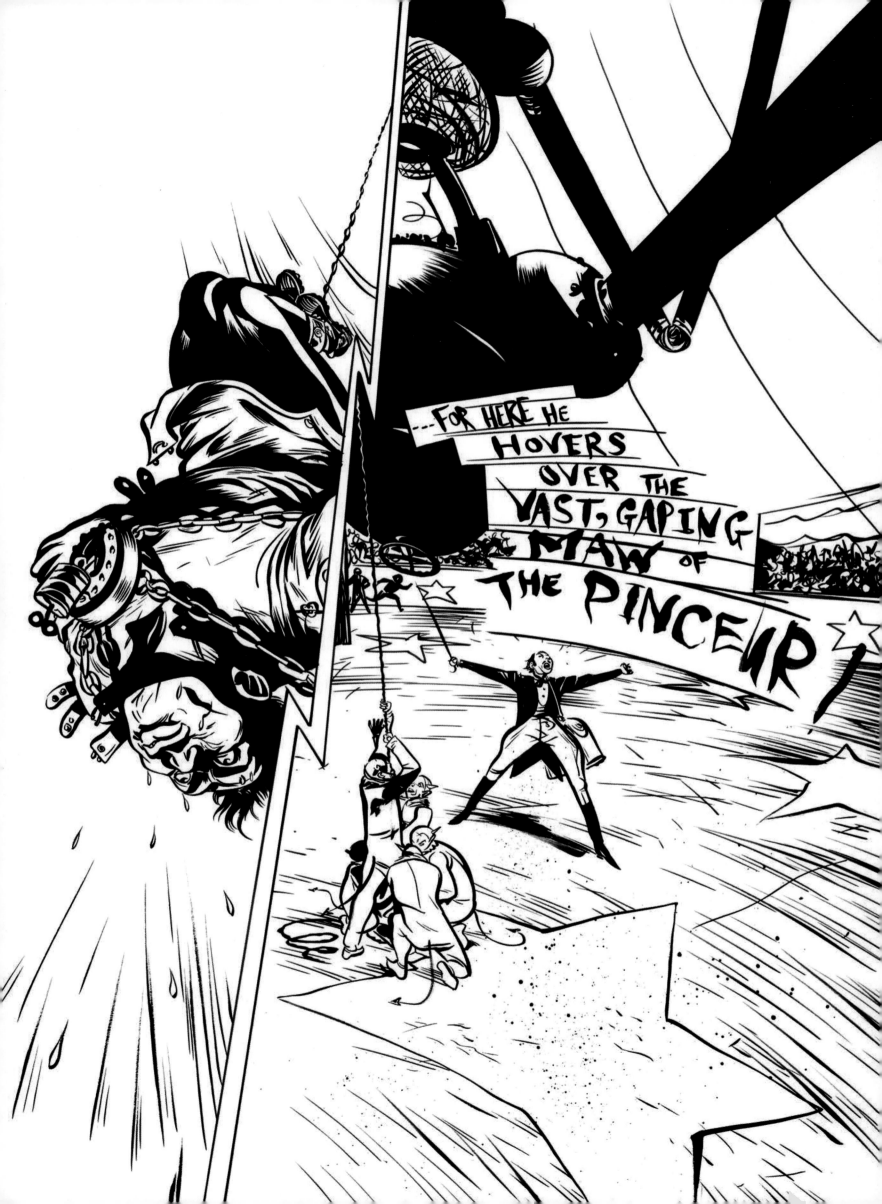

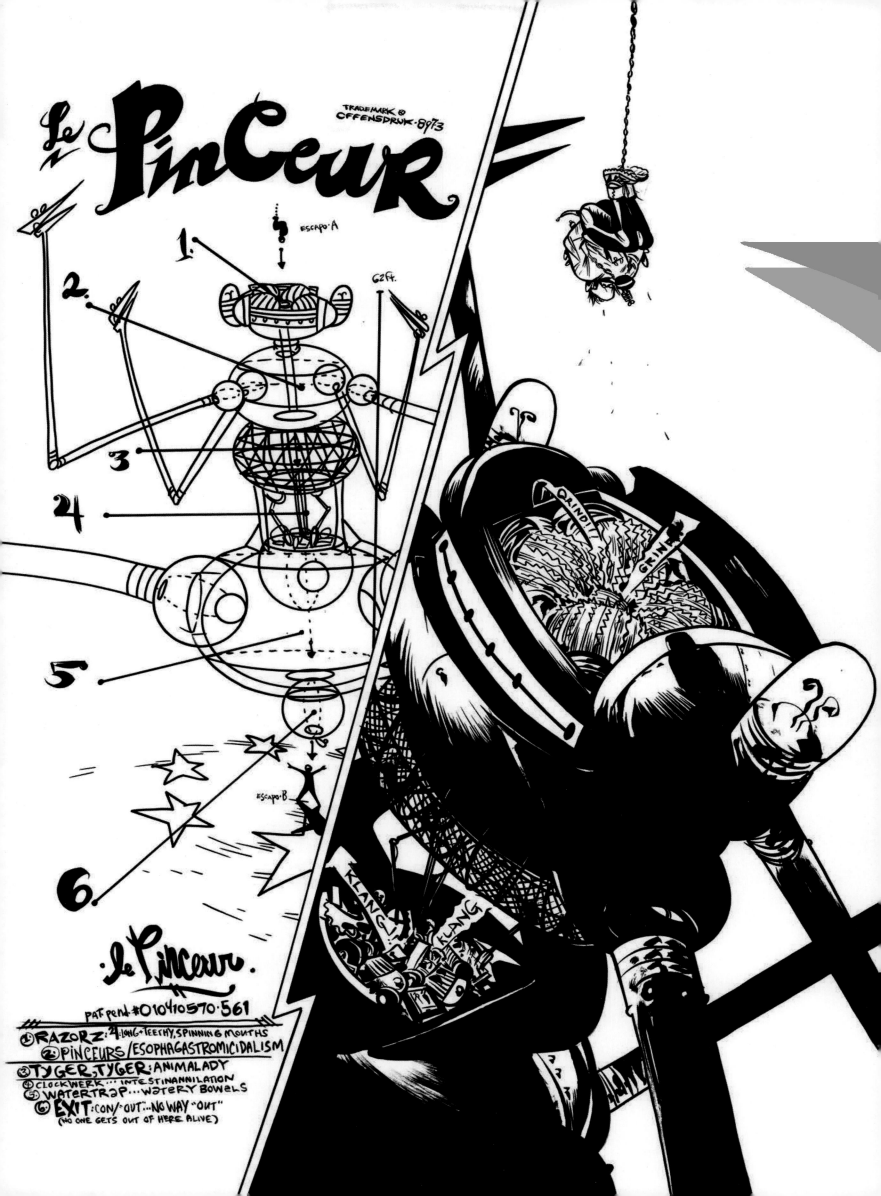

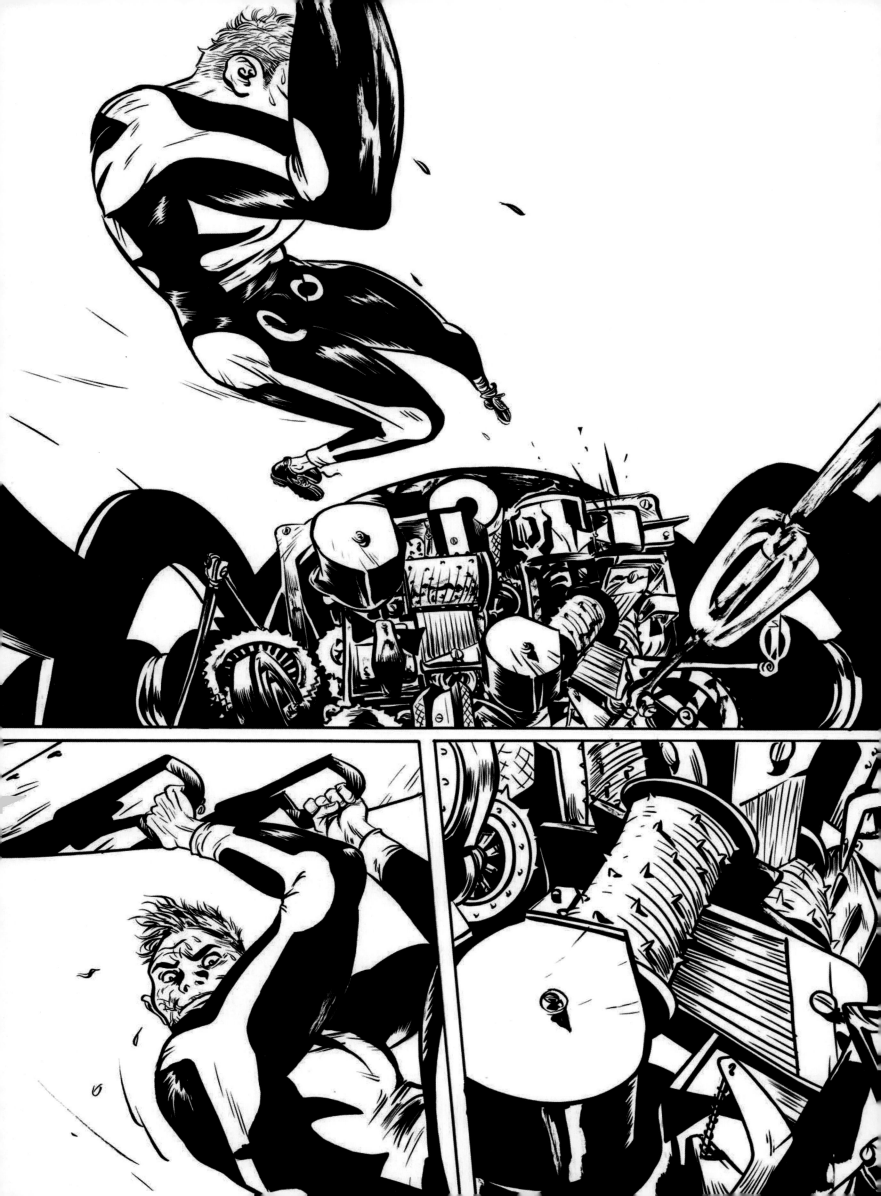

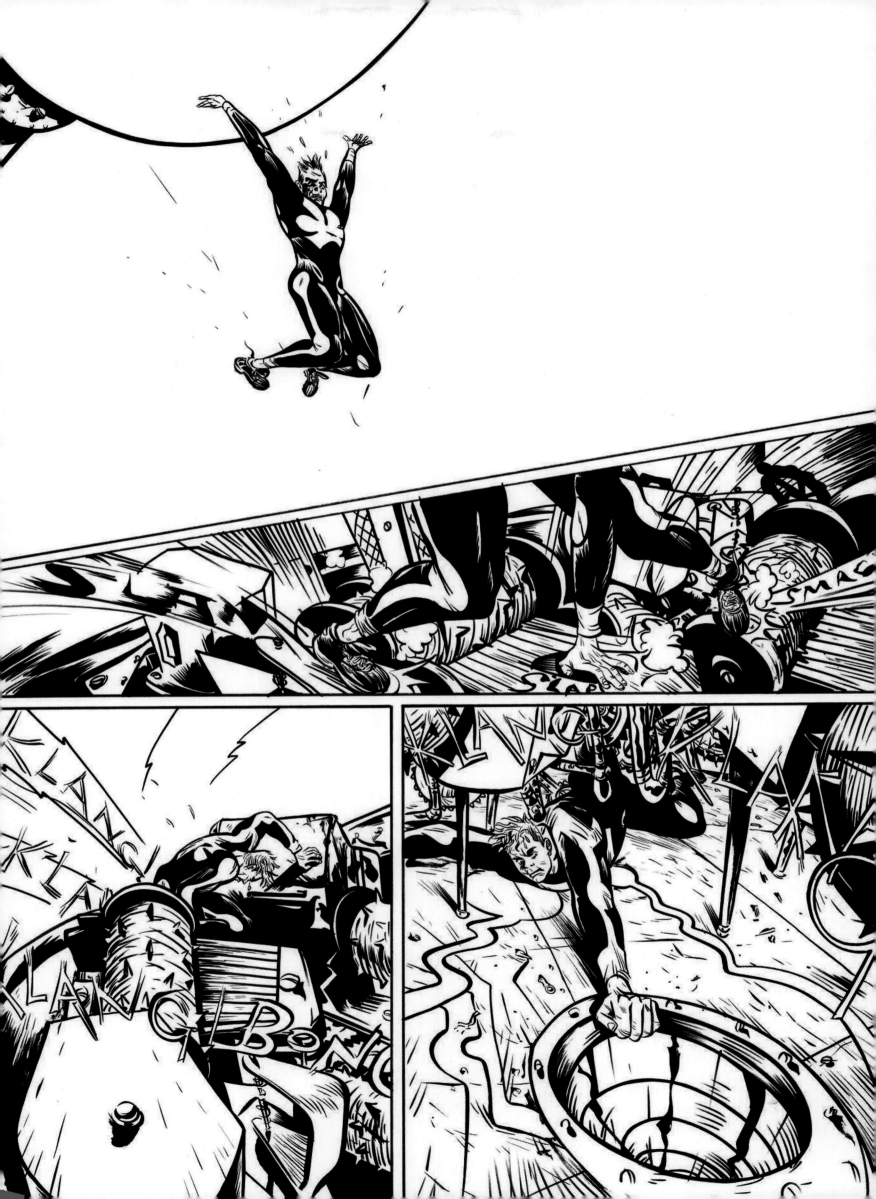

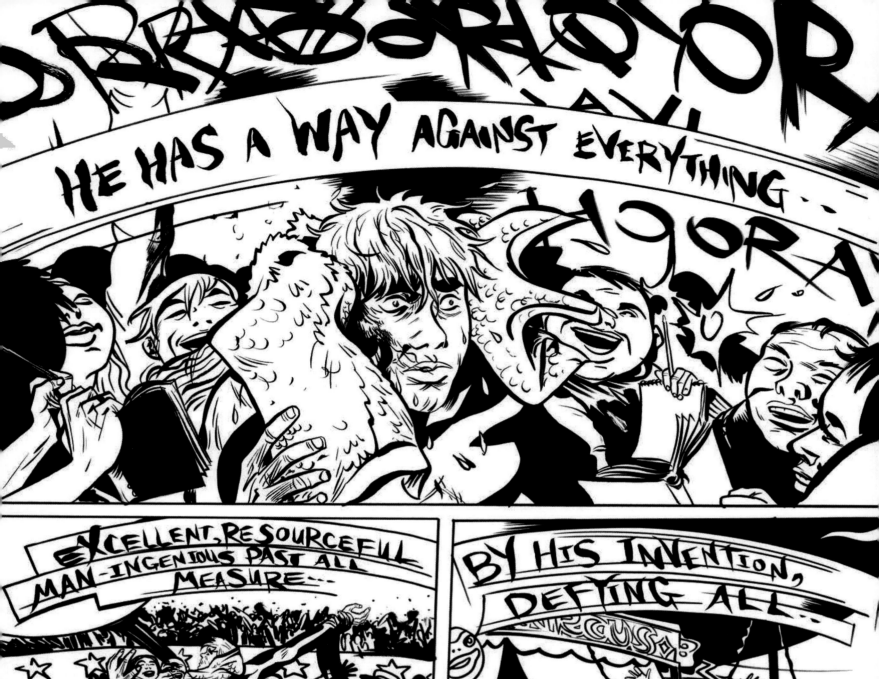

HE HAS A WAY AGAINST EVERYTHING...

EXCELLENT, RESOURCEFUL MAN-INGENIOUS PAST ALL MEASURE...

BY HIS INVENTION, DEFYING ALL...

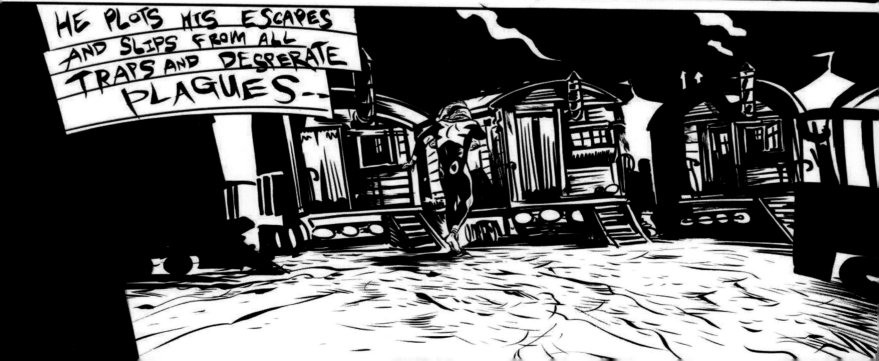

HE PLOTS HIS ESCAPES AND SLIPS FROM ALL TRAPS AND DESPERATE PLAGUES...

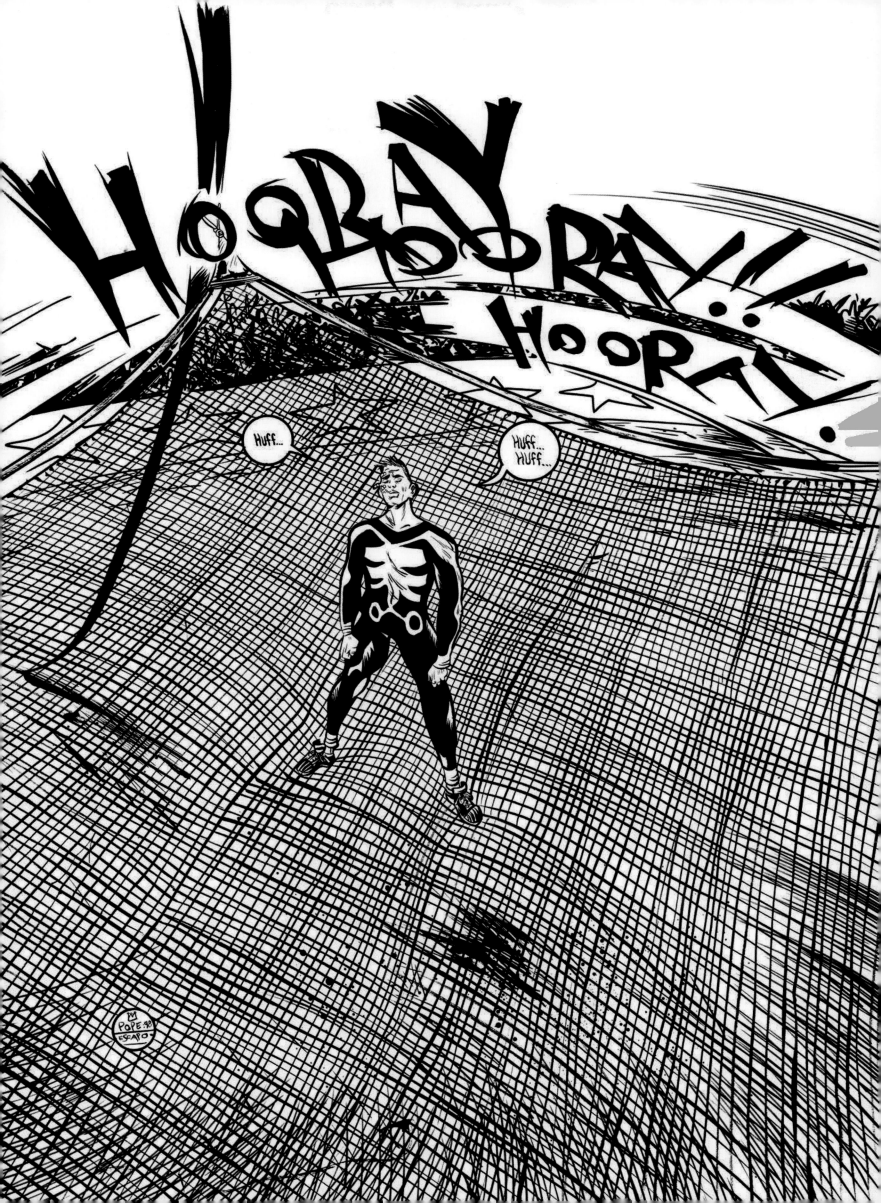

IN THE STUDIO:
What to Do When It Goes Away and How to Get It Back

There are different ways to work. I find the best is to do nothing but make comics for up to three days straight, breaking only to eat and sleep. If it's more than three days, the work's usually no good, or worse, even bad. Work three days, take off a day. That's ideal, like a sensory deprivation tank in reverse. I like to wake up and get right into it, no distractions — no radio, no television, no phone calls, no internet, no door buzzers, no clock, nothing. No interface at all except the eye, the hand, the drawing tool and the paper, maybe some music. I find I get my best, most fertile ideas first thing in the morning when my head is still swimming in the abstract shapes of dreams. The ideas then come like vague, half-heard voices, fuzzy and pliant, wanting for form and definition. I prefer to wake up and make coffee, sit at the table, and begin writing or drawing with a fresh sleep-wrapped head and a smooth, clean slate for a brain. This isn't possible on mornings when you wake up having gone out the night before, drinking, laughing, talking, carousing, arguing, bullshitting. Mornings like that you wake up groggy and disturbed, reviewing the events, even if they are completely uninteresting, even if they are annoying. Mornings like that, I think pacing is a good idea. Pace, drink coffee, and let the thoughts unravel like a script for a film written on a scroll of toilet paper — image after image, scene after scene, line after line, until they're all thought of and used up. Once you've used them all up, you can start thinking your own thoughts again.

This three-day stretch has always been my preferred method of working, and it is a method which has worked well for years and years. However, I must admit I haven't had three days of unbroken work time for longer than I can remember. I've had to build a trapdoor for the muse so she can come and go quickly. The luxury of the locked door is something I've had to leave behind. I accept this condition now as necessary, but not necessarily permanent. To live in Manhattan is to be forced to take a sabbatical from solitude. Now there is only a thin membrane between the inner spirit and the world outside. Now there is the phone and the socials, the constant stream and plaintiff cries. Counting down the hours until the next meeting, returning emails, the Zooms, the DMs, trudging something from Fed Ex up-and-down the stairs, tripping over boxes, doing online research for this or that, hearing the couple next door fighting or fucking or some delivery guy outside slide another neon green menu under the door for someplace I'll never go. Sometimes, late at night, I'm struck with the uncontrollable urge to pull back the drapes to check the fire escape to see if there is anyone standing outside waiting to come in. There's never anybody there, it's the residue of the distracted day.

The places where I've lived and worked are all pretty much the same — spartan cells with white walls and good lighting, facing away from the street, designed to facilitate the successions of looming deadlines. Eventually these boxy rooms become deadline veterans, and for all their battles, they get covered in layers of books and boxes and pencil shavings and junk, and their floors get covered in shoes and dirty clothes. Stacks of reference materials as tall as a child sit in precarious piles to the left and the right and behind the drawing tables. To the right, there are always scraps of cardboard, old xeroxes, hundreds of sheets of wadded up, discarded paper covered with a growing film of eraser edges burying the green plastic stencils used for making ellipses and circles. There's the Marshall speaker and the Bluetooth for the music. On the walls surrounding the table, there are drawings and reference photos, tacked up alongside postcards and photocopies and whatever else I might need to look at. To keep me inspired, to make me remember, to help me get done something needing to be done.

"It" is that precious quantity which lets you make artwork which is better than good and sometimes "It" allows for work which is truly inspired. I learned early on, you can't rely on "It" to get you out of a mess. It is capricious and wispy, disappearing for periods at a time, sometimes only half-returning, or returning for only half as long as you need it. It's also a problem to have to work without "It." That is a nightmare. Too much of that kind of thing will sink you into a strange kind of self-loathing, hard to describe, but which makes it hard to face yourself in the mirror. And sometimes "It" just inexplicably goes away. But you can get "It" to come and stay with you when you have great discipline and work hard without distractions. That is why I've always liked working for three days straight, and why I built the trapdoor for "It" so it can come and go quickly when I lost the three-day luxury. I find if you keep on working until "It" comes back, "It" always does. It eventually gets curious and wants to see what you've been doing while it was away. Looking back on Kirby's work, or Toth's, they seemed to almost always have had "It," even in their obvious mistakes and their sloppiest works. I get mad at myself then, for the vain luxury of complaint. Deadlines, bah. You have no excuse, I say, or something in me says. You live in a part of the world where you can do just about anything you want. Not everything, but anything. No one is firing mortar shells at your block. There are no attack dogs chewing at you, no mustard gasses perforating your lungs. No one is poaching you for your tusks. Your eyes work, your head works, you've got no excuse. Muse or no muse. So I try brewing coffee, then change the music or look at some comics. Nothing helps. So I leave my place. I don't do the laundry, stuffed into the crevasses of the closet. I don't do my dishes, stacked in their sullen sink side station. I don't shower or shave. I don't pay the bills, in their dizzying stack on the rickety table. I don't call my Ma who misses me and wishes I'd call more often. Instead, then, as I do now, when the deadline stress is too great, I wait until I'm hungry, then go eat Indian food. A good fish curry with garlic paratha, no butter. Aloo Matar and Raita. Mint chutney over some Vindaloo or a sizzling Tandoori platter. Or a good Vongole with Manilla clams and red sauce over linguine, fresh garlic. And a good red wine, preferably in what Hemingway called "a clean, well-lit place", where you can hear some good music and sit alone, pull out your problem, and look at it again from a different point of view.

And if you sometimes take a week off, or maybe even two, and you do absolutely nothing, you're only really stealing it from some other weeks yet to come. And regardless, every third or fourth week seems to be this sleepless, fitful, awful deadline time, this stretch of fifteen-hour-a-day accelerations. And there's nothing to do but learn to love this, even after the romance wears off. You must love this and learn how to burn with it, not to be burnt by it, otherwise "It" demands a miserable servitude without much recompense. "It" is your master. This is your choice; this is what you decided. This is your garden.

Now cultivate it.

PP

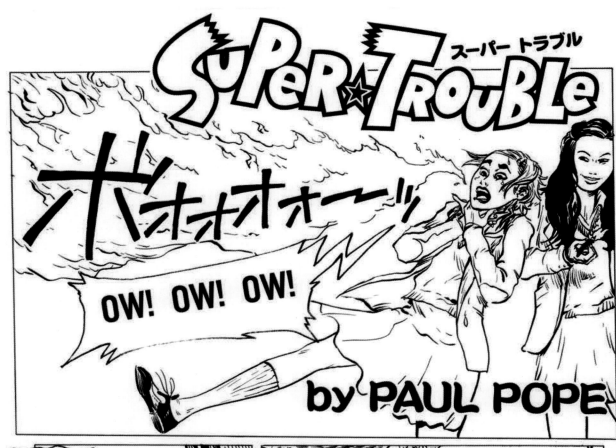

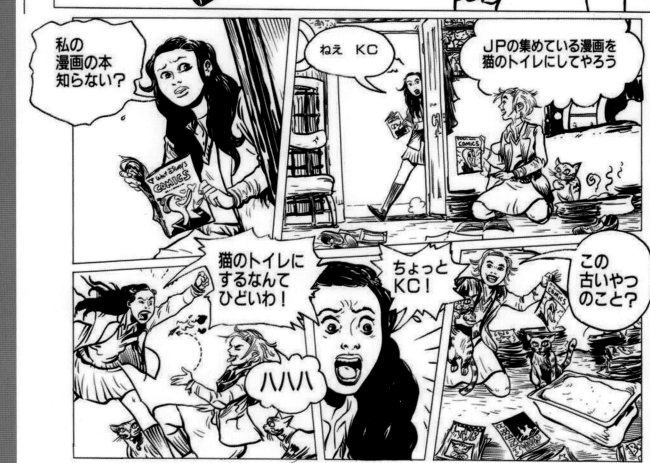

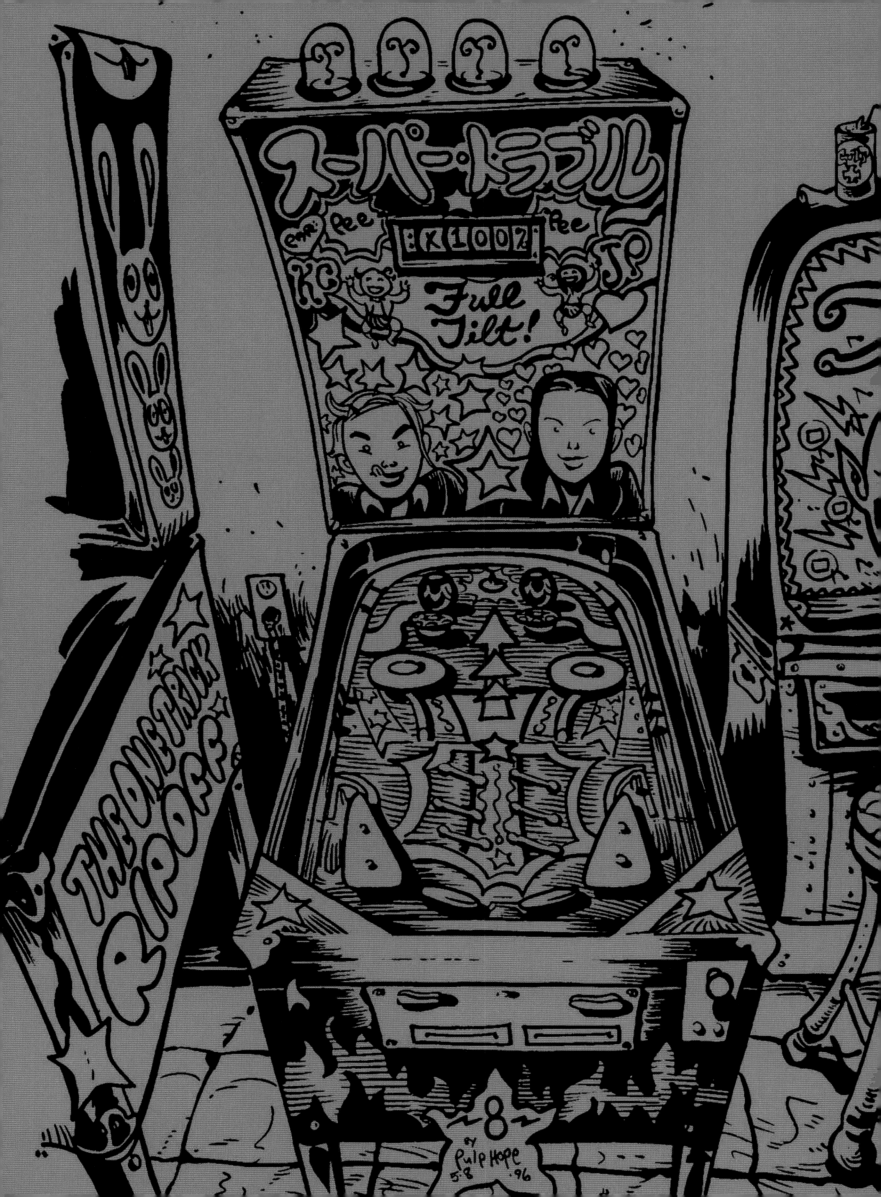

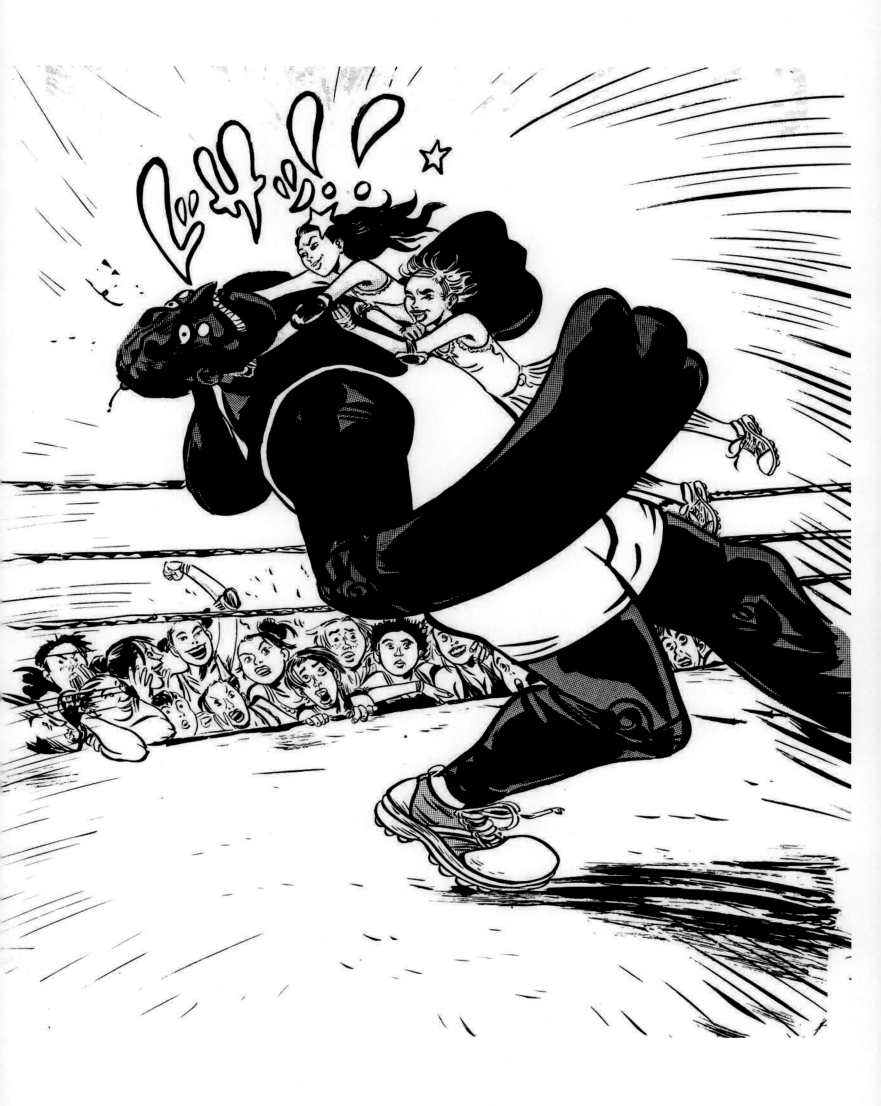

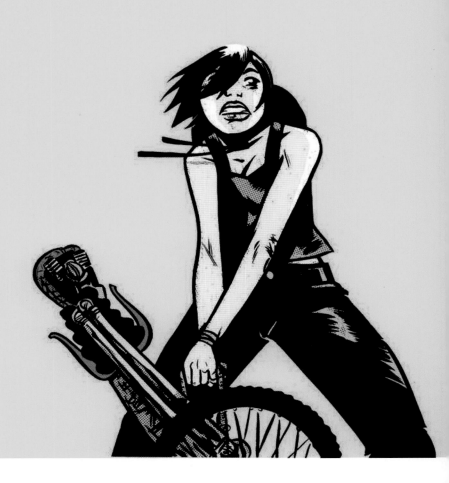

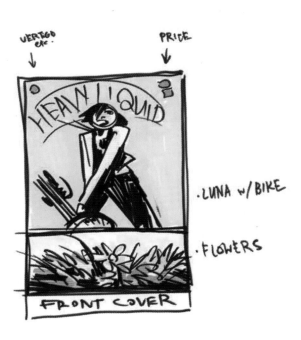

FRONT COVER

↓ VERTIGO etc. ↓ PRICE

HEAVY LIQUID

·LUNA w/BIKE

·FLOWERS

HEAVY LIQUID #2:

BACKGROUND TOP: PROCESS YELLOW
SKIN OF LUNA: WHITE + 162c = 11M 18Y
CLOTHES + BIKE SHADOW: } PANT. 278c = 38c
BKGRND BEHIND FLOWERS: } (LT. BLUE) 15M
FLOWERS: PANTONE 182c (LT. PINK) = 27M 9Y
 184c (SALMON Pink) = 72M 43Y
PRICE BOX + VERTIGO BOX: 184c

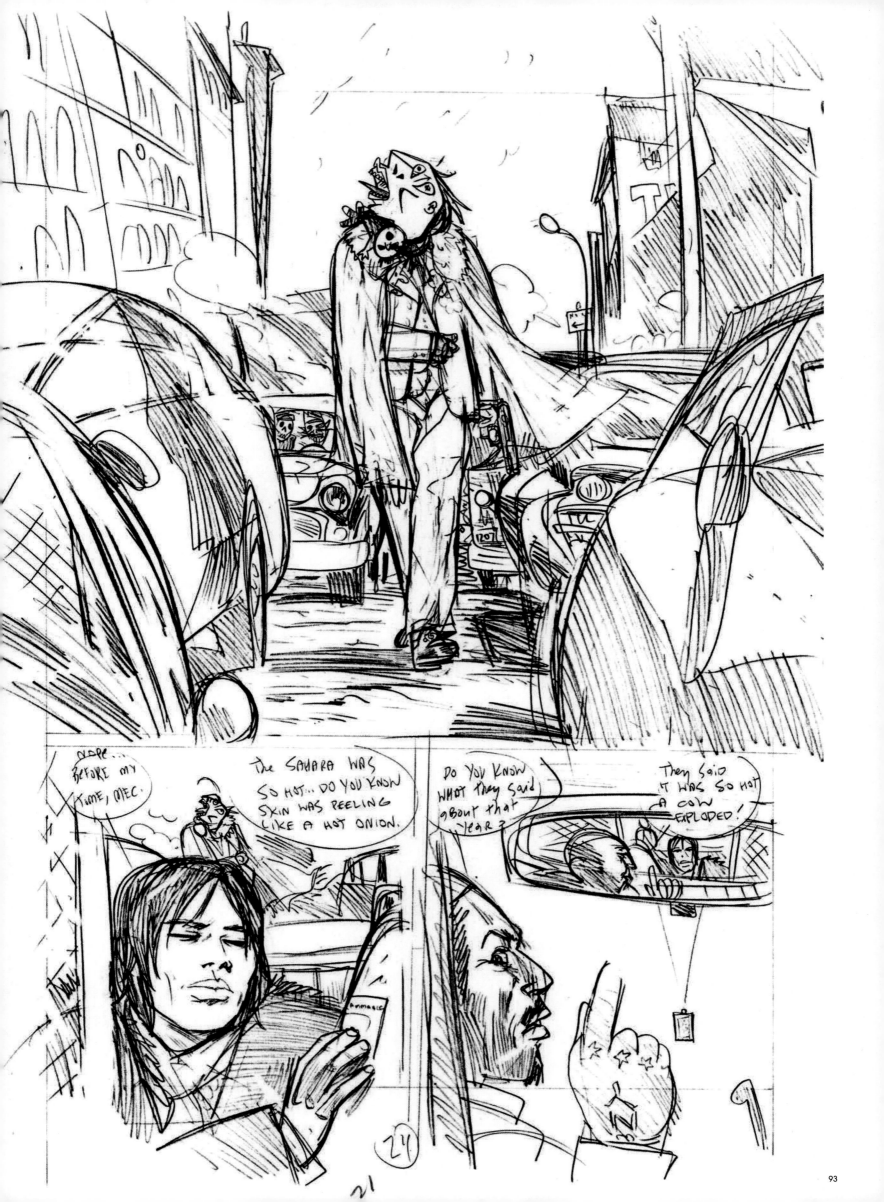

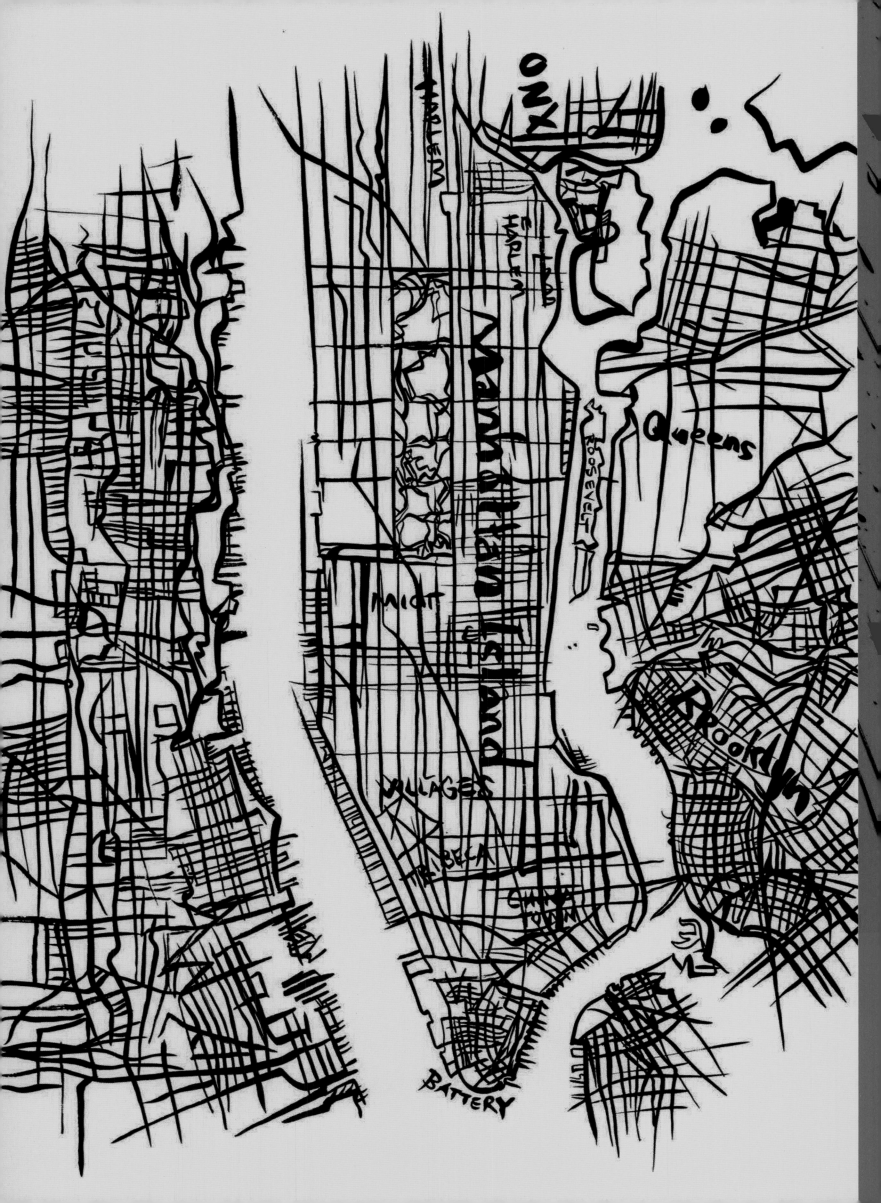

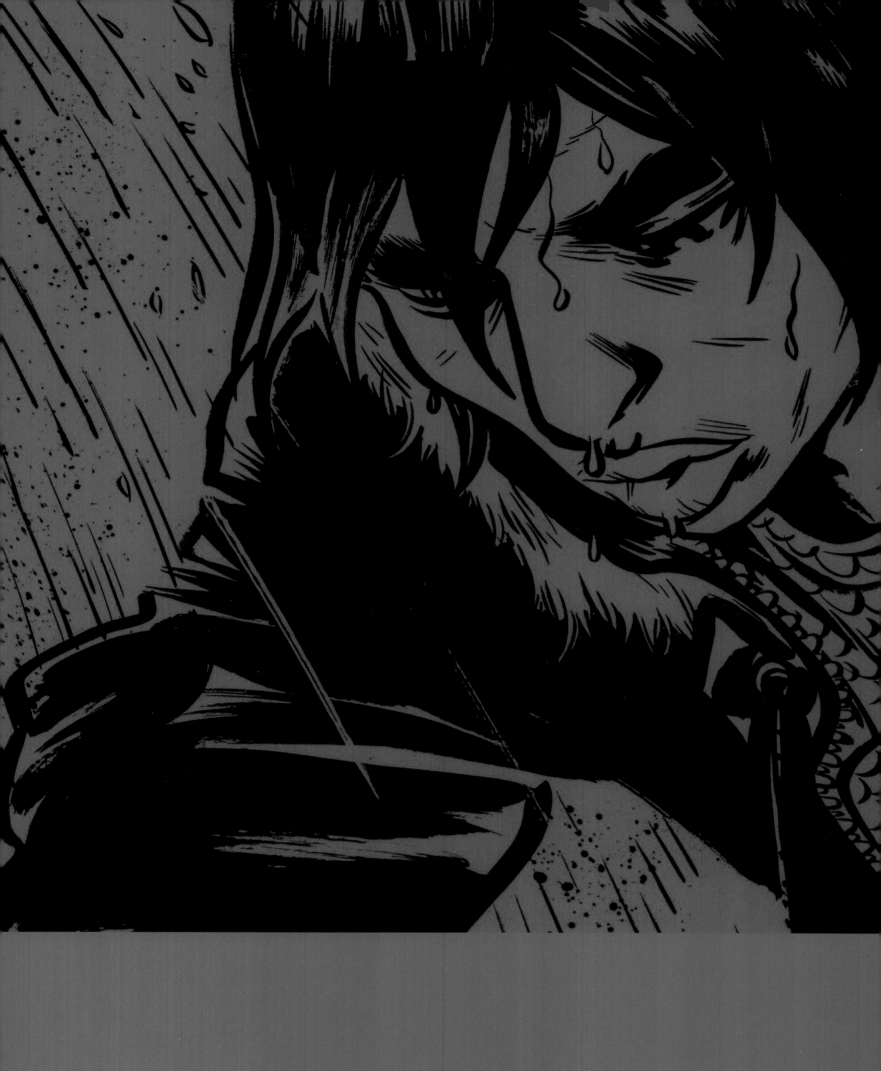

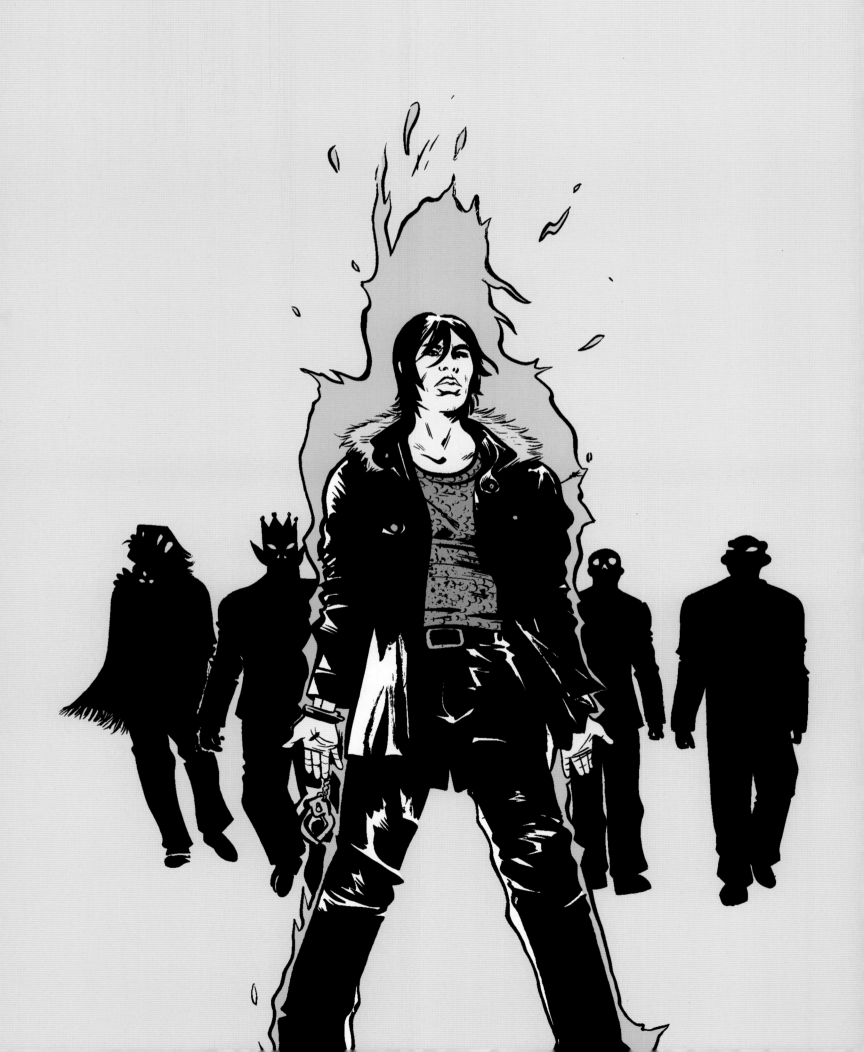

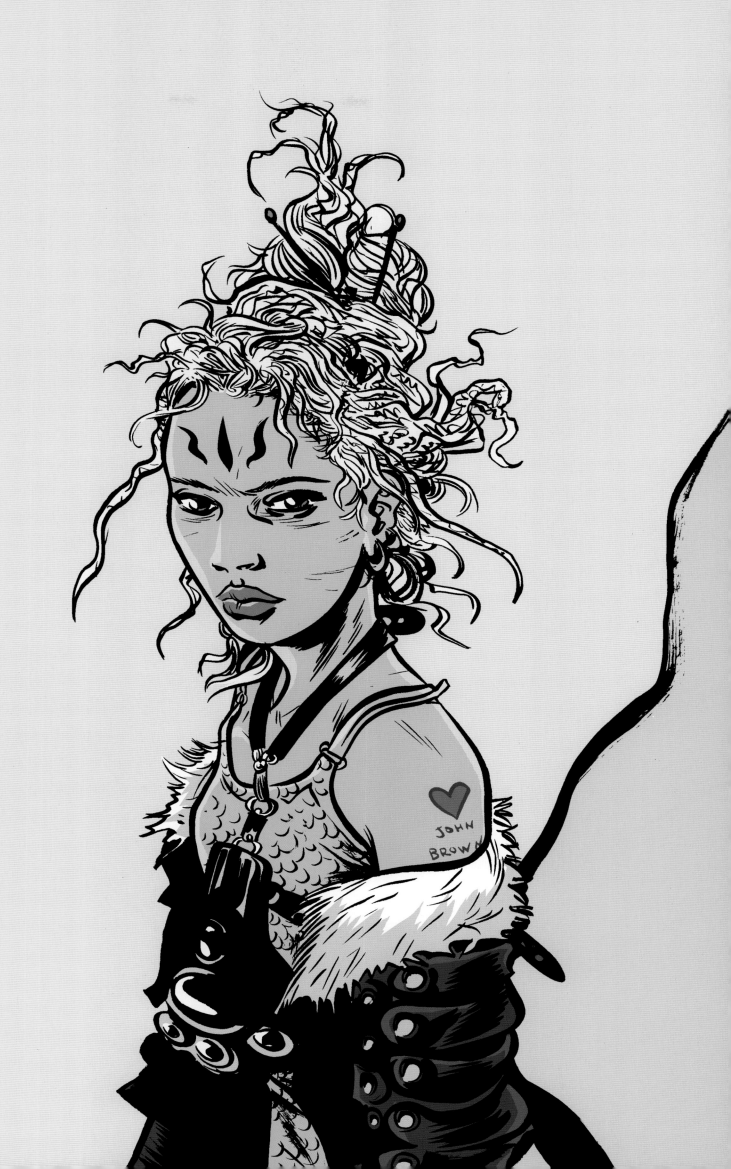

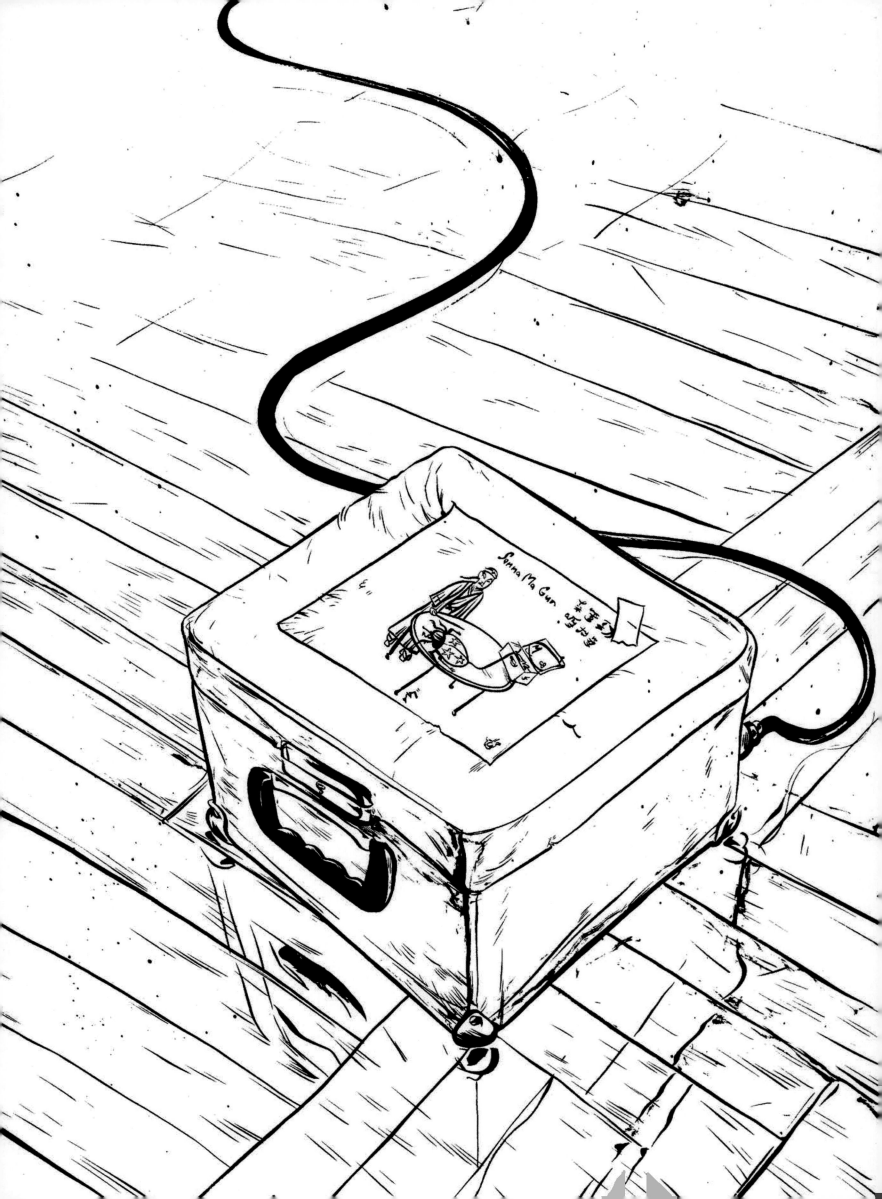

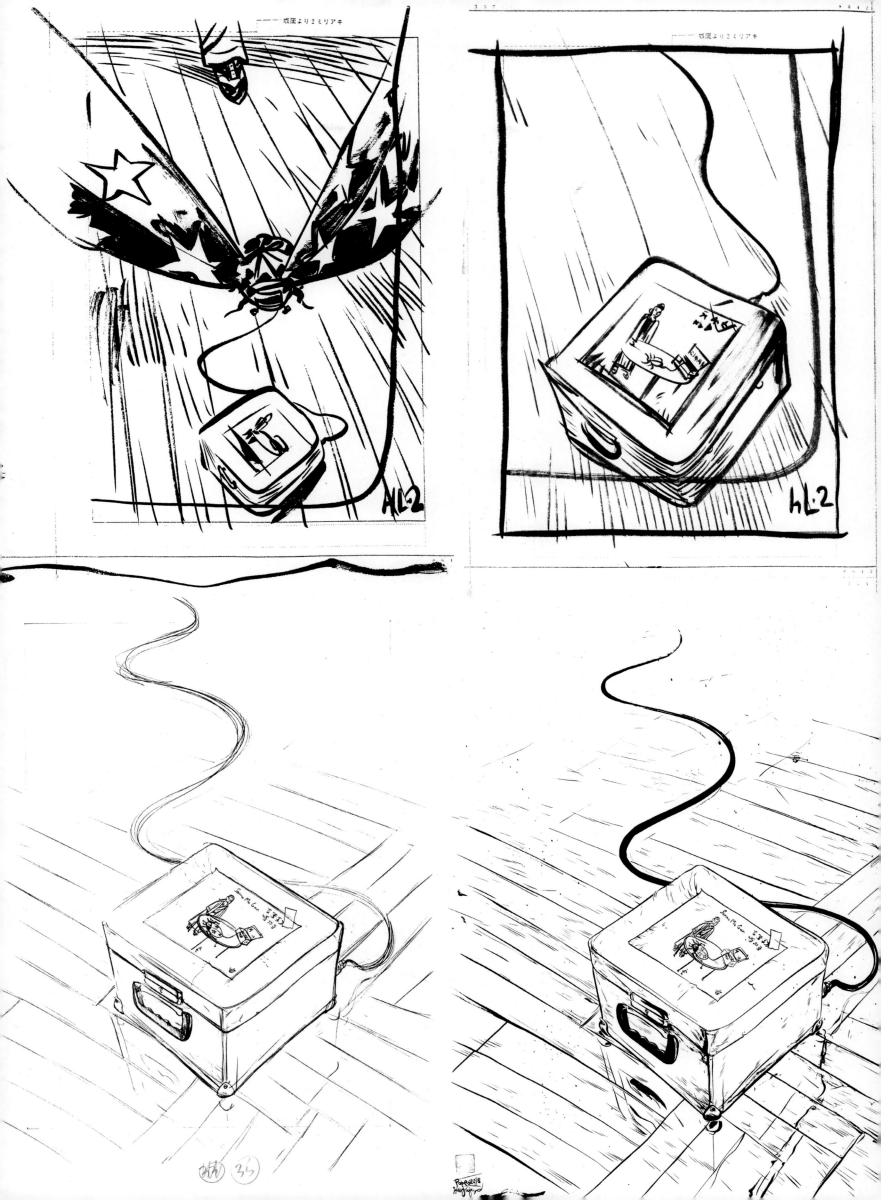

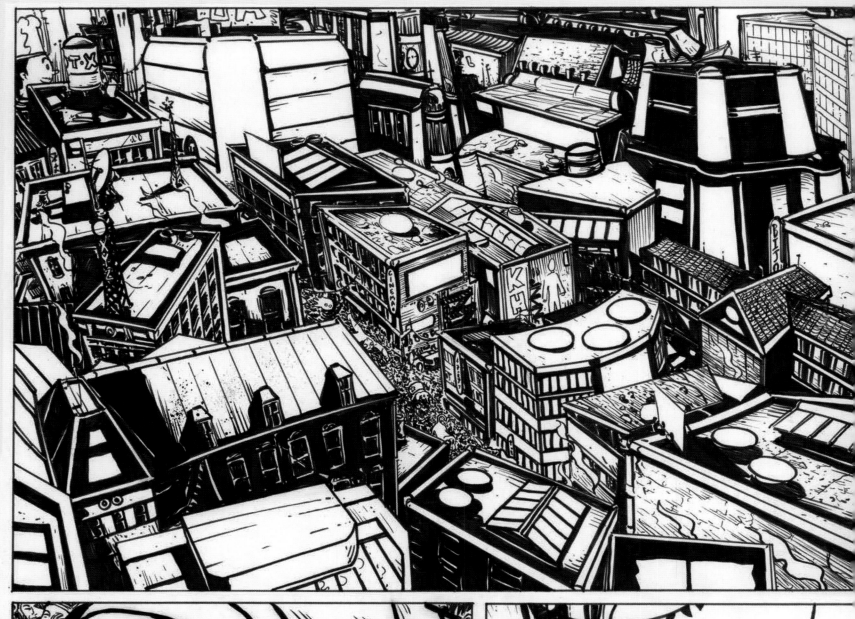

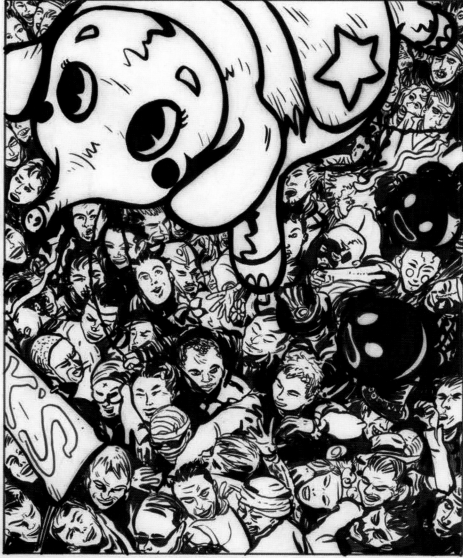

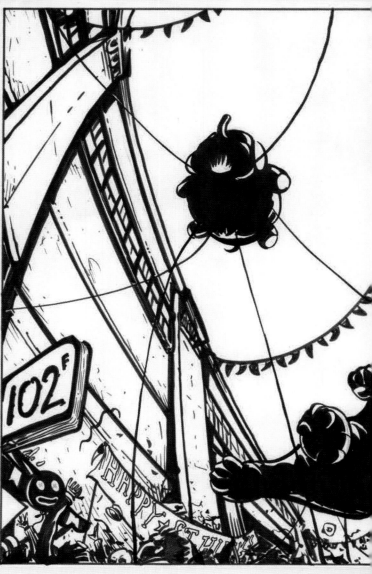

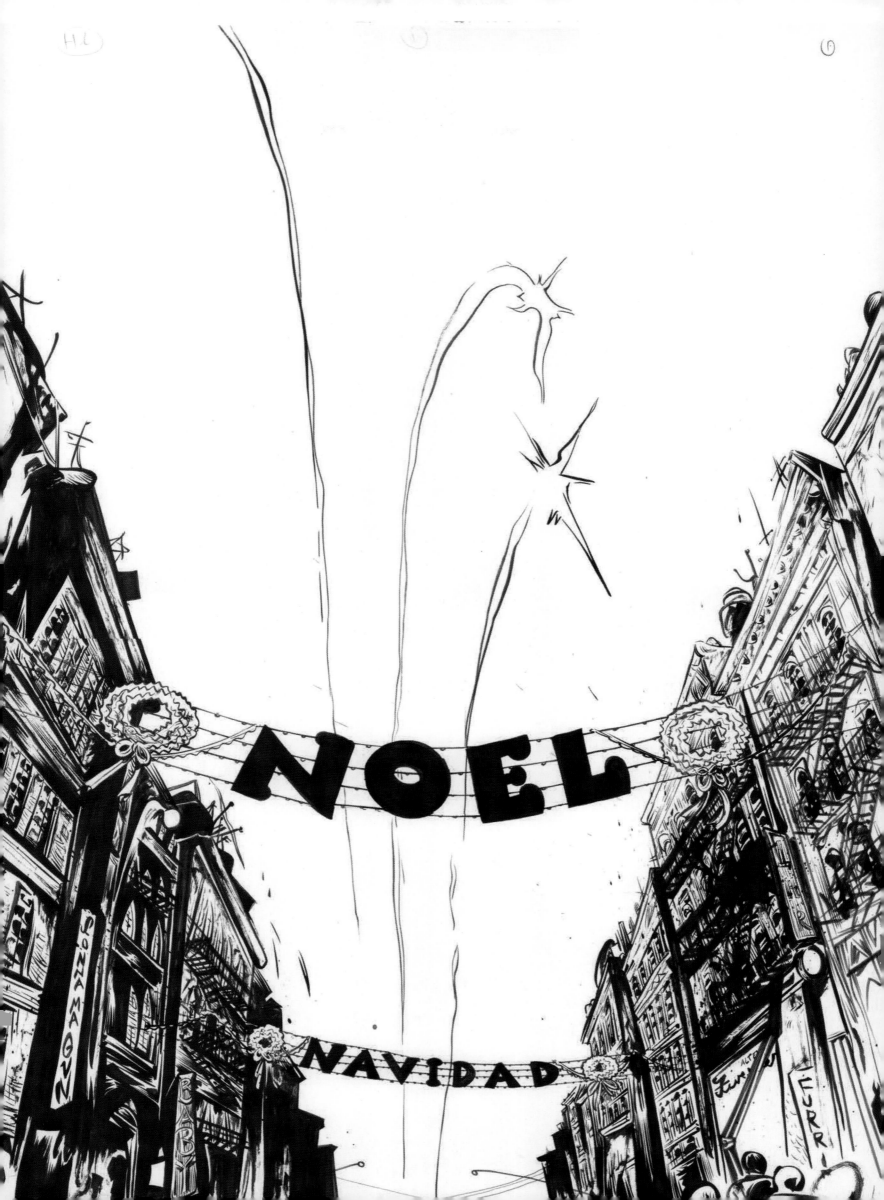

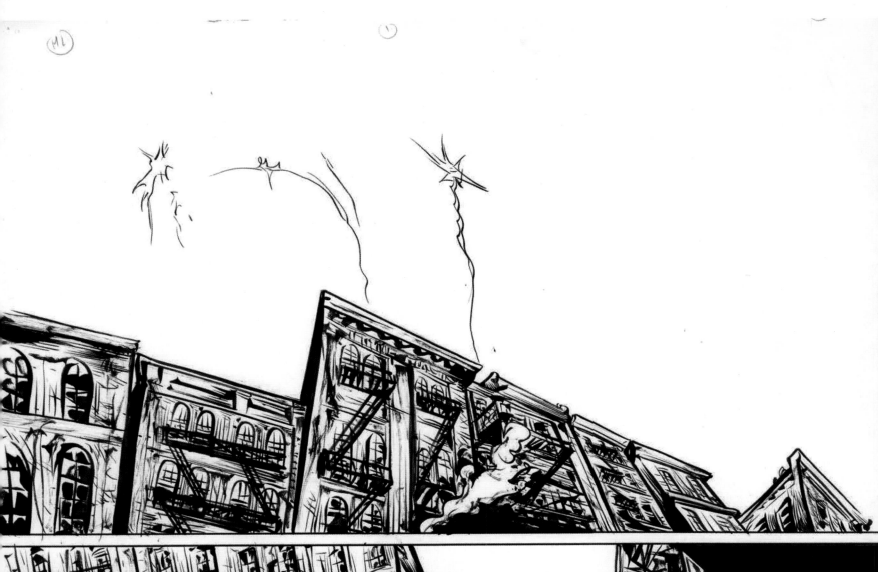
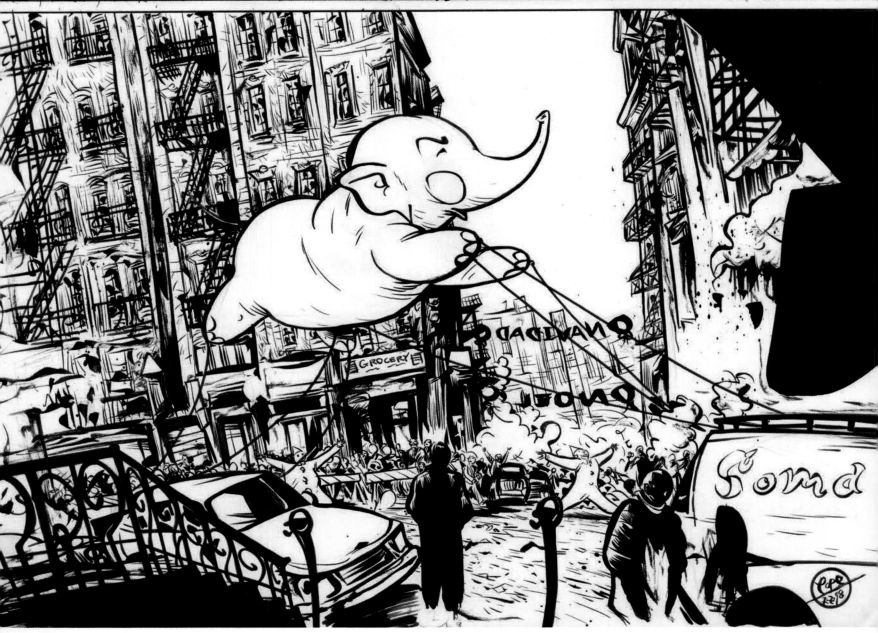

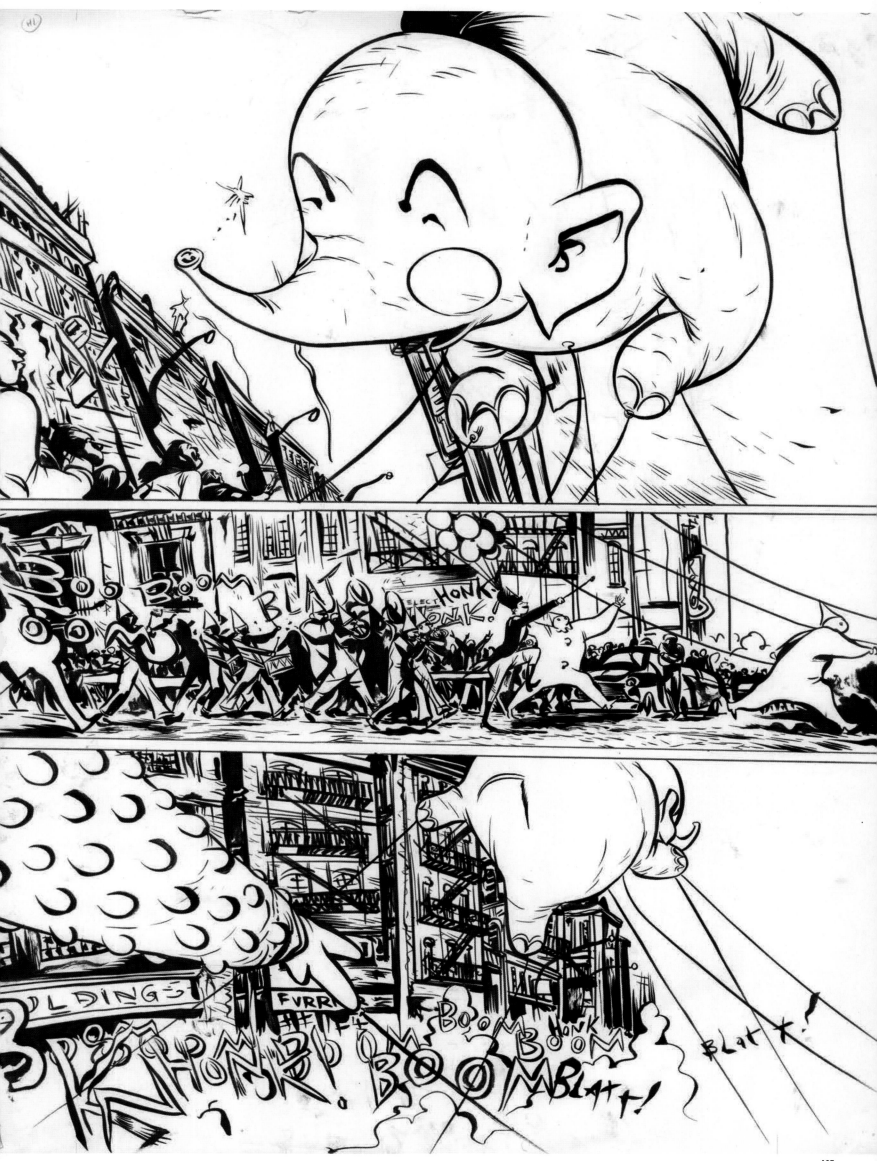

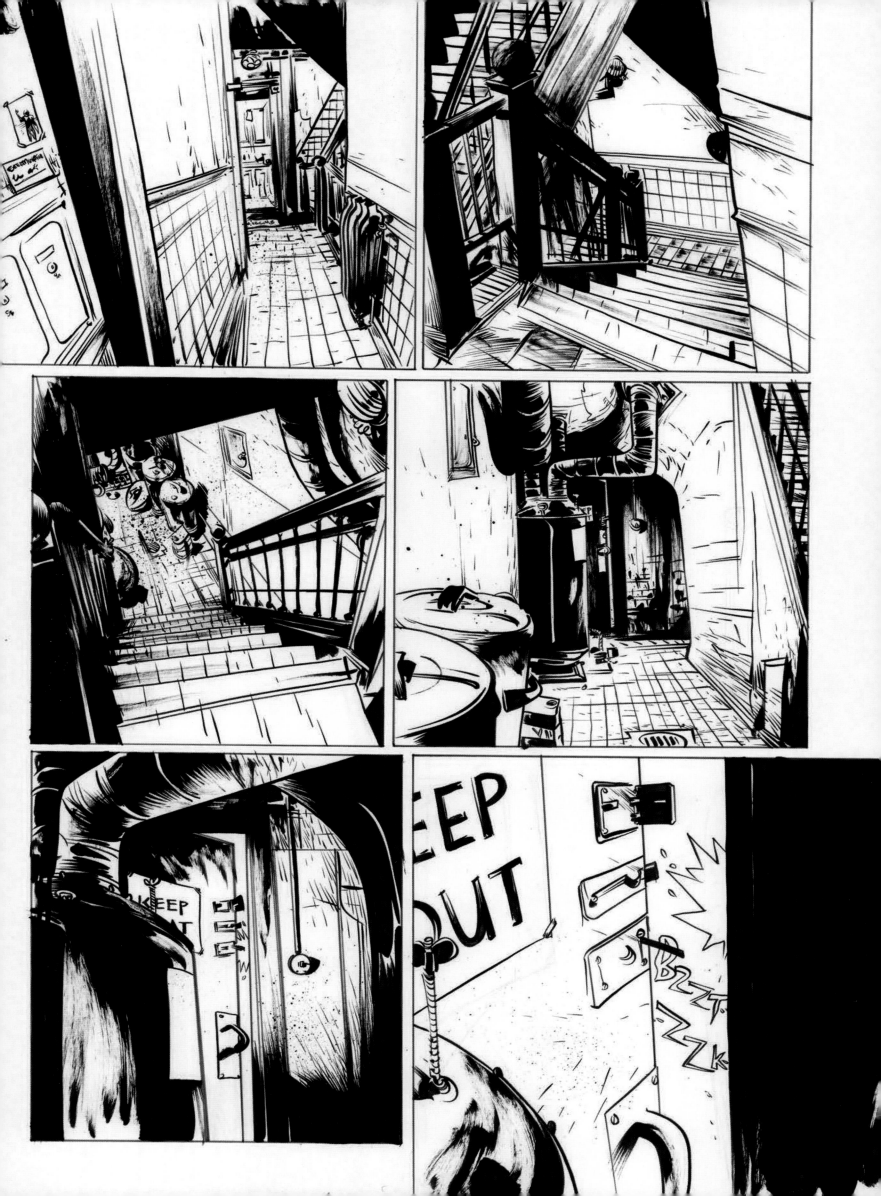

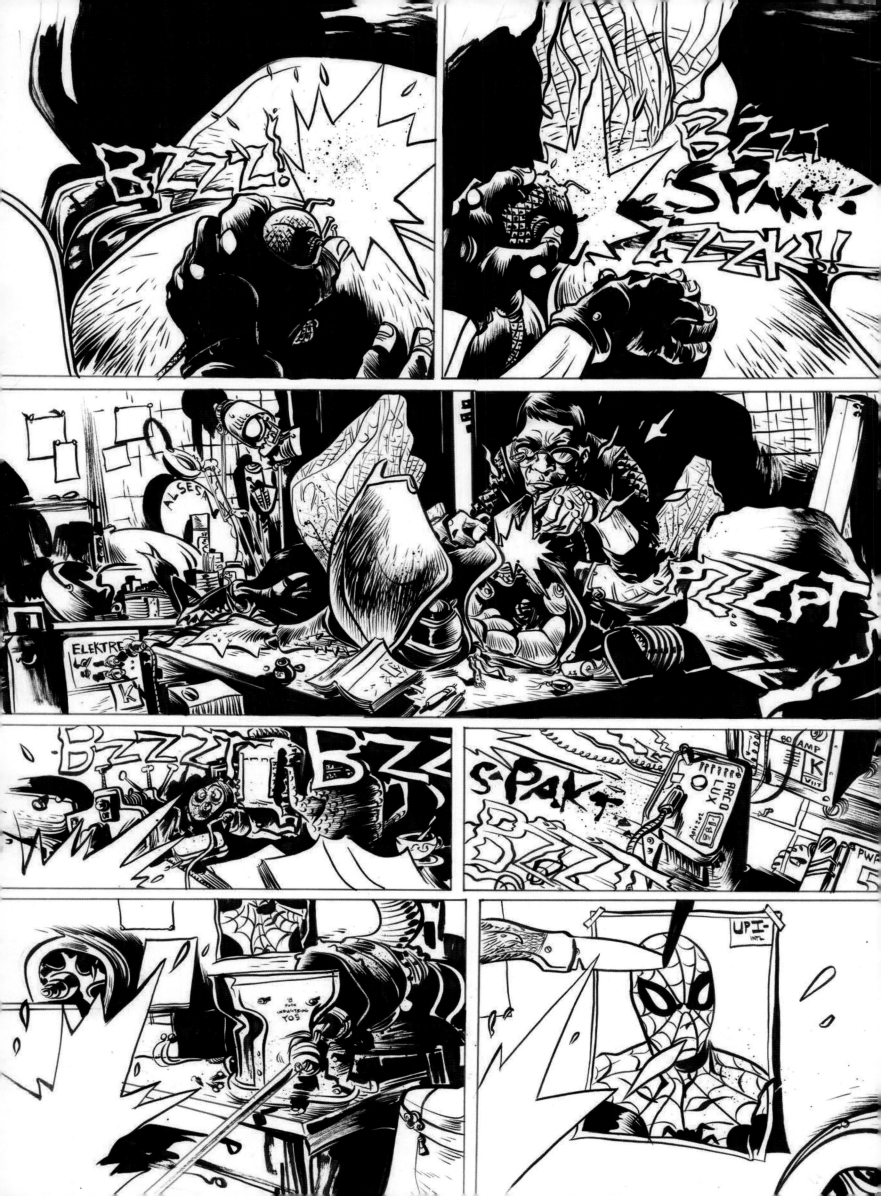

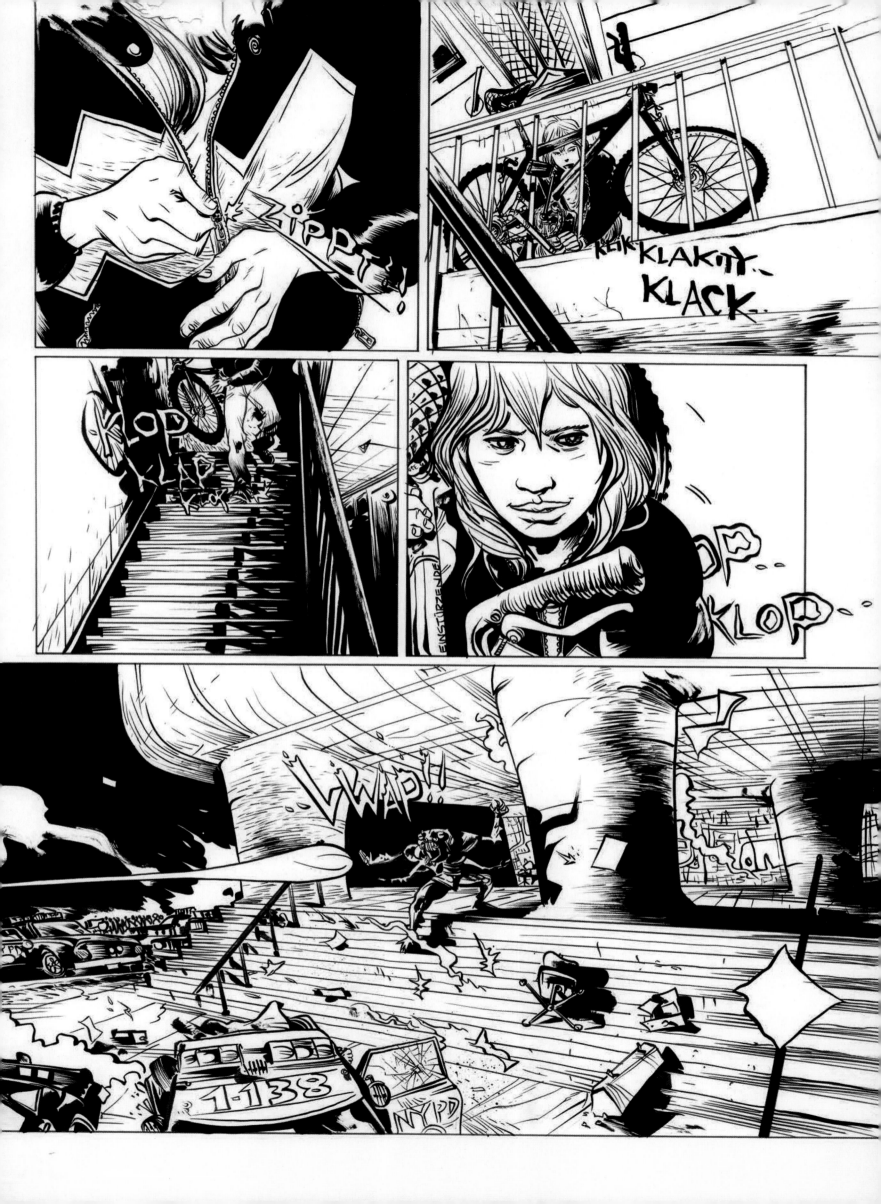

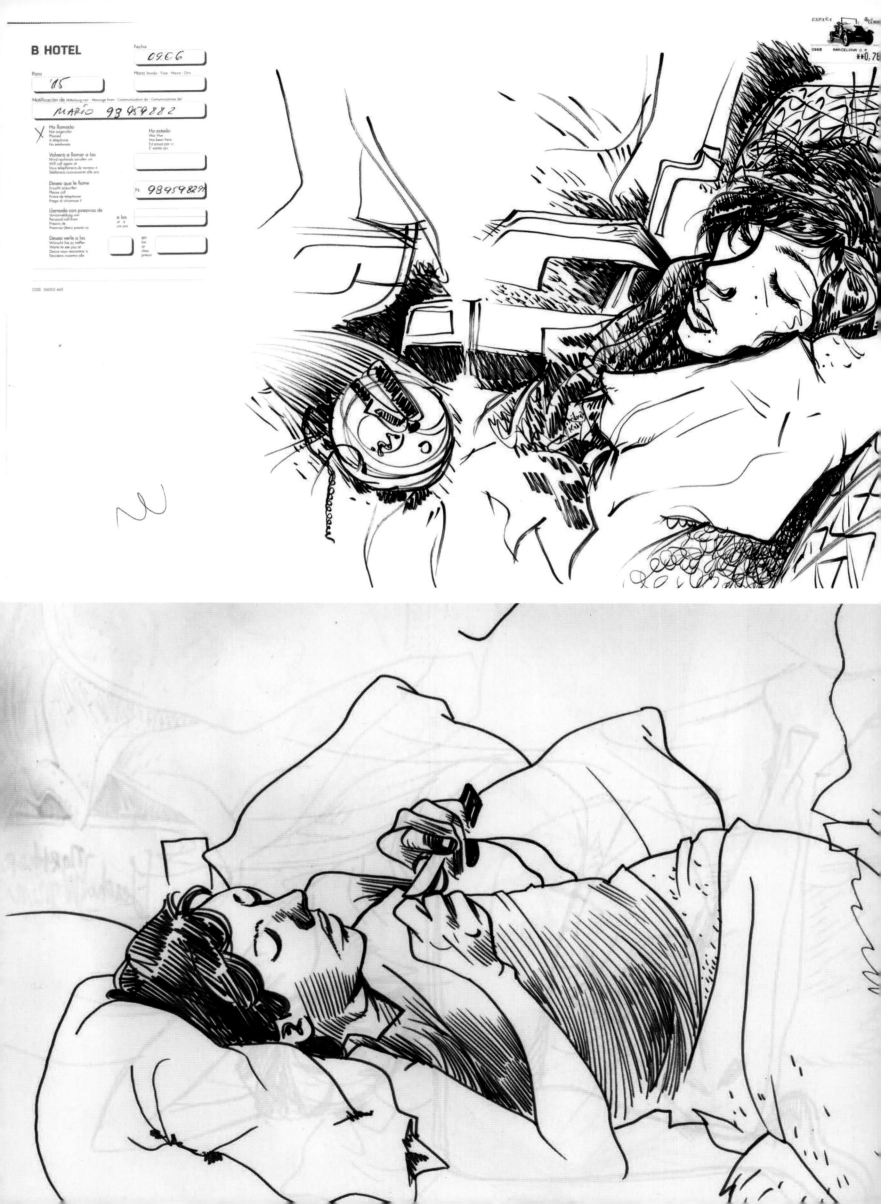

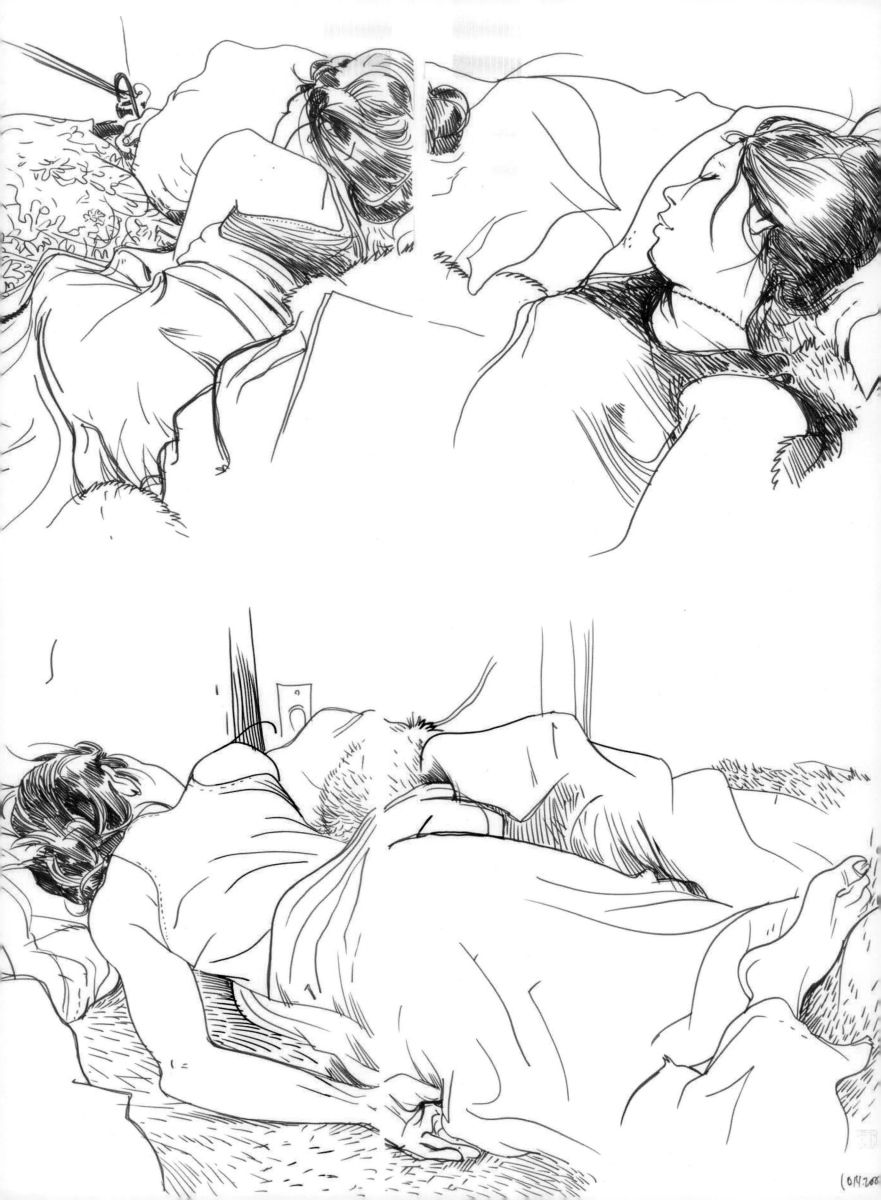

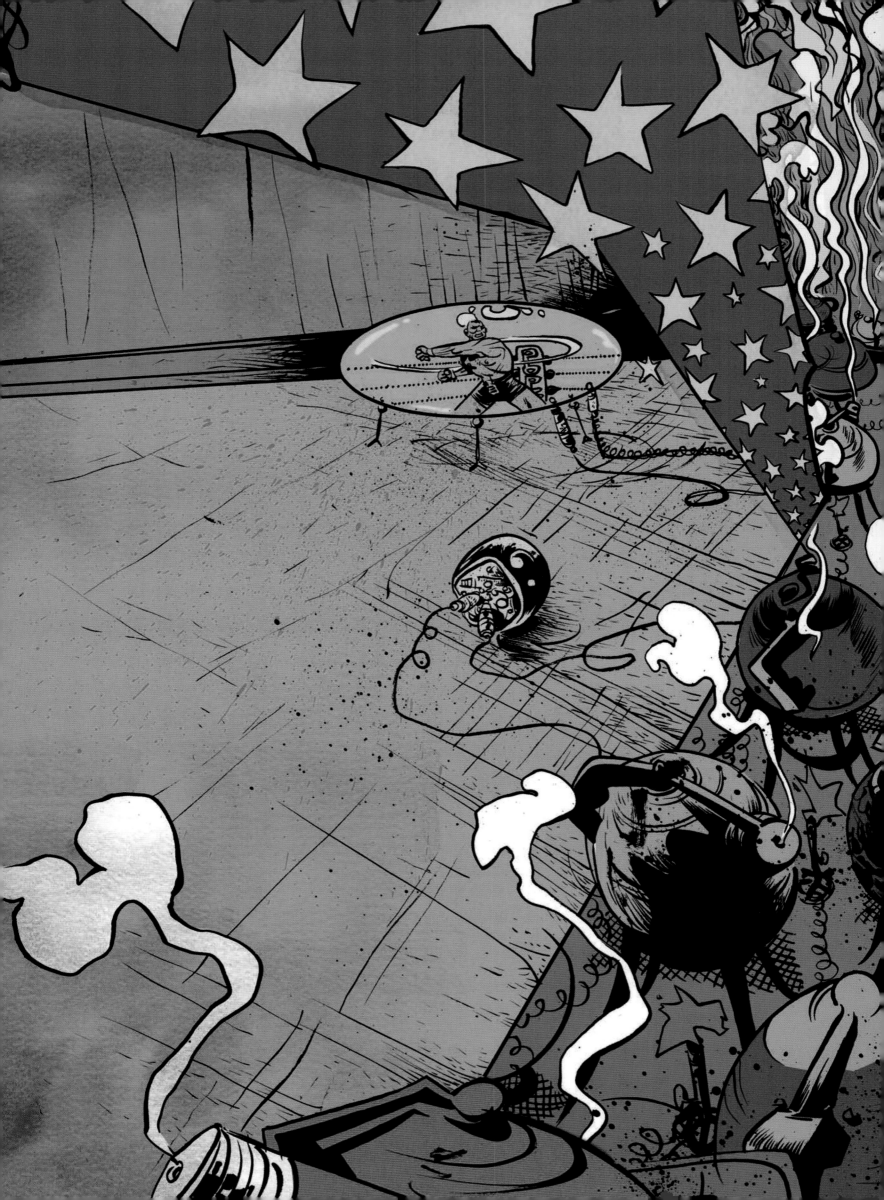

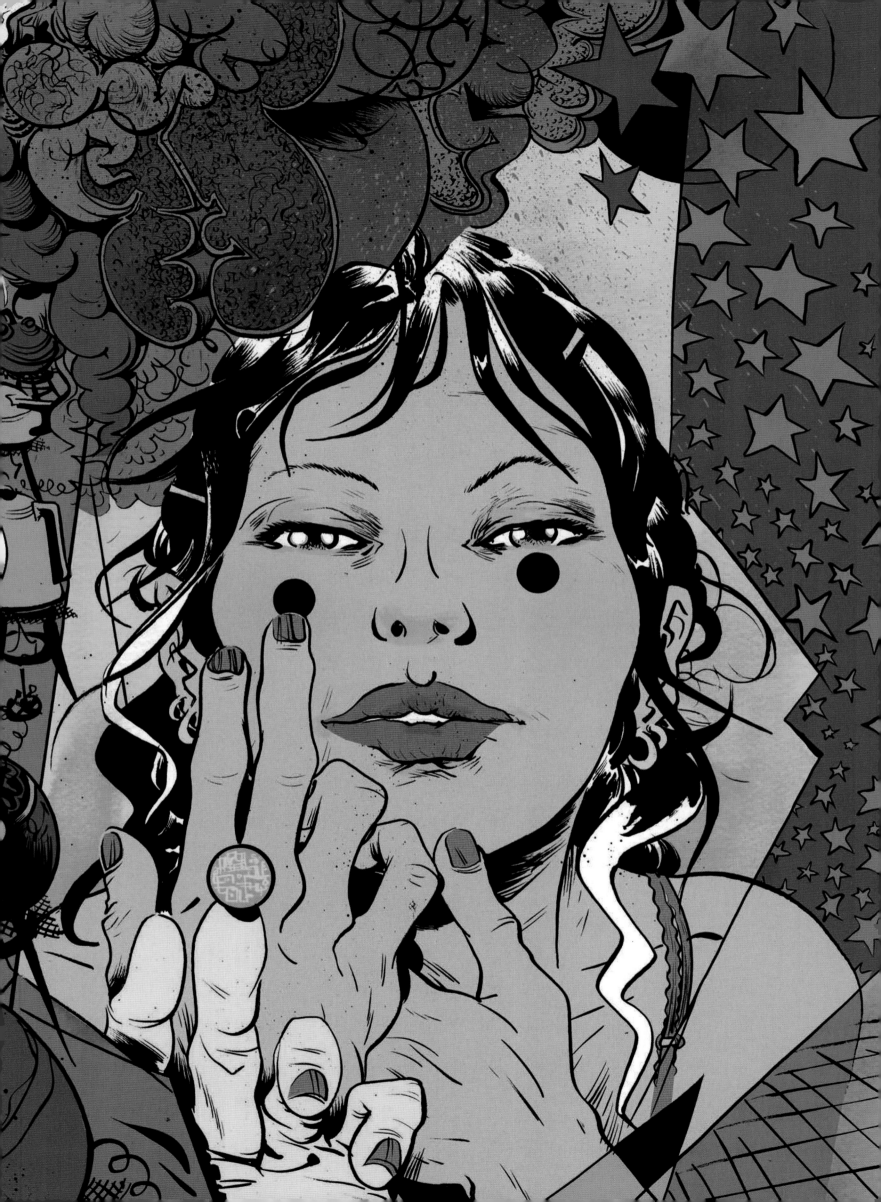

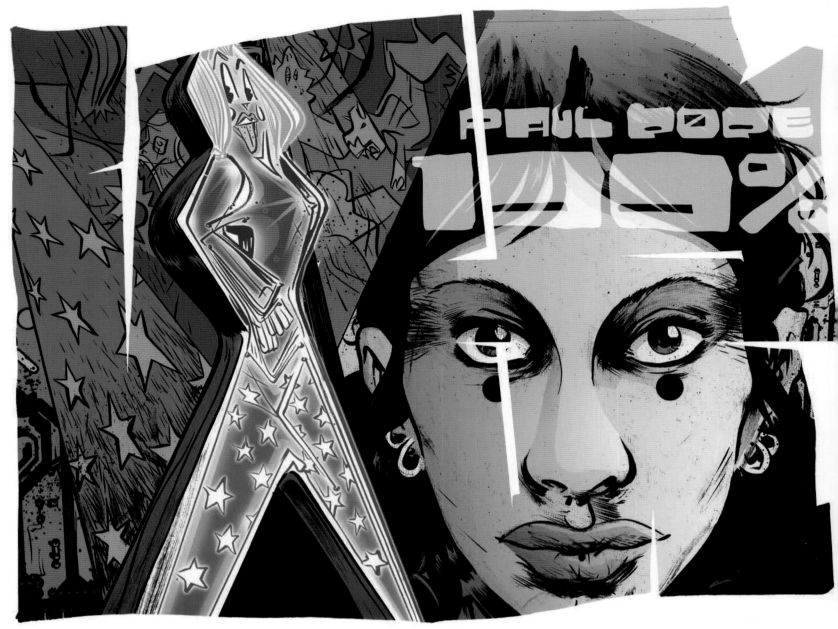

COVER ONE FRONT⟩ FRONT/element 3: DAISY'S EYE AND GUN TRIGGER...

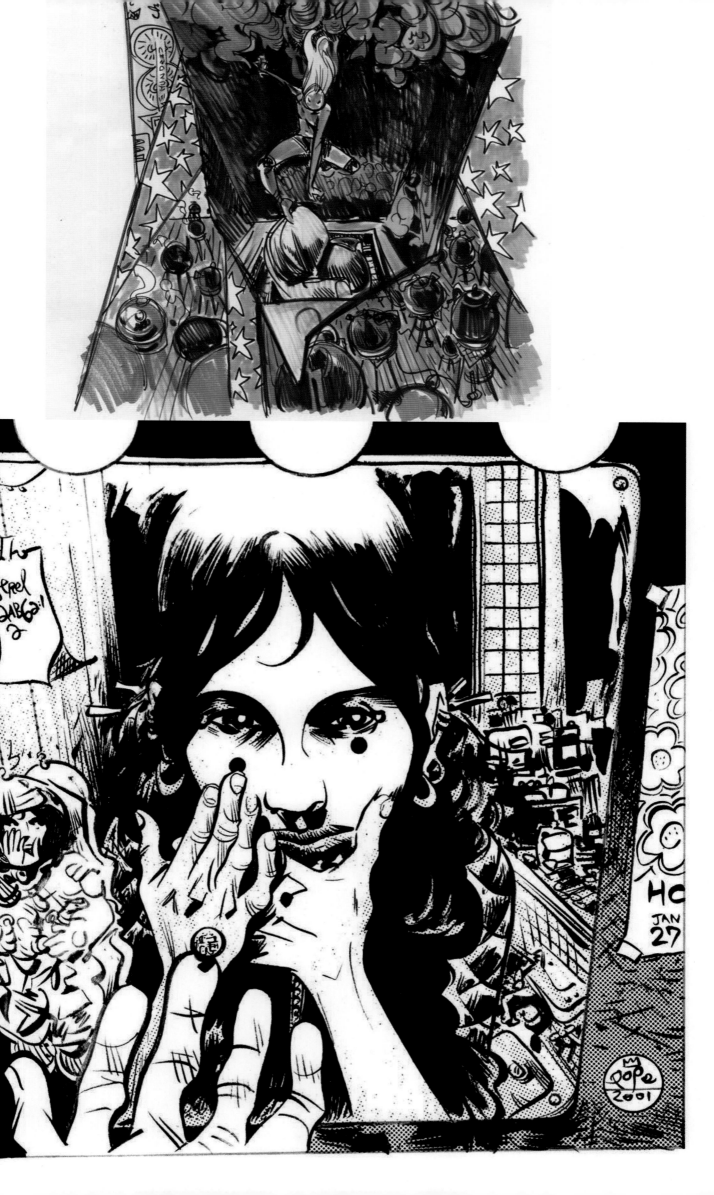

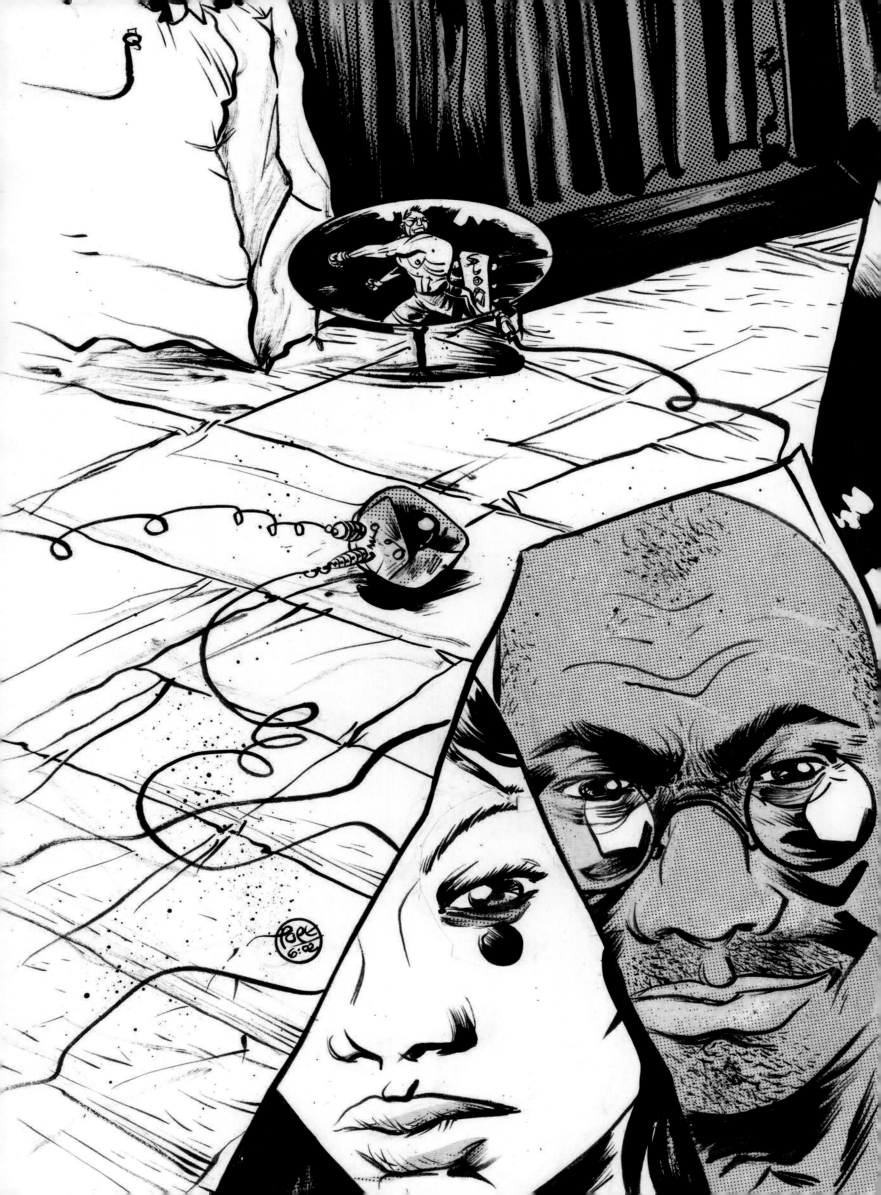

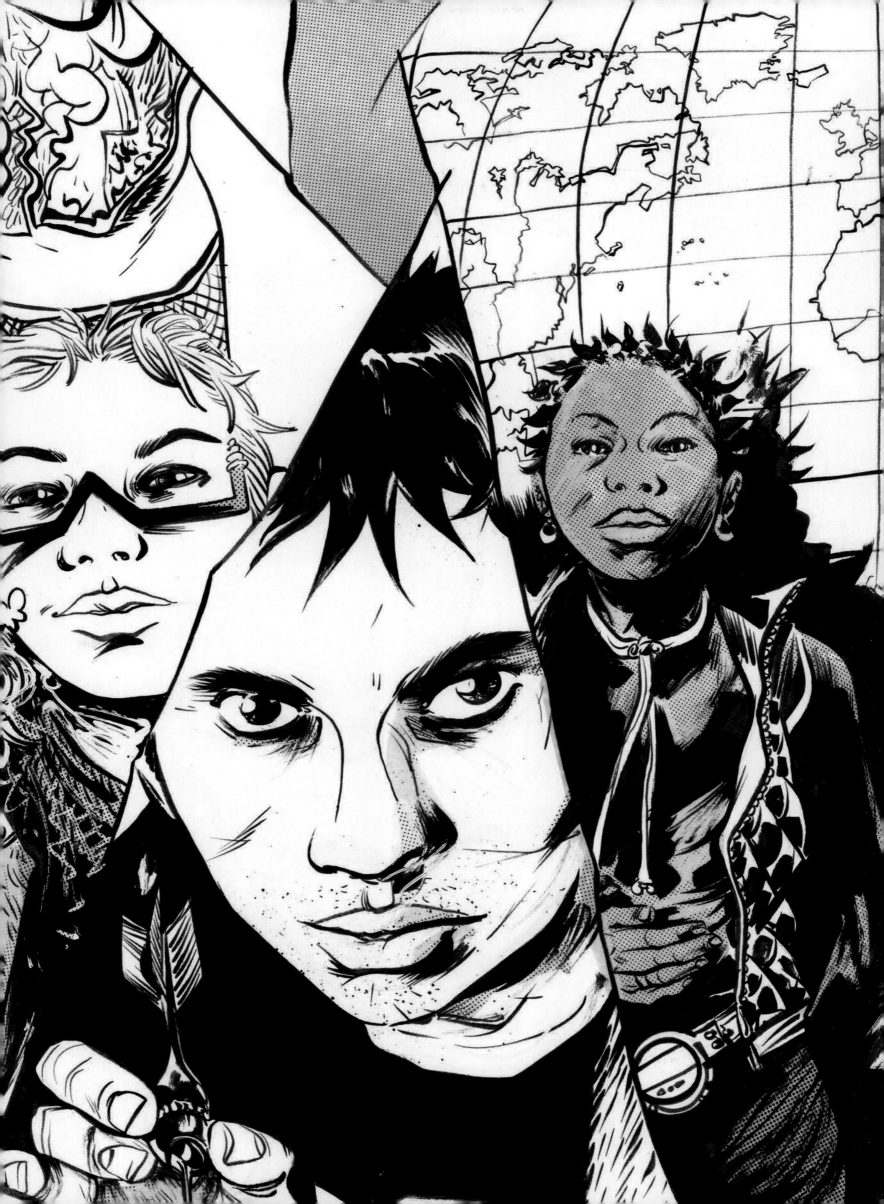

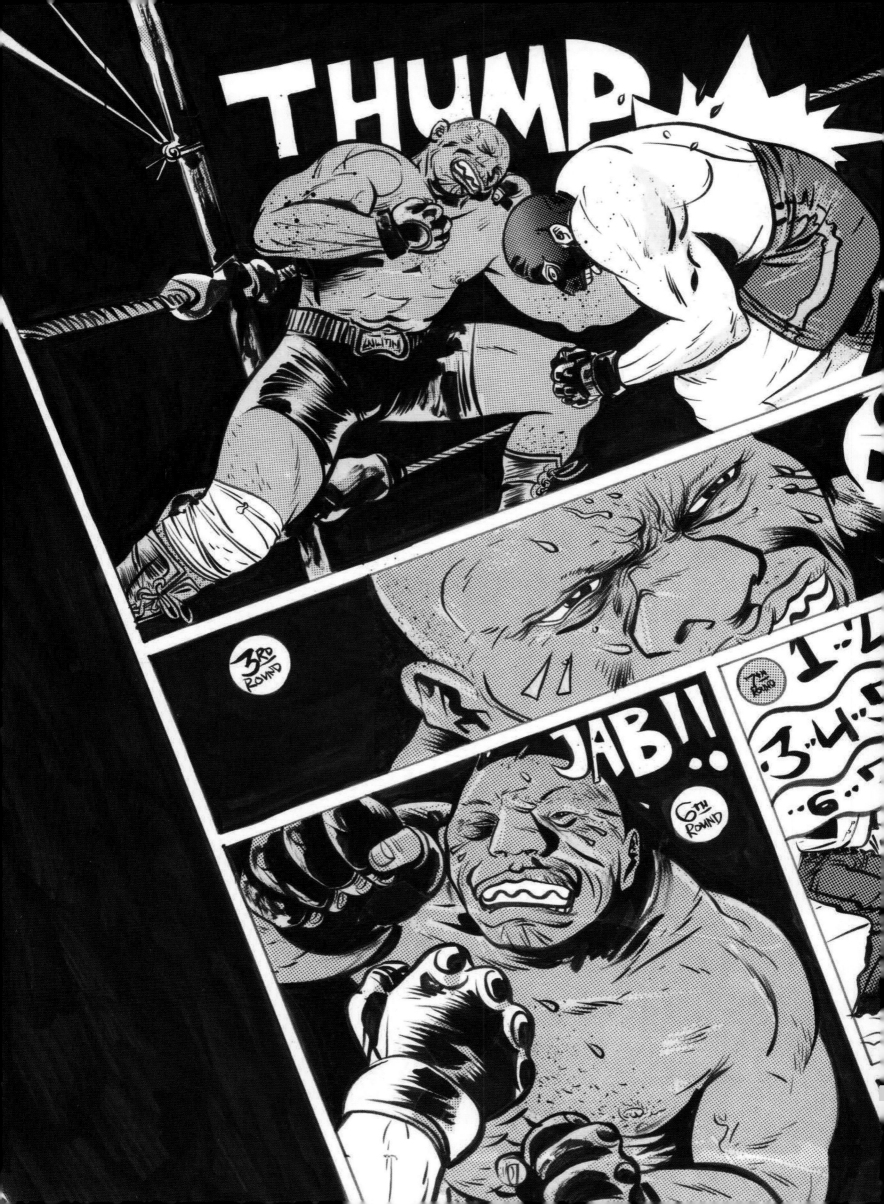

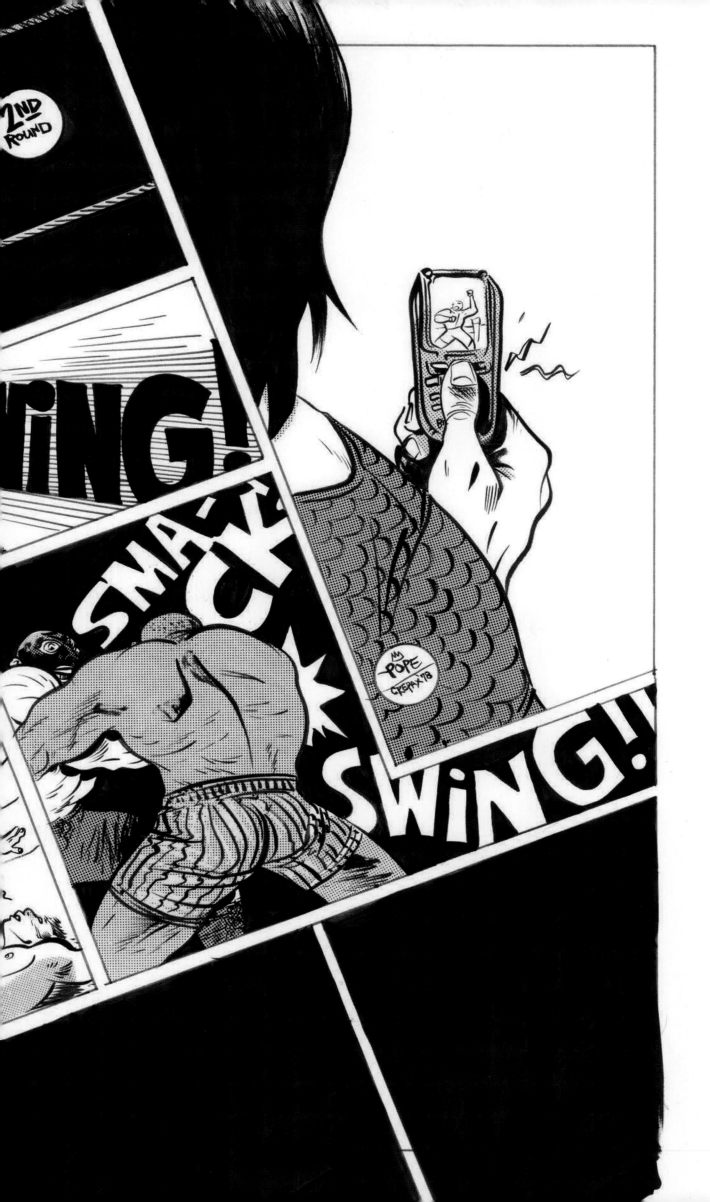

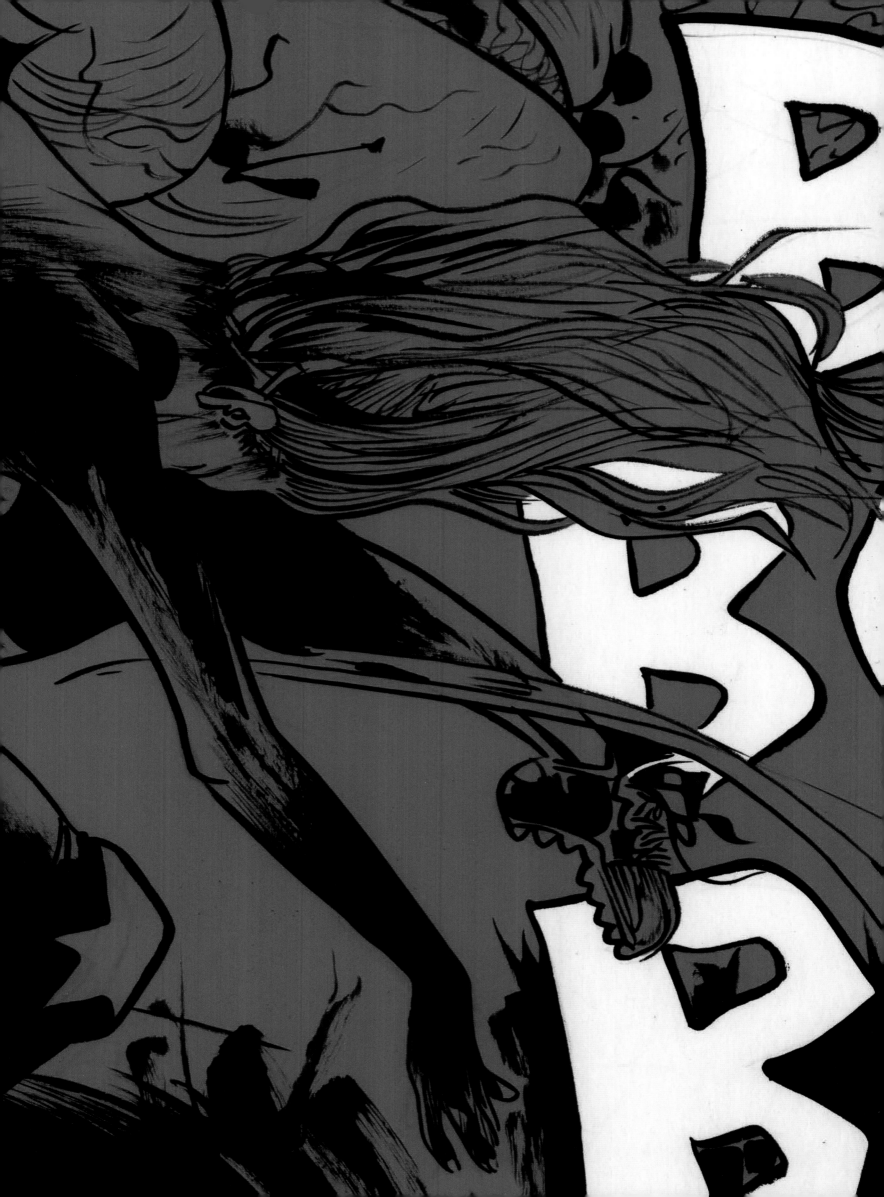

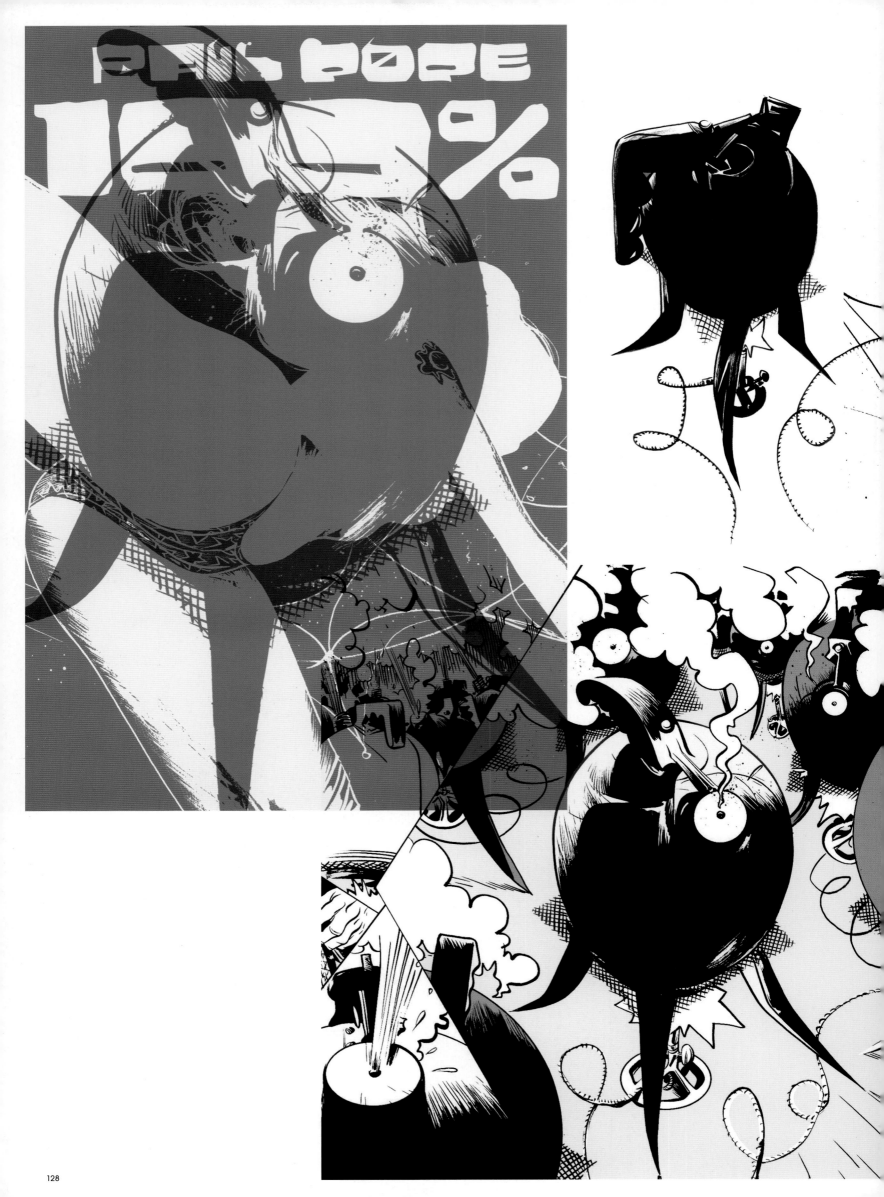

21.

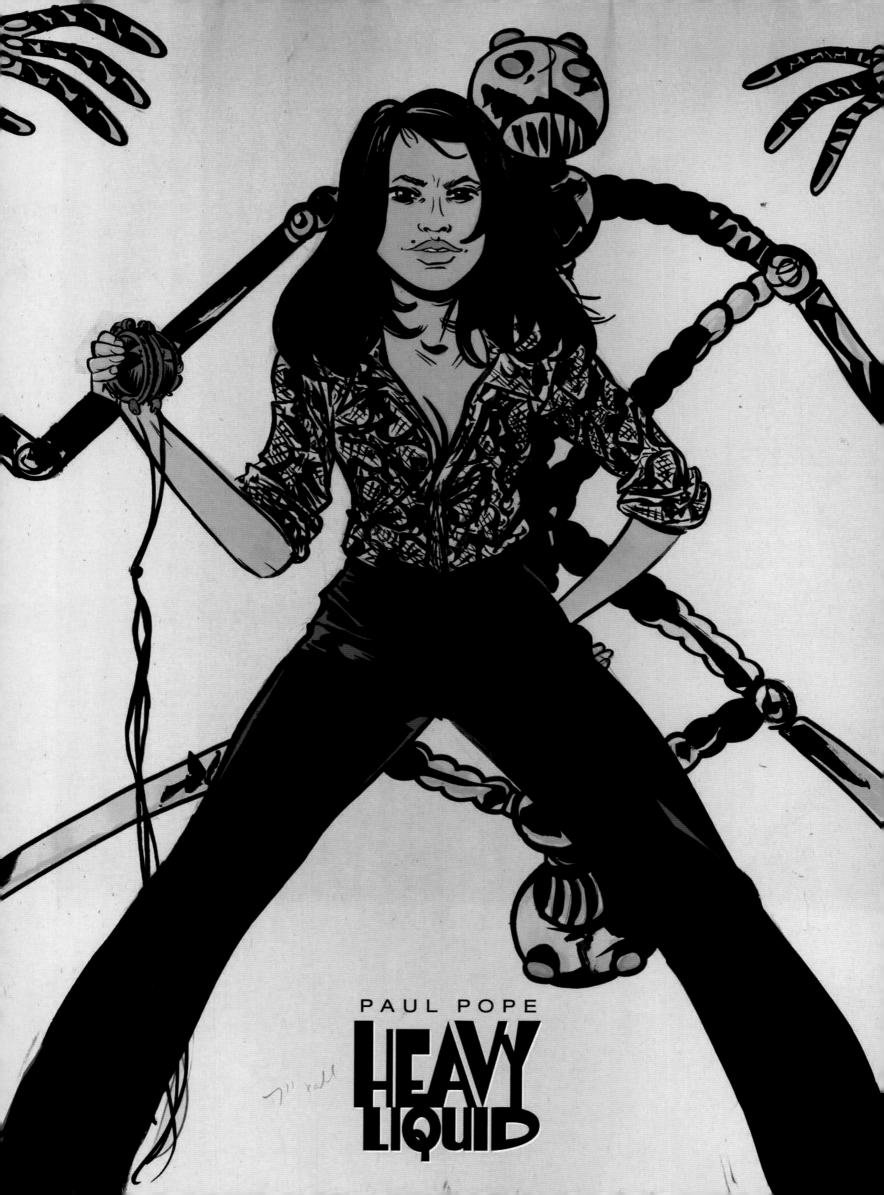

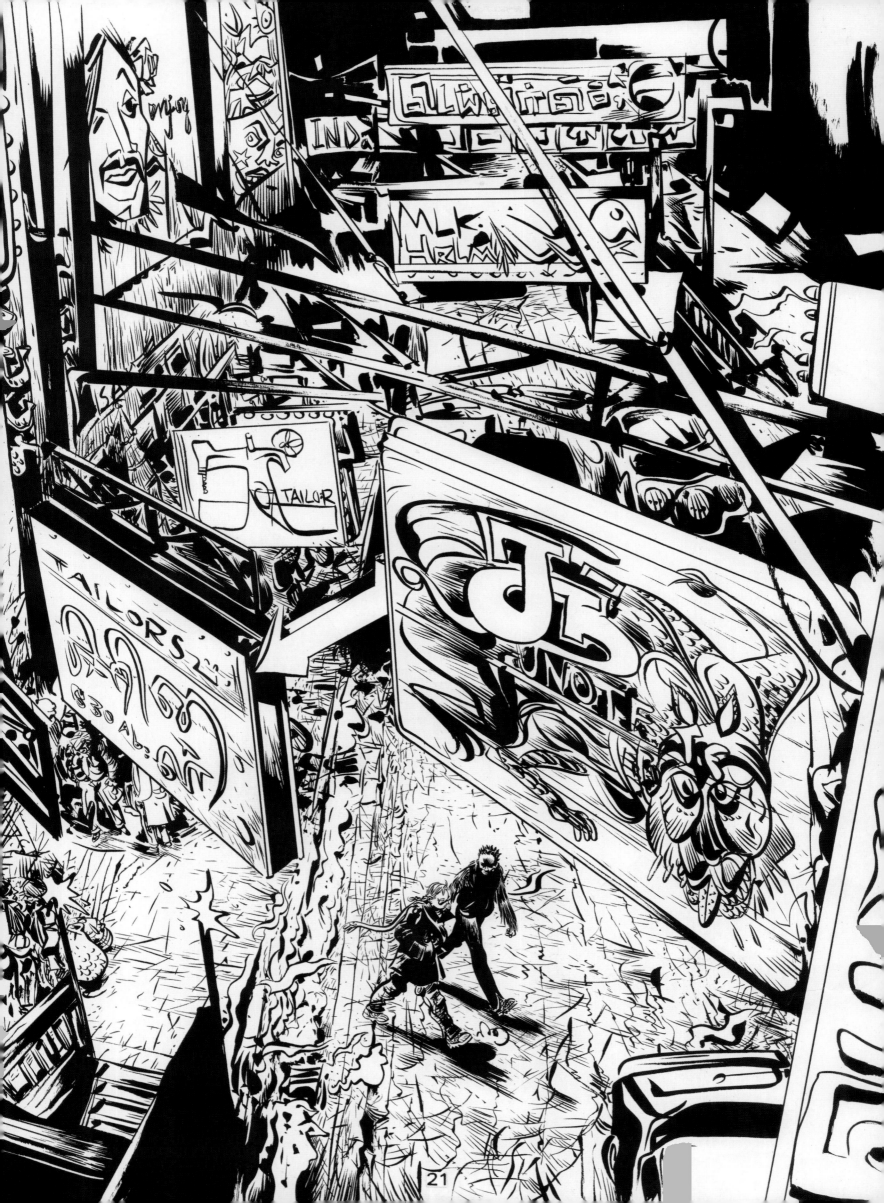

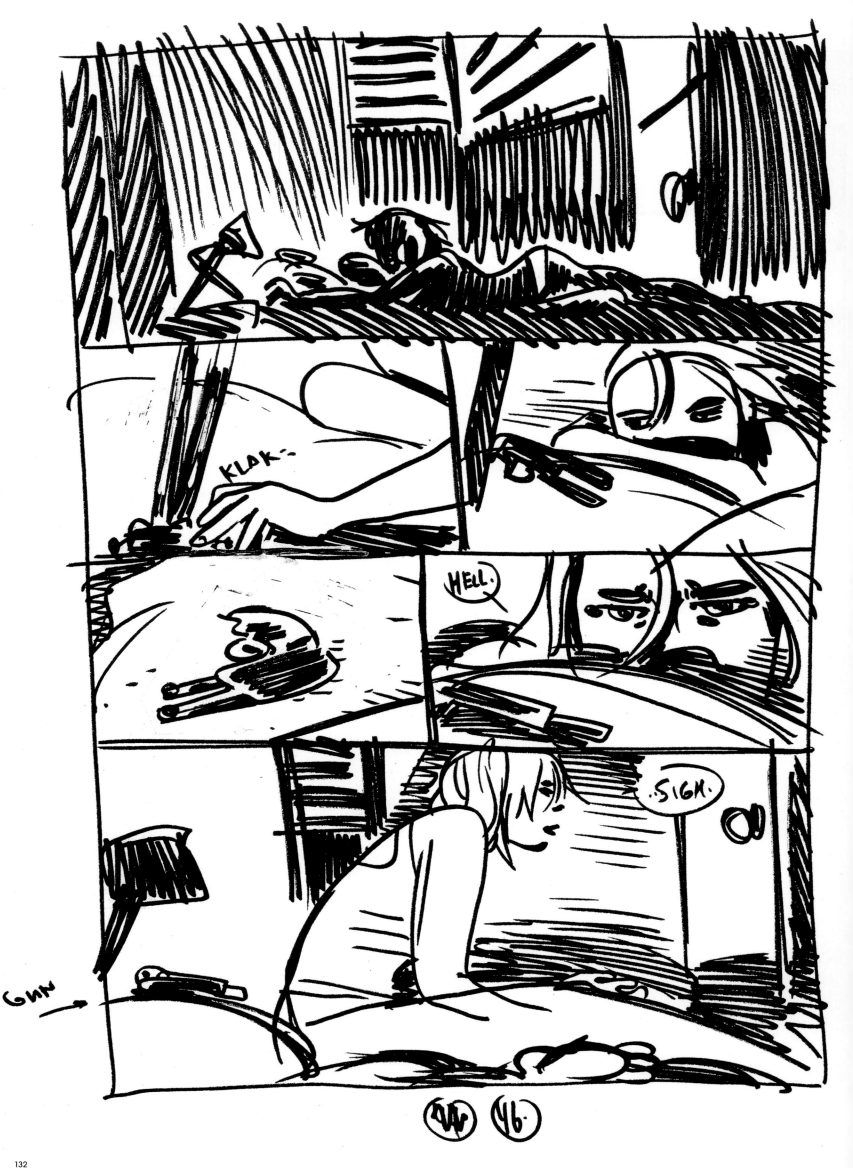

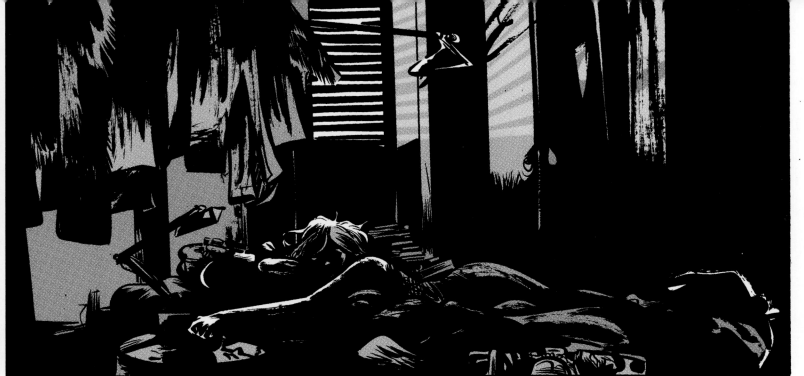

KLAK

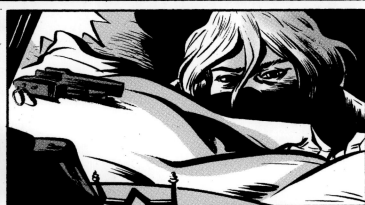

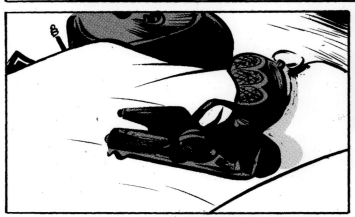

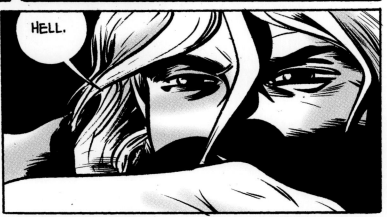

HELL.

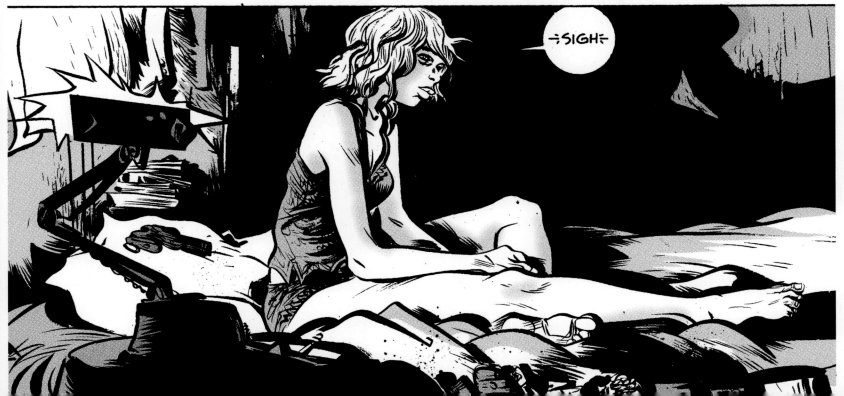

=SIGH=

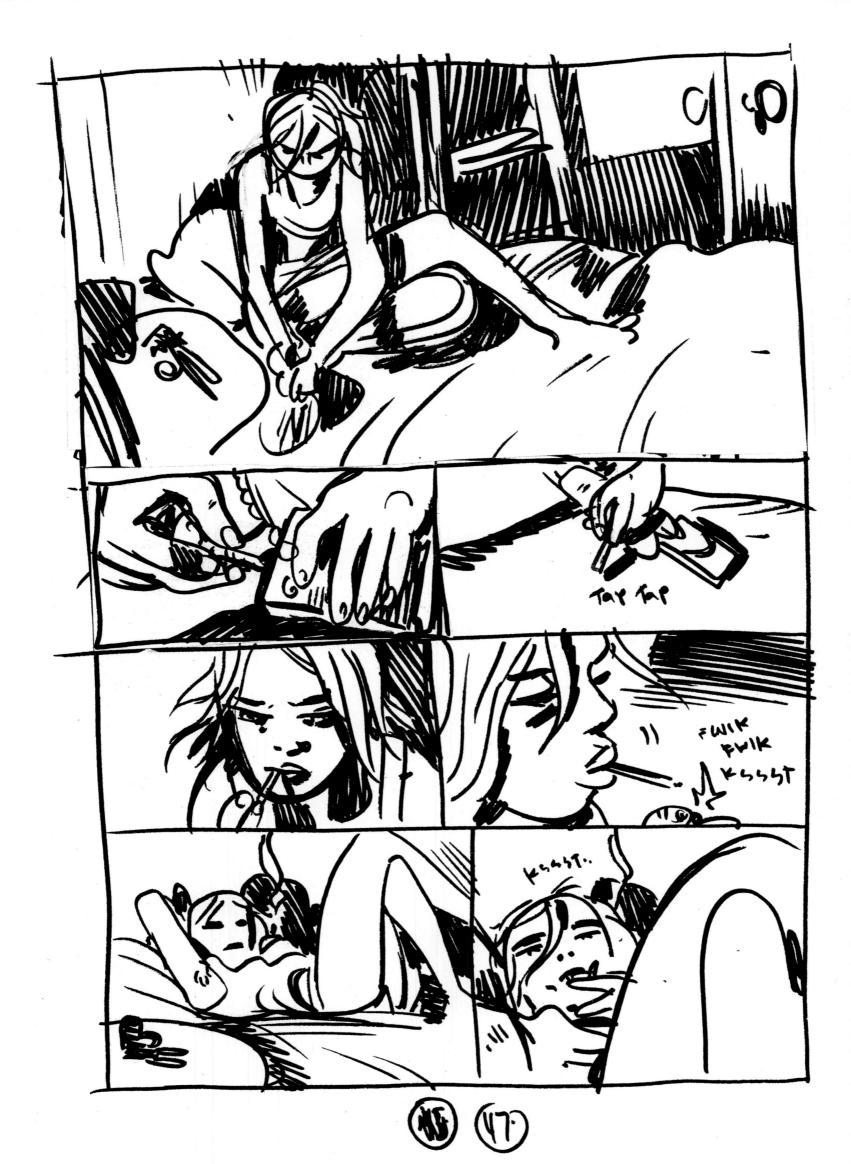

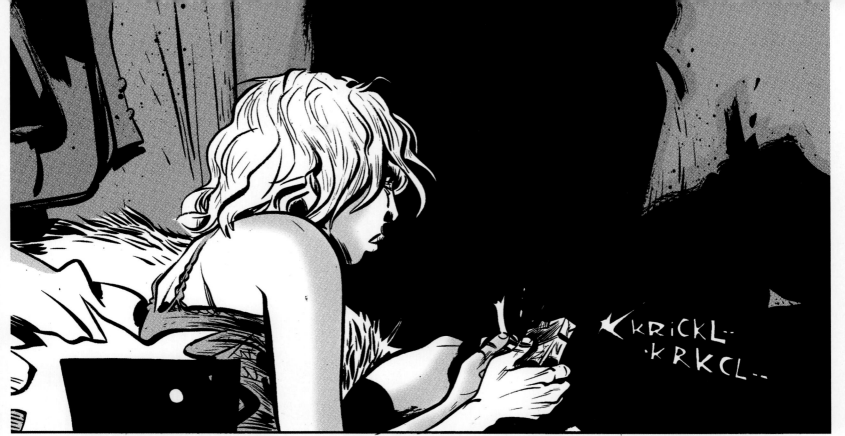

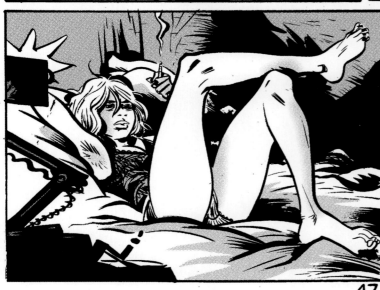

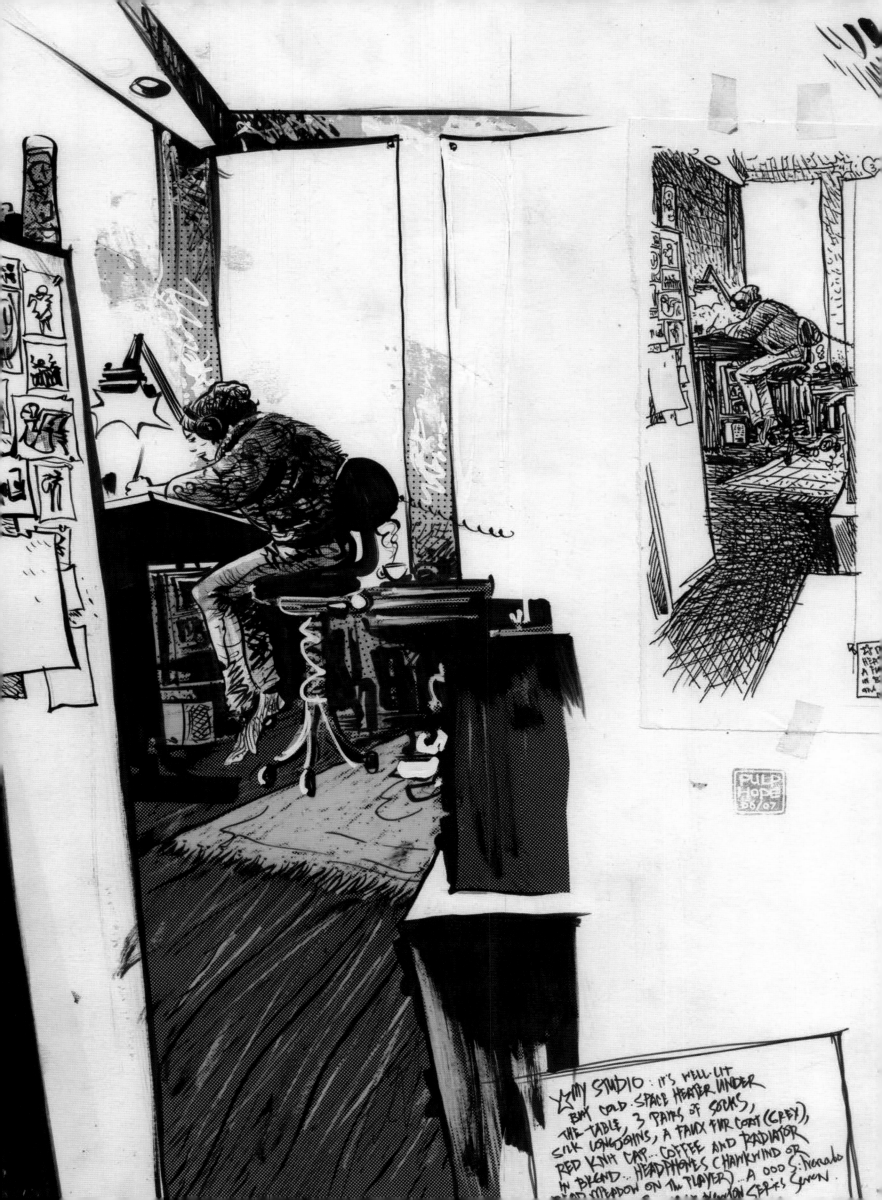

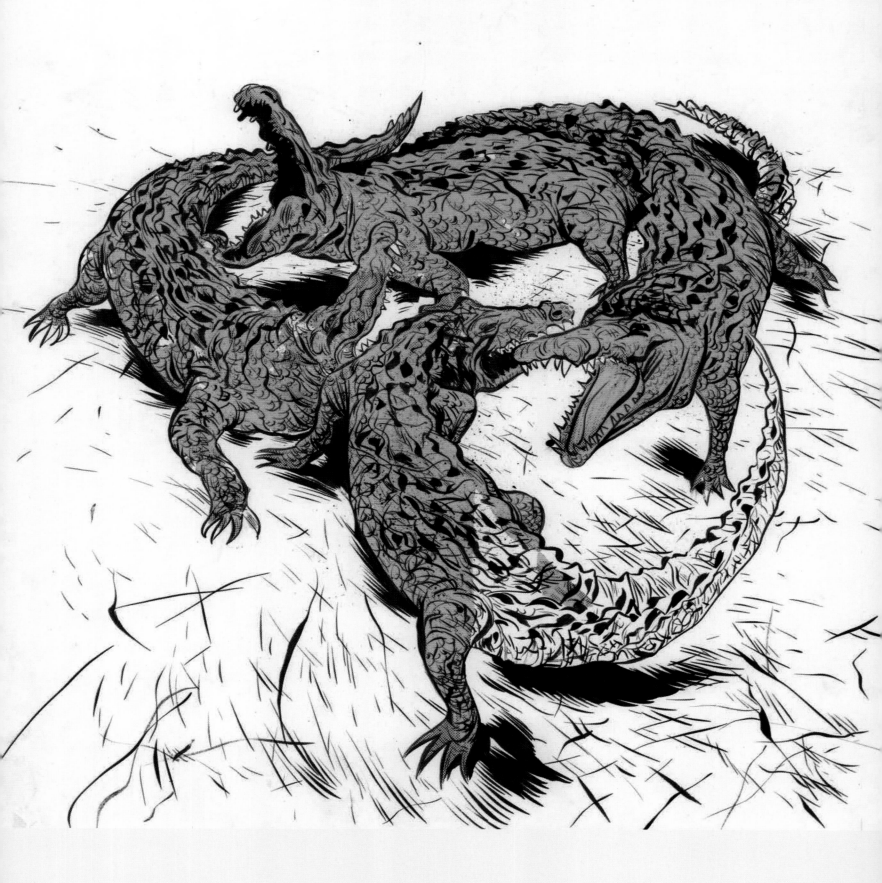

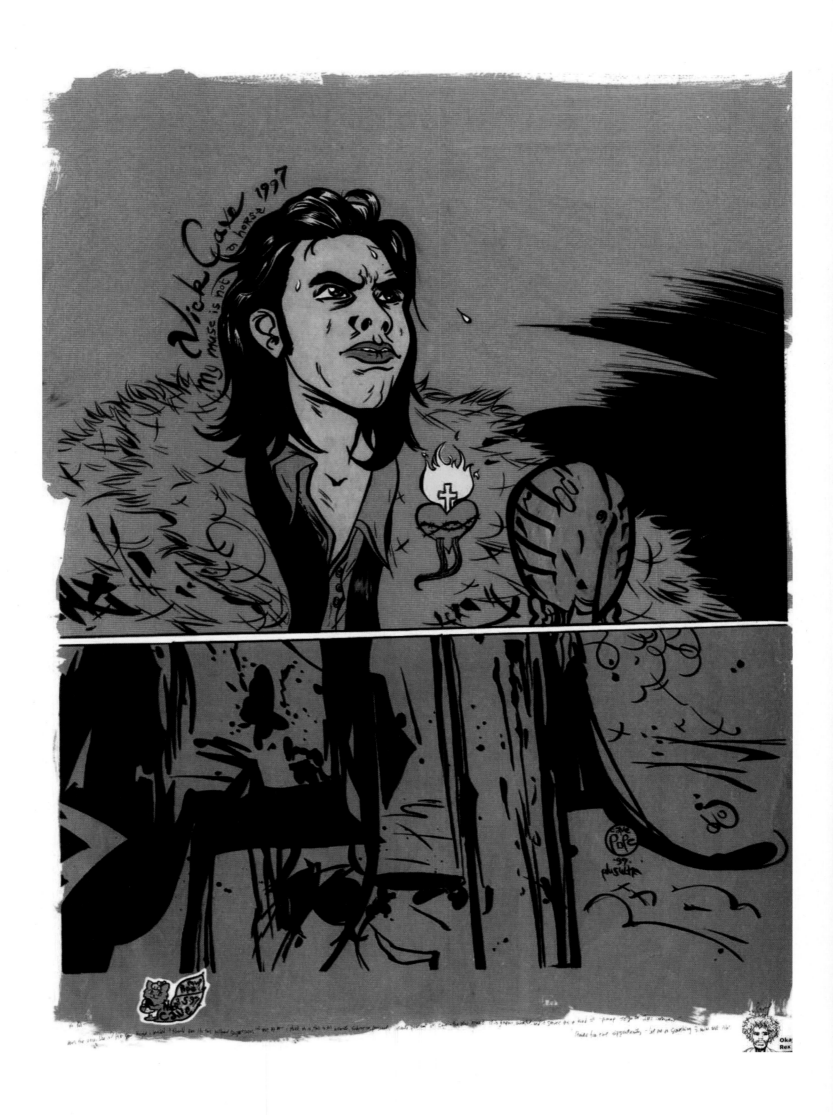

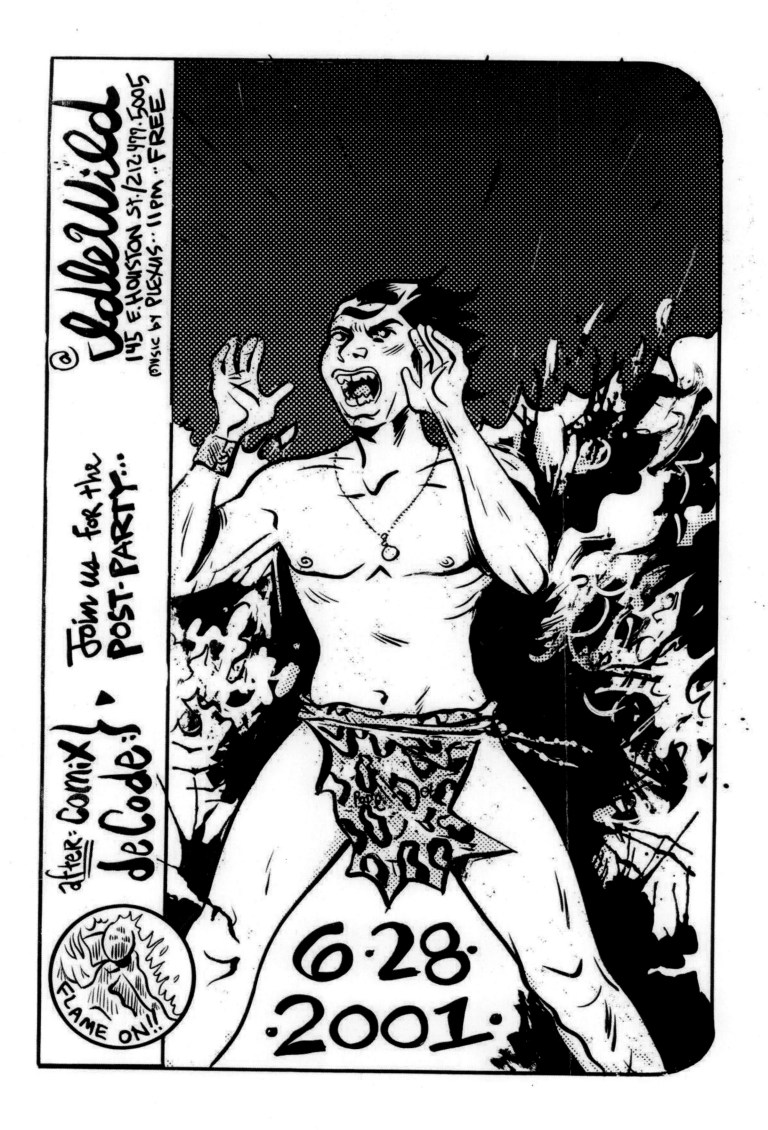

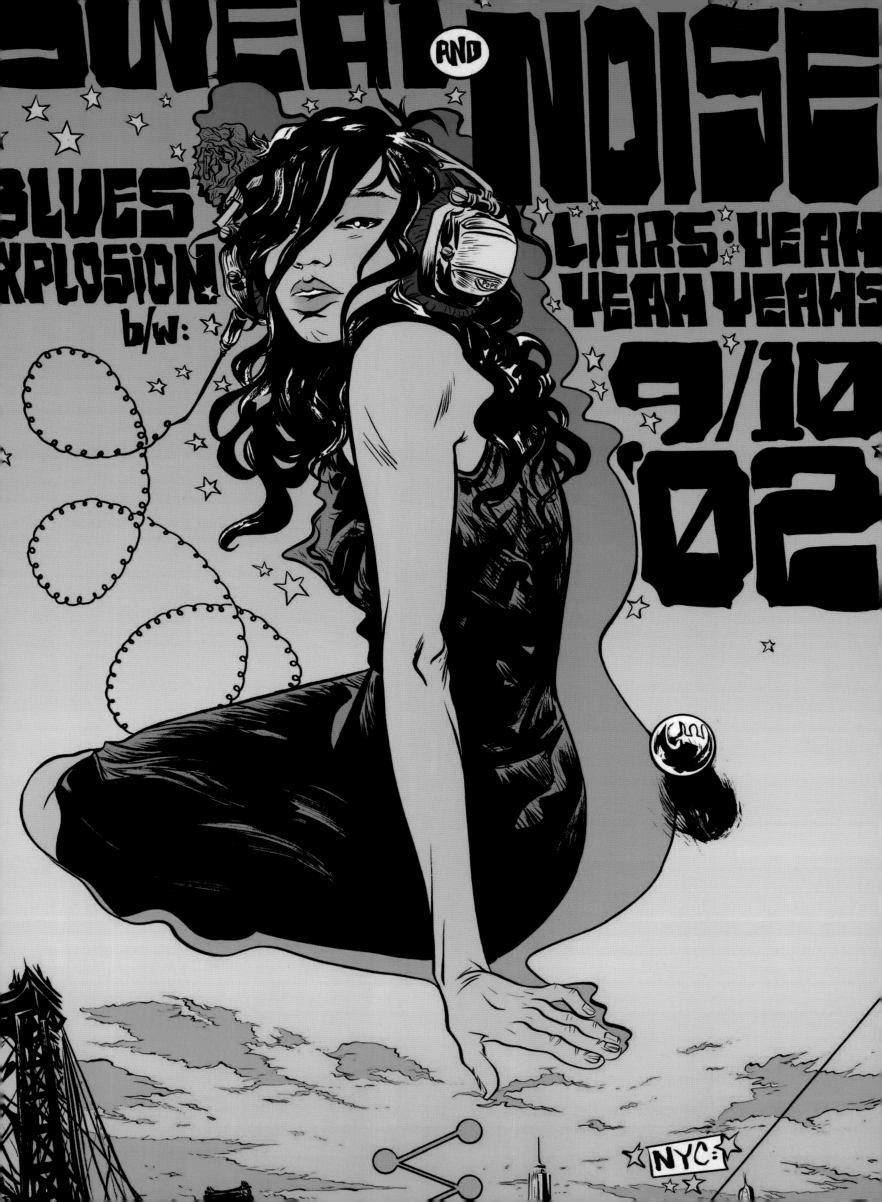

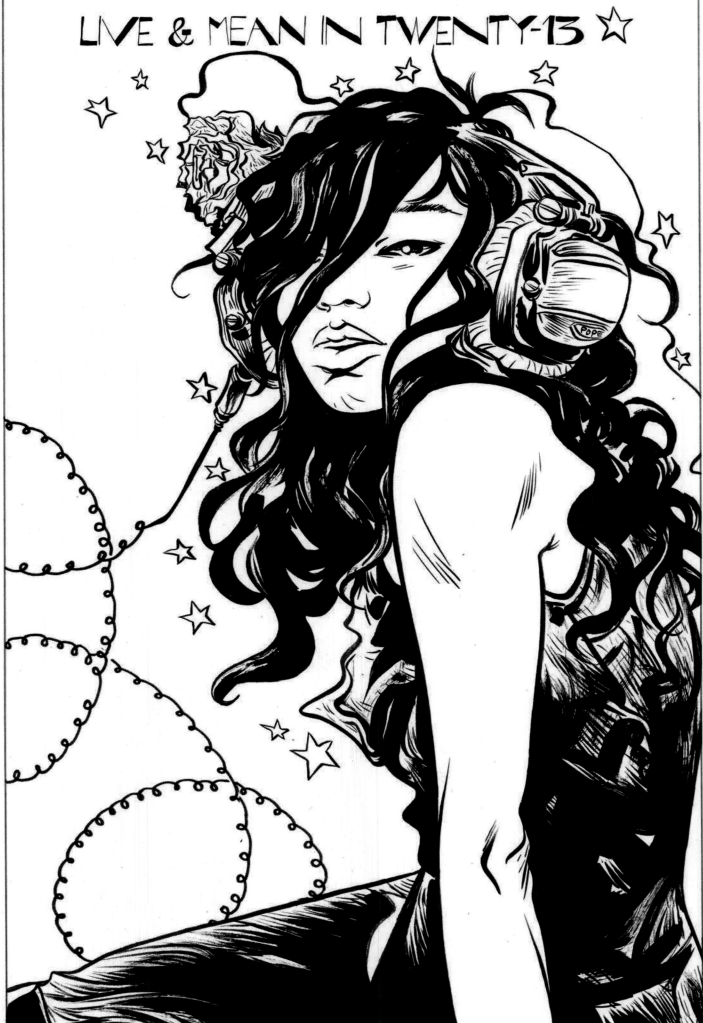

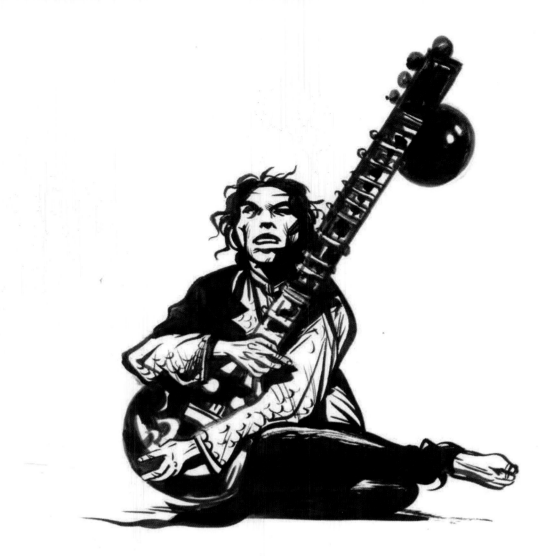

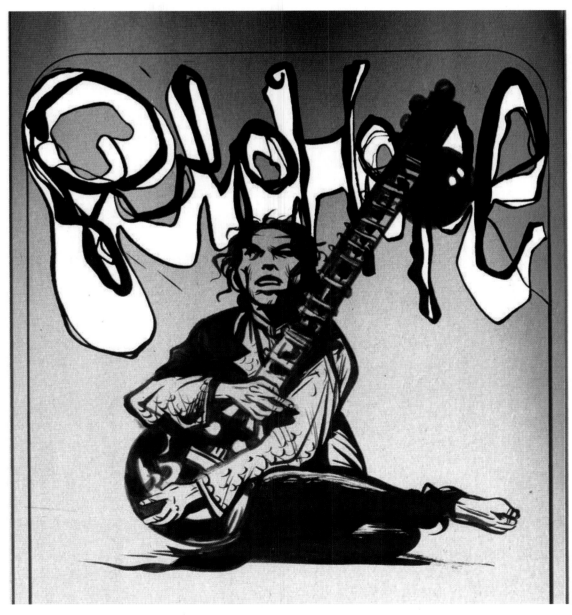

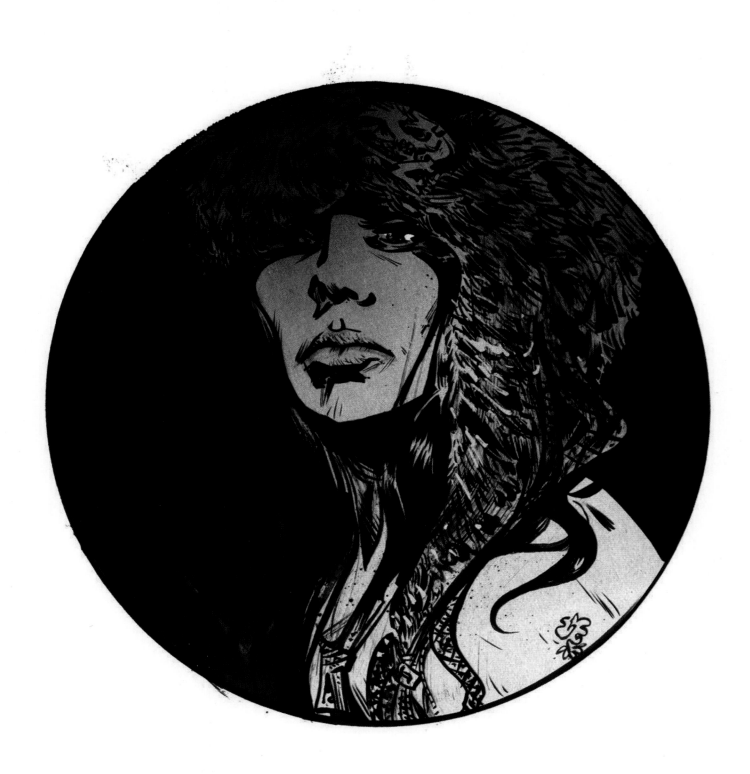

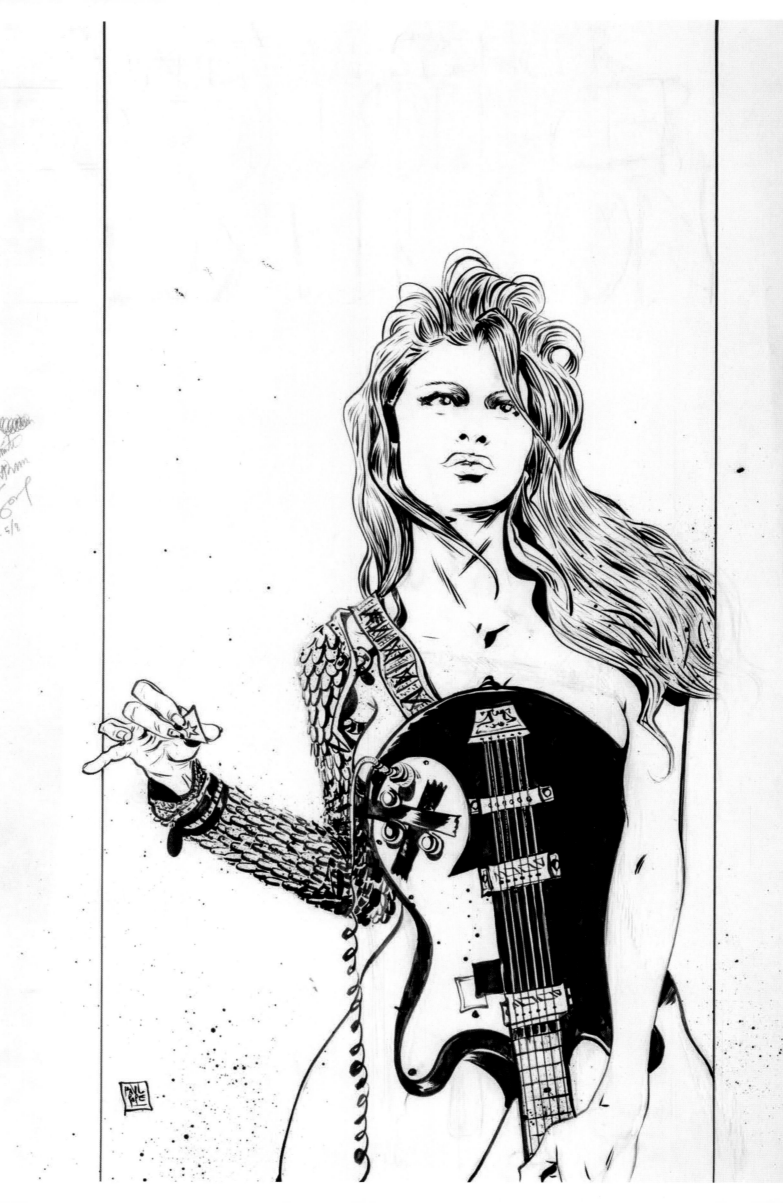

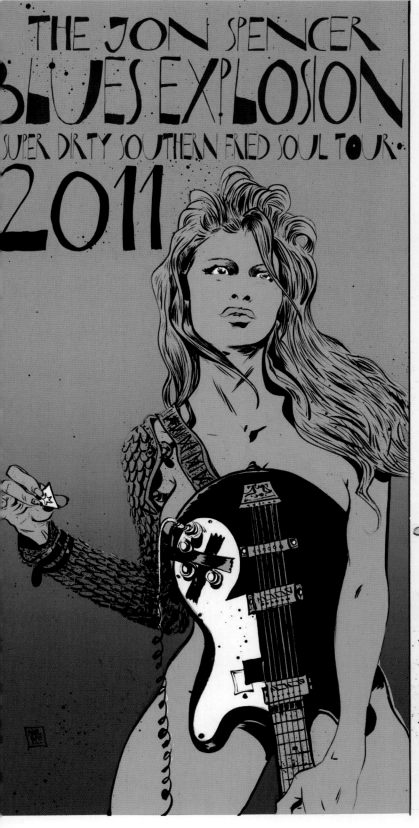
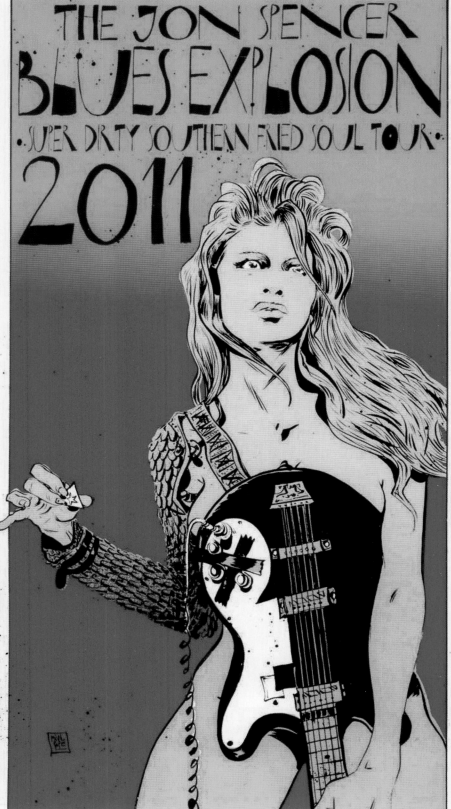

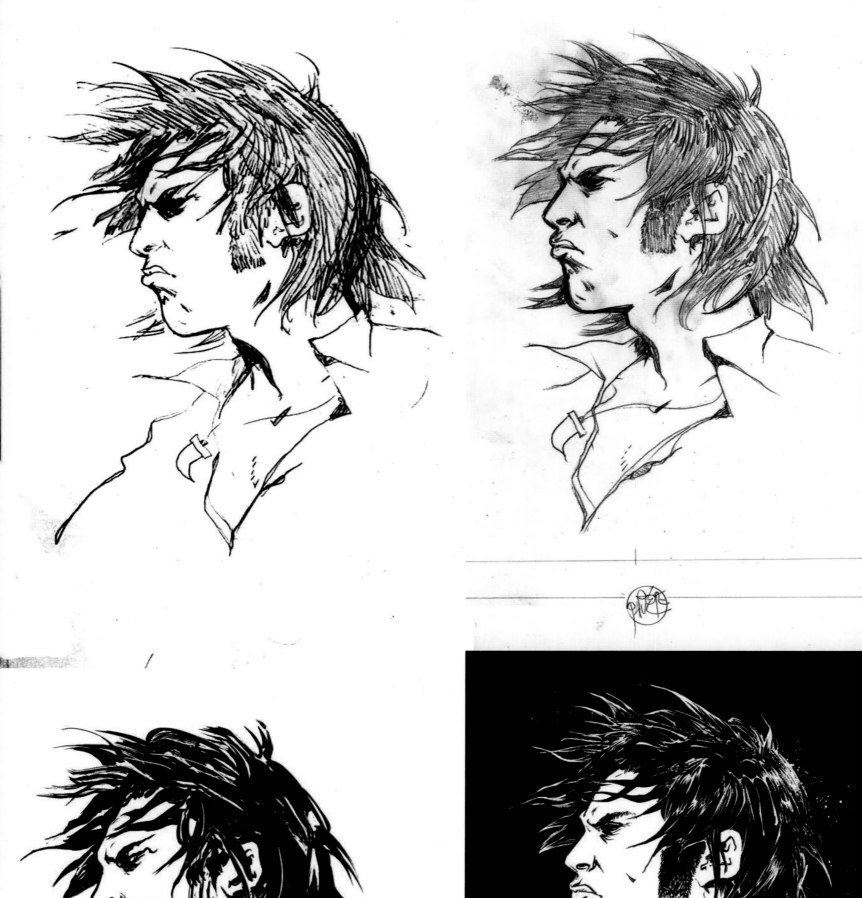
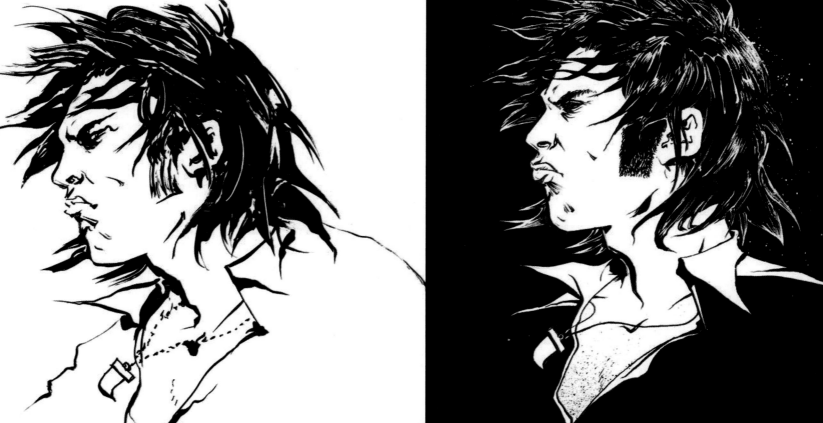

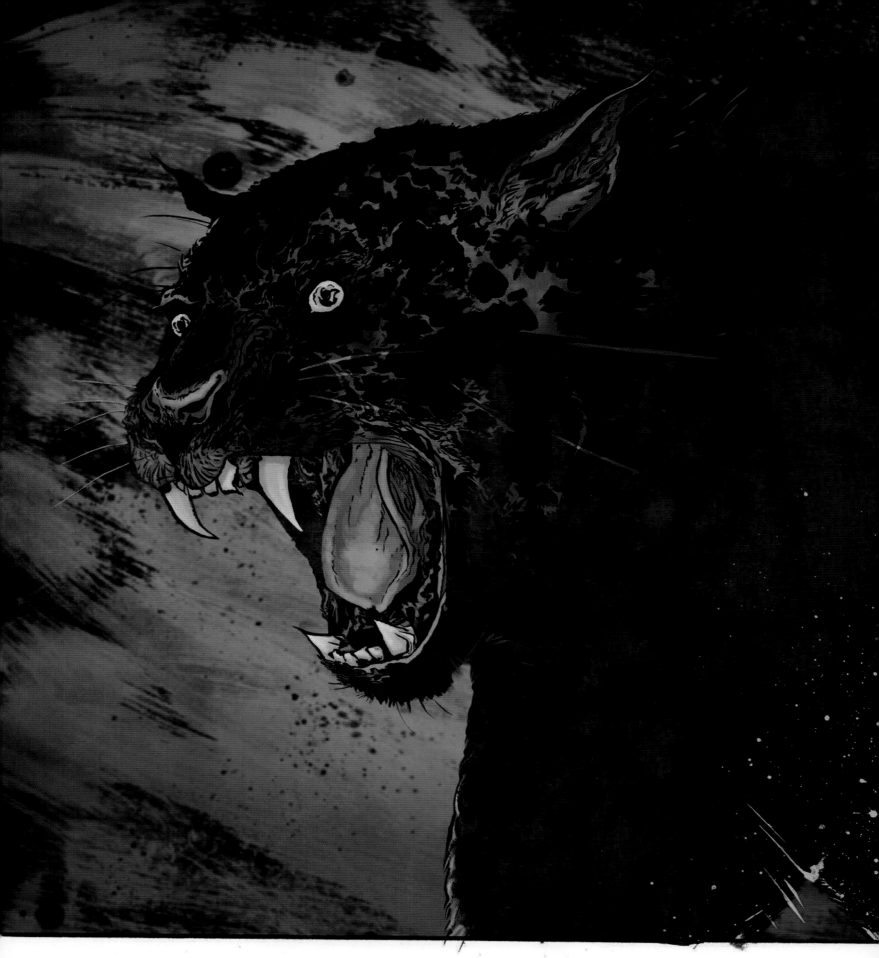

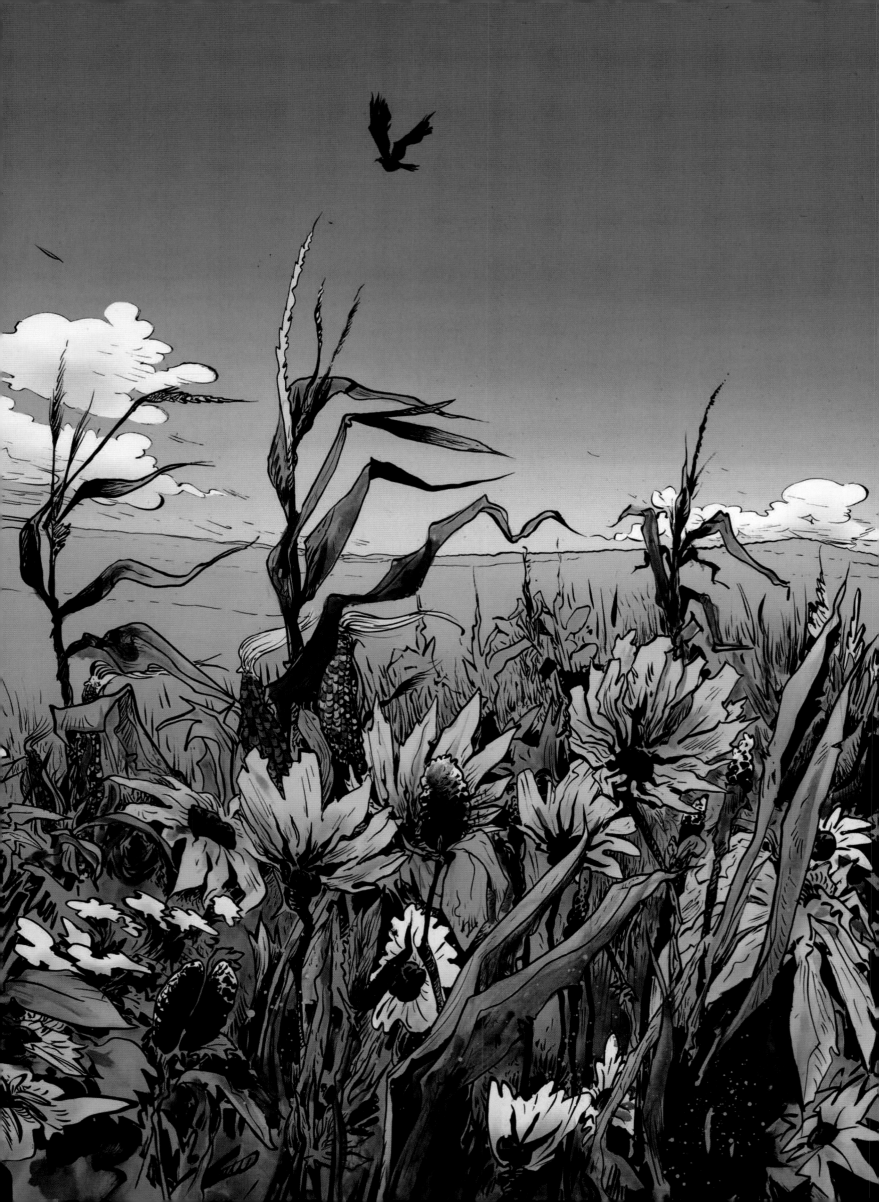

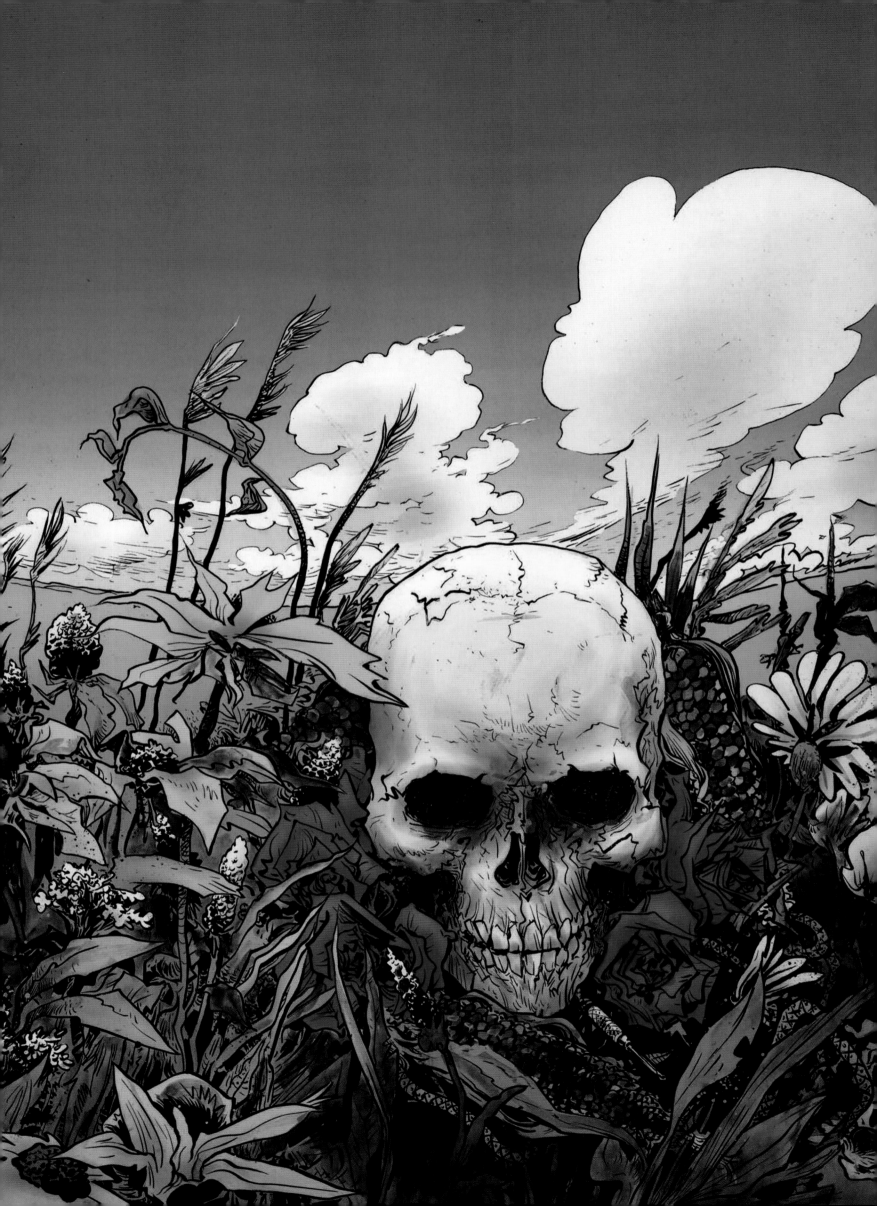

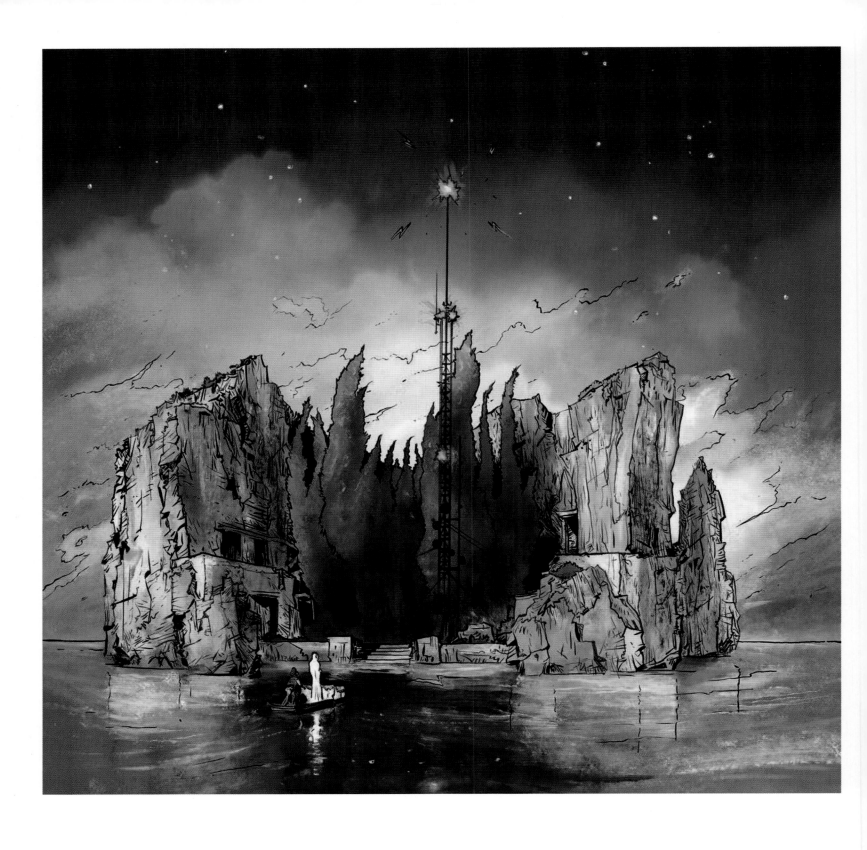

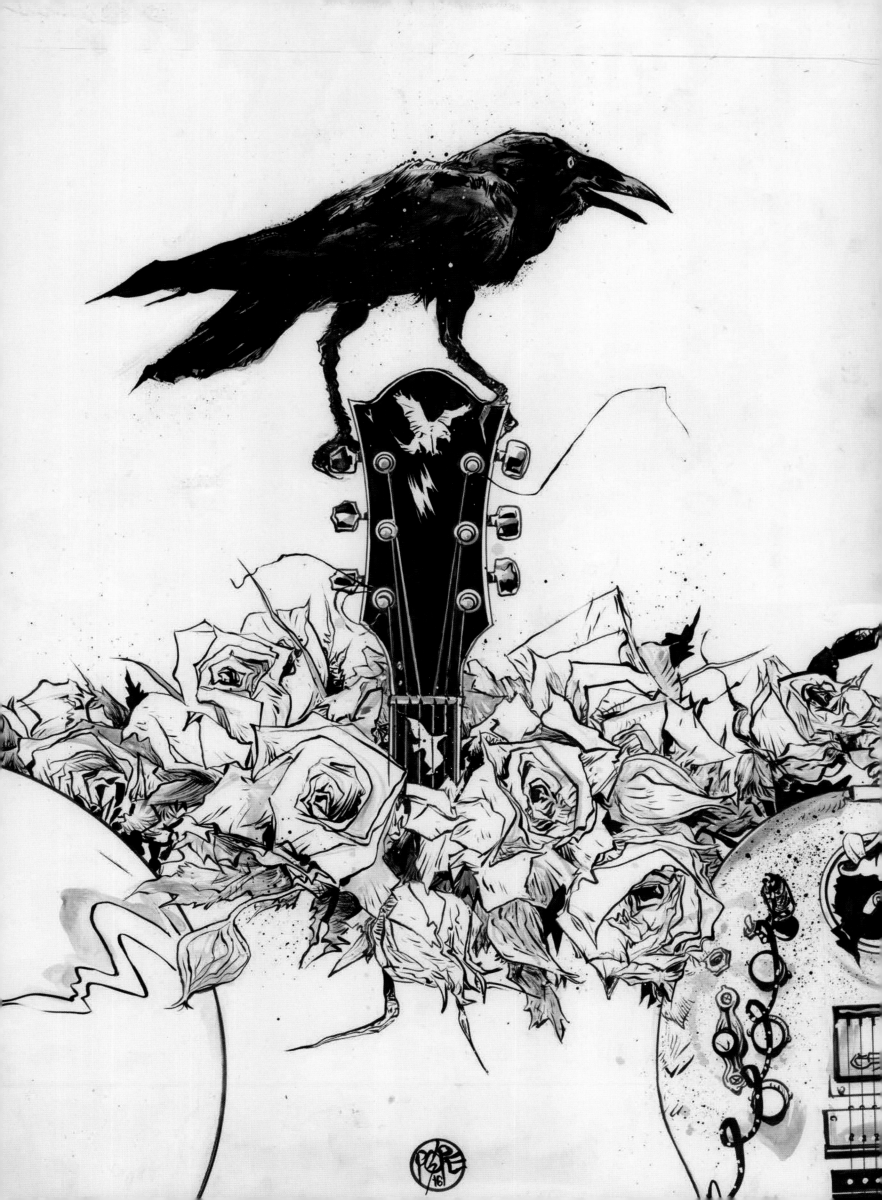

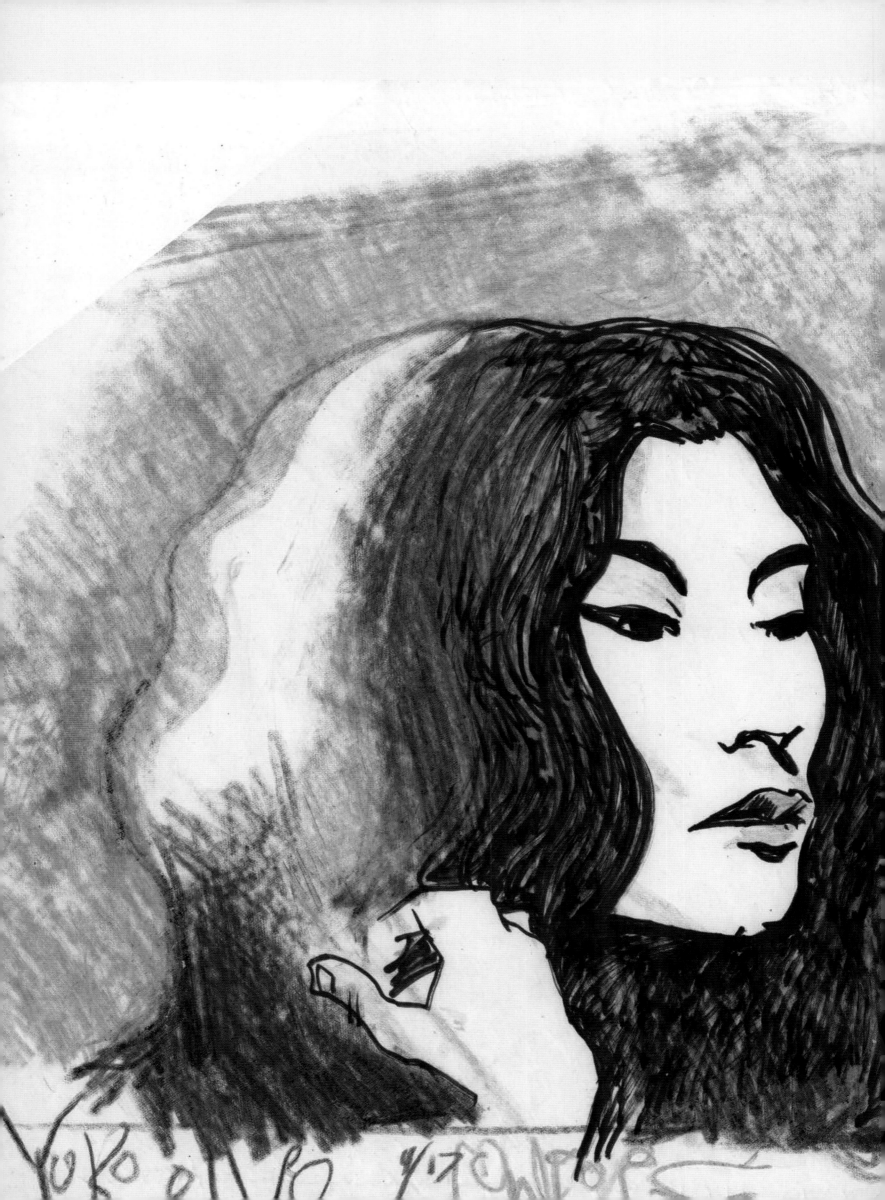

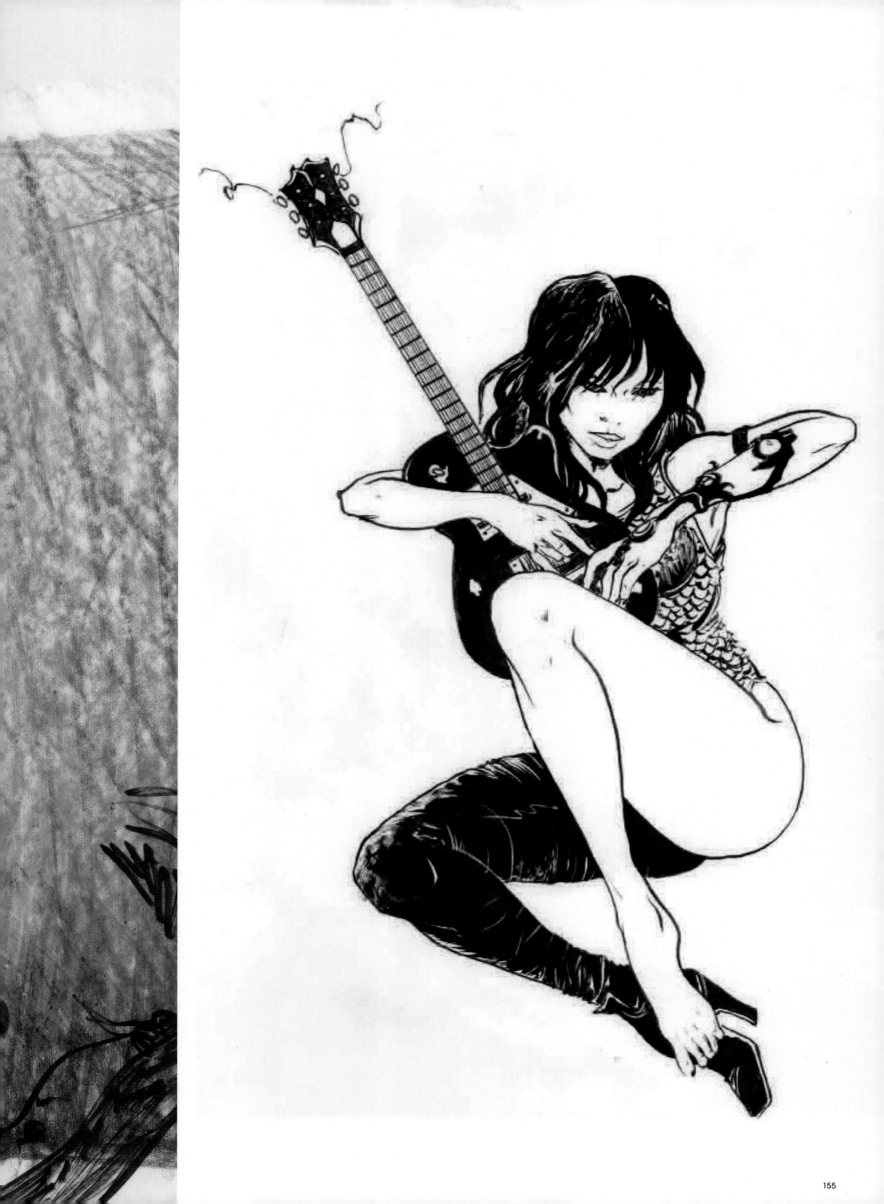

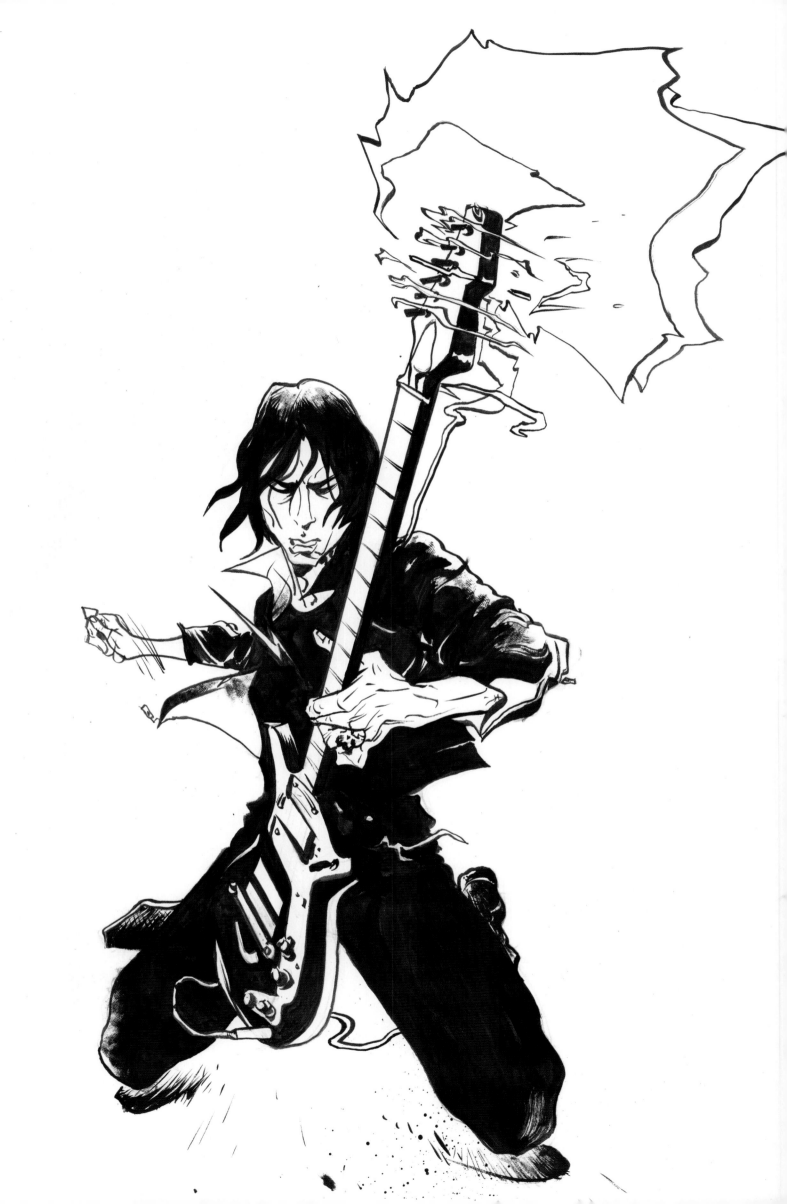

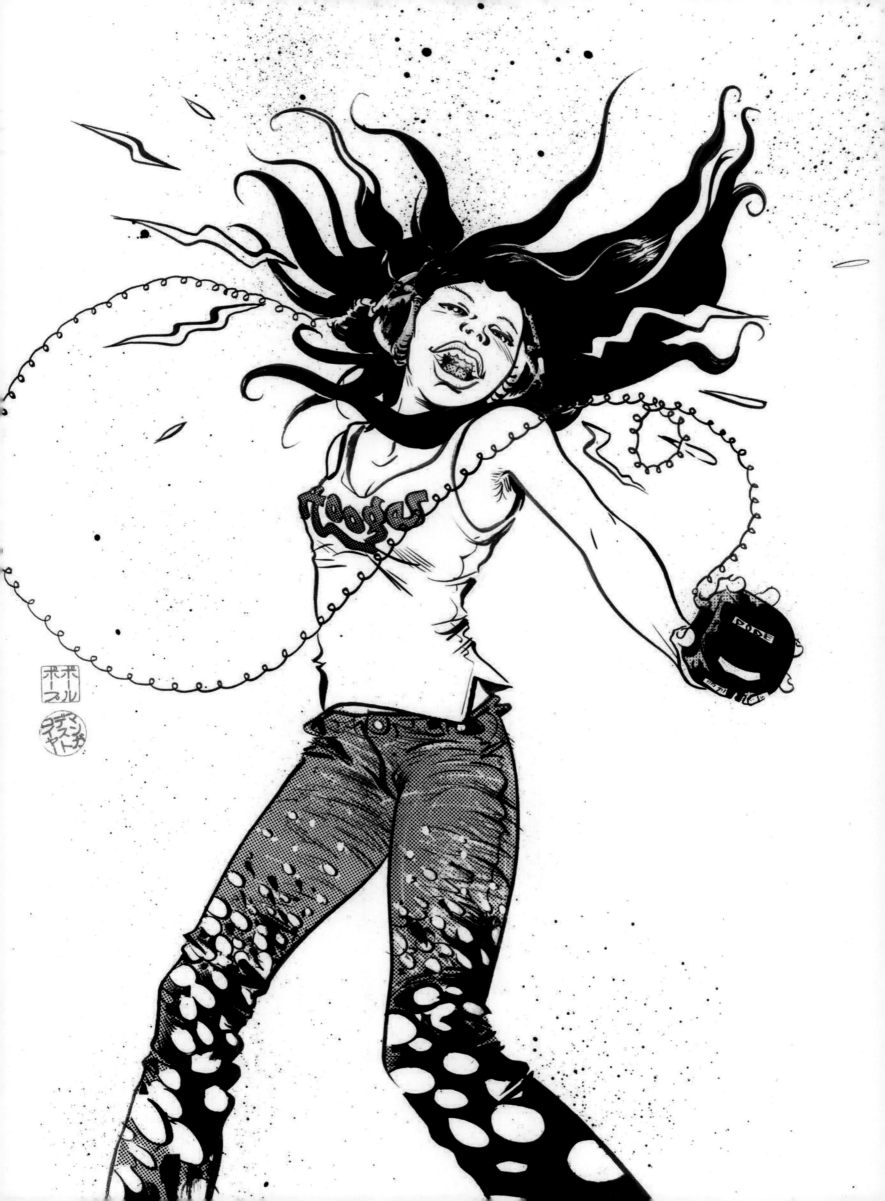

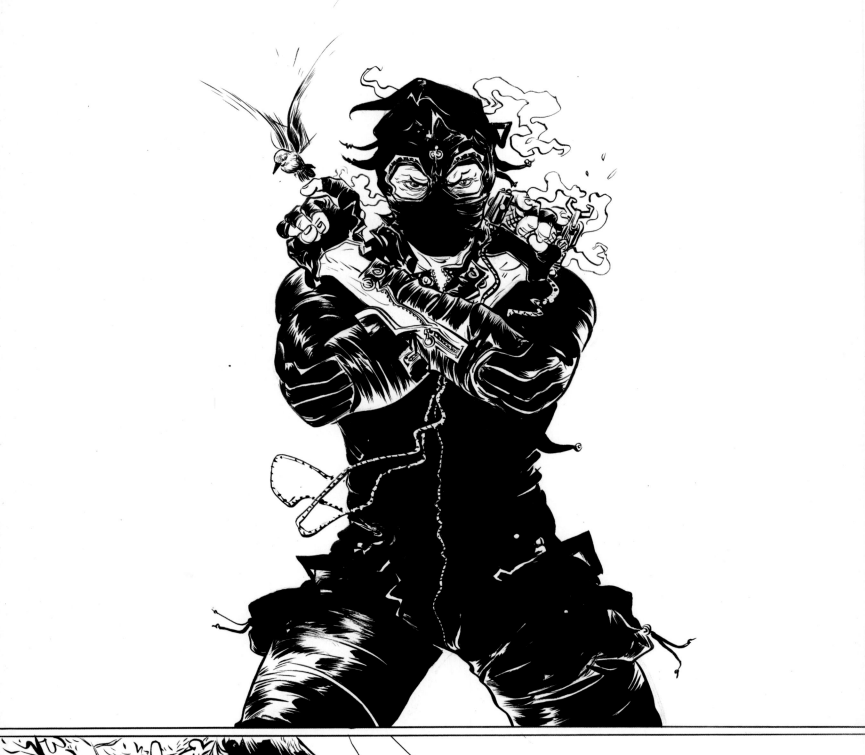

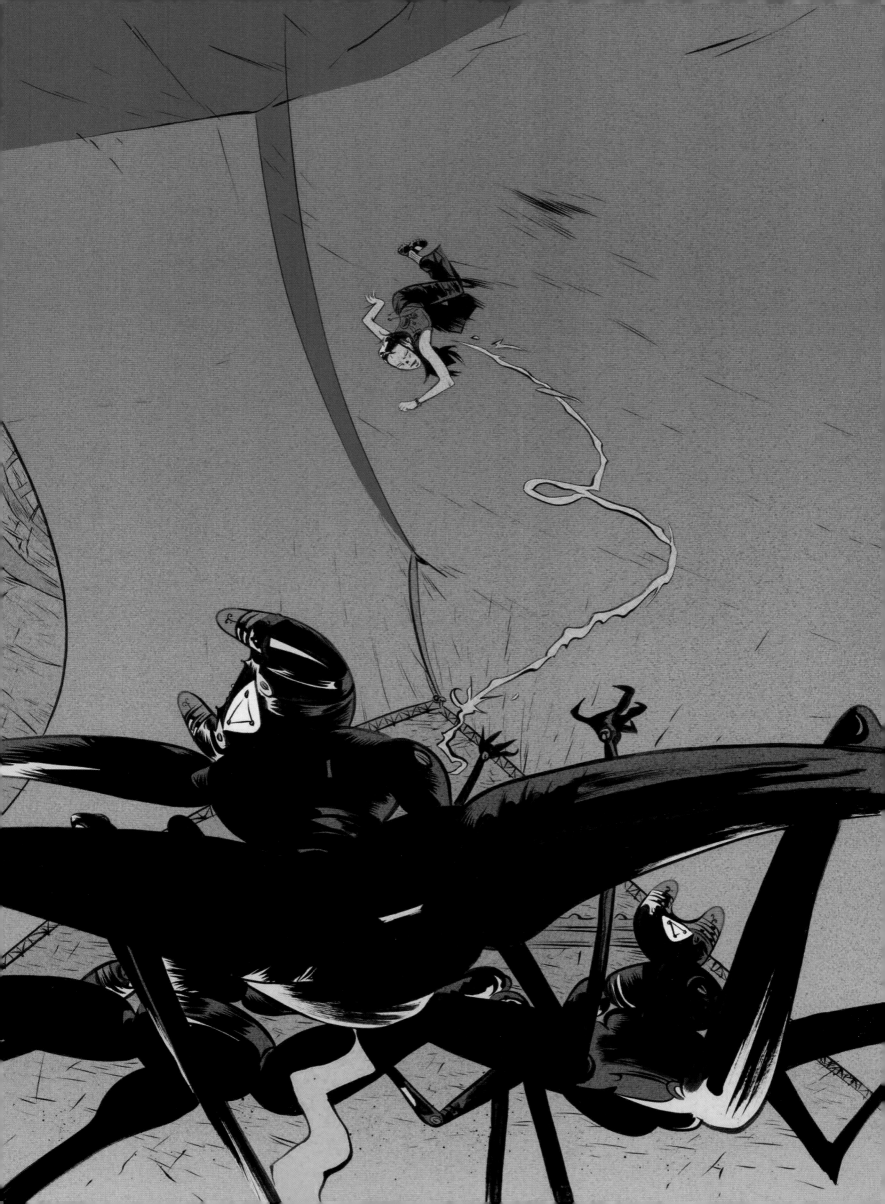

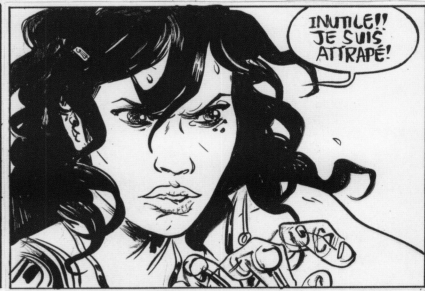

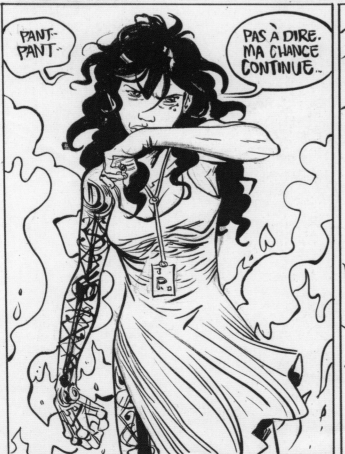

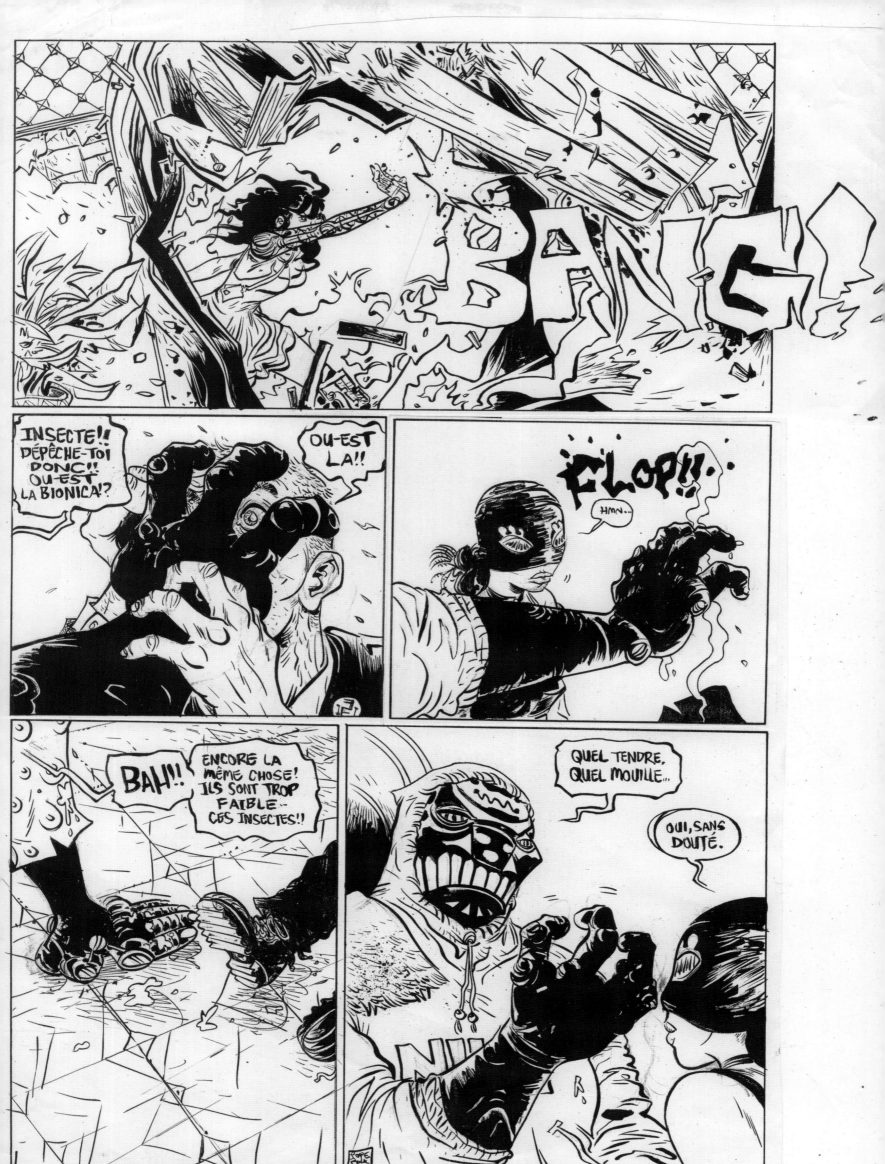

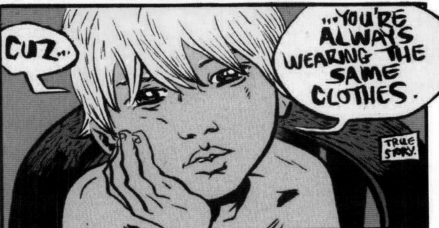
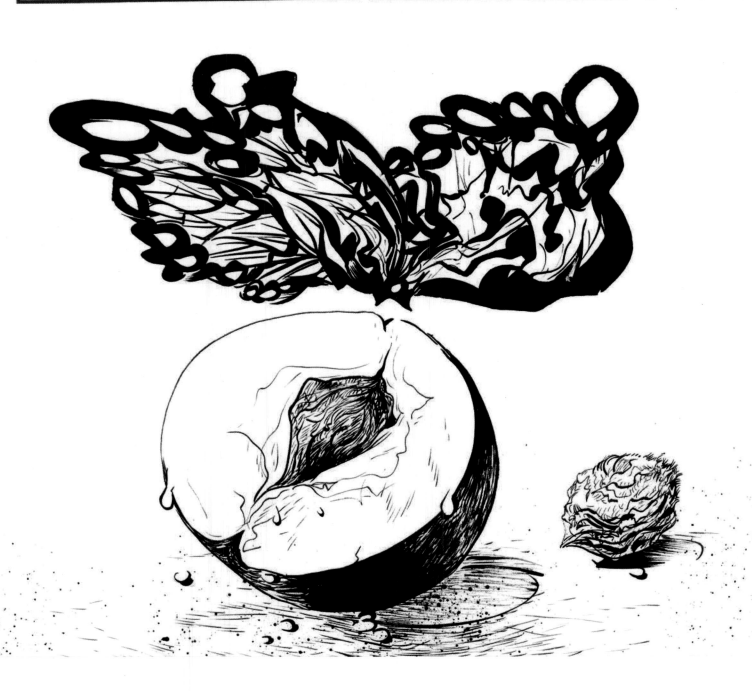

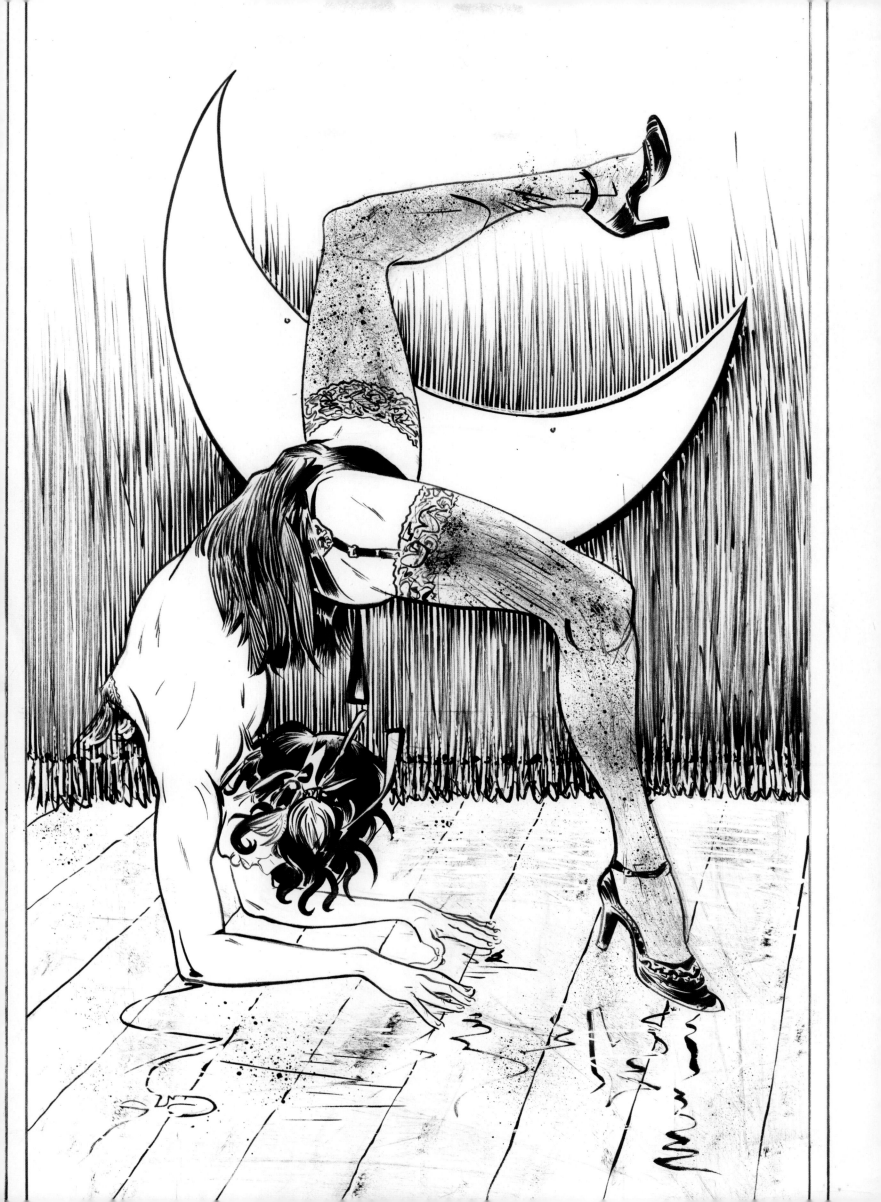

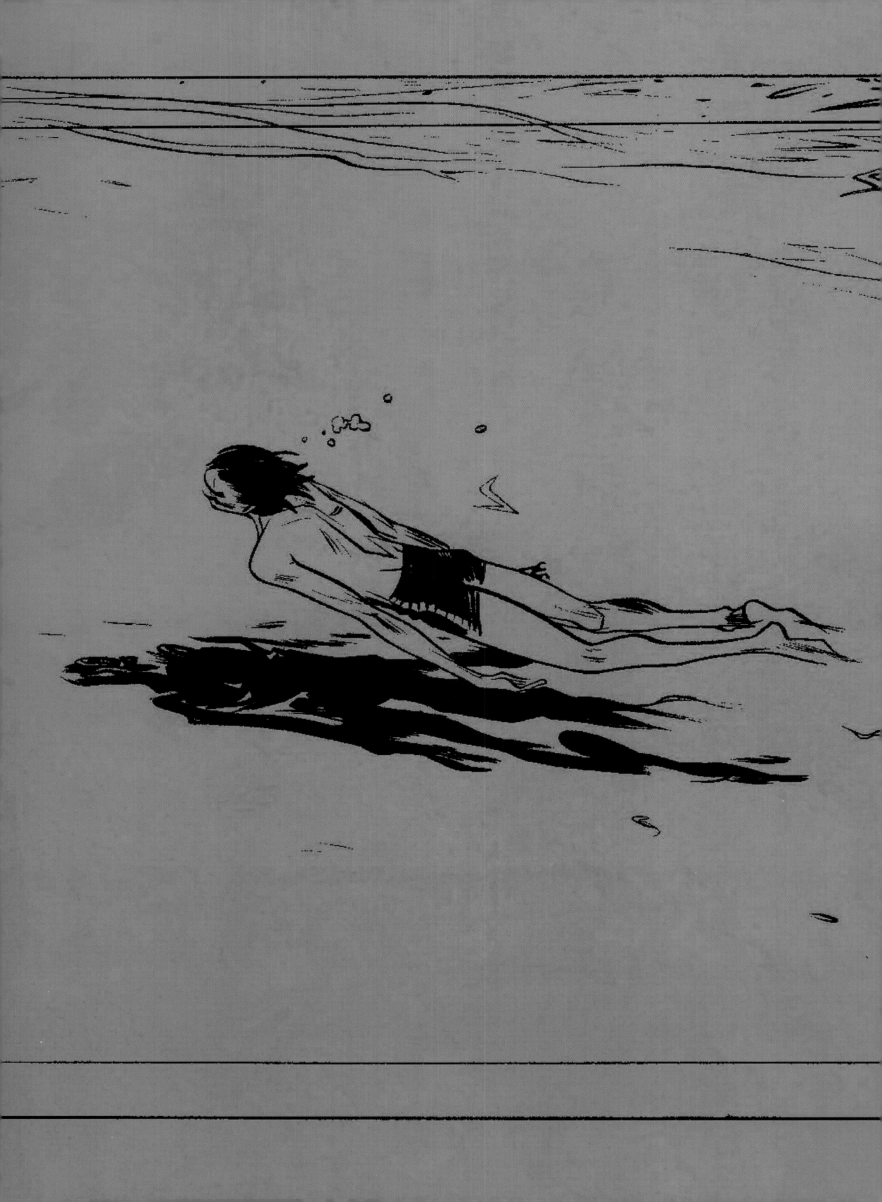

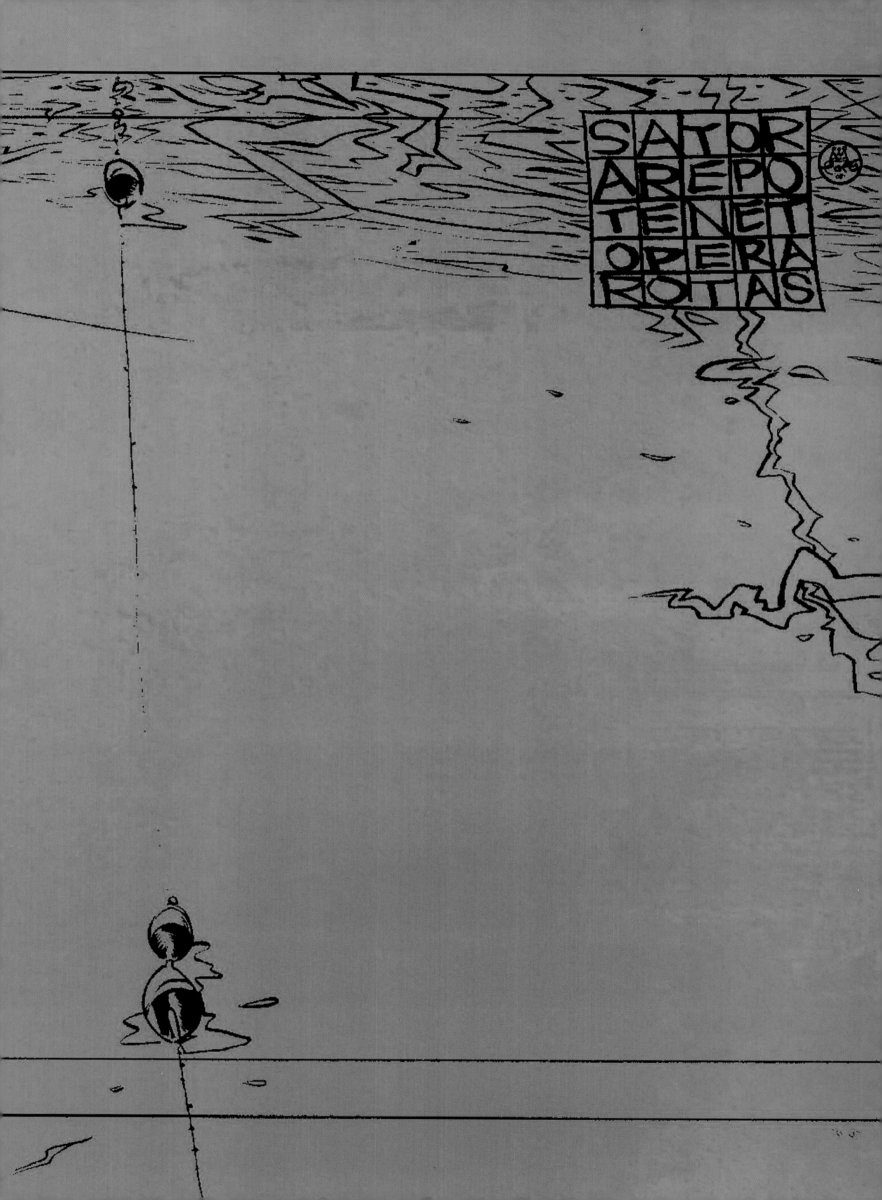

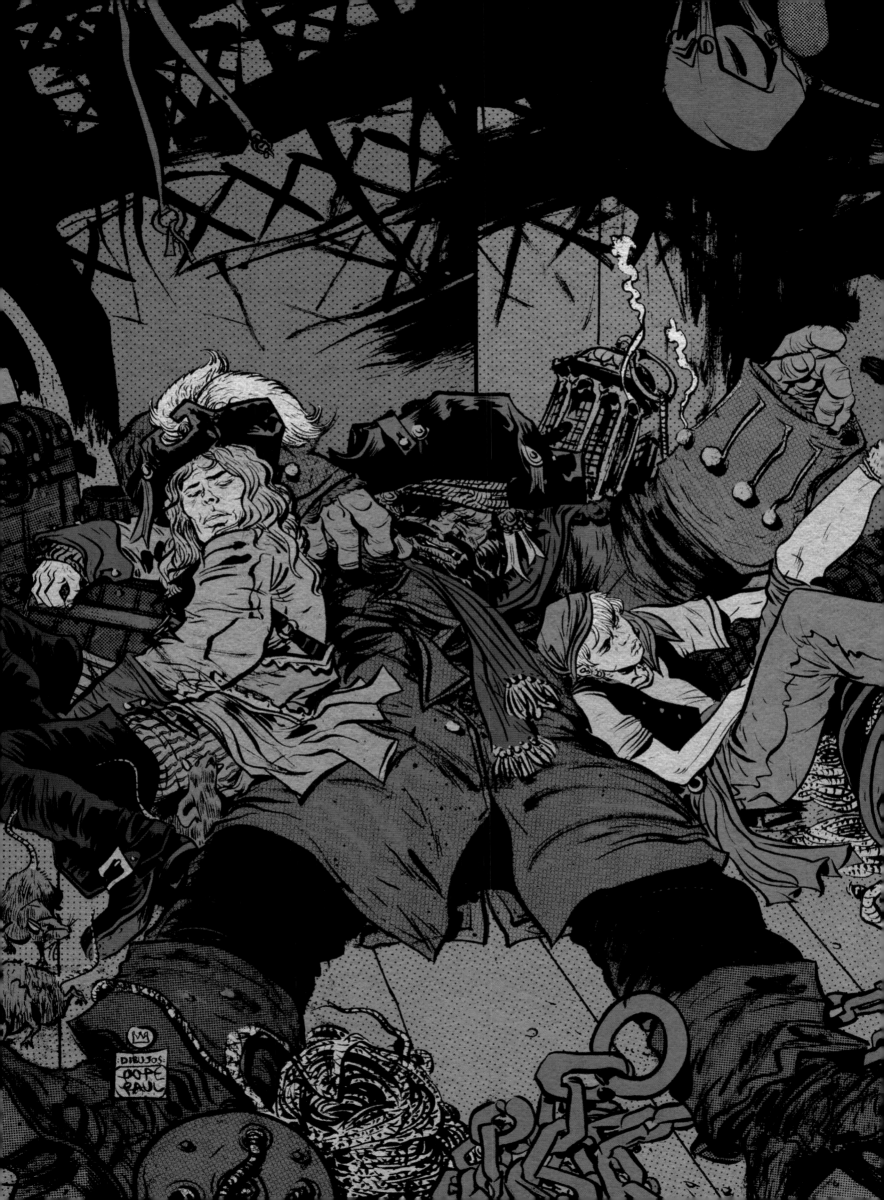

pulphope

.WHAT YOU.
HAVE LEARNED AND DONE
IS SAFE AND FRUITFUL...
WORK AND LEARN
IN EVIL DAYS, IN INSULTED DAYS,
IN DAYS OF DEBT AND DEPRESSION
AND CALAMITY.
FIGHT BEST IN THE SHADE OF
THE CLOUD OF ARROWS.
...R.W. EMERSON (1847)

deboudoule PULPHOPE - NAPOLEON III: 5 12-05 NYC

THOSE
FOR WHOM THE TAXES
ARE DESTINED
DEMAND SACRAFICE...
THOSE
WHO LEAD THE COUNTRY
INTO THE ABYSS
CALL RULING TOO DIFFICULT
FOR ORDINARY
MEN. BRECHT 9/2005

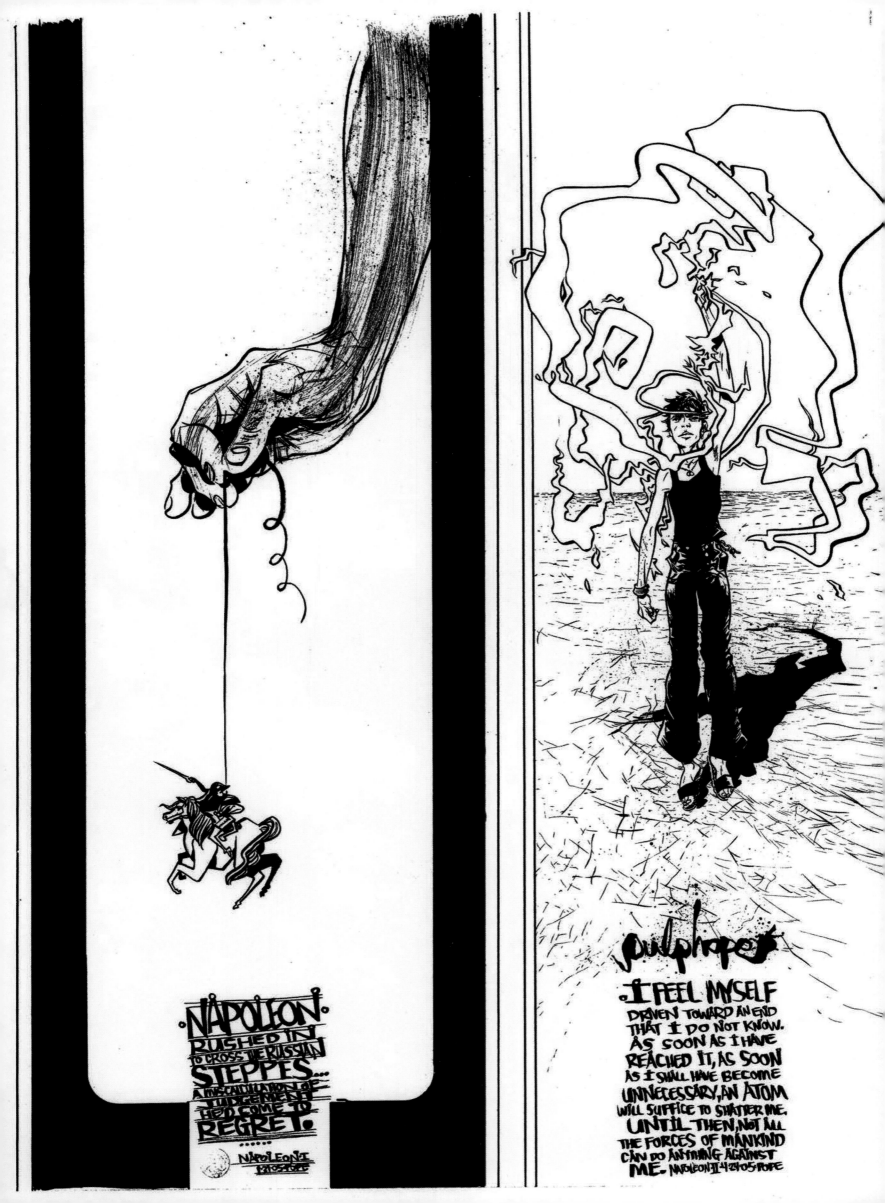

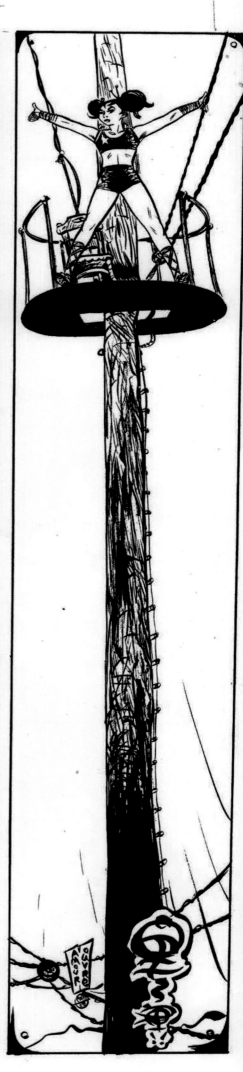

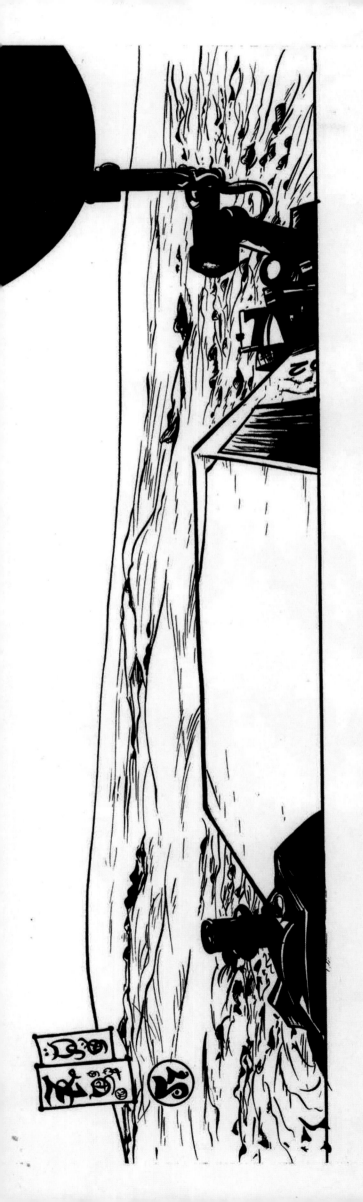

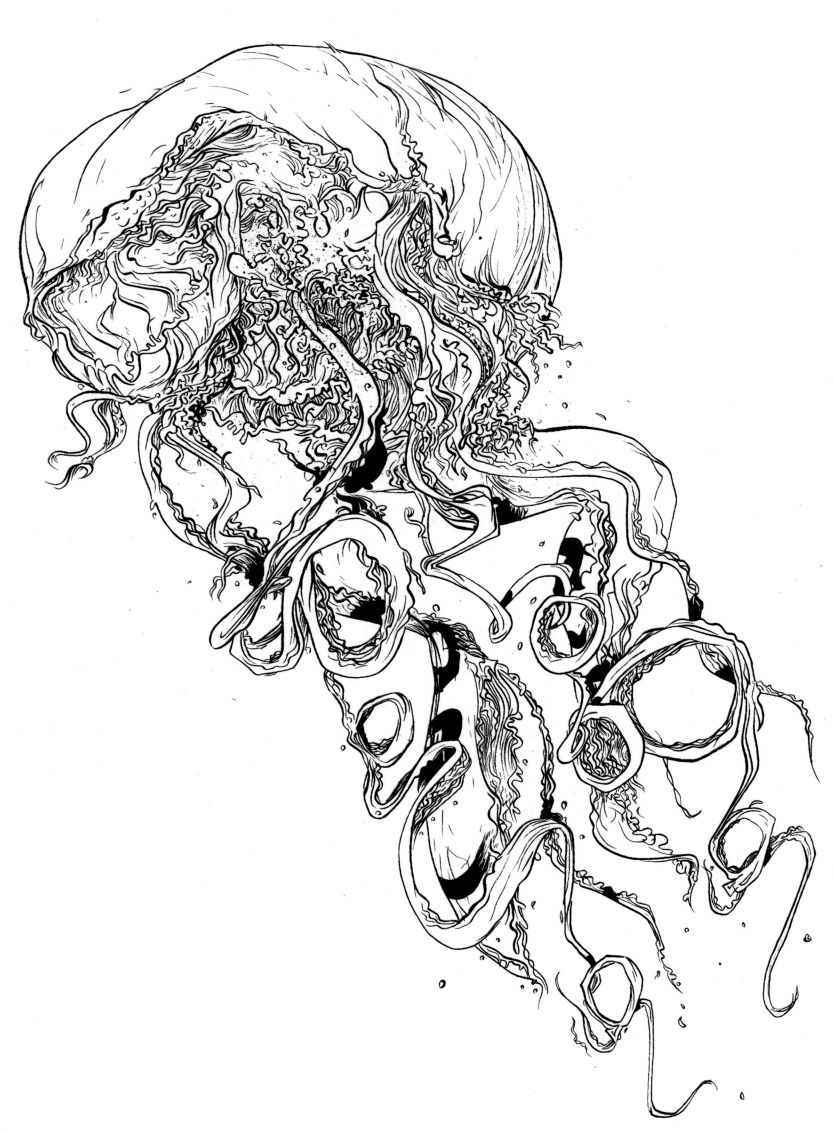

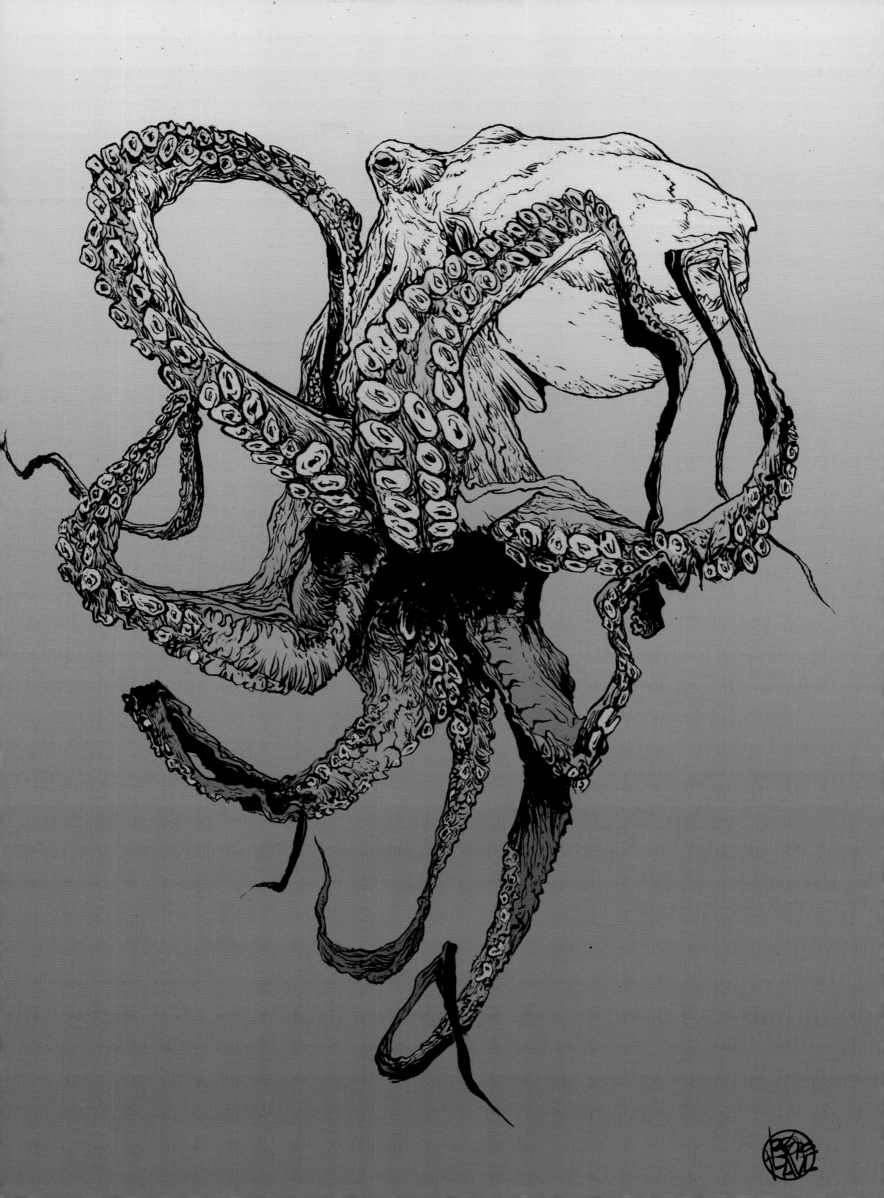

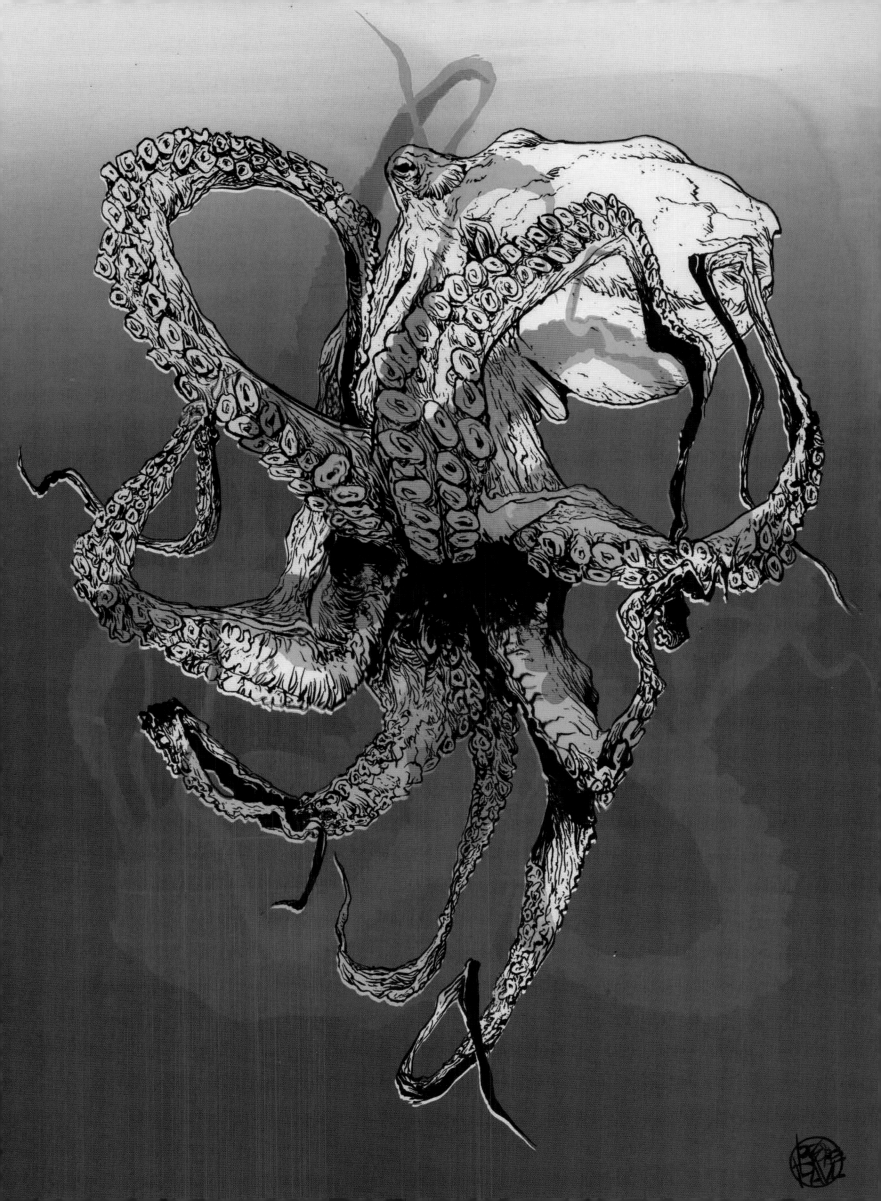

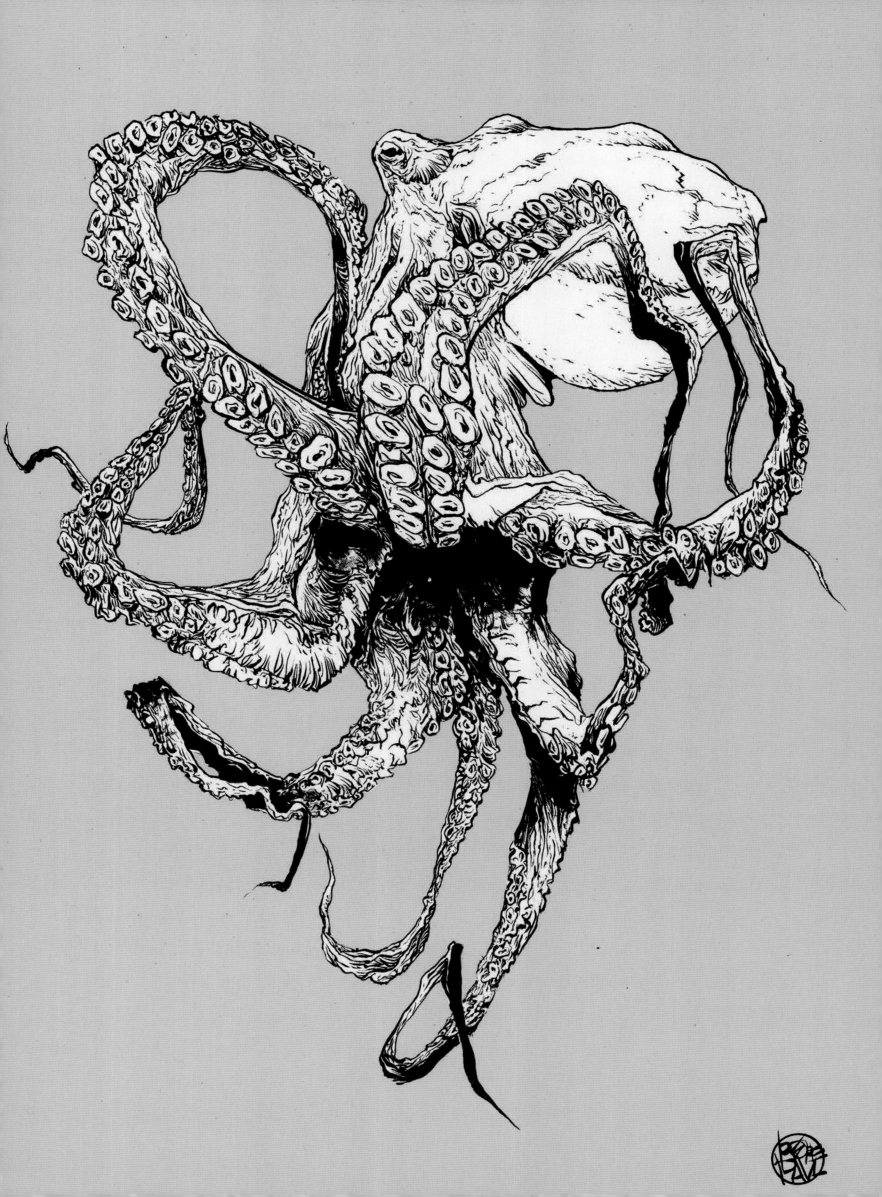

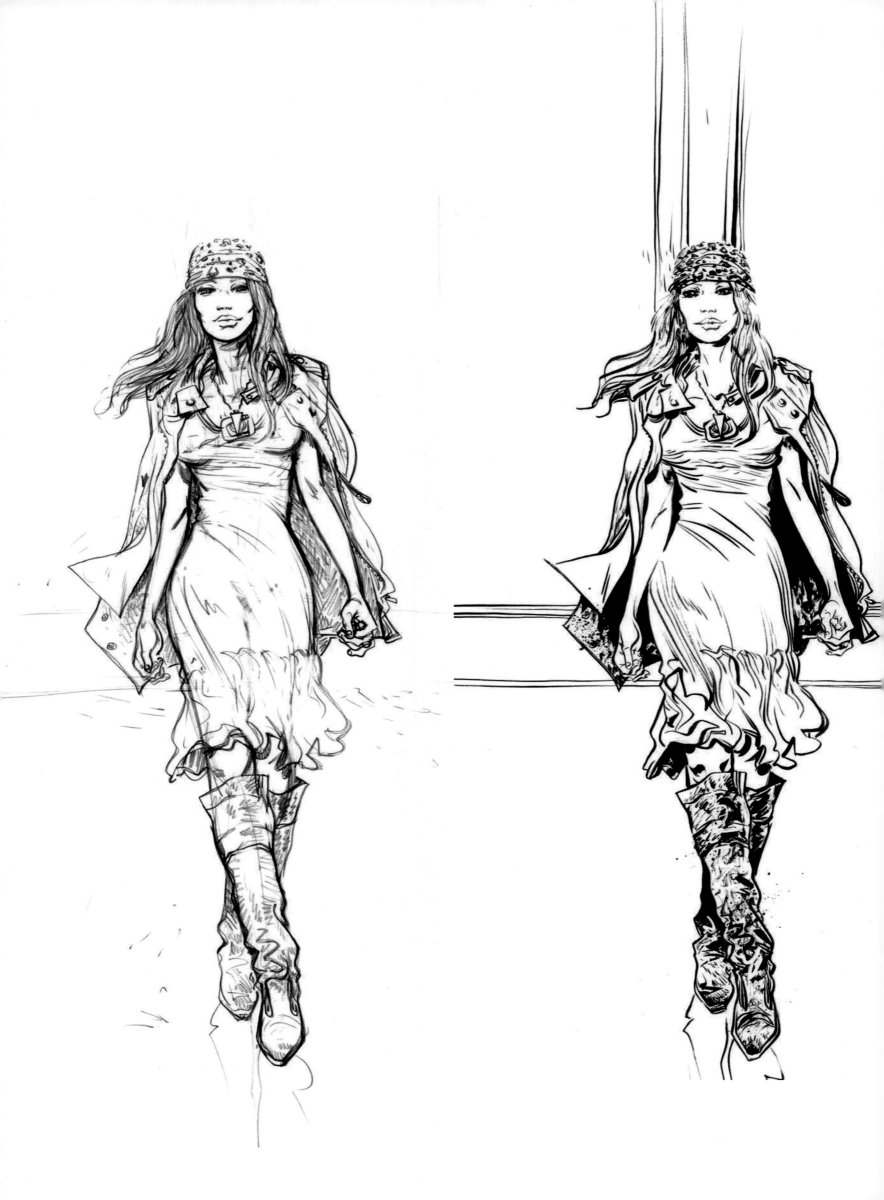

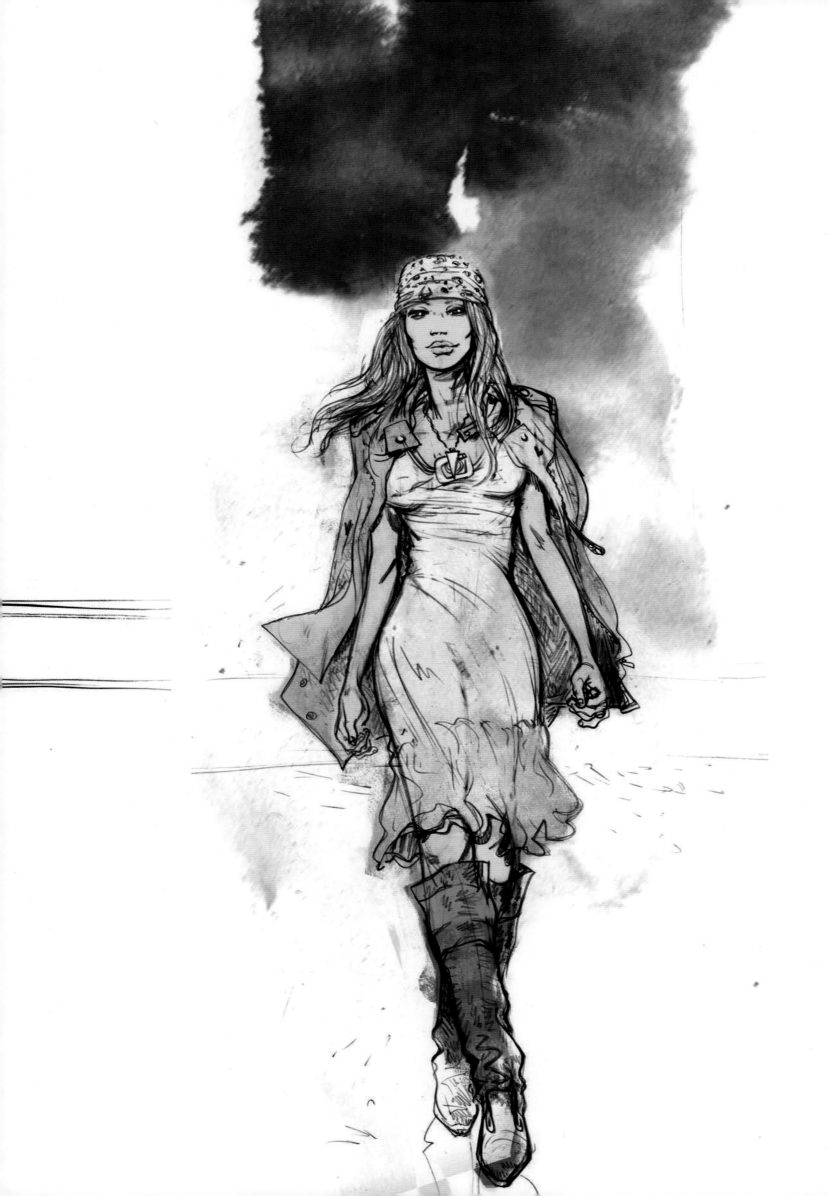

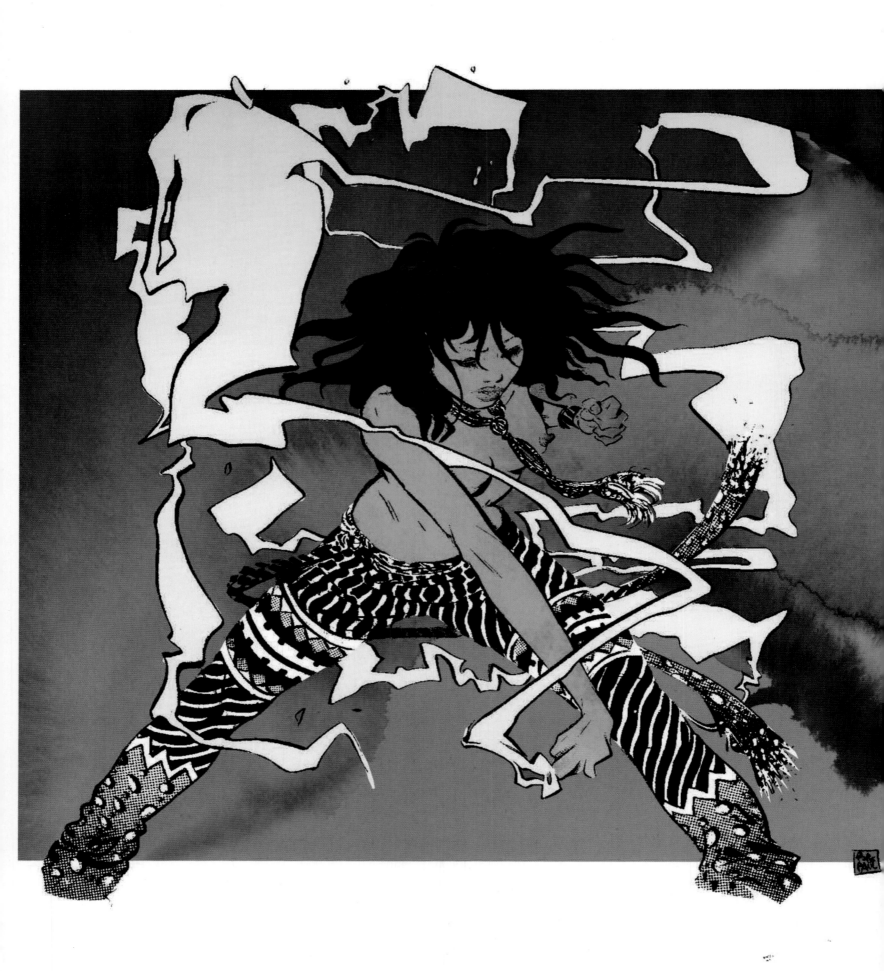

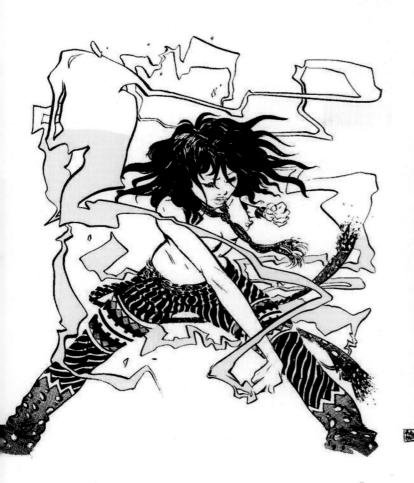

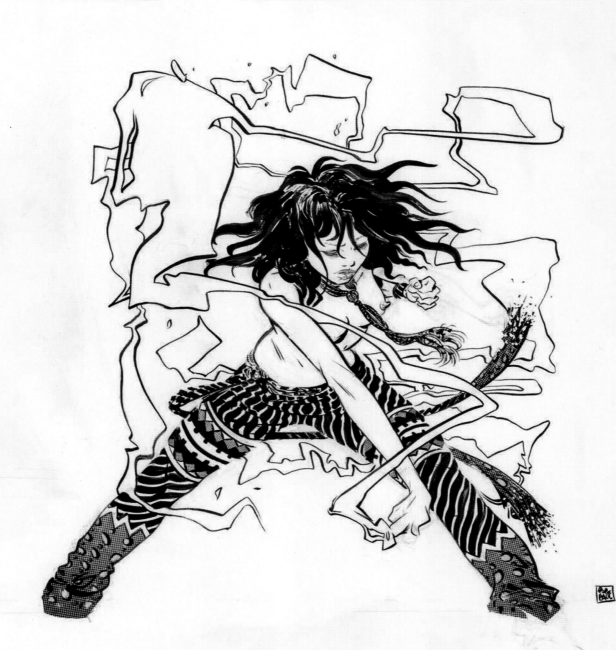

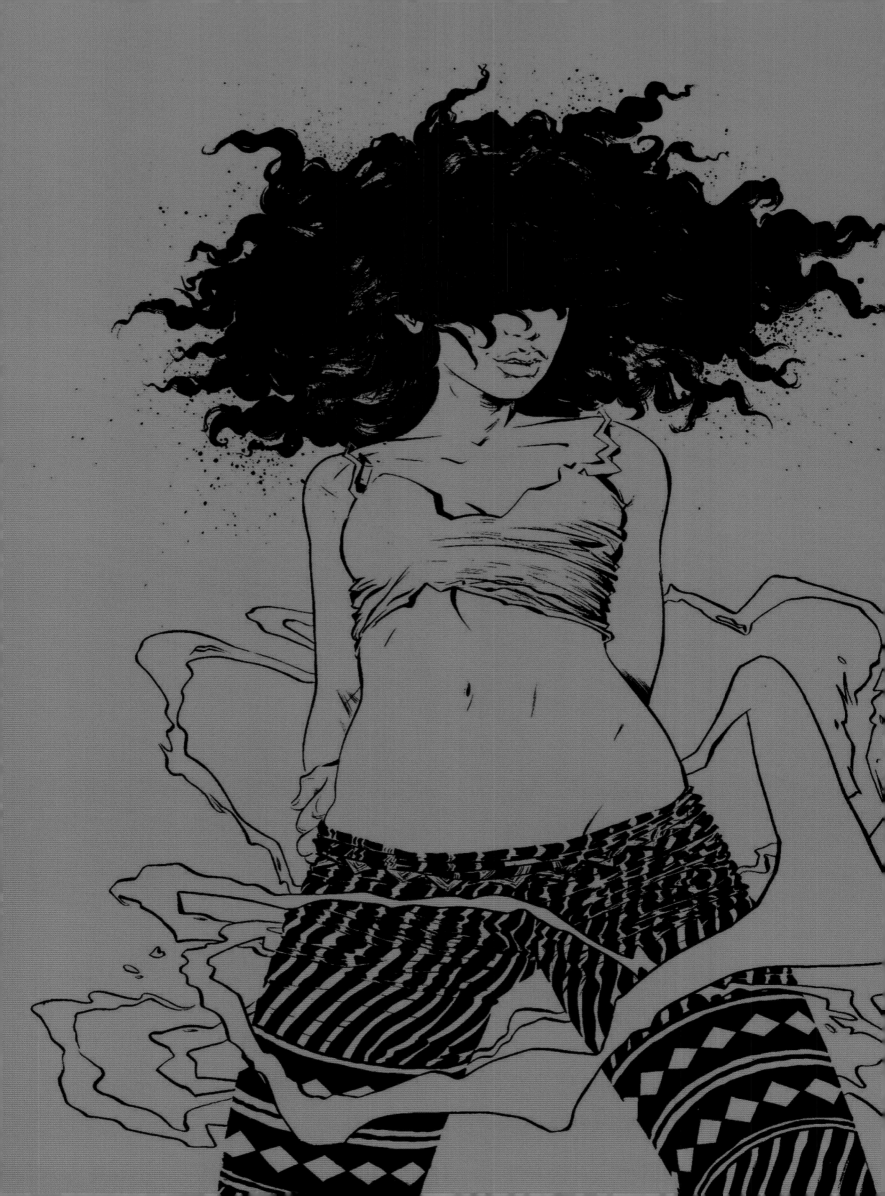

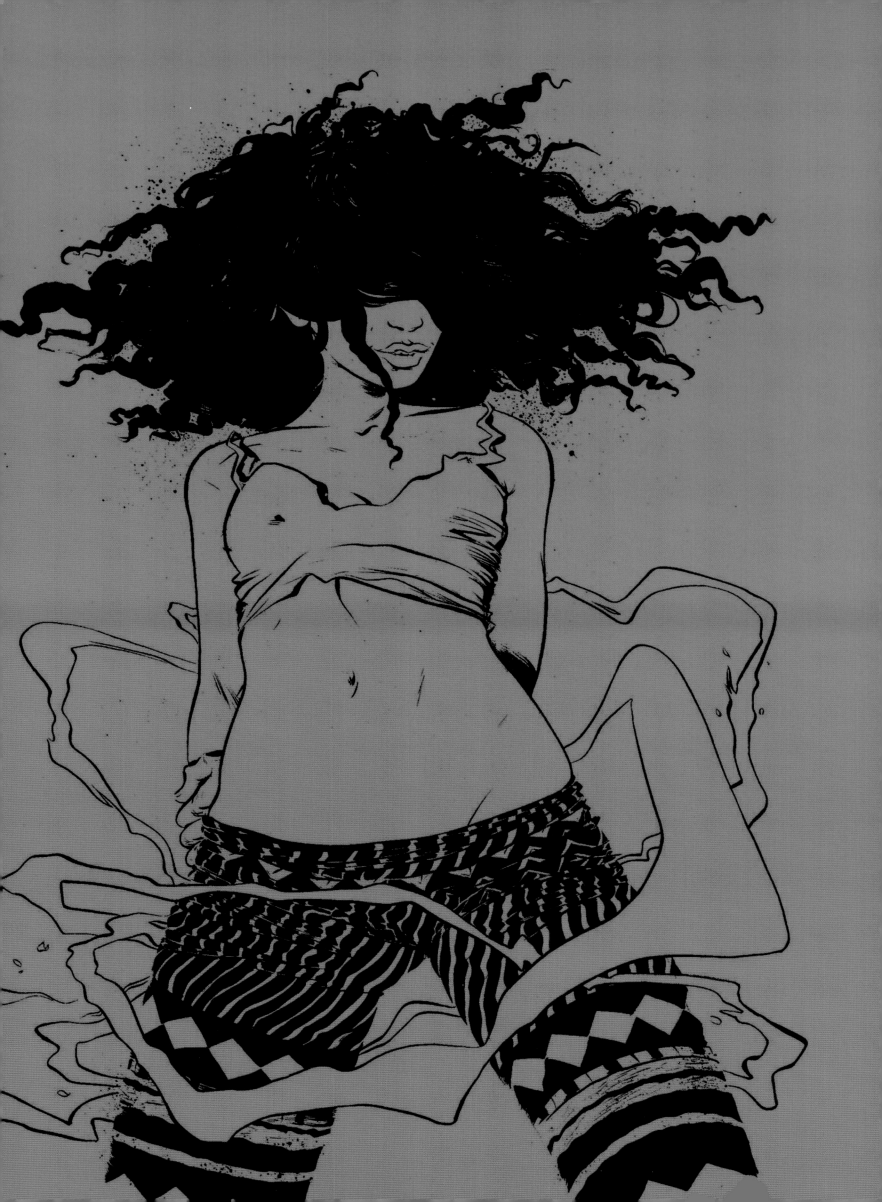

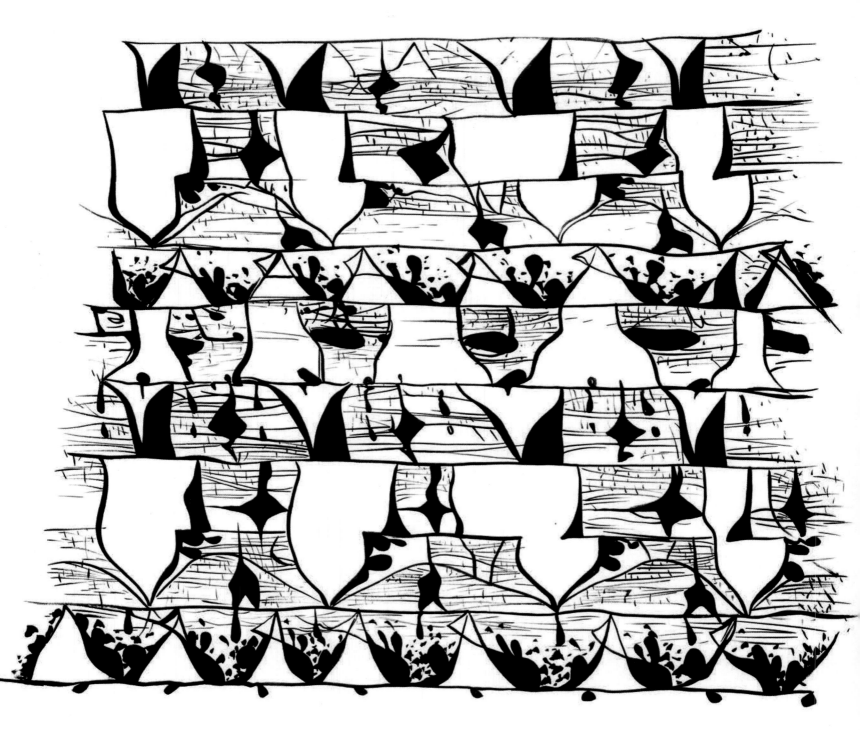

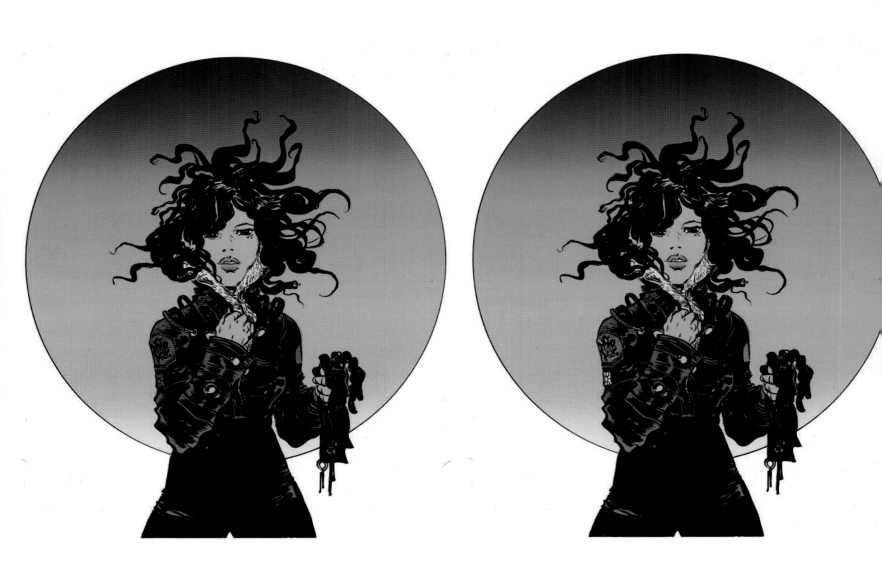

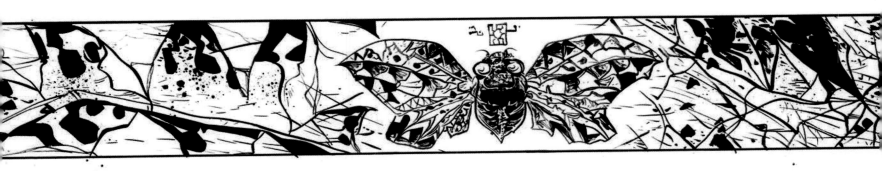

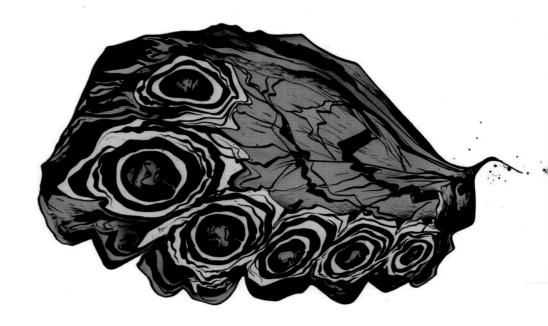

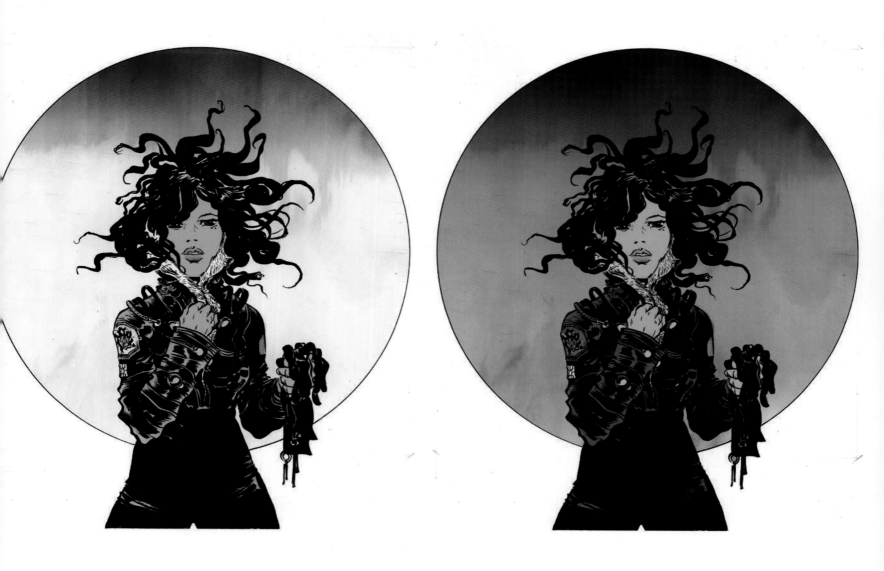

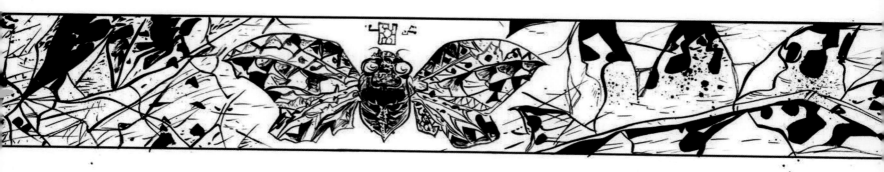

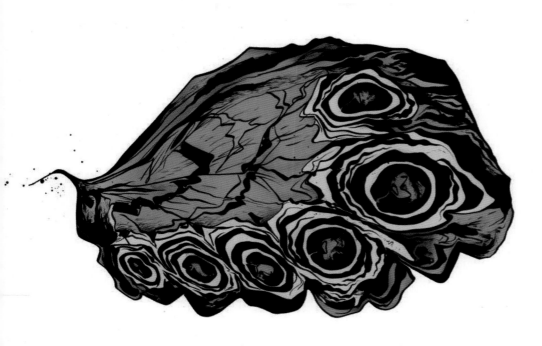

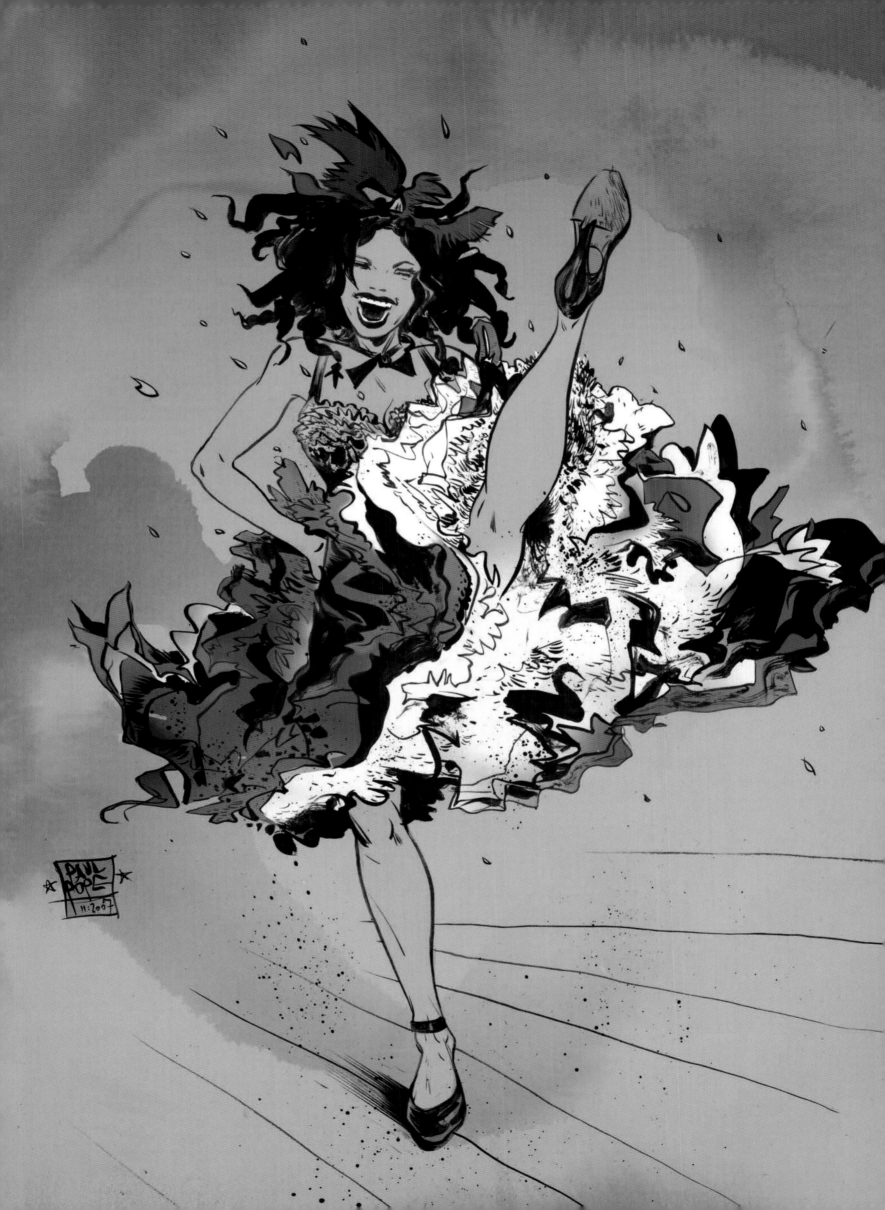

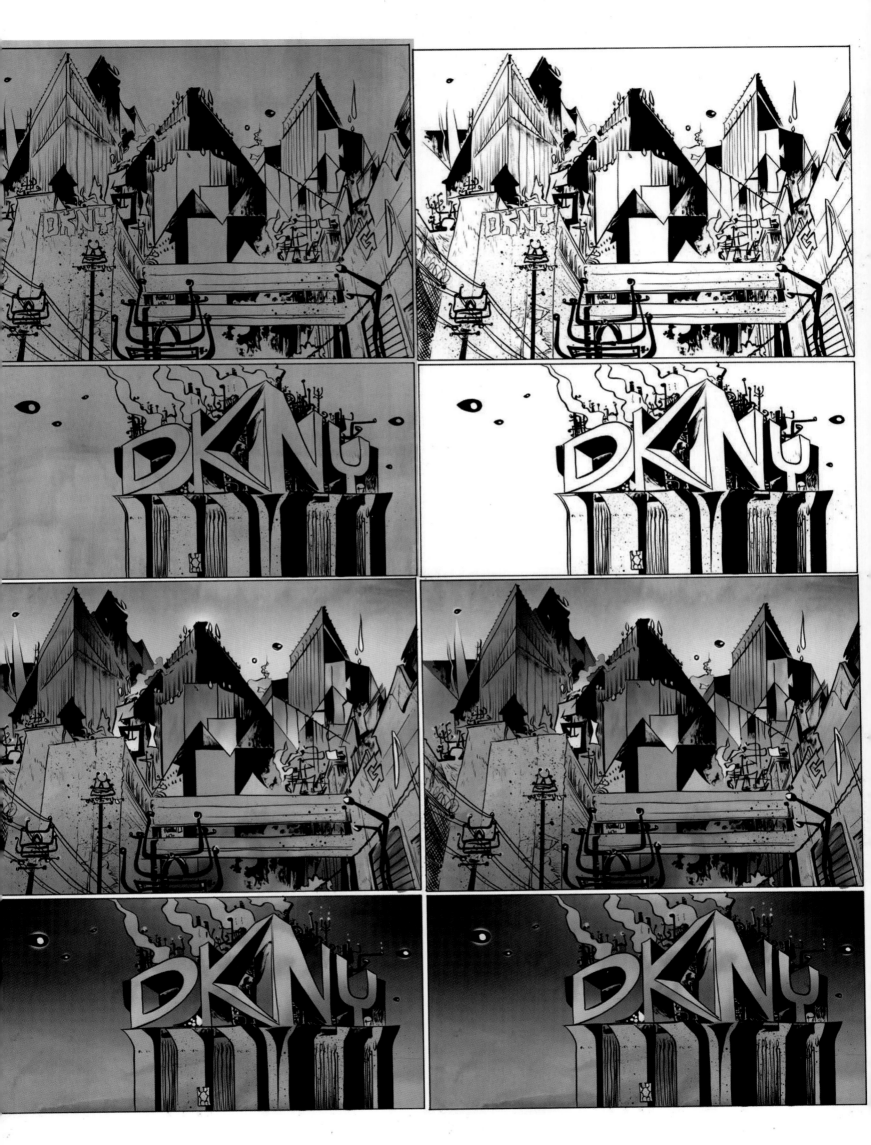

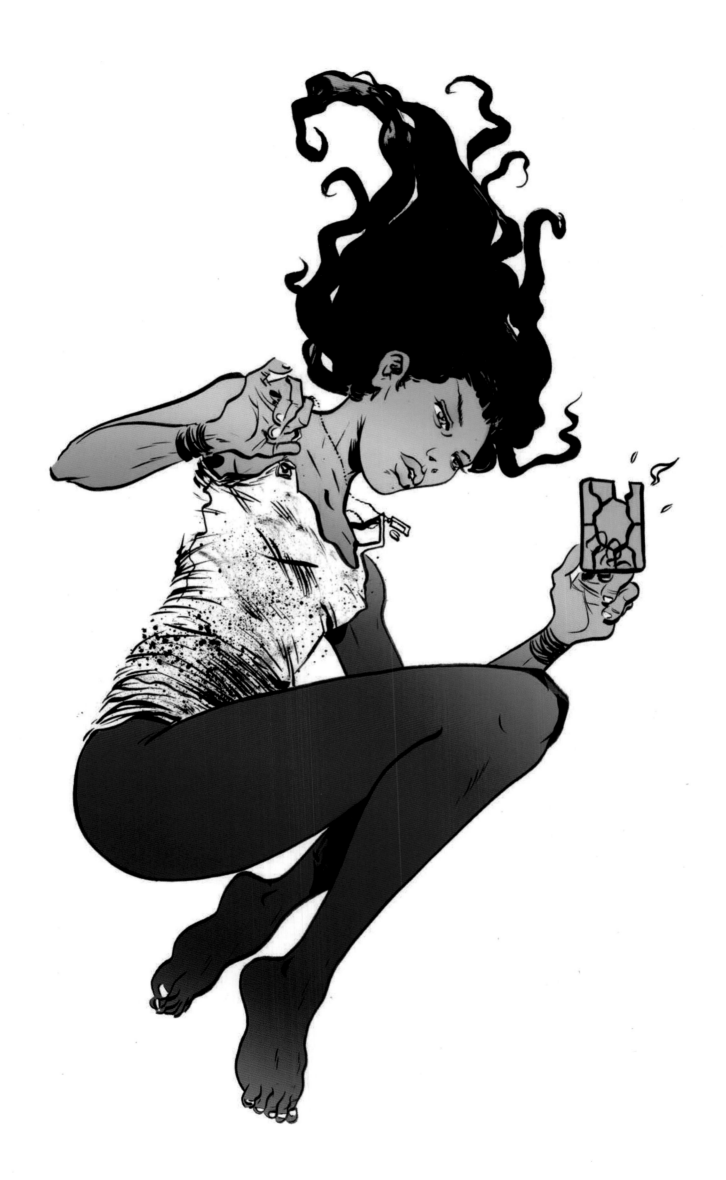

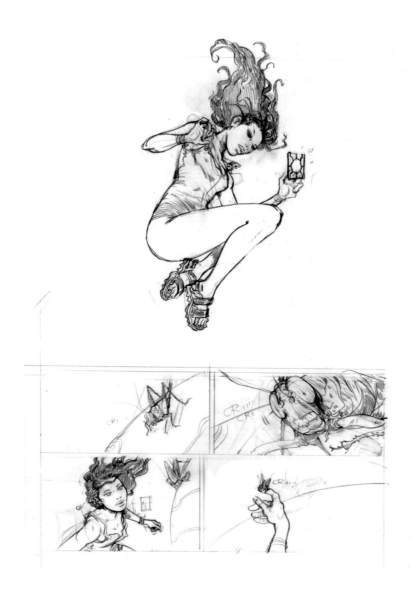
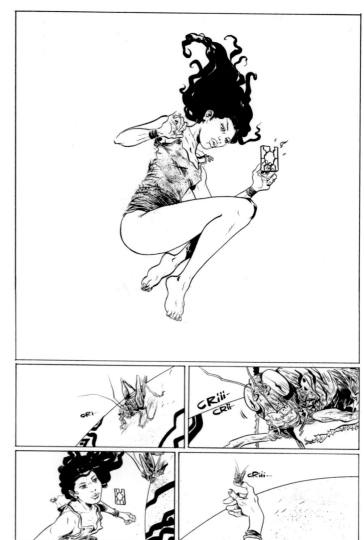
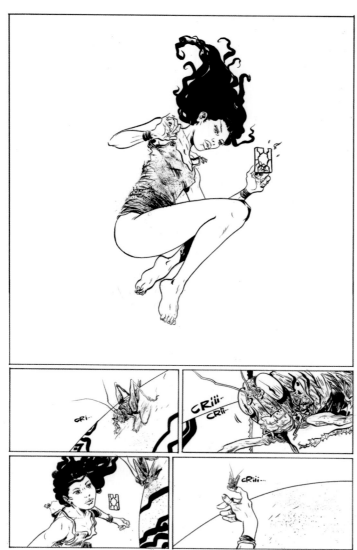
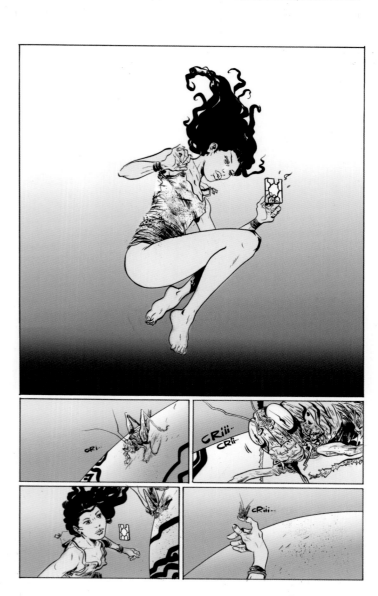

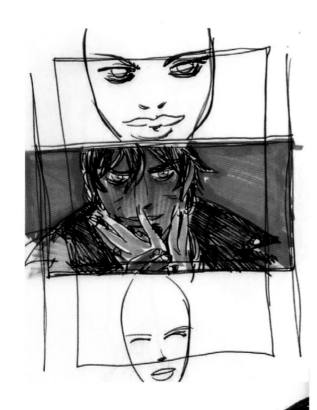

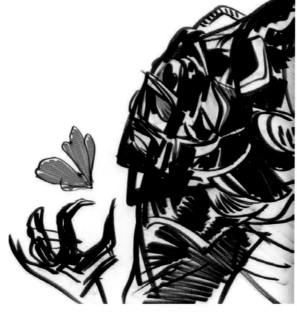

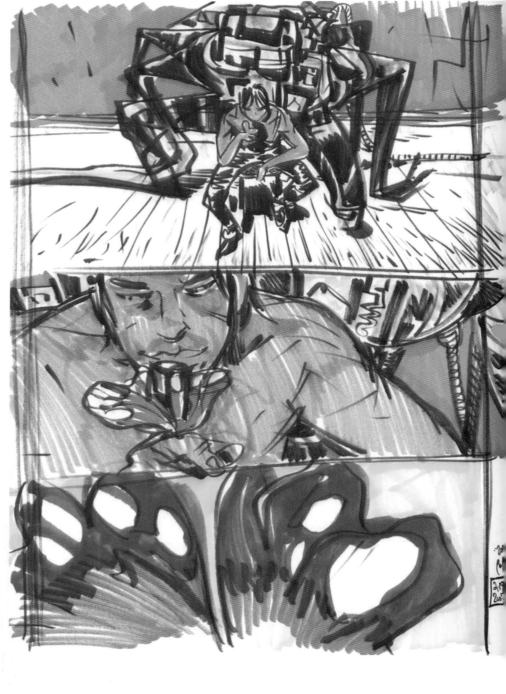

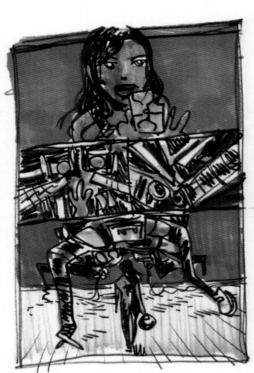

GIRL "TURNING ON"
HER SUPERMEK

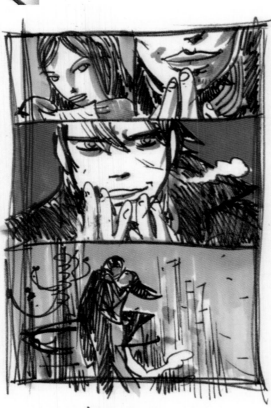

KISSING

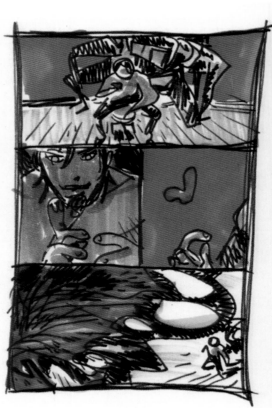

MAN w/ BUTTERFLY
PSYCHEMEK

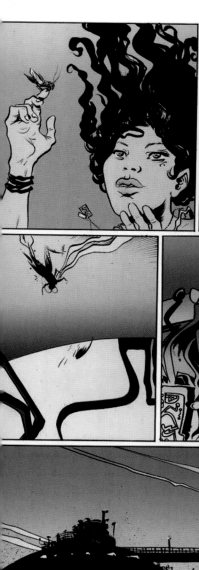

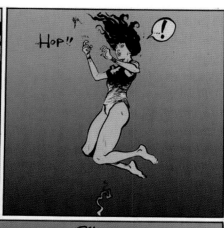

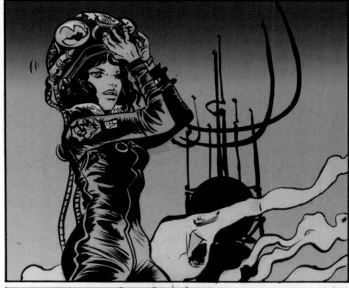
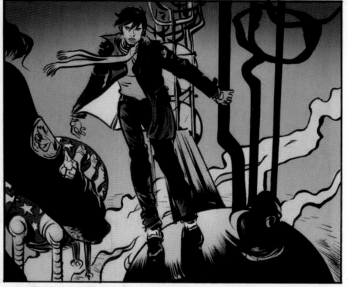
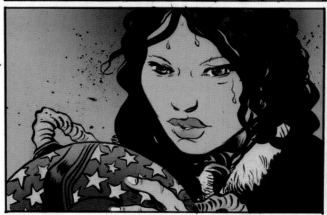
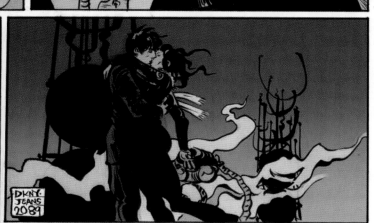

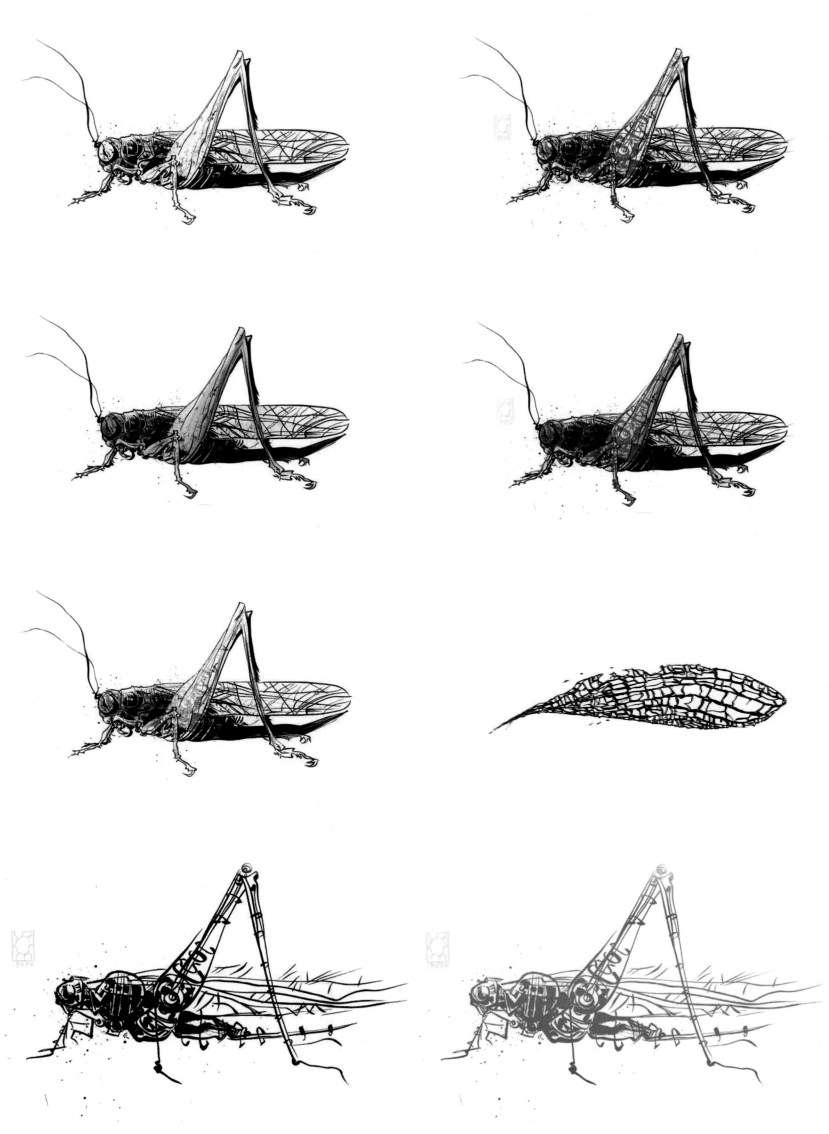

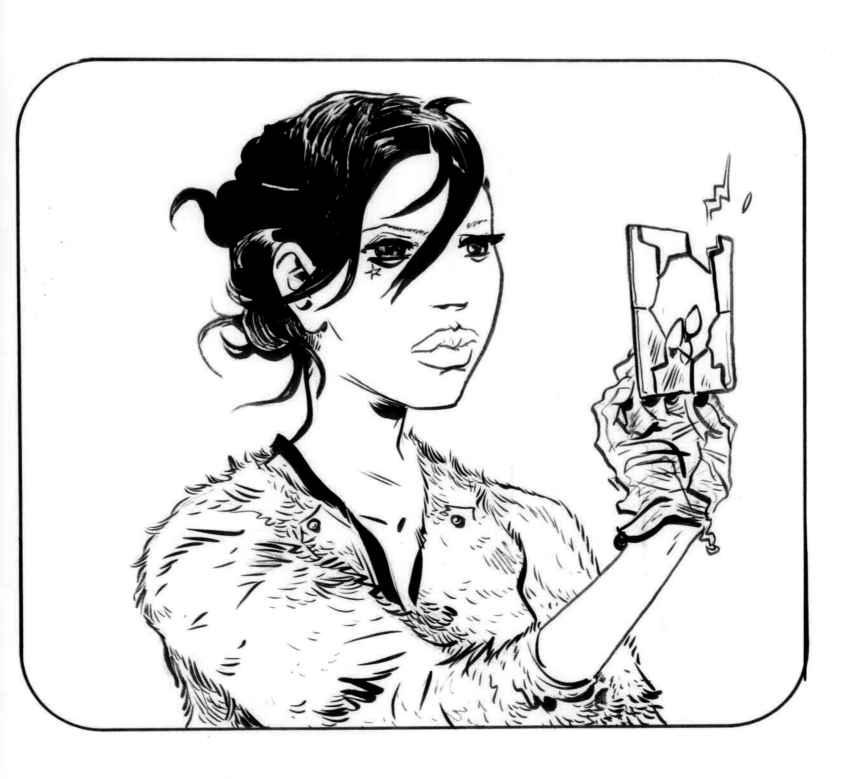

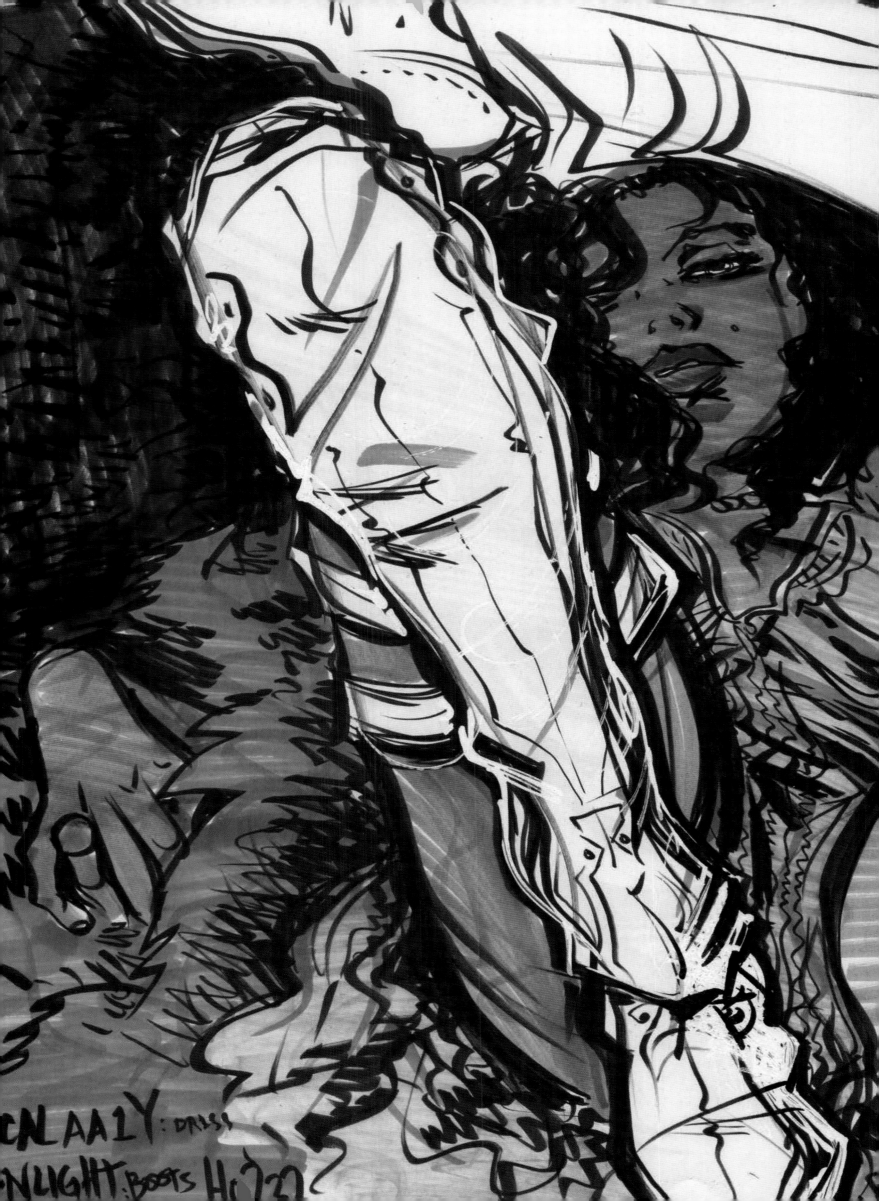

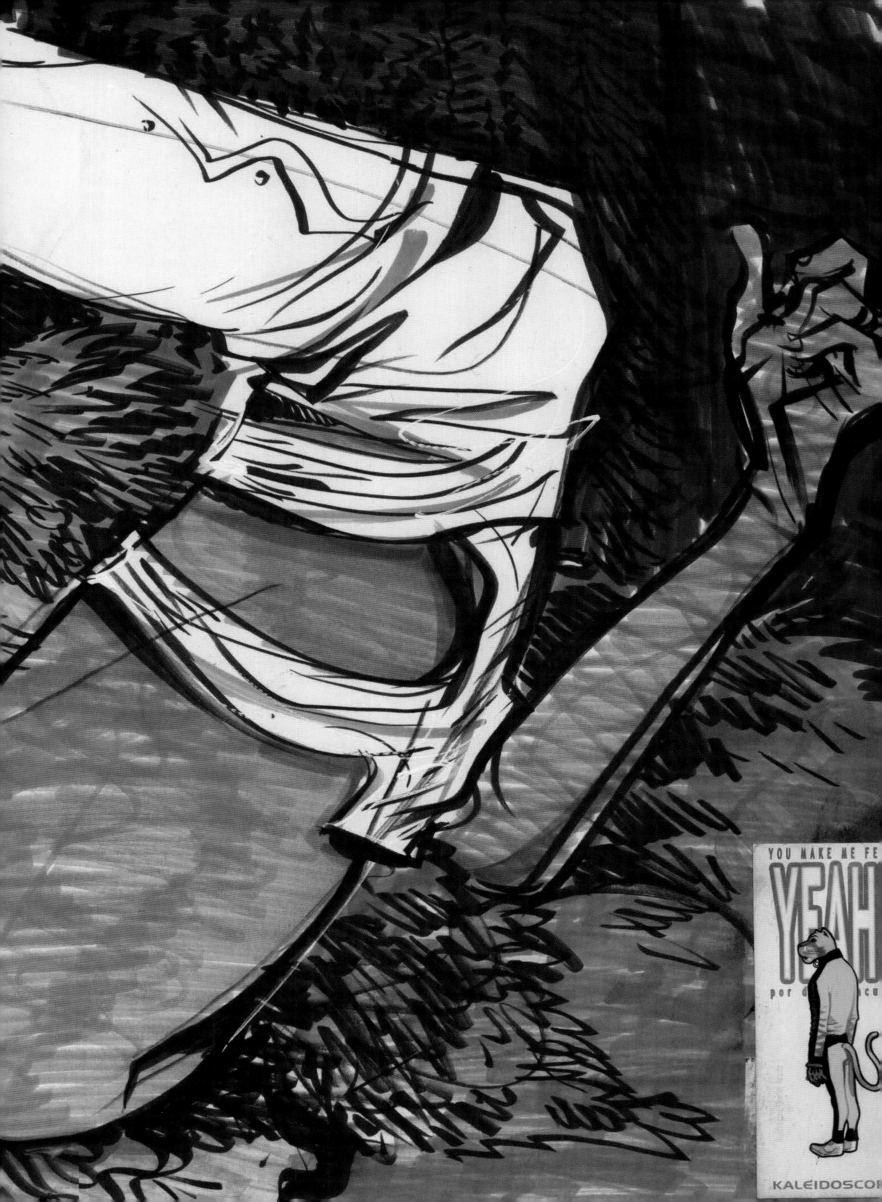

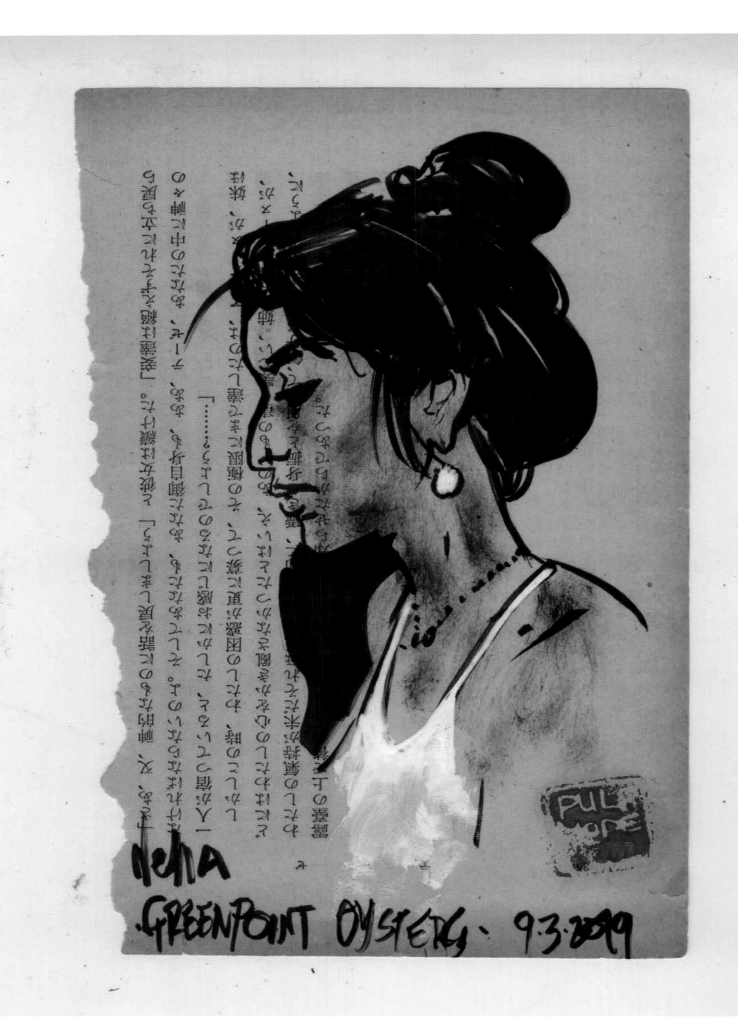

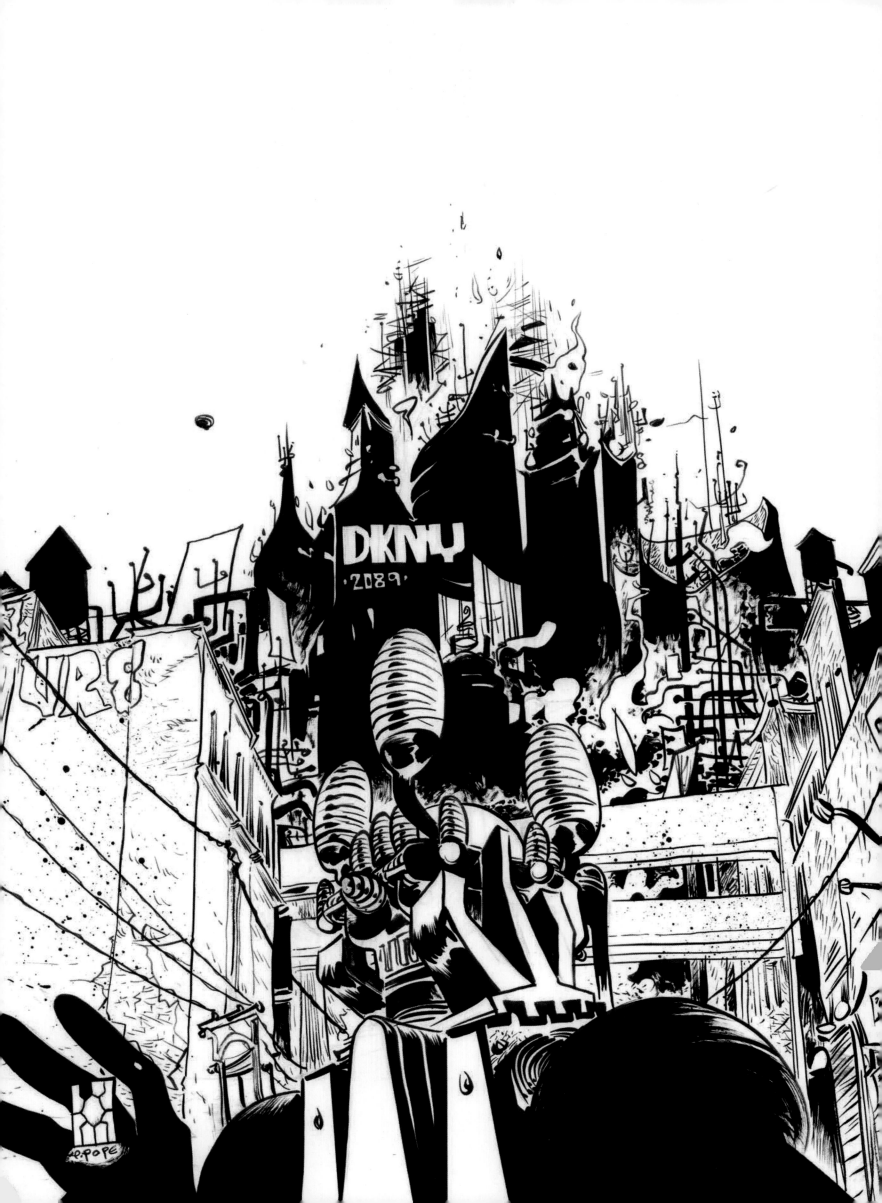

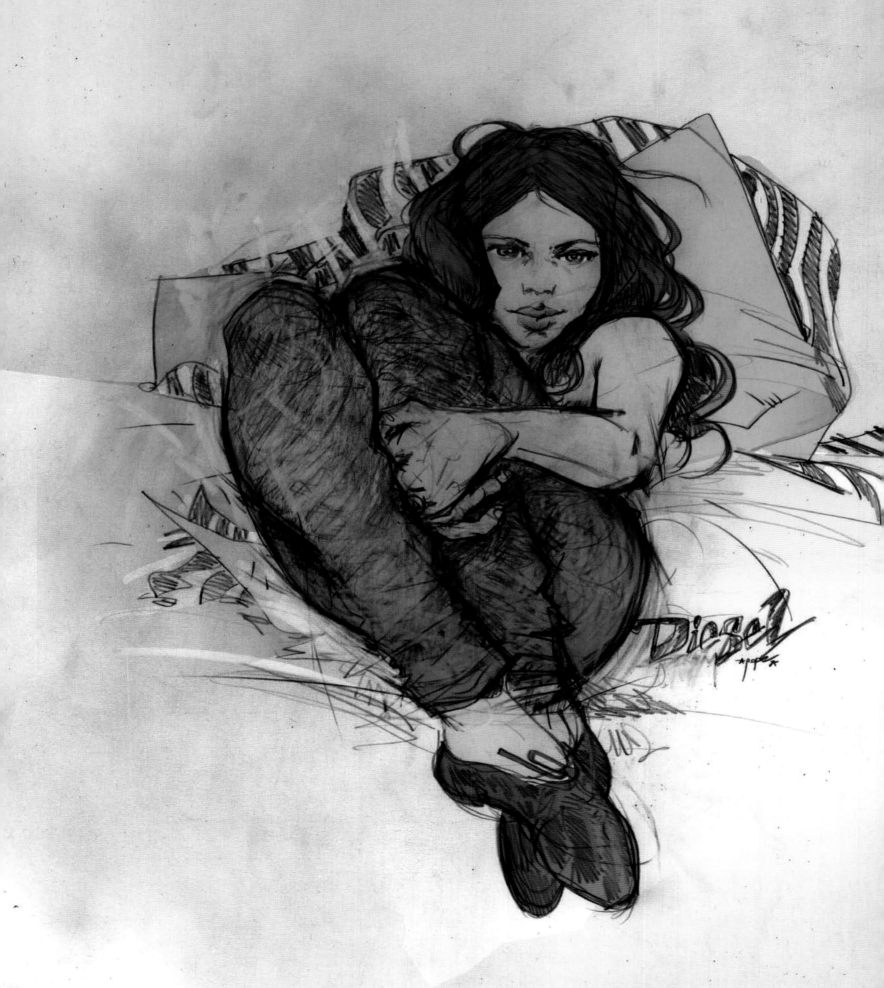

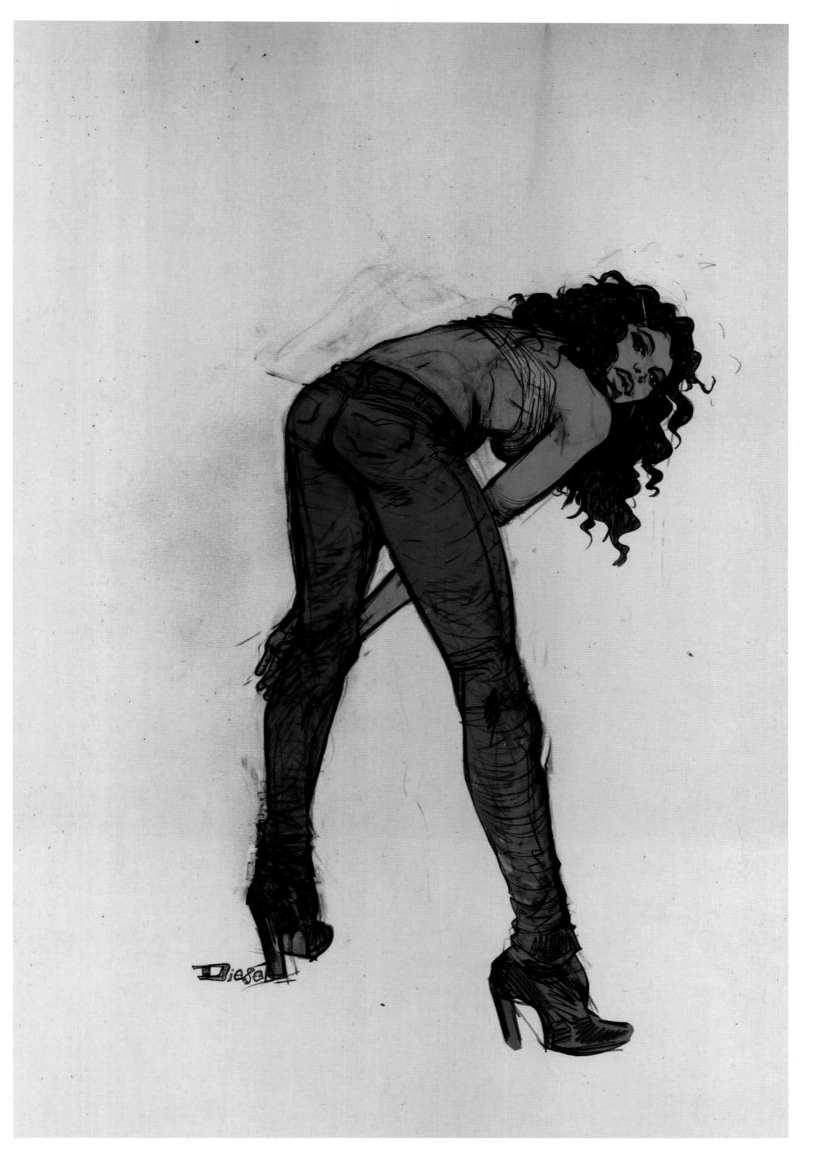

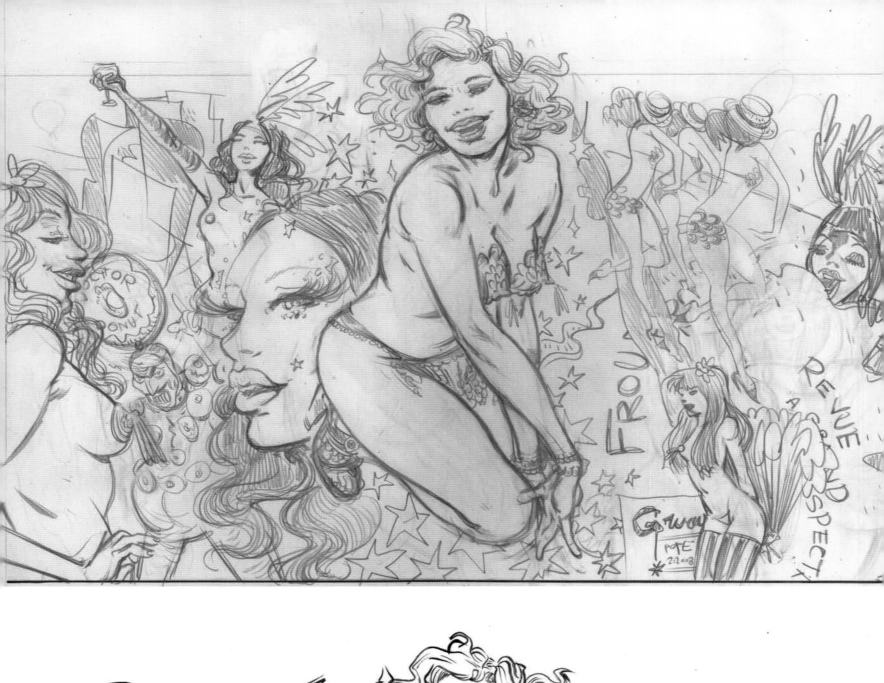

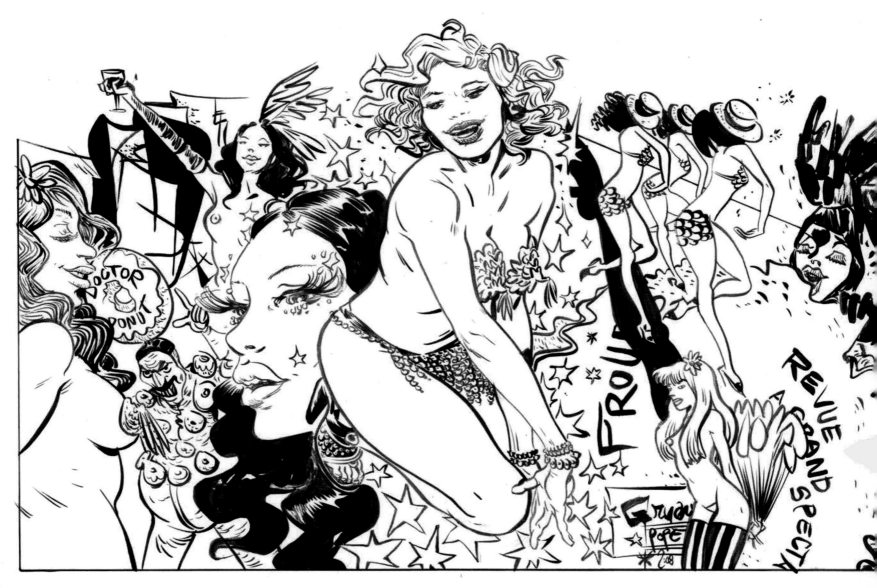

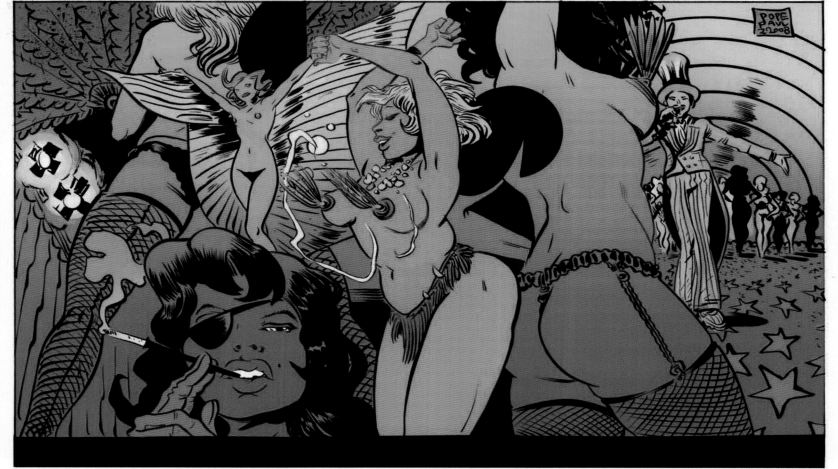

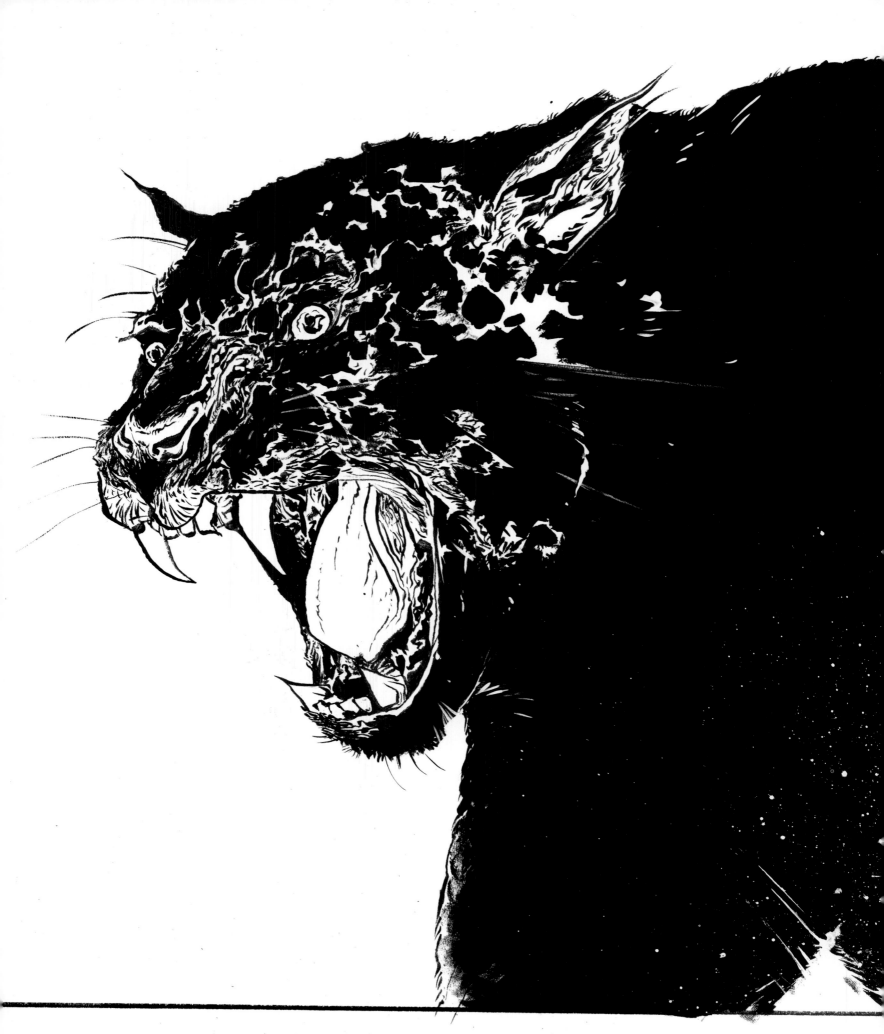

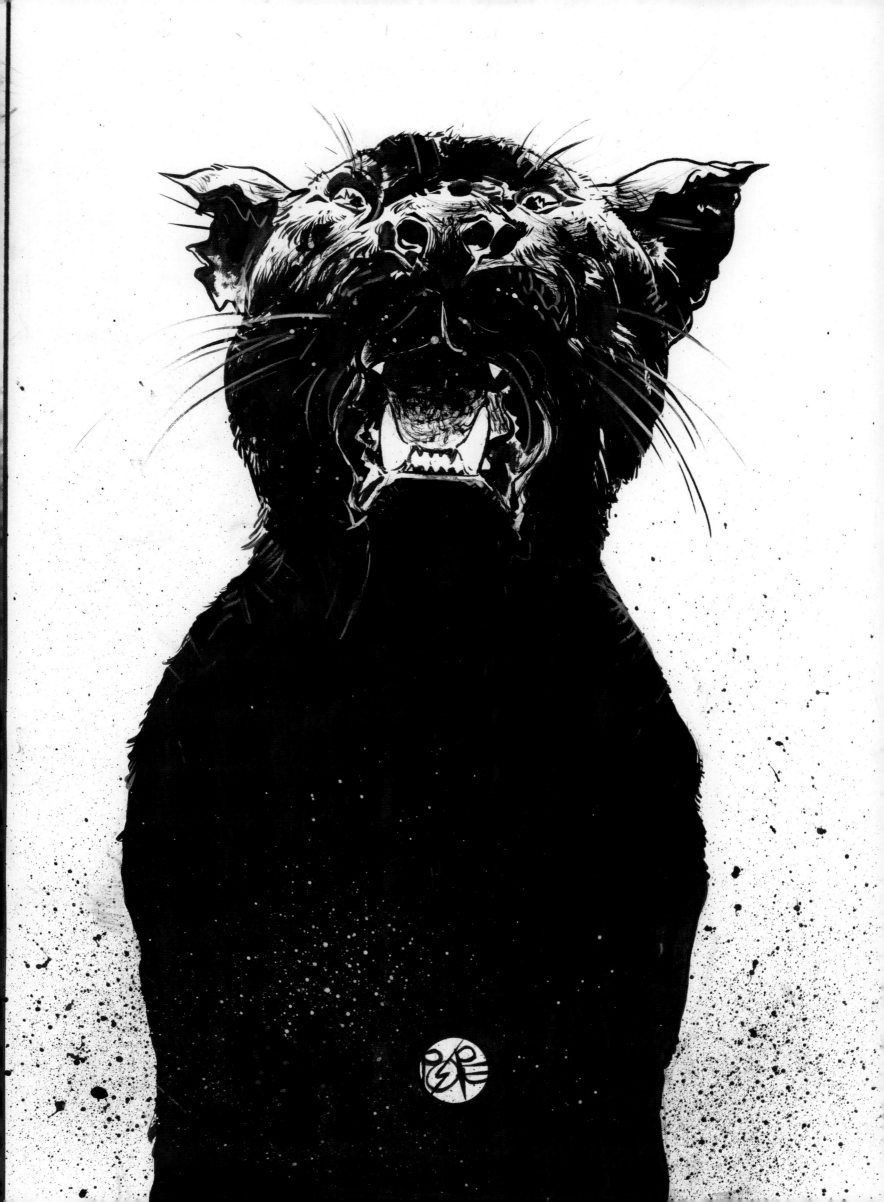

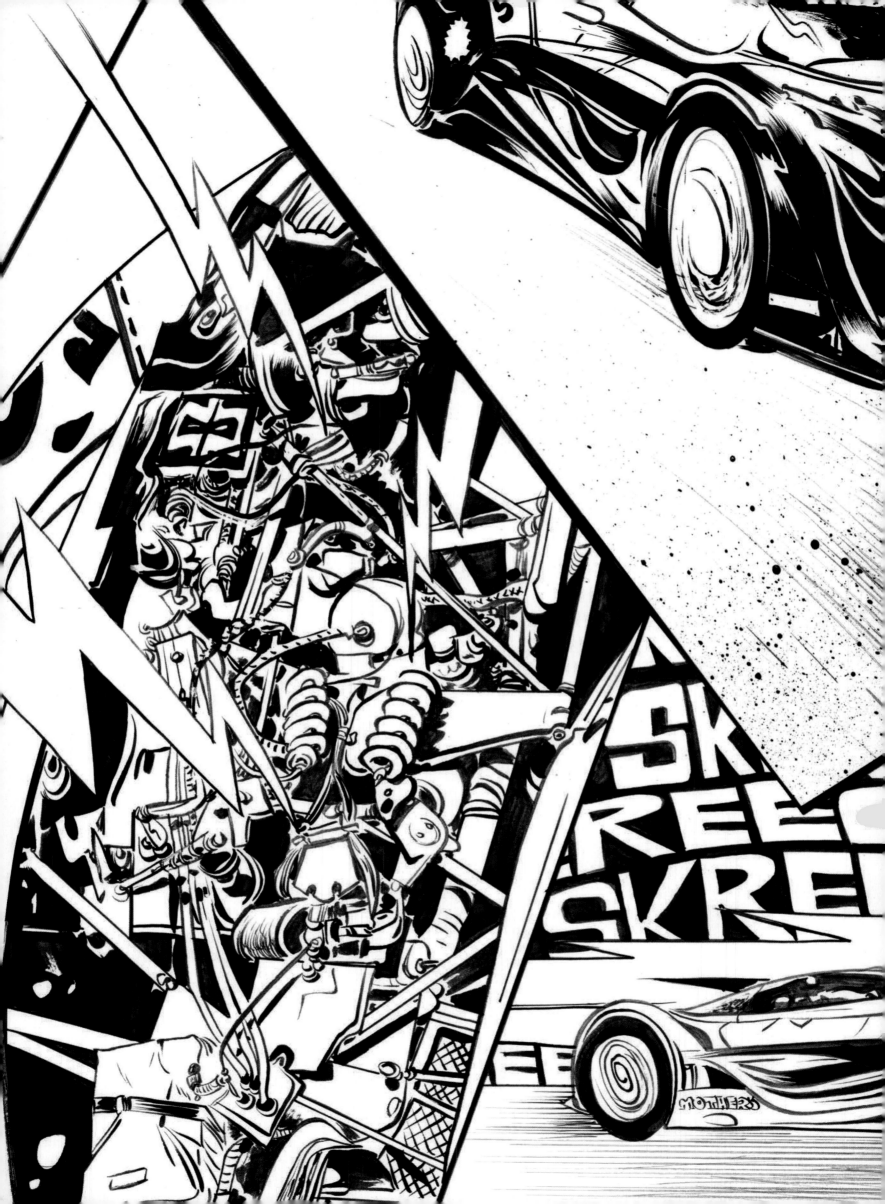

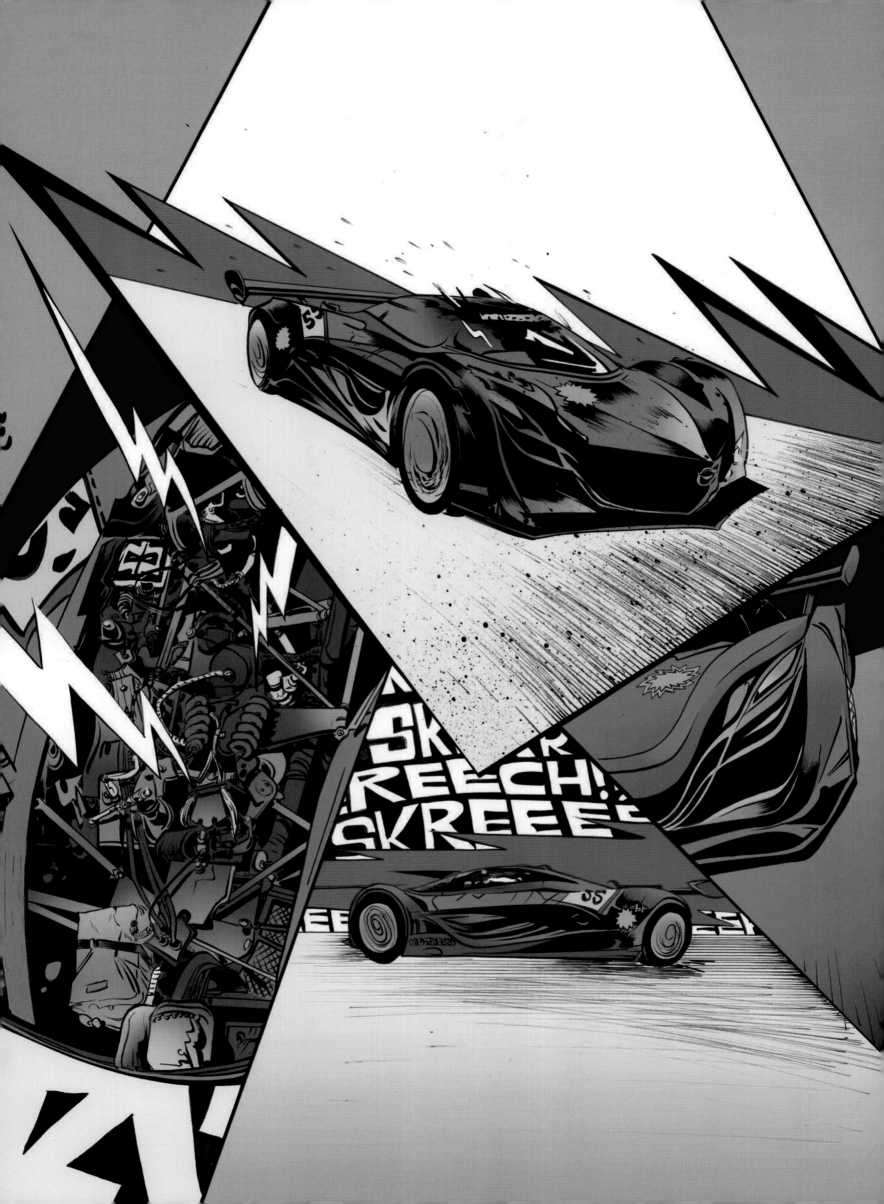

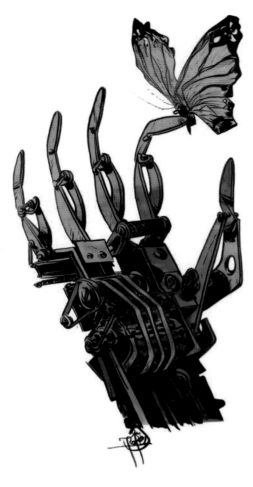

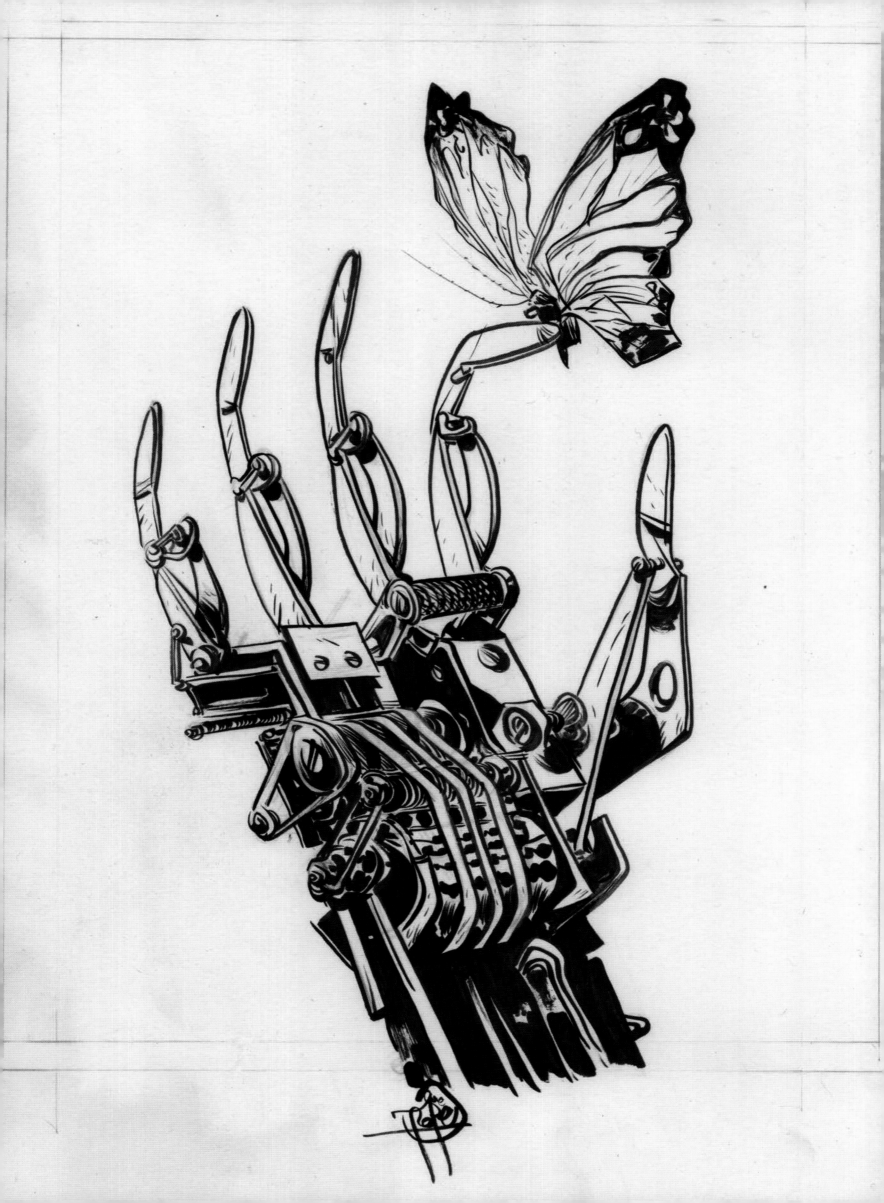

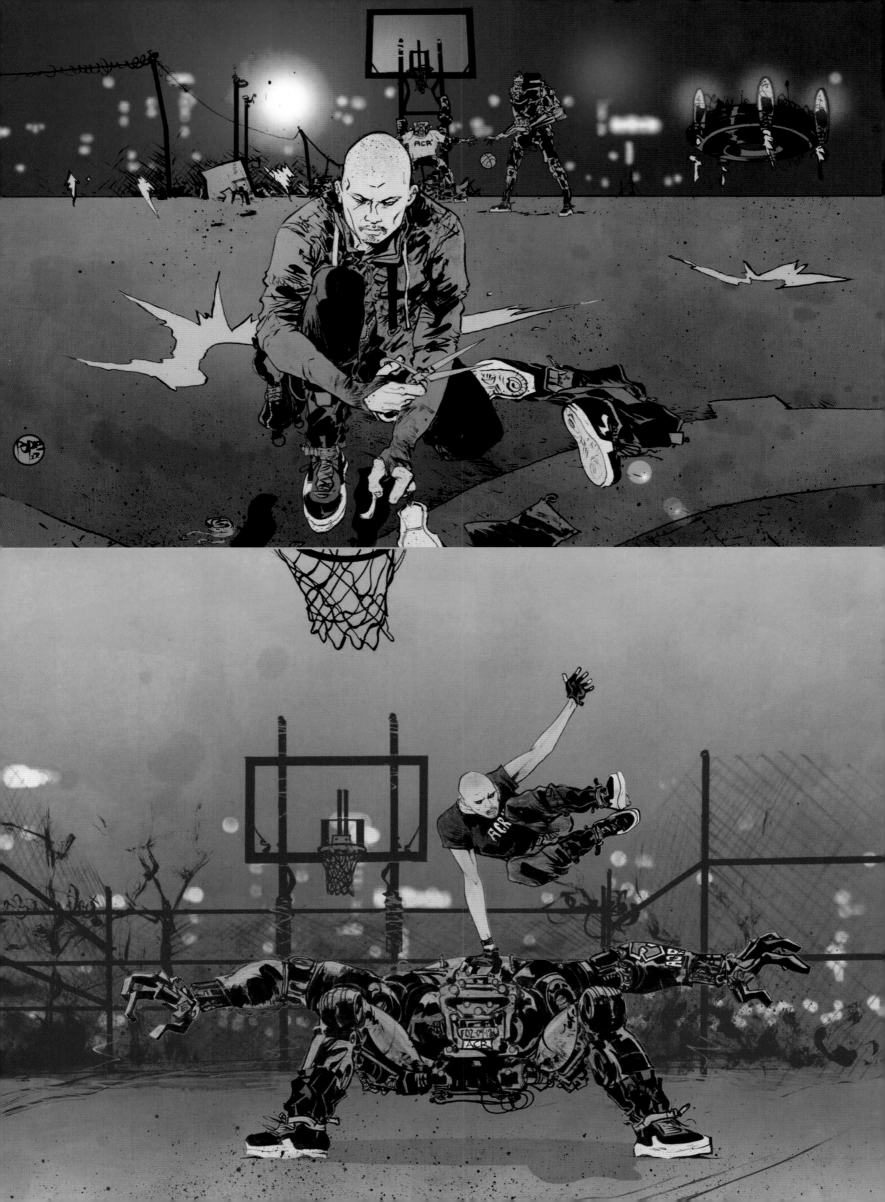

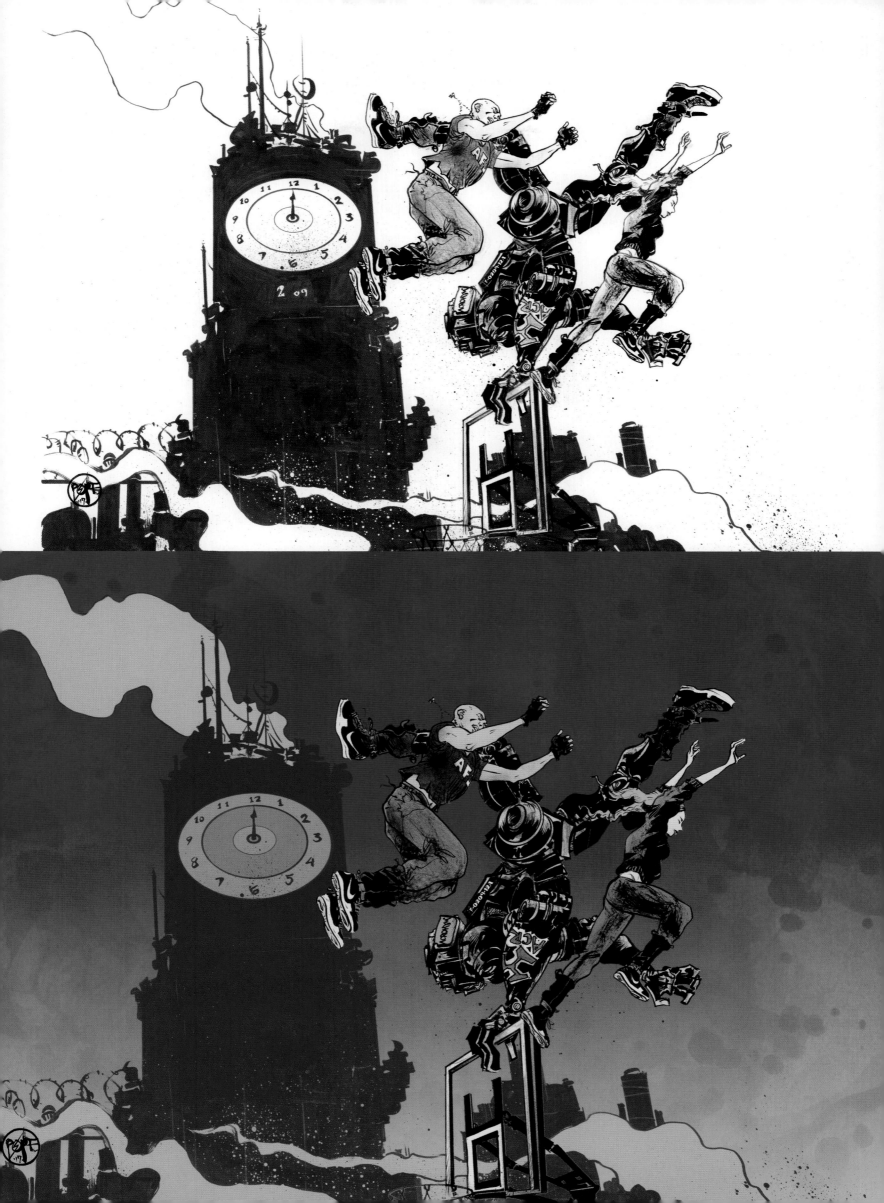

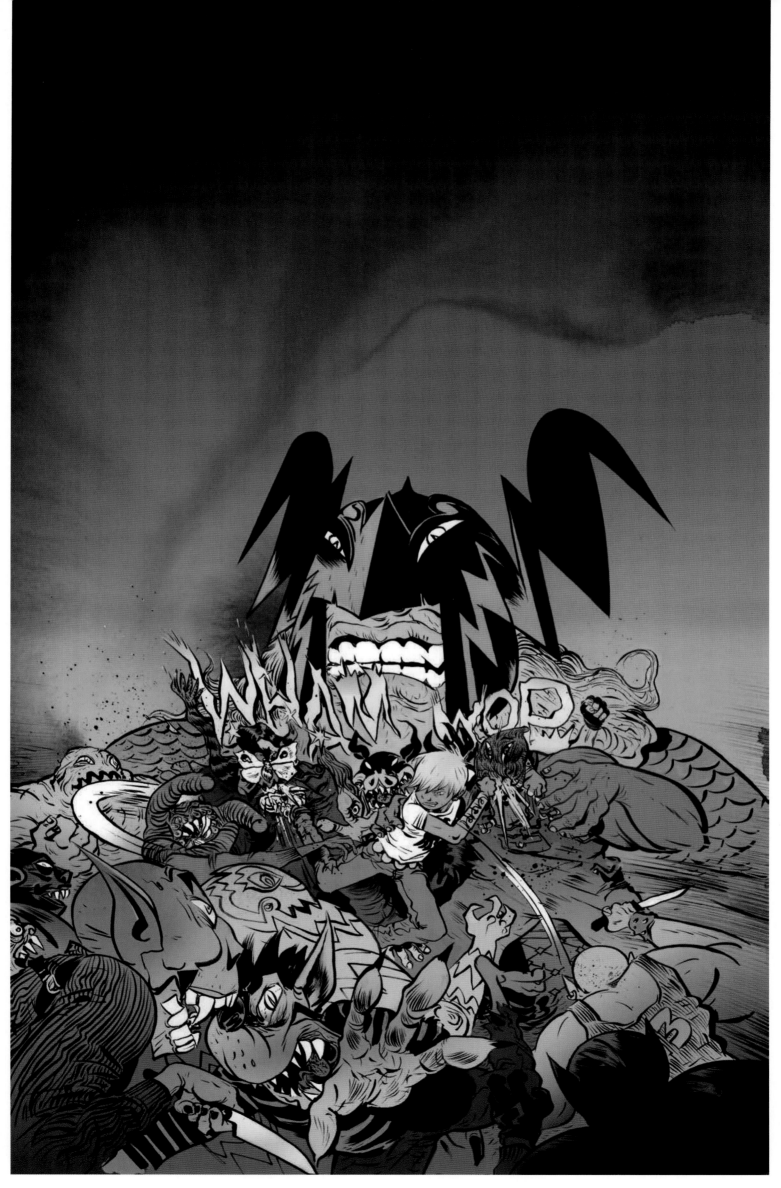

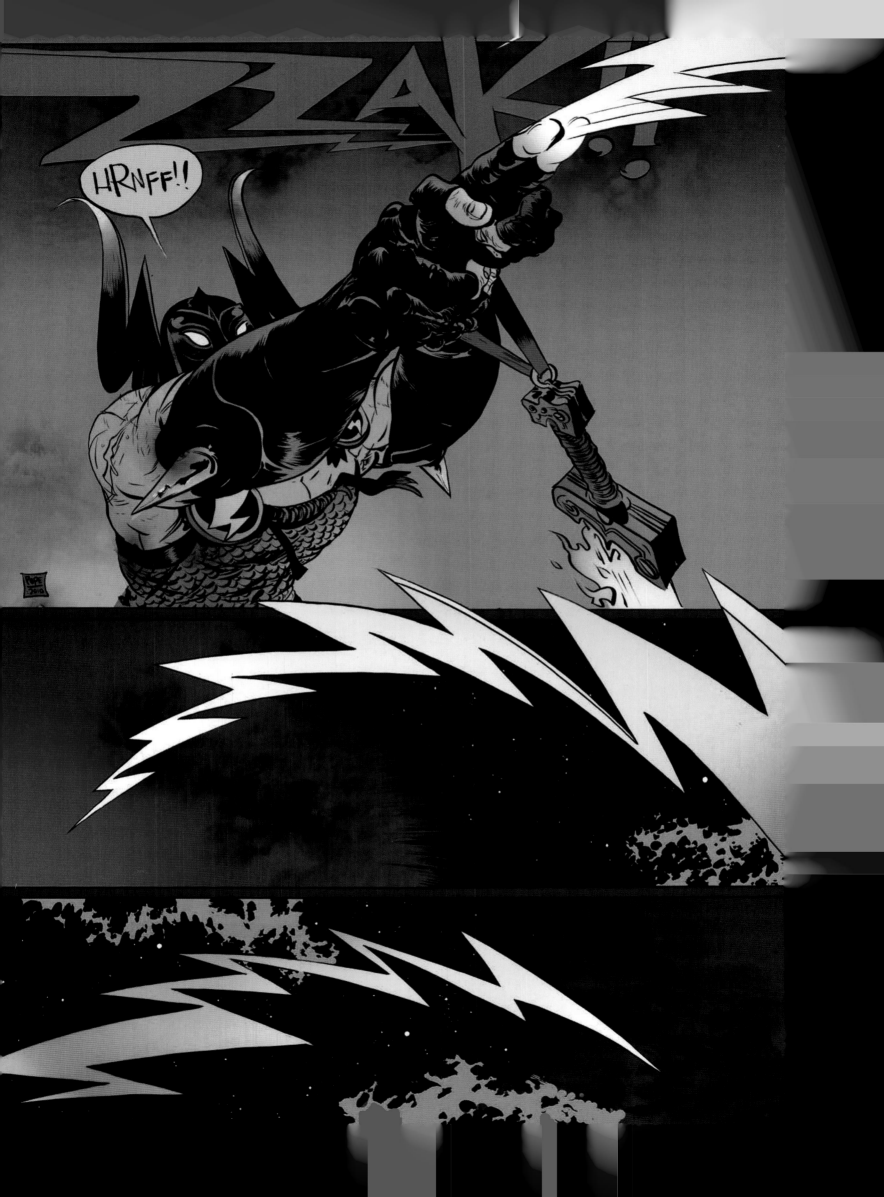

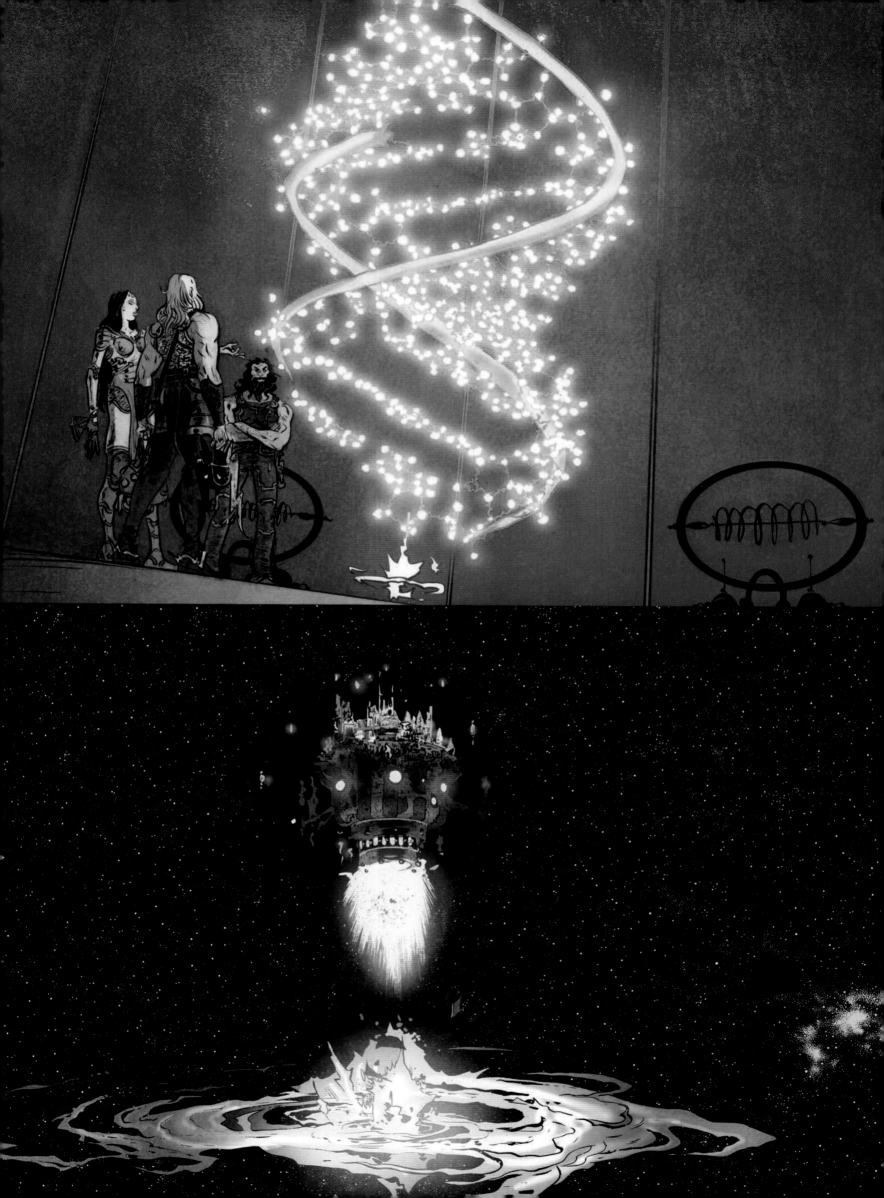

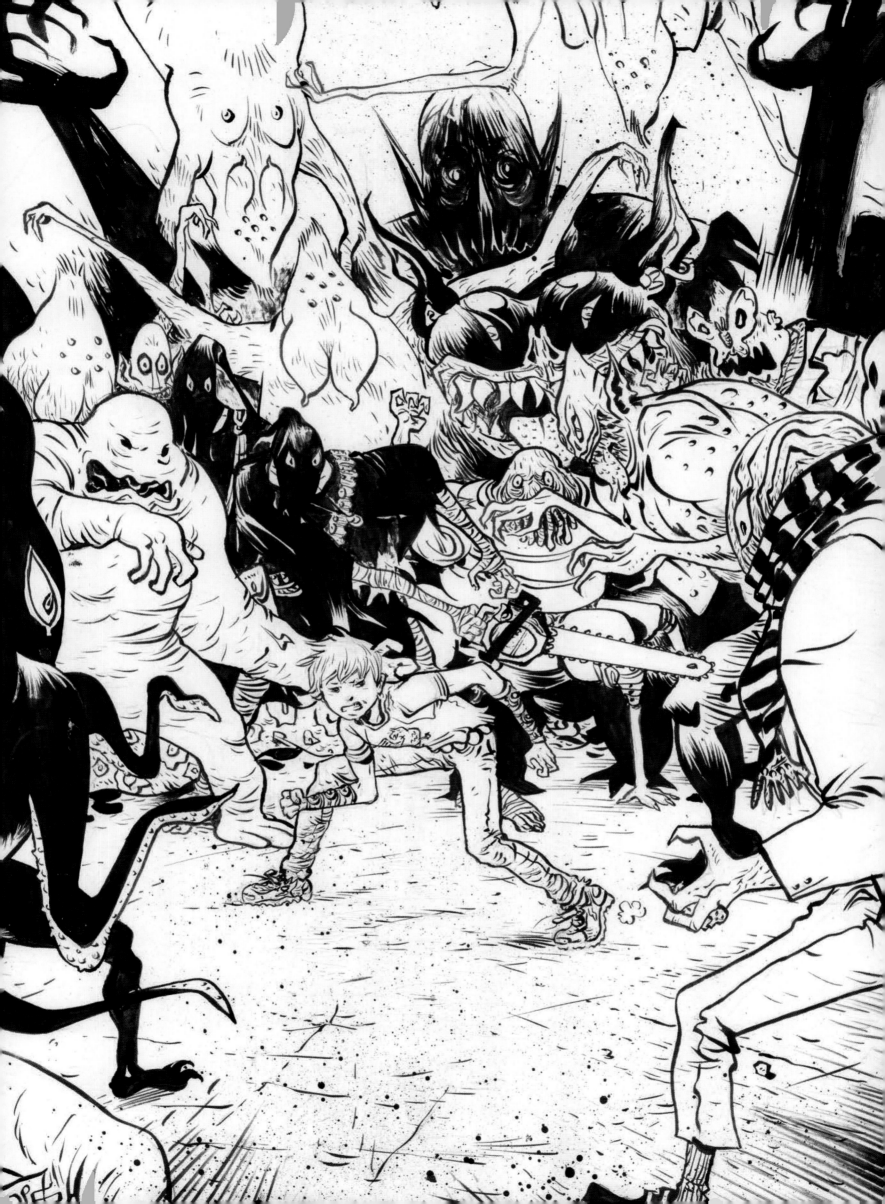

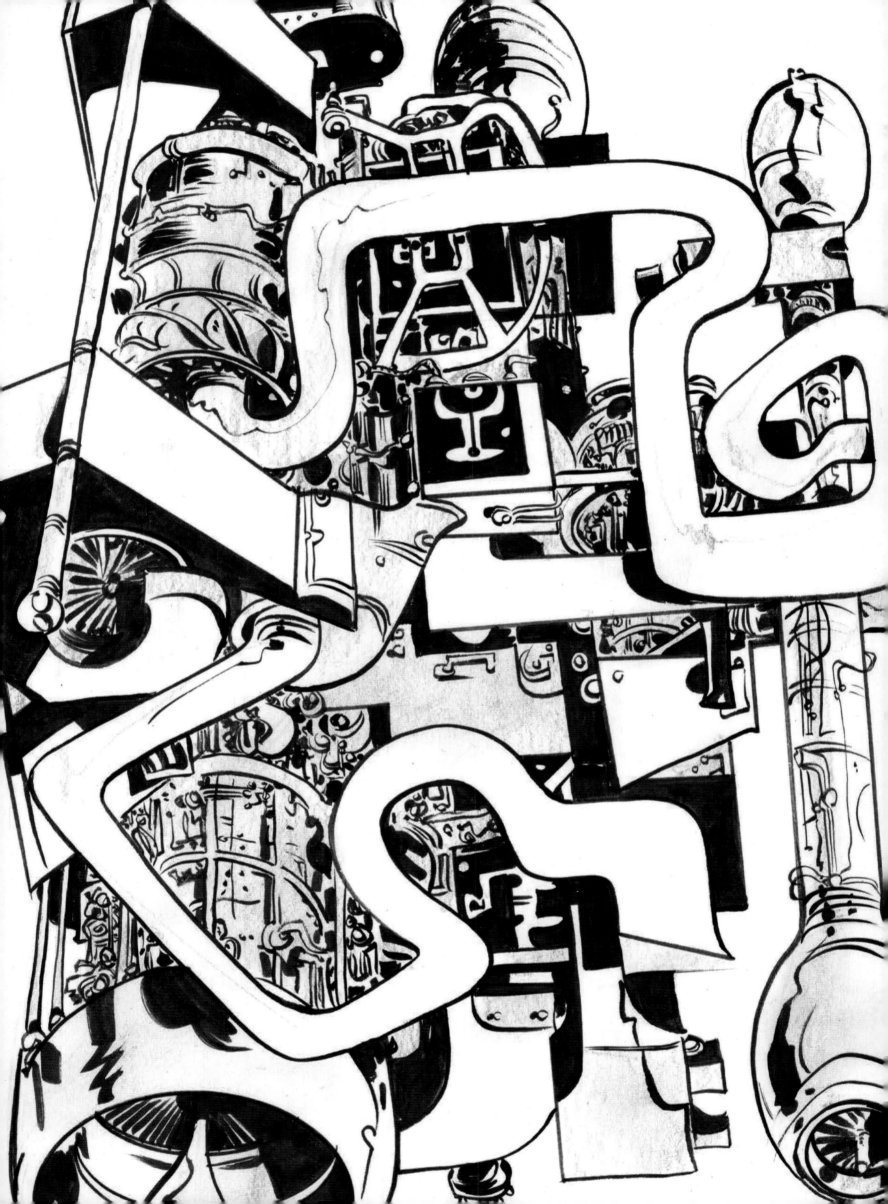

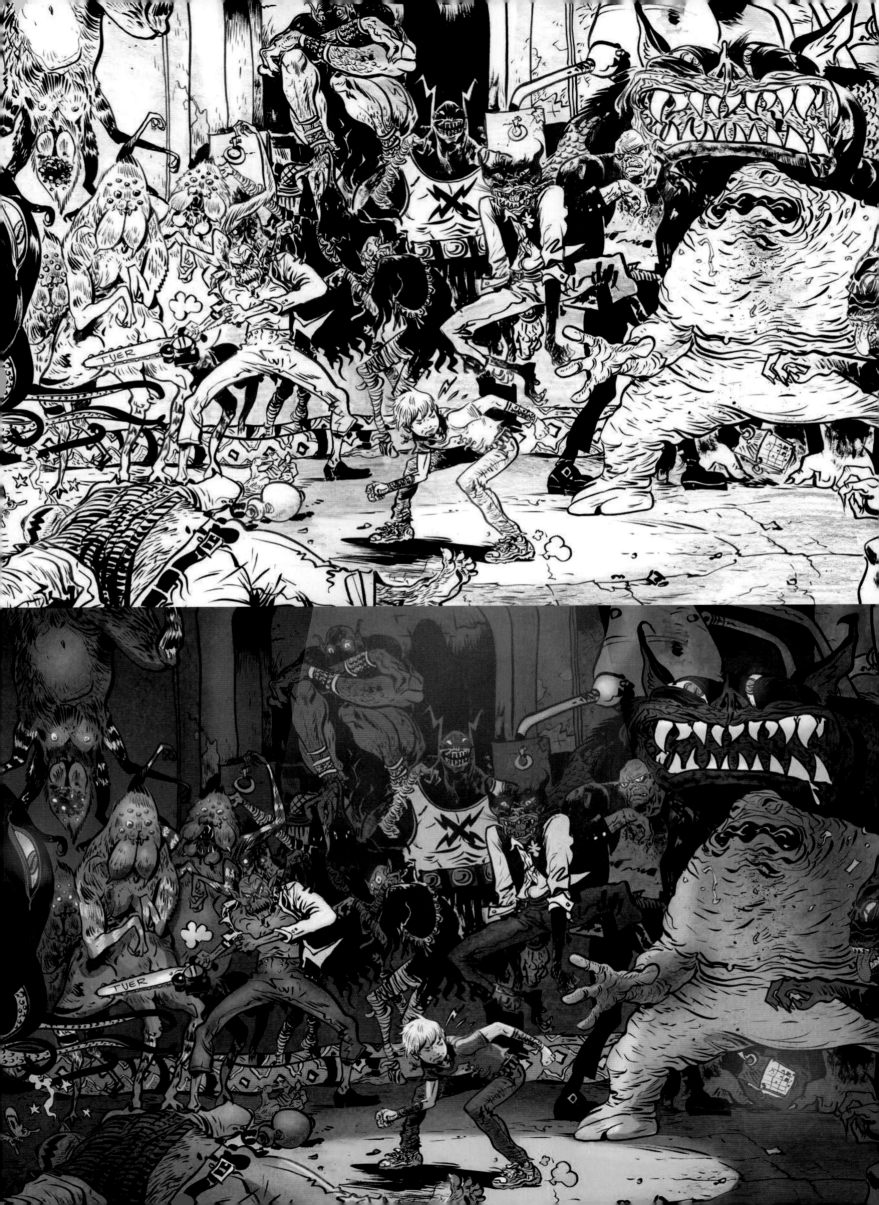

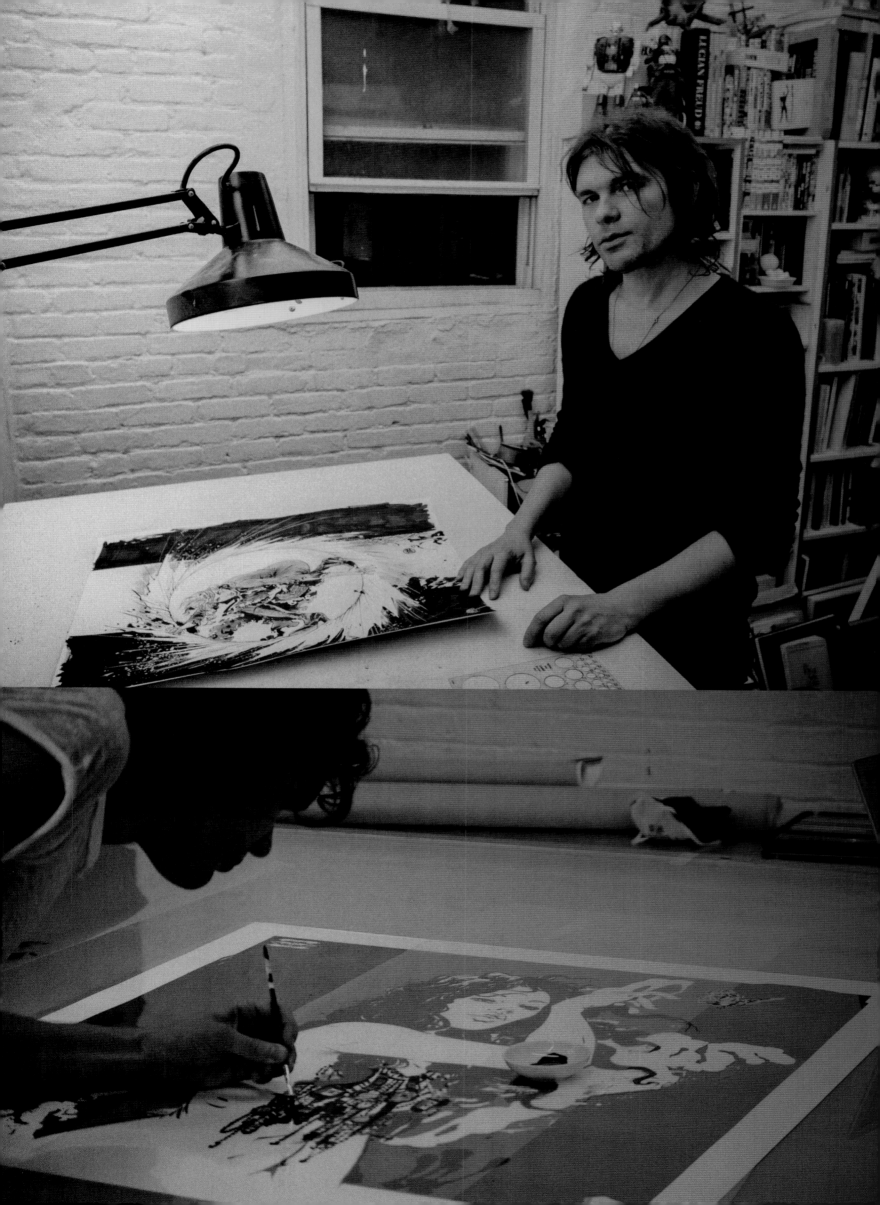

Sound In A Line
Part Two

Paul: I think drawings should be psychological and should sort of interpret the way people see things. Every single person has a subjective view of the world we live in, right? It's kind of different for everybody. Nuance is a tool that's often overlooked. It's really easy to be obvious. But like, to have the tool of nuance, you give 'em just enough to think about it for themself. That's what I love about art. I like looking at art that's surprising and strange.

Jim: Yeah. We've known each other for a very long time, and I want to go back to this concept of filtration and filtering the world into an artistic vision. Even earlier on with these (early '90s) self-published, slice-of-life books, I mean, they weren't particularly genre books yet, they were in this kind of literary tradition. There was a deep sense, even as a young man, that these were books about your view of the world. So as a cartoonist/writer/illustrator, can you remember back to what your challenges were? What led you to these kinds of decisions to do these extremely personal, and according to comics, very non-mainstream expressions?

Paul: Yeah, those early efforts were not mainstream at all. They were attempts to write about the human experience. (…) A very small story that's written large. I think that's what I was going for and what I loved about European comics. They didn't try to arc too much. I loved stories about Wolverine and Kitty Pride, but if there's no end to the story, (…) It's more of a soap opera. I feel like a lot of superhero stories are origin stories and they're not like "end stories." We got that with Captain America — we had a great ending, but that was in the films.

Jim: This idea that they know that it's not a never-ending train, with a character like Batman, the stories just don't stop. I think Umberto Eco talks about the myth of superheroes as it relates to comics, but tying it into these overall mythic characters like King Arthur, Robin Hood. These characters have endings — an origin, and a conclusion. The conclusion brings a certain gravitas and underlines the central point of a character.

Paul: Are we writing stories about life or are we writing these hero fantasies that keep going?

Jim: One of your characters, THB, doesn't have an end.

Paul: Not yet.

Jim: Okay, not yet. What does a story like that, that feels like the most "Paul Pope" story, say about your sense of these characters you started making 30 years ago, and where are these characters are going? You know they're ending, but talk about that dynamic.

Paul: Technology has always been on my mind and our relationship to it as humans. I want to always be able to anticipate where we're going as a culture. The type of writing I do is through comic books, which is visual storytelling. I write and I draw. But the themes are mostly Science Fiction. I could quote the great opening line from Robert Heinlein, "The door dilated." How do you depict a dilating door? That's what we do as cartoonists. With THB, I've always been interested in concerns about where society is going with what we now call "Artificial Intelligence" and a lot of these concerns we have right now. Getting back into it, I really hope to delve into these questions again.

Jim: Do you look back on THB with a sense of prescience? Maybe it didn't hit the mark because you didn't have the tools yet? I'm not trying to diminish the work, but you're so much more sophisticated as a person and artist now. I feel like you've never truly let it go, even if it's been years and years. These characters of HR and THB are kind of always alive.

Paul: Yeah, **I think it's important to be generous towards yourself as an artist.** You might've done good work when you were younger, and your ideas might've changed, but if you have a gem of an idea that is good and solid, I don't think there's any reason why you should reject it. What you might do, is you might re-plant it and you might change it, you know? I've been thinking a lot about THB and there's so much good stuff in this book that people were not even thinking about when this came out. Now it's like, this is all old stuff that's coming back in and I'm looking for a way to reframe this. As humans, I think these are important questions. I was talking with my girlfriend Neha about this. Dune took 45 years to fully get to screen, and the themes are still legitimate. So, that's how I feel about things, otherwise I like surrealism.

Jim: It's funny you say that. It's not that I don't think of you as a surrealist — I do. We both know that's an often misused, an often label draped across things that are superficial. I feel like your surrealist tendencies are more aligned with André Breton and deep psychological work of artists of the early 20th century, more than

So, I left with a hat full of ideas and a handful of hopes.

the melting clocks or LSD trip-type stuff. It's an interesting thread to your work. I would say your work is much more expressionistic. I see it as, "this is Paul playing with the form, pushing the boundaries of representation, bringing an audience's vision and awareness into the form, which is ink on paper, and the reproduction of ink on paper." As an interesting connection between psychological tendencies of surrealism and existential psychological tendencies of expressionism. Without being labelistic, talk about how you think your work represents itself.

Paul: I get really interested in mark marking in its own way. So when I draw I think about the line, color, tone, value, and basic art values. We spend a third of our life asleep, and when we do, we are unconscious. Yet we still think. I try to pay attention to the things my mind thinks about when it is sleeping, independent of me, Paul Pope. So, I try to remember these things and draw them and depict them. I think drawing is depiction. If you're a writer, you try to write words down — "and then I ran my tin cup heart across the prison of her ribs" — the Nick Cave line. Something like that. That's a poet. **For me, it would be a line or the same sound of what that lyric would be. I think that's the equivalent. If you take a master like Miles Davis, you get a really great sound. It doesn't have to really make sense, it's just a sound, but can hit people on an emotional level. We're not working like theologists or philosophers. Just trying to get an emotion or an idea across. That's what I love about this.**

Jim: I think what we're talking about is arguably the most important thing in terms of the discussion of art and culture in our society right now. Which is "de-emphasizing" or "de-centering" the importance of story in expression. So, when you're talking about the line as melody, the line as something that has inherent value in the same way that the tenor of Miles' horn has meaning that is beyond the melody that it is trying to capture...

Paul: Because it's a voice, don't you think?

Jim: I want to talk about your time in Japan and specifically about the Japanese sense of character. You said something to me way back when, when you were in Japan, that I've never forgotten. It's interesting to me and indicative of our friendship that I remember the question, and I don't remember the answer (lol). The question was, somebody in Japan asked you, "do you want to be famous or do you want your characters to be famous?" Can you give me that story again? Tell me if you can remember what your answer was then and is your answer different now?

Paul: Well, I'm just going to have to fall back on David Bowie again because I feel like he's the hybrid of both. It didn't matter to me to be famous. It was more important to me to have great work. I think when I was with Kodansha that was the option — you could be one or the other. Maybe they were gatekeeping so you couldn't do both at the same time? I don't know. I'd rather just learn the anatomy of manga and not worry about being famous in Japan, because it's frankly not gonna work, and that was my experience. **So, I left with a hat full of ideas and a handful of hopes.**

Jim: I feel like what you came away with from your time in Japan was an extremely valuable bag of tricks you continue to pull from and haven't left aside. Were you aware that that was the pot of gold?

Paul: No, I wasn't actually. I was just thinking about making some money to be honest. But I loved manga and I knew there were mysteries over there. **I knew if I could just go there and talk to them, I could unravel the bag and figure it out.** I think they got some mysteries and I came back with some knowledge that maybe, at the time, nobody had. They were very generous and gave me a lot of things that I never would've seen until they showed them to me. Then it's hybrid right? Now as an American artist in this day and age, it's trying to fuse the European and Japanese and American style into one style. That, to me, is very exciting.

Jim: I think your entire career points to this real melting pot of American sensibilities, European sensibilities, Japanese sensibilities. You have heroes and mentors in each of these cultures and disciplines you learned from and worked hand-in-hand with. Maybe not directly after Japan, but in the scope of this conversation shortly after that you ended up in New York and where you've been since. New York is famously America's melting pot in all of its things. How did landing in New York and being a New York artist alchemize all of these influences into something you maybe had been developing, that kind of was perhaps starting to really express itself as something truly unique in terms of a style or vision or something you'd been playing with from the very beginning? **How important was New York as a city and culture to where you are at in your artistic development?**

Paul: I was lucky to jump into New York in the late 90s when it still felt like kind of a creative wild west where you could just kind of be anybody. (...) **That felt like a way to live that was liberating, and allowed you to make your art, and you didn't have to explain yourself.**

Jim: New York is famous for many things, but in the comics world, it's famous for being the home of Marvel and DC. (...) Your trajectory was to work on your own stuff, develop an incredible fan base, then work for Marvel and DC — you're still working for Marvel and DC and still you're continuing to create your own stuff. **Talk about your initial experiences working with the big publishers, with those characters, and the importance of that initial work for those companies and how that added to your development.**

Paul: You always have to prove yourself, you know? In this field, you get some small offers in the beginning, and then you work on something small and then you do it well, and people like it, and then you get called back, and then you do something else. Eventually, it's Batman. I have this story I always tell about the Daphne Plant for Swamp Thing. I had never heard of a Daphne Plant, but I knew I needed the money to draw that drawing because I was eating bread and water at the time, literally. **I got the call, "Can you draw a Daphne Plant?" I replied, "Oh sure, I can draw a Daphne Plant!". I had no idea what a Daphne Plant was. I took my $11, I went to Barnes and Nobles, I bought an encyclopedia about plants. I saw what a Daphne Plant was, and I drew it. That's the story of freelance right there. So, one step after the other. If you ever give up on the next step, I think that's where you fail because you never know how close you are.**

Jim: That's some Napoleon Hill shit right there! That's bringing it back to classic Napoleon Hill.

Paul: Yes, I am absolutely! (...) Napoleon Hill has been a huge influence on my career and on my life in general — no question.

Jim: You know, we can talk about things that you've achieved. We can talk about things where you've expanded your audience or your pocketbook or whatever. But I feel like inside of you, you've always known that you are true to the artistic expression that you're trying to do. I guess what I'm saying is there's a lot of people that

speak of this kind of like, "one day I'm going to write the great American novel," right? I feel like you had a point of view, had a sense of will, that, "I'm doing it right now." **And you were doing it 30 years ago, you're doing it still to this day. But this idea of, "I'm just doing it. I'm in the present. I'm doing it right now. I'm not trying to create something in the future. I'm not trying to create some sort of trail, I'm not waiting for it."**

Paul: Well, isn't that the way it is? We have ideas and ambitions. Even when I was younger and I knew that my ideas weren't quite formulated, I still knew they were good. So, I tried to do the best I could. Some of my early work is embarrassing frankly, but you only have to take one step ahead of your next step to get there. That's why I make this metaphor with "three steps" from gold, because I really, truly believe in this idea. **If you have three steps ahead of you, you might hit gold — and if you don't, then take three more steps, and three more steps.**

Jim: I think the key word there is belief. This is something that I feel like you've never wavered on. Sure, you've maybe had personal moments of crisis and self-doubt, which we all have...

Paul: As everybody has. Yeah, of course!

Jim: But there is a sense that the work itself, and your dedication to the work speaks to a belief in the work. (...) There's a kind of holistic mindset that comes from that kind of approach. It can come across as confident, but I think that it really just comes down to believing that, "this is the time, this is the moment."

Paul: Right! And I think people shouldn't be afraid of confidence. Everyone should have self-confidence. There's no reason my self-confidence, your self-confidence, someone else's self-confidence should be a threat. If you believe in yourself, you're nonviolent, you're working on something creative, I think that's great. I say, keep going.

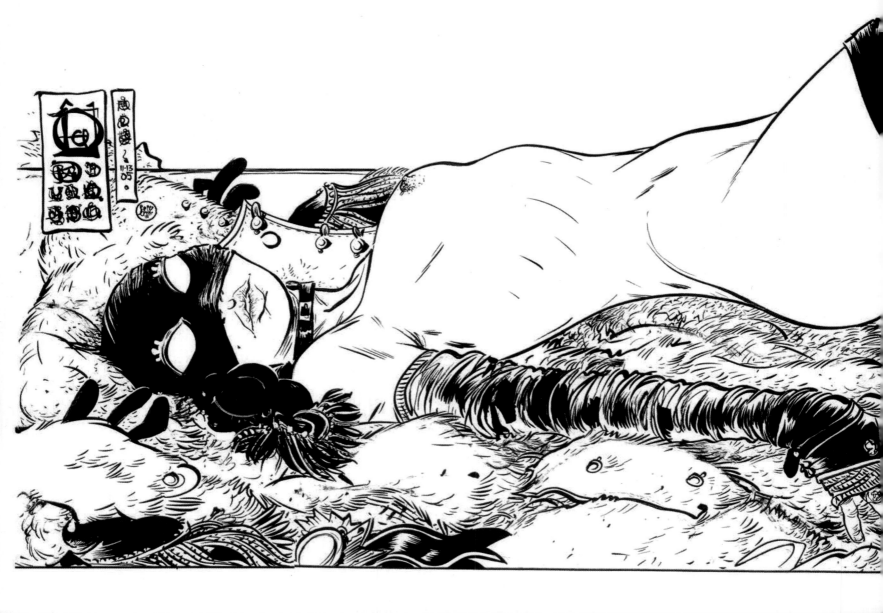

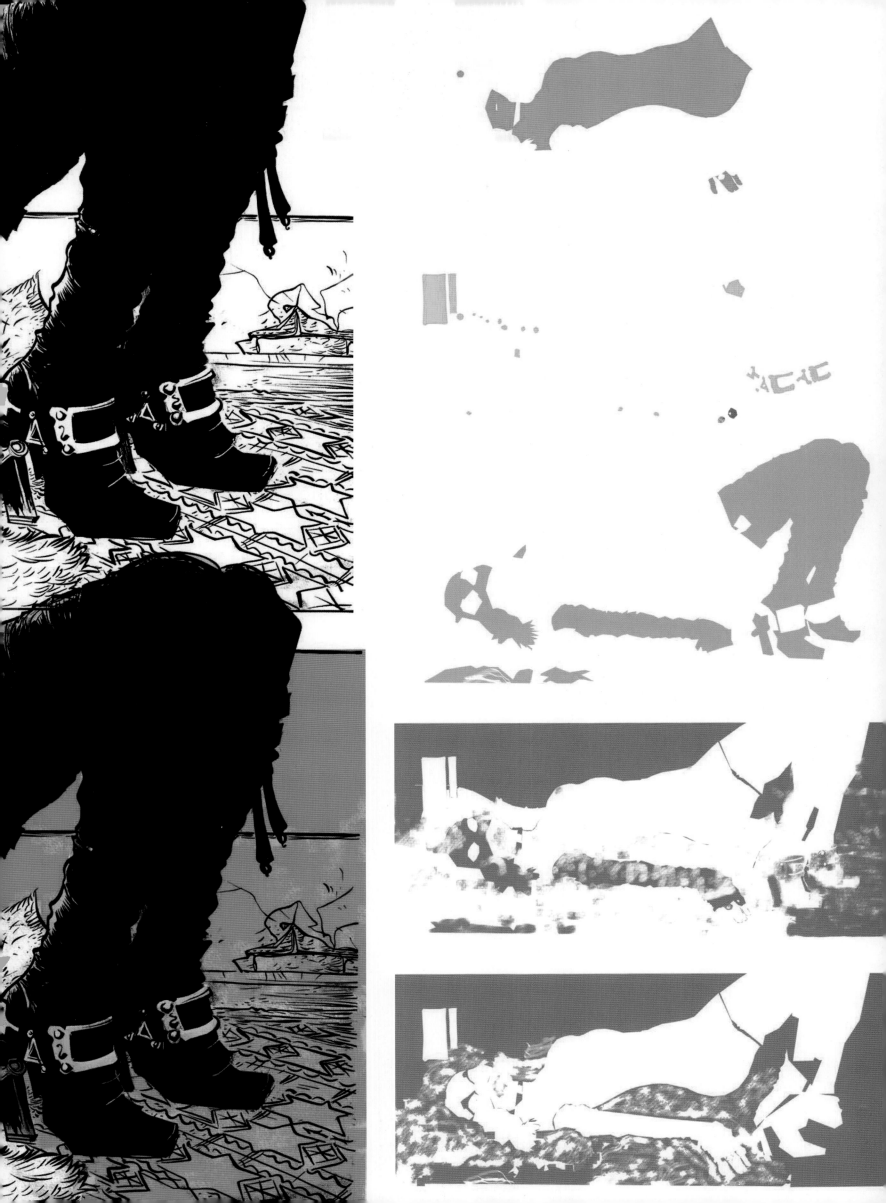

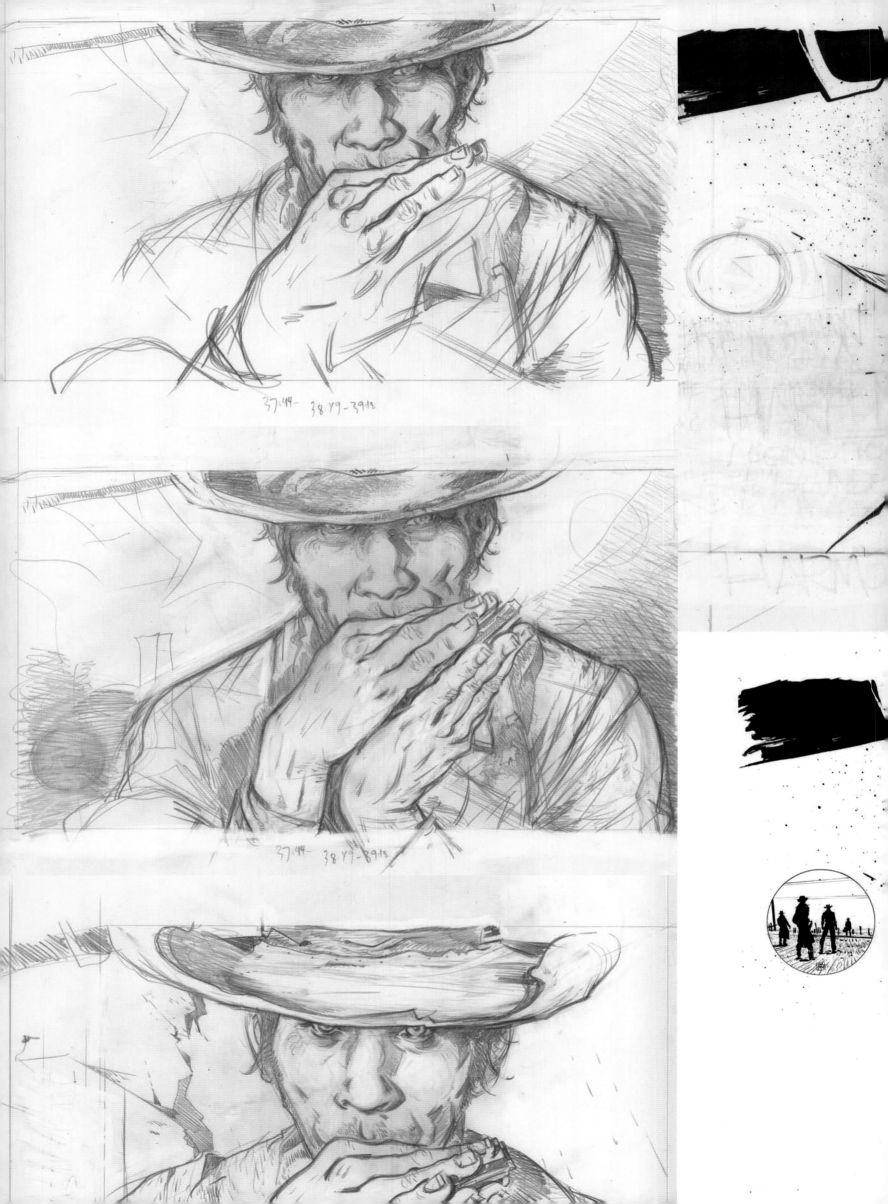

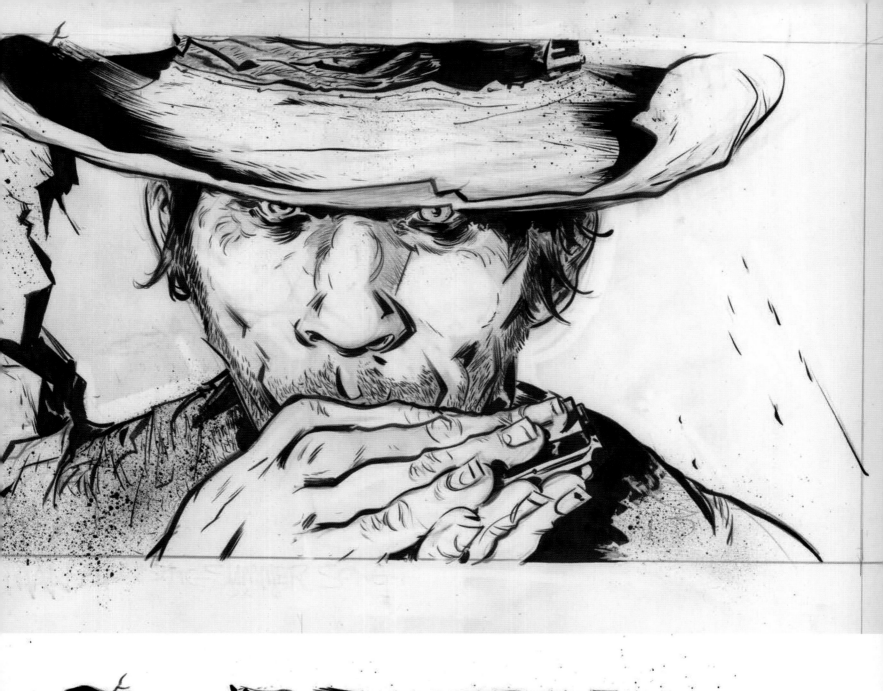
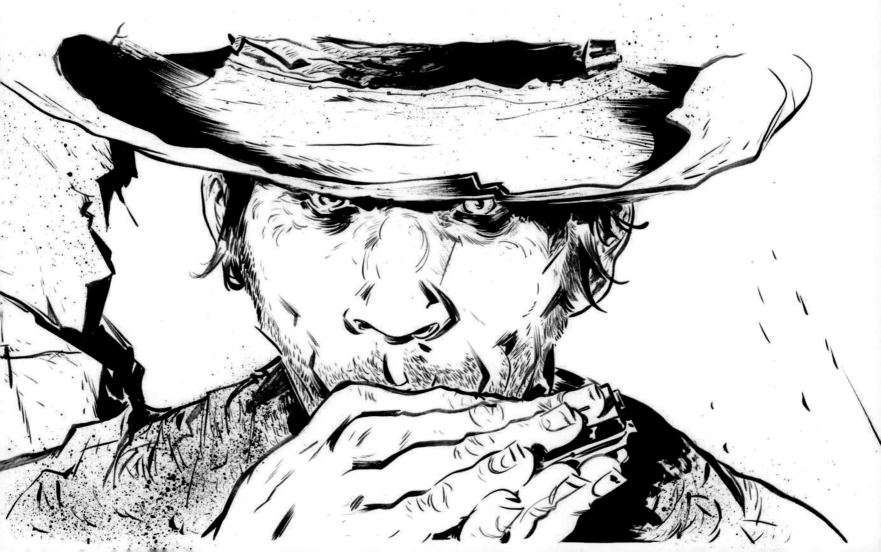

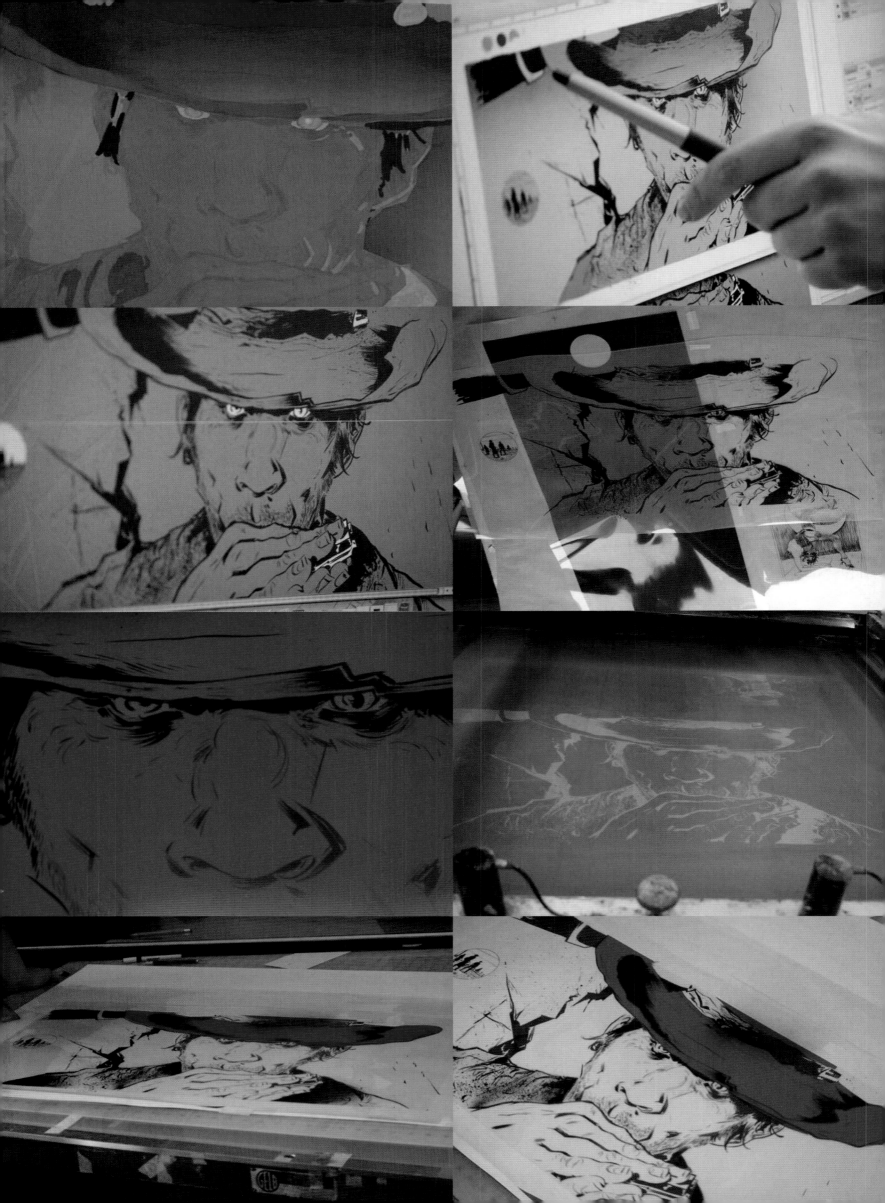

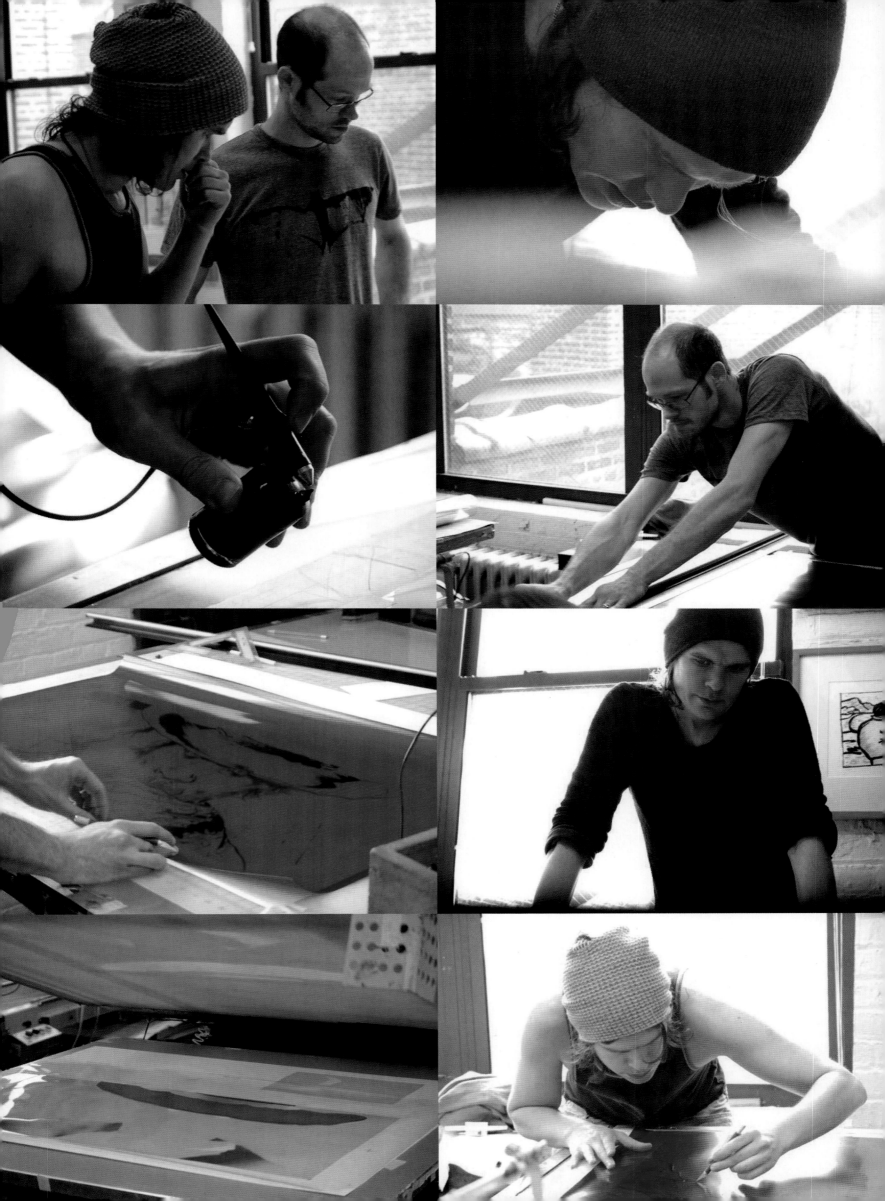

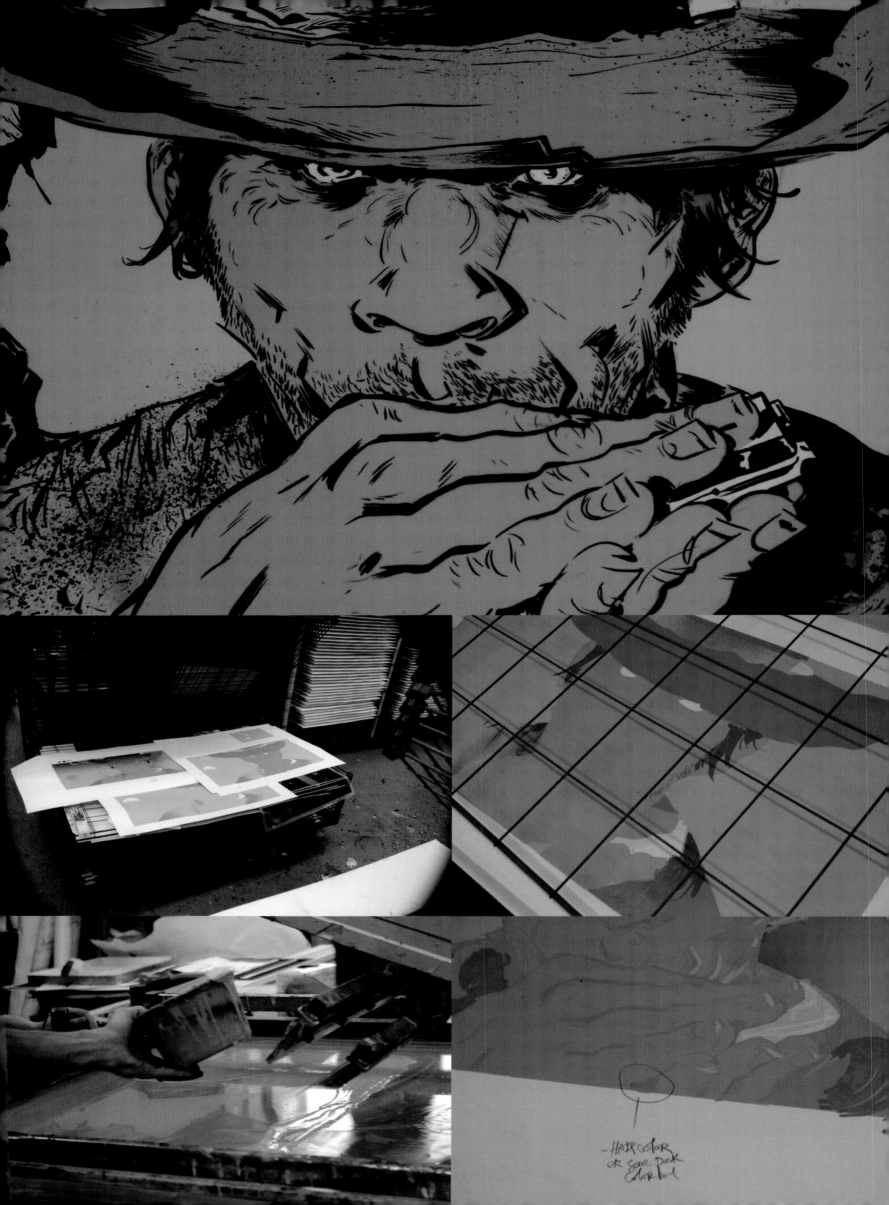

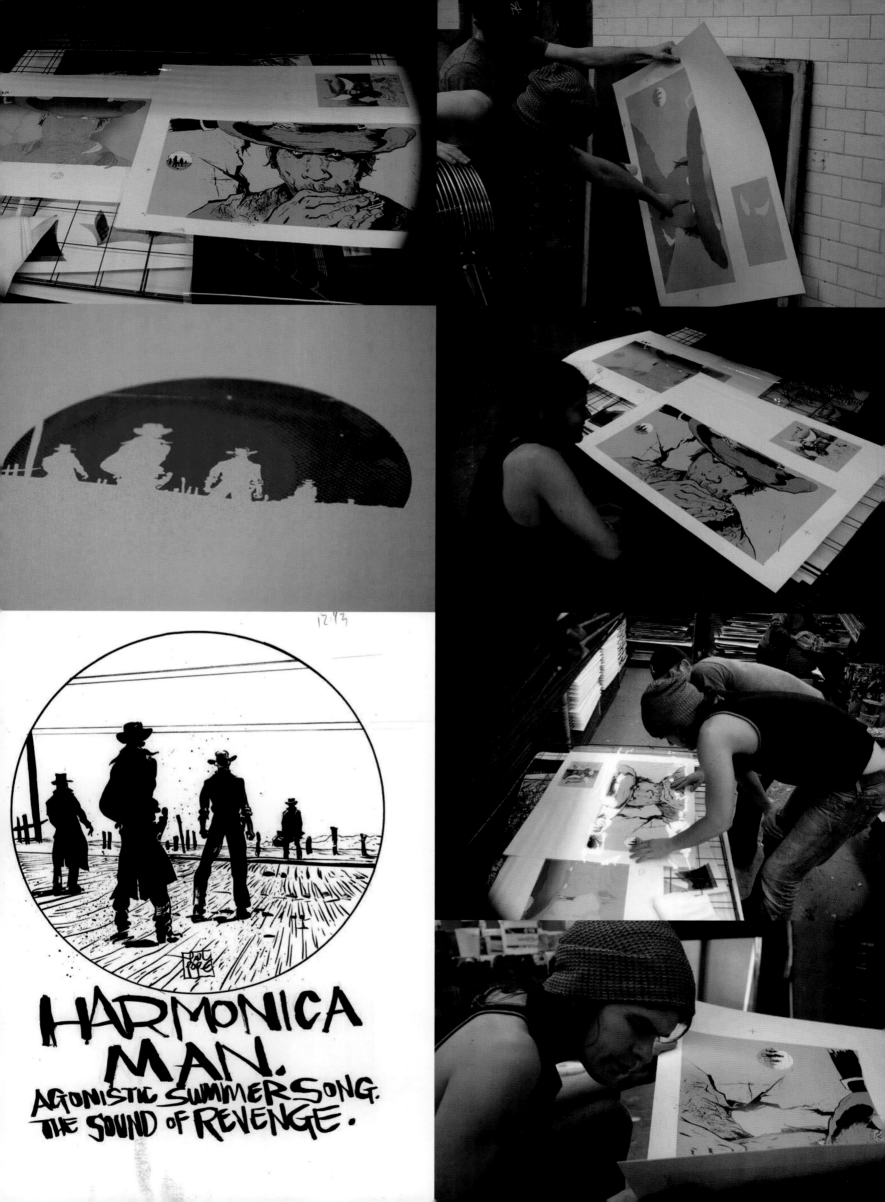

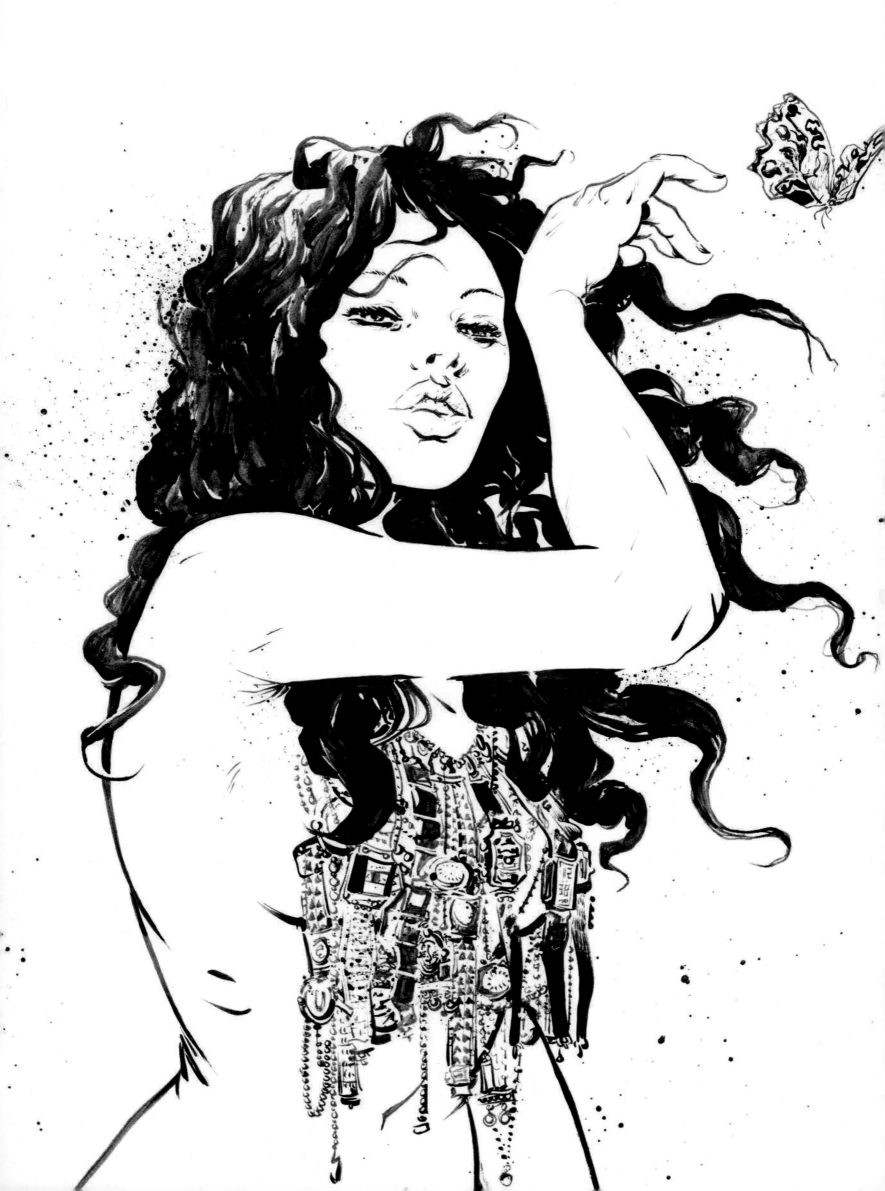

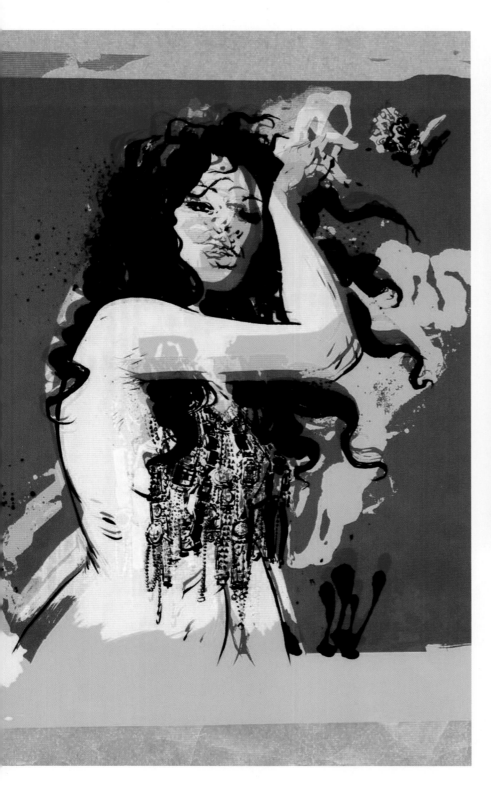
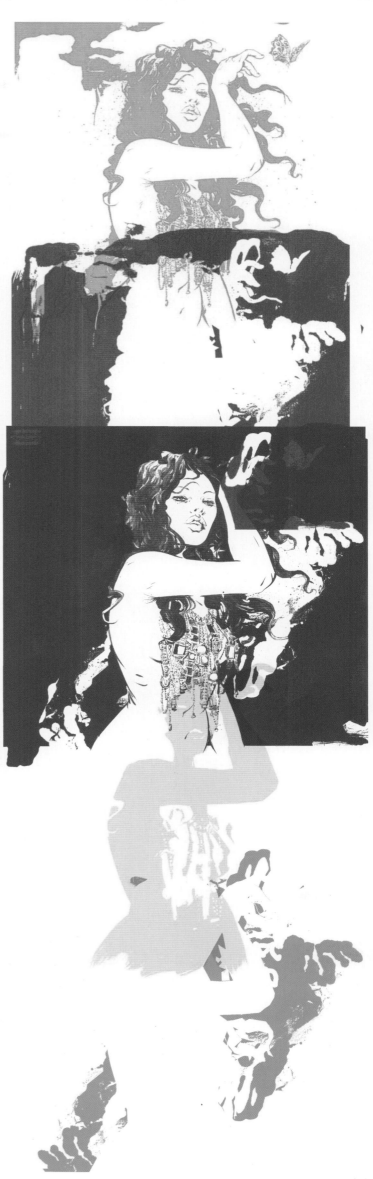

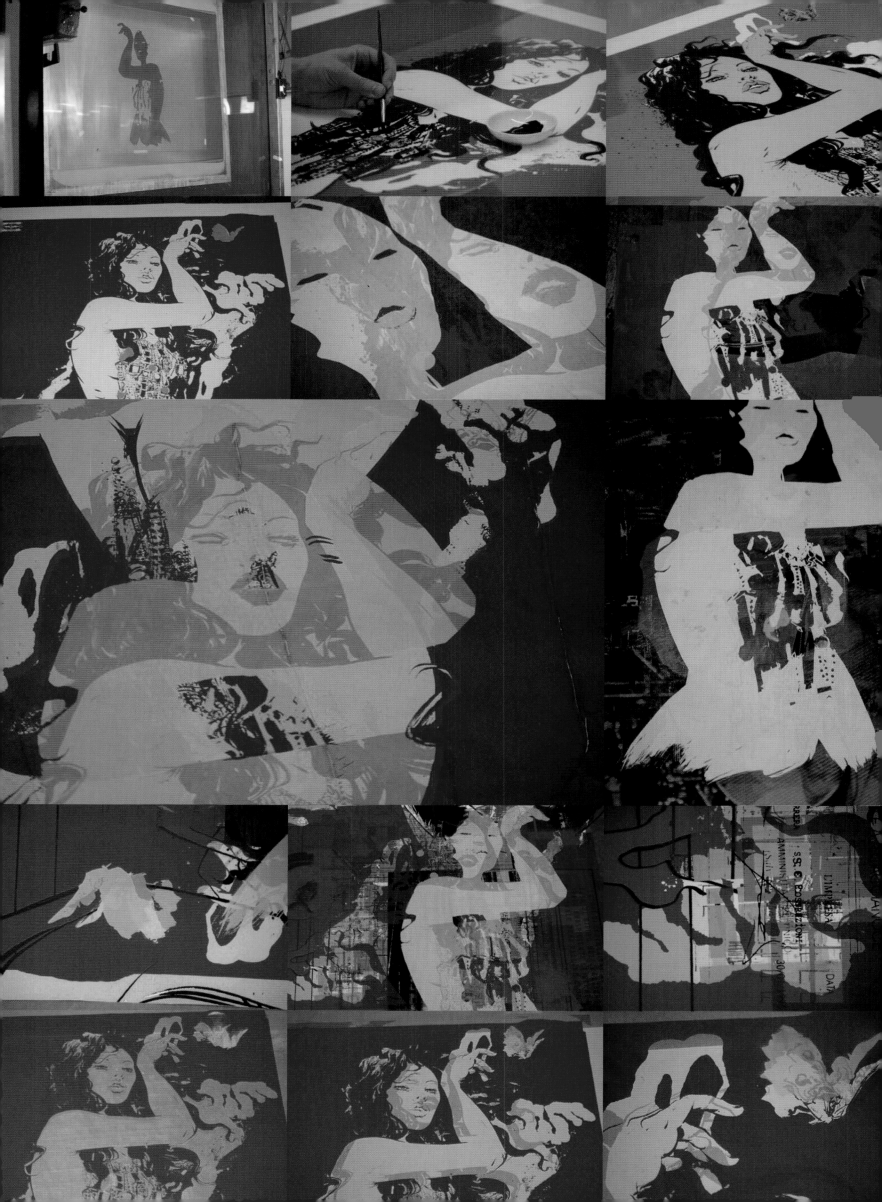

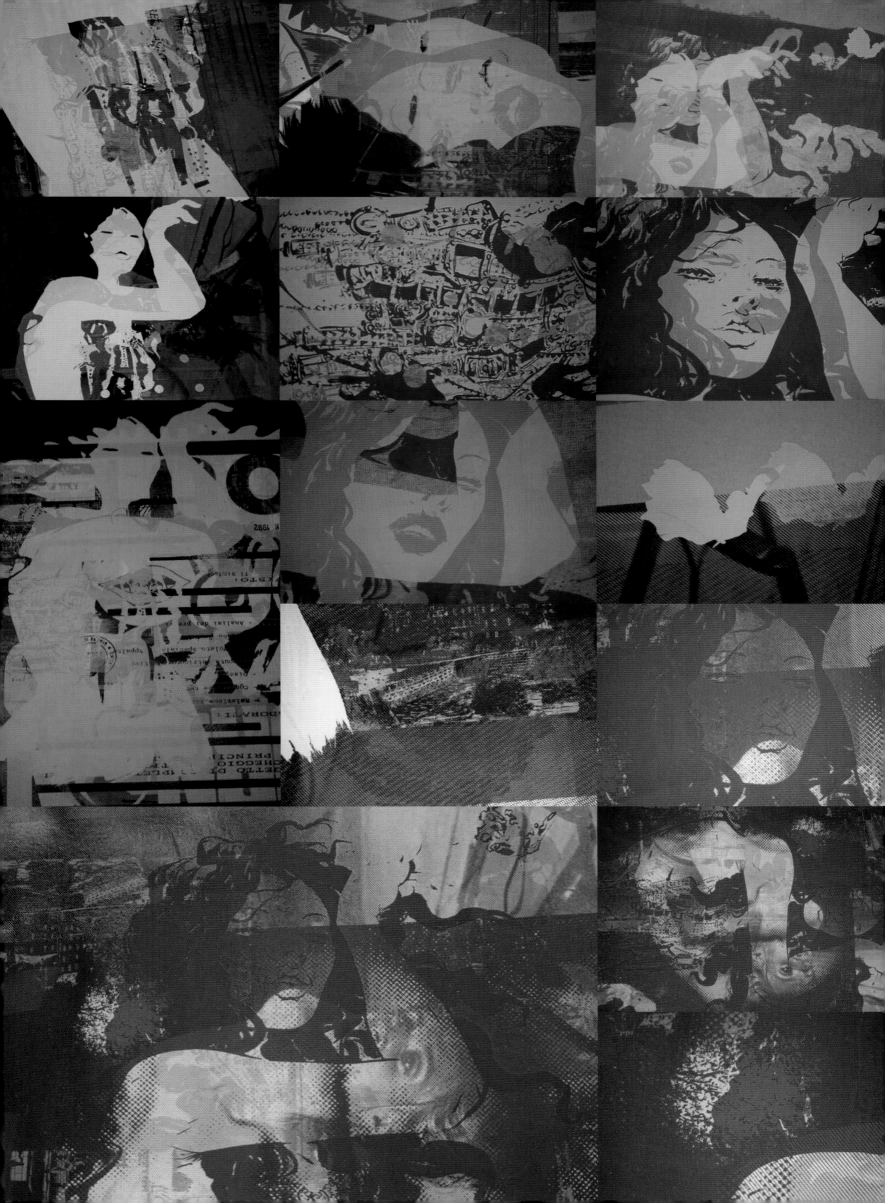

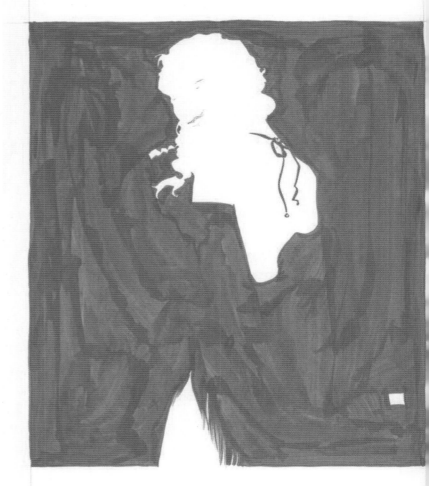

Red.

Fleshtones.

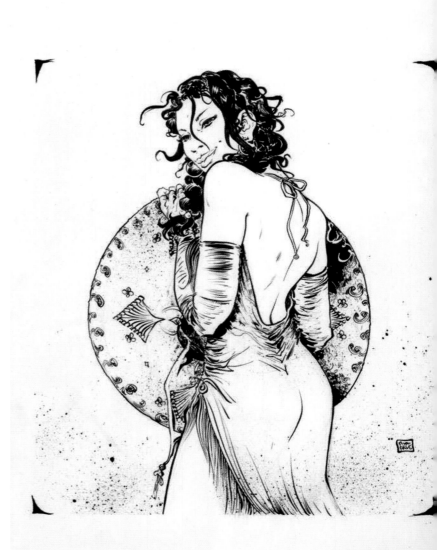

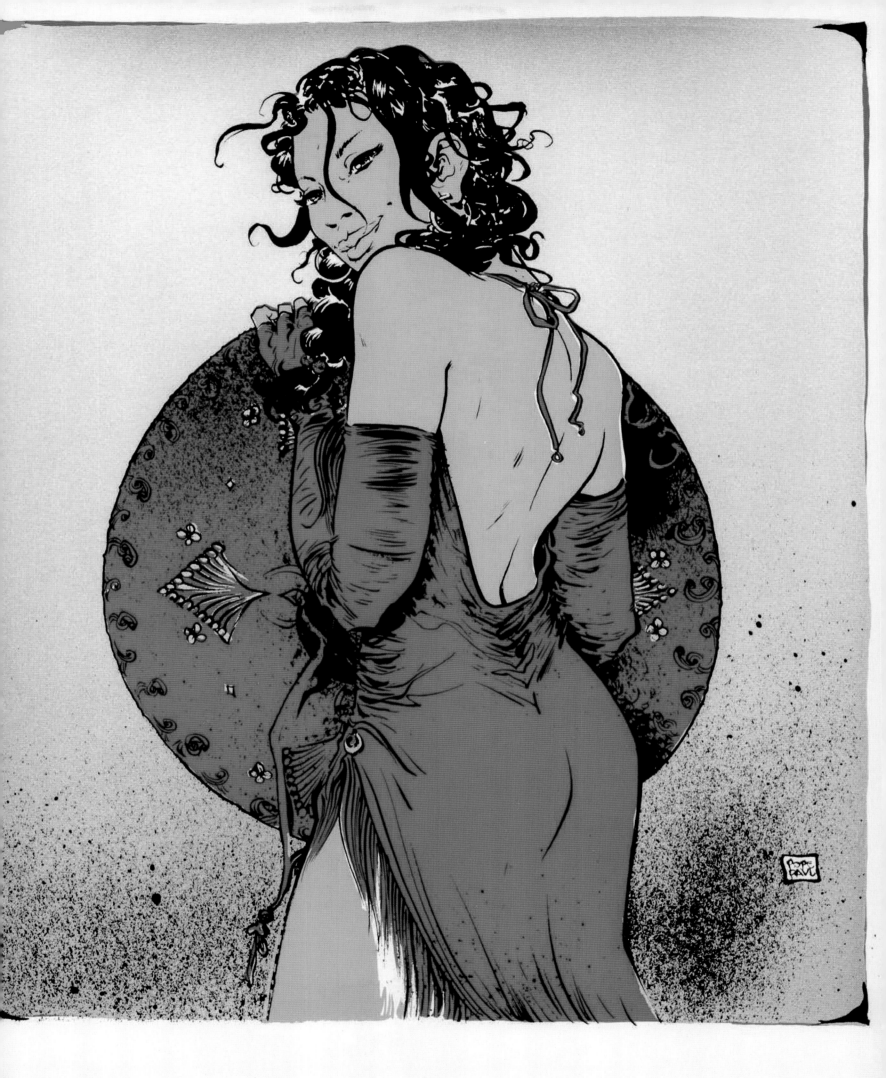

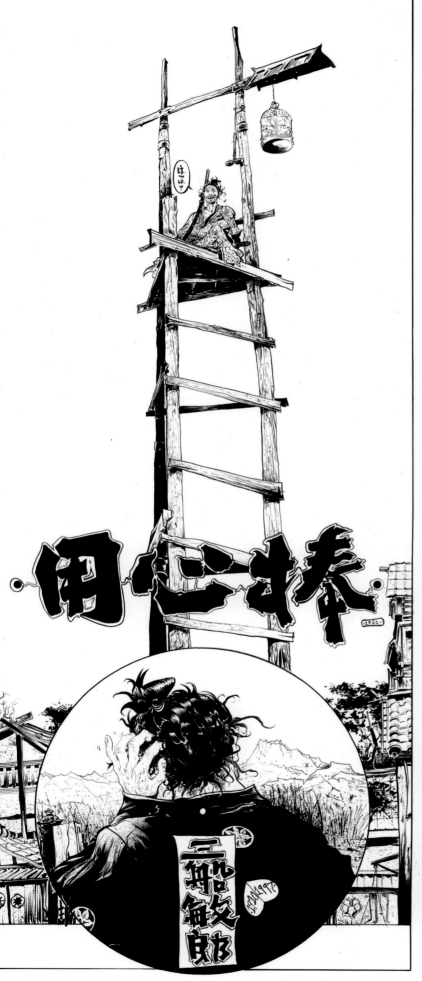
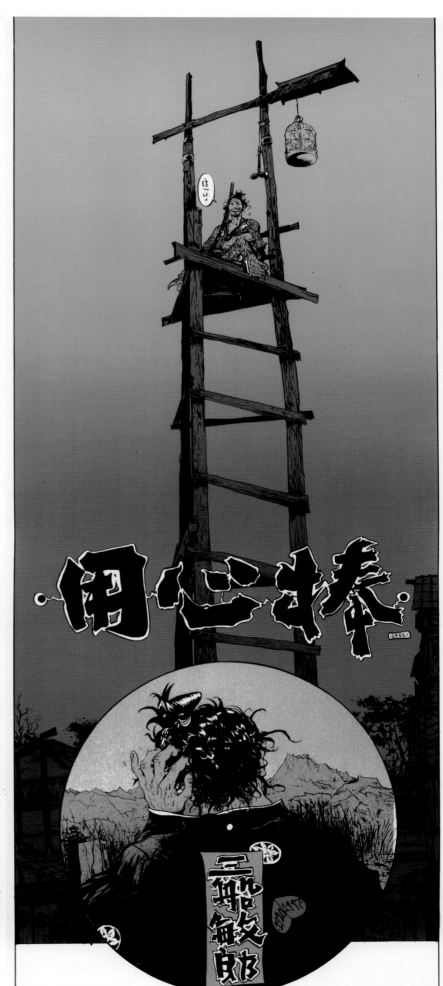

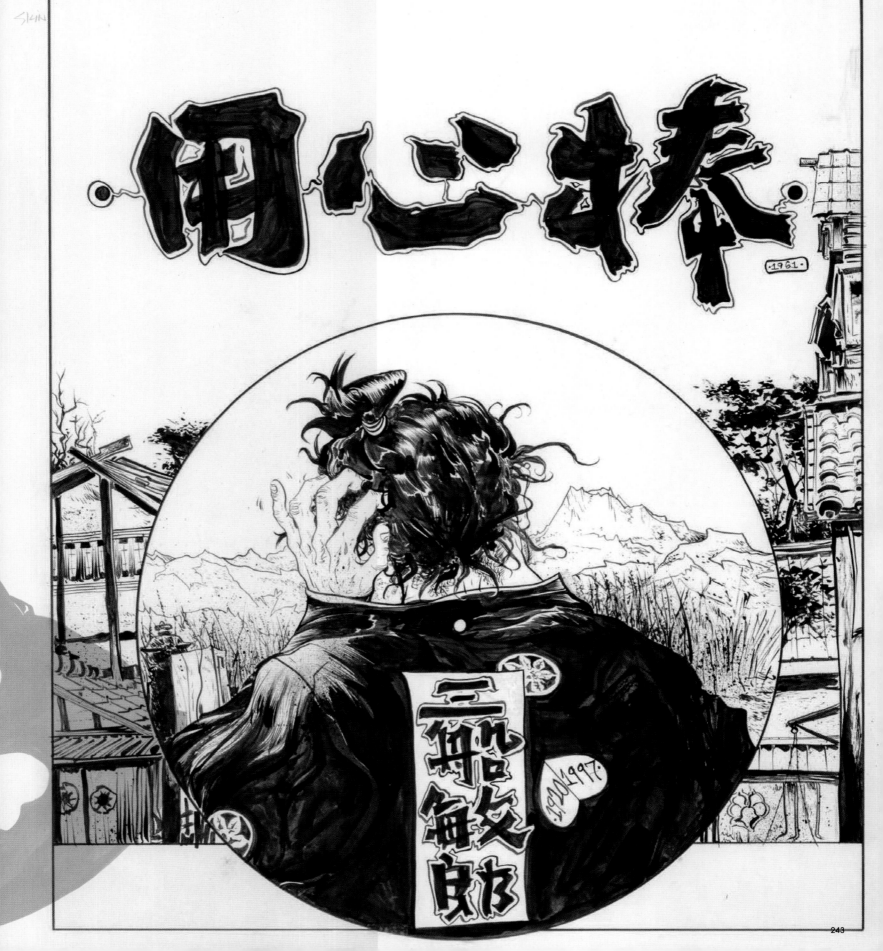

©1965 KUDOKAWA / STUDIOCANAL

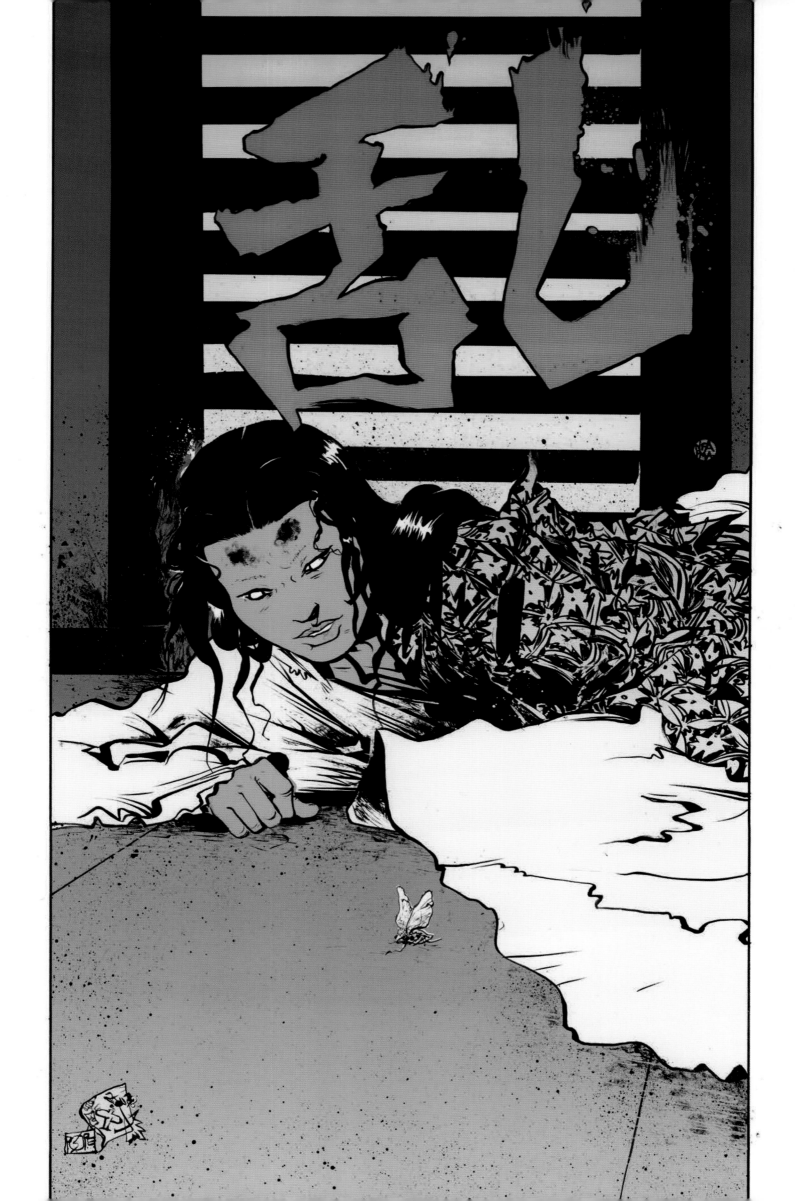

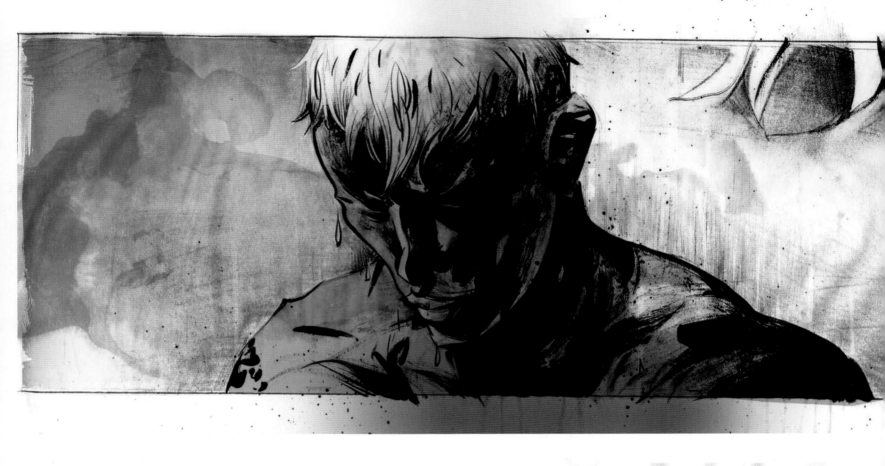

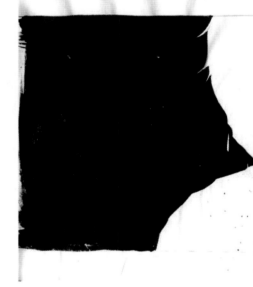

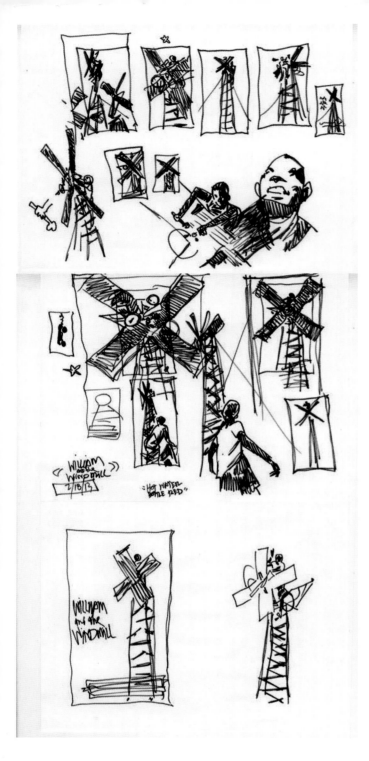

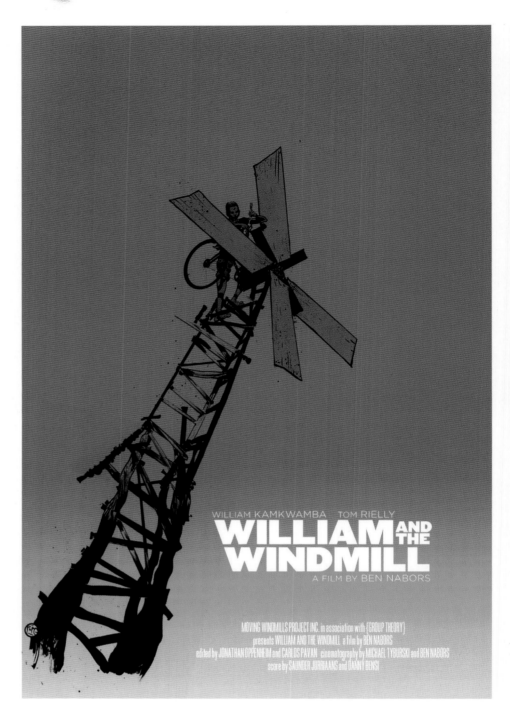

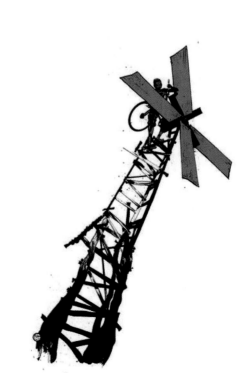

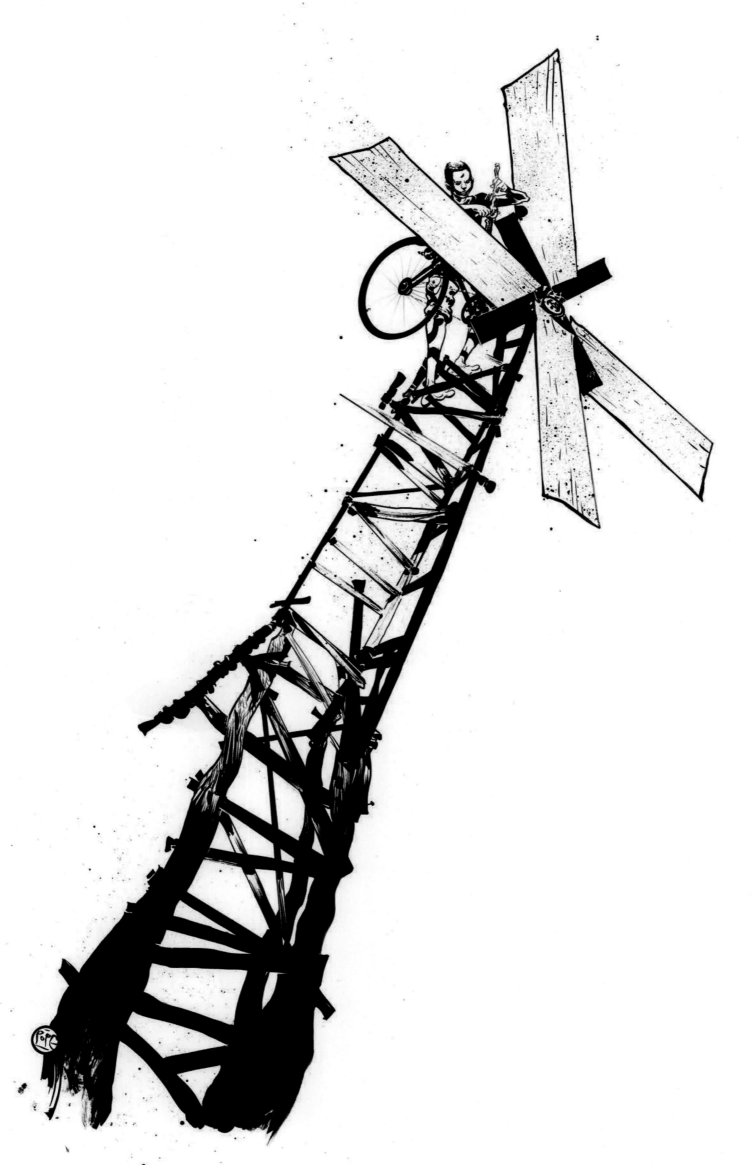

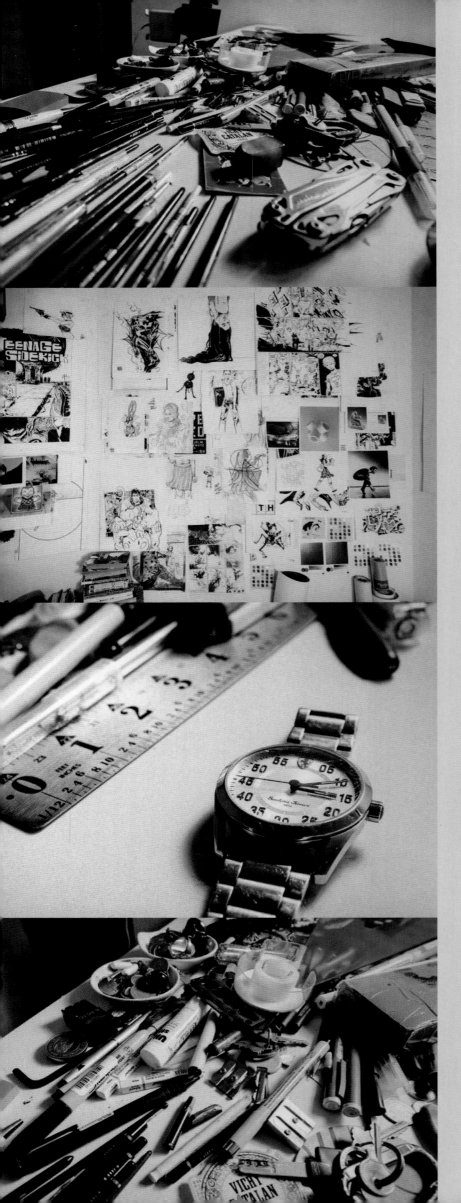

Jim: I want to talk about Battling Boy and specifically the idea of writing for children.

Paul: Well, you write for children too.

Jim: Yeah, so, it's a good question since neither one of us are children.

Paul: Well, at one point we were. I liked being one.

Jim: What's the fascination of working — designing something, writing something, creating something — for a young audience? The deeper thing is, Battling Boy is a modern myth. I want to unpack that: why myth-making is important for young people's literature.

Paul: Good question. (…) First of all, I don't think young people fully have the language to know for themselves how to interpret the world. So that's the first thing. As adults, you and I, we're well-aware of the dangers that young people are going to face in this world. Me and you as adults, we can give them stories, avatars, you know, even though the term has been overused these days. But I want to give them something to think about. When you and I were kids, we would think about Han Solo and Luke Skywalker and Aragorn and these characters and we had a blueprint for how it would be to be an adult. **So, through the filter of my life, I came up with this character and I was like, 'Okay, I'm going to tell a story about this kid who was kind of a latchkey kid,' which is what I was when I was a kid, with this wish-fulfillment and all these different T-shirts and stuff. He fights monsters and, you know, I thought it was a good idea and it seems to work.**

Jim: Yeah. In writing a modern myth, how aware are you with the importance of appropriation versus the importance of creating something new?

Paul: I think all of us in the creative arts have sort of accepted Postmodernism. We can look at traditions spanning from Greek mythology to Hindu mythology, across the board, you can pick and choose what you want to bring in. If you do it with respect, and you do it with intention, I think you can own it. My personal intention with my work is based on my own history — what I like, and finger on the pulse — what I think the audience wants. So I think somewhere between those you can get there. That's not much different from what Jack Kirby did with the Marvel comics, right? Go back and look at the iconic characters. I think they're always trying to respond to a need in society, and often based in older archetypes. **There's a great line that Carl Jung had where he said, "a superhero emerges when people's consciousness concentrates," I always love that. I thought, "that explains everything."**

Sound In A Line
Part Three

Jim: I think it's interesting because when I think of classic mythology, I think about civilizations that are trying to explain the natural world. Myths of the sunrise, myths of the season, myths of death, myths of rebirth, and regeneration.

Paul: Yeah, that's cosmological mythology. I do think there's a lot of mythology that does try to do that.

Jim: It's this weird conflict, that the more unique you make something, the more universal it becomes as a story.

Paul: I think it can. If you look at the great artists that we love, whether it's David Bowie or Miles Davis — I always go back to musicians, you know? Like the weirder they get, the better they are. I don't think it's any surprise to people that those have been my heroes. (...) If I listen to Miles Davis and all these different weird transmutations and the way he keeps changing as an artist, to me that's really cool and strange and inviting. It's at first off-putting, but inviting, and that's what I love about something as abstract as jazz.

Jim: I want to end with this concept of, fine art versus reproduction or fine art versus public art. Some of your current output is doing privately-owned commissions that are exceptional pieces of work, but they're private art. I think it's an interesting lens to look at this, versus what we were talking about years ago, which is the idea about self-publishing, **ink on paper, and mass reproduction versus a singular drawing on a wall in a gallery. In the broadest sense, what's the role of art and audience in the 21st century?**

Paul: Ah, that's a great question! To answer that, I think you have to ask, "what is the artist's role in the 21st century?" **I think the artist's role is to tell the truth, as always. In my case, it's going to have to be through my lens.** So, it won't be your truth or her truth or the next person's truth. It's going to have to be the way I see the world. So yeah, economics. I do private commissions for people. I'm grateful for that and they always go to good homes and they're always cool and nice people. I've met a few of them. **It's all about fueling the engine to get more art done. I live and breathe ink. That's all I think about. I dream about it. Whatever I can do to make this happen, is gonna be good. As long as we're honest through art, and we don't sell out. Just don't be fake and we'll be okay. You might have talent, you can sell at times, but I think that's pretty much what it is. You have a voice as an artist, you have a voice as an individual, and you have something to say. I don't care if your art is great or it's kind of bad, as long as you have something to say and you can say it with deliberation, I think that's the main thing.**

Jim: What do you think are the three biggest obstacles for young artists?

Paul: Money? I think money is number one. Family resistance to your dream is probably number two. Number three would be lack of focus — not knowing what you're really trying to do.

Jim: I think we live in a very distracted society, and I feel the lack of focus being an obstacle to young artists' success. I feel like I mean that's an obstacle to every single person's success. Practically, at least for everybody in a civilized society that has food and shelter and things like that. I think that there is a difference between focus in terms of doing the work, sitting down, finding the time, making the time.

Paul: Oh, I see, you're talking about something a little different then.

Jim: Right! But I think it's an interesting homonym of sorts.

Paul: I mean, how do we define passion? What is passion? Why do we do this at all? I mean, this is an irrational job, to be an artist. You and I both work on things that make us money and they are career advancing projects for us. But then you also have ideas that might not really fit in anywhere, but you're obsessed about them, or you're passionate about them. So you do them because you care about them and you want to see them exist. Those don't need to live in the world, but they do because we manifest it.

Jim: Passion is an emotion. Passion is about a connection. It's about a connection to something bigger than yourself. I feel like for me, the core of passion is about the creation of something. It's alchemy. It's not the creation of gold, it's the creation of love. It's the creation of an expression that I harvest when I read my favorite books and look at my favorite art. That feeling I get, I want more of. More specifically, I want to put more of it in the world.

Paul: And you have every right to do it. **I think every person has the creative spirit and different dreams and ideas. And I think that they should pursue that.** And I like what you said about alchemy, because I think that's what we do, man. Work with comics, for example. You take a piece of paper and you just take a brush like this, and you take some ink. There's nothing here. There's literally nothing here. The engine is this (Paul points to heart and head). That's what I think is the engine of all this stuff. It's really just ideas at the end of the day.

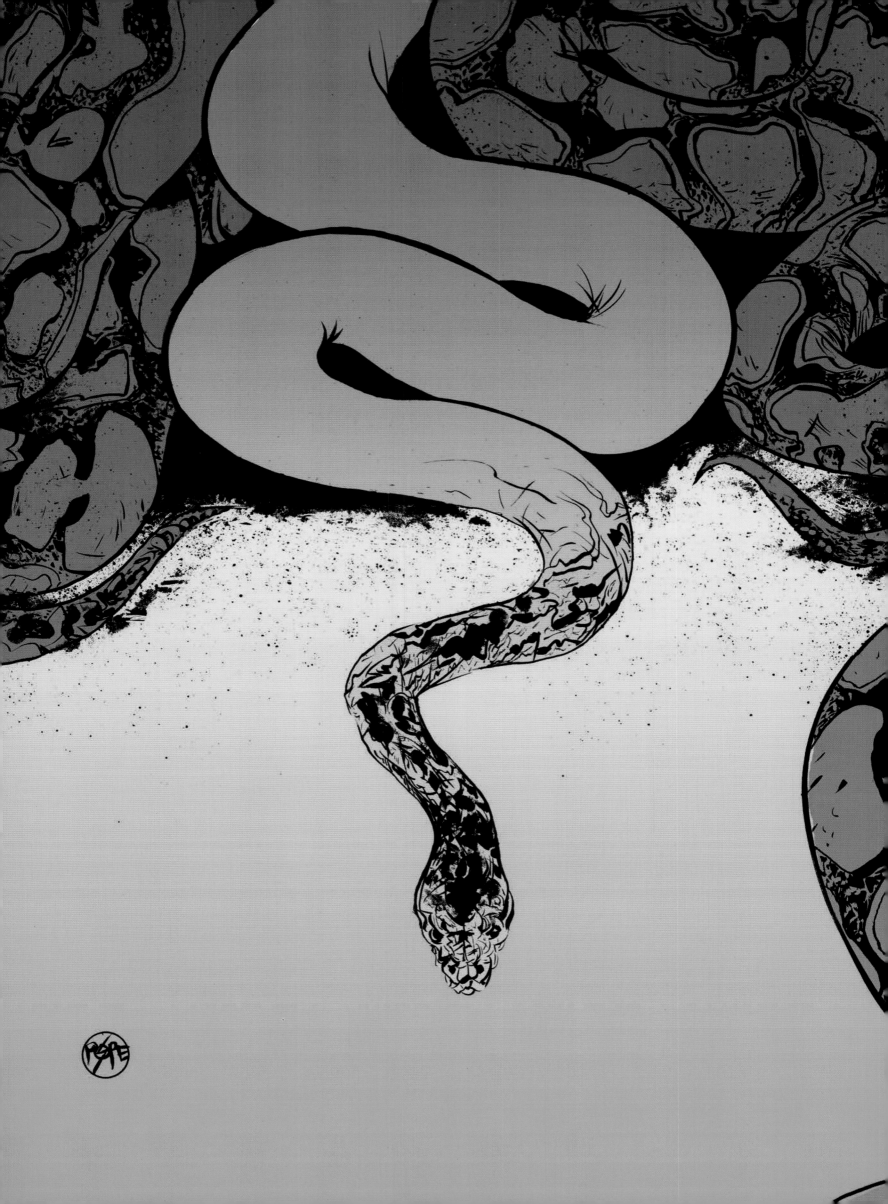

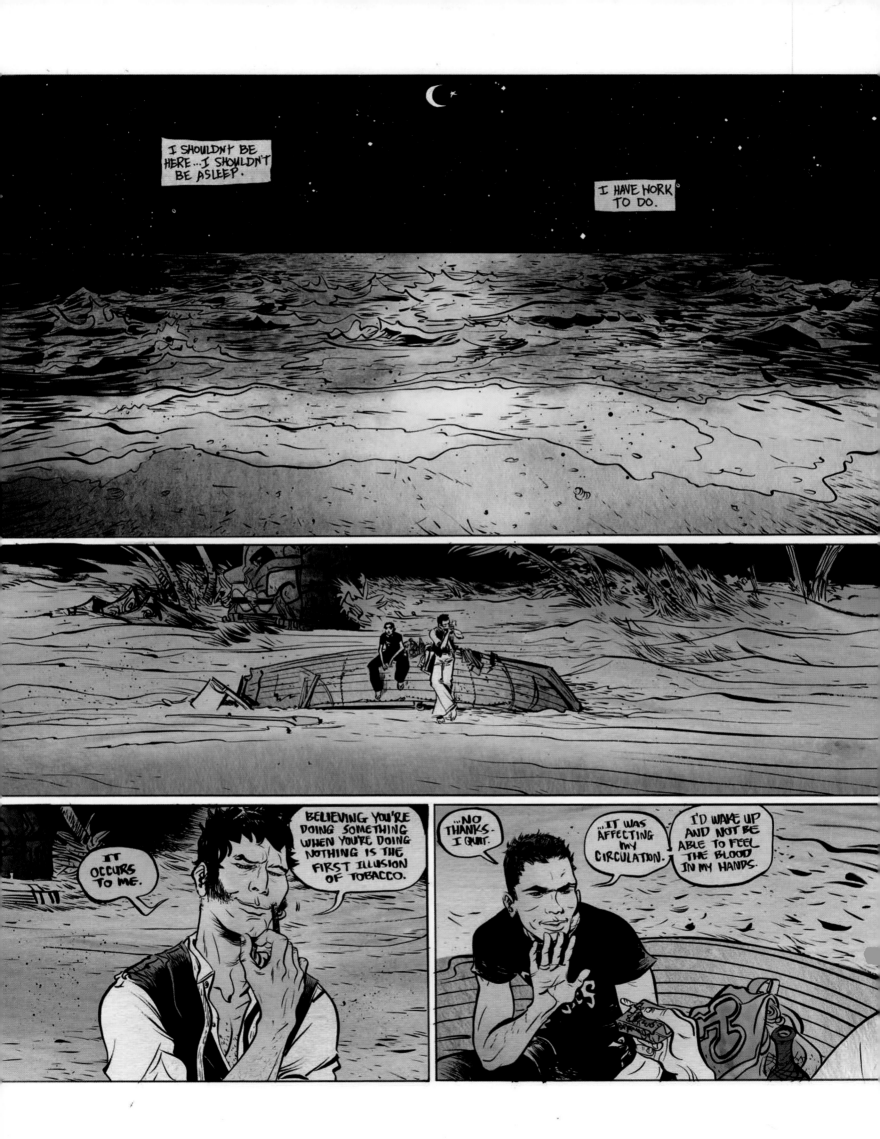

253

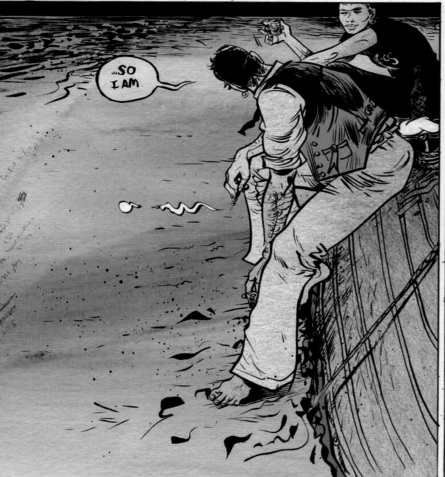

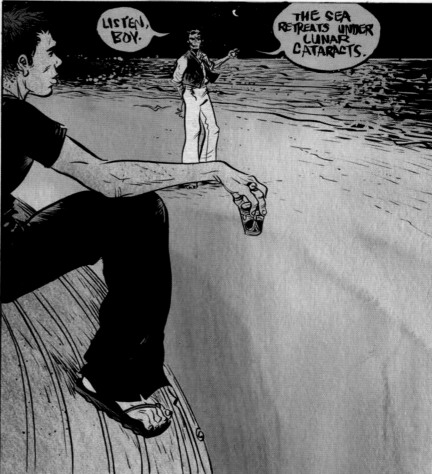

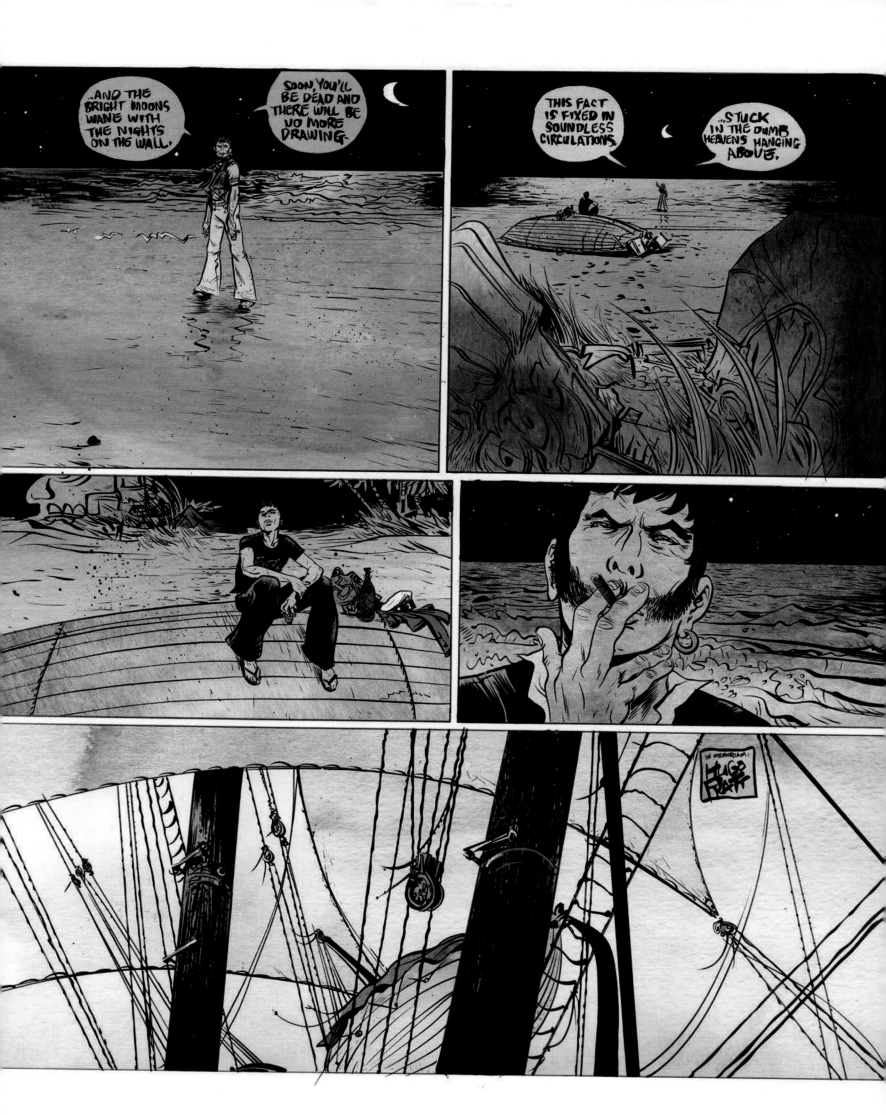

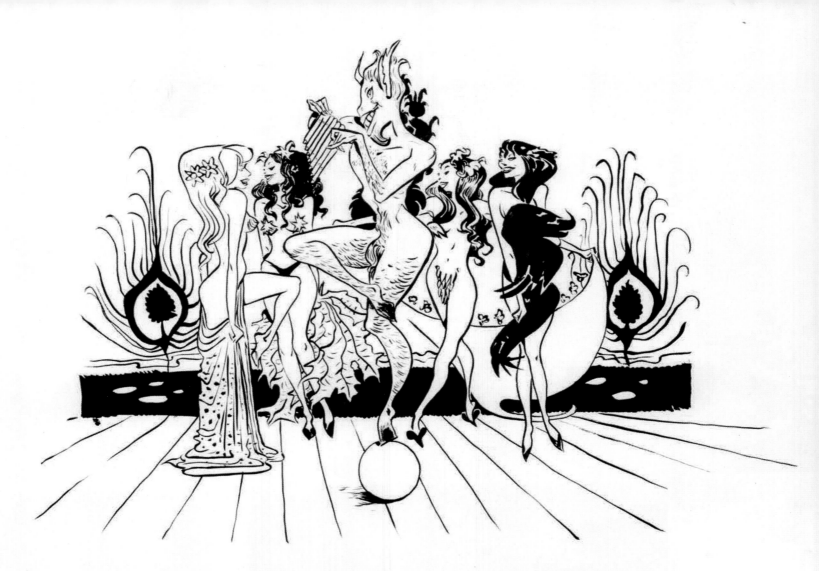

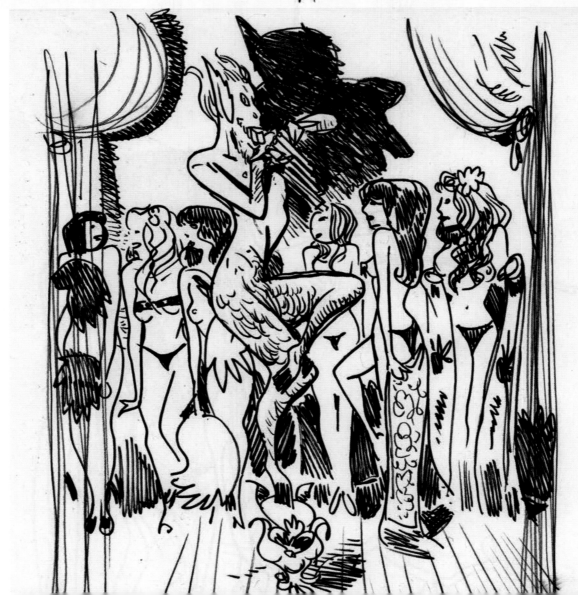

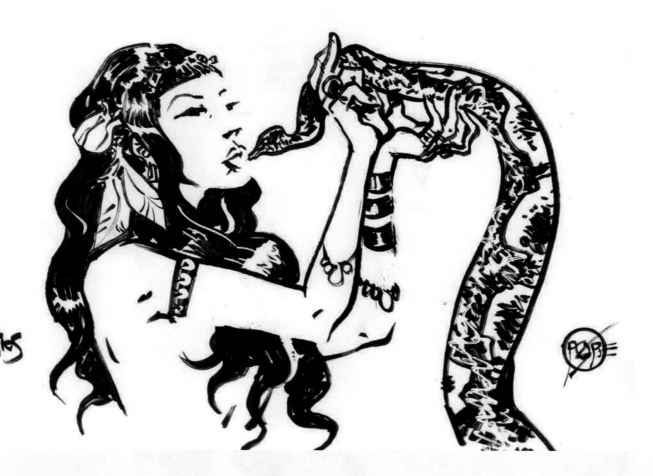

THEE
HYPNOTICS

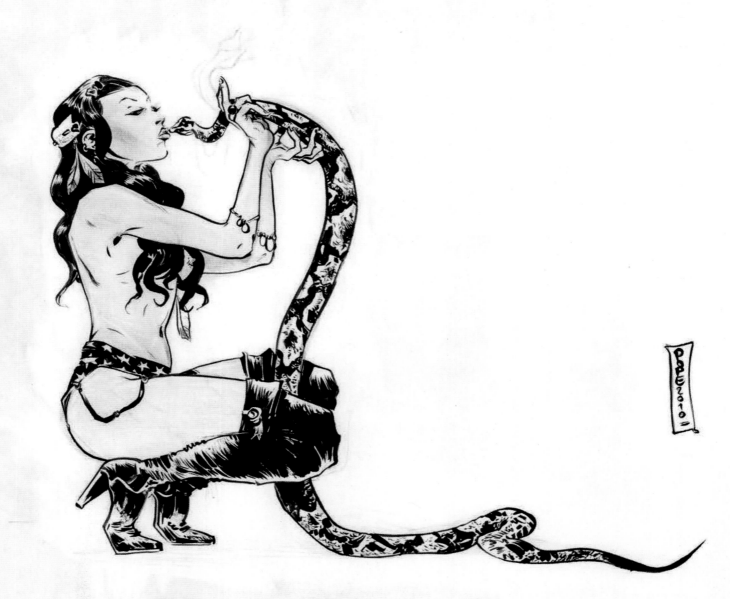

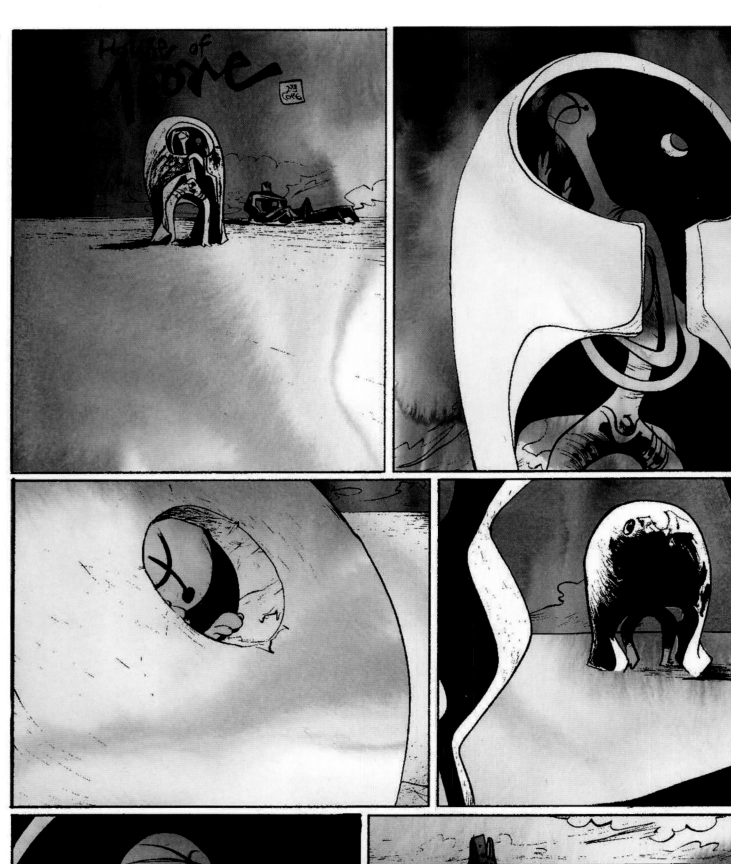

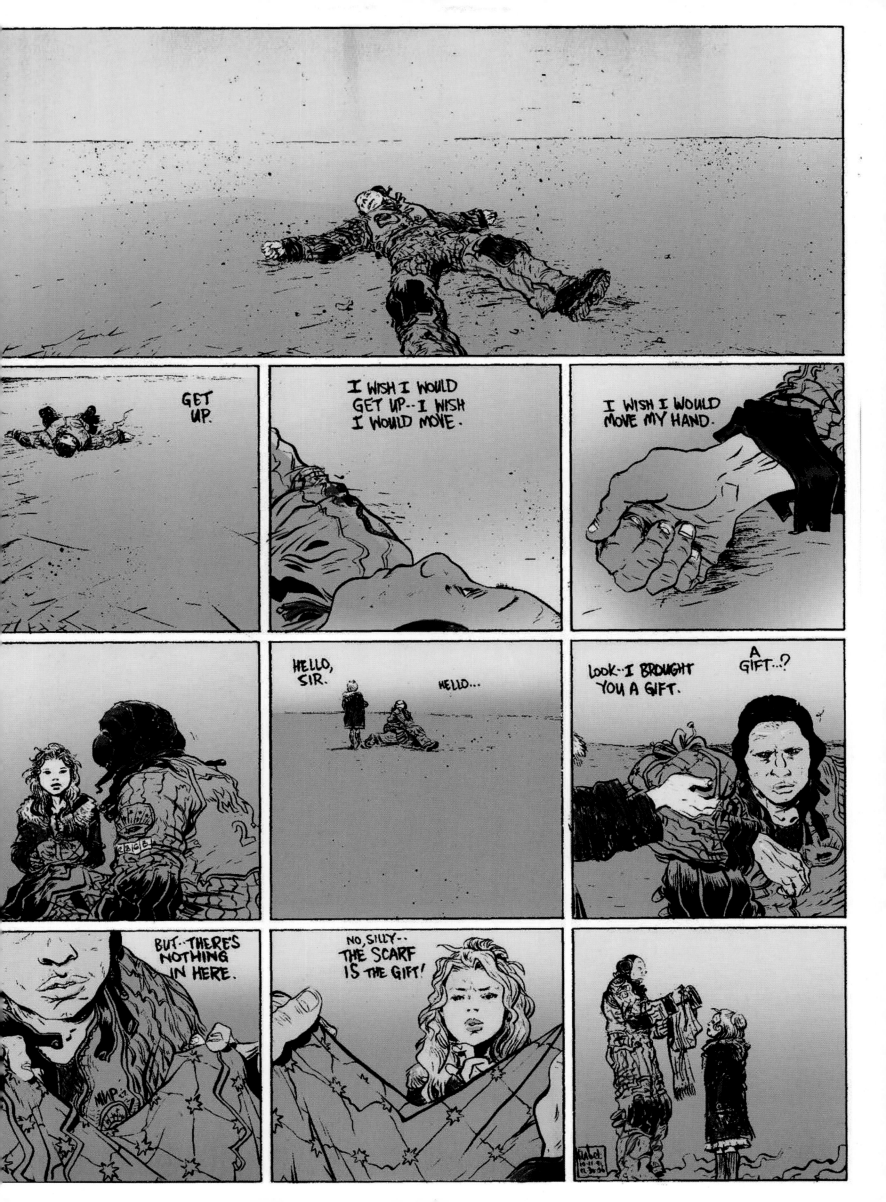

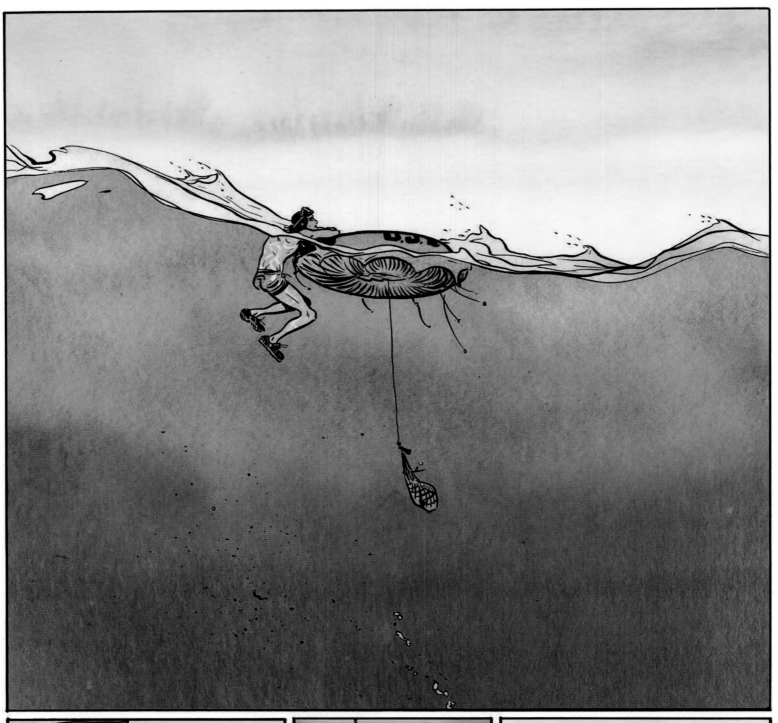

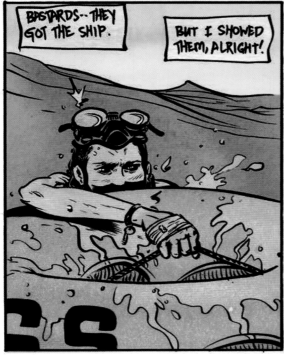

Feb. 2. 2009

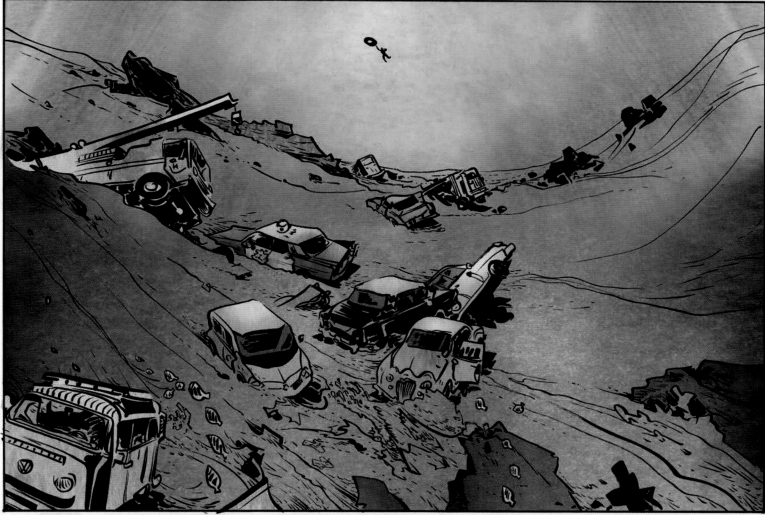

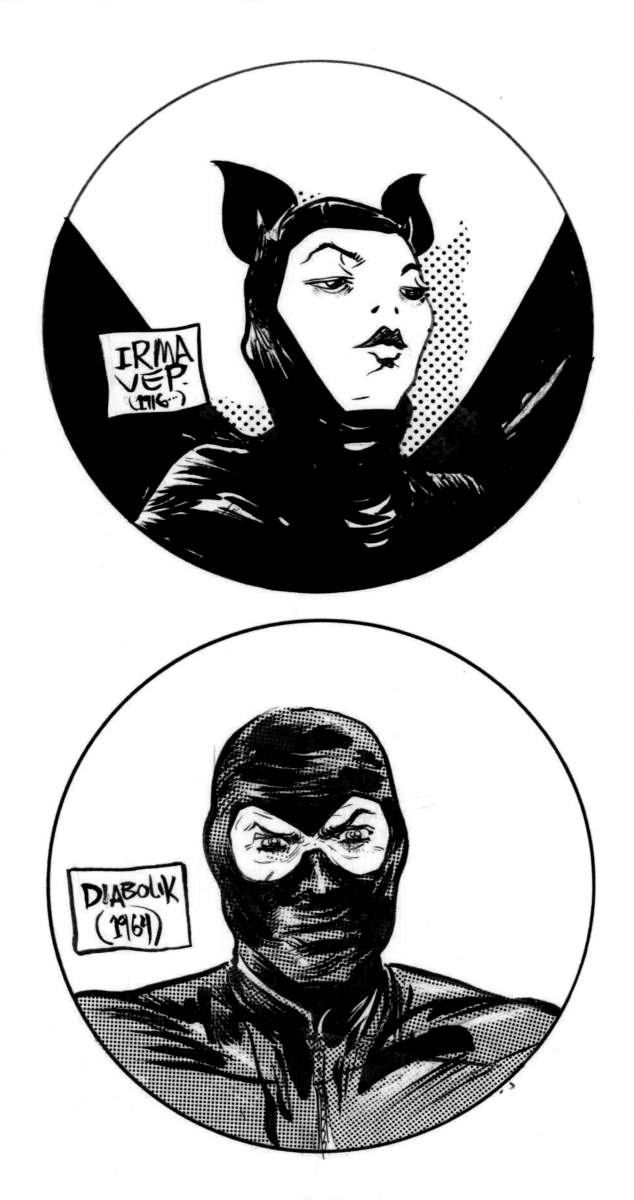

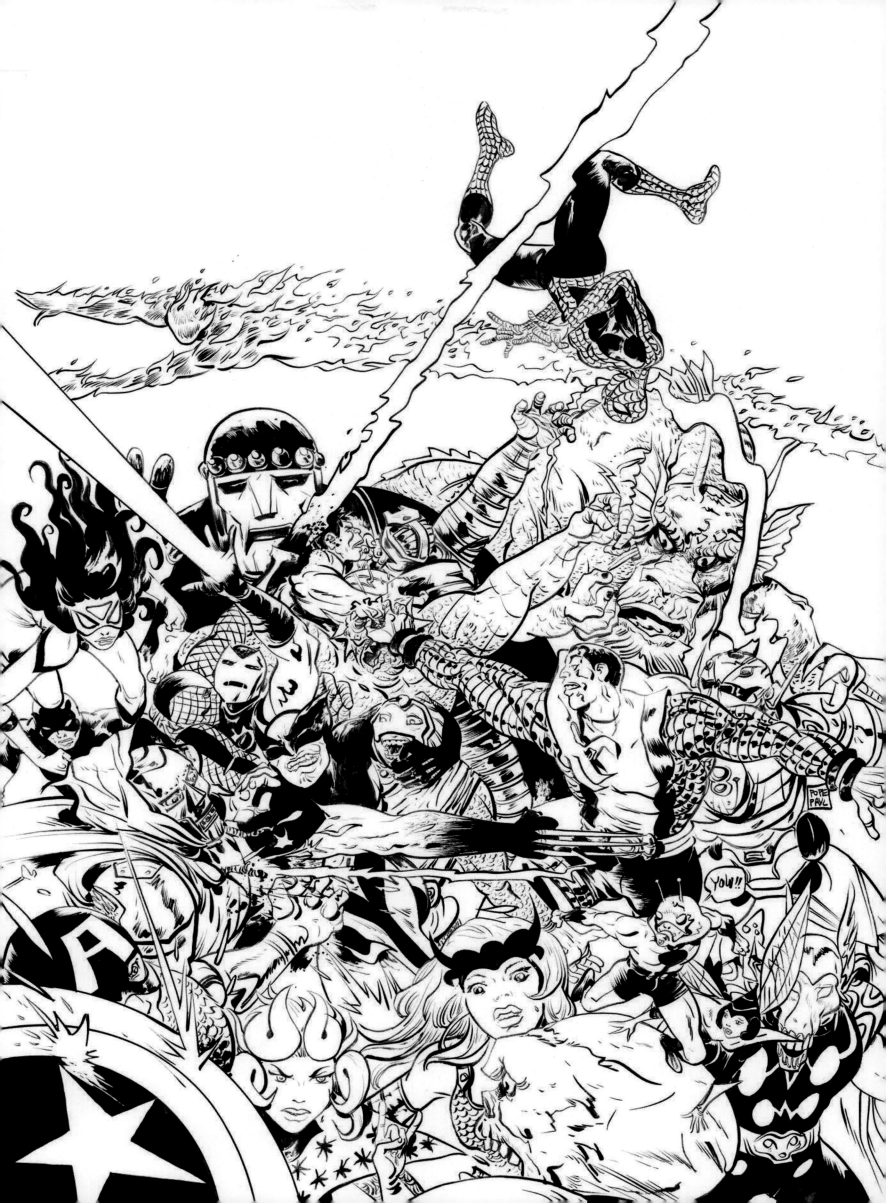

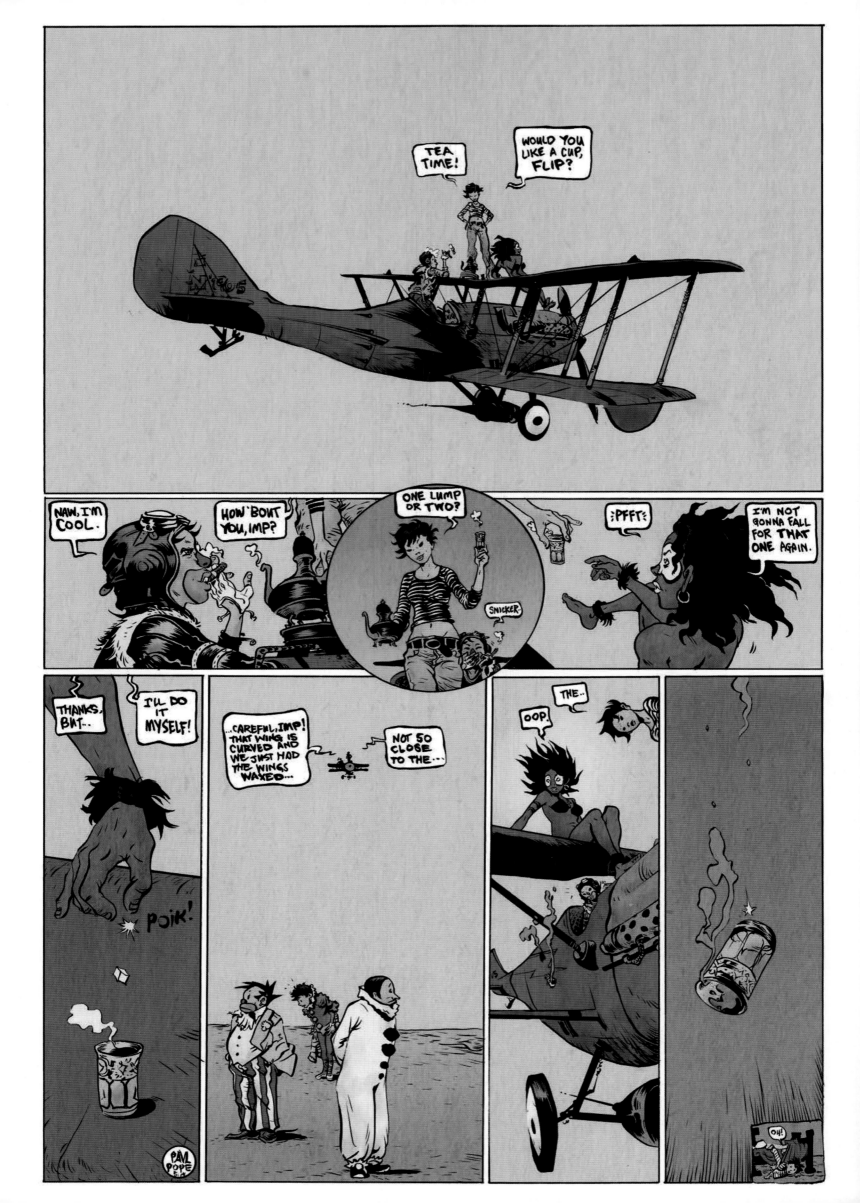

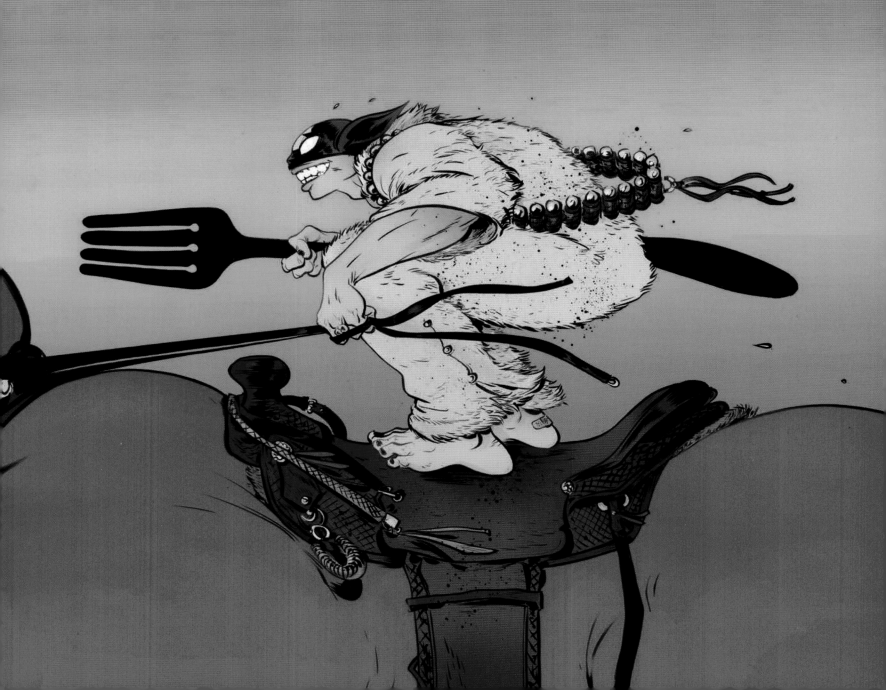

MEKBOX

MKbX

EXOMEK

ENDOMEK

·MKbX·
MEK BOX·WAFBOX·
1/1 SCALE
THB-3A / Paul Pope

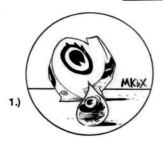

1.)

MKbX

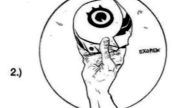

2.)

EXOMEK

3.)

4.)

ENDOMEK

5.)

 ·MKbX·

1.) MEK-BOX (showing ENDOMEK and EXOMEK units)
2.) MEK-BOX (the outer EXOMEK casing when closed)
3.) MEK-BOX (opening to reveal the inner ENDOMEK unit)
4.) MEK-BOX (the removeable ENDOMEK without EXOMEK)
5.) MEK-BOX (the freestanding ENDOMEK unit on its own)

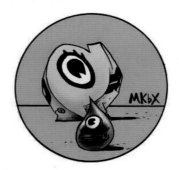

MKbX

EXOMEK

ENDOMEK

MKbX

·MKbX·
MEK BOX·WAFBOX·
1/1 SCALE
THB-3A / Paul Pope

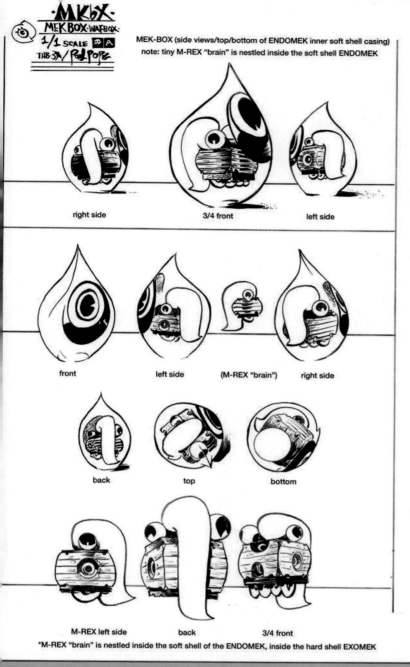

·MKbX·
MEK·BOX·WAFBOX·
1/1 SCALE
THB-3A / Rod Pope

MEK-BOX (side views/top/bottom of ENDOMEK inner soft shell casing)
note: tiny M-REX "brain" is nestled inside the soft shell ENDOMEK

right side 3/4 front left side

front left side (M-REX "brain") right side

back top bottom

M-REX left side back 3/4 front

*M-REX "brain" is nestled inside the soft shell of the ENDOMEK, inside the hard shell EXOMEK

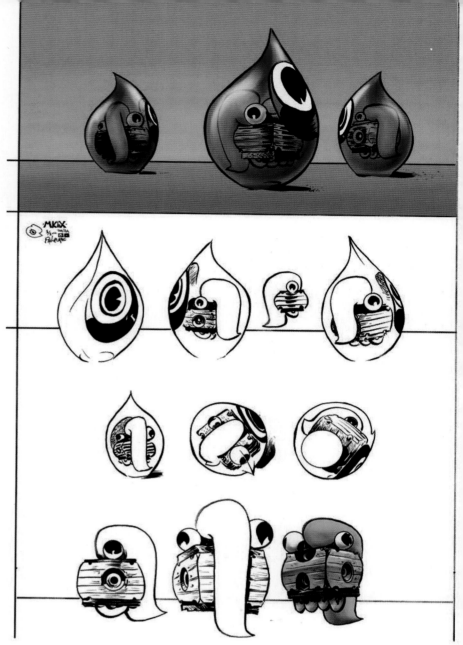

·MKbX·
THB-3A / Pope

·MKbX·
·THB-3A·
MEK-BOX (side views/top/bottom of EXOMEK outer shell casing, ENDOMEK soft shell on its side)

front back top 01 top 02 bottom

front right side back bottom

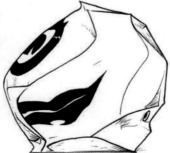
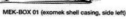

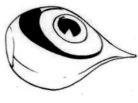

MEK-BOX 01 (exomek shell casing, side left) MEK-BOX 02 (endomek soft shell)

·MKbX·
MEK·BOX·WAFBOX·
1/1 SCALE
THB-3A / Rod Pope

3

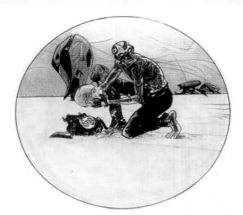

·ИVbMK·
·INVISIBLE MEK·
1/6 SCALE 💀 A
THB:3A / PaulPOP

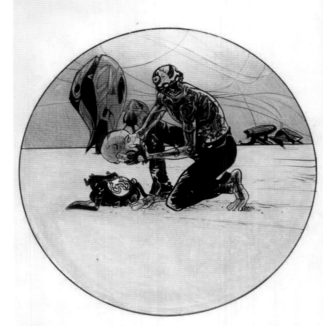

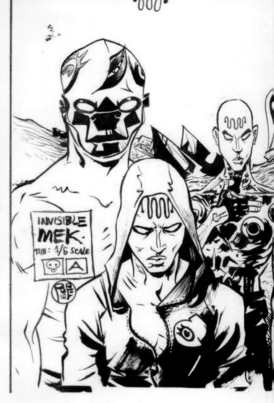

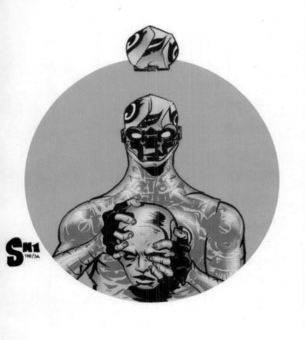

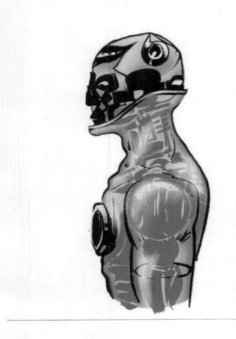

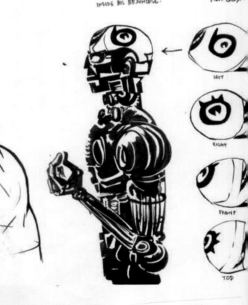

EXPOSED ARMATURE
The MEK-BOX sits
INSIDE his BRAINCASE:

MEK-BOX

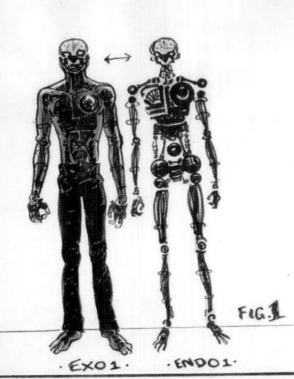

·EXO1· ·END01·

FIG.1

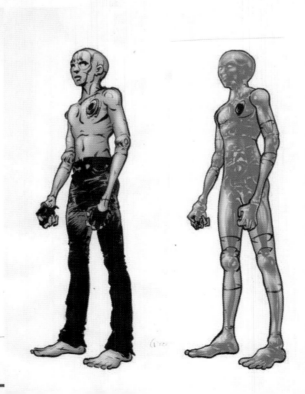

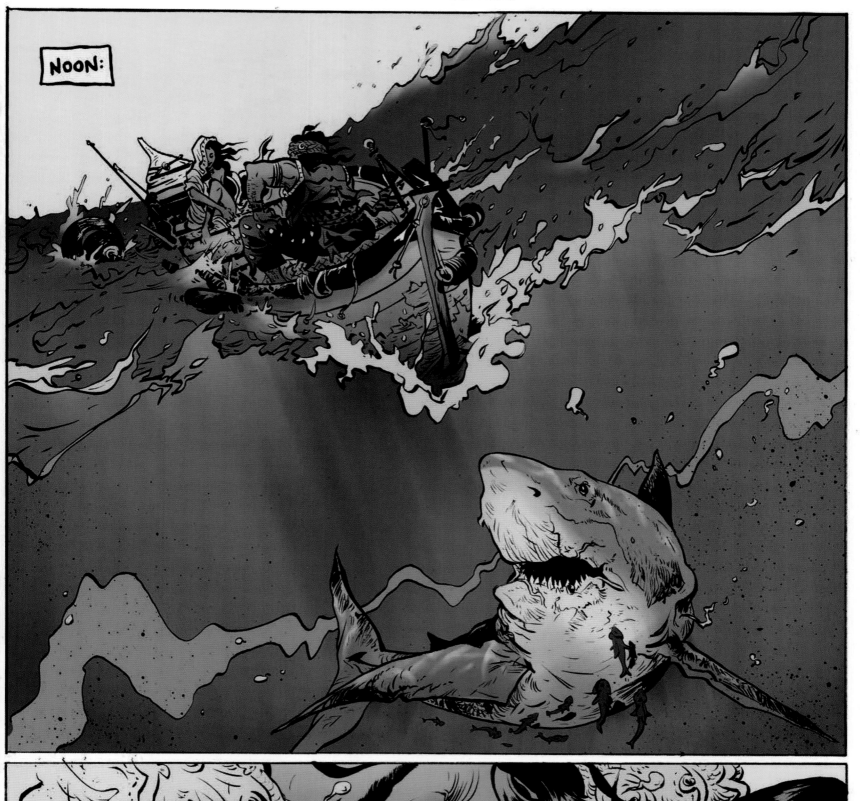

NOON:

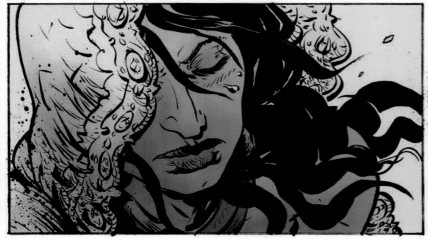

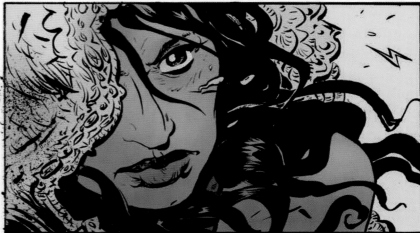

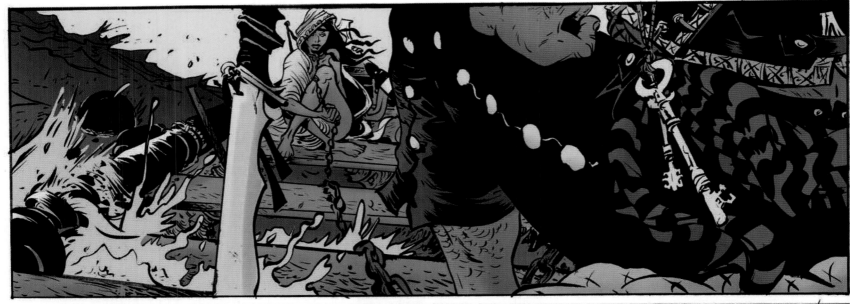

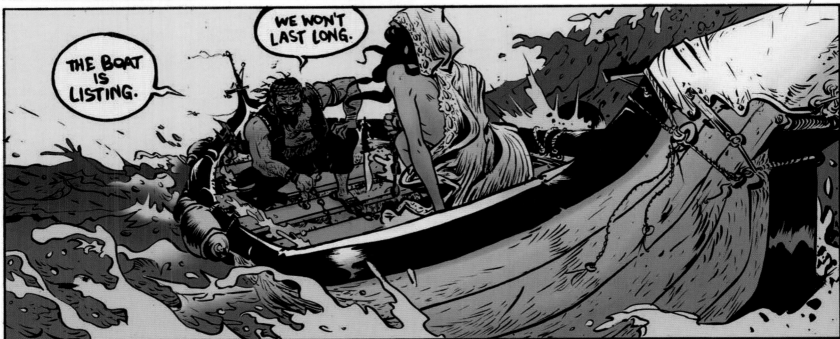

THE BOAT IS LISTING.

WE WON'T LAST LONG.

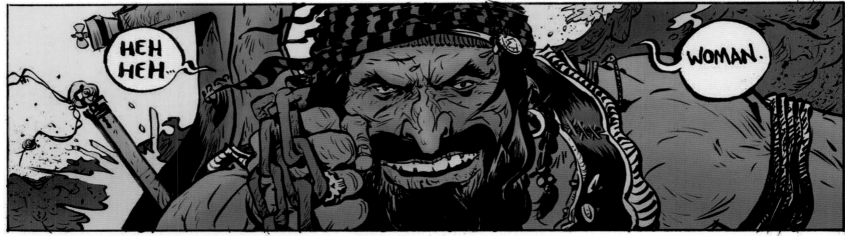

HEH HEH...

WOMAN.

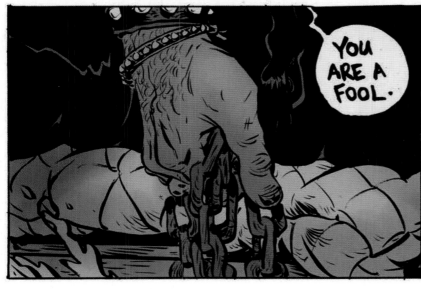

YOU ARE A FOOL.

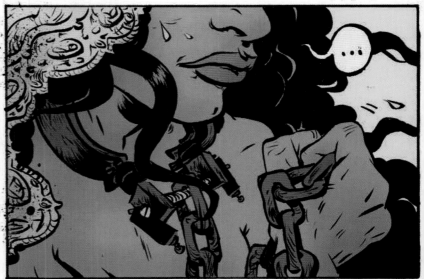

...

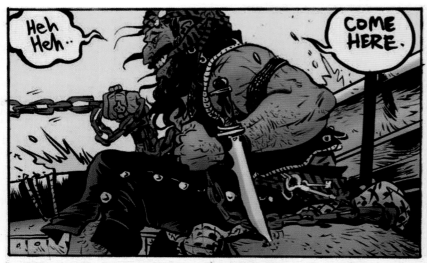

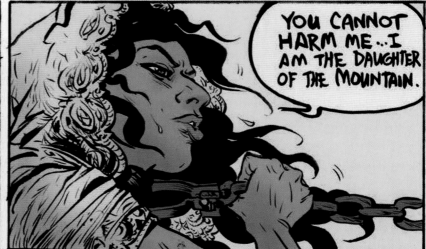

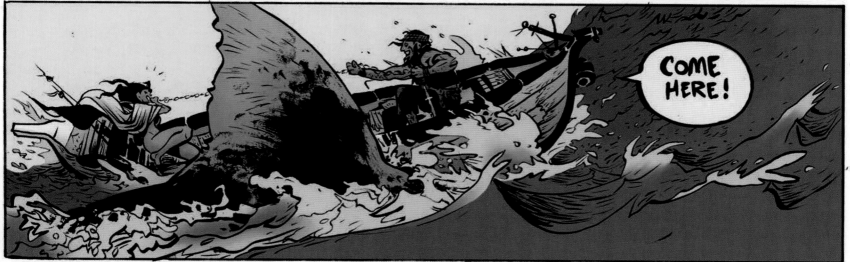

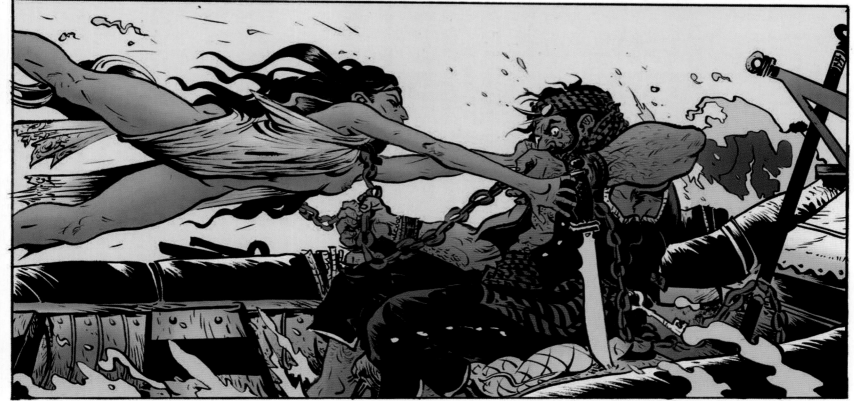

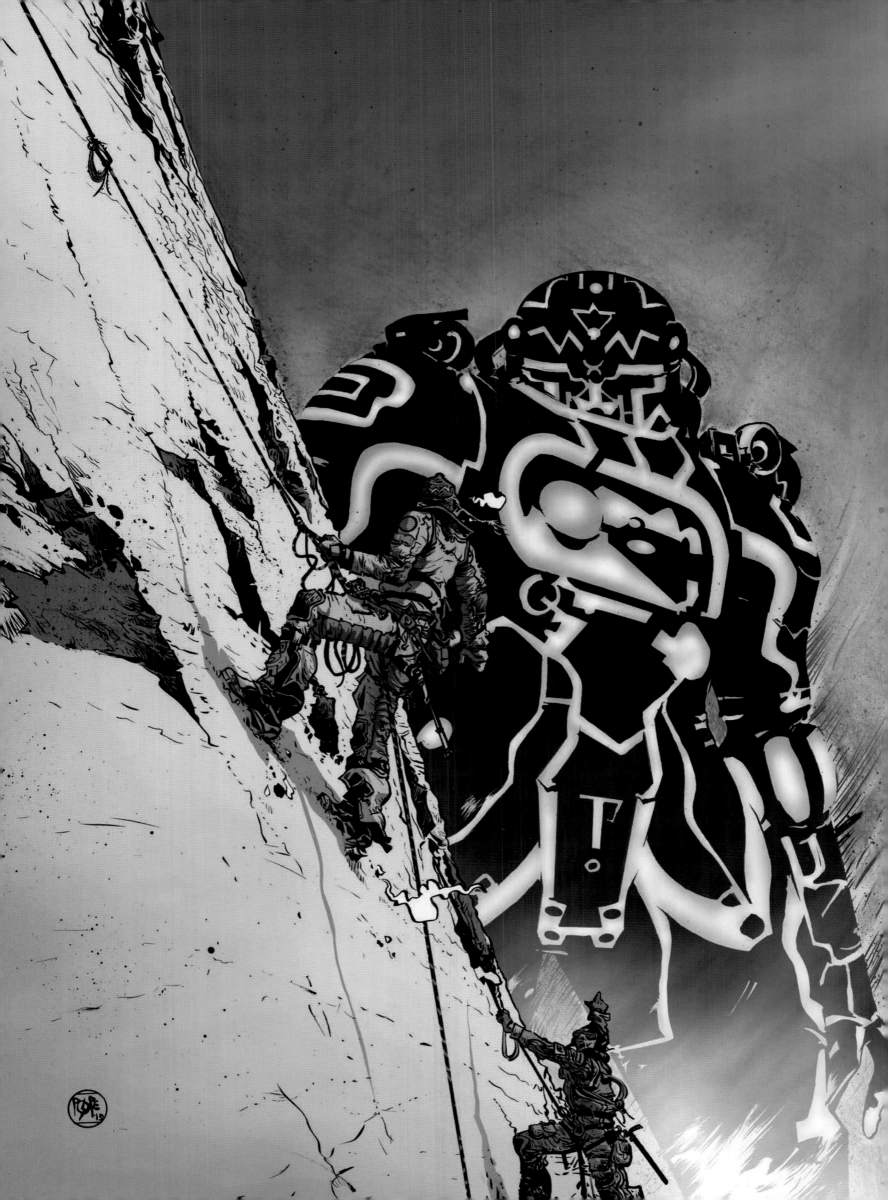

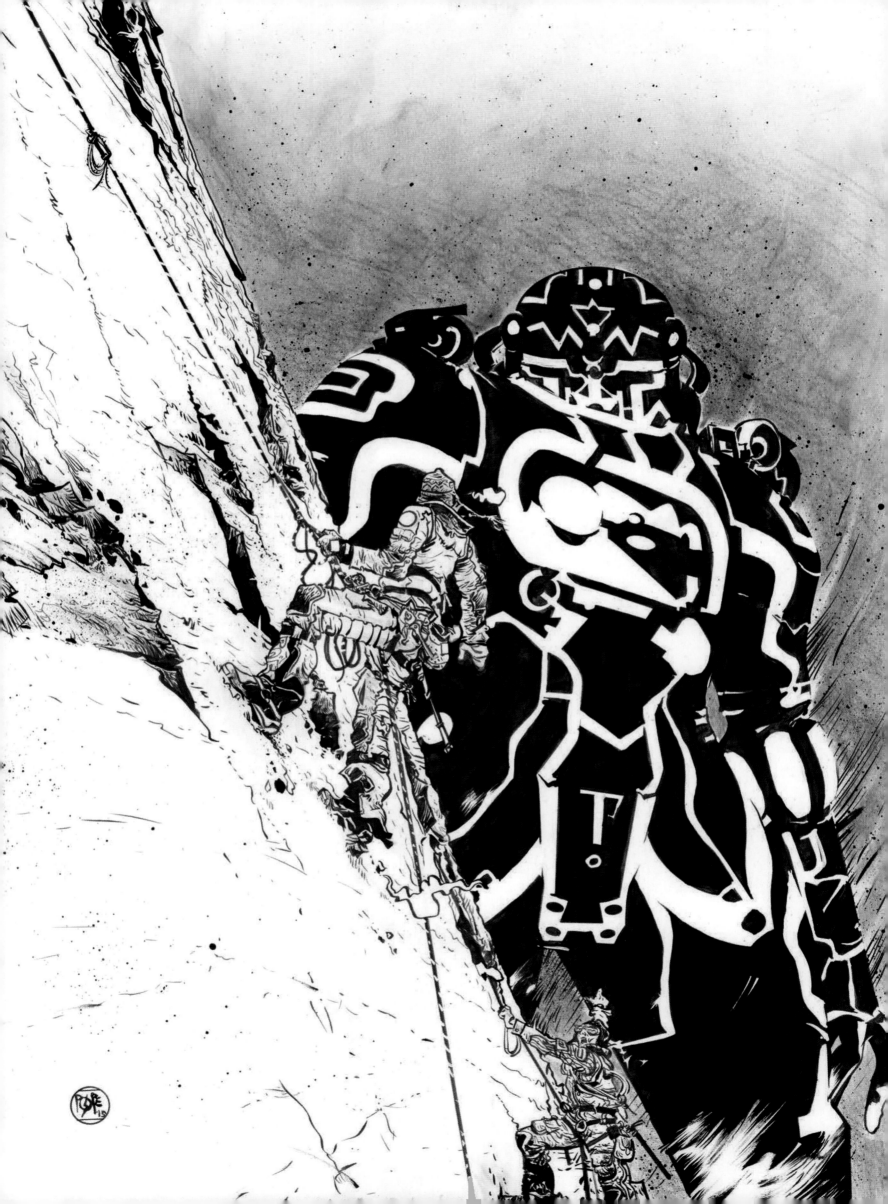

METAL ILIAD

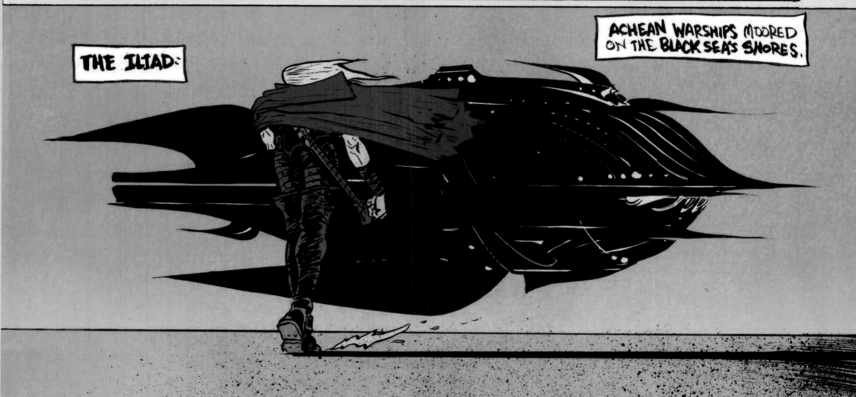

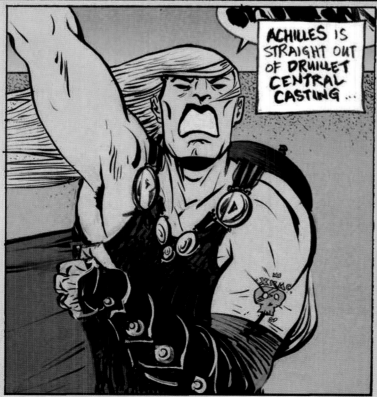

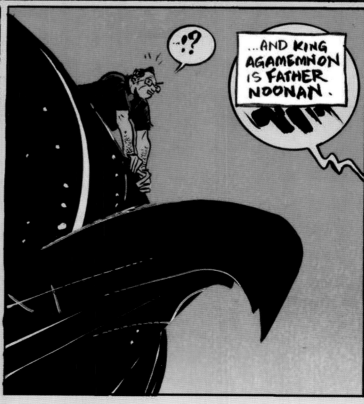

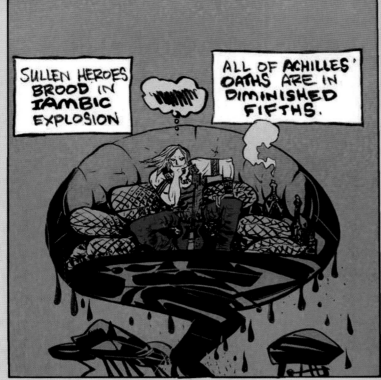

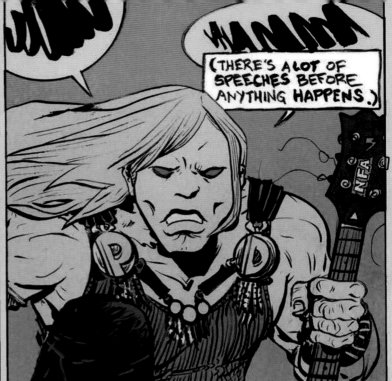

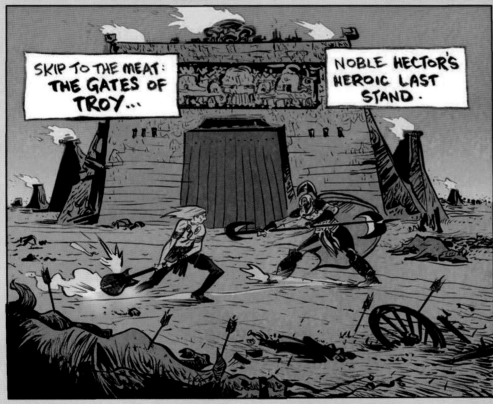

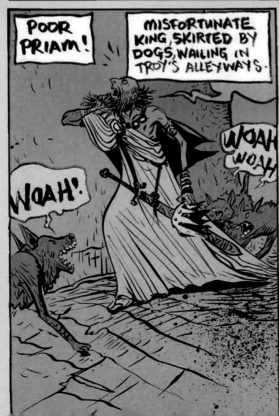

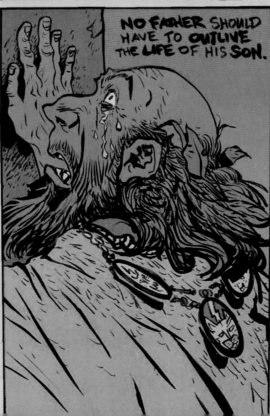

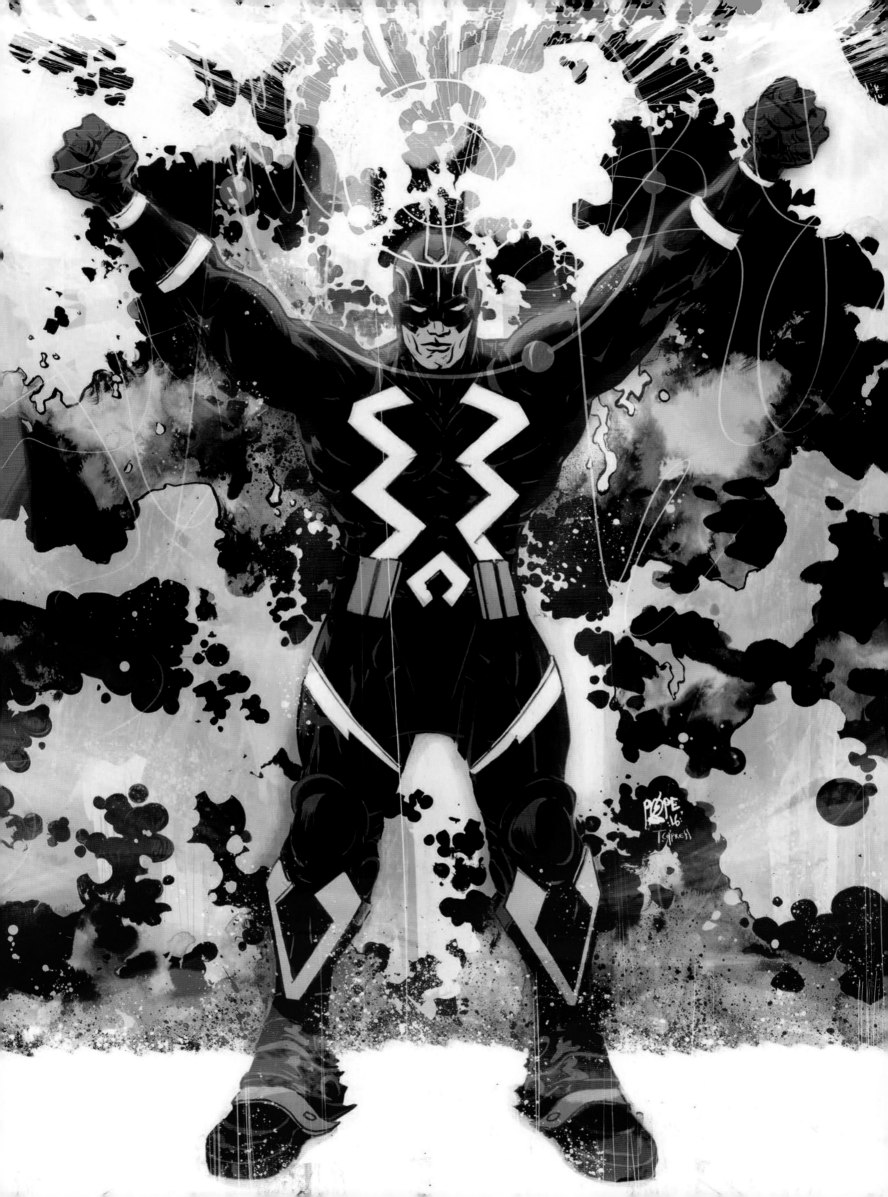

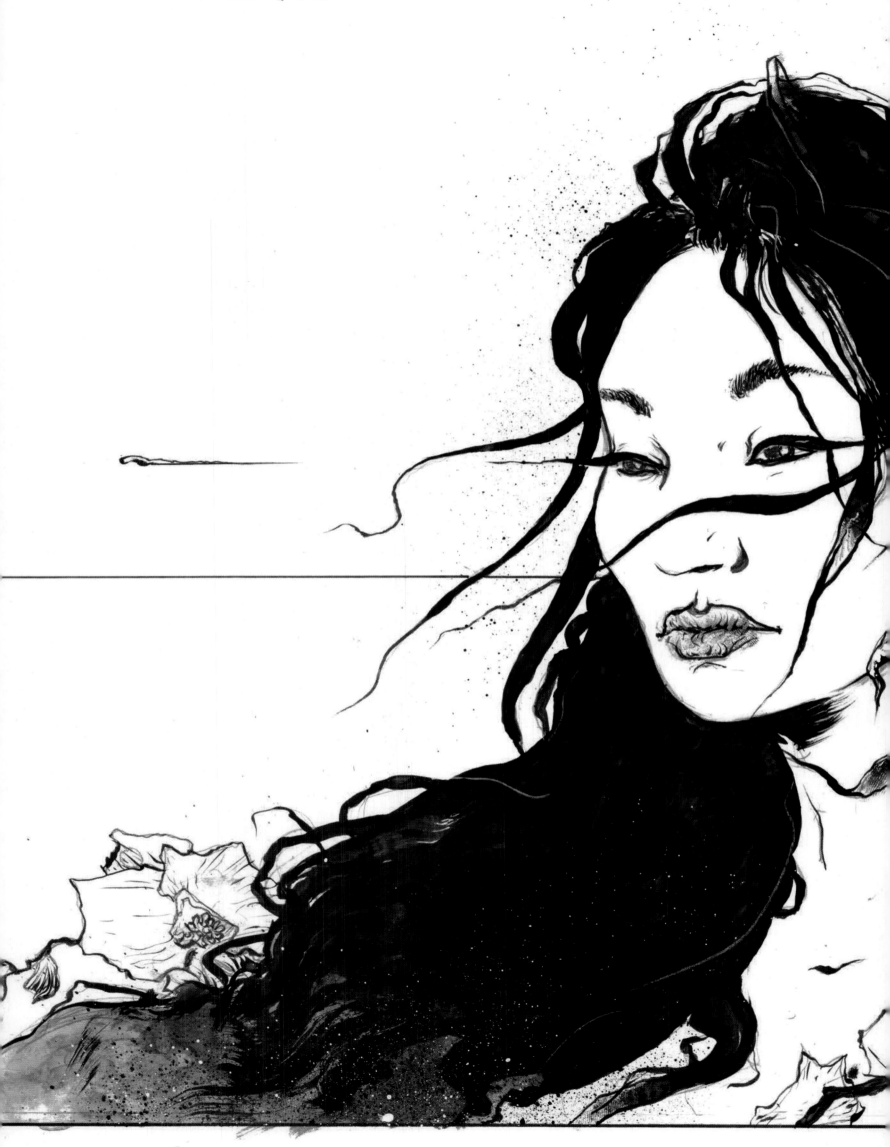

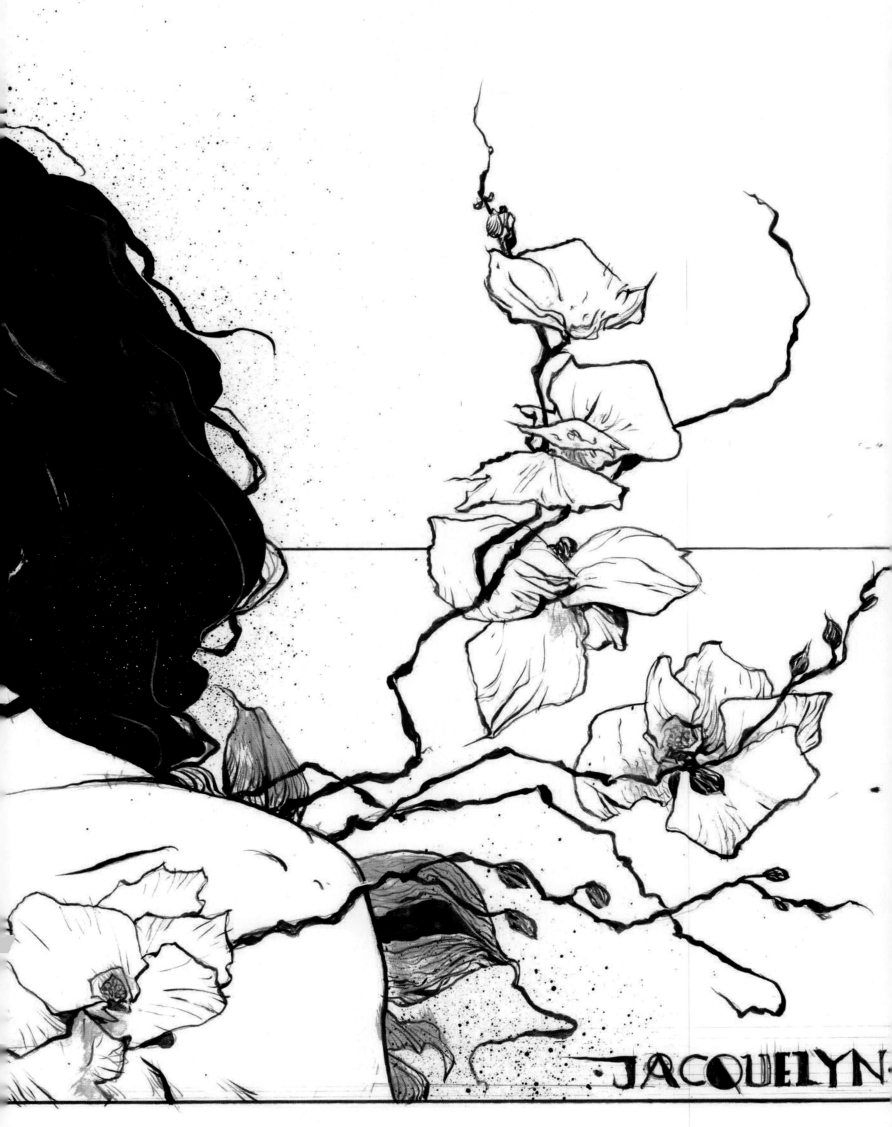

JACQUELYN

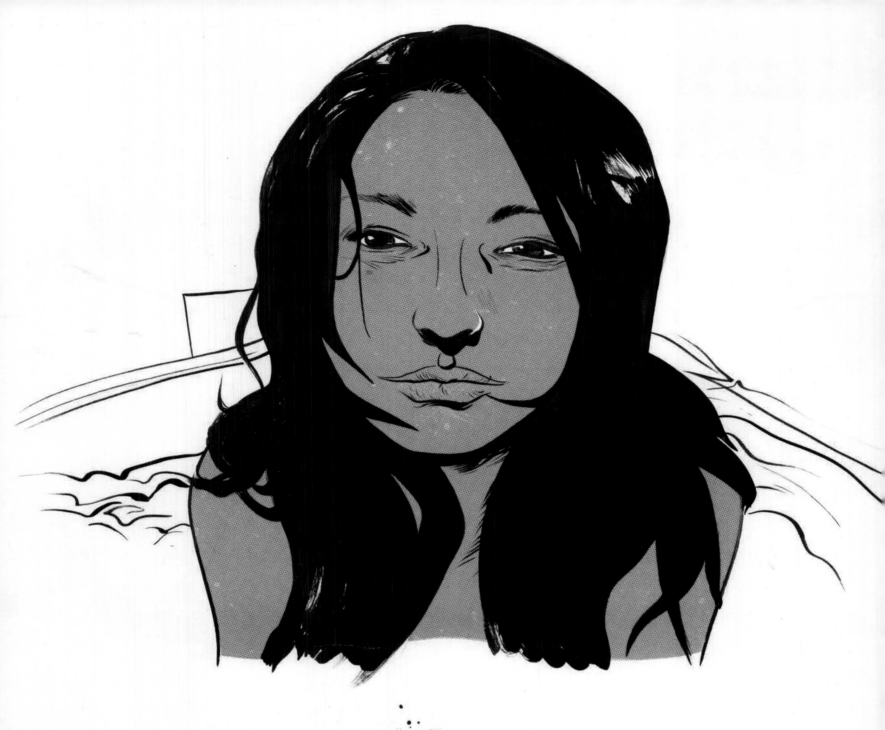

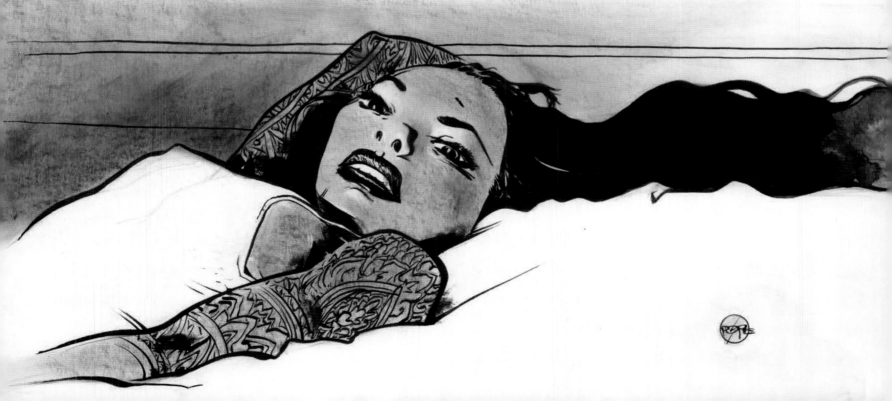

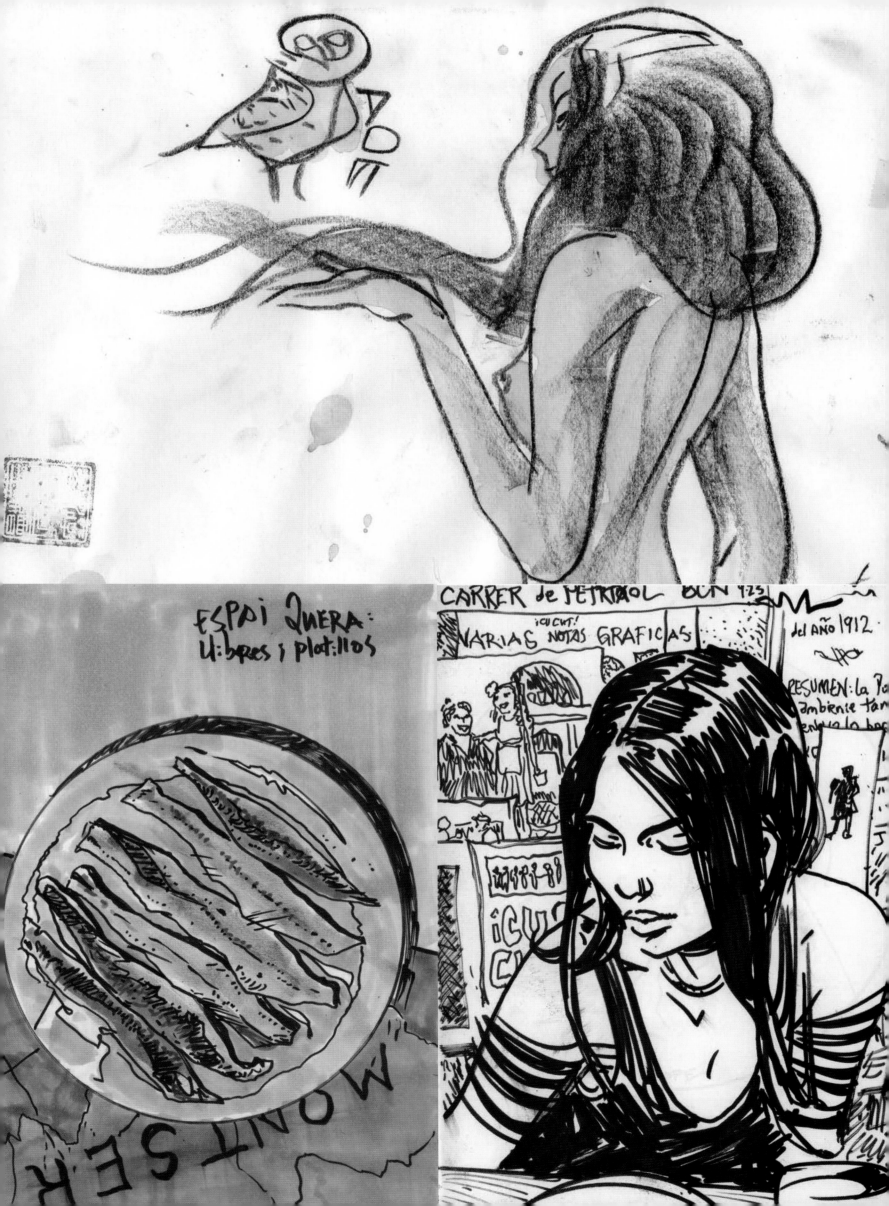

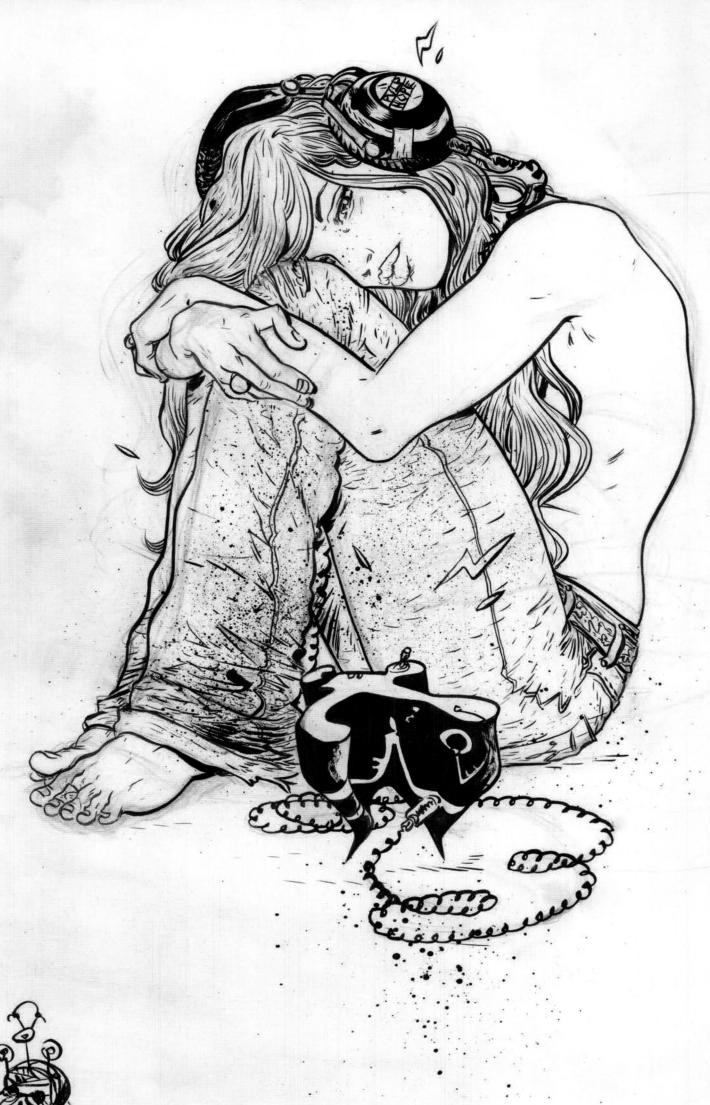

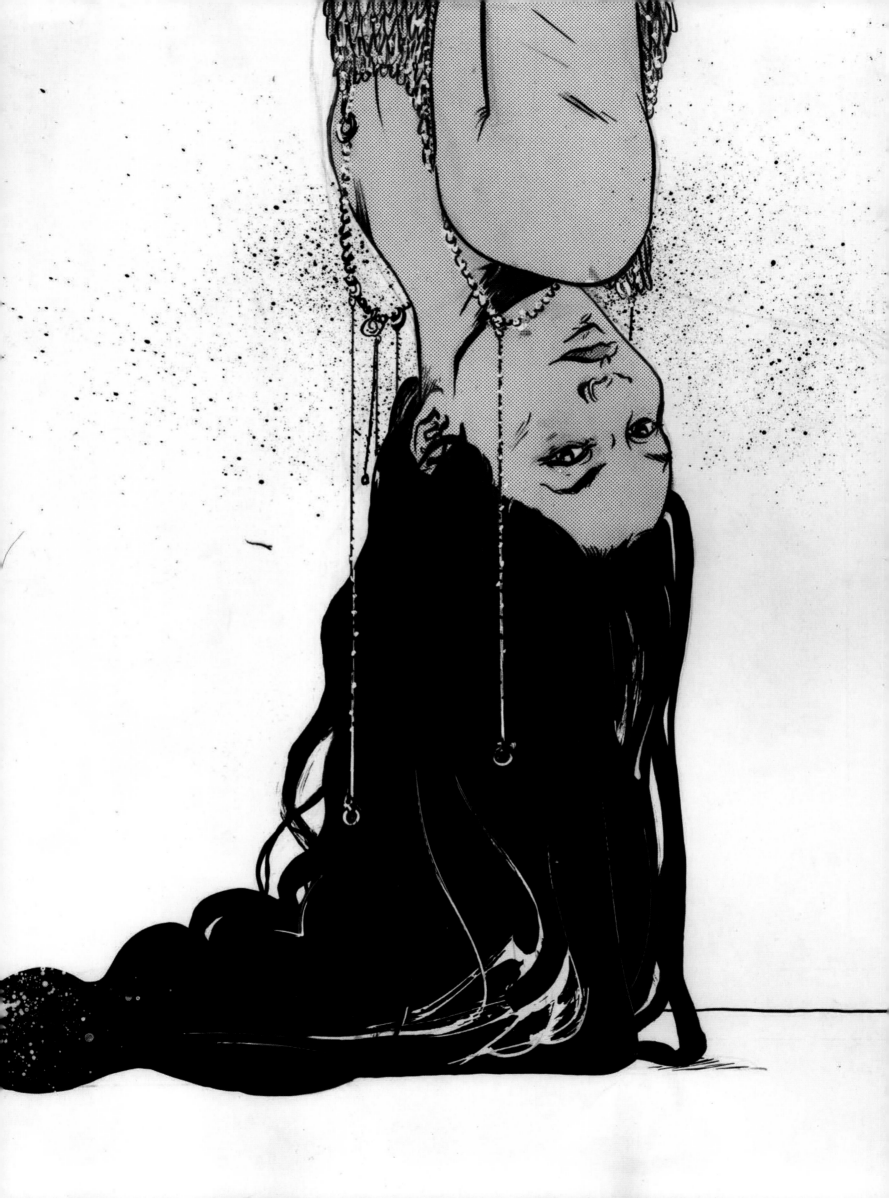

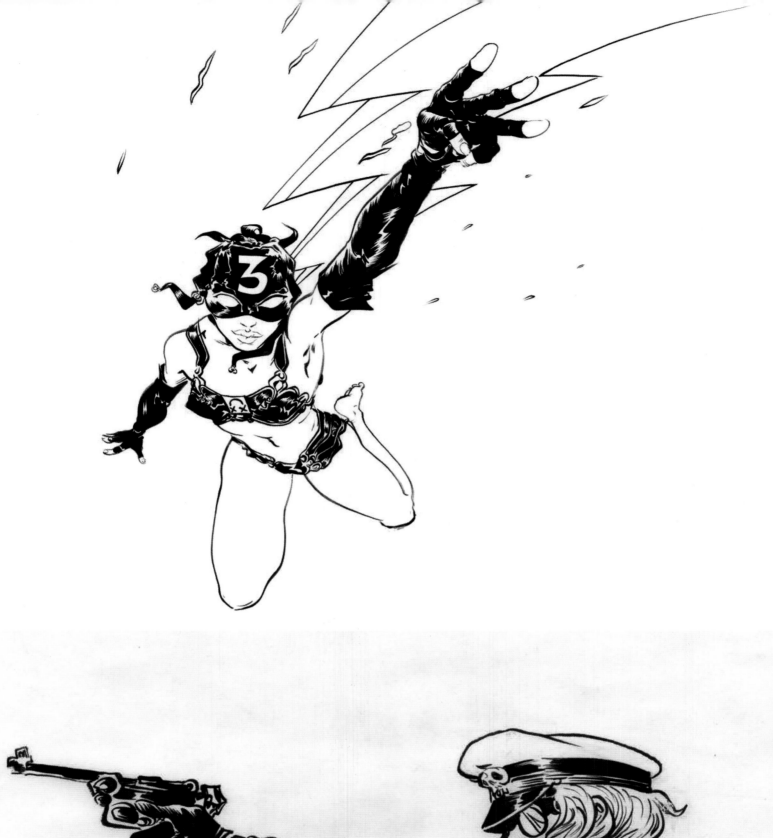
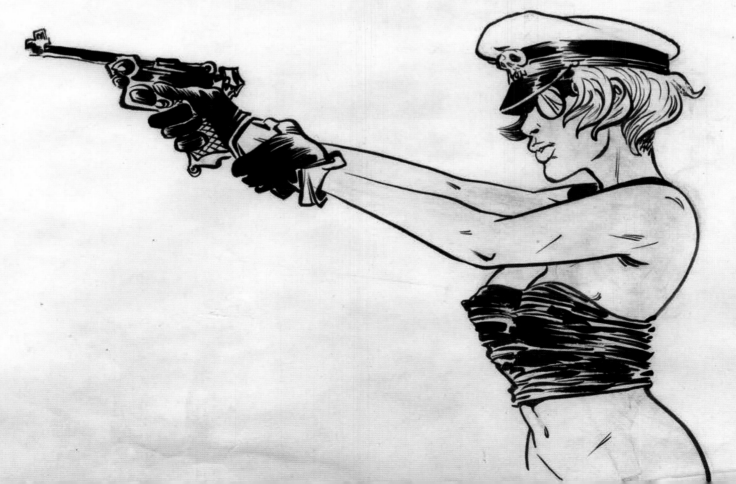

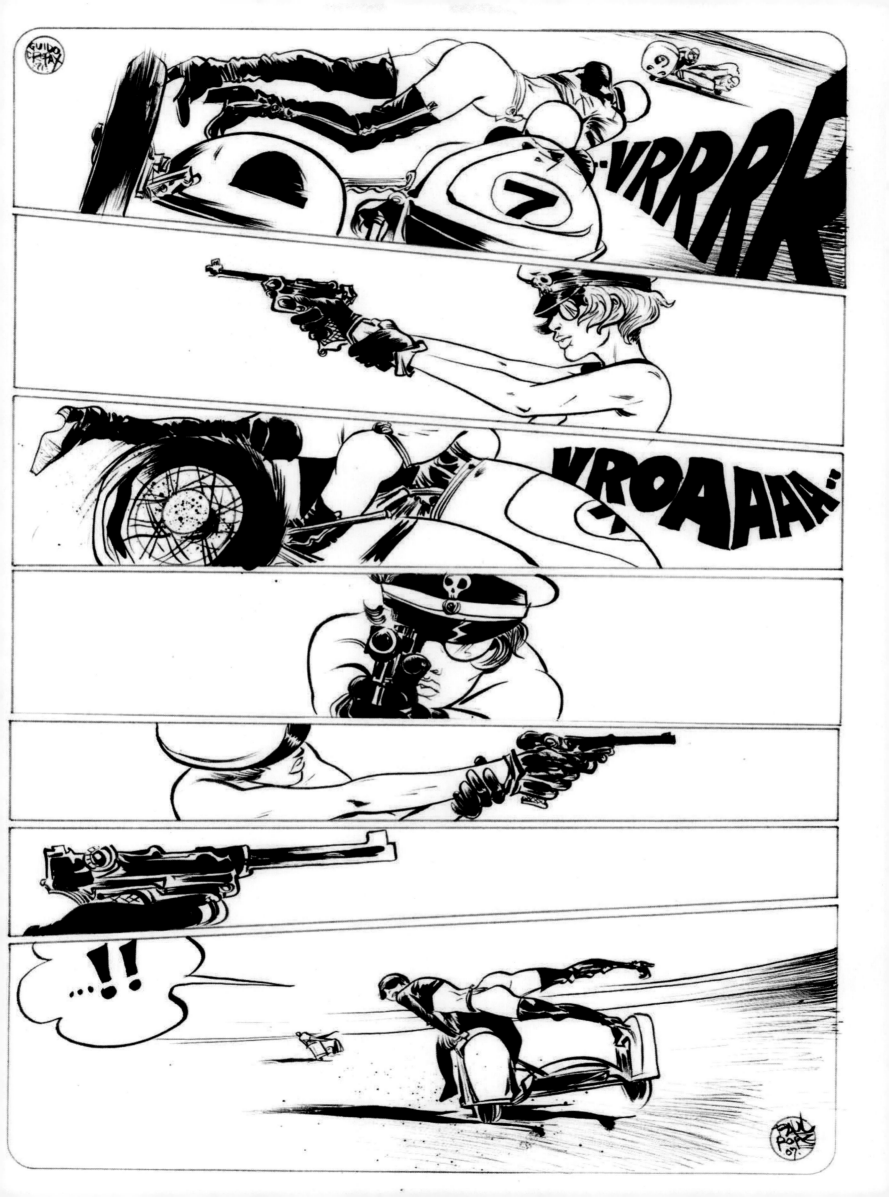

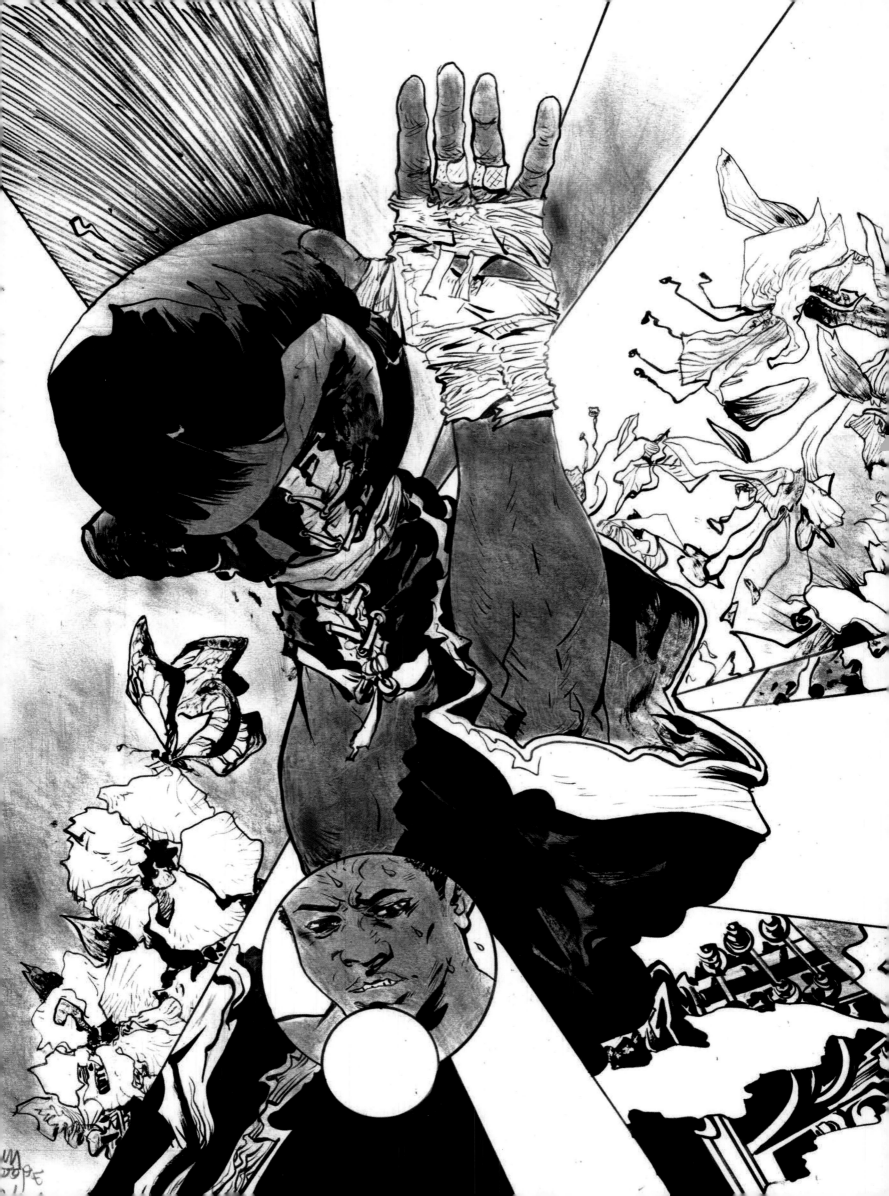

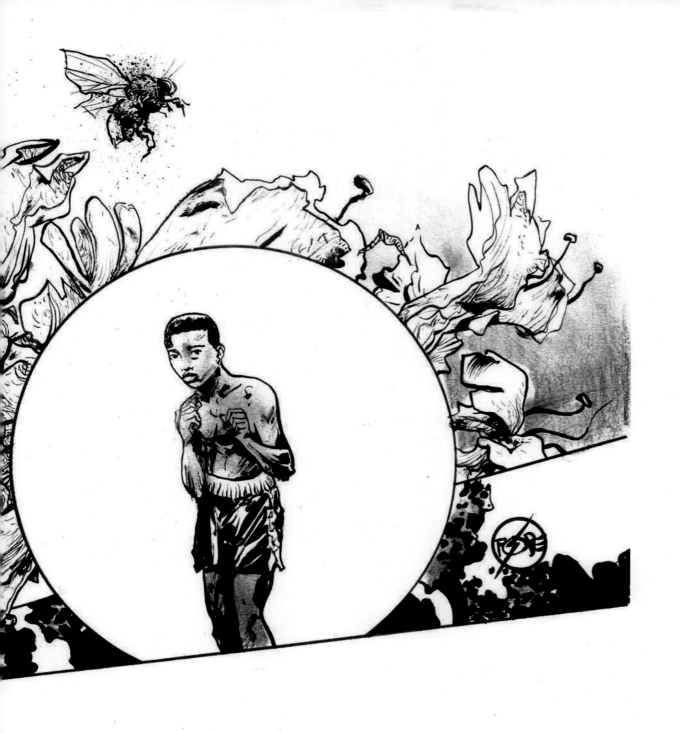

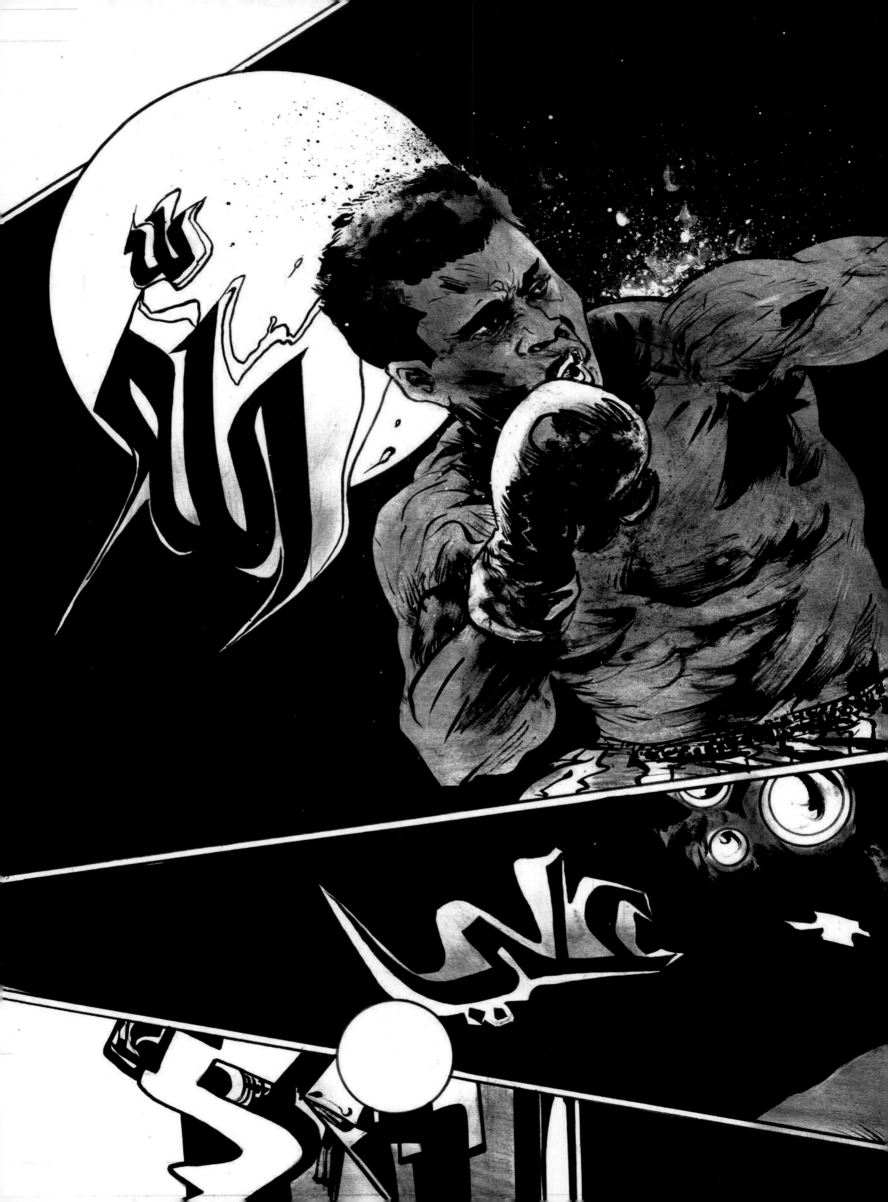

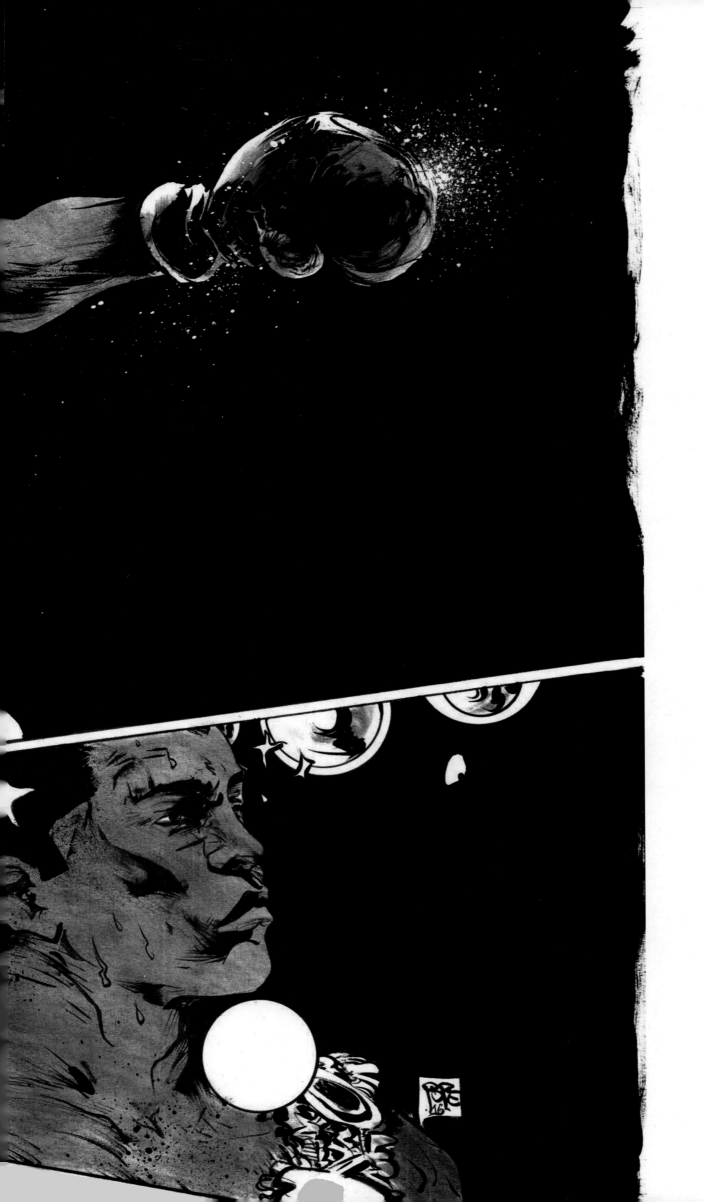

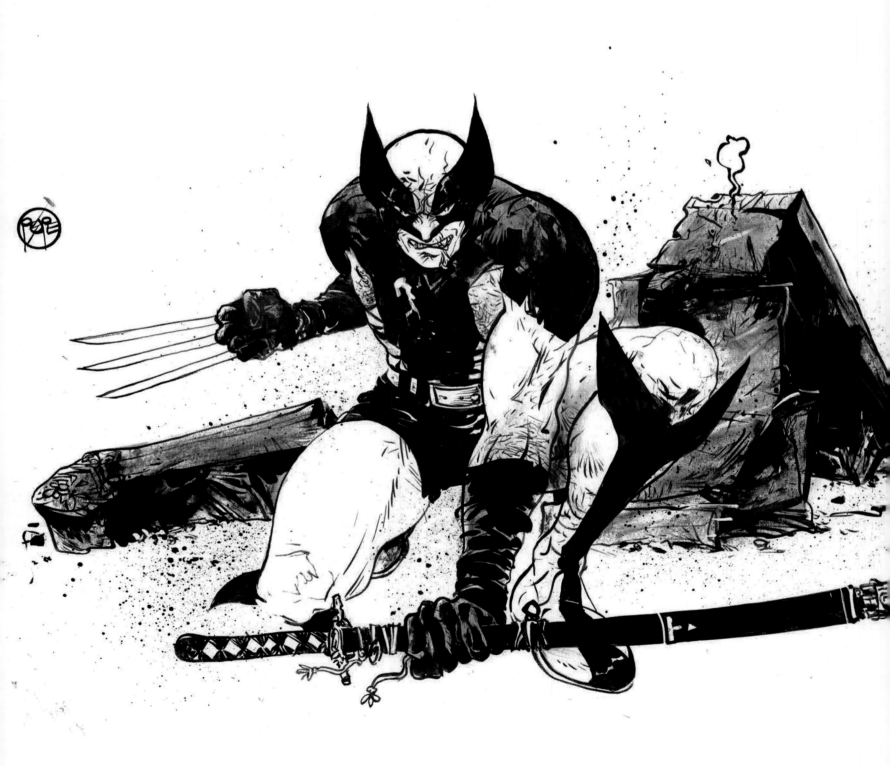

THEE HYPNOTICS

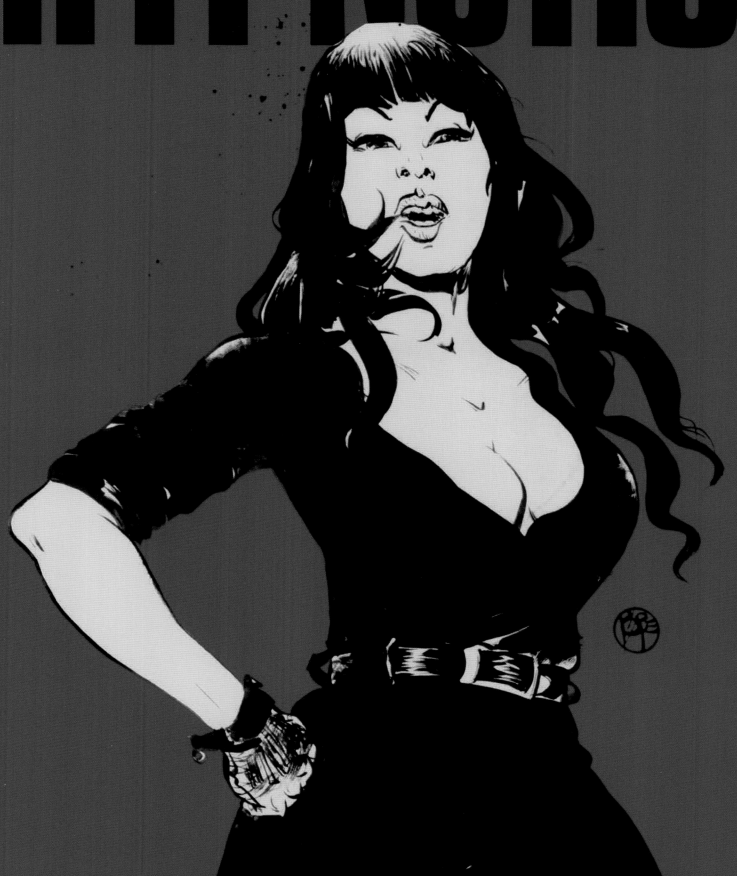

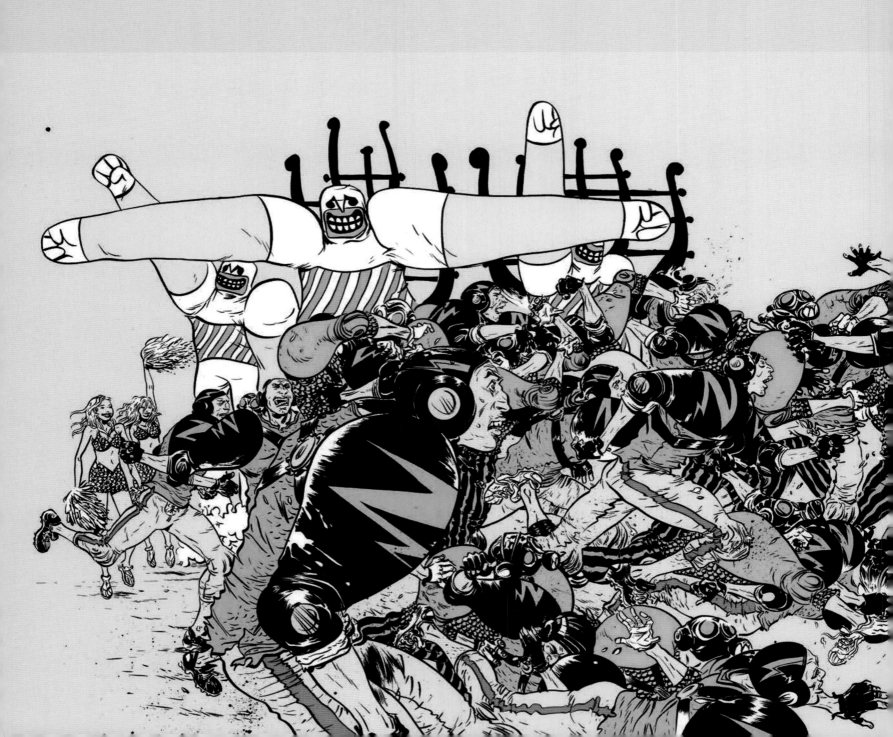

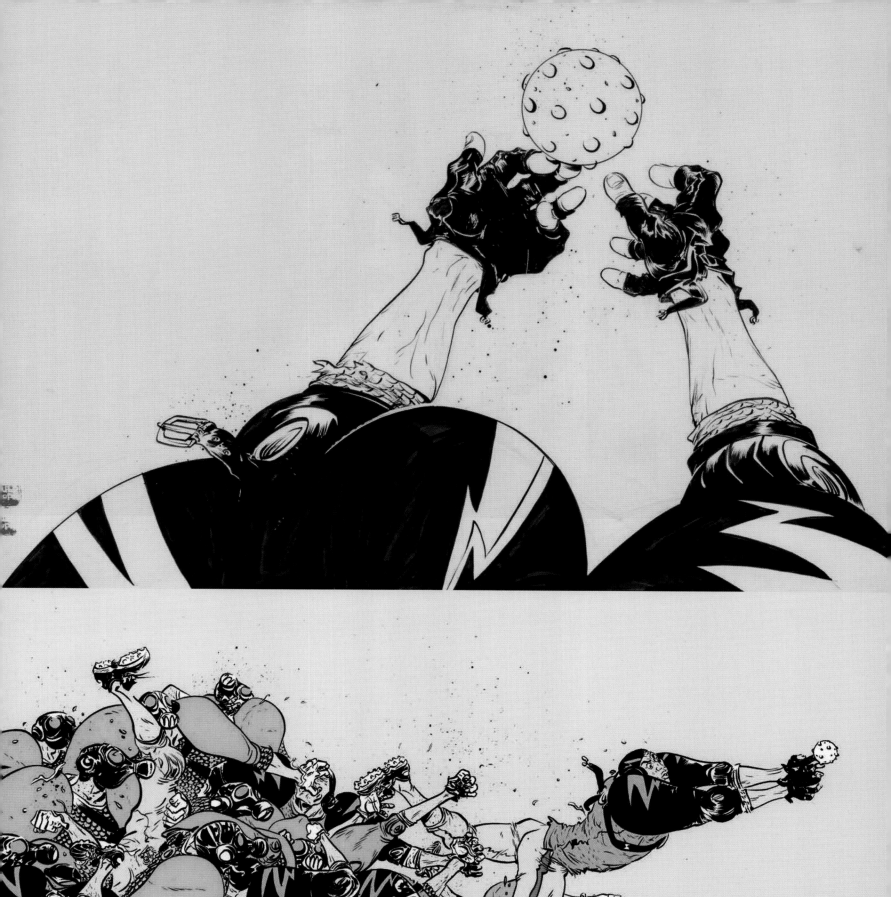
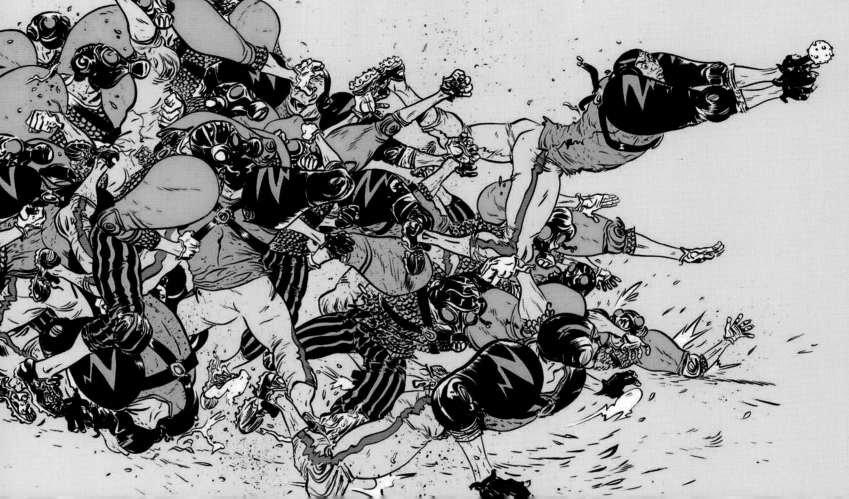

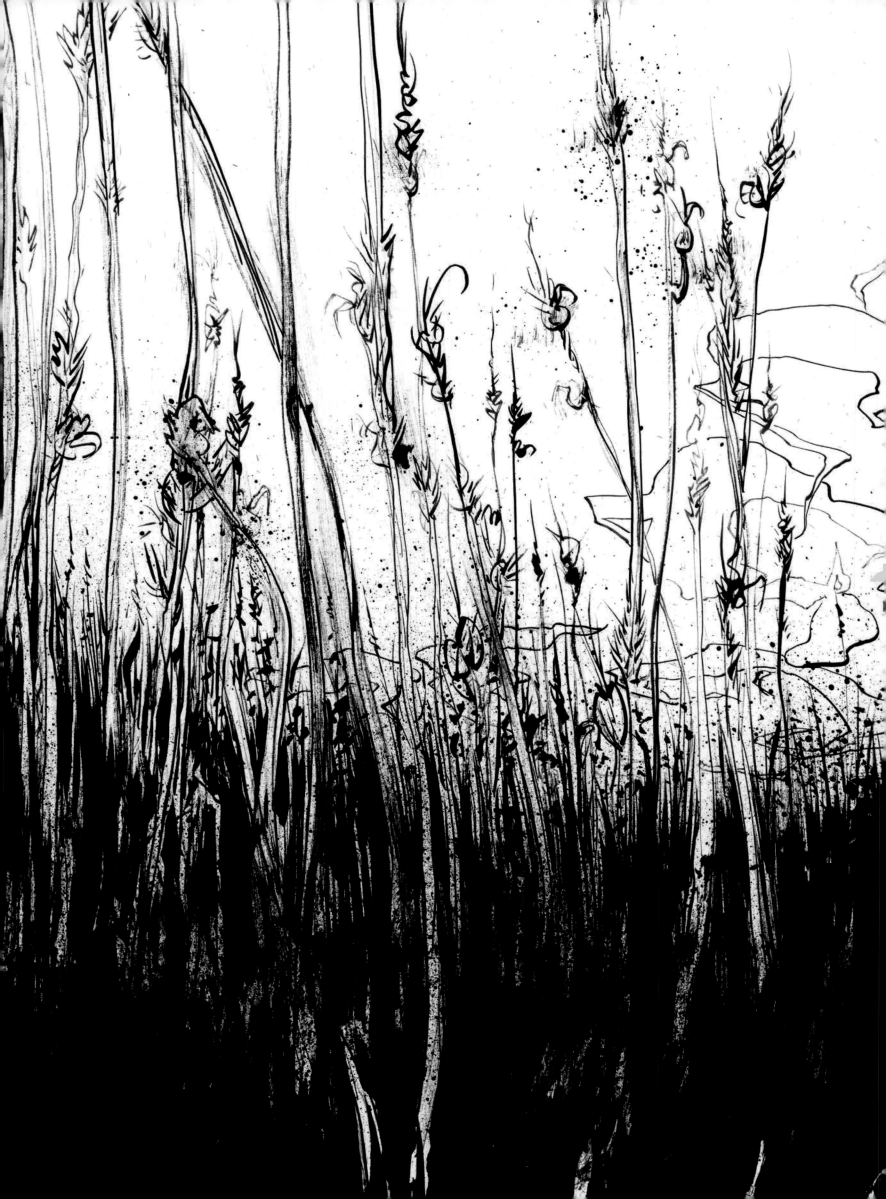

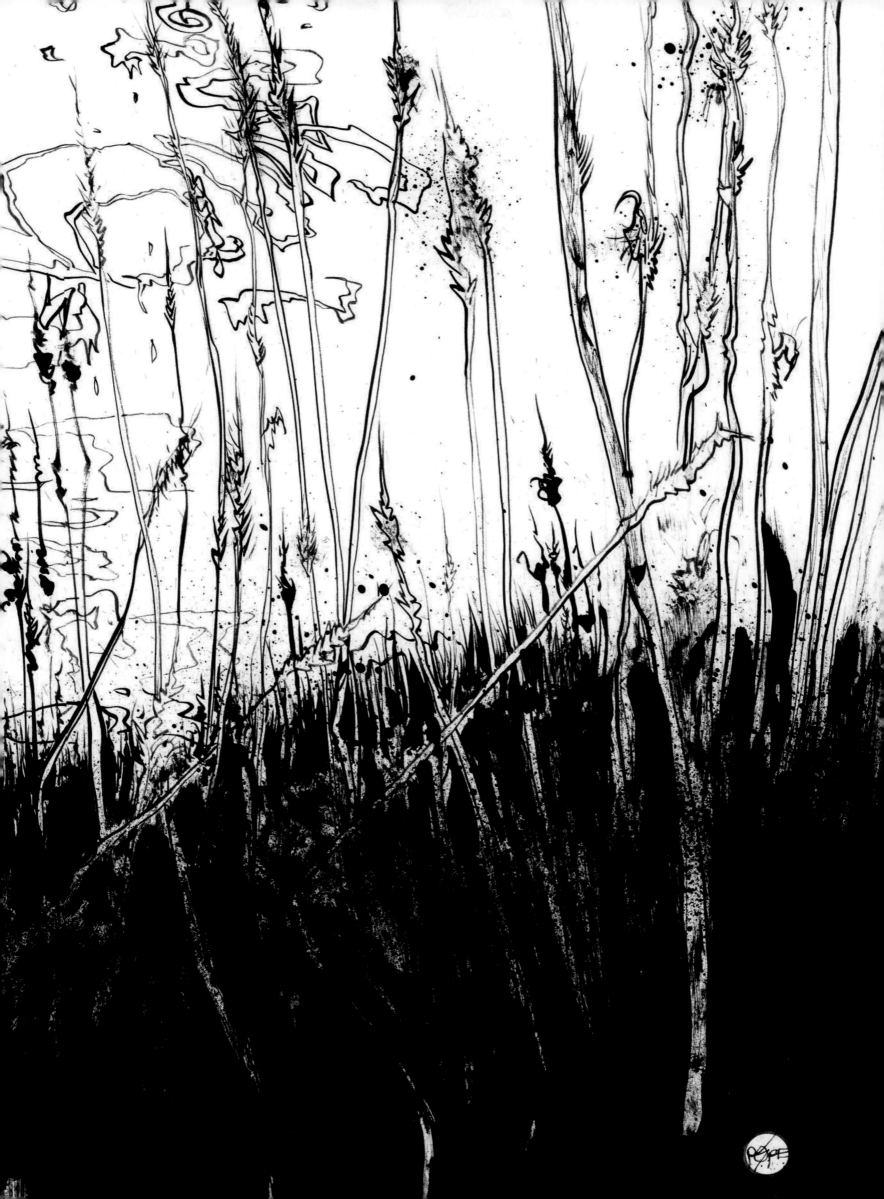

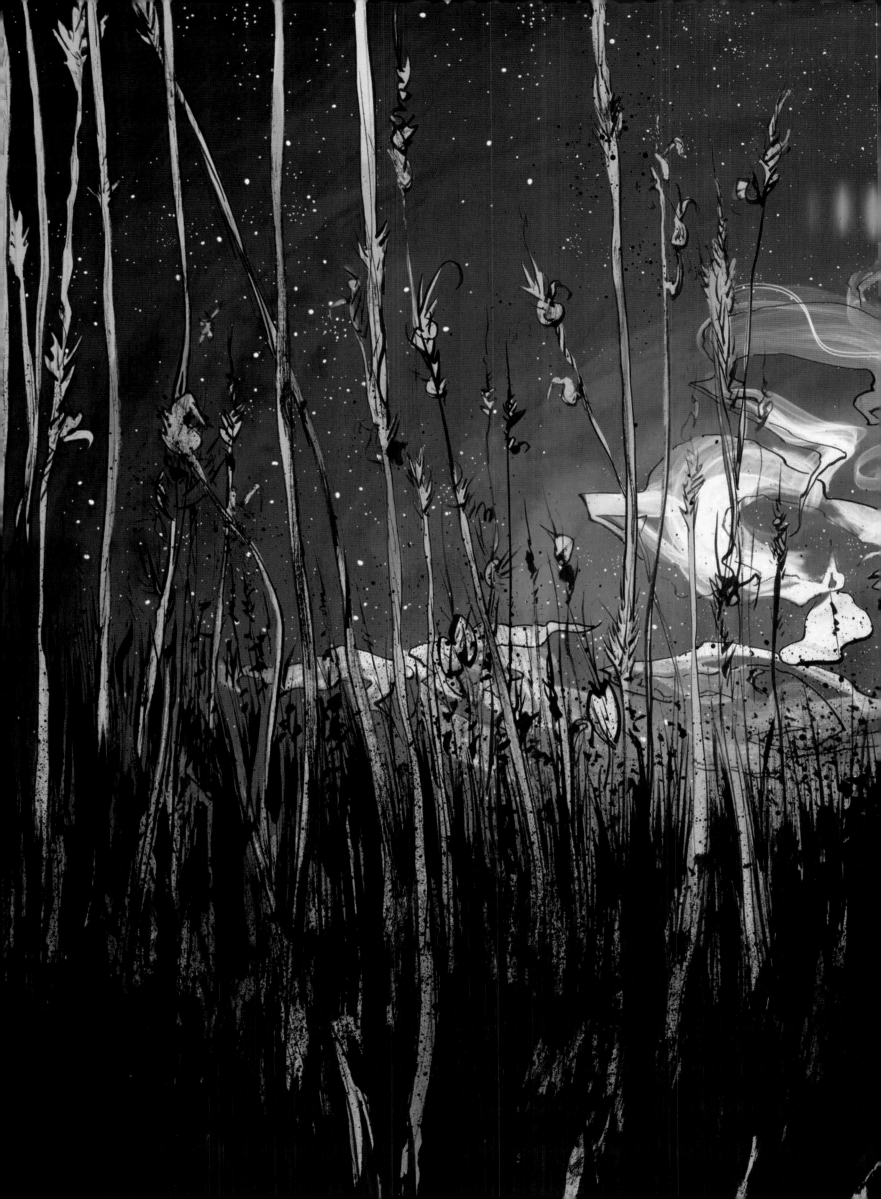

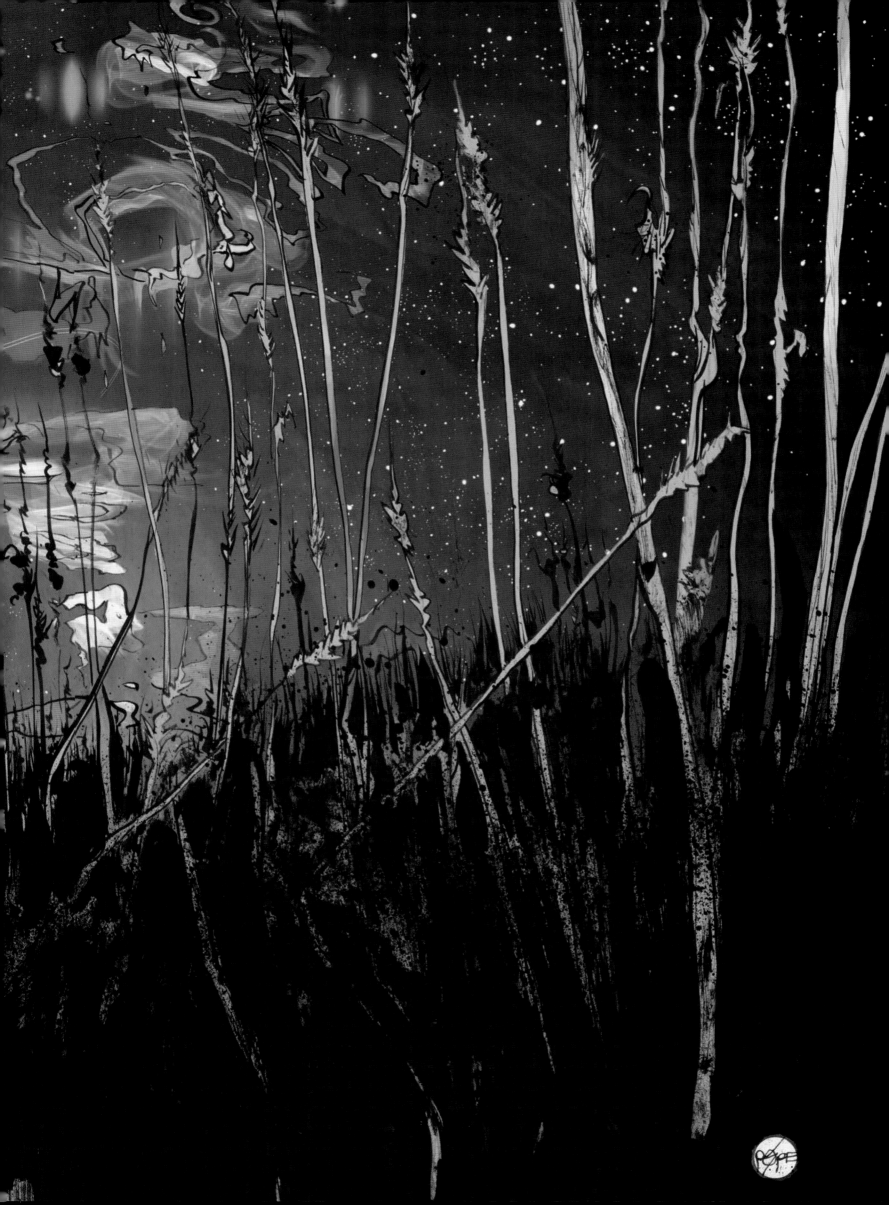

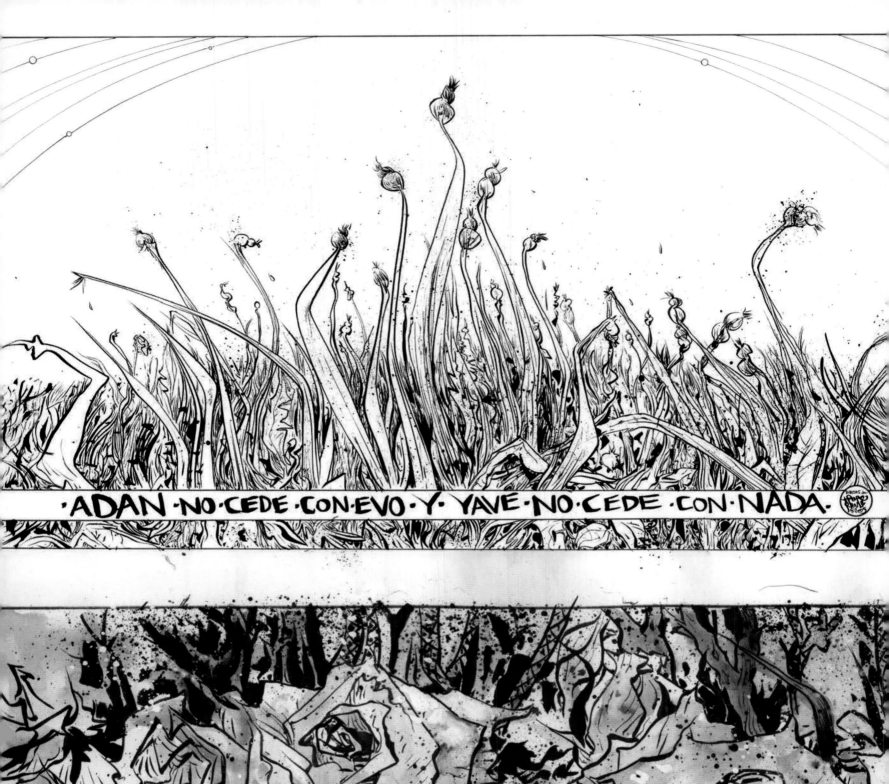

· ADAN · NO · CEDE · CON · EVO · Y · YAVE · NO · CEDE · CON · NADA ·

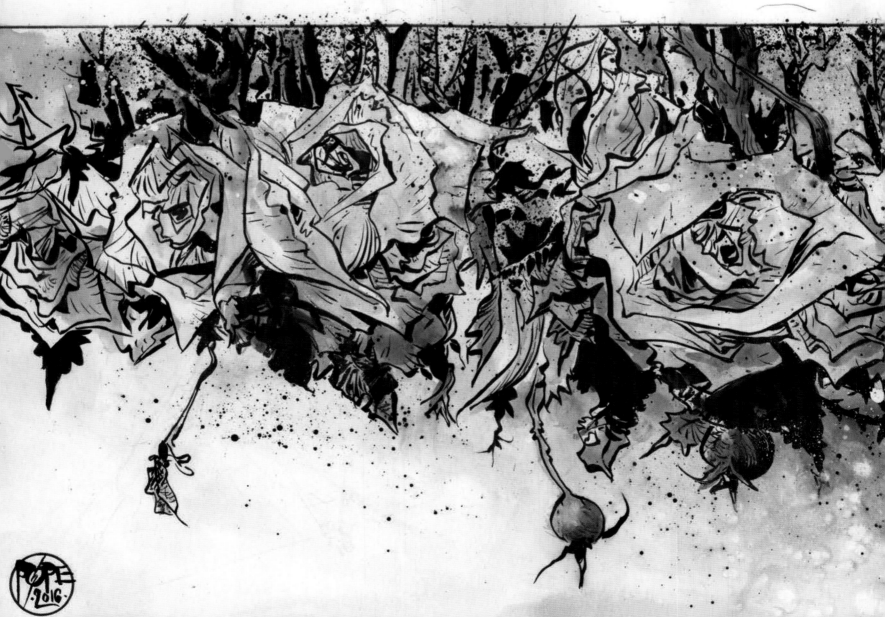

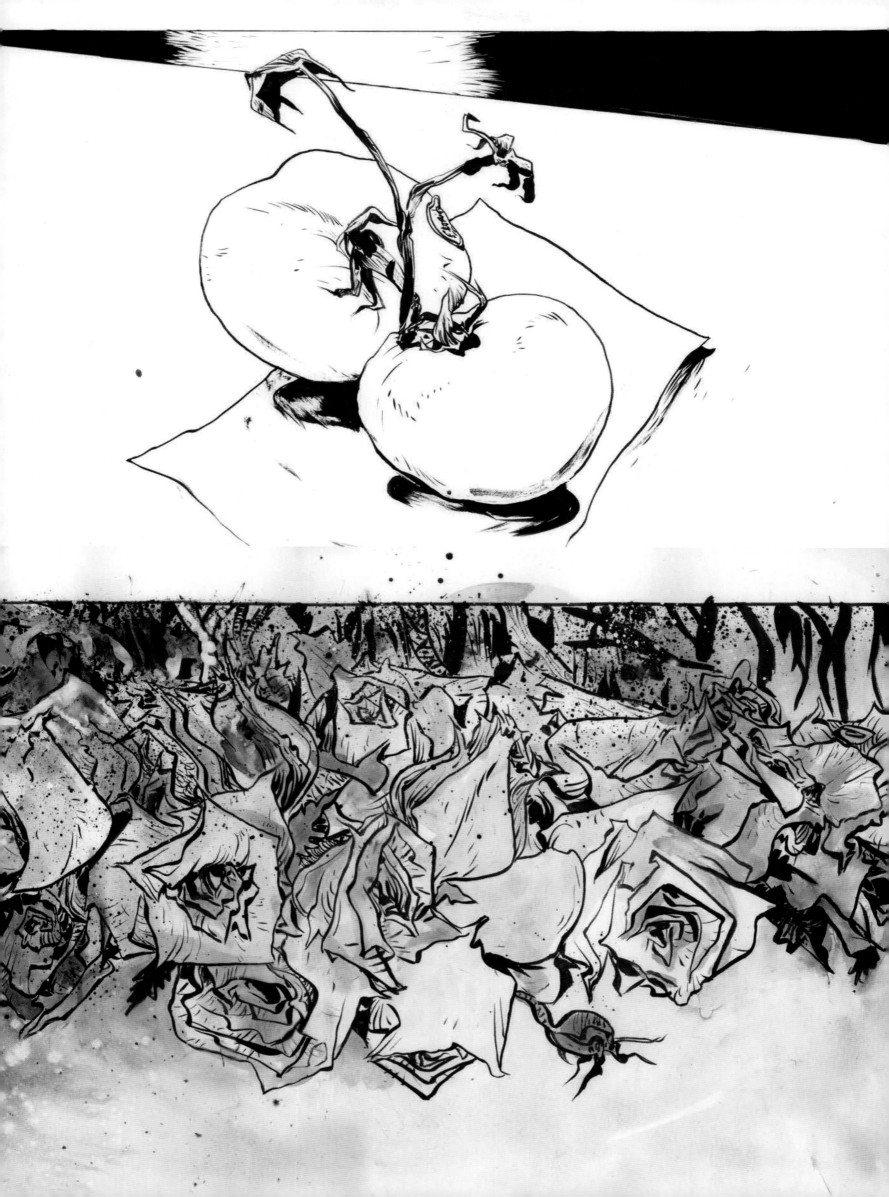

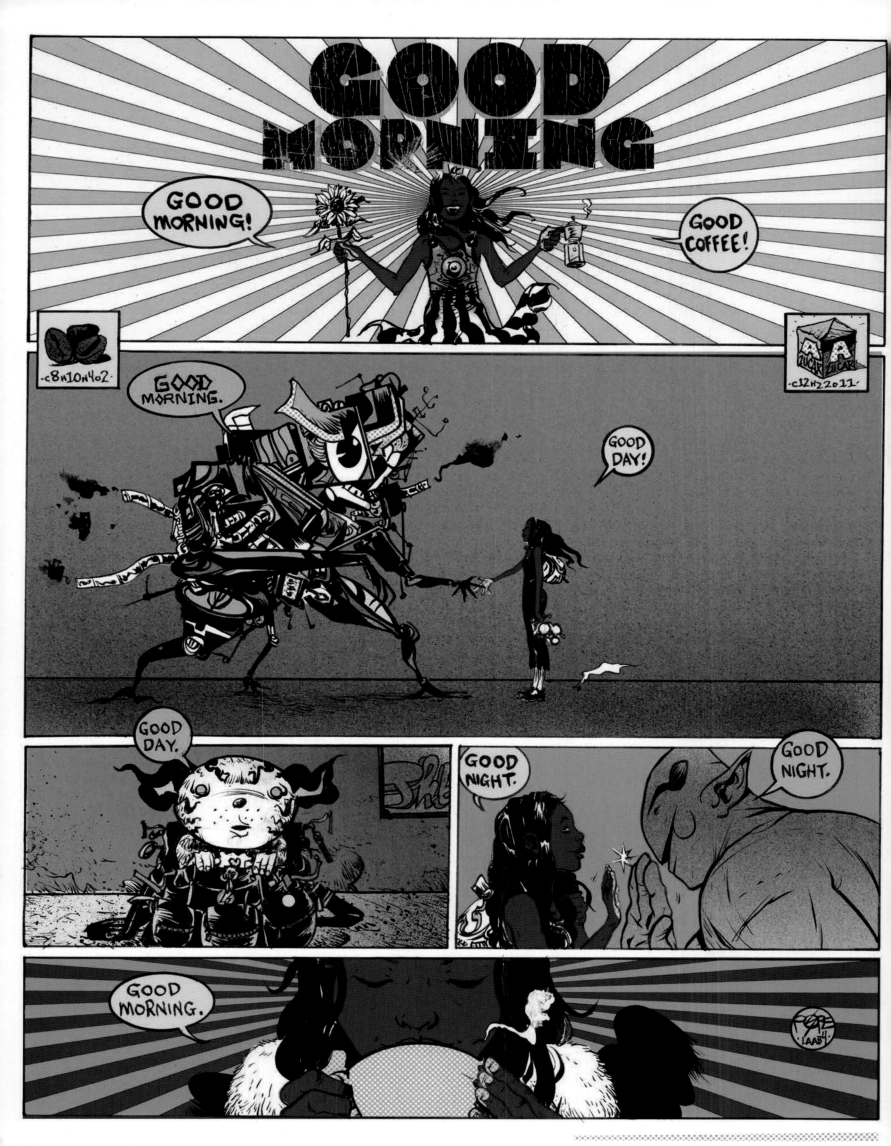

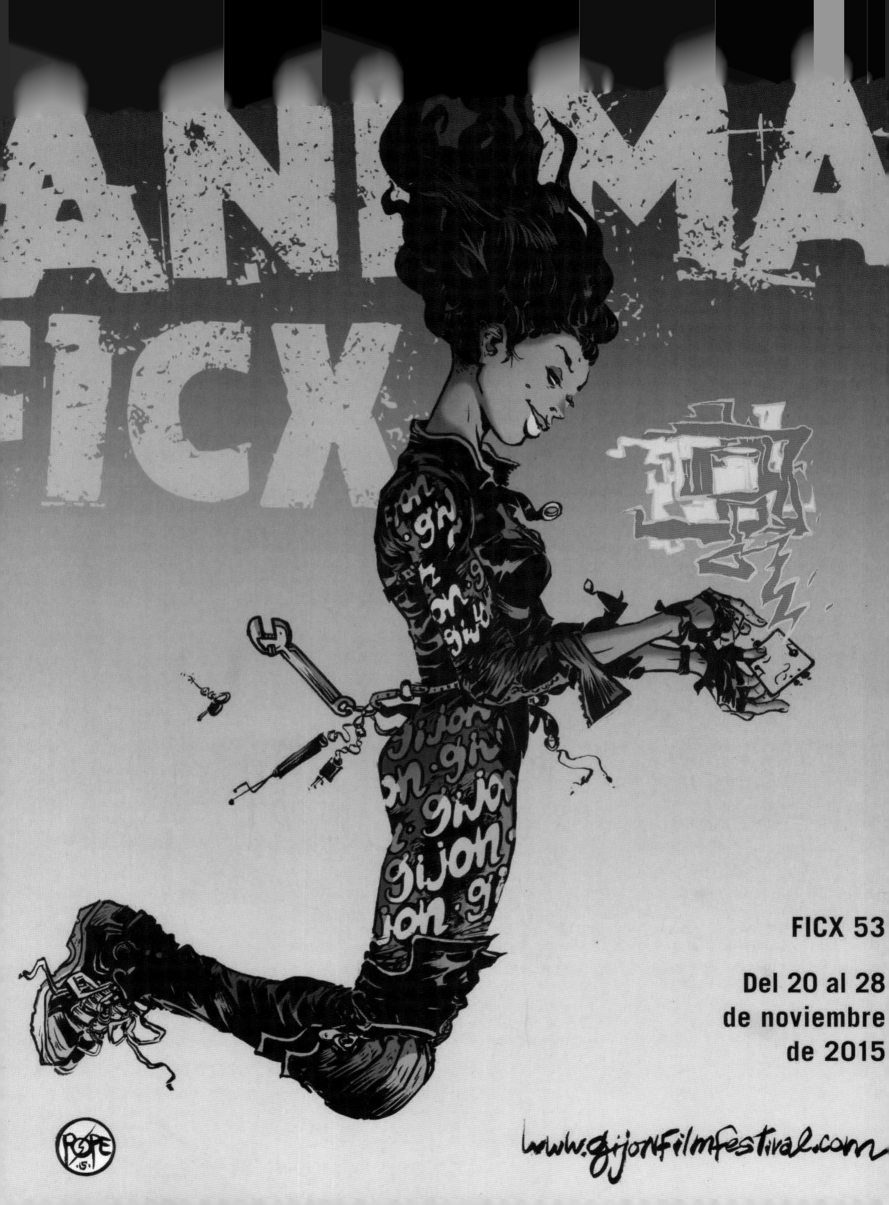

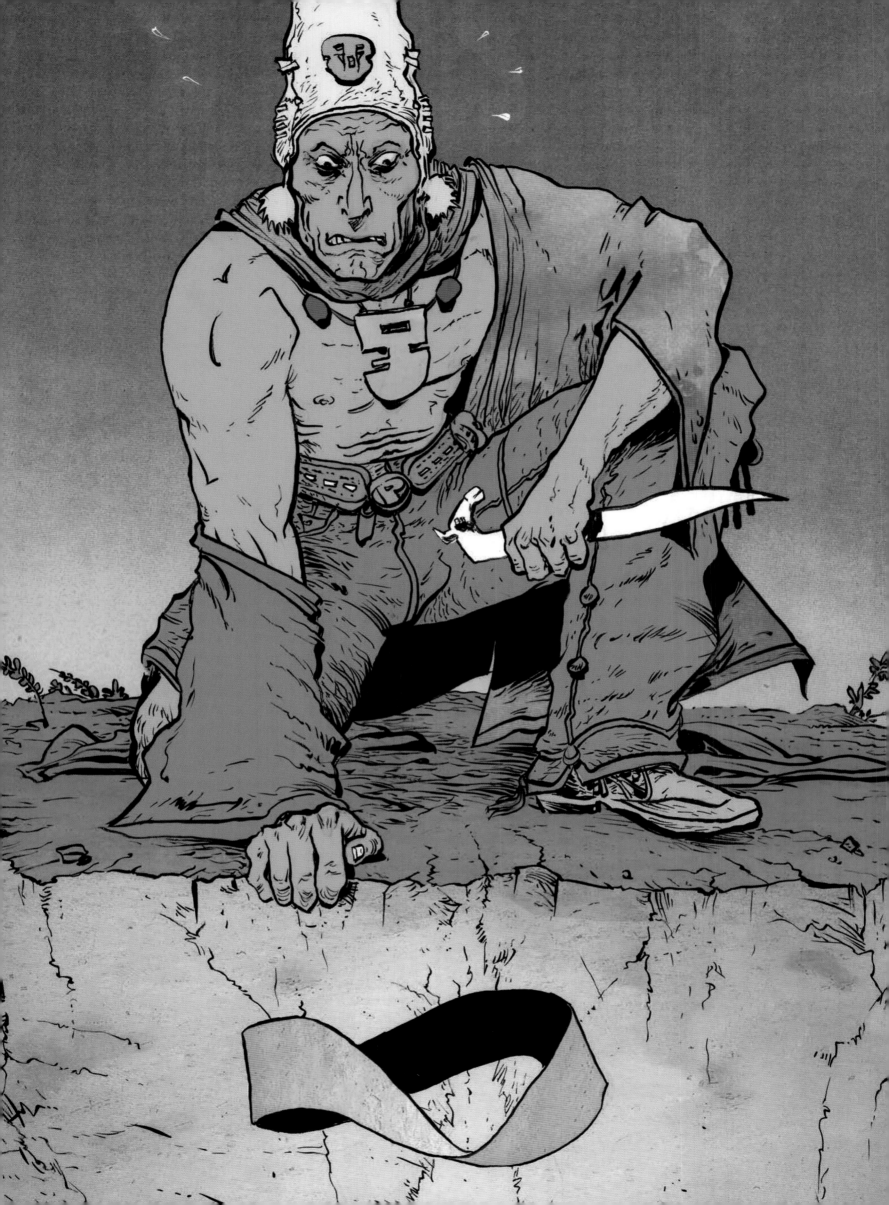

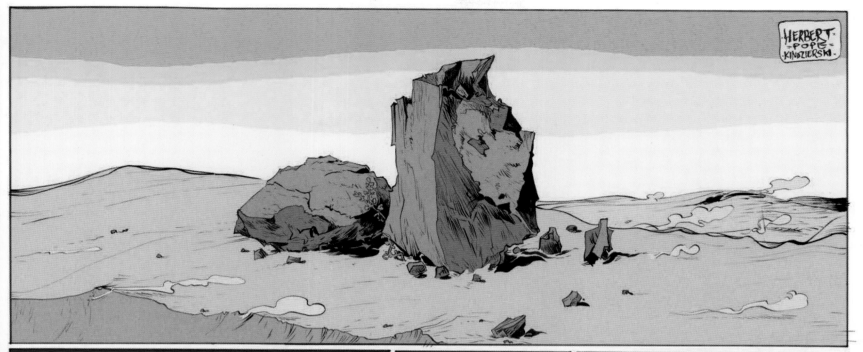

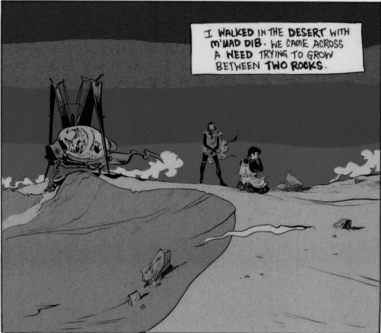

I WALKED IN THE DESERT WITH M'UAD DIB. WE CAME ACROSS A WEED TRYING TO GROW BETWEEN **TWO ROCKS**.

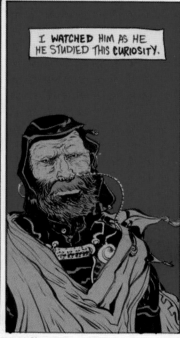

I WATCHED HIM AS HE HE STUDIED THIS **CURIOSITY**.

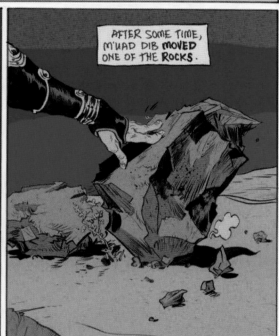

AFTER SOME TIME, M'UAD DIB **MOVED** ONE OF THE **ROCKS**.

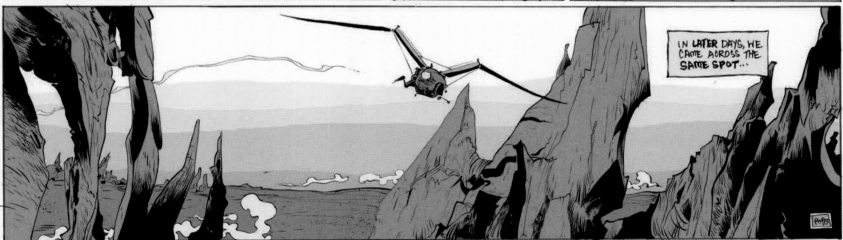

IN **LATER DAYS**, WE CAME ACROSS THE **SAME SPOT**...

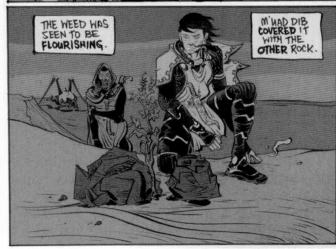

THE WEED WAS SEEN TO BE FLOURISHING.

M'UAD DIB COVERED IT WITH THE OTHER ROCK.

...THUMP.

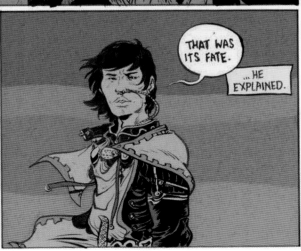

THAT WAS ITS FATE.

...HE EXPLAINED.

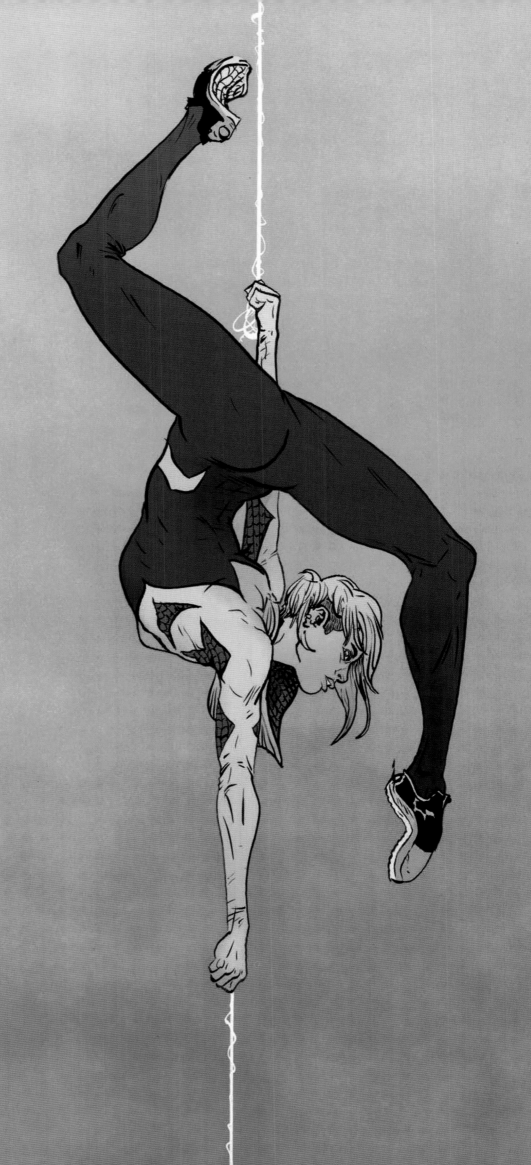

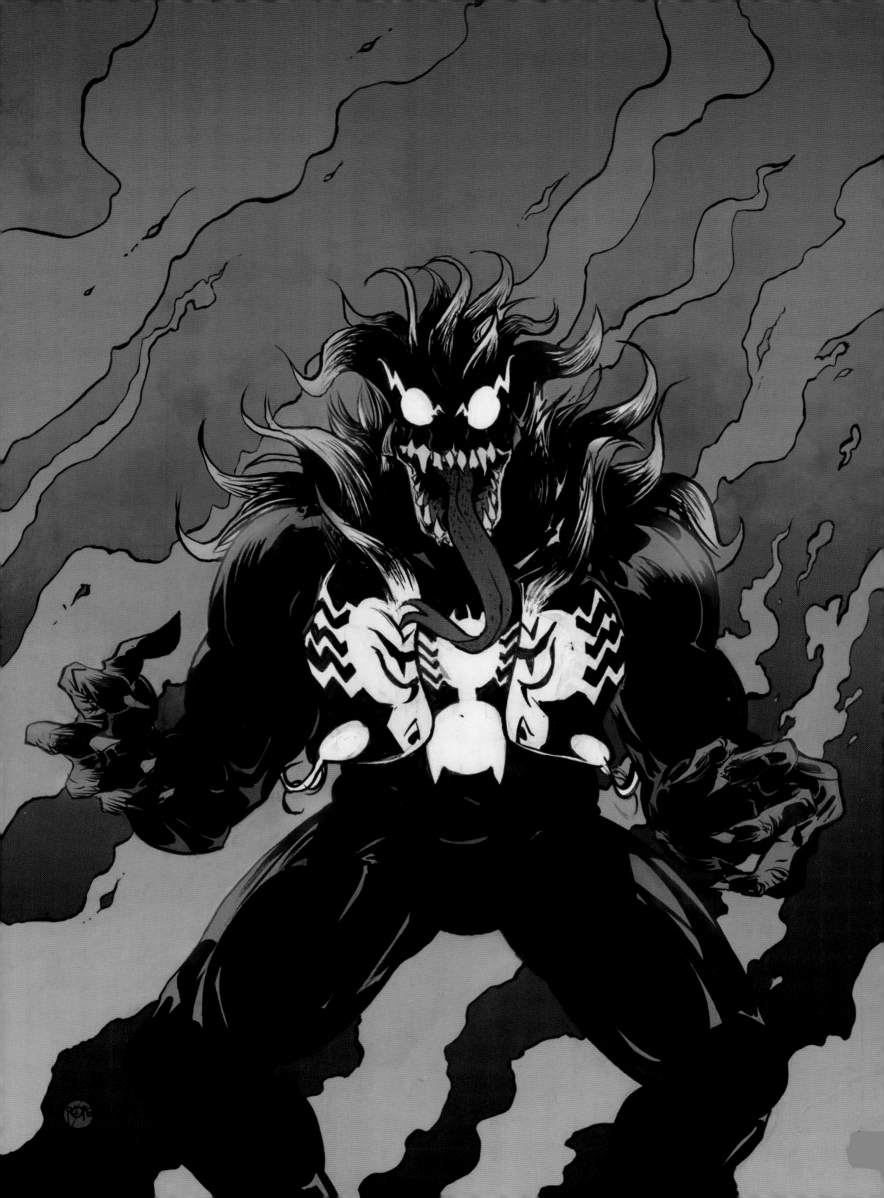

5·2·16

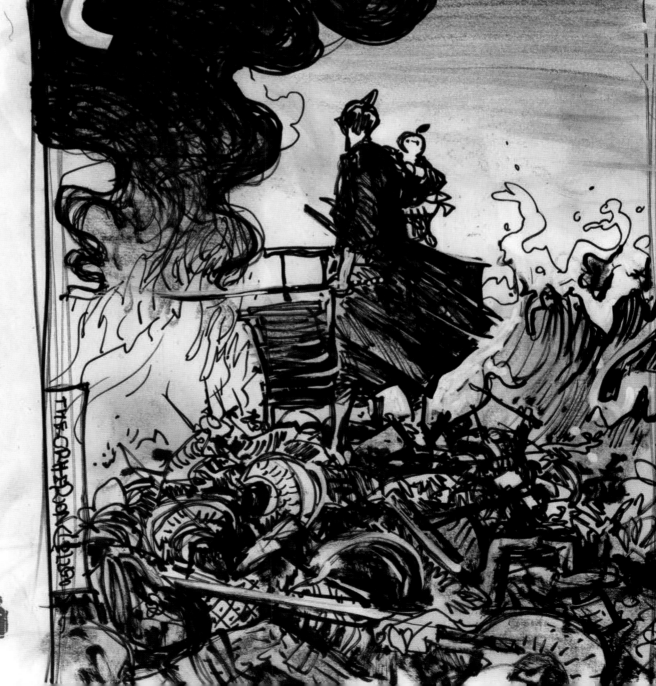

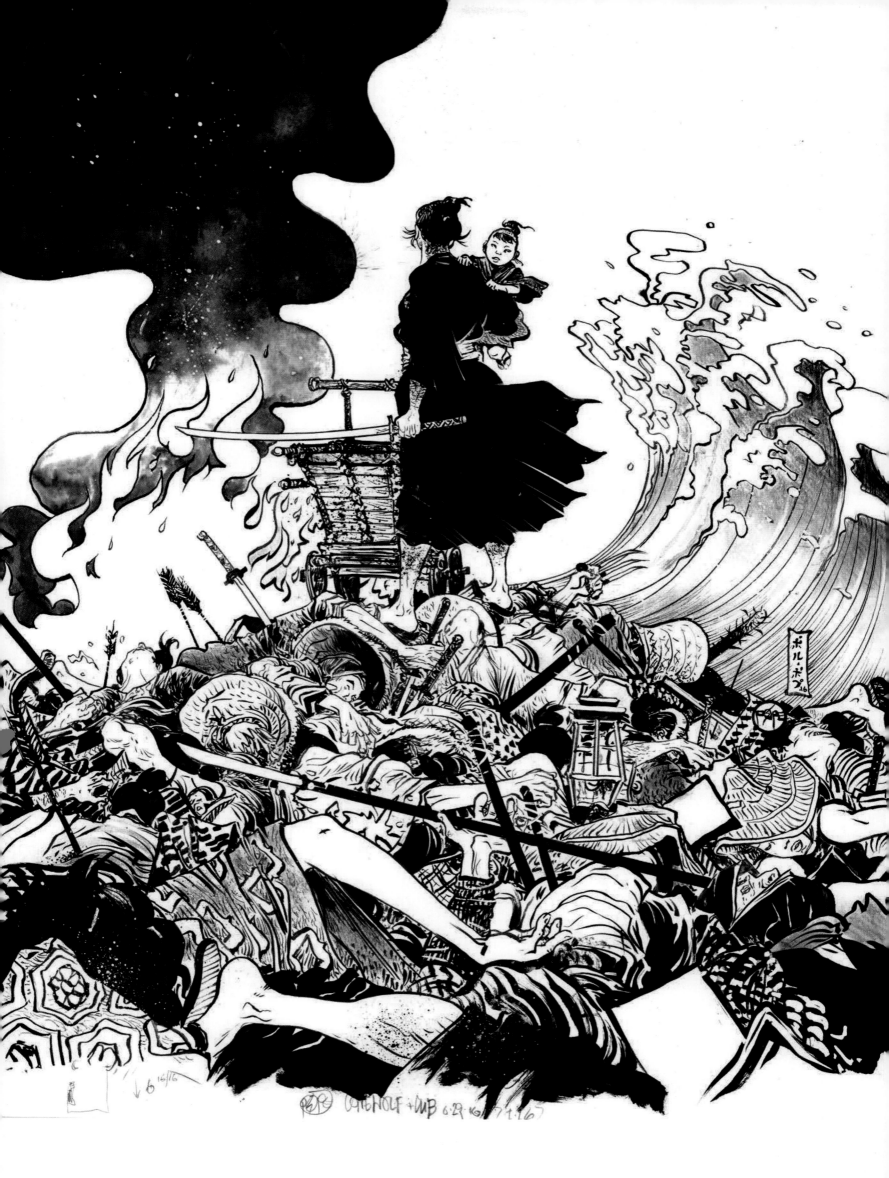

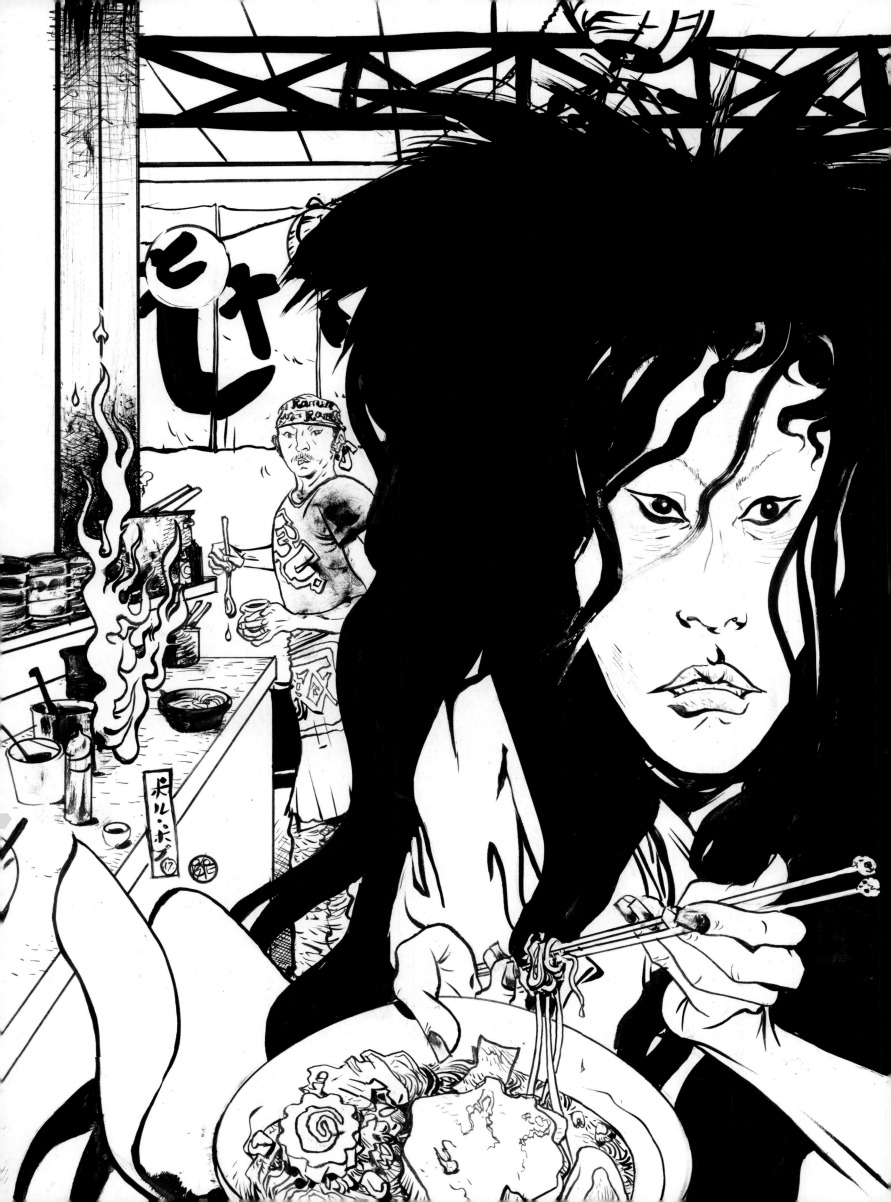

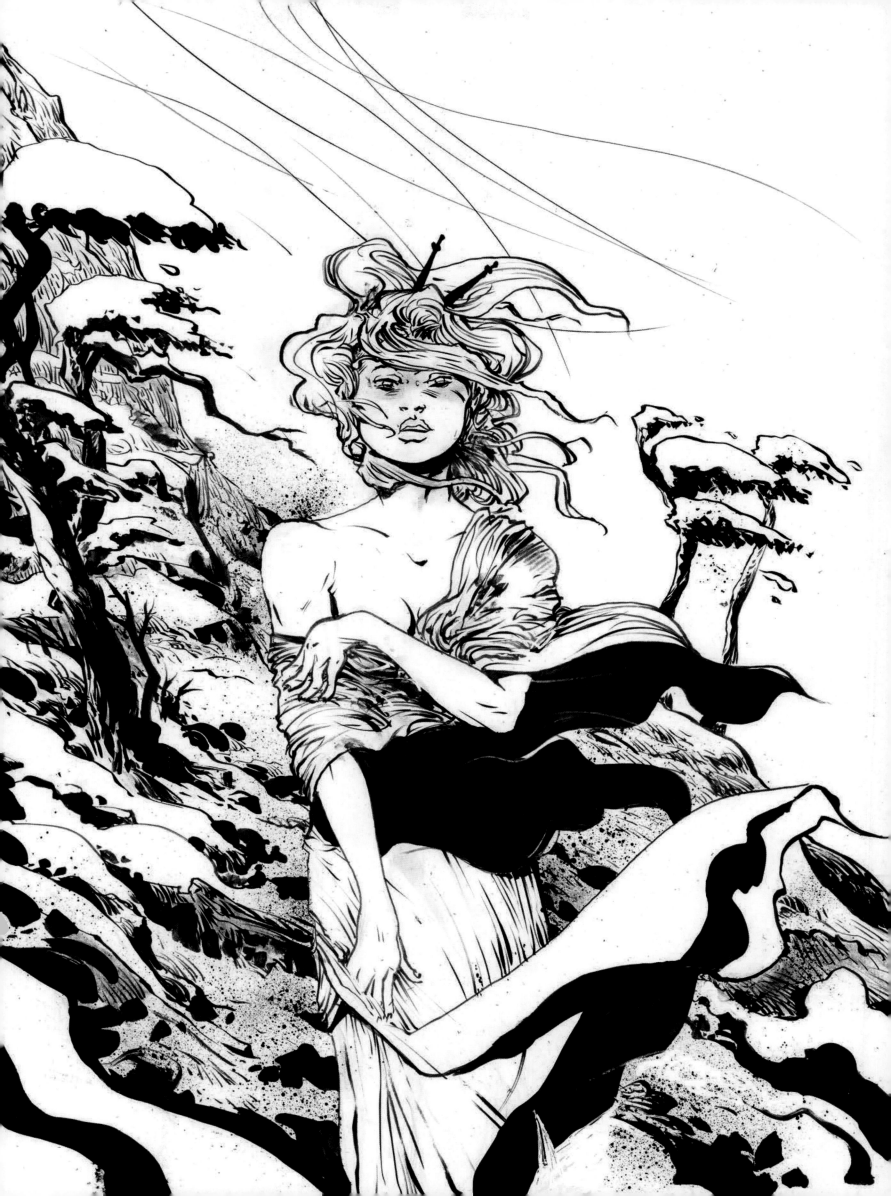

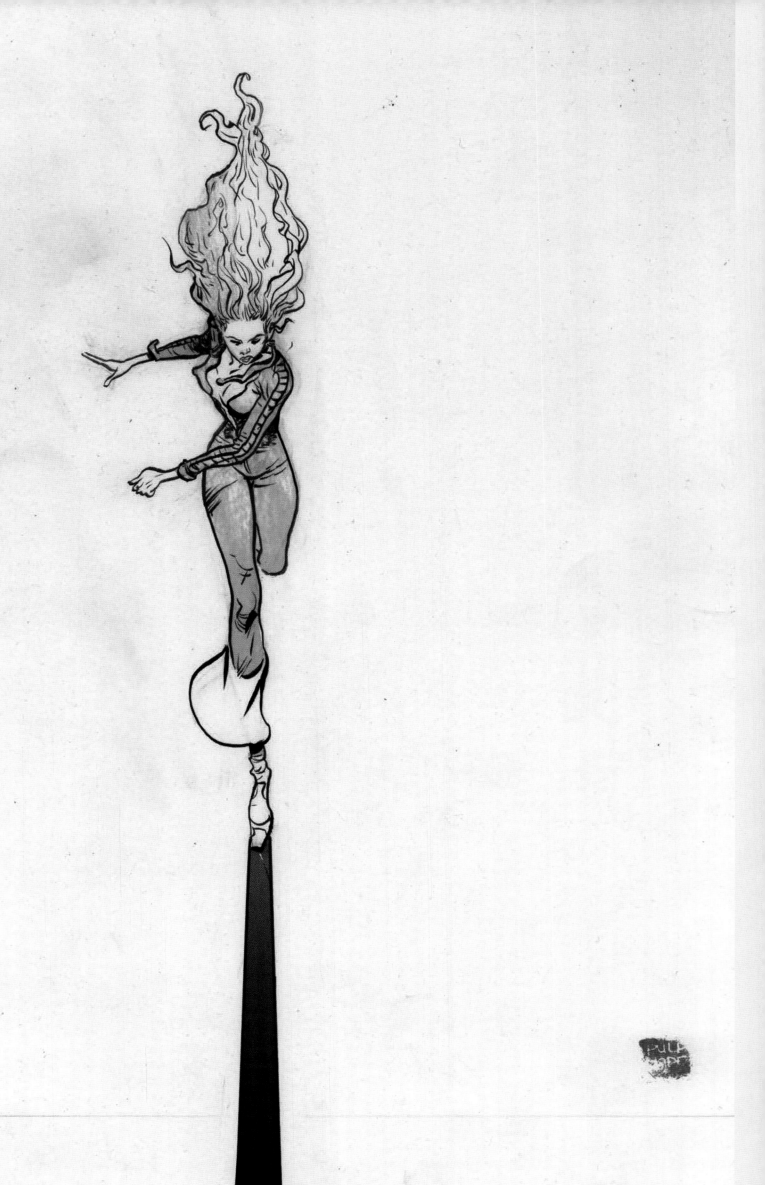

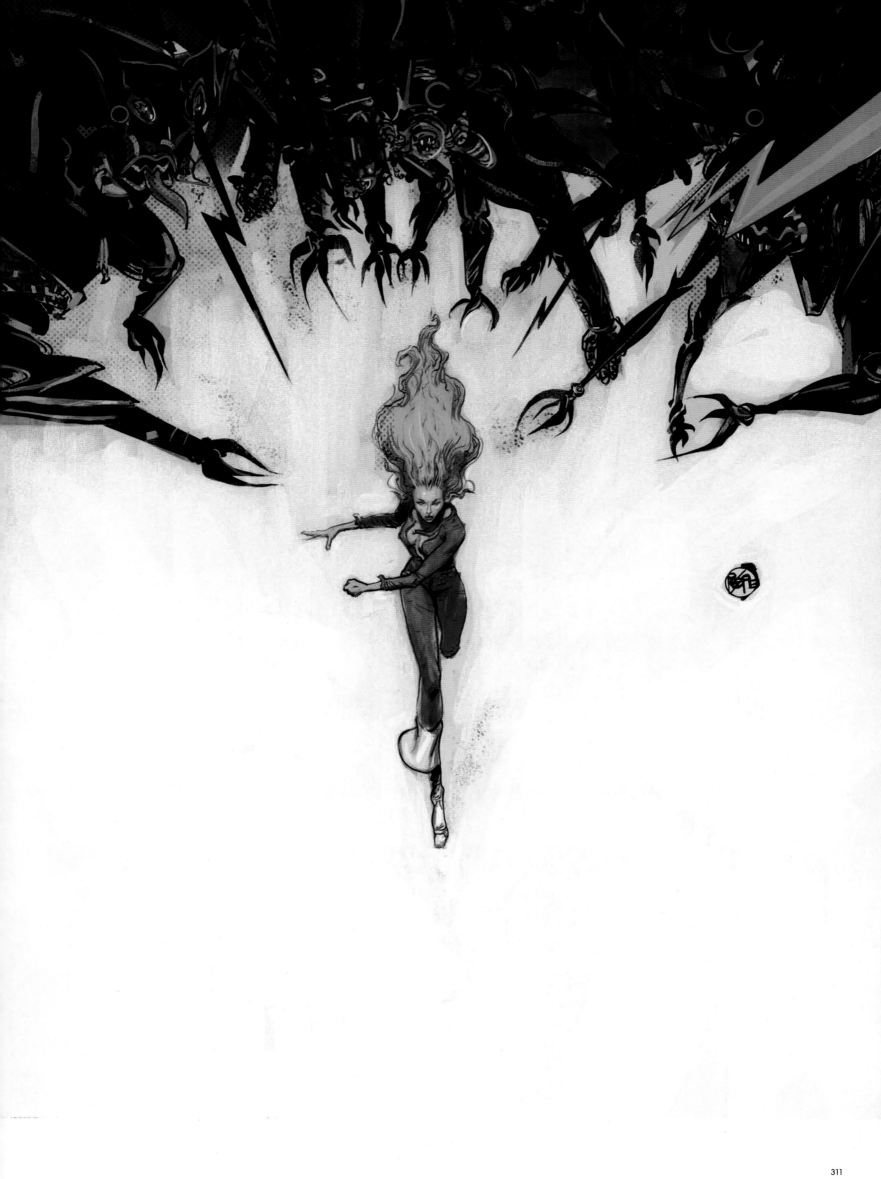

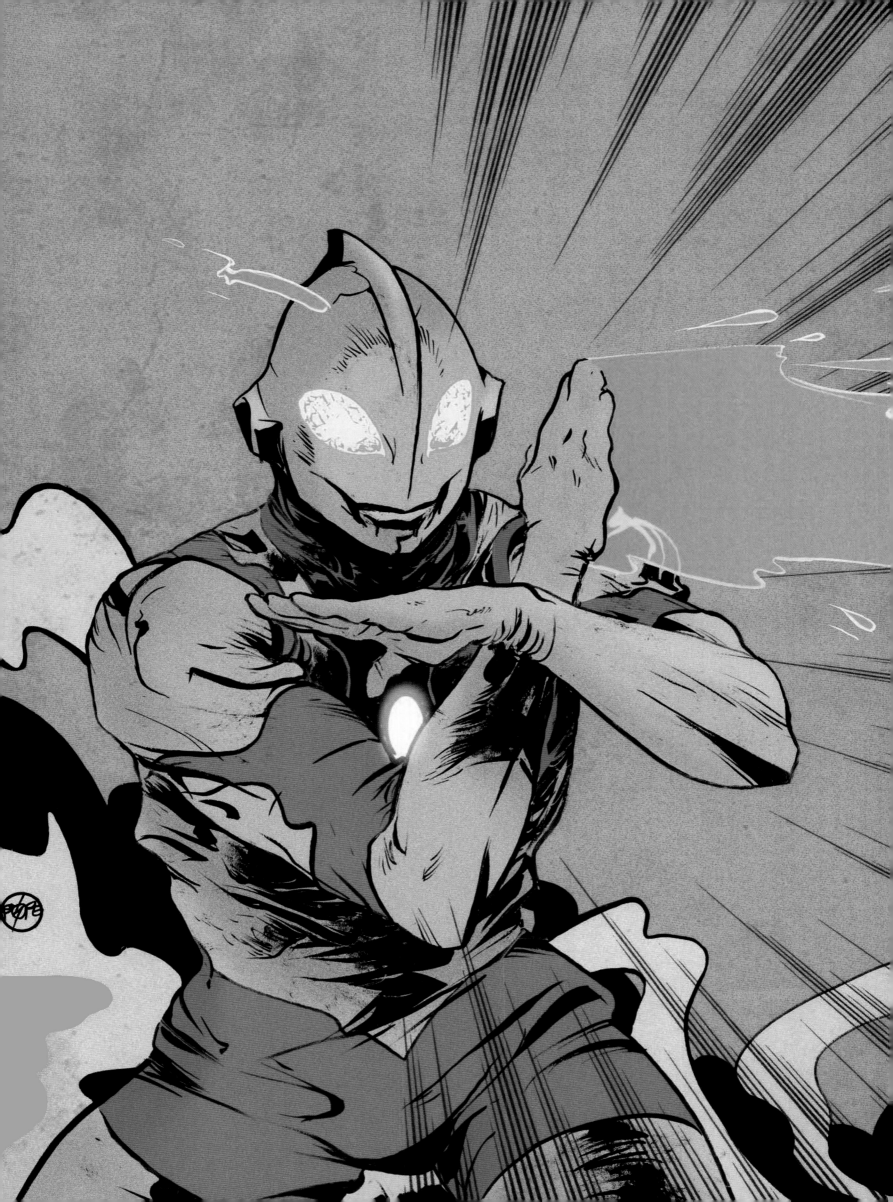

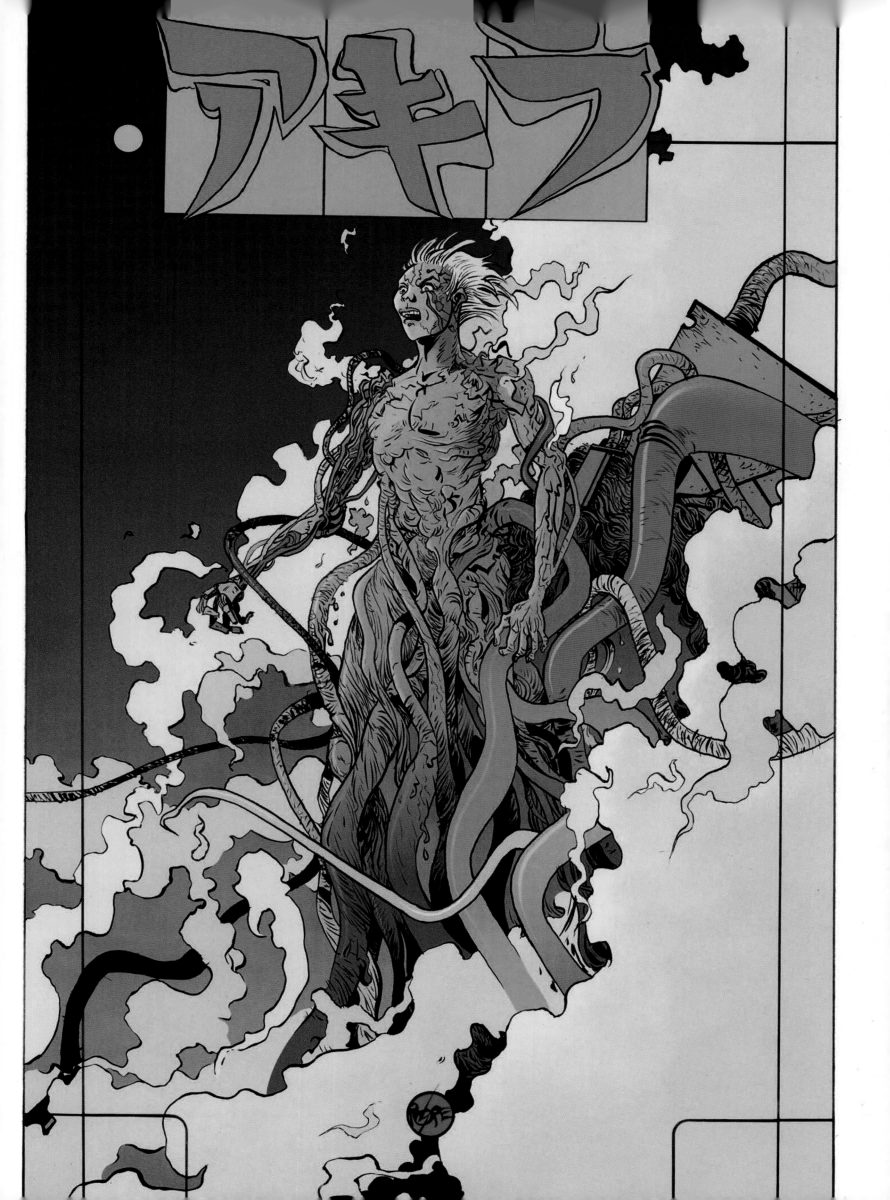

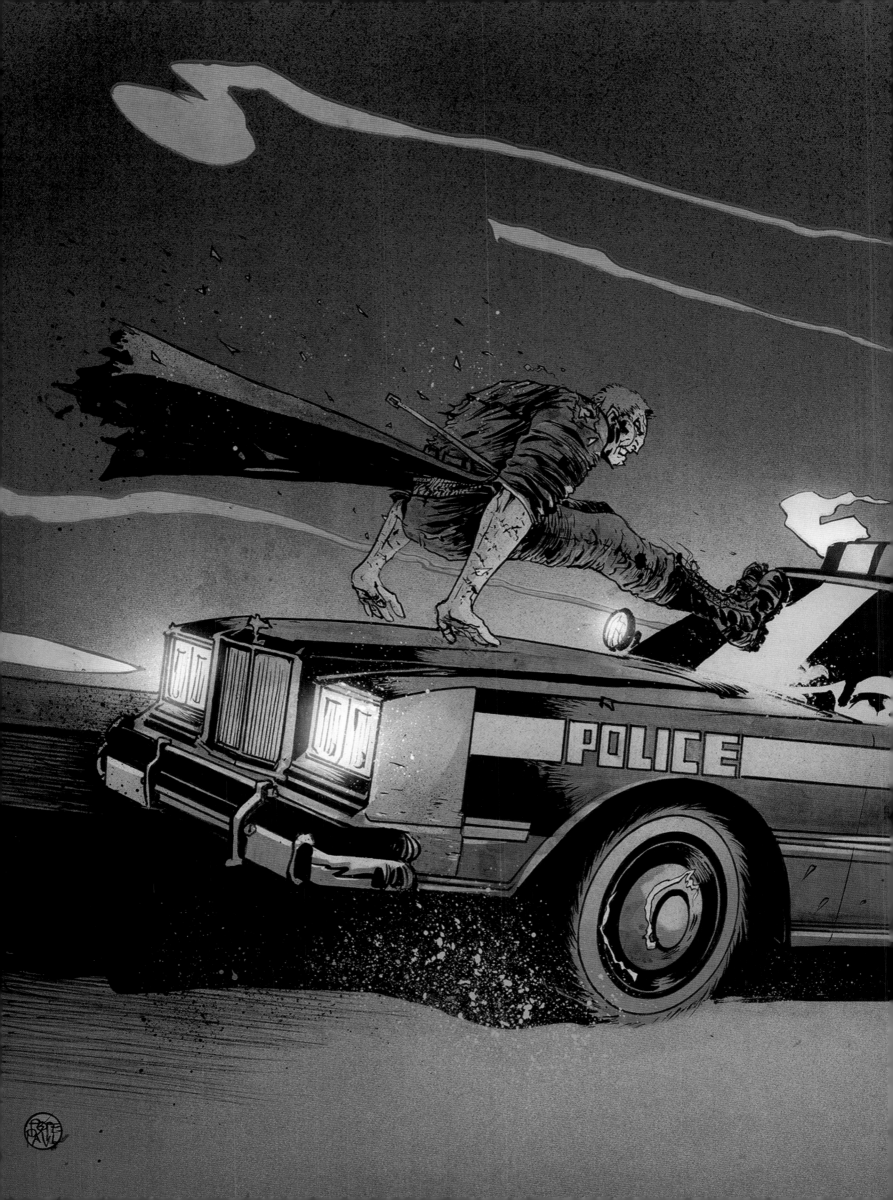

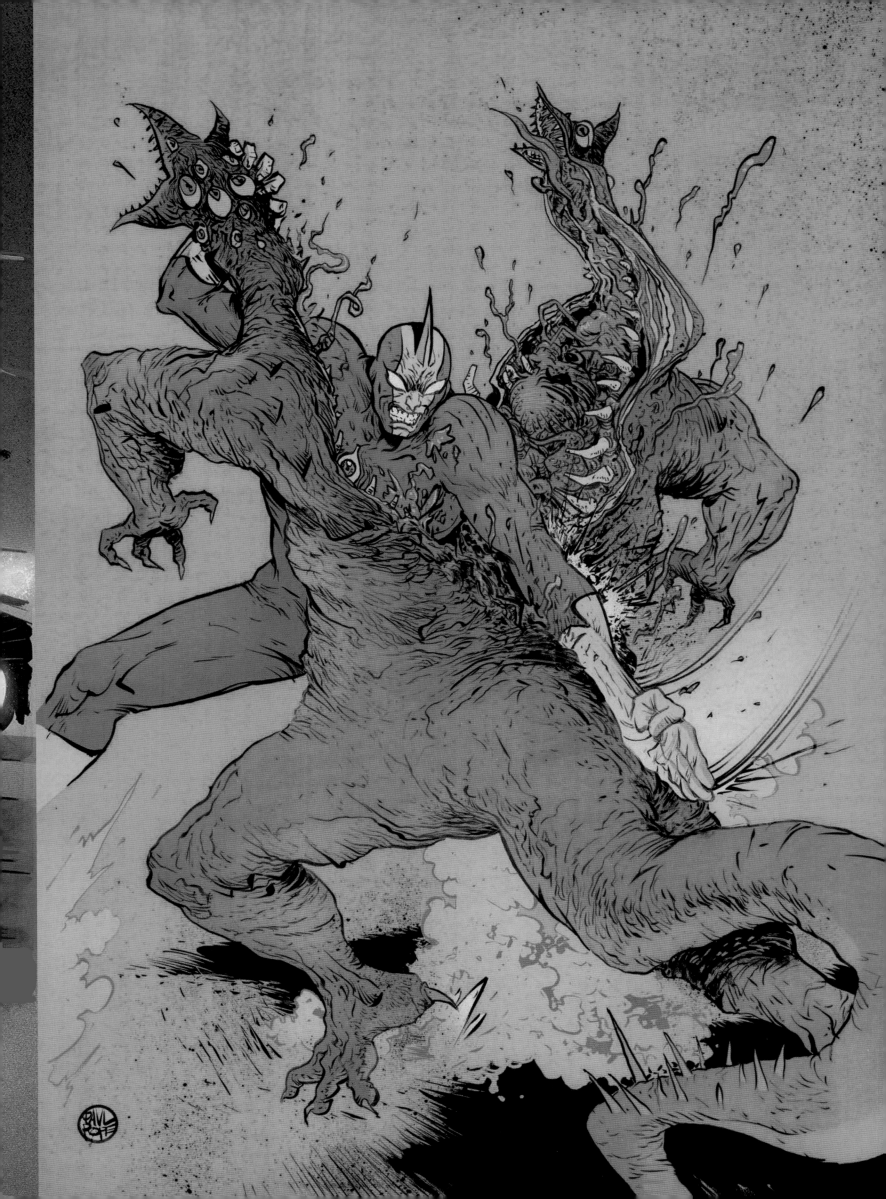

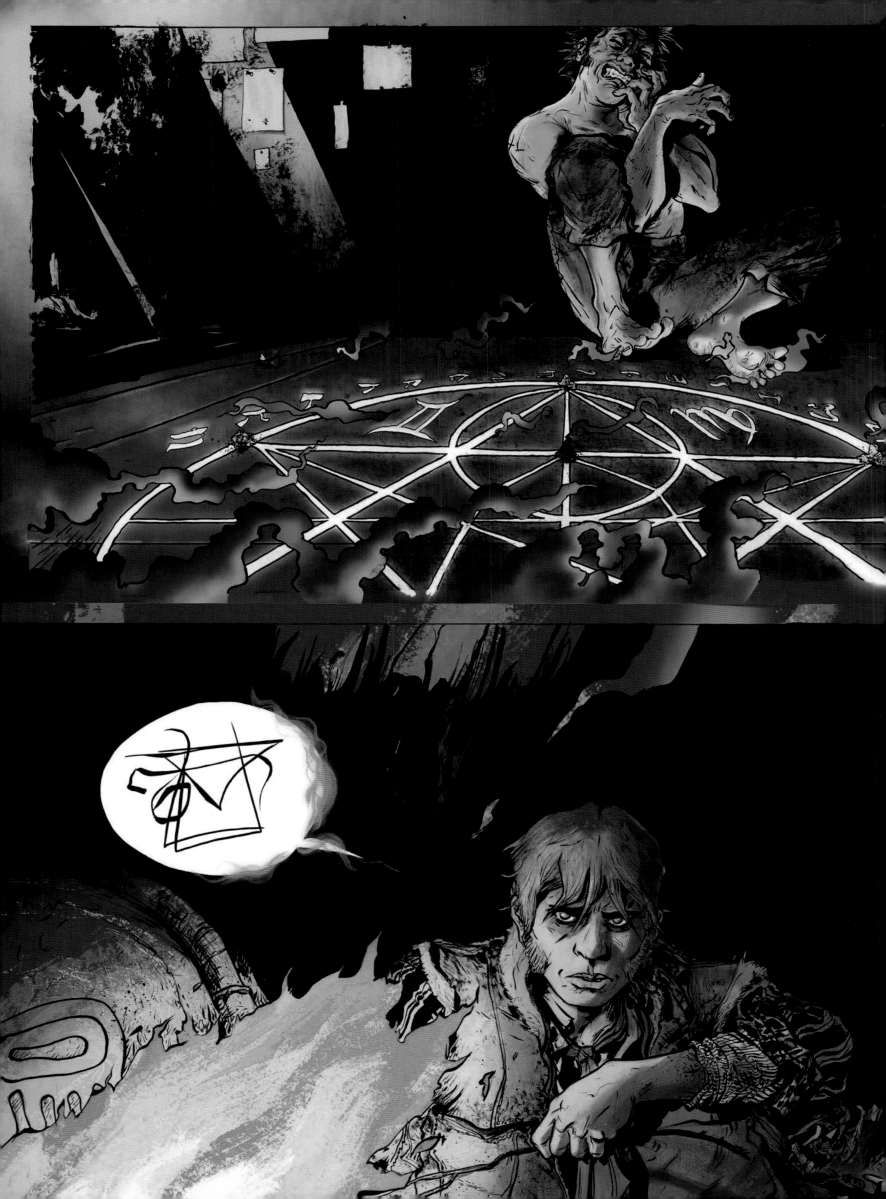

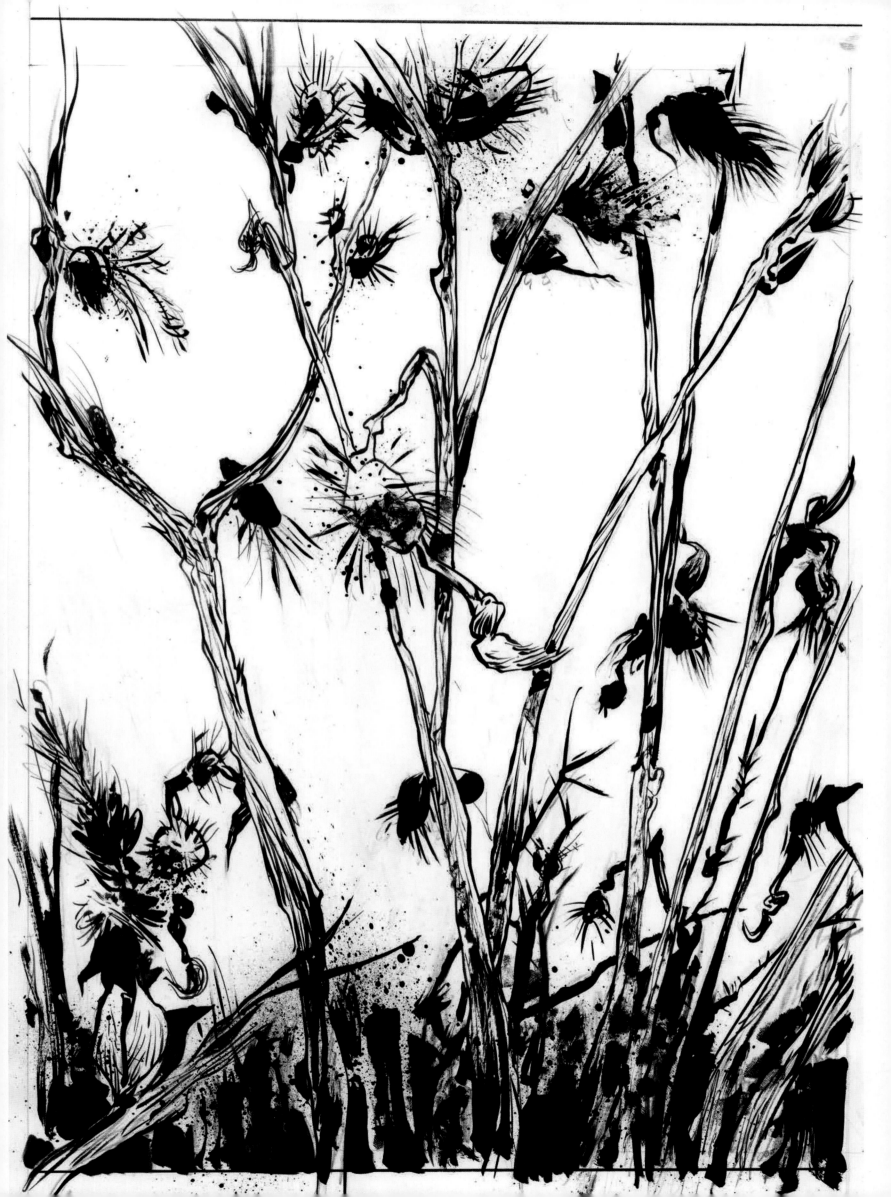

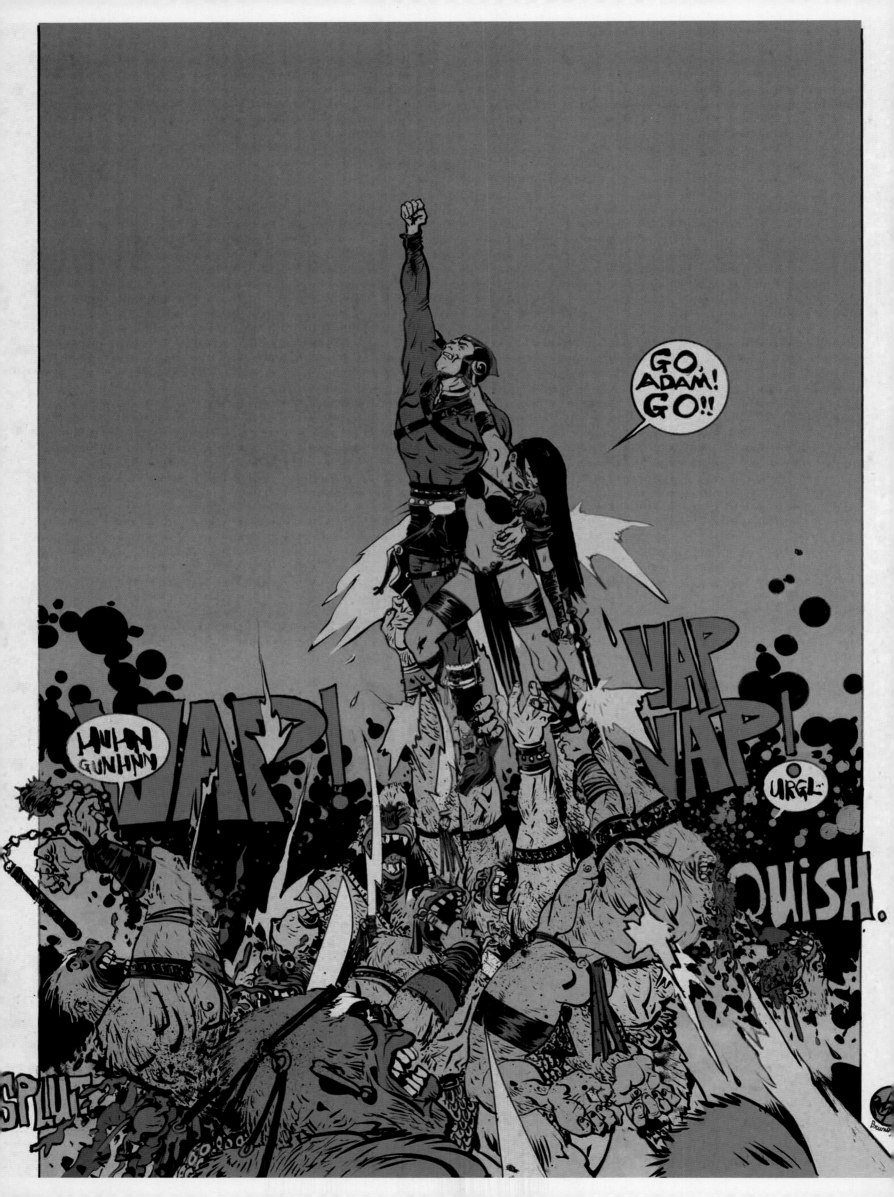

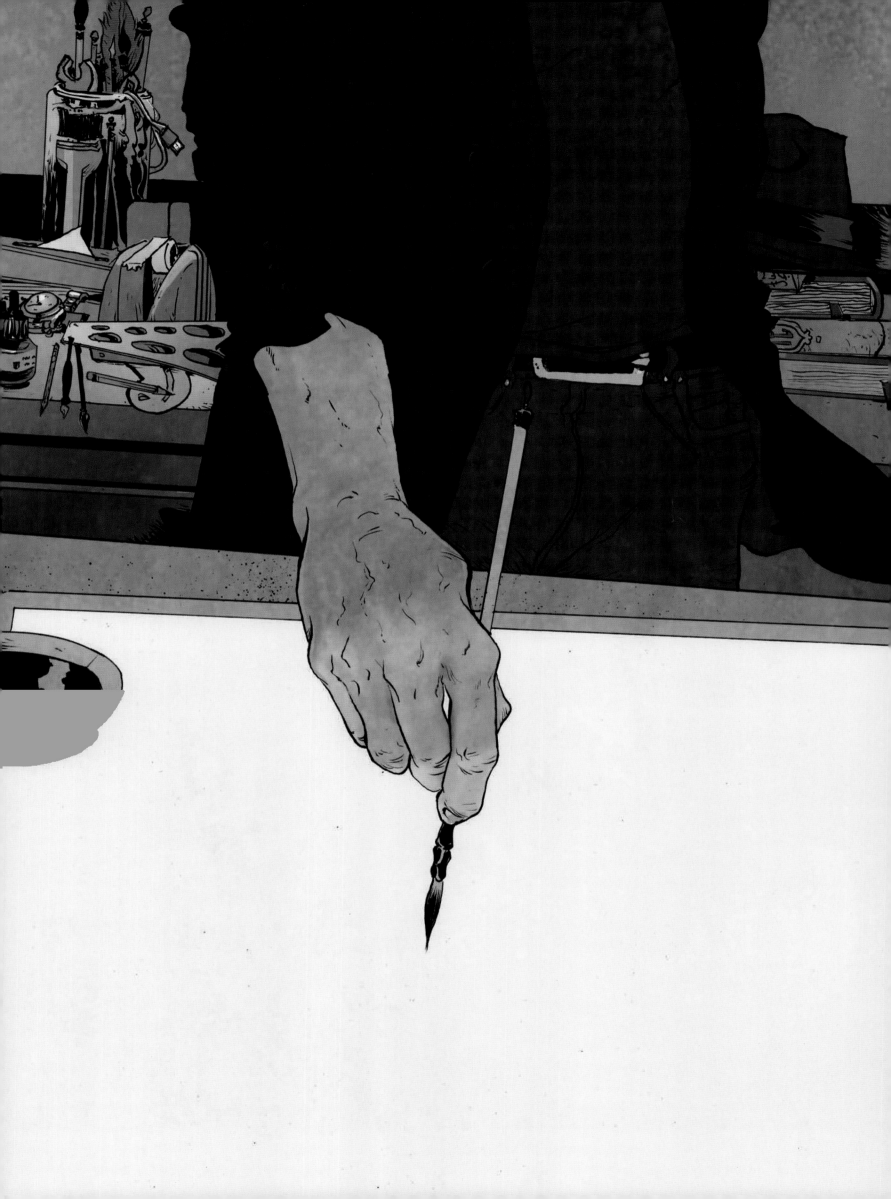

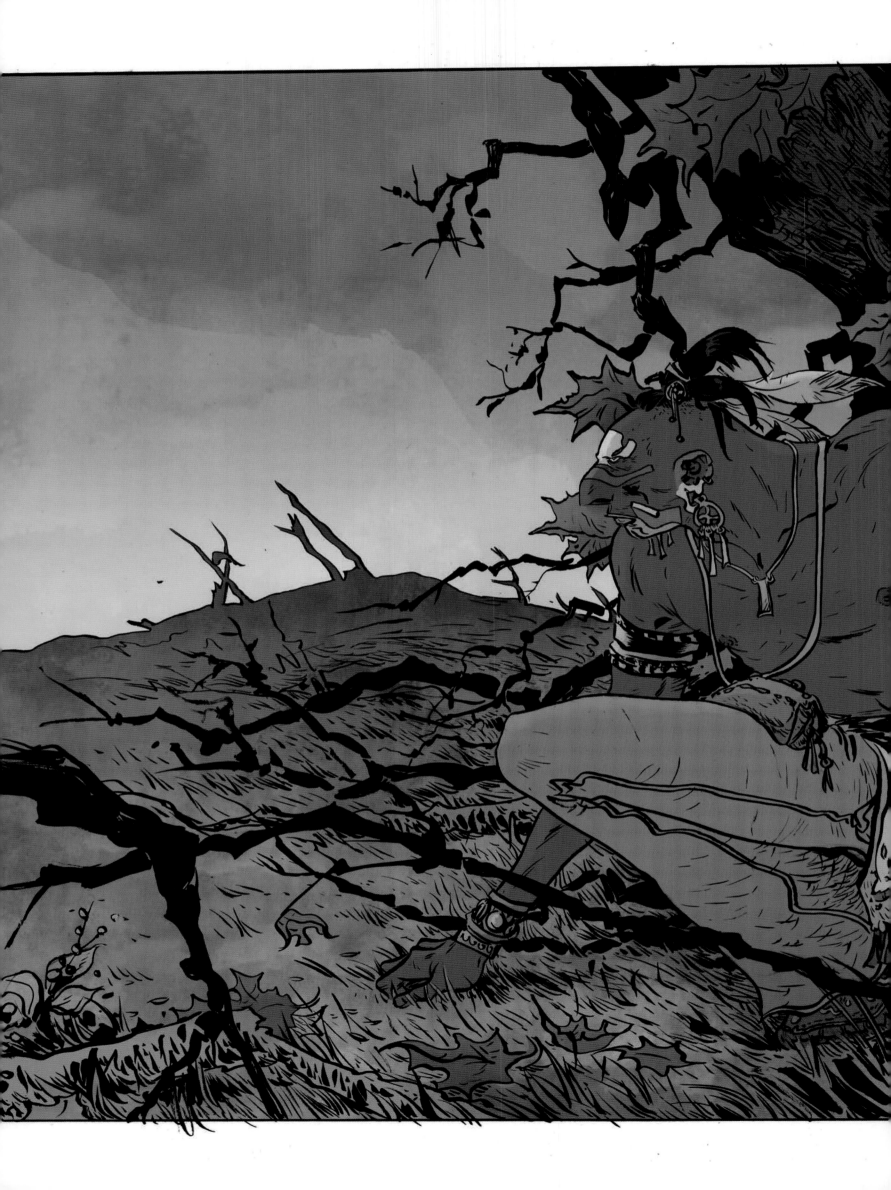

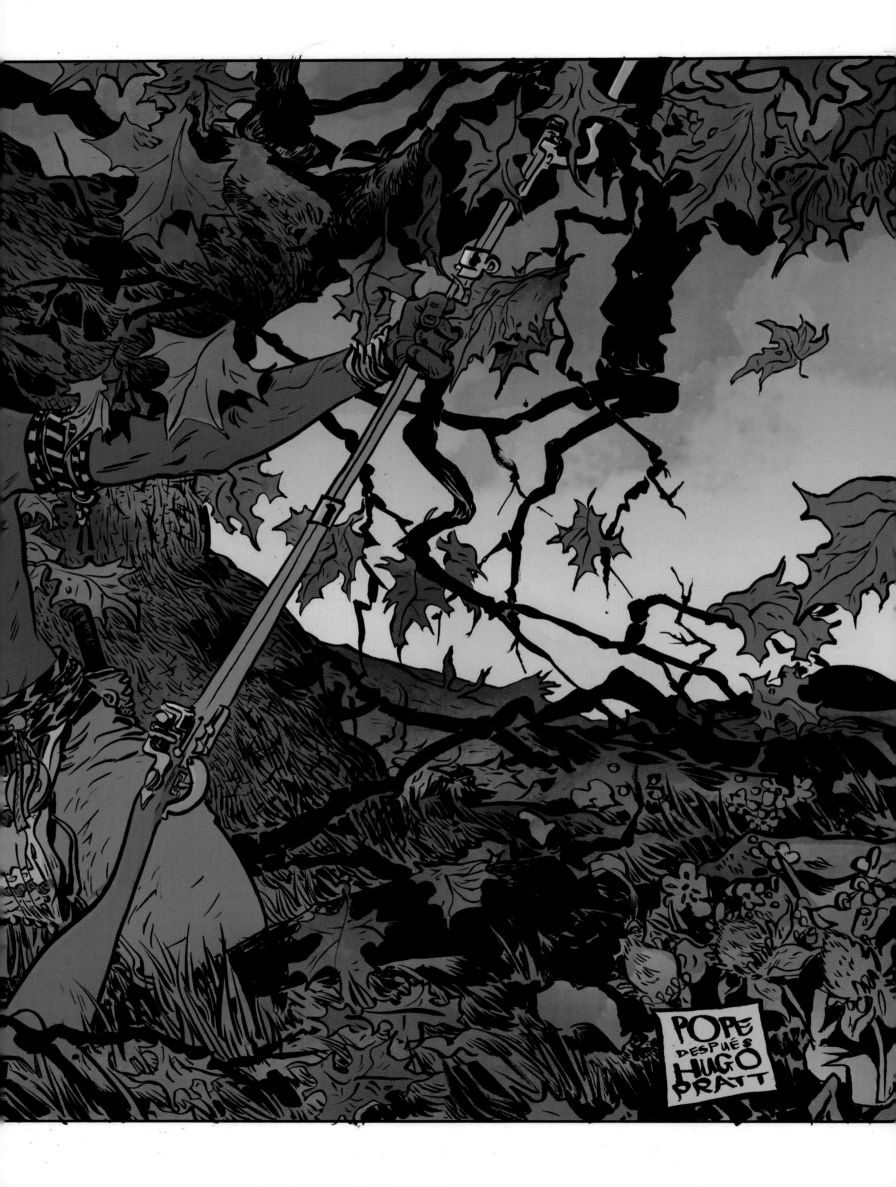

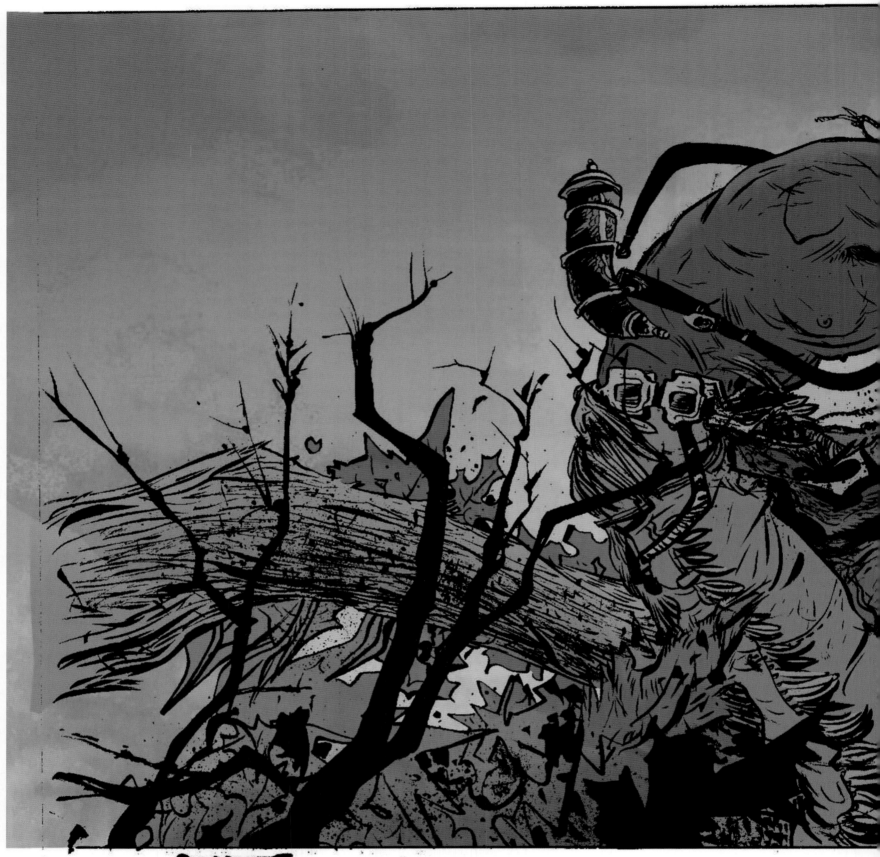

COMBAT.

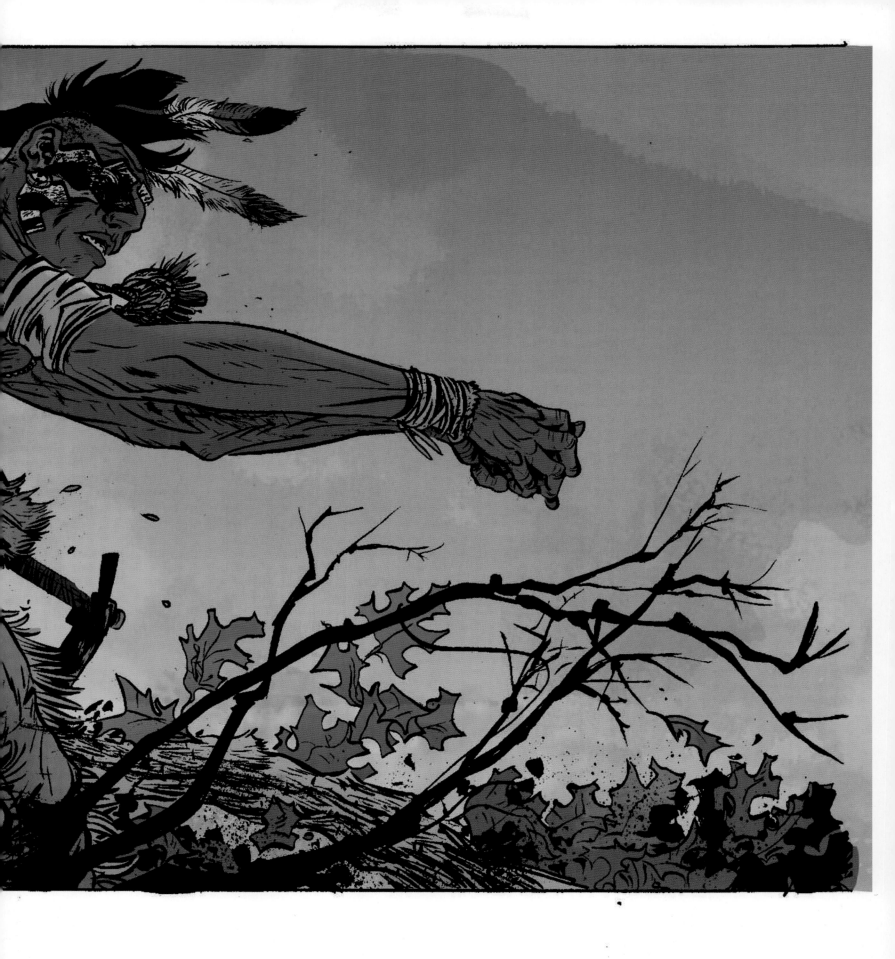

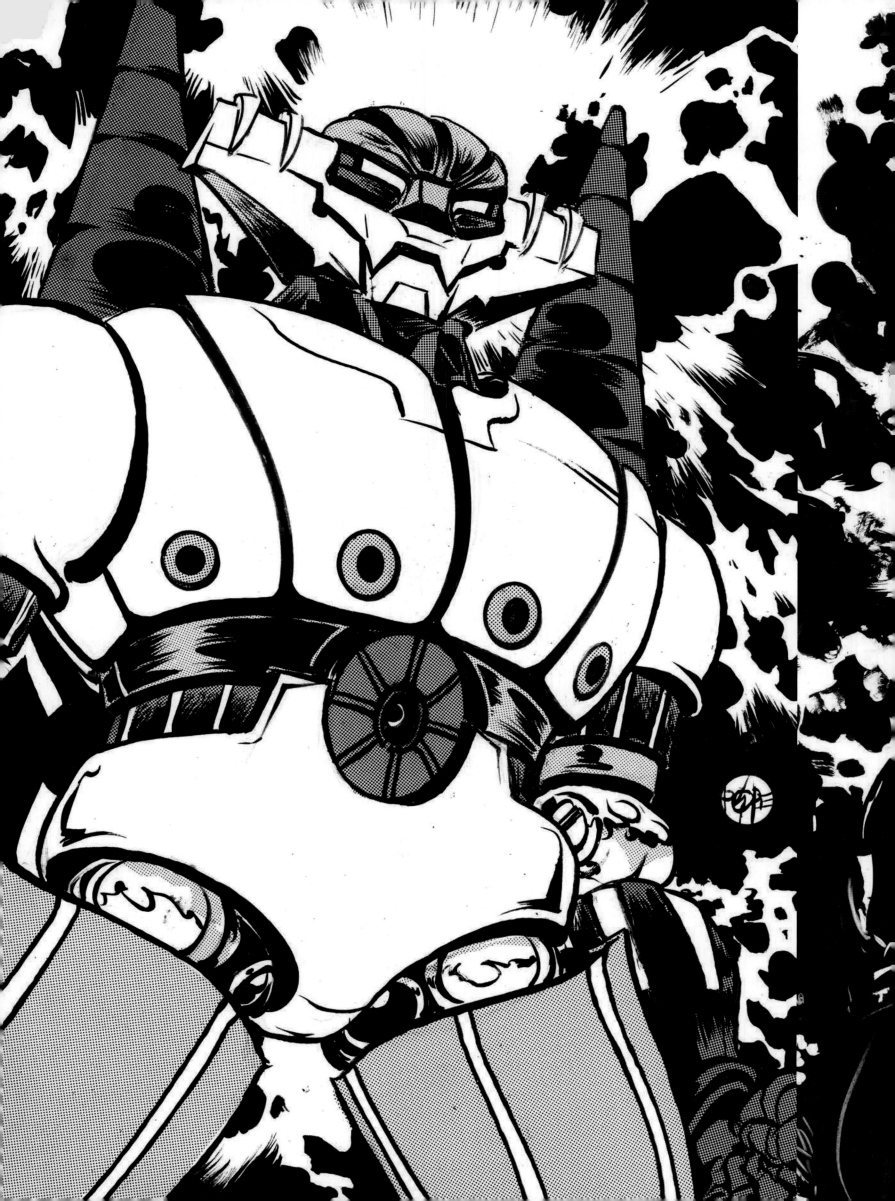

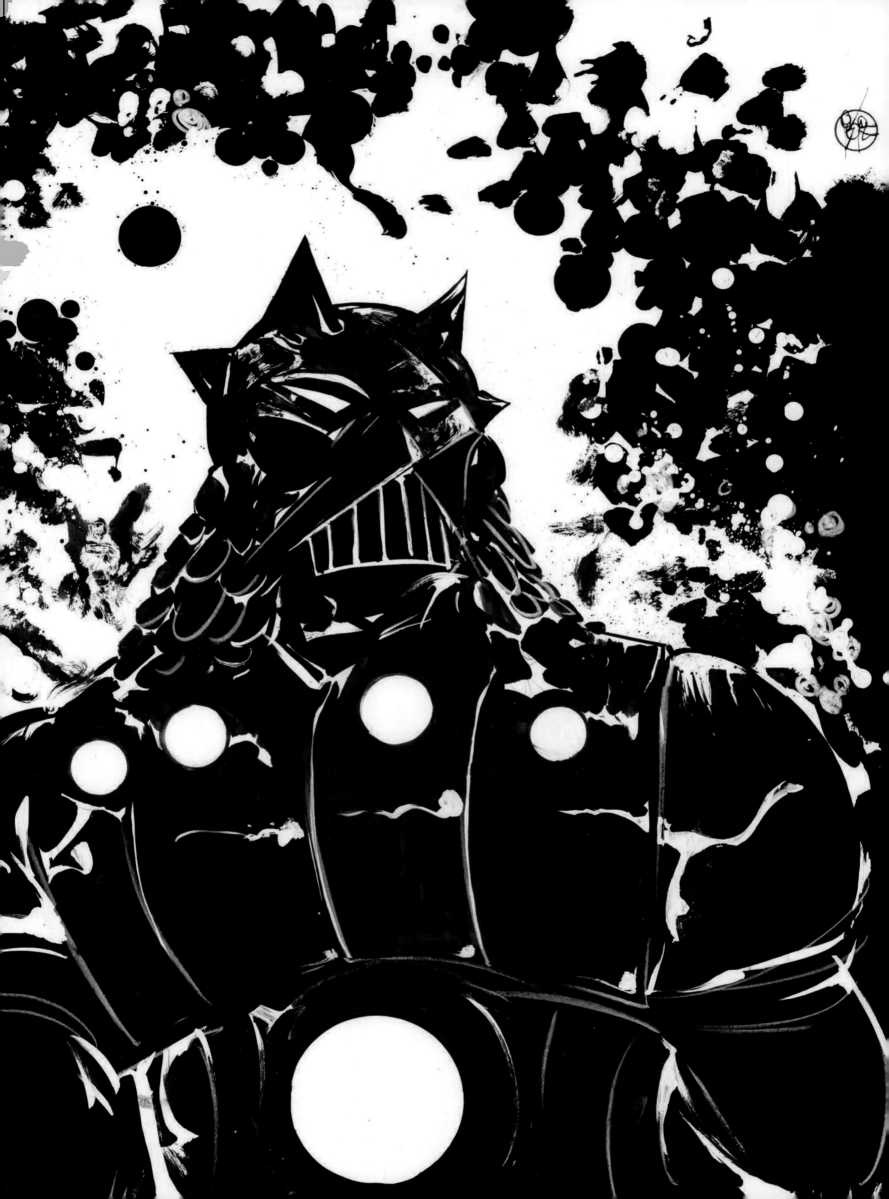

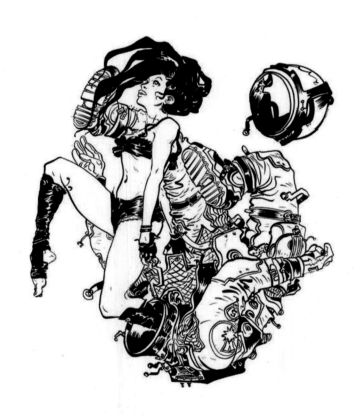

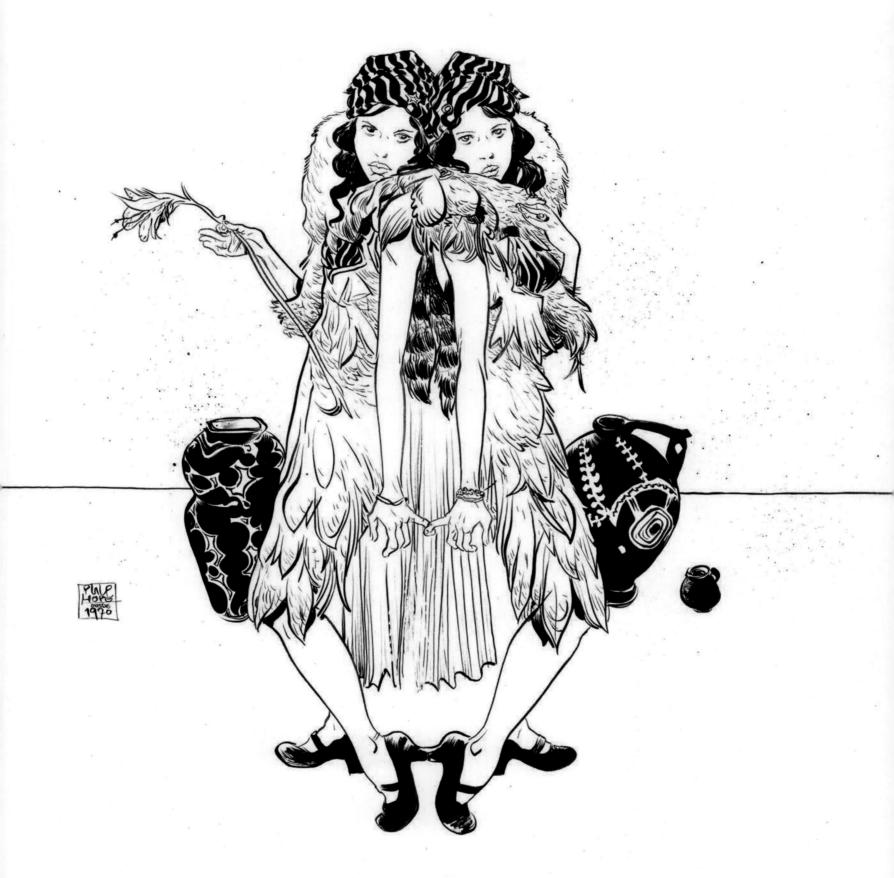

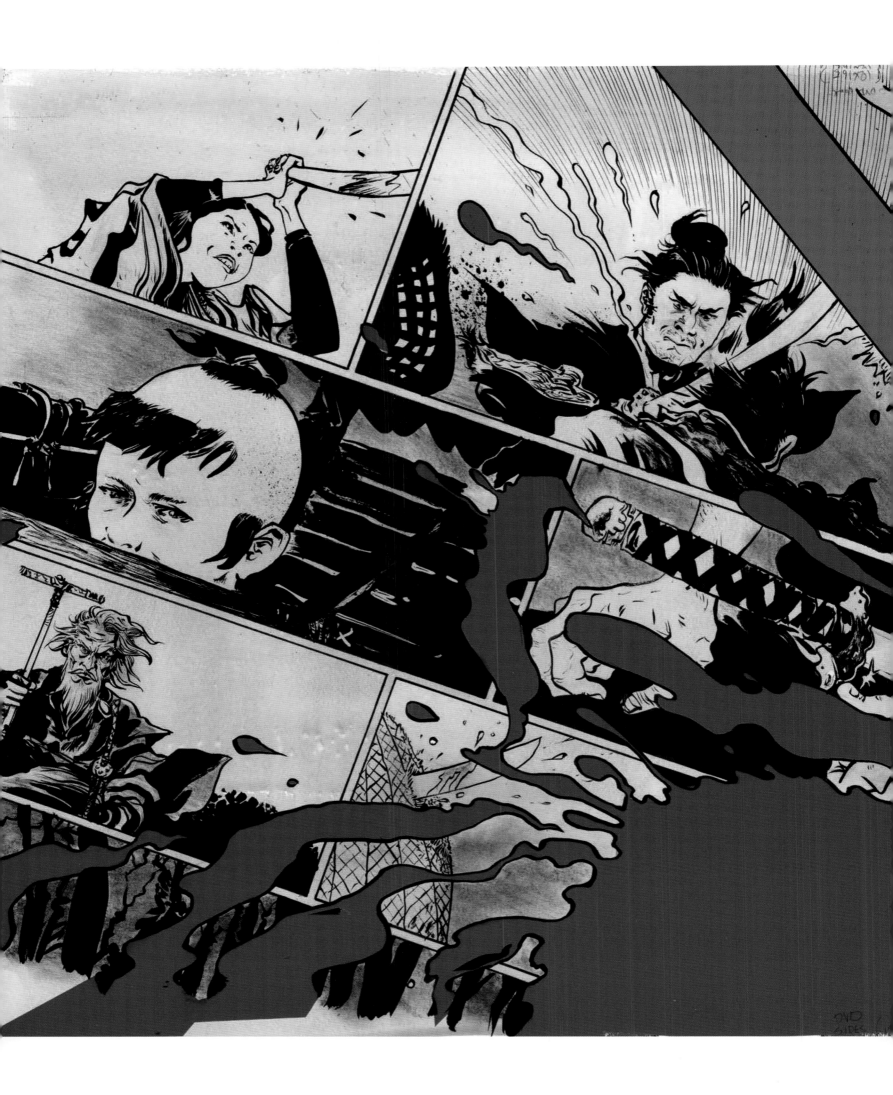

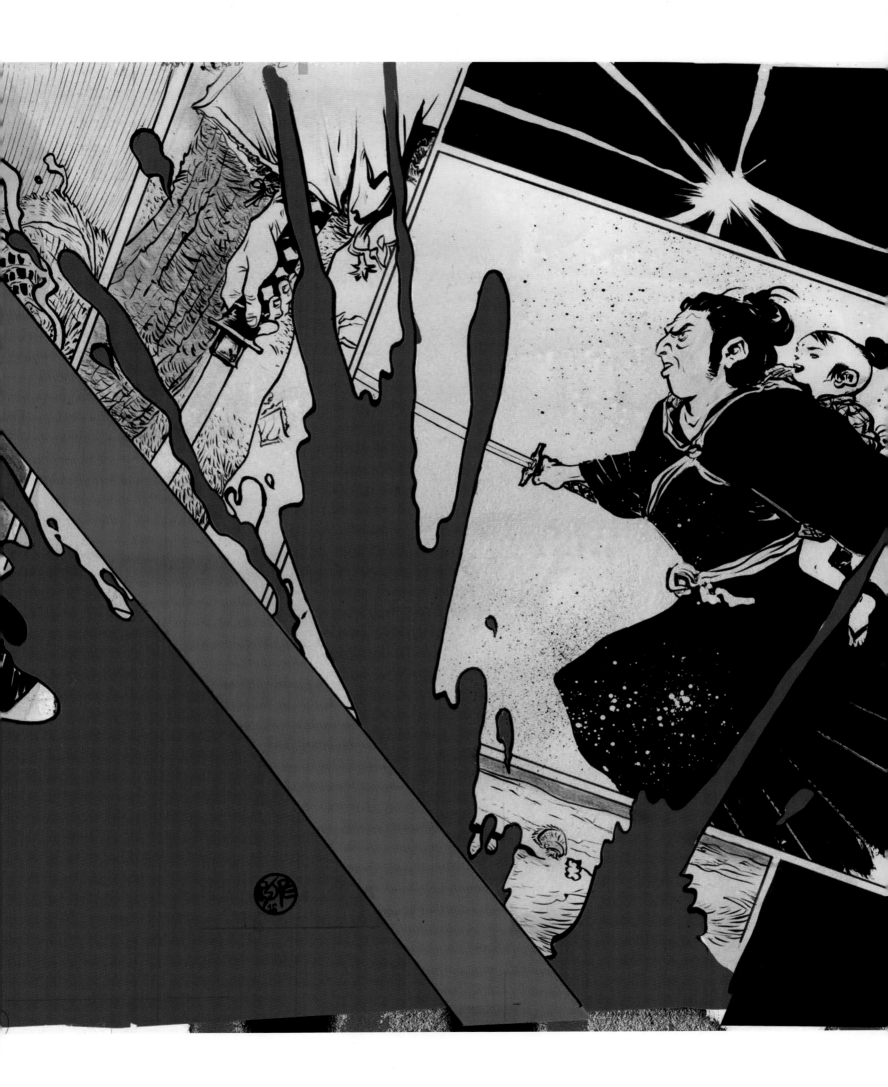

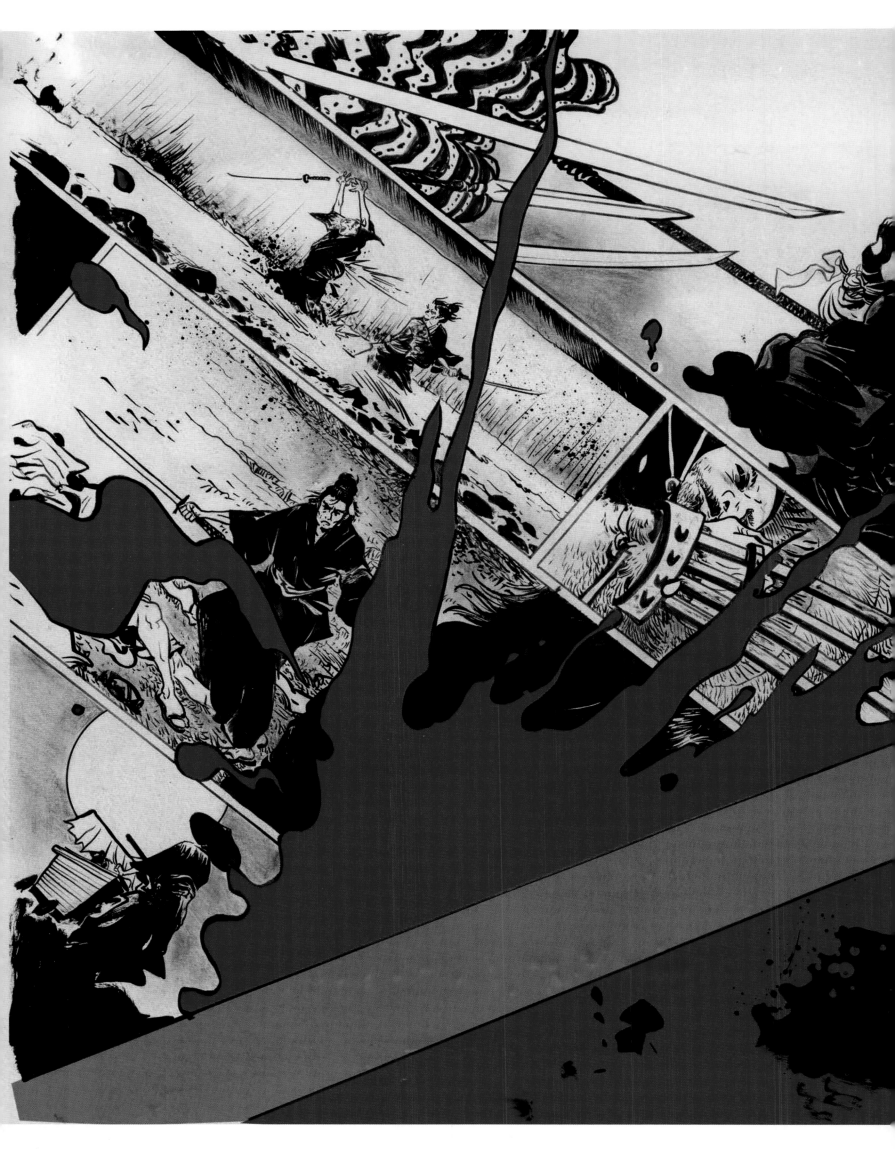

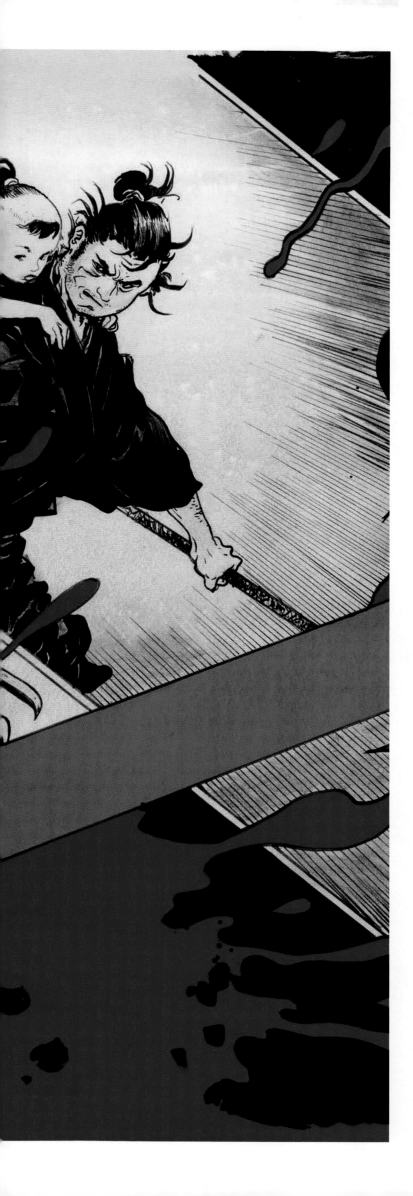

LONEWOLF+CUB #1
CRITERION COLLECTION

LONEWOLF+CUB #2
Criterion Collection

LONEWOLF +
CUB
DIGIPAK w/DISK

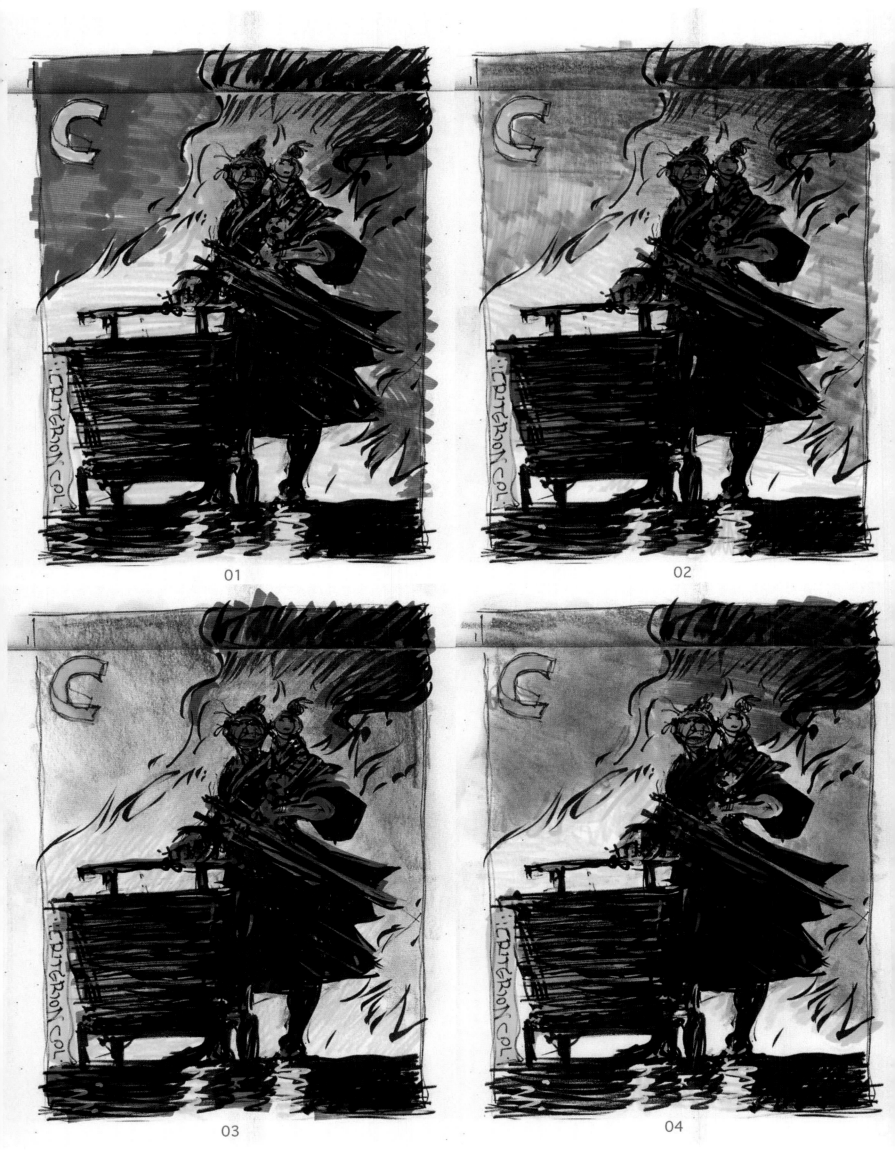

01

02

03

04

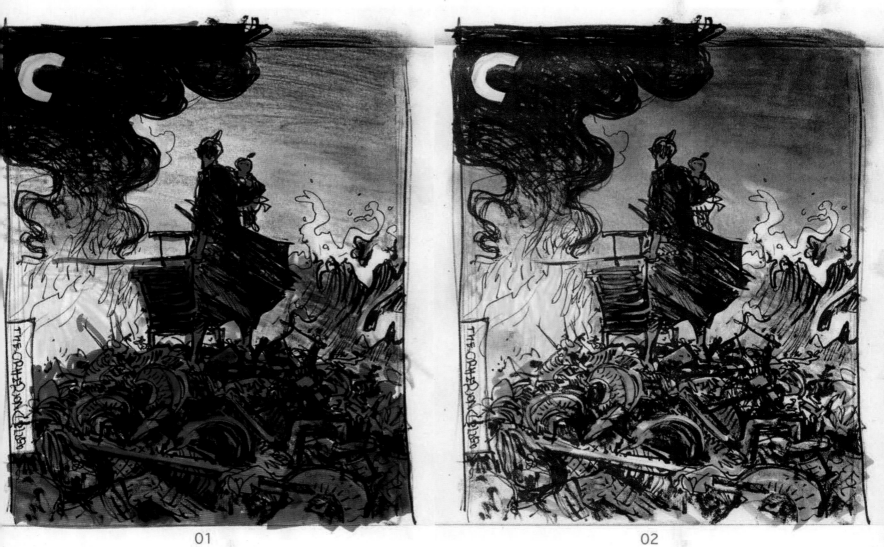

01

02

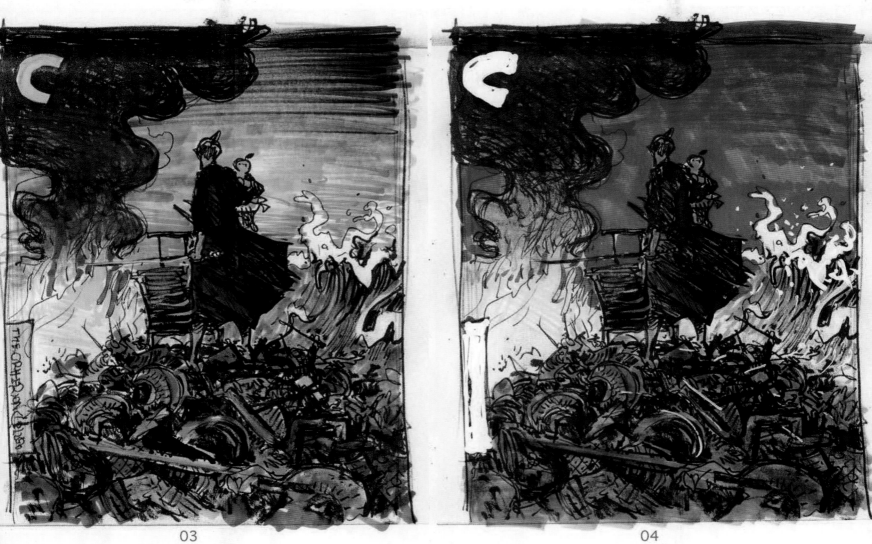

03

04

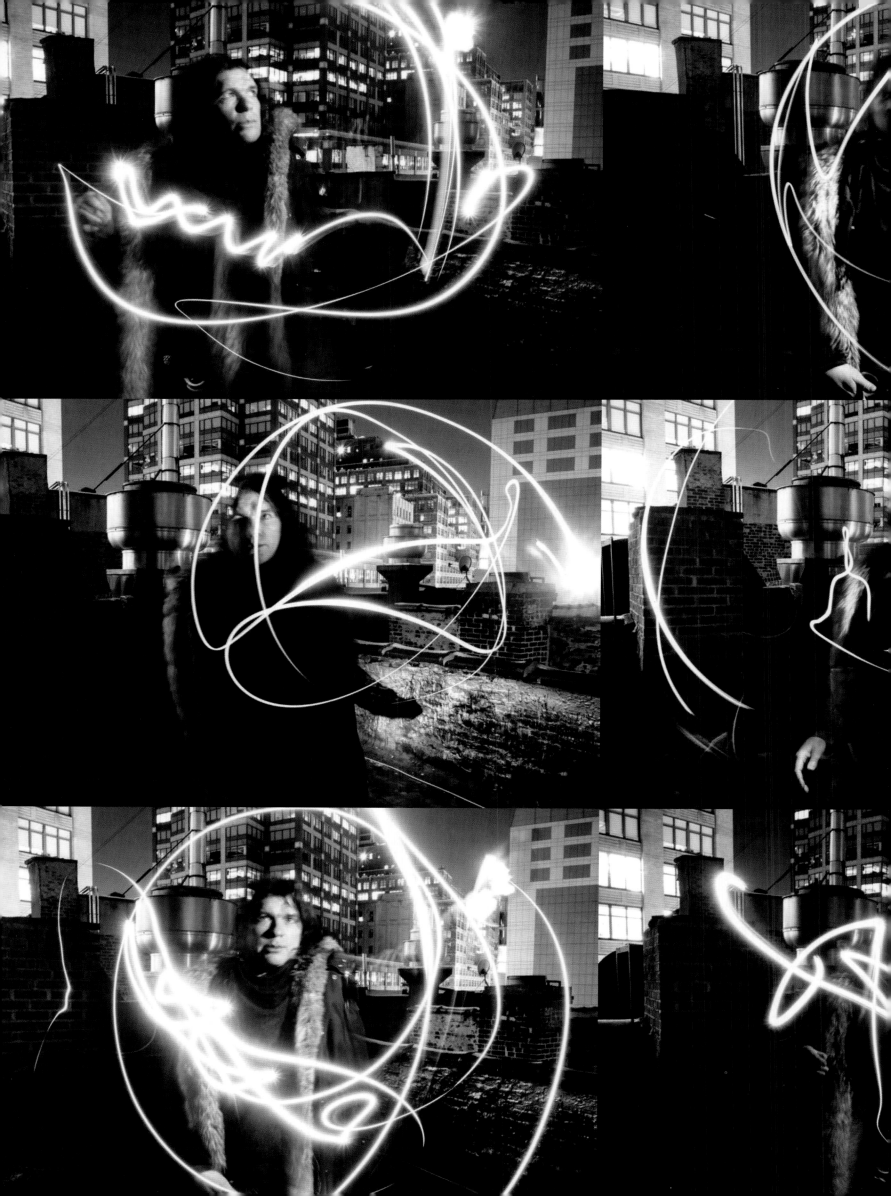

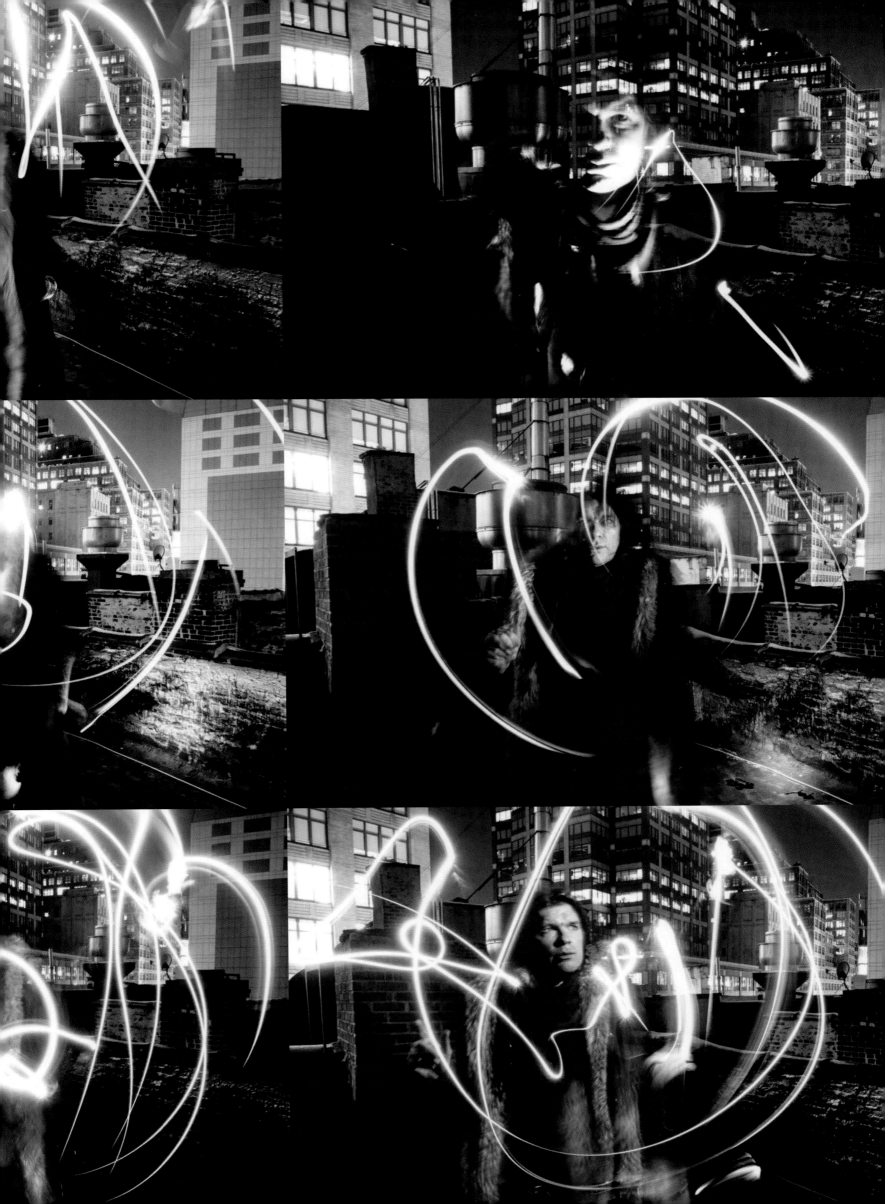

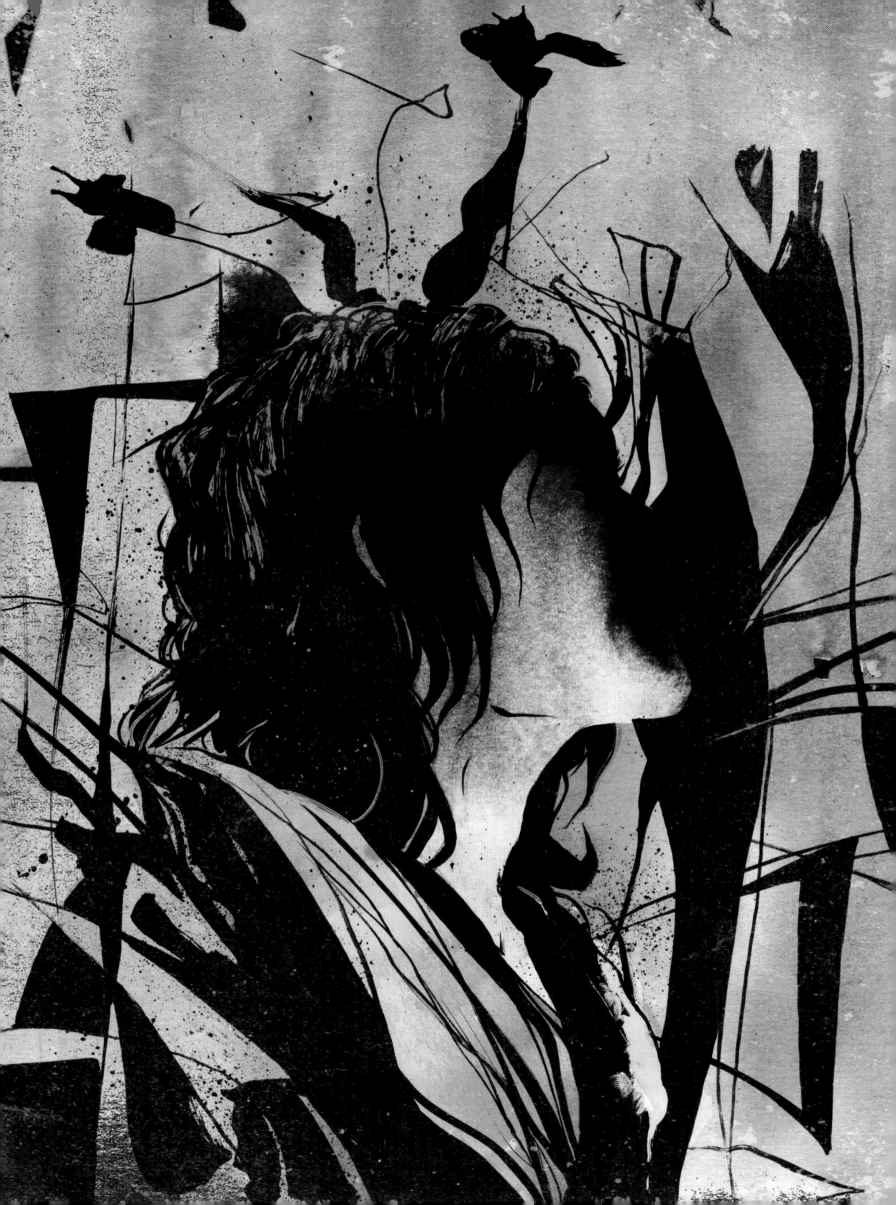

P02 (top) Thompson Street rooftop, NYC photo: Pope 2006 (bottom) Dobbin Street, Brooklyn (in the studio) photo: Andrew Foster 2017

P04-05 Queen Street, Toronto photo: Jennifer Bender 1997

P06-11 Kid Art drawings 1973-1976

P12 Self-Portrait with Kid Art, collage 2004

P13 Self-Portrait(s) 2024

P14-17 "1977" Best American Comics Anthology, Alison Bechdel editor, Houghton Mifflin Harcourt 2011

P18 Hess House personal drawing using Kid Art elements 2006

P19 Burp Gun (top) original Kid Art drawing 1975 and reassembled studies 2006

P20 (top) Shimokitazawa, Tokyo 1998 photo: Daisuke Akita, (bottom) CDG, Paris photo: Pope 2006

P22 Hunger Redux unpublished 2024

P23-28 THE TRIUMPH OF HUNGER (Arthur Rimbaud), Negative Burn anthology, ed. Joe Pruett, Caliber Comics 1993

P29-36 YES, Dark Horse Presents #100, ed. Bob Schreck, Dark Horse Comics 1995

P37 SMOKE NAVIGATOR, Buzz Buzz Magazine, Horse Press 1996

P38-39 Pope-Mek and Elephant-Mek THB Circus, Horse Press 1997

P40-45 THE ONE TRICK RIP-OFF, original series ed. Bob Schreck, colors: Jamie Grant, Image Comics 2011

P46 Dobbin Street Brooklyn (in the studio) photos: Andrew Foster 2017

P48 GIANT THB 1.2, ed. Pope, color/ logo design: RINZEN 2003

P49 TOKYO THB, unpublished drawing, Chiyoda Tokyo 1998

P50 GIANT THB PARADE, acrylic on emulsion film positive, Horse Press 1996

P51 WARHOL THB, unpublished 2022

P52-53 (left) NIGHT LIGHT, THB6d Horse Press/ (right) 2001. NIGHT LIGHT acrylic on emulsion film positive colors: Pope Visionaire Magazine, ed. Chris Bollen, Visionaire 2001

P54 THB CIRQUE, Horse Press 1997

P55 LIPSTICK THB THB:M3, Horse Press 1999 (colors: David Delloso 2023)

P56-57 RAGEOUS et CONTINUAE THB:M3, Horse Press 1999 (colors: David Delloso 2023)

P58 A BUGFACE THB6a, Horse Press 2000

P59 DIAMOND DOGS, unpublished 1999

P60 RADIO TOWERS Giant THB 1v.2, Horse Press 2003

P61 DESERT MUSIC THB6d, Horse Press 2001

P62 MANIFESTO THB:M3, acrylic on emulsion film positive, Horse Press 1999

P63 HIDDEN FACE (top) acrylic on emulsion film positive, Escapo TPB 1998 (bottom) Giant THB Parade 1996, both Horse Press

P64 concept sketches for THB poster set 2003

P65 THB poster set, color/design: RINZEN Horse Press 2003

P66 THB Circus, Horse Press 1997

P67 SQUAB Giant THB Parade, Horse Press 1996 (colors: James Harvey 2023)

P68 SUPERMEK THB6c, Horse Press 2000

P69 ELEPHANT-MEK Giant THB 1v.2, vector design: RINZEN, Horse Press 2003

P70 "I AM THE MOST HANDSOME" THB Circus, Horse Press 1997

P71 Parisian Rooftops, unpublished 1998

P72 HIDDEN FACE THB Circus, acrylic on emulsion film positive, Horse Press 1997

P73 UKIYO-E-POPE Dirty Stories, ed. Eric Renyolds, Fantagraphics Books 1997

P74-75 HR WATSON THB:CFM v.1, AdHouse Books 2007

P76 ESCAPO title page, Escapo (French ed), Editions Carabas 2001

P77 ESCAPO, acrylic on emulsion film positive, Editions Carabas 2001

P78-85 ESCAPO Giant THB (1996) and Escapo TPB (1998), Horse Press

P86 Dobbin Street, Brooklyn (in the studio) photo: Andrew Foster 2017

P88 SUPERTROUBLE title page, Morning, ed. Kenjiro Hiragashe, Kodansha Ltd 1996

P89-90 SUPERTROUBLE, Manga Surprise, ed. Kenjiro Hiragashe, Kodansha Ltd 1995

P91 SUPERTROUBLE, Morning, ed. Kenjiro Hiragashe, Kodansha 1997

P92 HEAVY LIQUID cover art (colors: Lee Loughridge) and sketches, ed. Shelly Bond, Vertigo/DC Comics 1999

P93 HEAVY LIQUID prelim pencils 1998

P94-95 HEAVY LIQUID cover art, colors: Lee Loughridge, ed. Shelly Bond, Vertigo/DC Comics 1999

P96-99 HEAVY LIQUID Heavy Liquid TPB (20th anniversary ed. remastered), colors: Pope, Image Comics 2019

P100-101 HEAVY LIQUID cover art (French ed), Editions Dargaud 2002

P102-103 SONNA-MA-GUN (portrait of Scott Mou) final inks and concept sketches, Heavy Liquid, Vertigo/DC Comics 1999

P104 HEAVY LIQUID initial proof-of-concept page #1 for Kodansha LTD 1996

P105-107 HEAVY LIQUID opening sequence pages #1-3, raw inks, Vertigo/DC Comics 1999

P108 100%, ed. Shelly Bond, Vertigo/DC Comics 2003

P109-113 FIGHT sequence raw inks, 100% Vertigo/DC Comics 2003

P114-115 THE COLLABORATOR, TANGLED WEB OF SPIDER-MAN, ed. Axel Alonzo, Marvel Comics 2002

P116-117 SLEEP portraits, 2000-2006

P118-119 100% wrap-around cover for the 100% TPB, ed. Shelly Bond, colors: Yuko Shimizu 2005

P120-121 (top left) wrap-around cover for 100% #1 (colors: Lee Loughridge), various concept sketches and line art, Vertigo/DC Comics 2003

P122-123 100% #5 wrap-around cover art raw inks and chartpak dot screens, Vertigo/DC Comics 2003

P124-125 FIGHT homage to Guido Crepax, 100%, Vertigo/DC Comics 2005.

P126-127 **GASTRO 100% (remastered TPB edition)** colors: Pope, Image Comics 2020.

P128-129 KETTLES/DAISY, 100% apparel capsule line, design/ colors: Josh Elowsky, Rock Roll Repeat 2020

P130 RODAN HEAVY LIQUID remastered 20th anniversary edition, colors: Pope 2019, Image Comics 2019

P131 100% lineart, Vertigo/DC Comics 2001

P132-135 KIM thumbnails and final art from 100%, Vertigo/DC Comics 2005

P136 Self-Portrait, Essex Street NYC (in the studio) unpublished 2003

P137 ALLIGATORS Escapo TPB, Horse Press 1998

P138 NICK CAVE promo art for The Boatman's Call, Hypno Magazine 1997

P139 COMICS DE-CODE afterparty flyer for live event 2000

P140-141 JSBX raw inks and published poster (details) for Blues Explosion/Yeah Yeah Yeahs/Liars tour, colors: Xylenol Studios 2002

P142-143 JSBX (details) for Blues Explosion tour poster, colors: Pope 2013

P144 RAVI studies of sitar maestro Ravi Shankar 2005

P145 WOLFCHILD portrait of Ian Astbury (The Cult) colors: Pope 2006

P146-147 RAQUEL raw inks and tour poster variants for Blues Explosion featuring Raquel Welch, colors: Pope 2011

P148 JIM portrait of Jim Jones, frontman of Jim Jones All Stars 2023

P149 EVIL EYE original cover design for Jim Jones All Stars' debut LP, Ain't No Peril. Colors: Lovern Kindzierski, Ako-Lite Records 2023

P150-151 NEBRASKA album art for Grateful Dead 1978 Red Rocks box set, Rhino Records 2016

P152 ISLE OF DEAD MUSIC (after Boecklin) cover art for Grateful Dead's "The Music Never Stopped" limited edition release, Rhino Records 2019

P153 CORVUS AND FALCON raw inks for Grateful Dead 1978 Red Rocks box set (featuring Jerry Garcia's Falcon guitar headstock and crow), Rhino Records 2016

P154 YOKO ONO personal crayon/ marker sketch, Sao Paulo 2018

P155 WATA design for Japanese rock band Boris 2022

P156 RAY HANSON (unpublished) drawing for Thee Hypnotics European tour 2018

P157 STOOGES cover art for PULP magazine, Viz Publishing 1999

P158 LE COLIBRI, a page from La Bionica (release date TBA), Editions Dargaud 2006

P159 SUPERMEKS poster design for THB, colors: Lovern Kindzierski, Horse Press 2018

P160-161 Sample pages for the Bande-Dessinée La Bionica, Editons Dargaud 2006

P162 (top) TRUE STORY, Project: Superior, AdHouse Books 2005

(bottom) OUVRE-AMOR from Psychenaut, Editions Dargaud (release date TBA)

P163 HARVEST MOON poster design Axelle Arts 2006

P164-165 SATOR AREPO from the Horizontal/Vertical series colors: Pope, unpublished 2006

P166 BLACKBEARD Fantastic Four study, unpublished, colors: Lovern Kindzierski, Marvel Comics 2005

P167-171 HORIZONTAL/VERTICAL unpublished personal drawings 1997-2006

P172 JELLYFISH apparel design for Bona Roba brand 2003

P173-175 KENJIN "octopus" silkscreen variants for Nakatomi Inc 2024

P176-177 DIESEL process art and final color design for Diesel Industries S/S 2007 Women's, Diesel 2007

P178-179 DIESEL poster design and process art for Melrose Ave Fall Fashion Week 2007 event for Diesel Industries 2007

P180-181 DIESEL poster design for Diesel Industries 2007

P182-185 2089 assorted insect wing patterns and placement graphics for Pope's capsule apparel line 2089, over 100 menswear pieces over two seasons for global market, colors: Pope, DKNY 2007

P186 CAN-CAN poster graphic for NYE event at Dove Parlour NYC colors: Pope 2007

P187-189 DKNY more placement graphics for 2089, colors: Pope, DKNY 2007

P190-193 concept sketches and final art for 2089 capsule line, colors: Pope DKNY 2007

P194 drawing of Neha over a tearsheet of Japanese poetry

P195 DKNY placement graphic (unused)

P196-197 more placement art for 2089, DKNY 2007

P252 KINGSNAKE screenprint for Metallica's North America tour 2019, Nakatomi Inc 2019

P253-255 CORTO homage to Hugo Pratt, colors: Omar F Abdullah (2024), unpublished, 2005

P256 SATYR concept sketch and final art for The Slipper Room, NYC 2013

P257 THEE HYPNOTICS concept sketch and final art for Thee Hypnotics' documentary film, Soul Trading, Phil Smith Productions 2018

P258-259 HOUSE OF MOORE two unpublished personal works, colors: Pope, 2006

P260-261 ADRIFT from Psychenaut, ed. Yves Schlirf, colors: Omar F Abdullah, Editions Dargaud (release date TBA) 2009

P262 IMA VEP/DIABOLIK unpublished personal works, unpublished, 2008

P263 STRANGE TALES cover inks for the Marvel anthology Strange Tales, Marvel Comics 2007

P264 LITTLE NEMO a page from Little Nemo: Dream Another Dream, ed. Chris Stevens and Josh O'Neill, colors: Jose Villarrubia, Locus Moon Press 2014

P265 KARIMBAH box art for The Masked Karimbah toy set, colors: Pope, Kid Robot 2007

P266-267 MEK-BOX design model sheets for the proposed Mek-Box 1:1 art object, colors: Shay Plummer, Kid Robot 2016

P268 INVISIBLE MEK design model sheets for the proposed Invisible Men 1:12 action figure, colors: Pope 2016

P269-271 PARVATI pages from the short story Consort To The Destroyer, colors: Shay Plummer, from the anthology The Tipping Point, Humanoids 2015

P272-273 CELESTIALS final colors and inks for the cover of All-New, All-Different Point One #1 Nezarr the Calculator Kirby Monsters variant, colors: Shay Plummer, Marvel Comics 2015

P274-275 METAL ILLIAD from the anthology, Once Upon A Time Machine, ed. Josh O'Neill, colors: Jose Villarrubia, Dark Horse Comics 2018

P276 HAGGARD WEST line art for The Death Of Haggard West #101 (a one-shot comic book), First Second Books 2013

P277 BLACK BOLT colors: Toby Cypress, Marvel Comics 2016

P278-279 JACQUELYN private drawing for singer/songwriter Jacquelyn Wells, 2022

P280 (top) Cynara, private drawing 2002, (bottom) Jodi, private drawing 2020

P281 (top) AOE, unpublished sketch 2019, (bottom) Neha in BCN, unpublished sketches 2023

P282 HEADPHONES line art for Pop-Gun anthology, Image Comics 2007

P283 NEHA private drawing of yogi/poet Neha Sharma 2021

P284-285 (top left) line art for the cover of MGZN #3, published by Happy Corp 2005 (bottom left) raw line art and (right) final line art for Guido Crepax homage screenprint "Justine", Nakatomi Inc 2007

P286-289 ALI two portraits of the Life Of Muhammad Ali, CBLDF Liberty Annual 2016

P290 LOGAN private commission 2017

P291 TURA SATANA poster design for Thee Hypnotics' UK tour 2018

P292-293 ZOOBALL line art and final screenprint for Zooball, colors: Tyler Skaggs, Nakatomi Inc 2021

P294-297 THE WILLOWS line art and final colors for the illustrated adaptation of Algernon Blackwood's masterpiece, The Willows, ed. Josh O'Neill, colors: Omar F Abdullah, Beehive Books 2019

P298-299 ADAN NO CEDE private drawings featuring plant and flower studies, 2006-2016

P300 GOOD MORNING a THB page for LAAB4 paper, colors: Ron Wimberly, Beehive Books 2021

P301 GIJON final poster art for the Gijon Animation Festival FICX 53, colors: Shay Plummer, FICX 2015

P302 ARZAK private commission, 2023

P303 M'UAD DIB private drawing, a study of a passage from Frank Herbert's Dune. Colors: Lovern Kindzierski, 2010

P304-305 SPIDER-MAN FAMILY covers for (left) Spider-Gwen, (right) Krenom, colors: Bruno Seelig, Marvel Comics 2019

P306-307 MEIFUMADO (left) concept sketches, and (right) final line art/inkwash for the Lone Wolf And Cub DVD Box-Set, ed. Eric Skillman, Criterion 2016

P308-309 YOKAI line art for two covers for Anthony Bourdain's series Hungry Ghosts (with Joel Rose), ed. Karen Berger, Dark Horse Comics 2018

P310-311 BARBARELLA two covers for the reboot of Barbarella, JC Forest's classic sci-fi series, (right) unpublished, and (right) published, colors by Vincent Nappi, Dynamite 2018

P312 ULTRAMAN, cover art and giclee poster design for WDW3 magazine, colors: Bruno Seelig, Holy Mountain Printing 2020

P313 TETSUO private commission, colors: Bruno Seelig, 2021

P314 MARV commissioned piece for the Deluxe edition of Sin City: The Hard Goodbye, ed. Diana Schutz, colors: Sean Spicer, Dark Horse Comics 2021

P315 ULTRA-MEGA cover art for James Harren's series of the same name, colors: Sean Spicer, 2020

P316-317 WILLOWS Smith (top left) The Swede (bottom left), and The Willows (right) from The Willows And Other Nightmares, by Algernon Blackwood, ed. Josh O'Neill, colors: Omar F Abdullah, Beehive Books 2019

P318 STRANGE ADVENTURES, private commission, colors: Bruno Seelig, 2022

P319 FRANK MILLER portrait of Frank Miller's drawing hand, poster design for the documentary film Frank Miller: American Genius, ed. Silenn Thomas, colors: Jose Villarrubia, Picturehouse 2024

P320-321 LIBERTY TREE commissioned poster for CBLDF Liberty Annual, colors: Bruno Seeling (2023), CBLDF 2014

P322-323 COMBAT private drawing, colors: Bruno Seelig (2023) 2006

P324-325 STEEL JEEG (left), private commission 2022 and BARON KARZA (right), private drawing 2017

P326-327 ZERO G (left), private commission 2016 and TWINS (right), line art for a screen print, Nakatomi Inc 2022

P328-331 LONE WOLF interior box art for the Criterion Collection Lone Wolf And Cub Box-Set, and (331 right) sketches for the DVD jewel case art, ed. Eric Skillman, colors: Pope, Criterion 2016

P332-333 LONE WOLF color sketches for the Box-Set cover art for Lone Wolf And Cub (no.04 lower right corner was approved for the cover design), colors: Pope, Criterion 2016

P334-335 LIGHTRAILS a photo portrait series by Gui Marcondes, using Pope's signature "light trail" effect, rooftop Broome Street NYC, Hazlitt Magazine 2022

PULP HOPE 2

PAUL POPE is an American artist/designer living and working in New York City. He has been working primarily in comics and screenprinting since the early '90s, but has also done a number of projects with Italian fashion label Diesel Industries and, in the US, with DKNY. His media clients include among many others Marvel Comics, DC Comics, Conde-Naste, Kodansha (Japan), Dargaud Editions (France), The Grateful Dead Estate, and The British Film Institute. In 2010, Pope was recognized as a Master Artist by the Atlantic Council Of The Arts. His short science fiction comic strip Strange Adventures (DC Comics)—an homage to the Flash Gordon serials of the '30s—won the coveted National Cartoonist Society's Reuben Award for Best Comic Book of the year. He has won four Eisner and one Harvey award to date and is a #1 New York Times best-seller.
https://paulpope.com/

STEVE ALEXANDER is a multi-disciplined designer and art director from California. Steve creates memorable collaborative and experimental work that plays with graphic design, animation, typography, light, sound, and video to create immersive and interactive exhibitions. He also designs books, fashion, and fonts. For over twenty years, he has curated the RMX series of collaborative art projects, exhibitions, and workshops. Steve's clients include Coach, Nike, Juxtapoz, MTV, Puma, Nylon, Absolut, Diesel, G-Shock, and many others.
https://stevealexander.design/

ANDREW T. FOSTER is an American visual artist living and working in New York City. A wide variety of interests in technology, performance, and media has led him on an eclectic career path including time as a freelance visual artist in photography, motion picture cinematography, aerial arts performer, international sports videographer, maker technologies artist, editor, and technology consultant. Andrew's still photography work of live nightlife events in NYC is well-known and has been published across many digital news outlets. Among many others, his clients include The New York Times, Hypebeast, BOOM! Studios, Image Comics, Conde-Nast, Garrett Brown's Moving & Talking Picture Company, Atlanta Olympic Broadcasting, NBC, FOX, the NFL, the NBA, and the NHL.
https://atfphotography.com/